Book Two in the Beyond Trilogy

Orbs and Beyond

Revelations from the Wider Reality

Katie Hall & John Pickering

6th BOOKS

Winchester, UK
Washington, USA

First published by Sixth Books, 2015
Sixth Books is an imprint of John Hunt Publishing Ltd., Laurel House, Station Approach,
Alresford, Hants, SO24 9JH, UK
office1@jhpbooks.net
www.johnhuntpublishing.com
www.6th-books.com

For distributor details and how to order please visit the 'Ordering' section on our website.

Text & images copyright: Katie Hall & John Pickering 2013
Website: www.lights2beyond.com

ISBN: 978 1 78099 382 9

A CIP catalogue record for this book is available from the British Library.

Title page painting copyright: Katie Hall 2010

Design: Stuart Davies
www.stuartdaviesart.com

Printed and bound by CPI Group (UK) Ltd, Croydon, CR0 4YY

We operate a distinctive and ethical publishing philosophy in all
areas of our business, from our global network of authors to
production and worldwide distribution.

CONTENTS

This book is dedicated to
Our families and dear friends,
who have shared in these experiences with us
and to the memory of our cats:
Oscar, Baggy and Thomas,
who brought us closer to the wonder of Life.
With thanks to all the friends who have shared with us
their own photographs and experiences.
Special thanks go to:
Jim Sherlock for his images of spirit healing;
Wendy for sending an angel;
Sara for Valentino;
Laura Campion and Julie Owen for their images of
motherhood;
Sandy for her friendship and thoughts;
Maybel and Sylvia for believing;
Fran and Mike for their enthusiasm and friendship,;
Annabel for her support and inspiration;
and to Ester Dove for just being there!

FOREWORD

This latest offering by Katie Hall and John Pickering on the nature of strange light phenomena, reveals even greater insight and evidence that we are not alone in this universe.

What these light-forms are, is still open to question; however, there does appear to be a kind of interaction and participation at some level, and you will come to this realization more and more as you read through this book, which takes us on an evolutionary journey from orbs to beyond.

Who are those beings of light?

What is the significance of Sirius?

Who is the mystical lady dressed in mauve?

Why is the symbolism of orbs so important for us all today?

Their first book, *Beyond Photography* created a stir across the country and this second book, in Katie and John's Beyond Trilogy, will excite and enthral readers even more. Generally we are so busy living in our three dimensional world, accepting what the 'experts' tell us about the nature of reality, that all crop formations were created by two old men with planks, or that orbs and ethereal light-beings are nothing more than dust particles on the camera lens, that sometimes we simply just miss the wonder and mystery that surrounds us. In *Orbs and Beyond* we encounter some of that mystery and wonder first hand, through all the astounding photographs and unique insights.

And here I can do no better than offer a quote from *Orbs and Beyond*:

"One positive thing about encountering anomalous or paranormal phenomenon is that it often provides a kick start to get us thinking out of the box; to look beyond what is commonly acceptable to see new possibilities; new horizons".

If this is the time for you to open your own mind and learn more about our 'other-worldly' neighbours, you will certainly be doing yourself a favour if you begin your journey by reading this book, for you will not be disappointed. In this personal account of their encounters with paranormal phenomena, well documented with astounding photographs, Katie and John have created a visually exciting book that is eminently readable, informative and inspiring. More importantly it is also a book that challenges us all at a spiritual level; this comes through very strongly in both their words and their amazing photographs.

Whether you are well informed or new to the subject of paranormal phenomena, this is a book that everyone should read; for every time you go back to it you will find something new! Following on from their innovative beginnings in *Beyond Photography*, the authors continue to break new ground, bringing new insights, and one wonders where all this is heading as we move further and further into the Great Mystery that surrounds us. Are we the observer or the observed? What is it that we are all part of; what is it that we are?

In *Orbs and Beyond* we are certainly given an intriguing and inspiring glimpse into new possibilities beyond the commonly accepted views of reality. This opens up a whole Pandora's Box of new questions about life and the cosmos.

Well done Katie and John for this truly inspiring and ground-breaking work. I am already looking forward to the Third Book in your Beyond Trilogy!

Mike Oram, author and lecturer.

Books by Mike Oram:
Does It Rain In Other Dimensions?
The Zen of Ben
Alien Interface
The Strange World of Jimmy Hayes

www.inotherdimensions.com
www.bens-world.co.uk
www.cafepress.co.uk/bensfunworld

PREFACE

For the benefit of any readers who may be approaching this subject for the first time, the term, "orbs", has become synonymous with the anomalous circular images which appear on photographs. There are many beliefs about what orbs may be, ranging from the gullible and ludicrous to the innovative and reasonable; equally there are also many sceptical misconceptions about orbs. Sadly some of these, just like the two old men with planks explanation for crop formations, have become instant *received wisdom* for the uninformed sceptics amongst us.

Our previous book, *Beyond Photography*, was first published in December 2006 by O-Books.

It was the first book in the world to document one couple's encounters with paranormal visual phenomena and to examine orbs in any detail.

When *Beyond Photography* was first published it included eight pages of full colour photographs, but because of increased printing costs it has not been possible to reproduce our images in full colour at this time, even though we have included many amazing new images. In our presentations we do show all our images in full colour; you can also see some of them on our website: *www.lights2beyond.com* and because we have had so many requests we will be creating a YouTube video which will include most of the photographs in this book, so do look out for that under the title of ORBS AND BEYOND, which is in effect also the Second Volume in our Beyond Trilogy, published by O-Books. The Third Volume: BEYOND REALITY is currently still being written and will be published as soon as possible.

From the start, we tried to understand the phenomena we were witnessing not only in terms of our own subjective experience but in the wider context of history, metaphysics and science. At the time neither Katie nor I had any idea of the effect

our book would have on our own lives or on the lives of many others around the globe. We had been given a unique opportunity to photograph and interact with incredible phenomena and we knew that the right thing to do was to share that with others. Since then, interest in orbs has mushroomed all over the world. Type "orbs" into Google and you'll find many websites on the subject, ours included: *www.lights2beyond.com*

Along with Ufology we now have what could be called, "Orbology" – and it seems that "orbographically" speaking, in New Age terms, orbs have arrived! This has had its positives and negatives for we must not forget that consumerism is just as endemic in the New Age as it is in mainstream society; with orbs, as with UFOs and Crop Formations, we must all be careful to distinguish between those opportunists who have simply jumped onto the bandwagon, and the accounts of genuine experiencers and researchers.

Phenomena such as orbs, crop formations and UFOs not only appeals to intelligent New Age believers and progressive thinkers they also unfortunately have a tendency to attract the lunatic fringe that inhabits the twilight zones of all major religions, beliefs: New Age concepts and progressive movements, whether spiritual or political.

For instance, at a recent conference we were approached by another speaker.

"I see you are going to be speaking about orbs. I know everything about orbs."

He then went on for quite a while pedantically expounding his own pet theory. Having once worked in mental health as a therapist, I inadvertently found myself slipping into therapist mode.

Then he said, *"Oh, yes, I can even create orbs and make them appear at will!"*

Duly impressed, Katie said, *"That's great, can you make one*

appear now?"

This seemed a reasonable enough request, because if I said to someone, *"I'm a cartoonist"* and they then asked me to draw something, I'd have no problem whatsoever doing so.

But our erstwhile orb expert obviously couldn't do what he claimed, as his shocked response was instantly, *"No! That's just tempting me to pander to your ego!"*

And off he went happy in the delusion that he really had all the answers to orbs and everything. The point of this little tale is that we have to be aware that self-delusion and ego driven thinking is often as alive and well in the New Age as it is in the media and religion! To be grounded it is important to realize that when it comes to paranormal phenomena – theoretical physics, parapsychology or the mystery of consciousness – we are all equally on a learning curve! Those who claim to know all the answers invariably do not understand the questions in the first place.

As much as we humans may know about life and the universe, the sum of our ignorance as a species massively outweighs our knowledge. Endemic to both religion and the New Age is a minority of people who claim to know all the answers, not just for their own life but for yours and mine! We have to beware that such people may not only be deluding themselves but sometimes, for whatever reasons, may be deliberately trying to deceive the rest of us as well. When it comes to the crunch, it is not what such people say that defines them, but what they do! Bluntly, if they cannot do what they claim, they are either deluded or deceivers.

To not be aware that deceptions exist is simply naïve. Recently someone sent us some photos taken at a wedding; every photograph had orbs, but it was instantly obvious to us that all these were faked; indeed they had been created by an App that you can now get for your mobile phone to jazz up your images with orb-like effects. Not that they are convincing or meant to be, but in

that context I feel impelled to point out here that our images have not been artificially contrived and apart from being lightened in some cases, the photographs are exactly as we took them. In the few instances where we have used photo-enhancement this is clearly stated. But when O-Books decided to publish *Beyond Photography*, I did wonder if, as we were both artistic, this would be more likely to incline sceptics to think we had created the images in some way? Of course we could have equally been gardeners or accountants. Those determined to be sceptical, come what may, will invariably seize on anything to try to deny what they don't like, or find uncomfortable. The fact is orbs are photographed by all kinds of people with all kinds of cameras. Our own experiences and photographs are simply part of on-going worldwide phenomena. However, we must all be aware that practically anything can be faked: UFOs, Crop Formations, Ghosts etc, especially today with digital technology. The popularity of "ghost hunting-type" TV programs has inevitably resulted in facts being bent and so called "paranormal events" being faked for the sake of entertainment. Yet even so this has resulted in raising the profile of genuine paranormal events. The mobile phone orb App that has appeared since *Beyond Photography* was published may be a testament to the popularity of orbs in the general consciousness, but we have to question, apart from harmless entertainment, why would anyone want to try to fake orbs? It is after all a bit like sticking on a false moustache when there millions of people with real ones!

That fact that something *can* be faked does not mean that it *is* faked! All we know from our own experience is that the phenomenon we have photographed is the tip of the iceberg: photographs in themselves are not conclusive proof, but they are definitely visual evidence. Put together with thousands of similar images from all over the world taken by old SLR film cameras, digital, video and CCTV cameras and mobile phones, such images are, we believe, indications of a wider reality inter-

facing with our own.

In any honest examination or investigation into any phenomena, natural, scientific, paranormal or otherwise, finding the truth should be our goal, not bending data to fit previously conceived theories or beliefs. No matter how much we may cherish our pet theories! Fortunately when we began our study into orbs and other related phenomena we approached the subject with good advice from the late Carl Sagan firmly in mind: that of keeping a balance between scepticism and wonder! We also have to remember that all experience, especially paranormal experience, is subjectively perceived and translated by the individual experiencer. In that context all we can do is share with you our experiences, our photographs and our own questions, opinions, beliefs and speculations. Essentially this book reflects a personal view of encounters with what we term a "Beyond Reality"; hopefully we have presented this as reasonably and as interestingly as possible.

We sincerely hope that you will find the astounding images in this book, as thought provoking and inspiring as we do.

Katie Hall & John Pickering 2013

PART ONE

ORBS IN FOCUS

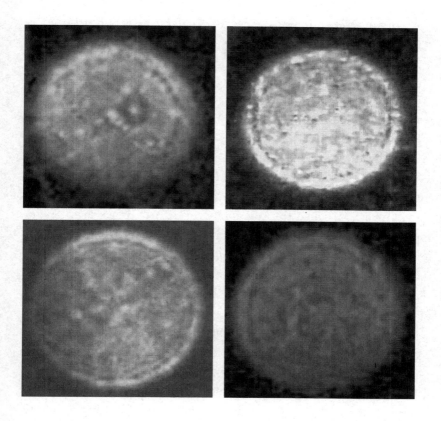

A brief but comprehensive overview of the orbs phenomenon
for both past readers and also for those
who have come to study this subject for the first time

AN INTRODUCTION TO
A PHENOMENON

As mentioned, our book, *Beyond Photography* was not only the first book to examine orbs in any detail, it was also the first book in the world to photographically document one couple's encounters with a wide spectrum of unfolding paranormal phenomena. This included, *Orbs, Luminosities, Light Rods, Light-Forms and Light Beings*. We must stress again that although we applied terms to all the phenomena, such terms are descriptive only – not definitive!

ORBS AND BEYOND is divided into two distinct parts. Part One: Orbs in Focus, deals specifically with orbs and is the shorter of the two, because the phenomenon of orbs is covered extensively in our previous book. Part Two: Beyond Realities, deals specifically with events and phenomena beyond orbs, and includes experiences and new photographic evidence that only occurred after the publication of *Beyond Photography*.

In ORBS AND BEYOND we have included many images never before published and have tried to convey both the mystery and the wonder of our experiences, which still continue to unfold.

Over the years we have had to question many things: not least the nature of what exactly it is we were photographing and how it was possible for us to photograph paranormal phenomena in the first place. Our personal experiences with unusual phenomenon began many years ago, when we were both only children. Our quest into the paranormal for both of us is essentially a personal one: to try to gain more understanding; to discover the truth – whatever that may turn out to be.

All the extraordinary events leading up to this present moment have been like the focussing of a lens in which things which were once hazy, have come into sharper focus.

In retrospect it seems rather synchronistic that at the very same time we ourselves were questioning the phenomenon manifesting in and around our home in the United Kingdom, across the other side of the Atlantic in the USA, similar photographs of orbs were being taken and similar questions asked by other researchers. *The Orb Project*, by Miċeál Ledwith and Klaus Heinemann was published the year after our own *Beyond Photography*. More recently, and in my opinion the best book so far on orbs to come from the USA in the past few years is the great book by Sandra Underwood, *Orbs, Lightwaves, and Cosmic Consciousness*, which we thoroughly recommend.

From both sides of the Atlantic, orbs have now entered the public perception. All over the world today awareness of paranormal phenomena is increasing. This has both positive and negative aspects for the search for truth, because popularising anything can easily blur the distinctions between fact and fiction; opportunism and marketing forces are, as we have all seen in the whole 2012 debacle, as alive and well in religion and the New Age as in mainstream business.

Once the existence of orbs had filtered into the "New Age consciousness" it was almost inevitable that someone with an eye on the market would link orbs to angels or faeries – or even aliens. Orbs appear in various colours, and some have attached (bogusly, I think) a significance to this and have related the colours of orbs to the colours (so far unproven) of certain angels. From there it was only a small step to then state categorically that orbs *are* angels!

Now, there is nothing wrong with someone *believing* that orbs *may* be angels, but to be dogmatic about this seems to me less than intellectually honest in the circumstances. The exact nature of angels is open to question anyway and there is no evidence whatsoever that certain colours in the spectrum relate specifically to particular angels. It's all purely arbitrary, and in some cases complete fiction; we may as well believe that all red orbs

are Santa's elves or that different colours relate to various flower faeries or that grey orbs are alien greys. Although the New Age movement contains some progressive concepts and cutting-edge thinking, we must all be aware that it also contains some very fuzzy thinking and largely unfounded notions often incorrectly claimed by some to be the incontrovertible truth, about Orbs, UFOs, Crop Formations or whatever. Dogmatism is just as alive and well in some areas of the New Age as it is in fundamentalist religion; we all need to be careful to keep that balance of wonder and reason. Today there is much "received wisdom" as to the meaning of life and events coming not only from the tabloids but also from certain popular gurus and channellers who just like some professional debunkers, make a business out of being right all the time about "spiritual" or "paranormal" matters. In the whole area of metaphysics and paranormal phenomena too many tenuous opinions are purveyed as facts to the unwary. The fact is there are far more opinions than there are facts – and that is a fact!

This is why we have been careful in our presentations and in this book to place clearly our views, insights and opinions within the context of our own subjective experiences, both as intuitive individuals and as rationally inquiring human beings. We claim no supernatural assistance; neither do we know all the answers. Our quest is the human quest; it has both a rational and a spiritual dimension, and that is true for every one of us; we are each on our own individual journey through the mystery and wonder of Life.

Over the past seven years we have photographed an unfolding phenomenon which although it began with orbs has included, Luminosities, moving columns or Rods of Light, swirling, dynamic Light-Forms, and Light Beings; but throughout it all, orbs have been the one consistent factor.

This book is not only an account of our personal experiences

and speculations, it is also intended to be an informative guide to the whole phenomenon of orbs. So before we proceed further here is a quick summary of Seven Common Aspects of the Orb Phenomenon, as we see it:

1. The most notable aspect of orbs is the consistent ubiquity of the phenomenon. Thousands of individuals all over the world are photographing the same phenomenon with different cameras in widely different conditions.

2. The vast majority of orbs cannot be adequately explained in prosaic terms, i.e. they are not dust, moisture, digital errors or the planet Venus etc.

3. There is reported evidence of a definite interactive aspect to orbs and luminosities, often relating to people as specific individuals.

4. In psychological terms the circular image of the orb recalls the archetypical symbol of Unity and Oneness. Coincidentally this symbolism is appearing at a time when the concept of Oneness is critically meaningful to us in planetary terms, and is also particularly significant in light of the new perspective of a connective reality underpinning our physical universe.

5. Orbs cross faith and cultural boundaries. All across the planet interest in orbs is increasing by people of all beliefs – or none at all.

6. Incidents of synchronicity are regularly reported as being experienced by many who photograph orbs and luminosities.

7. Many individuals from a variety of professional backgrounds report both purpose and intentionality associated with the visual phenomena.

In Part One we shall examine each aspect of the orbs phenomenon through our photographs and experiences. Some of

this is covered in our previous book, but here you will also find much that is new, as here published for the first time, are many events and photographic encounters that happened well after *Beyond Photography* was published.

The Study of a Phenomenon

As mentioned some of this is covered in depth in *Beyond Photography* but before we take a step beyond orbs we must, for the sake of continuity, begin with an overview of orbs as we have come to understand them through our own experiences, research and photographic encounters.

From the context of our study of the orbs phenomenon we divided it into two basic categories:

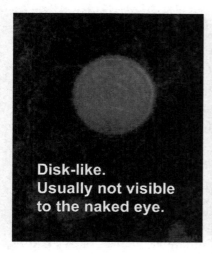

**Disk-like.
Usually not visible
to the naked eye.**

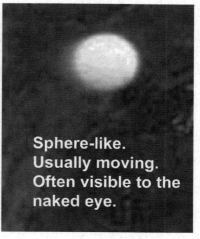

**Sphere-like.
Usually moving.
Often visible to the
naked eye.**

In our experience, orbs are part of a wide range of interconnected anomalous phenomena which includes *Orbs, Luminosities, Light Rods, Light-Forms and Light Beings.*

In endeavouring to convey the essence of what we have photographed, as we perceive it, we have of necessity used various terms such as Sprites, Light Beings etc, but please bear in mind that the terms we use in relation to this phenomena are descriptive – not definitive. We are all on a learning curve in the area of paranormal phenomena. In that context it is only sensible for us all to hold our personal beliefs and speculations on an

open hand.

Some people will wrongly tell you categorically that orbs are angels, aliens, spirits of the dead, unborn spirits etc. These are all beliefs or opinions: not facts! They may or may not be correct.

All we can honestly say is that so far nothing in our experiences or study of this phenomenon incontrovertibly confirms any such views or beliefs. In fact the indications seem to be that orbs can be seen as manifestations of any of the above, or none of them!

We cannot tell you what the paranormal is anymore than we can tell you what God is: all we can do is share our views, experiences and photographs. This does not mean that we know nothing, in fact through our experiences and photographs we have learned much that is of value about the paranormal in general and we shall be discussing some of that later in this book. However, whatever views or opinions we each may have about paranormal phenomena, we should always be ready to revise or modify those views: for the paranormal, like the quantum universe, is never exactly what it may seem and is always full of surprises.

As mentioned in our first book, *Beyond Photography*, we began by sceptically questioning the nature of the orbs that appeared on our photographs; we tried to eliminate all natural causes before we moved on to examine the possibility of some kind of paranormal association. This took both time and patient examination and comparison of hundreds of photographs and the conditions in which they were taken. For example, we did not do any screaming or running around such as you may have seen in some psychic entertainment programs on TV; it is impossible to do serious research into psychic or paranormal phenomena in such circumstances.

A year after *Beyond Photography* was published by O-Books in 2006, another book, *The Orb Project* by Miceal Ledwith and ex-NASA scientist, Klaus Heinemann was published in the USA, this

qualified our own view that genuine orbs were the interactive indications of a wider reality interfacing with our own. This is not just about the photographs but about the reality of a ubiquitous phenomenon seen and experienced by people all over the world. In our case, as with many others, this has gone far beyond the photographs, and has in effect informed and changed our own lives in ways that would not have happened otherwise. Certainly in our experience of this phenomenon the associated synchronicities have been so many and so accurate that pure chance seems extremely unlikely as an explanation. In line with the late Carl Sagan's eclectic approach to science, our own experience in studying the phenomenon of orbs qualifies that by being open to both wonder and reason we may all learn something new.

This is a point made in our Ben's World cartoon, as in this strip below:

Sometime we may be just walking along, minding our own business, when for no apparent reason a piece of the universal puzzle falls right in our path. When that happens, whatever it is, we can choose to ignore it or to walk round it – or we can choose to try to figure out where it fits. Whenever we do that, as puzzling as it is and as incomplete as our answers may be, we are no longer mere bystanders in Life, but active participants in the mystery and wonder of Existence!

This is essentially where we are in relation to the question of orbs: what are they really, what do they mean? How do we fit the

orbs phenomenon into what we know about life in general: our own experiences and the experiences of others. Then there are the wider questions of how something like orbs fit into what we may know of physics, the paranormal or consciousness. No phenomenon whether normal or paranormal exists in isolation; whatever it is and however it manifests, it is always connected through many levels and in many different ways to everything else that makes up Reality as we all experience it. But this of course does not mean that our current scientific or rational paradigm of Reality can explain everything – of course it cannot, for science as methodical and precise as it may be, only offers the best approximation of what is. It is always subject to updates and modifications. Once a scientific view of the Universe becomes moribund and un-bending it ceases to be scientific progress and becomes the same kind of dogmatic orthodoxy you find in some religions. We humans are capable of lapsing into static thinking about a whole variety of things: orbs and the paranormal included. We have probably all met such people at conferences: those who know all the answers, or have a rigid view of science, religion or what constitutes truth about anything and everything! The fact is there are always more opinions than there are facts, especially in relation to paranormal or spiritual matters – and that is a fact! If you don't believe it, check it out!

Some people just want to have everything tied up in a neat package labelled, The Answer to Everything! Unfortunately real life is not like that; as Charles Schultz, creator of the famous Peanuts comic strip, once remarked through his erstwhile hero, Charlie Brown, *"In the book of Life, the answers aren't in the back!"* Whether we are believers or sceptics we still have to keep that balance of wonder and reason to stand a chance of discovering the truth about orbs, but even then, as in quantum physics, we always have to allow for the unexpected.

Sceptical Misconceptions

The worst kind of sceptic is not one who intelligently disagrees with you but the one who is both opinionated and uniformed. There have been many sceptical misconceptions about orbs; a wide spread misconception amongst uninformed sceptics is that orbs are only photographed by digital cameras. This is a complete fallacy. Orbs have been photographed by all kinds of cameras: film, digital, analogue video, even by mobile phones and CCTV!

The fact that the majority of people photograph orbs with digital cameras today is solely due to the proliferation of digital technology. Another sceptical misconception is that orbs are merely the result of CMOS errors in digital cameras; this in totally incorrect. The fanciful notion that the same digital error affects every make of camera in the entire world causing them all to photograph orbs, is as unlikely as every Crop Formation in the world being made by two old men with wooden planks! Interestingly we had our first digital camera for two years; we took hundreds of shots but never photographed even one single orb with that camera! If orbs are a digital effect then one would have thought that we would have photographed them as we were then taking shots of similar subjects in the same places in similar conditions as we did later photographing orbs with different cameras!

Recently at a conference we met a professional photographer who had the latest Nikon digital SLR. He pointed out that according to the sales pitch this camera would *not* photograph orbs and said that he had never taken orbs with any camera and so was understandably sceptical.

Even so he listened patiently as Katie presented our photographs and related our experiences. Half jokingly he asked how he too could photograph orbs; Katie advised him to just ask! He said he'd give it a go but he had no real expectations. However, the very next day he was back to excitedly show us the

photographs of orbs he had taken the night before with a camera that was advertised not to photograph them! This is but one of a number of similar instances we have encountered on our travels.

There is more to orbs than meets the eye

If as sceptics claim they are simply a product of digital photography, why are they discovered on film negatives by people looking back through their old photographs? The fact is orbs seem to have been around a long time, and as we shall see later they go back to before the earliest days of photography; when it comes to orbs we have learned to expect the unexpected!

Orbs Before the Digital Age

Orbs and other strange luminosities have been with us for a long time, much longer than digital cameras or even photography itself, as shown by this Woodcut of mysterious spheres over Basle in Switzerland in 1566.

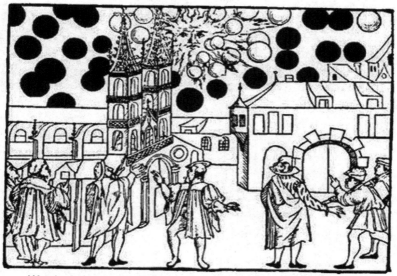

Woodcut of strange globes seen in Basle, Switzerland, August 1566

Interestingly a few hundred years later Basle was the location for the enigmatic shot below left, one of the earliest photographs of a strange orb-like luminosity. This was taken in the Zoological Gardens in Basle in 1907. Compare this with the photograph opposite it, which is a shot of a similar luminosity taken by us in our garden in 2004!

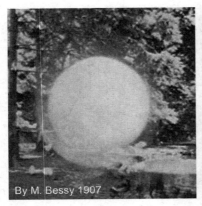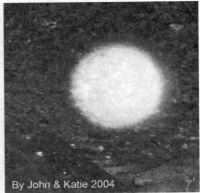

By M. Bessy 1907

By John & Katie 2004

There is a long-standing continuity to this phenomenon and today orbs are seen by many as a worldwide phenomenon with paranormal implications. That orbs have impinged on human consciousness as well as the camera is witnessed to by both myths and legends and also by some early science stories involving strange orbs and spheres.

Orbs in The World Beyond the Camera

Most sceptics totally ignore the implications of the visual evidence, especially those convinced that orbs are the result of digital errors. As some of the photographs we, and many others, have taken show orbs have appeared behind objects – and anything behind an element in a photograph is clearly part of the world outside of the camera and therefore not the result of some nebulous digital malfunction. Even if you don't believe orbs to be paranormal it would seem highly unlikely in the extreme that all orbs are the result of some vague digital error that affects all makes of digital cameras in the world. This seems much less reasonable than orbs simply being paranormal phenomenon; plus the fact that orbs appear behind elements in photographs completely cancels out digital malfunctions as a valid explanation anyway.

We have often photographed orbs behind objects and people: for example, here below on the left is one behind our coalscuttle in the front room. One weekend Katie's son Dan came over and earlier that day, being a photographer himself, he'd asked if we ever got Orbs behind things. We could certainly confirm we did. Following that conversation it seemed synchronistic that later that night we took this shot (below right) in our garden of an orb behind a leaf just above Dan's head!

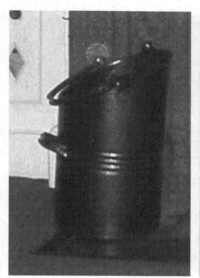

Some people, and even us at first, wondered if some of the orbs we took outside at night could be insects caught by the flash, but the photograph clearly demonstrates that this is not so for here we can clearly see an orb *behind* the moth.

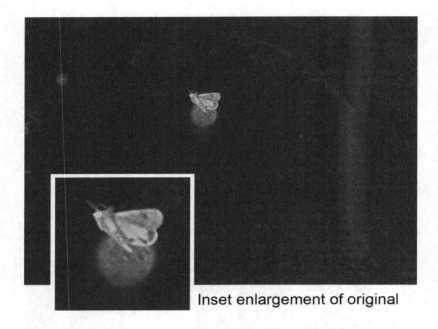

Inset enlargement of original

No doubt some circular images, which appear on photographs, may be due to ordinary effects such as sunlight striking the lens, rain drops, reflections, or flash feedback. But it does not take more than simple observation and common sense to realize which photo-anomalies can be explained as ordinary events. What we are concerned with here are those that cannot be adequately explained in such terms. The photograph below was taken at a company's leaving party in 1999 with an SLR film camera, and as you can see there is an orb *behind* the girl's head.

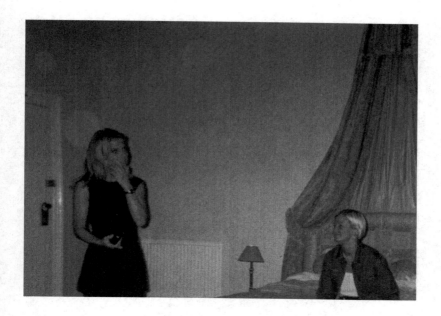

Here below on the negative we can clearly see that the orb is definitely behind the head of the girl. This convincingly demonstrates that the orb here is not due to dust or moisture in the air, both of which appear in the foreground and *not behind* elements in the photograph.

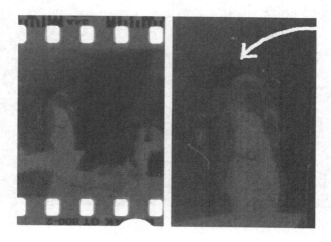

To again emphasise the fact that orbs are NOT the result of digital photography, CMOS errors or digital artefacts, here is a photograph taken in 2010 in daylight with a film camera during the official unveiling of the 12 foot long "Spirit of Life" mural, which Katie created for our local Unitarian Chapel. The photograph was taken by Sally Jones, a member of the congregation.

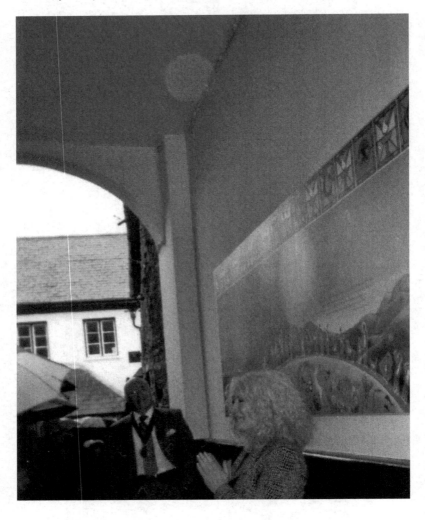

Light

The symbolism of Light has always been a key element in spirituality and the nature of Light has fascinated thinkers and philosophers throughout recorded history. In ancient India of the 5^{th} and 6^{th} centuries philosophers were already developing complex theories about light, for instance, in the Samkhya school, light was seen as one of the five primal "subtle" elements. The *Vishnu Purana* (first century BC) referred to sunlight as the "the seven rays of the sun" indicating that even long ago someone must have made the connection with the rainbow and sunlight. By AD 1021, in his *Book of Optics* the Muslim scholar, Ibn al-Haytham, also known as *Alhacen* was writing about his own theory of light based on geometry and anatomy. His study of light led him to imagine the pinhole camera, invent the camera-obscura and discover the laws of refraction! Then in the 1660s atomist Pierre Gassendi put forward the particle theory of light which was later taken up by Isaac Newton and incorporated into his exotic but wrong, corpuscular theory described in his *Hypothesis of Light* published in 1675. But it wasn't until the quantum mechanical theory of light and electromagnetic radiation came along in the 1920s and 1930s, that it led to quantum electrodynamics, being finally developed during the 1940s. It is this that forms the basis of our current understanding of light and the electromagnetic spectrum. Today, conceptually light years away from Newton's corpuscles, quantum experiments have revealed that when photons hit objects they transfer their momentum so light can actually push objects in its path in much the same way as wind does. This has raised the exciting possibility of satellites or spacecraft using solar sails powered by photons to move through the solar system.

Everything we naturally see or photograph falls within the visible light wavelength of 4000 to 7000 angstroms, sandwiched between ultra violet and infrared in the electromagnetic spectrum.

If we made a diagram of the electromagnetic spectrum, say, 157 mm long and marked off sections to represent gamma rays, X-rays, ultraviolet, infrared and radio waves, then the visual spectrum (all that is visible to our naked eyes) would represent only a mere 5mm on that scale!

Unaided by technology our ability to detect anything beyond visible light is almost non-existent. The vast expanse of the electromagnetic spectrum is closed to us.

For anything to be seen or photographed, if only for a fraction of a second, it has to be within the visual spectrum and is therefore part of the normal world.

This raises the question as to whether photographs of ghosts, orbs or whatever, can truly be said to be "supernatural" because at the very moment we photograph them, they are already part of our normal reality. But whatever generates the visual interface with our reality to make such phenomena visible to us is beyond detection by methods currently available, and in that sense only, I think, orbs and related phenomena may be legitimately considered to be "paranormal" as and when they are photographed.

Digital Cameras and Infrared

According to some researchers, orbs are shifted towards the infrared, which is the closest detectable wavelength to visible light. Incontrovertibly digital cameras do see much further into the infra-red than film cameras but even so they merely translate infra-red colours into visual spectrum wavelengths.

> Red light emits at over 400 billion cycles per second. Every time you look at red light, your eye receives over four hundred trillion waves every second!

Wavelengths too short for us to see are "bluer than blue". *This is called "Ultraviolet" light.*

Wavelengths too long for us to see are "redder than red". *This is called "Infrared" light.*

Your TV remote emits an infrared beam, and if you photograph that beam it will reproduce as white on your image. This has led some to the view that when we get white orbs on our photographs, such as the daylight luminosity below spotted flying through our woodland, that what we are actually seeing are infrared entities fleetingly captured by the camera.

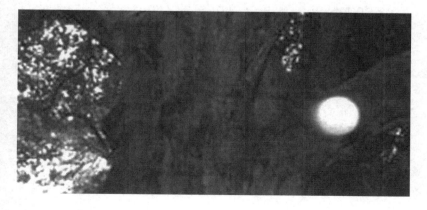

Is There a Physical Theory for Orbs?

Some believe orbs to be the visible signs of something impinging on our visual reality from the infrared. Some have speculated that more orbs are photographed at dusk because of the higher content of carbon dioxide released into the air by plants at that time. Both these notions are worth more investigation but the theory, which seems to fit most of the observed physical characteristics of the phenomenon, is the idea that orbs may be plasma concentrations, akin to ball lightening.

Ball lightning is well recorded all across the world and the most credible physical explanation for it so far, is the idea of electrically propelled plasma concentrations.

The basic premise of plasma theory relating to orbs is that orbs are complex plasma structures, which may become visible when exposed to large quantities of photons such as are emitted from a camera flash. The instant you fire your flash, electrons in any directly facing plasma concentration move instantaneously to a higher energy orbit when struck by the photons from the flash. When these now highly charged electrons return to their original orbit, new photons (light) are instantly released. This is known as luminescence. All this happens within microseconds and the luminescent plasmas are captured as orbs by the fortunate photographer.

In terms of a purely physical explanation this seems reasonably credible.

Unfortunately the plasma theory does not explain the repeated purposeful behaviour and synchronistic interaction of orbs and luminosities with human beings. Neither does it explain the photograph below: luminescent plasma, energised by the photon blast of the camera flash would be in the foreground, not behind the foliage as we see in this instance.

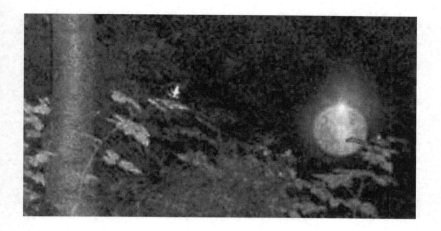

Getting Orbs in Focus

Considering all the above evidence that we have briefly noted here we can reasonably say that there are two distinctive features concerning orbs:

1. The consistent ubiquity of orbs.

 Thousands of individuals all over the world are photographing the same phenomenon with different cameras in widely different conditions.

2. The vast majority of orbs cannot be adequately explained in prosaic terms, i.e. they are *not* dust, moisture, digital errors or the planet Venus etc.

Some New Age Notions About Orbs

Since our book *Beyond Photography* was first published there are now all kinds of theories and beliefs about what exactly orbs are; some believe orbs to be departed spirits; some claim to see faces in orbs or scenes from past times; others see orbs as manifestations of Telluric (earth) Energy. Along with Ufology we now have what could be called, Orbology!

Once the existence of orbs had filtered into the "New Age consciousness" it was almost inevitable that someone with an

eye on the market would link orbs to angels or faeries or even aliens. Because orbs appear in many colours, some have even attached a bogus significance to this and have tried to relate the colours of orbs to what they claim are the colours of certain Angels. From there it was only a small step to then state categorically that orbs *are* Angels! Ipso facto – case closed! Some things are possible, others are less probable. There is nothing wrong with people believing that orbs *may* be angels, spirits or faeries, tree divas, or whatever, but if we get too dogmatic about any of this it would seem, to me at least, to be less than intellectually honest in the circumstances, as there is no evidence whatsoever for certain colours in the spectrum relating specifically to particular Angels. For one thing, the existence of aliens or angels in the way some people portray them is seriously open to question anyway. I'm inclined to believe that the angels as described in the Bible relate to something real – but there is no evidence whatsoever that certain colours in the spectrum relate specifically to particular Angels. It's all purely arbitrary and in some cases it seems to be complete fiction! You may as well believe all red orbs are Santa's elves or that different colours relate to various flower faeries or that grey orbs are alien greys. We can consider many possibilities – but we have to bear in mind that wonder must be balanced by reason!

We ourselves use words such as "sprites", "light beings" etc. but we are always careful to point out that the terms we use to relate the phenomena we have encountered are *descriptive only, not definitive!* We are careful not to label orbs categorically as angels, elementals, divas or any other kind of popular entity simply because we realised a long time ago that whatever we may think we know, the truth is always more. From our own experience of this phenomenon, none of those labels adequately define it anyway.

Most experiences of the paranormal are entirely subjective; orbs in particular have different meanings for different people.

Beware of those who are too prescriptive; it is all too easy to get hooked up on labels. Indeed labels are very useful, as long as we remember that is all they are. Food manufactures, for example, are careful to know all the ingredients before applying the label.

THE ENCHANTED GARDEN

This photograph of Katie that opens this chapter was taken in our garden one afternoon in spring 2004 with a Pentax MV1 SLR film camera, without flash, using the 1:2 50mm standard lens.

This shot uniquely captures the essence of our enchanted garden.

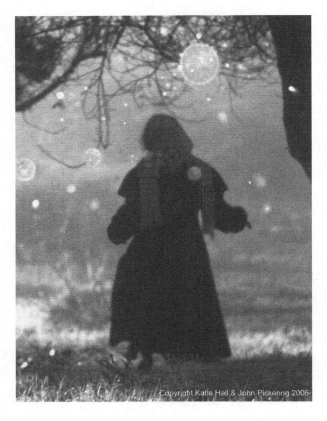

The majority of our outdoor photographs of orbs and related phenomenon (which we shall look at later in this book) have been taken in and around our garden and woodland.

To one side of our drive, an old millstream runs through that

part of the garden which backs onto woodland. The first plank bridge over the stream leads directly into a small glade which Katie named "The Faerie Dell" from the moment she first saw it, three years before we began to photograph orbs there. It seems quite coincidental that we have taken many incredible other-worldly photographs in or near to the Faerie Dell.

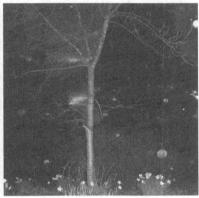

Above are two typical shots taken in the Faerie Dell: daylight luminosities and orbs at dusk.

Below (left) is the garden stream in daylight and (right) at night with a small group of luminosities.

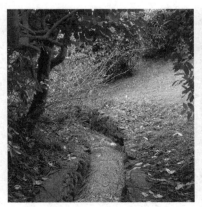

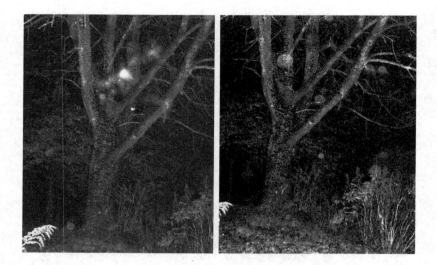

Above are two photographs, taken on two separate occasions, of the old cherry tree at one end of the Faerie Dell, as you can see at both times there were orbs and luminosities around it.

Below is a photograph I took two years ago one autumn afternoon of Katie and two visiting friends in the Faerie Dell. The day was dry but cold. The small lights Katie saw in the air showed up as an elongated anomaly accompanied by orbs and an ethereal mist that was not visible at the time.

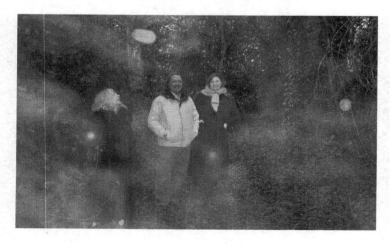

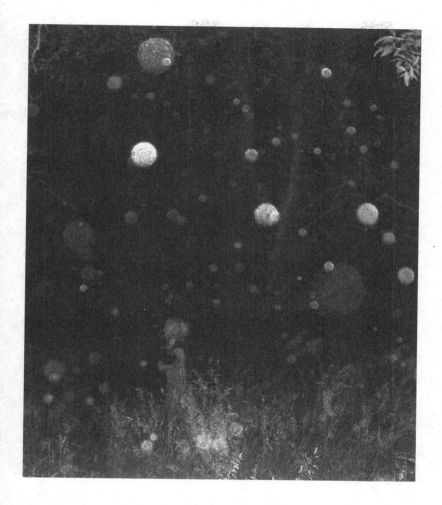

The above shot, which I took of Katie walking through the Faerie Dell, not only shows a whole gathering of orbs it makes an interesting point about the phenomenon. As you can see there are several large orbs that are *behind* smaller, brighter orbs.

If night time orbs are, as some sceptics claim, simply the result of moisture or pollen in the air, then the motes of pollen or moisture nearer to the camera would always be larger and always in the foreground. But in this photograph the small brighter orbs are seen clearly in front of larger, dimmer orbs; this

shows that the large orbs are actually further away from the lens, even though they are considerably bigger. This is one of many shots which, if we look at them carefully, are evidence that orbs are not adequately explainable in terms of moisture or pollen, or has we have seen earlier, not in terms of insects either. Something else is happening here.

Looking north towards the house from the Faerie Dell this summer evening shot shows numerous orbs around the ash tree in the centre of the Dell. You can see the gables of the house and our South facing veranda in the background.

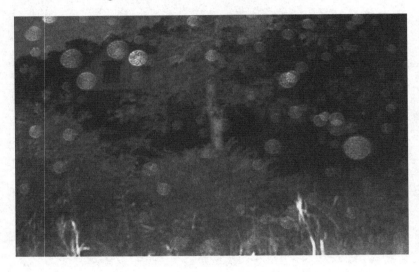

Where we live was once the home of an English Lord, this is a classical style country home built in 1833, and would have been home to both the family, their servants and gardeners. The original gardens were landscaped in the style of the period with various imported shrubs and trees such as the large Redwood at the bottom of the drive. The gardens are much less now, the original layout having changed over the years due to nature and lack of regular maintenance, which has resulted in an enchanting mixture of an established Victorian garden merging into undergrowth and wild woodland. It is in this enchanting place that we

have taken the vast majority of our photographs. Here below are two shots of orbs taken by the little bridge into the Faerie Dell. Below left is a blue daylight luminosity taken one afternoon, without flash, from inside the Dell. Below right is a night shot of Katie with orbs having just crossed the bridge and heading back towards the drive.

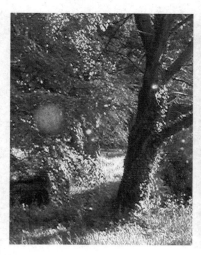 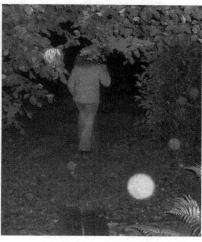

We have taken many shots of clouds, flocks or gatherings of orbs, in or around the Faerie Dell. There is no pattern to this – except that even on evenings when we have been out to take shots and got nothing at all – invariably when Katie steps onto the bridge to take one final shot before leaving the Dell, she consistently gets one parting image of an orb or luminosity. This rarely works for me, but always happens for Katie. Perhaps this is because she always asks for one to appear as she leaves the Dell and always give thanks when it does. Katie called this place the Faerie Dell, long before we began to photograph orbs. But judging by the consistency and number of orbs, luminosities and other amazing Light-forms we have photographed and encountered there, it has truly lived up to its name. We often wonder if those who lived here before had also felt this to be a special place. Indeed

that whole part of the woodland has that magical feel of a betwixt and between place: an enchanted place where mysterious events may occur at any moment! Indeed, sometimes the air there is full of orbs; here below is a typical gathering of orbs in the Faerie Dell.

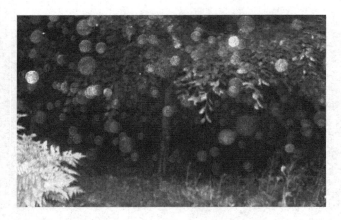

The shot below of a single luminosity crossing the Faerie Dell was taken without flash on a summer afternoon using my Pentax Optio 30 digital camera. It reminds me of the previously shown image taken in 1907 of luminosity in the Basle Zoological Gardens.

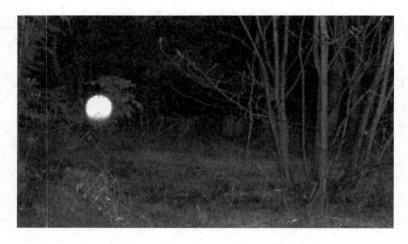

This striking shot below, taken by Katie, of orbs and vapour around the ash tree in the centre of the Faerie Dell is evocative of the notion of tree spirits and the idea of the "Fairy Tree". According to legend faeries are associated with trees, especially thorn, hazel, elder, rowan, oak and ash, most of which grow in or around the Faerie Dell and woodlands.

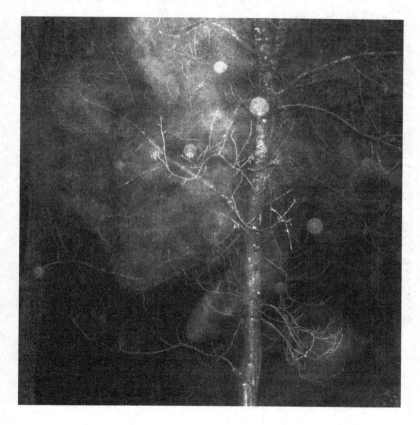

Sometimes it is easy to believe we are in the enchanted abode of dryads: at the edge of the old tangled woodland with its shades and shadows just beyond the Faerie Dell. It certainly is a "magical place" in which we have seen and photographed not only orbs, but other extraordinary phenomena which we shall look at later in this book.

CATS' EYES AND ORBS

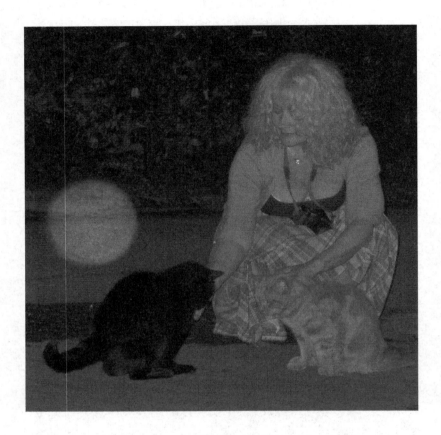

The cat's eye view of orbs and how we photographed what our feline friends were seeing.

Whenever we went out into the garden or woodlands to take photographs, our cats would always tag along; from the very beginning they were enthusiastic participants in our "orb hunting" endeavours. Although we did not realise it at first there was a good reason for this.

Throughout history, cats have been seen associated with magic, the occult and psychic powers. In ancient Egypt cats were sacred to Bastet, the cat-headed goddess of protection also

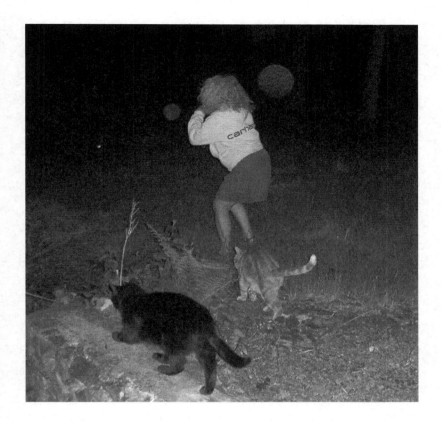

known as *The Eye of Ra*. The ancient Egyptians venerated cats as divine animals, something most cats automatically take for granted. Someone once remarked, "Dogs have owners, cats have servants"!

Cats are traditionally credited with psychic abilities – ours certainly knew when there was a chicken in the fridge, but whether or not that had much to do with the spirit of a departed chicken is very much open to question. We had to chain up the fridge to stop them getting into it anyway. Thomas, Oscar and Baggy were certainly masters of improvisation – but did they really have psychic senses? Did they know when orbs were about? We began to have our suspicions.

Here below is a shot of Thomas, the first cat that we photographed in the act of seeming to notice an orb. Was it just coincidence? Apparently not, for thereafter we got more shots of our cats appearing to see or interact with orbs and luminosities.

Thomas died of old age about a year after the above photograph was taken but Baggy and Oscar continued to dedicatedly follow us around the woods, probably wondering why we never caught any mice. However, we did now catch many shots orbs with the cats. The photograph below is interesting because it demonstrates something that happens fairly frequently: the number of orbs matching the number of people in the shot – or this case, person and cats.

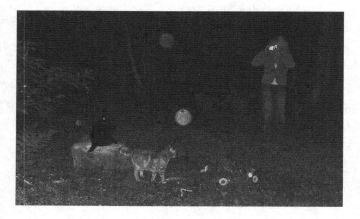

Over the years it has been Oscar, our ginger tom who seemed to be most attracted to whatever orbs were around. Perhaps he thought he could catch them? As these shots show, he always managed to get into the picture somehow, and at times seemed to be deliberately looking for orbs.

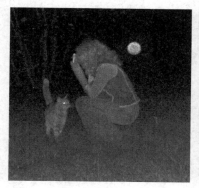
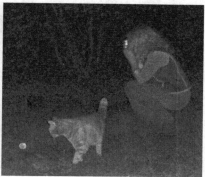

Perhaps when we notice cats staring intently at something that's apparently not there...perhaps they are really looking at something that actually *is* there, even though we may not see it at the time. The fact that whenever the cats seemed to be looking at something, if we managed to take a shot we would consistently photograph orbs in their line of vision, seems more than coincidence.

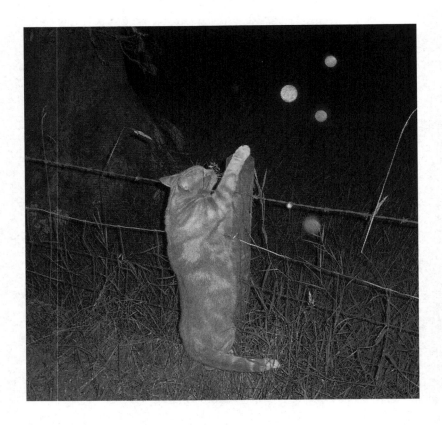

The above shot of Oscar and the one opposite were taken the same evening. In the above photograph he is definitely reaching for something, perhaps even playing with, the orbs above the fence post and in the photo opposite he certainly seems to have noticed the remaining orb to the left, for he turned at that point to look back at something. Of course, our cats are not the only animals to be photographed apparently seeing such phenomenon. Quite a lot of people have shown us or sent us their own photographs of dogs, birds and even horses, which appear to be looking directly at orbs or luminosities.

What does this tell us about the phenomenon of orbs?

Firstly it tells us that orbs are probably something real – they are visible, not just for some humans with cameras, but are

detectable by other species too.

Secondly, whatever meaning we may attach to orbs, is purely arbitrary and subjective to the human condition – for other species seeing the same phenomenon it may have no more meaning than say, watching a leaf blowing in the wind.

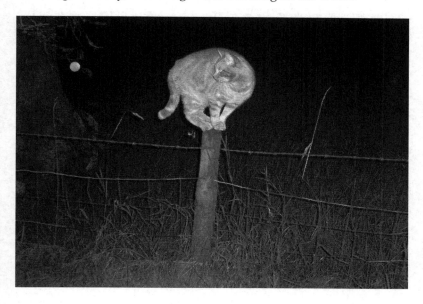

On a purely physical level, as mentioned previously, if orbs are possibly electrically propelled plasmas similar to ball lightening, it is then quite feasible that animals, which are much more sensitive to electromagnetic changes than we are, could indeed be aware, to some degree, of such a phenomenon in their vicinity. In metaphysical terms we perhaps should not be too surprised if animals can see orbs and other paranormal phenomena, for it is possible, as both metaphysics and quantum physics indicate, that all things are connected, then such phenomena may simply be a visual aspect of a connective consciousness linking all life.

SEEING THE LIGHTS

Many people photograph orbs, but there is one factor, apparently discovered by accident, that led to many of the astounding images we have taken. In brief it is this: Years before Katie and I met, when she was going through a particularly troubled time, Katie asked the universe, or God or the good forces at work in the world for help, not only for herself, but also for others who may be going through similar bad times. One day, soon after this period of asking, Katie was suddenly aware of something that had never happened before, she began to intermittently see tiny twinkling lights that appeared in the air, then soon also on her artwork and around people. At first she thought she had a problem with her vision, or worse, so she went and had herself medically checked out.

There was nothing physically wrong.

Even so, these tiny neon pink or sometimes electric blue lights persisted; eventually she got used to them, but it was only later she discovered that certain other people also saw them. Especially people involved with holistic healing such as aromatherapy or Reiki. It wasn't until a few years later that Katie and I first met. After about a year or so we decided to make our home together and so Katie moved in with me and the three cats. She instantly loved the house with its gardens and woodland. It wasn't until four years later, one afternoon, some months after orbs first started to appear on our photographs, and we were still wondering what they were, that Katie was in the sitting room with her camera when she saw her tiny twinkling lights. Instinctively and quickly she took a shot in that direction. The result was the photograph below which was taken without flash.

Fortunately Katie had now discovered a vital connection: her tiny twinkling lights were actually photographable! We began to experiment and after taking further shots we found that

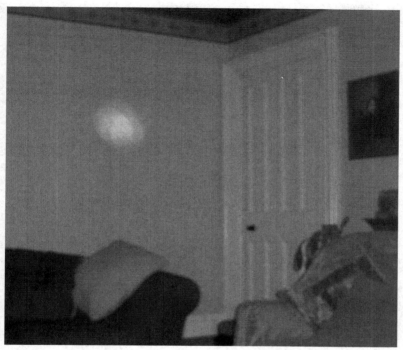

wherever Katie saw her little lights we would fairly consistently photograph orbs or luminosities! We were now both convinced that this was no mere chance coincidence.

However, such tiny lights are not unique to Katie. Many healers and psychics also see them. Tiny twinkling lights are often reported as common during healing sessions or times of meditation; some refer to them as Prana, others as Chi Energy. In metaphysical terms, an appearance of small lights over or around people and other living things is often linked to consciousness or to the energy field around the body. The fact that all over the world many have reported orb phenomenon to be interactive and also to evidence purposeful behaviour would seem to qualify some kind of connection between these tiny lights and orbs.

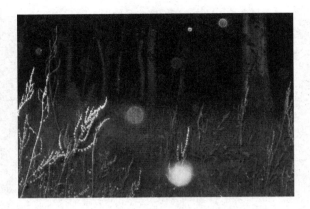

Small Transient Light Phenomenon

We eventually termed these brief tiny lights, "Small Transient Lights" or STLs. This gave us a totally new perspective by which to evaluate the phenomenon of orbs; it also helped us to take many photographs of them whenever Katie saw STLs. The photographs on the next pages demonstrate how working together we were able to take many shots of the STLs as Katie saw them at the time which were then instantly reproduced as orbs or luminosities on our photographs. This also eventually resulted in other extraordinary light phenomenon shown later in this book.

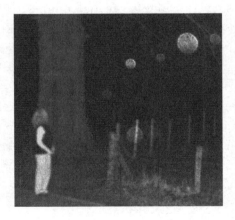

In the above photograph Katie is looking towards what she saw

as tiny twinkling lights (STLs); following her lead I quickly took this photograph in which they were reproduced as orbs. You will notice that there is an orb *behind* the fence post. (Again more evidence that orbs cannot simply be written off as dust, moisture or digital errors.) However, this did not work every time (probably because I was not quick enough to take the shot before they'd moved on or disappeared), but it worked consistently enough for us to become convinced there was a direct connection between STLs and orbs. Since we first highlighted this in *Beyond Photography*, other people, who also see STLs, have reported similar synchronicity occurring when taking photographs. From all accounts seeing these small twinkling lights, either directly or in peripheral vision is common for many hundreds of people; not only for those involved in meditation, healing or spiritual practices.

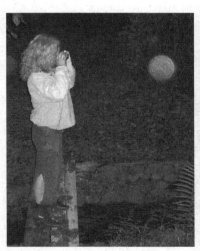 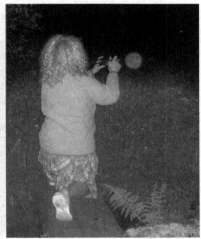

The fact that STLs can be photographed as orbs means this is a real external visual phenomenon: something in the visual spectrum that can be both seen and recorded. From my point of view STLs are a natural phenomenon with paranormal implications; in that sense I do not consider them to be "supernatural"

in any way whatsoever. Everything we see and experience, even the extraordinary, is part of natural existence; something only becomes "paranormal" when we cannot account for it in terms of our understanding of physics and normality at our level of reality. If we accept there is a wider, beyond reality, that interfaces with our own and of which we are but a small part, the concept of the supernatural becomes redundant; everything is natural – we simply just need to understand it better than we do.

The chances of STLs being repeatedly photographed as orbs by sheer random coincidence seemed highly unlikely. It was much more probable that STLs were a real visual spectrum phenomenon. The fact that they are photographed as orbs when hit by the photon burst from the flash did lend credence to the theory that whatever generates them manifests at our level of reality as small plasma concentrations, but of course that is not the complete picture anymore than the photograph of a human face is the complete picture of the living individual person.

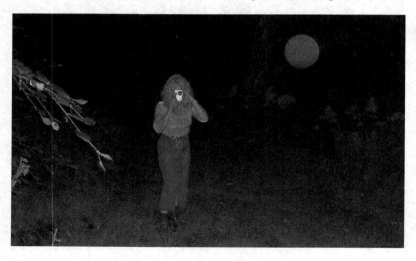

The photo above shows Katie at one side of the Faerie Dell about to photograph "little lights" and an orb, to the right in the middle distance, I took it just before she pressed the shutter. The photo-

graph below shows the photograph Katie took of me at the other side of the Dell with the orb to the left in the middle distance. Was this the same orb?

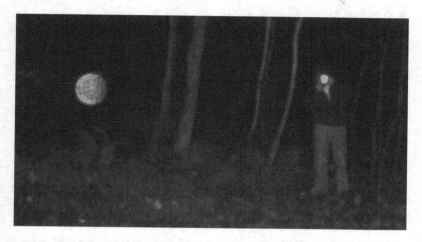

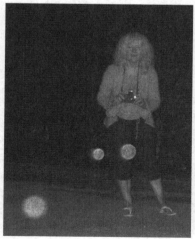

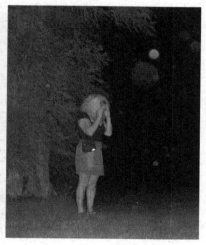

If you too occasionally see tiny sparkles of light or a brief flash in your peripheral vision and have wondered what it is – you could try photographing it, as we have done; the chances are that you'll get orbs or other luminosities appearing on your own photographs.

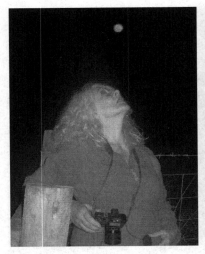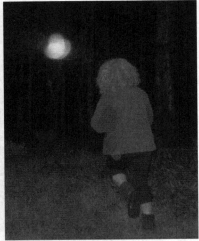

The two photographs immediately above were taken in 2013, so we can clearly see that since we first photographed Small Transient Lights nearly ten years ago, the visual STL phenomenon has remained consistent: when photographed it still reproduces as orbs.

To round off this chapter here below is a stunning blue luminosity I photographed in the air between Katie and myself. The two small "orbs" (bottom right) are simply the reflective eyes of Baggy, our black cat. What he thought of our camera flashes going off I'm not sure, but he often managed to get into the picture; as he was black as night you never knew where he was going to pop up. Our cats loved being in the Faerie Dell, it was the first place they would make a beeline (or is that catline) for and interestingly the number of twinkling little lights in the air have always been more numerous and more consistent there than any other place in the garden.

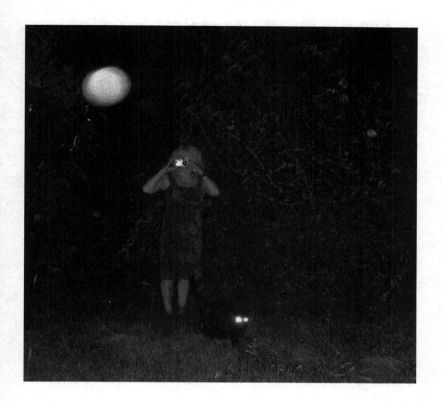

AN INTERACTIVE PHENOMENON

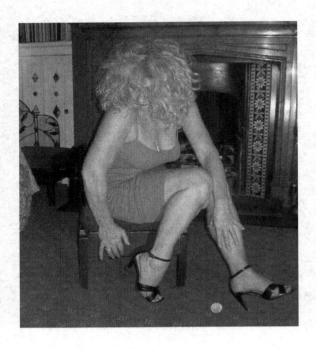

When I took this photograph of Katie in a new pink dress we weren't surprised to see the small orb on the floor, because when I took this shot, for months this was the only room in our home where orbs appeared. You could hardly take a shot in there without orbs on the image.

For months, no matter how we tried shots in other rooms, orbs only appeared in our sitting room. We just couldn't photograph them anywhere else either indoors or outdoors. It was this anomaly which initially led us to investigate the phenomenon and to eventually rule out possible obvious causes such as dust, moisture, lens flare, digital processing errors etc. This was an exciting time of discovery for us but nevertheless it also gave a couple of our relatives cause to believe there was a quite ordinary explanation for the orbs photographed in our sitting room.

 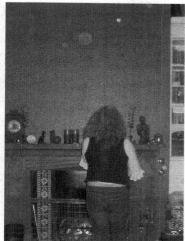

Our more sceptical friends had decided it was definitely reflections from the mirror (see photo above left) that was causing the orbs on our photographs. As you can see from the photograph (above left), this wasn't such an unreasonable idea in the circumstances.

So one evening we had our two sceptical relatives, plus partners, over for dinner, after which we removed the mirror and all tried taking shots with different cameras. They had brought their own. It seemed a good way to put us and orbs to the test; they were more than quietly confident their theory would be proved right. Accordingly, we all took shots with three digital cameras and guess what – no orbs! For the sceptics the case seemed to be closed – it was the mirror after all.

However, we knew the phenomenon a little better by then and suggested taking another couple of shots. We now got a few orbs above Katie as shown (above right). Notice the bright white one sitting nicely between the clock and the Egyptian cat on the left, almost mimicking the two smaller blue glass decorative balls on the shelf. If you didn't know it was an orb, you'd think it was just another crystal ball we had on our mantelpiece, but it wasn't! Also notice the other smaller white orb positioned between the

two ornamental discs on the right, just below the mantel shelf. Again one could be forgiven for thinking it was part of the decoration, but it wasn't!

Katie's brother, Sam, who was the chief sceptic at that time, looked at the few orbs on our photograph, then jokingly, but a bit grudgingly, said, "Okay, then – but I'd be more impressed if you got a whole roomful."

At the time this was exactly the wrong thing for a sceptic to say!

For on the very next shot, that is exactly what we got – a whole roomful! We were all completely astounded, even us! This was such an amazing, immediate and pointed response to Sam's challenge that even our sceptics got goose bumps!

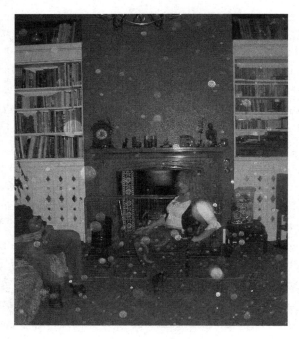

Notice that the orb that was between the clock and the cat on the mantelpiece has now moved and so has the smaller one that was on the right below the mantel shelf. Had they gone or were they

now part of the 200 or more orbs that now filled the room? This was very encouraging and we all set about taking more shots, even the sceptics, but very pointedly, even with three different cameras flashing for the next hour or so, we simply got no more photographs of orbs that night. It really was as though something had made a statement! The orbs had been challenged and had unequivocally answered. This event left us all tingling with the exciting possibility that we had just encountered a conscious interactive phenomenon from beyond our normal reality that also seemed to have a distinct sense of humour.

In this next batch of photographs we shall look at how orbs seem to interact closely with people; particularly with Katie. Interestingly the next four shots (below) show orbs near to Katie in roughly a similar area in all four instances. Sometimes they definitely seemed to be following Katie around with such consistency that we could not help but feel this was some form of purposeful interaction.

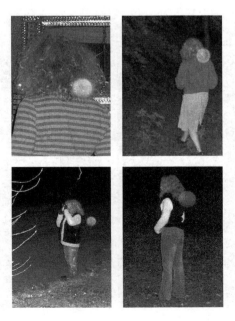

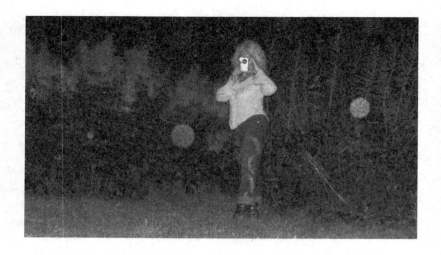

Sometimes they seemed to have a sense of humour – as this "family photo" (above) shows. And occasionally, as shown in the photograph below of Katie and her mum, they seemed to be playing hide and seek. Was this just our interpretation or was it really purposeful behaviour? We noticed that the instances of apparent purpose, interaction and synchronicity certainly began to increase.

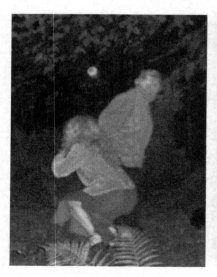 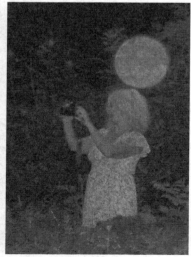

Above are two photographs taken on the same night, literally seconds apart with orbs directly over Katie and Baggy (only just visible in the grass) in the Faerie Dell. It is interesting to note the fact that the orbs are overlapping in the left hand image; this indicates real visual objects that to some extent have density and colour, otherwise there would be no tonal difference. The effect is like two disks of tinted glass partially overlaid one on the other.

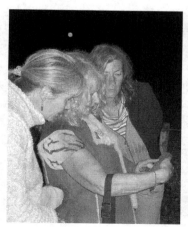 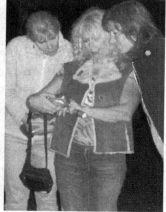

"Mmm, that looks interesting!" This photograph (immediately

above) shows a tiny bright bluish orb close to Katie and her friends, Wendy and Carol. Whilst they are looking at photographs of other orbs on Katie's camera taken that night, this small orb appears to be moving around them as though inquisitive. I did not see it and none of them were aware it was there at the time, it simply showed up on the photographs. The right-hand image is lightened slightly.

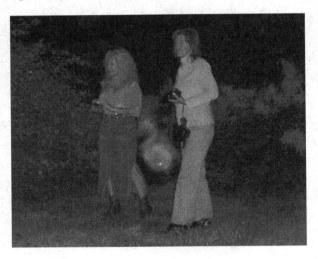

A few years earlier, one weekend when Wendy was visiting I took this photograph of Katie and Wendy walking through the woodland. I wasn't using a very high spec camera and it was running out of battery so when we checked the shots we were surprised to see this strange tailed sphere apparently just floating between Katie and Wendy. Yet again synchronicity was at work for although neither Wendy nor I knew it at the time, this strange sphere was particularly meaningful for Katie because it vividly recalled a recurring dream she'd had many years before in which a very similar but much larger floating sphere played a key role.

Another interesting aspect of the phenomenon is that sometimes we get orbs or luminosities forming what looked like geometric configurations. One of the most common is triangular

configurations. Here below are a couple of examples of orbs forming triangles around Katie.

 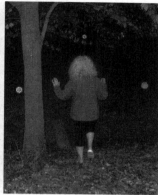

Below is another triangular configuration, again around Katie, on the little bridge over the stream leading to the Faerie Dell, this was taken on the same night as the photo above right. In the next chapter we shall look at this location again for it was on that same bridge that we photographed one particular orb configuration that mirrored something that was literally quite astronomical.

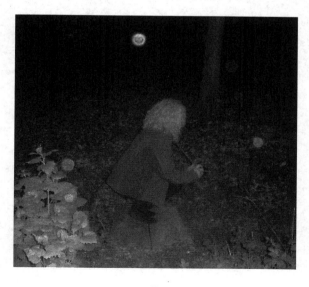

COSMIC CONNECTIONS?

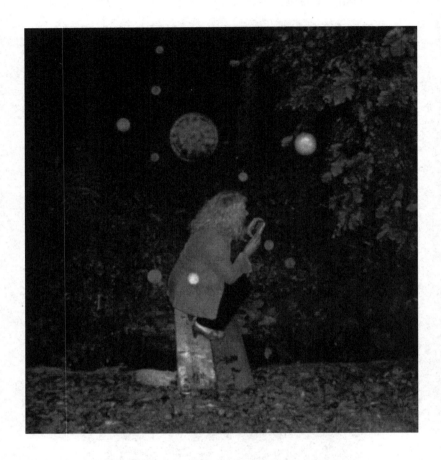

This shot was one of many taken in September 2004, but it wasn't until the first week in November that we had time to look through them on the computer. We may not have seen any particular significance in it then, except for the events of the previous evening.

That evening it was an absolutely clear night – brilliant for star gazing. We were sitting out on the veranda watching the night sky. Above the trees we could see the constellations of Orion and Canis Major, with Sirius the Dog Star shining bright. Suddenly

out of nowhere came an even brighter light moving through Canis Major to finally disappear in the direction of the Eridanus constellation. It certainly wasn't a plane or satellite, we had no idea what it was – and so in effect, as far as we were concerned it was a UFO.

The next morning we had decided to check through the backlog of September shots now on the computer, it was while we were doing that we noticed that on one shot and couple of others the orbs looked as though they were not completely random. They seemed to be in some kind of pattern. The more I looked at one shot in particular the more vaguely familiar it seemed to be. Katie said, "It's almost like we should join up the dots!"

An incredible thought suddenly occurred – what if they were not just random orbs?

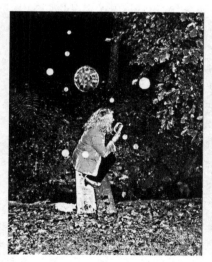
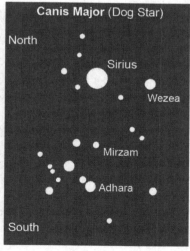

Quickly reducing a couple of the pattern-like images to fit on an A4 sheet, I then increased contrast and brightness and printed them out. *(The above image on the left is the photo-effect version of the original photograph on the previous page.)* Next I made a tracing of each one and with no clear idea except Katie's "join up the dots".

I pulled out some astronomy books and began to compare these with the star maps. It took some time – but eventually we discovered that the orbs pattern matched, almost exactly, 11 out of the 21 stars in the constellation Canis Major! Of course it did; it was so obvious! Katie had been on the right track. Why hadn't I seen it right from the first? We thought of the bright UFO we had seen only the previous night passing through Canis Major, and yet – this synchronistic photograph was taken nearly a month before! What was happening? The implications here were beyond anything we could have expected.

This wasn't just another photograph of orbs – was it some kind of connection, perhaps some type of communication across time and space? We didn't know, but whatever it was, something incredible was happening. What with this and other events there were now far too many interactive anomalies and synchronicities attached to orbs to ignore the increasing possibility of there being some kind of consciousness at work through this phenomenon.

But the orb configuration that reflected the Canis Major constellation was not the only strange pattern we unearthed from our backlog of photographs from that September. There was at least one other that puzzled us, that looked like it should be something, though it was not until 2010 that we finally identified it. Originally I had been looking only at the familiar major star constellations and the Zodiac; because of that I missed it completely. That is, until years later whilst researching something else I was looking through the constellations that made up the 14 sign Zodiac that was first suggested in 1970 – and there it was; as you can now see below the orb configuration on the left mirrors almost exactly a pattern of nine stars in the constellation of Cetus. In Roman mythology Cetus represented the Sea Monster sent by Neptune to devour the goddess Andromeda. The constellation of Cetus spreads across the Southern sky, between Aries and Pisces and is the second sign in the Fourteen Sign Zodiac. Cetus contains the star Mira Ceti,

which coincidentally is marked by the largest orb in the configuration and is the brightest star in the constellation. This repeats the pattern in the Canis Major configuration where the largest orb also marks the position of Sirius, the brightest star in that constellation. This would seem unlikely as chance coincidence, but what the relevance is, we do not yet know. One thing is pretty certain, Mira is a binary star, consisting of the red giant Mira A and Mira B, about 200–400 light years away from us. In Latin "Mira" means *"wonderful"* or *"astonishing"*, and is credited as being first recorded by the astronomer David Fabricius on August 3rd 1596. With the exception of the star Algol, Mira was the first non-supernova variable star to be discovered, and is also the brightest periodic variable in the night sky that is invisible to the naked eye for part of its cycle. It was certainly invisible to us prior to making the link, years later to the orbs formation shown below.

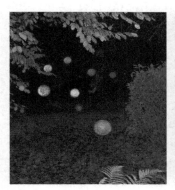 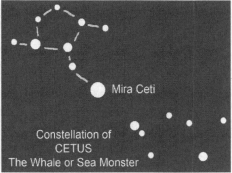

Mira Ceti

Constellation of
CETUS
The Whale or Sea Monster

The two orbs configurations we have mentioned definitely seem to reflect the constellations of Canis Major and Cetus; the largest orb in each case seems to represent the brightest star, but what else, apart from the usual astronomical mythological references, connects both these constellations? And what, we wondered, had any of this to do with us?

All we could do was to check to see if there were any correlations between the two constellations and the brightest stars in each case. In the second century BC, Ptolemy of Alexandria in books VII and VIII of his *Almagest*, used Sirius as the location for the globe's central meridian and included both stars in his catalogue of 48 constellations. Egyptians of the Middle Kingdom era, based their calendar on the heliacal rising of Sirius (the day when just before sunrise it first becomes visible after moving away from the glare of the Sun), which occurred at the summer solstice, just before the annual flooding of the Nile. Like many constellations both had Latin names and astrological or and mythological connections; both were representations of animals but none of that seemed of any great significance. For what it may be worth we shall note here the main mythological references for both constellations.

Canis Major variously represented the following: a dog that was a gift from Zeus to Europa; or the hound that Diana, the goddess of hunting, gave to her favourite nymph, Procris; or the hunting dog given by the goddess Eos (Roman – Aurora) to Cephalus the husband of Procris, which was so famous for its speed that Zeus honored it by placing it amongst the stars. Ancient Greek writers, Aratos and Homer referred to Canis Major as one of Orion's hunting dogs pursuing Lepus the Hare or helping Orion fight Taurus the Bull, perhaps reflected by the fact that the stars in Orion's Belt point directly to the star Sirius.

For the ancient Greeks the constellation of Cetus represented the dreadful sea monster that was sent by Poseidon to devour Andromeda, daughter of King Cepheus and Queen Cassiopeia of Ethiopia, who had been forced leave their daughter chained to a cliff as a sacrifice to Poseidon.

In some accounts of this myth the hero Perseus uses Medusa's head to turn Cetus to stone; in others, Perseus kills Cetus with his sword. In any event when Cetus came up to devour Andromeda, Perseus slew the monster and later married Andromeda.

Let us next look at some of the key astronomical facts.

In Canis Major the brightest star is Sirius, 30 times brighter than our sun, and is in fact the brightest star in the night sky; in Cetus the brightest star is the binary Mira, which is also the brightest periodic variable star in the night sky. So a common factor in both constellations is that they contain a distinctively bright star. However, Sirius is very bright, simply because it is closer to us at only 8.6 light years from Earth whereas Mira is much further away, estimated to be 200–400 light years away from our sun.

Both constellations appear in the Southern Hemisphere, although because Cetus is one of the largest constellations, the complete figure is only visible from October to the end of January. Look for the head, which is a circle near the constellation Taurus, with the body stretching towards the southwest. Cetus is in the same region of the night sky that contains other water-related constellations: Aquarius, Pisces, and Eridanus. Apart from Mira there are several other bright stars in Cetus, all at varying distances from Earth; Beta Ceti being the brightest. But the star Tau Ceti is noted for being the nearest stable Sun-like star although it has only about 78 percent of the Sun's mass.

In December 2012 came evidence that possibly five planets orbited Tau Ceti; it is thought that one of these is potentially in the habitable zone. However, it seems that any planet orbiting Tau Ceti would face far more risk of impact by solar debris than our own planet. Even so because of Tau Ceti's Sun-like characteristics it has been listed as a possible abode of life and is now targeted by the Search for Extra-Terrestrial Intelligence (SETI). This is of course a long shot, but we may yet be surprised.

Perhaps more importantly, in 2011 the star Sirius in Canis Major was in the news when researchers with SETI using the Giant Arecibo Antenna in Puerto Rico, discovered a signal that lasted for 20 minutes originating from the direction of Sirius. SETI astronomer Doug Holm commented, *"The Transmission was*

within the wavelengths used by Radio Communications on Earth", adding that, "It was constantly changing, but within a regular set of parameters, which is just like a TV show or Radio broadcast from Earth would look if picked up by Radio Telescopes".

Apparently this signal showed signs of being a deliberate transmission. But even though scientists attempted to determine the nature of the transmission, attempts to decode the signal failed.

SETI astronomer Dan Wertheimer explained, "We probably won't be able to decode the Signal. We'll know something's out there, but we won't know much about their Civilization."

That all seemed more interesting but, as far as I can now ascertain, within days of the first announcement all records of the signal from the Sirius region had mysteriously disappeared.

When certain astronomers then attempted to track down the computerized records, reportedly they were officially told to turn their attention elsewhere. A SETI astronomer commented, "I've only seen orders like this once before, and that was when a University Radio Telescope Accidentally Intercepted Coded Signals from the CIA Surveillance Satellite". Then tellingly remarked, "But this was definitely not a Signal that Originated from anywhere near Earth, this Signal originated from the Dog Star Sirius".

In that context I would recommend you go online and check this out for yourself; you could try the Official SETI website or type CSETI into Google and go to the DISCLOSURE PROJECT website.

As mentioned previously before we discovered the strange orb configuration that reflected the constellation of Canis Major, we had witnessed a UFO moving through Canis Major to finally disappear in the direction of the Eridanus constellation. In the light of the SETI signal this now seems even more synchronistic especially as there was already an extraterrestrial connection with the star Sirius.

In the 1930s two French anthropologists, Marcel Griaule and

Germain Dieterlen, were living with a West African tribe called the Dogon. Whilst there they recorded four Dogon priests relating their oral traditions, which included the legend that people from the Sirius star system visited Earth thousands of years ago. The Dogon called this race the Nommos: amphibious beings resembling the mermaids and mermen of myth. Similar beings also appear in Sumerian, Accadian and Babylonian myths. In ancient Egypt the Goddess Isis, was at times depicted as a mermaid, and very interestingly she is also linked with the star Sirius. According to Dogon knowledge, which includes a 400-year-old artefact seemingly depicting the Sirius configuration and ceremonies held by the Dogon since the 13th century to celebrate the cycle of Sirius, the star Sirius has a companion star that is invisible to the human eye. This unknown companion star has a 50-year elliptical orbit around the Sirius, is incredibly heavy and rotates on its axis. Amazingly the anthropologists had discovered that locked into Dogon myth and ceremonies was a surprising amount of specific and fairly accurate information about the Sirius star system.

Even though the Dogon had oral traditions and ceremonies relating to Sirius's companion star that stretched back to at least the 13th century, it was not until several hundred years later, in 1844, that German astronomer Friedrich Bessel observing changes in the proper motion of Sirius, deduced that it had an unseen companion. This was not qualified until almost two decades later, when in January 1862, Alvan Graham Clark the American telescope-maker and astronomer first observed the faint glimmer of the companion star that is now known as Sirius B.

The Dogon legends about the companion star being small but very heavy were amazingly accurate because Sirius B turned out to be a "white dwarf" star and it was the pull of its gravity that had caused a wobble in the movement of Sirius.

The story of the Dogon and their legends of Sirius first came

to popular attention in the book, *The Sirius Mystery* by Robert K.G. Temple, published in 1977.

However, knowing about Sirius B that was not the extent of Dogon's incredible knowledge about the Sirius star system. According to Dogon legend there is a third star around which the home world of the Nommos orbits. When Robert Temple's *The Sirius Mystery* was first published there was no solid evidence for the existence of a third star in the Sirius system, so this whole idea was criticised by sceptics. But in 1995 an article by two French researchers, Daniel Benest and J.L. Duvent, appeared in the well revered journal *Astronomy and Astrophysics*; the title of the article was, "Is Sirius a Triple Star?" Based on new observations of motions in the Sirius system Benest and Duvent suggested the existence of smaller third star that was probably a red dwarf with about only .05 the mass of Sirius B. We now know that Sirius C exists and if we correlate all this with the recent possibly *"intelligent"* signals picked up from the Sirius system in 2012 by SETI then the Dogon claim that intelligent beings from there visited Earth in the distant past may not be as unlikely as it sounds. Certainly for us the fact that we had photographed two orb configurations that later proved to have such significant astronomical connections is a strong indication that none of this is happening by chance. Even though it is not yet clear to us, and may never fully be clear, there is obviously some purpose connecting all our experiences, events and photographs.

And it is from this point on that we began to travel from orbs to Beyond. Pieces of the Universal puzzle had been falling right in front of us on our own front doorstep; it was time to pick them up and try to figure out where they belonged. For here was an opportunity not just to be bystanders but to be active participants in the Mystery and Wonder of the Universe that we have been privileged to glimpse. In that context the photograph below of our grandson, taken one summer's day during an afternoon stroll

through the woodlands with his mum and dad, sums up for me the child-like wonder of encountering such amazing phenomenon and the questions it poses.

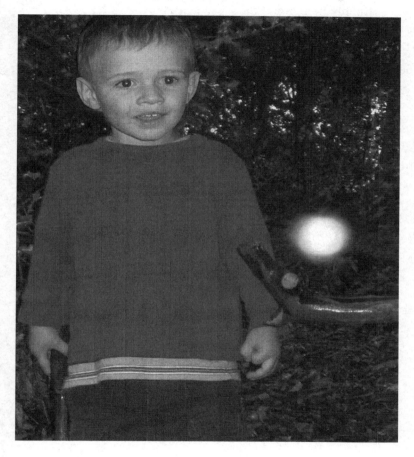

By this point in our journey our summary of Orbs and Luminosities was as follows:

a) Evidenced aspects consistently not explicable in ordinary terms.
b) Were related to or generated by Transient Light phenomenon(STLs).

c) Were at times visible to animals and to some people.
d) Evidenced conscious purposeful interaction.
e) Meaningful synchronicity was consistently associated to the phenomenon.

In the context of all the above it was not *too* surprising when not long after the star configuration appeared our orbs phenomenon began to shift into more exotic forms and images through which we encountered other realities beyond photography. So at this point we shall leave orbs for the moment and move on to look at the visual evidence for an evolving phenomenon, which may indicate the astounding possibility of communication from another aspect of Reality.

PART TWO

BEYOND REALITIES

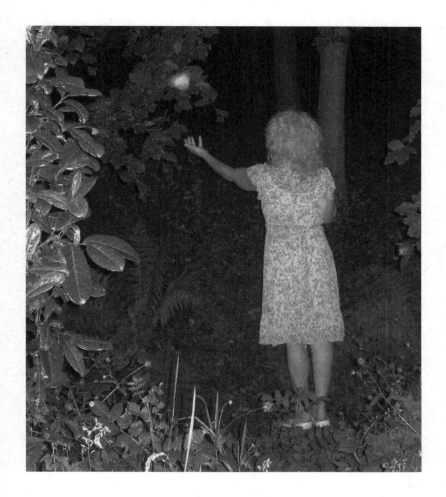

The photograph above of a "Faerie-like" occurrence was taken in July 2010 and introduces the next phase of events and photographic encounters that began to unfold and which to us seemed to indicate the presence of a "Wider Reality beyond" interfacing with our world. In this part of the book we shall be specifically

looking at events and photographs which for us offered compelling evidence that we were encountering something extra-ordinary. It was this "something" that led us to a wider view of the interconnection of life in all its diversity: of both normal and paranormal phenomenon, of the reality of synchronicity and its connection to a wider understanding of consciousness.

What is Beyond Reality?

What do we mean by a "Wider Reality beyond"? Before we proceed further it may be useful to more precisely define our terms. As we have mentioned previously we have always been careful to stress that the terms we use in speaking about all the phenomena we have encountered and photographed are descriptive, not definitive. For instance, we may call something a "Sprite" or a "Light Being", but let us be clear – that is *not* what they are; all such terms are merely labels we have applied to this phenomenon.

Today the new views of a "conscious universe" coming from quantum physics, cutting edge scientific theories about the inter-connection of matter and consciousness, what is now thought to constitute the primary fundamental forces underlying existence, has radically changed since the days of Darwin; in fact the all too rather neat idea of natural selection and macro-evolution, in the context of what we now know of quantum realities, no longer seems a completely credible reason for the vast process of Existence.

The Problem of Origins

The main scientific problem for both creationists and evolu-tionists is that there is no scientific validation for the origins of Life. Scientifically it is impossible to observe or repeat the origins of Life. Science cannot create something out of nothing; all it can do is describe what is and manipulate what already exists. Which is why it is completely incorrect to say such things as, *"Life has*

just been created in a test tube" – all scientists have done is to manipulate the life that was already there. Because of their scientific honesty many scientists today, whilst rightly being advocates of science and scientific methodology, are also realistic enough to be aware of its limitations and admit that scientific truth is never absolute; it is essentially the best approximation at the time; in most cases it is the one that has proved reliable in terms of the vast majority of physical phenomenon. However, life is full of anomalies both physical and metaphysical. Some of these anomalies seriously call into question long cherished popular scientific theories. Today's quantum physics and genetics present us with a whole range of anomalies, which do not match or support the views of standard 20th- century physics or biology as they are taught in schools and universities. Our increasingly sophisticated technologies for investigating and exploring the cosmos have resulted in new revelations from the furthest reaches of space and from the deepest levels of the quantum universe that do not fit at all with the 19th- and mid-20th-century notions of a completely material mechanistic universe that just happened by chance.

Mirror Universe: A Metaphor

So in that context, what do we mean by a "Wider Reality beyond"? The best way I can convey this is by use of the following metaphor: Let us imagine that the physical, energetic and conscious reality we are all part of is like a mirror. According to the currently acceptable Big Bang theory everything that exists was once one primordial atom about the size of a grapefruit, which then for some unknown reason exploded thus giving rise to everything that now exists: you, me, atoms, stars, galaxies, cats and mice etc. If, metaphorically, we instead then think of that primordial state as one complete mirror that reflects a Reality beyond itself, then even if that mirror is spontaneously shattered into a million pieces, all those tiny pieces of the mirror

will still reflect the original Wider Reality. Paranormal phenomena, synchronicity, metaphysical anomalies and experiences that are not explicable in terms of the natural laws and physics operating at our level of Reality, are reflections of that beyond-the-mirror reality interfacing with our own fragment of the original mirror. In that sense we can say that metaphysical and paranormal phenomena may be indications of the existence of a Wider Reality beyond the confines of the physical/energy based universe we inhabit. It is reflections of this Beyond Reality that strongly pervades the quantum universe, for here, it could be said, we are at the very edge of the interface between the reflection and the Reality. This is why, I believe, the deeper we go into the quantum universe the more physics gives way to metaphysics and we find ourselves in that betwixt and between place at the edge of Existence. This Wider Reality permeates our whole universe; in some areas its reflection is dimmer, in other areas such as in metaphysical and paranormal phenomena and at the quantum level its reflection is more intensely brighter. In those terms we may think of paranormal phenomena as the reciprocal reflections of the existence of a Wider Reality beyond our own!

But of course at the time we were going through our photographic encounters with the phenomenon we had no clear idea what was happening or where it was all going. For over three years the phenomenon continued to unfold into new forms; all of which posed their own new set of questions. However, the longer we studied this phenomenon that more we realised there were consistent and common aspects to all the unfolding events we were experiencing and photographing. These can be summarised as follows:

1. Orbs appeared consistently throughout all the visual forms we were photographing.
2. Once we had photographed one unusual visual form, it

repeated numerous times afterwards.

3. Synchronicity was consistently associated to the forms we were photographing.

4. The same forms had been photographed by others independently of us.

5. The unique aspect of our own case was that we were photographing a whole range of evolving visual phenomena that displayed some purpose; i.e. the indications were this was not happening randomly, it was happening due to some internal logical constant.

6. Throughout all its stages the phenomenon showed indications of conscious intent.

7. The phenomenon definitely appeared to be interactive.

In the next chapters we shall look at how this phenomenon unfolded into new visual forms. We first became aware that this was happening when for the first time we began to photograph images that were definitely not orbs. This opened up a whole new Pandora's Box of possibilities.

PHOTOGRAPHING FAERIES?

After orbs there soon appeared other visual phenomena, the first of these were what seemed to be winged faerie-like images. Orbs were one thing but faeries at the bottom of the garden? Well that was something else. Here below is the first photograph of one of those winged things.

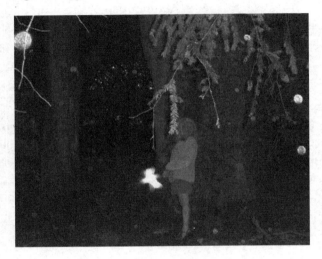

Before this first "winged" image appeared we'd only ever photographed orbs in the garden at dusk. Here below are a couple of enlargements, as you can see it isn't a bat or a bird. The critical point is that after this photo similar winged or faerie-like manifestations began to consistently appear on our shots, whereas before we had only photographed orbs.

Below are four more photographs, taken months, or even years apart, of very similar faerie-like phenomenon. Again, like the orbs, they often appeared right next to Katie.

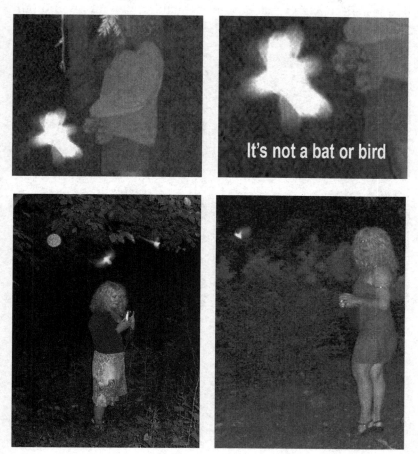

Just as when Katie saw STLs and I photographed them as orbs, now, on occasion they reproduced on our photographs as these faerie-like forms, as in the below left photograph. These faerie-like visual effects persisted until something new came into our focus.

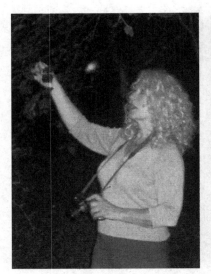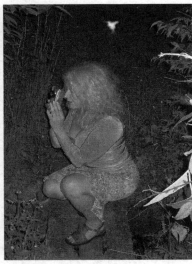

MOVING COLUMNS OF LIGHT

One evening just as it was getting dusk, Katie was in the Faerie Dell when she saw a flash of light moving vertically on the opposite side of the stream. Shooting in quick succession she managed to get a sequence of moving images which showed a column of light moving vertically across the garden. Here below are three shots out of that sequence.

We came to call this new aspect of the phenomenon "Light Rods" and as with the "Faerie-like" images, once we had seen or photographed one such occurrence, others followed and repeated.

As you can see in the above images the Light Rod is moving vertically from right to left in front of the laurel hedge. In the whole sequence the Light Rod next moves back to the right again before disappearing. This new occurrence was totally different to both the orbs and the Faerie-like images but it was a manifestation that intermittently repeated several times in and around the Faerie Dell for quite a few months. Mostly the Light Rods were always moving vertically like moving columns of light but occasionally they could be seen moving horizontally through the

trees around the Dell. Initially we did various tests to try to replicate this effect, in case it was due to some natural cause; the obvious suspect was spider webs but we soon ruled out because whatever way we tried to photographed them from every angle they looked nothing like the Light Rods. In the end nothing in or around the garden could account for this phenomenon; photographically it made no sense in terms of what was naturally there.

Below left, is a lightened and only slightly enhanced photograph of a Light Rod, which gives some idea of its height. The laurel hedge, just to the right of the Light Rod, is approximately five feet high so the phenomenon itself appears to be over six feet tall. The un-enhanced enlargement (below right) shows the glowing middle section, or core, of the Light Rod.

Perhaps it is this glowing core which generates the energy that propelled the Light Rod as it travelled vertically across the ground. Perhaps this moving column of light travels in much the same way an electrically propelled plasma concentration such as ball lightening. Various people have put forward different expla-

nations for our "Light Rods". These have included geomagnetic energies (often called earth lights), chi energy, and even dimensional portals. We did consider the earth light idea, as where we live is intersected by ley-lines, but as earth lights are mostly thought to be produced by the friction of crystalline rocks rubbing together, such as in a tectonic plate shift, this did not seem likely. The other possibility we considered was the fact that at night there is much more carbon dioxide in the tree level atmosphere than there is during the day, and perhaps this excess of carbon dioxide in some way could be the gaseous medium through which small low level plasma concentrations, being hit by the photon burst from the flash, could somehow be reflected back as vertical columns of light instead of orbs. However, this idea did not seem to work either as we then began to get photographs of moving Light Rods during the day. So far the jury is still out on what this is, but we still continue to occasionally photograph Light Rods, mainly now moving horizontally, but as and when this happens, it still makes no sense in terms of all the ordinary natural flora and fauna in our garden. Put in context of all our other experiences and photographic encounters here it would seem that whether we understand it or not Light Rods may be part of a continually unfolding visual phenomenon that are indications of the presence of a Beyond Reality interfacing with our own.

THE WATER CEREMONY

Above is a view from the beach on the isle of Iona, it is special place, long valued for its peace and serenity. But the main thing about Iona is that, like all other islands, it is surrounded by water. You are never far from the sound and sight of the ocean. Our world is called Earth – but perhaps it should really be called – "Water World". Water covers two thirds of our planet's surface, making it a bright, beautiful blue sphere in the ocean of space. One of the great mysteries of life on Earth is how water actually got here. So far science has been unable to account for the presence of water on our planet. If the standard scientific view of how our solar system began is correct – then Earth should be a barren rock, like the Moon. In the terrible glare of our sun, Earth could never have evolved an atmosphere. Unprotected by an atmosphere, Earth would have been a scorched world, burnt by the destructive power of the sun's radiation – and yet we have the "Miracle of Water", which underpins all life. In the first verse of Genesis – even before God said, *"Let there be Light"*, we are told

that, *"The spirit of God moved over the face of the water"*.

In the Genesis story, water was the fundamental element from which God created the Earth and all life upon it. The first raindrop was also the first prism, which split white light into all the colours of the spectrum and without water there would be no Rainbow. So we speak of Holy Water, Sacred Water, and the Water of Life!

Dr. Masaru Emoto is a Japanese scientist, internationally renowned for his research work in visually capturing the structure of water at the moment of freezing. His work in showing how positive intention can affect the formation of water crystals has won him world wide acclaim and led to the 'United Nations World Water Day Festival of Love and Gratitude' in 2010.

Masaru Emoto was born in Yokohama in 1943. He was educated in Humanities and Sciences at Yokohama Municipal University; he later became a Doctor of Alternative Medicine, subsequently studying Magnetic Resonance Analysis technology in the United States. Dr. Emoto comments,

From ancient days they say water is the origin of all creation. When you truly understand this and realize human consciousness or word can impact on the structure of water is when you understand all creation is made up with our conscious mind.

And of his own work he says,

I undertook research of water around the planet not so much as a scientific researcher but as an original thinker, as a human being. At length I realized that it was in the water crystal that water showed us its true nature.

We first heard about Dr. Emoto from our friend Fran, who told us that on July 25th (2005) all around the world there would be a ceremony of "Love and Thanks to Water", inspired by the work of Dr Emoto. We'd only heard about this a week before and it sounded like a good thing to do: focusing on the gift of water and putting out positive thoughts to help clean up polluted water. It seemed at least worth a shot so we decided to join in. But both being busy, we did not remember this until half way through that day. Even so we went down to our stream about 4pm that afternoon and began our meditation. Katie spent more time than me connecting with the flow of water in the stream. As it was a pleasant sunny afternoon, unknown to Katie, I took a few shots to record the event. The above photograph shows that we were not alone; for want of a better term here is what some have

described as a little "Water Sprite". Concentrating deeply on her meditation, Katie was not even aware I'd taken this shot, only coming out of it when she became aware that her left hand was freezing cold and other very hot! What this image actually shows is of course open to question but for various reason we believe it to be another instance of a Beyond Reality at work.

Looking closely at this funny little "Sprite" it did rather seem to be mimicking what Katie was doing: she had both index fingers half in the water at the time. Below left is an enlargement of the "Water Sprite" which as you can see was also partly in the water, almost as if it was joining in – or perhaps it was a manifestation of the conscious connection with water itself. Did the fact that humans themselves are approximately 78 percent water have anything to do with the "Water Sprites" appearance during Katie's intense meditation on water? She was both amazed and excited when I showed her the little Sprite on the camera display screen. I then tried a few more shots around the stream but got nothing. What we did get though was the next photograph (below right) of a wonderful glowing luminosity near the bank of the stream.

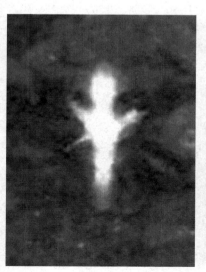 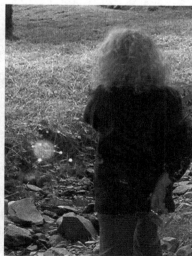

None of these photographs were taken using flash, but the glowing luminosity reminded us very distinctly of a similar luminosity we'd photographed one night the previous year – again by the bank of the stream. As you can see if you compare the two photographs below they are very similar, even though the one on the right was taken using flash and the one on the left was not.

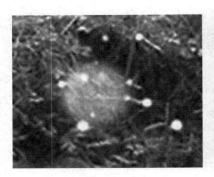 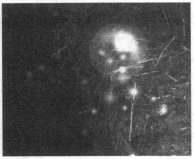

The appearance of the Water Sprite and the luminosity on the bank on the very day we were there to join in with Dr. Emoto's World Day of Love and Thanks to Water is highly synchronistic to say the least, and indeed a few years later, the interest generated by this phenomenon led to another water related event inspired by our stream and the little Water Sprite.

Monday, March 22nd 2010 was "The United Nations World Water Day Festival of Love and Gratitude", which took place at Lake Biwa in Japan. By this time we had become members of the Unitarian Movement, and Katie suggested marking this day by holding a Water Meditation at our local chapel. This was an inter-faith event to remind people of the precious gift of water and to mention Masaru Emoto's work in gathering people together around places of polluted water to concentrate in positive prayer and meditation that had resulted in restoring the water to a purer state. Here below is a photograph of Katie, at our local chapel

conducting the water cleansing with the aid of the minister and two members of the congregation.

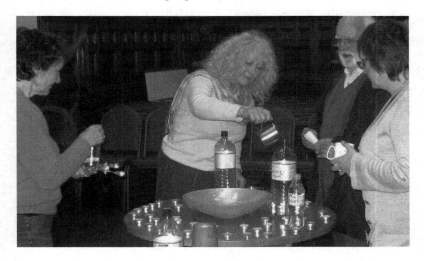

Over seventy people, from different faiths and walks of life, attended this simple ceremony to offer prayers of thanks and positive meditations directed at helping polluted water to be made clean again. Katie spoke of the many poor countries where women are the water carriers, not just in terms of carrying the waters of life in their wombs – but by walking miles to get water to drink and to wash. She spoke about the women of the then war torn Iraq, taking water from the rivers contaminated by the phosphorous, used in the bombs dropped there, and how babies were now being born with terrible deformities. We take so much for granted here, simply because here we have clean water on tap, but the fact is we are in the minority of the people on this world. Two thirds of the world do not have clean water on tap, they struggle to get water, they struggle to live.

We humans are much like our world. In the womb a foetus is 90 percent water, as an adult our bodies are 78 percent water, and our brains are 80 percent water. We are all linked physically and spiritually to water. Perhaps this is why we are drawn to the sea,

to holiday by rivers and lakes. All over our land there are Holy Wells, Sacred Springs and Rivers, places that testify to the reverence our pagan ancestors gave to water. But today our industrial civilisation carelessly pollutes the rivers and the oceans of the world; in fact humankind abuse water, consistently and continually. A few years previously, not long after photographing the little Water Sprite, our own stream, which once flourished with crayfish, became dead and sterile due to farm pollution further up into the fells. After the water ceremony Katie and other members that were there, took bottles of the positively charged and blessed water and poured it into the sea, a lake, a river, and our stream.

Literally a few months after this we noticed that the stream was alive again; the crayfish had returned and are now abundant there. All this came from that one day back in July 2005 when we went down to our stream to join in with the World Day of Love and Thanks to Water, where we photographed the little Water Sprite. Our encounter with the strange phenomenon in the stream had started a chain of synchronicity that touched other lives in our local community and beyond.

THE LIGHT-FORMS

One evening Katie had gone out into the garden alone to take some photographs, as I was busy working on a publishing deadline. Not long afterward she excitedly rushed in to tell me to come out into the Dell – and to be quick! She said something different was happening. All she could see in her viewfinder was white static just like a TV not tuned in. As soon as I entered the Faerie Dell, I could feel it – it felt like a thunderstorm. The air was crackling with electrostatic and Katie was enveloped in a twisting, swirling mist – this was the start of the Light-Forms.

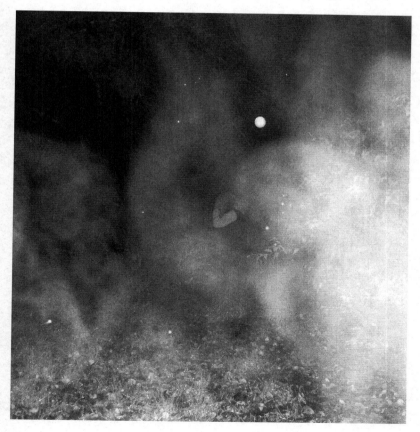

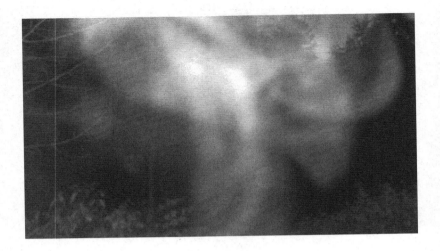

These swirling dynamic shapes we came to call "Light-Forms", as with our other phenomena, once we had photographed one, they began to recur. The image above and below seem to give the impression of dancing in the air. The same crackling electrostatic in the air Katie had felt during the first encounter was present in many subsequent occurrences but mostly to a much lesser degree, yet each brought with it the same feeling of being on the verge of something not quite real, or beyond our perception of what is real.

Living in the country we are well familiar with the effects of moisture and mist, and of breath in the air. After taking the next couple of shots we deliberately checked to see if this was the affect of ground mist or breath but it wasn't. But from then on we made a point of holding our breath in cold conditions. Whatever they were these Light-Forms were not shapeless mists, they have definite form; at times they are almost like constructed works of art.

To me the one above looks slightly like the head of a horse and the one below like some kind of insect. You may see other images. Close up they are visually stunning and energetically invigorating; at times it seemed as though we were in the presence of some vital force.

The photographs shown here we have chosen to give some idea of the variety of forms we have taken. At times they seem like dynamic living artwork constantly unfolding into different aspects.

Sometimes, as in the beginning we also photographed orbs

appearing alongside or in amongst the Light-Forms. To me the two images below give the distinct impression of flying forms ascending into the night sky, but there again you may see something different.

Over the years the Light-Forms have given way to other phenomena but occasionally they still appear. This was very much an intermediate state in our photographic encounters and if we look back we can see some kind of progression at work from orbs (which are still always there) to the winged Faerie-like forms, to the Light Rods, the Water Sprite and now the Light-Forms. Retrospectively, from this point in time we can now discern an unfolding phenomenon, which we have come to see as indications of a Beyond Reality interfacing with our own level of Reality, but at the time all this was happening we were still trying to make some kind of sense of it as and when it was happening. It was a bit like trying to see the whole picture when actually you are in it and part of it. But instinctively for whatever reasons we seemed to be heading in the right general direction. Certainly by the time *Beyond Photography* was published in 2006

we had come to understand the phenomenon we were encountering in a much wider context.

 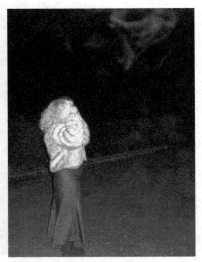

As you can see in the two photographs above, both taken on the same evening, there appears to be definite structures that are becoming almost figurative. The one on the left is the first shot and I managed to take the one on the right as the Light-Form occurrence was fading into the night. We did not realise it at that time but the evolving figurative shapes within the Light-Forms were heralding the next major transition of the phenomena.

LIGHT, BEINGS AND ANGELS

One evening in early 2005 we returned from a stroll through the woods, during which neither of us had photographed anything; we were about to go indoors, so I pressed the "Off button" to switch off my Pentax digital camera, except that I didn't – instead, by mistake, I'd pressed the "shoot button". Unexpectedly the flash went off! I glanced down at the screen and immediately called Katie back from going indoors. What we saw there was an image (below left) of a misty figure hovering over the veranda. We stared at it in disbelief for a moment – then Katie said, "Quick – take another one!"

I pressed the right button this time, but all we got was this last shot (below right) of the veranda as we both saw it: totally clear and empty of any kind of mist or apparition.

I took no more shots because at that point the battery instantly died – but this was our very first photograph of what we later came to call "Light Beings". It was at this very point that the phenomenon that began with orbs transitioned into completely new anthropomorphic forms.

We have applied various names to the phenomenon we have photographed, but as mentioned previously, all out terms are descriptive – *not* definitive. The term, "Light Beings" used here refers to them as anthropomorphic figures manifesting in the visible light spectrum, not to whether they are spirit entities, angels or whatever. We simply do not know, all we know is what we can see and photograph. What we may each believe them to be is a matter of personal belief or opinion.

Obviously what we are photographing is not the whole picture, anymore than the flashing of a mirror in the distance is the person doing the signalling. We have to consider the possibility that such images may be a reciprocal effect of consciousness or simply a means of communication: visual signs by something or someone to attract our attention for some

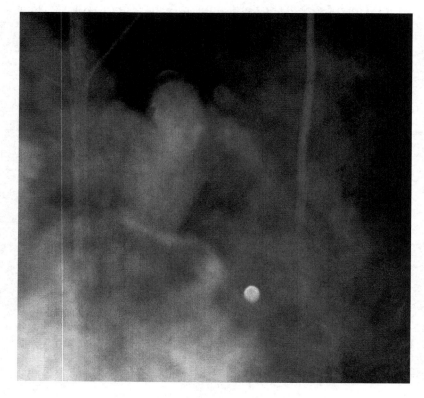

unknown reason. We could speculate many possibilities. But in the context of the whole unfolding phenomenon we had experienced and photographed, it seemed to us that here again we were witnessing another visual indicator of the existence of a Beyond Reality interfacing with our own. Just as with the previous transitions, Light Beings became a recurring phenomenon in a variety of anthropomorphic forms. For instance, the impressive blue figure below, photographed one night moving through the woodland, we estimated to be about 12 to 14 feet tall.

In the photograph below the blue figure is about human size. It looks, for all the world like someone sitting under the tree – and perhaps it is. Some would see it as a ghostly apparition from the afterlife, but we do not view it that way. In the context of all the other Light Beings we have photographed we see it as part of the same unfolding phenomenon.

If we put it into the context of a Beyond Reality manifestation, which as far as we can tell is both reciprocal to, and interactive with, consciousness, it begins to make some strange kind of sense. Remember the shattered mirror metaphor! If all the diversity of life at every level, physically and metaphysically, are, like the trillions of shattered pieces of mirror, continually reflecting One Conscious Universal Beyond Reality, then because of its very existence, that Beyond Reality invests both our physicality and our consciousness. It would not be surprising then that if we both liked all things Tolkienesque, which we do, that the two blue woodland figures may look as though they belong in Middle Earth or in some myth or legend.

 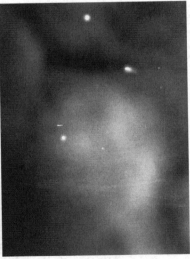

Let's just follow this idea further: we are both interested in UFOs and aliens, so we got the four images on this page. All four are strikingly reminiscent of aliens, especially the two below: on the left is a spaceman type figure and on the right a floating alien. These we believe are reciprocal visual phenomena resonating to our own individuated consciousness and generated by the interface between our reality and the wider Beyond Reality.

If our world, in fact our whole universe both physical and metaphysical, in all its vast diversity is but a mirror world continually reflecting One Ultimate Conscious and Universal Beyond Reality then it is quite probable that anomalies will recur and repeat which do not fit into our prevailing mirror world paradigms. This is because all our concepts are based not on one observable absolute Reality but on the mirrored images of that Beyond Realty filtered through both physics and metaphysics. In that sense we are like a person with a fixed point of view who can only look at the reflection of the moon in a puddle, as it passes overhead, but who cannot look up to see the actual moon in the sky. From his puddle observations he may well come up with some reasonable conclusions about what he sees in the water. The moon and stars passing across the puddle right beneath his nose would seem to be part and parcel of the puddle universe, but of course they are not. In terms of the wider reality happening in the great unknown above, the whole orientation of the puddle universe is wrong, and though it may seem to be complete within itself it is actually an incomplete view of Reality.

If that is so,then anomalies will appear, and that is exactly what happens here. Genuine paranormal phenomena presents us with anomalies not explicable in terms of the ordinary.

Anomalies are not only found in paranormal phenomenon, they exist at most levels of our universe. But they are only anomalies in the first place because our mirror world or puddle world rationalizations are largely built on incomplete information mostly derived from representations or reflections of Reality rather than upon the One Self Existent Beyond Reality itself. For instance, here is a quite physical anomaly: because we find dinosaur bones in 500 million year old sedimentary strata, evolution theory requires that dinosaurs lived 500 million years ago. But over the past ten years or more palaeontologists have discovered soft tissue in fossilized dinosaur bones; even in dinosaur bones in museums! The problem with this is, at the very best outside estimates, soft tissue cannot exist for more than 30,000 years! This means even if the rocks are dated at 500 million years old, those same dinosaurs were walking around some 40,000 to 50,000 years ago. This flat lines the theory of evolution. As does the second law of thermodynamics for in a universe where empathy is the status quo, where everything degrades and decays from a perfect starting point, this is the exact reverse of the principle of evolution. Have we all missed something here? I think we have. In our puddle universe we are missing the complete picture. The closer we get, as in quantum physics, to the interface between the reflection and the Beyond Reality the more we realise how incomplete our view of Reality really is.

Once we realize our limited perspective we have to accept that all our concepts of Reality are flawed and incomplete; of course I include my own views in this also. This, however, does not mean that we can know nothing about our existence, we know quite a lot, but as much as we learn our ignorance will always be greater, simply because the One prevailing Universal Reality will always be beyond us: always unknowable. We simply have to accept it

on its own terms; we don't have any cosmic bargaining chips here. Certainly science can do a lot but it cannot create something out of nothing; all science can do is to describe and manipulate what is. We cannot create anything new. That would have to come from somewhere else, from a wider Reality beyond our puddle universe.

One of the ordinary everyday indications of a wider or Beyond Reality impinging on our own is the existence of synchronicity. The famous psychologist C.G. Jung first coined the term, Synchronicity to designate, *"the meaningful coincidence, or equivalence, of psychic or physical states or events which are not directly related; or when an inwardly perceived insight, such as a dream, vision or premonition has direct meaning for external reality"*.

Synchronicity can also be used to describe similar or identical thoughts or dreams occurring at the same time in different places. Jung called this an "Acausal Connecting Principle" and cited it as possible evidence for his hypothesis of the collective unconscious. Though even Jung seemed to struggle at times to reconcile the inexplicable existence of synchronicity with the then orthodox assumption of a purely relative mechanistic universe, saying that, *"meaningful coincidences are unthinkable as pure chance..."* and pointed out that, *"their 'chance' concurrence would represent a degree of improbability"* so great that it would have to be *"expressed by an astronomical figure"*.

Certainly, in our experience, one of the major hallmarks of the phenomenon we were experiencing and photographing were the consistent instances of synchronicity that we believe, in the context of a Beyond Reality, indicates an underlying connectivity of consciousness and meaning linked to the paranormal phenomenon we were encountering. Something was definitely picking up and replaying to us things that had meaning for us in particular. For instance, my interest in the Old Testament and ancient accounts of angels. You can clearly see this reflected in the following photographs, especially in this stunning photo-

graph below of an imposing figure, which was the first of its kind taken in 2006. This and the following images reminded me very much of what the Hebrews called *"Mal'achei elyon"* or Angels from the Celestial Realm.

The concept of angels comes from the ancient civilisations of Mesopotamia. The Old Testament word for angel is *malak* – the

New Testament uses the Greek, *aggelos,* translated into Latin as *angelos.* In both Old and New Testaments the meaning is messenger: describing only the function of the being, not its type or species, race or gender. An angel is simply a messenger of God.

Once that first image had occurred, other very similar apparitions followed, but spaced out across a few years. Compare the two photographs below: the one on the left was taken in 2007 and the one on the right taken in 2010. Here again both these misty figures have an imposing presence that recalls the idea of an Old Testament angel: other worldly, imposing and awe inspiring.

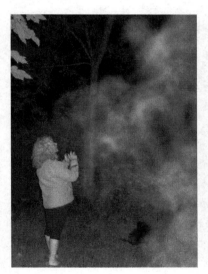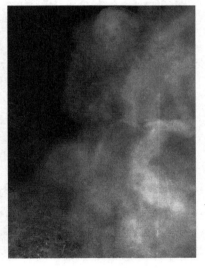

To me all these three images seem half-formed, like sketches or impressions of those Old Testament angels: anthropomorphic vaguely winged figures conveying the essence of something ancient and otherworldly. Indeed, the 2007 photograph (above left) of Katie looking up at the misty figure, is very reminiscent of some kind of angelic visitation. But as with the paranormal in general we must not get carried away with what it *appears* to be.

What we are dealing with here are more probably visual metaphors, than actual angelic beings.

Comparing the three angel-like apparitions (above) from three different years, using the same Photoshop Un-sharp mask settings, we can see that all three figures have definite constructional similarities, which go beyond mere chance coincidence. Something deliberate is happening here; something beyond normal reality. They are all distinctly individual yet distinctly the same kind of entity. In the case of the 2006 and 2007 images, prior to photographing them, what Katie saw was the tiny twinkling lights (STLs), but she saw nothing prior to the 2010 image, which was one of a random few shots taken by me of nothing in particular just in case I could get any orbs, which I didn't.

Further Thoughts on Light Beings and Angels

The "accidental" shot I took of our first Light Being, could, at first glance look ghostly, and some of the larger anthropomorphic apparitions and angel-like figures we have since photographed may seem strange or even a bit scary to some; but again, this was never so for us. Nothing we have seen or photographed over all this time has ever given us cause for fear or alarm. Although

some of these entities may look different to what one may expect, or be awesomely impressive, they have always felt friendly. Even in the dark of the woods that night when we photographed the 12 foot tall ethereal blue figure coming through the trees! We may have felt a bit apprehensive as to its appearance but it certainly wasn't terrifying in any evil sense. Powerful, awesome, astounding, certainly; but only in the way one may feel looking up in a forest of Giant Redwoods or being a few feet away from a gorilla or tiger in the zoo.

Some may also consider the Light Beings we have photographed a bit too fearsome looking to even be called angels. But that is the very reason we have termed them angel-like! If we look at the Biblical accounts of angels, these celestial intermediaries are not the fuzzy-feel-good kind of angels that have been sanitized and repackaged by "New Age" sentimentality. No – they are impressive, other worldly beings, who are so awe-inspiring to the humans they visit, that their first words are usually, *"Fear not!"*

And with good reason – for if you have ever been in the presence of a non-human entity that is of a different order of being to us, then you will know exactly what I mean.

On this world we are all a bit like fish in an aquarium and, as St Paul said, *"We see through a glass darkly"*. Beyond the glass, beyond the capabilities of our space and time bound perceptions, there is a Wider Reality. Some of the beings, which have their abode there, may be as different to us as we are to microbes.

The paranormal phenomena we and others have seen or photographed, may be a communication: a visual indicator of a Wider Reality beyond normal perception that is interfacing with us at the level of individual consciousness. We see the same phenomenon manifesting in a variety of visual forms: the Virgin Mary, spirits, aliens, angels etc. Why is contact specifically individual? Perhaps because individuated consciousness acts like a transceiver connecting to a Greater Consciousness perme-

ating every level of Existence. If individuated beings exist in that Wider Reality then the most malleable interface between our material reality and theirs may indeed be Consciousness itself!

Our material existence here may be important to us, but to higher beings we may seem like short-lived larvae: incomplete creatures, a transitory stage in the development of being, but not the complete being itself. If our ultimate destiny is that Wider Reality, paranormal phenomena may be part of the process of our development as non-material beings.

However, as we discovered, we were not the only people photographing anthropomorphic or angel-like images. The amazing photograph that follows was taken on the track leading to her farm by our friend Sara, who lives about three miles away. Since first reading *Beyond Photography*, she too began to take photographs of orbs, many of them in that very same place; and as you can see there are also orbs moving across the path in front of the apparition, which appears to be a figure emerging from the undergrowth on the left. Again, like our angel-like figures, this apparition has an ancient feel to it as though it is of another time. Romantically Sara called this figure "Valentino" because it appeared on Valentine's Day.

Here below is Sara's photograph of "Valentino.".

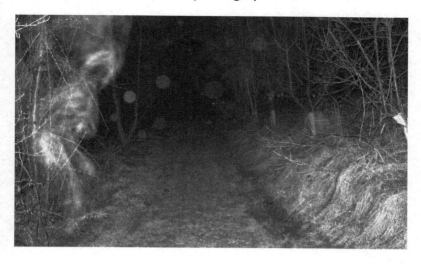

Added to this below is a photocopy of an article which appeared in the Daily Mail in 2007, it features a photograph of an angel-like apparition taken in the Vatican by Andy Key, a retired police officer. This photograph, much like our own, has mystified professional photographers. It was taken in 2007 the year that we

took our second angel-like apparition; as mentioned, our first one out of the three shown here was taken back in 2005.

For copyright reasons we cannot use the actual high-resolution photograph Andy Key took but you can view it online at www.dailymail.co.uk/news or www.nsacphenomena.com

THE CIRCLE OF SPIRIT HEALING

Strange visual phenomena have been photographed by many people. When we did a presentation at Glasgow University we met people who were researching or experiencing, such phenomena, including psychic, Jim Sherlock. The photographs below and on the next page were sent to us by Jim and show what he describes as images of spirit manifestations taken by visiting Belgian medium Isobelle Duchene during a meeting of Jim Sherlock's Psychic Circle. According to Jim, over 200 hundred orbs were photographed that evening as well as other phenomena.

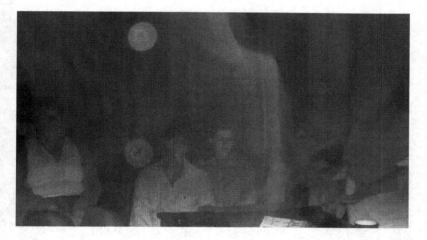

As we were not present, the account of what happened that evening and how it relates to the photographs shown here has been supplied to us by Jim Sherlock, who confirmed that all the photographs are genuine images of psychic phenomena. The two shots below shows a member (Pat) sitting in the chair while "spirit" gives him healing. Jim explained that the dark shadow area you can see on Pat's chest was felt as actual pain by the other mediums in the room that night. Notice the presence of orbs and

how electrical appliances in the room seem to be affected.

Here below are two more images of "spirit manifestations" around the sitter, photographed that same night. Again notice how lines or strings of light seem to be coming from, or are attracted to, electrical appliances. This time the sitter in these two photographs is a different person but the visual phenomena gathering around her is very similar to the previous manifestations.

Again these two photographs show what seems to be a figure standing behind the sitter. Jim explained this was the visual manifestation of the spirit healer. Note that orbs are again to the left of the sitter. Something unusual is happening here, of course what it may be is open to question, but if we examine the photographs closely there are many internal consistencies, suggesting the probability that the same phenomenon is happening across all the photographs Jim sent to us.

As with our own or anyone else's photographs of a paranormal phenomenon, once it is captured in the visual spectrum, it is at that very moment part of our normal reality and as such subject to the same laws of physics by which any other visual phenomenon can be tested and verified.

THE GREEN MAN

Early one evening in 2007 Katie went out to take some shots in the Faerie Dell. Amongst her images was the above photograph. At first glance we saw nothing special, then as we looked a bit closer I suddenly said, "Is that a tree? I don't remember a tree there?"

We lightened the image – and then we saw it! And, as you can new clearly see from the lightened image below, there is what appears to be a green figure standing to the left of the tree. As this strange anthropomorphic figure is predominantly green, we simply called it, "The Green Man"!

 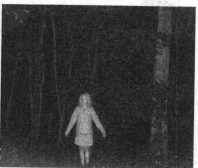

The next evening Katie decided to try and get some idea of the height of our Green Man and so I took the photograph (above right) of Katie standing in roughly the same place. When we compare it with the lightened image (above left) we could see that, as Katie is 5 feet 2 inches, the Green Man must have been over 12 feet tall!

Again we had to ask, "Why an image of a tall green figure?" Was this a tree diva or woodland spirit? According to folklore and legend, entities like The Green Man have long been believed to haunt England's woodland. Certainly our own woodland feels like an enchanted place, full of old and ancient trees; just the place where you would expect to meet Elves or even Tom Bombadil.

Even so we have never photographed a Green Man before or since. Neither did it seem to mean anything, except in terms of our own interests. Both Katie and I love Tolkien's stories of Middle Earth – and, of course, this tall green figure instantly reminded us of an Ent. Could this be another instance of the reciprocal nature of that Beyond Reality through which a wider Consciousness, which may at times interface with our own, which we may then experience or record in some way as a paranormal phenomenon.

If this is indeed so, it is not unique to us; it will affect everyone, everywhere to a greater or lesser degree: déjà vu,

synchronicity, inexplicable anomalies and psychic phenomena. This is, of course precisely what we see in a whole range of diverse extraordinary phenomena recorded as affecting human beings throughout history.

In terms of our own small local events that may have had any connection to this appearance, the only event we could relate it to was the previous day when we had taken out a few saplings in that area as the trees needed more light. If everything is connected physically and metaphysically then perhaps because Katie was concerned to say out loud to the surrounding trees, that we were sorry to do this, but it had to be done, that this evoked some resonance somewhere? Perhaps the Green Man image was a response to Katie's intent in affirming that connection.

SYNCHRONICITY AND A WOLF

When our friend, psychic and numerologist Ellis Taylor, came to stay for a few days, as you do when friends visit, we ended up going to places we'd not been to for ages. We suggested a visit to one of our favourite stone circles: Long Meg. It was there, at the Long Meg stone circle, that a series of synchronicities and interconnected paranormal events began to occur. Those with us on our trip to Long Meg were Ellis, Mike and Fran. Long Meg is one of the largest stone circles in the country and is virtually in the middle of nowhere. It took a while to get there but eventually we were all walking around looking at the stones. Ellis was chatting about the people we'd met at conference we had all attended the previous weekend, saying what a pity it was that they couldn't have been here too.

On the wind I heard a distant voice calling my name, and turning was surprised to see walking towards us the whole group of folks we had just been talking about from the previous weekend's conference. None of us had any idea the others would be there at Long Meg and we all had a good laugh about it. As we waved them goodbye we did not realise that this unexpected meeting was not the only instance of synchronicity we were to experience there.

Below is a photograph of part of the circle with Long Meg in the distance between two stones.

As I walked around the stones with Ellis he was asking questions about the stone circle, of which I did know a little, but I explained that the man who knew most about this circle, indeed all the stones circles in Cumbria, was Tom Clare, once the county archaeologist, who had written the definitive book on stone circles, but whom I had not seen for a few years. I had just finished telling Ellis this when I turned to notice a figure walking vaguely towards us through the middle of the circle. I recognised him immediately: it was Tom, the person I had just been speaking about!

This was the second incidence of synchronicity. Tom who was there researching his new book on stone circles, was then able to answer all Ellis's questions. It was really good to meet Tom again and hear how he was doing. As we waved goodbye to Tom, I had the intuitive feeling that perhaps something other was happening more than just a visit to Long Meg. Like most stone circles it was a place with its own distinct atmosphere: an ancient place, a betwixt and between place, where one could almost expect the unexpected to occur.

Indeed as I took some photographs to record our visit with Ellis, I took one of Fran standing next to a stone and there right next to her in front of the stone was an orb. Here is the photograph below and as you can see from the enlargement on the

right the orb is clearly visible even in sunlight and taken without flash; so this is definitely no reflection or flash feed-back.

In the context of what happened later, I do not believe that either the synchronicities or the appearance of this orb were unrelated. Although I have no idea what any of this may mean, that may be for those who come after us to discover. The next day we decided to take Ellis to the coast, to an ancient historical site overlooking the sea. If you recognise this place please respect it, you will probably know why I deliberately do not mention its specific location here.

This is an ancient sacred site that predates the coming of Christianity and upon which the first Celtic Christians from Ireland built a church and monastery. Kath, a local lady, now departed, spent 40 years studying and a mapping this site and making tracings of the various petroglyphs of eagles, animals and symbols hidden in the landscape. On a rocky outcrop high above the sea are what appear to be five narrow graves cut into the rock. Ellis was instantly drawn to this and as he had brought his dowsing rods, suggested doing some dowsing. Ellis was an experienced dowser, I've done some but Katie had not done any before. By simple yes or no questions, Ellis hoped to learn something more about the site than the little that was printed on the historical notice in the ruins of the little church. We took turns using the dowsing rods, each standing on the slab of rock where the ancient graves were cut. We got some unexpected answers to our questions, which I will not reveal here so as not to prejudice anyone else's results. After about thirty minutes we came to a point in the dowsed responses that now required a verbal response from us. Katie was using the rods at the time, but when she spoke the words we had agreed on, she was suddenly flung off the rock slab to land on her back on the grass! I rushed to her side immediately and called her back but she had no ill effects and was not hurt in any way. Ellis thought it happened because the energy there was so incredibly strong. This was her

first time at dowsing and Katie's own sense of psychic connection was acute. Fortunately this did not put her off dowsing, but we all thought that was enough for one day.

That night after dinner, Ellis went for a wander in the garden but soon came rushing back to get his camera as he thought he'd seen something in the dell. We joined him, armed with our own cameras and strolled into the woodland, followed as usual by the cats.

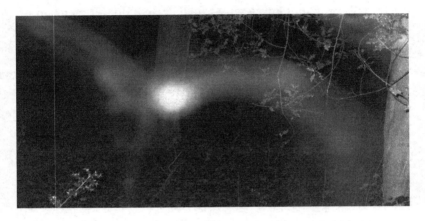

Not long after, Ellis wasn't far away when he saw a blue luminosity through the trees and took the photograph above. I managed to take the photograph below, as it was moving away. So, here we have two photographs of the same moving luminosity, taken by two people, using two different cameras. This does not often happen but put in the context of our other events that day, and the day before, perhaps it wasn't so surprising that it did.

We continued looking but saw nothing more. Shortly afterward Ellis said that he thought he sensed something like a wolf spirit in the woods (he says things like that). The cats certainly didn't seem disturbed; they were probably more concerned with mice spirits, or preferably just mice.

However, only a few minutes later, taking a random shot of Katie, I took the next photograph which now certainly qualified Ellis's psychic senses, because this shows what looks like a misty wolf or fox-like image right next to her. In terms of synchronicity this photograph was absolutely spot-on.

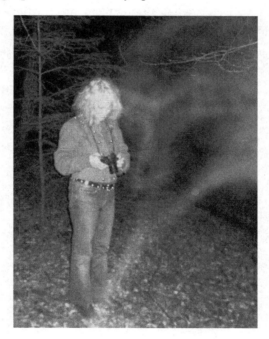

The wolf image, shown above, was particularly interesting for us, not only because Ellis had sensed it before it was

photographed, but more specifically because it was only a few yards away from where Katie was standing. It was there, three years before (as mentioned previously) we had photographed the orbs configuration that matched the constellation of Canis Major, in which is the star Sirius, the dog star. Significantly and astrologically Sirius is the ruling star for both dogs and wolves. Added to this we have another synchronistic link to the dog or wolf. The cartoon strip Mike Oram and I do together, Ben's World, is all about a little dog called Ben, and Sirius is even featured in one of the early comic strips. When we think of the wolf as a symbol, we have to realise that this is not literally one specific animal; it is representative of a genre that includes dogs, foxes, wolves and pretty much all canines. In terms of a Wider Reality, there seems to be a connection of consciousness running through all these events and images but what it may mean, apart from affirming to us that such connectivity happens, is still open to question. However, as outlined at the end of the first part of this book, all the connections with Sirius would seem to be more than mere chance coincidence and may be part of a wider picture not yet fully seen. In terms of the mirror Universe concept St Paul's comment in 1 Corinthians 13:12, would seem quite appropriate here: *"For now we see in a mirror but dimly, but then we shall see face to face. Now I know only in part, but then I shall know in full, even as I am also known."*

LIGHT STREAMING

Today we speak of streaming video; that is a video file that is sent in a constant flow directly from a website to your computer, laptop, tablet or mobilephone. When you click on YouTube to play a video you are streaming the video file from that website to the media player on your computer or tablet.

It is called "streaming" because it happens in real time; the file is delivered to your computer like water flowing from a tap. A streaming file is not saved on your device you simply watch and listen to streaming video or music as it comes direct to your media player. It is the speed of your internet connection that mainly ensures getting a smooth viewing experience.

Sometimes it seemed that the experience and phenomenon we were witnessing was a bit like streaming video: although we could capture bits of it, we couldn't save the whole file. So much was happening at different levels in a constant state of "streaming" phenomena, which seemed to suggest that the connection, or interface, with the service provider, the Beyond Reality, was active in real time and working at high speed. A good but rather prosaic example of this is the electrical effects that translated literally into streaming light signals. In the photograph below you can see one of the touch lamps in a corner of our bedroom. I took this when it was having a session of coming on for no apparent reason; notice the orbs to the left, a sure sign of interaction.

My daughter, Annabel, gave us these lamps a few years ago. At first they worked fine: you tapped them, they went on or off, no problem. You had to definitely touch them to make them work; a light touch would not do it. Then in 2006 not long after *Beyond Photography* was first published something odd happened. It was the time when Katie was reading that wonderful book, *The Secret Life of Plants* by Peter Tompkins and Christopher Bird. That night she had been reading the section containing a quote from Gustav Theodor Fechner, a 19th-century professor of physics who was one of the first scientists to explore the possibility that plants had awareness. We had actually referred to this in *Beyond Photography*. Fechner's ideas had later been verified by the research work of Cleve Baxter and others. Fechner had also put forward the notion that human consciousness was made up of three stages: One, a continuous sleep state from conception to birth; two, the half-awake state we think of as our terrestrial existence; three, the fully awake state which only begins after death. This is referred to in Fechner's own book *Comparative Anatomy of Angels*, in which he traces the evolution of consciousness, from simple organisms, through animals and humans to higher angelic beings, who he believed to be spherical in form and who communicate through light itself by the use of

luminous symbols. It was this section Katie had been re-reading again just before she put the light out to go to sleep. About three hours later she suddenly woke up and was just lying there wondering why she was awake when suddenly both lights came on! Katie was amazed and excitedly woke me up to tell me what had happened.

I don't think I was quite as impressed as she was at the time. I just wanted to get back to sleep.

But Katie quickly related this to what she'd been reading about Fechner's idea of higher beings communicating through light. Considering everything else that had happened, this did not seem too improbable. From that moment on the touch lamps, either both or one or the other, would spontaneously come on, but not randomly; it only happened at times that were uncannily synchronistic, such as when Katie or myself were reading something spiritually meaningful, or something paranormal had occurred, or on or before some special occasion. This all seemed too coincidental; so first we investigated this thoroughly for any likely normal explanations.

We discovered that our touch-sensitive lamps used a property of the human body to trigger the "light on mode". Our lamps worked because of "capacitance" – that is the capacity an object has to hold electrons. When it is standing by itself on a table, the lamp has a predetermined capacitance. Touching the lamp with your hand simply adds to its capacity. Because it takes more electrons to fill a human body than it does to fill a lamp the electrical circuit in the lamp is designed to detect that difference; when it does so the light goes on. Like most touch-sensitive lamps ours have three brightness settings; the circuit changes the brightness of the lamp by changing the "duty cycle" of the power reaching the bulb. For instance, in the lamp circuit a 0 percent cycle equals "Off" and a 33 percent cycle equals 66 percent brightness and a 100 percent duty cycle equals full brightness. Touching the lamp with any object such as, a book, a duster or a

glove will not activate it. Not even a fly or moth landing on it will set it off. Switching the radio, or other electrical appliances, on or off did not affect it. We tried everything likely but nothing other than direct contact with the human body worked. So we just accepted that this was happening, but always at meaningful times, for reasons we could not fathom. There was no pattern except synchronicity. Some weeks it would happen two or three times, then nothing for months, until it coincided with something particularly meaningful for us. Mostly now it only happens with one lamp not two as in the beginning. This has happened for a few years now. Repeatedly over that period when it hasn't happened for a couple of months, Katie gets to thinking it may never happen again. Then if we are in the bedroom, afternoon or evening, it doesn't matter, she will say to me something like, "Do you think, that's it, it'll not happen again?" Typically then either instantly or later that evening, the light comes on. The best one so far was one afternoon in 2010, on my birthday, we were in the bedroom getting ready to go out. The lamp hadn't come on for months, when suddenly on it came!

Katie was really pleased and excited, "Look at that – I think it's come on because it's your birthday!" But then added, "Odd it only ever comes on the first setting, and it never switches itself off, maybe it can't..."

The words were only just out of her mouth when the lamp suddenly went through all three brightness settings three times; then for the next fifteen minutes it went – on – off – on – off – on – off – we could hardly believe it. This unprecedented light show was so amusing and went on so pointedly for so long that we both ended up laughing; then suddenly it went off and never came on again for another couple of months!

Since 2006, Katie has been logging experiences and strange incidents, including our spontaneous lamp lights, as they happened in a little book, so my birthday light show was duly noted down. The lamp continues to light up if Katie needs a light

at night, if something important to us happens, or when she is reading or even if we are discussing something new related to our spiritual journey.

Certainly Light has been critical to our entire phenomenon, to our experiences, and to our spiritual perspective. Light streaming from our Beyond Reality Service Provider, was not just amusing us by connecting to the lamps, as you will see in the next set of photographs.

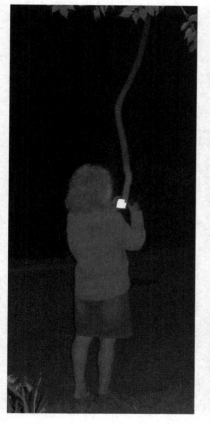 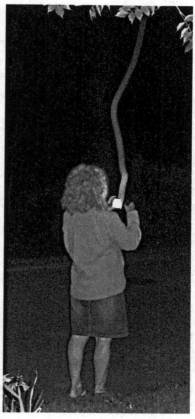

One evening, after taking a few shots, Katie was checking through them on her camera's display screen, when I took this photograph from the veranda. It shows something we had never

got before, or since: a stream of light either going into or coming out of the camera. The photo on the left is the original image; the one on the right has been enhanced slightly using the Adobe Photoshop Un-sharp Mask tool.

In the above photograph you can see what appears to be a light stream flowing, or streaming into Katie's camera. You can more clearly see this on the right hand version. If we think of this photograph in metaphorical terms with Katie's camera being symbolical of the very means we have used to record the entire phenomena, then the stream of light flowing into or out of the camera could well represent the "streaming connection" between the device and the Service Provider: the Beyond Reality that generates the whole phenomena!

Above and opposite are two enlargements of this unique image that I have enhanced by using the Adobe Photoshop Un-sharp Mask tool. Both these enhancements, clearly reveal smaller elements within the light stream. But what are they, random pixilation or actual images?

Some have claimed to see faces in enlargements of orbs but we have always thought this slightly dubious because the mind is geared to see recognizable patterns in even random elements, such as pictures in clouds, faces in rocks, tree trunks, or even in patches of damp etc. But whether or not this light stream does contain real tiny images is not as important as the metaphysical implication of another reality actually connecting with the camera. In the context of our entire visual phenomena, from our point of view this is a visual communication affirming that connection.

AN ANGEL VISITATION?

2006 2007 2010

As you have seen previously the above three images, in our estimation, represent three angel-like figures, though taken in different years, have a construction so similar that they must belong to the same genre or group of entities. Or as metaphysical communications from the Beyond Reality perhaps they are consistent representations of angelic archetypes pulled from the collective consciousness?

As touched on earlier in this book, the concept of angels is derived from the ancient civilisations of Mesopotamia and later from New Testament Christianity. The Bible speaks of guardian angels and of angels as messengers of hope, which still very much seems their function today by those who believe in them. Angels are generally viewed as transcending any one particular religion; they are seen as beings of light or pure spirit. There are numerous books written about angels but it is not our purpose here to discuss the nature or meaning of angels except as it may relate to our own particular experiences with the phenomenon of photographable paranormal manifestations.

As mentioned previously whether known in Hebrew as *malak* or in Latin as *angelos,* an angel is simply a celestial, messenger. In

that sense, as we originally wrote back in 2006, in *Beyond Photography*, *"our luminosities and light-forms could be said to be angels; for they had been continually giving us messages on various levels..."*

At least one popular New Age writer subsequently took this idea literally and later produced one or two books asserting, with unprecedented certainty, that orbs were in fact angels. One cannot help but wonder that if orbs had not become so popular whether anyone would have ever thought of this? So let us be clear on this point, we personally do not consider orbs to *be* angels, neither do we consider the figurative images that look angel-like, that we have photographed, to *be* actual angels. In the context of the whole range of the phenomena we have experienced, encountered and photographed, we believe it is probable that these are reciprocal visual manifestations generated through the interface of connective consciousness between our reality and a Wider Reality.

In our world of individuated consciousness a whole range of diverse paranormal and metaphysical phenomena has been recorded throughout human history. At times such phenomena has spiritually transformed individual lives; sometimes it has even changed the human world, religiously, politically and socially. Considering all this and in the specific context of our own experiences we would like you to also consider all the following photographs from the perspective of a wider Reality beyond all that is contained at our own level of existence.

As shown previously, our veranda was the site of the very first appearance of a Light Being – but that was not the only occasion that an anthropomorphic image appeared there, as you can see from the photograph above.

The background to this photograph of a decidedly angel-like figure is this: it was 2007 and we were soon due to go on our first trip to the USA to speak about our book, *Beyond Photography*. There was a lot going on at the time, both physically and metaphysically, and Katie's best friend, Wendy, was a little concerned that we had too many things to cope with. Wendy and Katie have known each other for years and also used to work together. Wendy is a kind, caring and spiritual person. Just like

Katie, Wendy also, from time to time, also sees the tiny lights we now call Small Transient Lights, and she is also a believer in higher angelic forces. Katie and Wendy share a close connection, not only as best friends but as kindred spirits on the spiritual path. Wendy lives many miles away and so we do not get to see her that often, but one evening totally unknown to us at the time, Wendy had decided to do an angel meditation for us and had asked Archangel Michael to be with us and to protect us. Unknown to Wendy that very same evening I was up working late on a publishing deadline. It was about 2am and I was just about to give up and go to bed when there was a tap, tapping on the study window.

I looked up and was surprised, at that unearthly hour, to see a blackbird tapping at the windowpane. I immediately had a strong sense that something "Other" was about. Because of all our other experiences I picked up my camera and, without waking Katie, went outside to see if there really was anything around. The moonless night was quiet and still but I was too tired to go far so I took a few shots from the steps in front of our door. I got a couple of orbs, and thought that was it, but then a kind shimmer in the air at the far end of the veranda caught my eye; I instinctively quickly took a shot in that direction. There was a small burst of tiny lights and the winged image you see above, appeared in my viewfinder. Then it was gone!

In the two photographs above you can compare the roughly eight feet tall angel-like apparition with the apparition of the first Light Being; in both instances both figures appeared in almost the same place on the veranda. To me this seems to go beyond chance coincidence. Let us just think about the winged figure and its connection to Wendy's angel meditation that very same night. She had specifically asked for Archangel Michael to visit us and *that very same night*, miles away, an angel-like image is photographed on the veranda of the very friends she was meditating on; again this goes beyond chance coincidence.

But if a larger Reality beyond all that we know exists, and our world is part of it, then it may be reasonable to assume that it is imbedded in every atom of our existence; in every flicker of our consciousness. Should we then really be surprised that such synchronistic events happen – I don't think we should! All that we are now learning of the vast and mysterious immensity of Existence, both physically and metaphysically, is leading us towards new radical views of consciousness; the interconnection of mind and matter in relation, not only to the diversity of life in the universe around us, but to a Wider Reality beyond.

For us the angel-like figure was not, as some may well have taken it to be, an actual angel. No, for us, this was an image, a

visual message; more like semaphore. We were seeing the flags waving but we were not seeing the flag waver. For that is always beyond us. For instance, ants may see the signs of the passage of humans or the intrusions of the human hand into their world, but even though they share this world with us, any appreciation of our nature or even our existence is always beyond them. How much greater will the gap be between our time-limited consciousness in the created universe and the vast eternal consciousness of that self-existent Reality that is beyond everything we can know or imagine.

In the next chapter we shall look at a completely different but nevertheless amazing manifestation of this Wider Reality that occurred in full daylight one afternoon.

AN ALTERNATIVE AFTERNOON

One afternoon Katie and I were strolling around looking at the garden and taking some shots of the trees when quite suddenly something odd began to happen to the images on *both* our cameras at the same time! Everything had been normal up to that point then suddenly for no reason every time we took a shot it was as though some kind of frequency change had taken place, as though we were photographing an alternative view of normal reality. The images became distorted, as in the photographs below. Bits of the landscape went missing; there were ethereal images of what looked like other people; strange flowing elements began to appear.

Although it wasn't at all stormy, the air felt heavy just like it does sometimes when you get low-pressure conditions. In the photograph above left, the trees have disappeared and in the next (above right) you can see there is the ghostly impression of another, taller figure standing right next to Katie. Below left is an enlargement of what should be the sky and below right, an enlargement of strange white vertical anomalies that appeared over leaves and greenery on most of the shots.

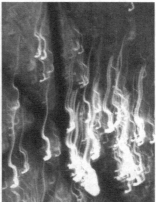

No flash was used on any of the shots, by either of us; sometimes images are both in and out of focus on the same shot, which should not happen with digital cameras set on auto, as ours were that afternoon. All the photographs taken by both our cameras were affected by the same anomalies that day, which convinced us that it was something outside of the cameras casing these very strange effects. But all that was just the forerunner to what appeared next. As Katie walked through the Faerie Dell she took this incredible photograph (below) of what appears to be a tall lady dressed in mauve apparently floating about three feet above the ground.

There is nothing pink or blue, no flowers or bushes there. She (if she it was) was very tall; our estimates put her at over seven feet in height floating above the tall grasses. As you can see the same white vertical anomalies are on this image too; they shouldn't be there anymore than what we came to call, the "Mauve Lady", should be there. Nothing natural to the garden could account for anything we photographed that afternoon; neither was it rainy or stormy, it was a dry though dullish afternoon.

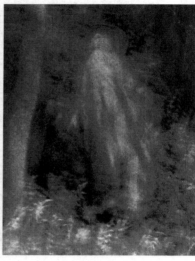

Above are two enlargements of our "Mauve Lady". On the right is the enhanced image using the Photoshop Un-sharp Mask tool; some have thought this strange ethereal floating figure could be a ghostly image of a past member of the original household from nearly 200 years ago! Notice also how the image frequency changed to duplicate the tree and foreground. Whilst not wishing to pour water on any ideas of ghosts, in this instance we feel that this image may reflect something else. However, we understand there once was a large lily pond at the bottom of the garden and this certainly is the direction the apparition seems to be heading in.

Of course the old idea of ghosts, spirits or persistent resonances from the past manifesting visually in present time, could in today's view of the quantum universe equally be from the future, or from some other alternate reality. We have to keep an open mind here, but if we analyse this image as we have done many times, upon close examination this is not a human figure, although at a quick glance it gives that impression. That is more accurately what it is: an impression, almost a visual metaphor in colour of a walking figure. It is totally out of keeping with the environment, the only thing that ties it together with the other photographs taken that afternoon are the other strange visual anomalies that were consistent on all the images taken by two distinctly different makes of camera; mine was a Pentax and Katie used an Olympus. That both cameras would suffer from exactly the same digital anomaly at the same time seems highly unlikely. The only other explanation, in the context of the fact that both cameras recorded the same phenomenon, is that we were both photographing something external and real. That this caused visual reality to be reproduced as distorted and shifting indicates that some form of energy, whether physical or metaphysical, was affecting both cameras. In our estimation this was another occurrence of the "orbs and beyond" phenomenon.

CONCERNING PROPHETIC
APPARITIONS

For the past few years I had been writing a book on prophecy and prediction, a subject I had a long time interest in. Essentially this is a rational overview intended to inform and help people to better distinguish the facts from the fiction. The history of prophecy, both Christian and otherwise, is littered with the rusting debris of self-delusions and deliberate deceptions of false prophecies. The last few years of prophetic hype spinning out in all directions from the marketing driven bandwagon incorrectly promoting 2012 as the so called "End of the Mayan Calendar", the end of the world as we know it, is the most recent example of the power of false prophecy as an all too effective spiritual deception. Added to this, prediction has now become a huge money making business, with a celebrity style psychic glitterati at the top of the money tree. The huge incomes and consistent predictive failures of some highly paid media psychics have quite rightly resulted in well-justified criticisms from sceptics everywhere. Unfortunately, it has also resulted in genuine psychics being tarred with the same brush. This was one issue I was very concerned to deal with in my book about prophecy; for there *are* genuine instances of some people correctly predicting the future, albeit none of these people were making a business out of doing so.

In our first book *Beyond Photography* we mentioned the apparition of Fatima in 1917, commonly accepted by Roman Catholics to be a miraculous appearance of the Virgin Mary. The story of Fatima centres around three village children who one day, while out watching sheep, saw a bright flash of light. Drawn towards this unexpected phenomenon, in the centre of the luminosity they saw a radiant being, later described as a "small woman", subsequently believed by thousands of Catholics to be

a miraculous visitation of the Virgin. There were five appearances at Fatima altogether, and on the last appearance, what is termed, "The Miracle of the Sun", was witnessed by over 70,000 people. Many photographs, such as the one below, were taken at the time by believers, non-believers, sceptics, and journalists who were there. Just type Fatima into Google and you will be able to check all this out for yourself.

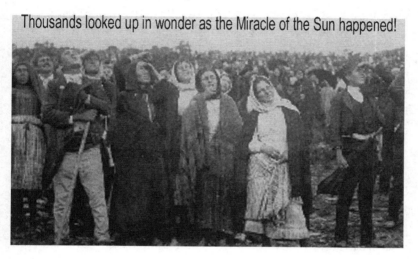

Thousands looked up in wonder as the Miracle of the Sun happened!

We referred to Fatima in our book primarily because it is one of the best-documented appearances of luminosities, beings of light and other paranormal light phenomenon, similar to our own phenomenon. What we did not discuss were the prophetic implications of the appearances of this "Lady of Light". Even by the time I was doing the second draft of my book on prophecy, I had still not intended to include Fatima or any other such Roman Catholicised accounts of visions or miraculous appearances in the book. In the context of our own experiences of paranormal visual phenomena this omission may seem strange, but the fact is I saw the whole panoply of Roman Catholic Icons and miracles and all the surrounding religiosity as something to be avoided because it smacked too much of religious dogmatism; an unwill-

ingness to think beyond the theological box. I still think this to be true in terms of specific religious interpretation of such apparitions, but one day something happened that made me seriously reconsider and re-evaluate some of these "prophetic apparitions" from another viewpoint.

On the morning of 21st of December 2010 at 8.30 in the morning, our bedroom touch-lamp came on again all by itself. As explained previously, this only occurs at some synchronistic time; it just happened to be a total eclipse of the Sun on the 21st, but as far as we were concerned that was not the only significant event to happen that day. That evening we were invited to have dinner with our good friends Mike and Fran. Now Mike, as well as having a lifetime interest in UFOs and other phenomena is also an antiquarian book dealer; his hall and sitting room was full of various boxes of books and piles of books, either waiting to be sorted through or waiting to go to the next book auction. It was a common state of affairs, so we gave it no thought. Later, after dinner, as we were all talking over hot drinks, chocolates and mince pies (it was after all, almost Christmas!), out of nowhere I suddenly had a very strong image of a book in my mind; a green cover with orange or red elements on it; after this was a white page with the number 61 on it. On the page was a picture of a bright light, and the words "spindle" or "spinning" came to my mind. All this was a bit like a sudden flash of memory, or like the images I sometimes got on the odd occasions I'd practiced psychomety. Sensing something, Katie asked me what was wrong and I explained what I'd just seen in my mind's eye. I said, "I think there is a book here I'm meant to look at, Mike, do you have anything like that?" It didn't seem to fit any of his own books that he could remember, or any of the ones he'd put out for sale, but Fran said, "I think we should all look, for it may be amongst the books he's not looked at yet?" We looked through various piles of books for about thirty minutes. I was about to say let's not bother, as it was now getting late, when I lifted up a whole stack of books

and there was a book with a green cover that looked very like the image I had seen. Without opening it I handed it to Katie. The book was, *Revelations of Things to Come* by Earlyne Chaney (see the photograph below). I'd never even heard of it. Katie, Fran and Mike looked at the book. I sat opposite and said, "Just turn to page 61 and see what's there." When they did, there it was, in the middle of a chapter on Fatima, a picture of the "Miracle of the Sun"; underneath it was the caption *"The sun began to spin like a giant wheel, giving off rays of terrifying heat and vivid colours"*. This was something of an exaggerated depiction of the event; nevertheless, it was exactly what I'd seen previously in my mind's eye; this was too accurate to be random coincidence!

This does not in any way mean that I agree completely with Earlyne Chaney's personal viewpoints as expressed in her book; I definitely do not. This was simply the catalyst that led me to inquire more closely into certain religious visions and what they may possibly mean.

Indeed from then on I began to research the history of such apparitions, even though I had originally not intended to include

any so called "miraculous events" in my book on prophecy. In narrowing down the cases that seemed to have a genuine prophetic content, I discovered that in the most well documented instances there were four common factors that connected them all:

1. A lady of light commonly thought to be the Virgin Mary.
2. The visionaries were all children.
3. A religious message with a prophetic content.
4. They all took place in predominantly Roman Catholic regions.

Naturally this last fact accounts for Roman Catholic interpretations placed on all these events. Today secular Ufologists see similarities in some accounts of alien contact, which have also often involved luminous globes and shining human-like figures. Strange lights, air-born phenomena, floating figures and telepathic communication are common to both religious visions and ufology.

Possibly the first authenticated appearance of a *"Lady of Light"*, commonly believed by Roman Catholics to be Mary, the Mother of Jesus, was the apparition of *"Our Lady of Guadalupe"* that appeared in Guadalupe in Mexico in December 1531, since then various similar apparitions have occasionally occurred across the world at different times, mostly in predominantly Roman Cathoic countries. To date about ten appearances of *"Our Lady"* in small remote Catholic communities have been recognized by the Roman Catholic Church. In each case there are discernible common characteristics that lend uniformity to the appearances, the most common being the arrival of a globe of light; this light is surrounding the figure, and there is the delivery of a message with a prophetic content.

From 1846 to 1917 there were three well reported appearances of prophetic apparitions, believed by thousands of Roman

Catholics, and indeed eventually by the church itself, to be visions of the Virgin Mary. Similar events then later occurred in the 1960s in Garabandal in Spain and there have been other such claims of similar apparitions such as the "Madonna of the Roses" in San Daminiano in 1961, and the well witnessed appearances of a Lady-like apparition over the Coptic Church in Zeitoun in 1968. The question is not *did they happen*, but rather *how and why* did they happen? What these appearances may actually be is very much open to question. I must state here that I have no affiliations to Roman Catholicism and am not a believer in the whole panoply of icons and religious miracles. However, four accounts in this genre seemed worthy of further investigation in relation to prophetic apparitions. In chronological order these are:

1. The apparition of La Salette, France, in September 1846.
2. The apparitions of Lourdes, France, between February and July 1858.
3. The apparitions of Fatima, Portugal, from May to October 1917.
4. The four visionaries of Garabandal, Spain, in the 1960s.

In each case the apparition of a "Lady of Light", commonly thought to be the Virgin Mary by most Roman Catholics, made alarmingly accurate predictions, which included the coming of famines, wars, diseases and other events. The fact that the visions of La Salette, Lourdes, Garabandal and Fatima, all have common characteristics and documented prophetic statements seemed to indicate they may all have a common origin; so I included them in my book on prophecy. None of which would have happened if I had not had the experience that led to finding Earlyne Chaney's book that evening back in December 2010.

By 2012 I had finished my research into the prophetic apparitions and had included them in my, as yet, uncompleted book.

According to many New Age prophetic gurus (who were all

later proved completely wrong), the year 2012 was the end of the Mayan Calendar and the end of life as we know it! My own views on this were written and documented in 2009, 2010 and in 2011 published on Kindle at www.amazon.com/dp/B0084735VC, under the title, *2012: Prophetic Meltdown*!

In spite of all the New Age hype, astronomical misconceptions, false prophecy and the whole bogus bandwagon of Doomsday predictions, 2012 turned out to be a good year for us. Even though 2012 had loomed large as the culmination of New Age prophetic baloney it was merely the year after another failed Doomsday deadline, the one predicted by Christian false prophet, Harold Camping, when Christ was again supposed to return and the world come to an end! In May 2011, six days before Camping's silly deadline for Christ's return on May 21st, we were out in the garden taking some shots, which we had not done for quite a while. It was a warmish dry night; we had got some orbs in the Dell; Katie had also got a few over by the rockery, so I tried a couple of shots. I didn't photograph any orbs but what I did get was the amazing image below, which appears to be a classic apparition in the tradition of the religious visions

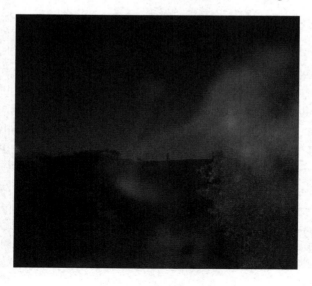

discussed earlier. Considering the timing and all that had led up to it, this was a very synchronistic image!

Opposite is an enlargement of this evocative image; on the right is an enhanced version using the Photoshop Un-sharp Mask tool so that the configuration and detail of the image becomes more obvious. So what are we actually looking at here?

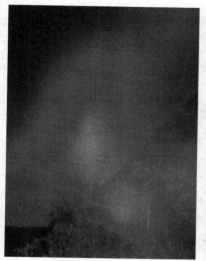 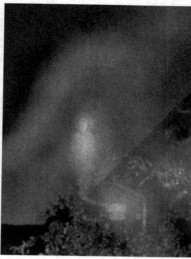

If we slot this into the same context as the angel-like images we looked at earlier, this is certainly more like the classic image of an angelic apparition than anything we photographed before, with the exception of the first Light Being. In terms of all our other phenomena and considering the unusual circumstances surrounding the discovery of the book, *Revelations of Things to Come* by Earlyne Chaney, which led to me including accounts of such apparitions in my book on prophecy, and the synchronicity of this image appearing six days before a false prophetic deadline expired in May 2011, the very year before the biggest prophetic hoax in recent history expired, it seems probable to me that this image is again another instance of a manifestation indicating the reciprocal nature of a greater interactive

consciousness that interfaces with our level of reality all the time. We constantly see this greater consciousness at work in every instance of synchronicity in our lives. But sometimes, due to factors we as yet do not fully understand, like streaming video, it makes a direct connection streaming into our reality which we then see or experience as paranormal phenomena. Because our individuated minds and indeed the whole matrix of our existence, is a reciprocal and active part of a Greater Consciousness, a Greater Reality beyond our own, we may all at times subjectively experience instances of what we call, paranormal phenomena. At the quantum level, the distinction between physics and metaphysics ceases to have any meaning; here we are in a world where thought, intent, directly affects quantum phenomena. This indicates that Consciousness is ubiquitous and universal, connecting everything that exists at every level. This is why synchronicity happens; why Dr Emotos's positive thought meditations can change the nature of water crystals, why dowsing works, and why some people, at times, have had accurate glimpses of the future.

To me this vision-like image over our veranda is a message: a symbol, a metaphor, that as individuated beings we are still connected to a Greater Consciousness. As created beings we are made in the image of our Creator; we are reflections of a Greater Reality both within and beyond the universe that we are part of.

This has been the consistent message of mystics throughout history and of practically every major religion on our planet, most of which were originally initiated by Celestial or Heavenly visitations or through experiences of paranormal phenomena.

In the specific context of our own experiences and paranormal photographic encounters this image was a confirmation to me that the book I had just written on prophecy was part of something larger, a small reflection perhaps of that same Wider Reality.

LIGHT BEFORE BIRTH?

Some while ago two distinctly different photographs taken by two people who do not know each other were sent to us on two separate occasions months apart. Both these photographs drew our attention to the concept of the soul and the possibility of life before birth.

Since ancient times people have believed in a wider reality beyond the physical world; this has been expressed through cross-cultural beliefs in gods, demons, elementals and all kinds of spirits and supernatural forces; the belief in reincarnation is a typical example. Where or how the idea of reincarnation originated is unknown. But discussions relating to reincarnation appear in the philosophical traditions of both India and Greece from about the 6th century BC.

According to Julius Caesar the Celtic druids of Gaul, Britain and Ireland held the idea of the soul's rebirth as a fundamental doctrine of their belief.

Reincarnation is widely accepted by the major religions of the East, particularly Hinduism and Buddhism. But the major religions in the Abrahamic tradition – Judaism, Christianity and Islam – do not accept the idea of individual soul reincarnation. However, a few minority sects within these traditions have affirmed a belief in reincarnation: particularly followers of Kabbalah; the Cathars; and in Islam such sects as the Alawi Shias and the Druze, in which context I would recommend investigative journalist Roy Stemman's book, *The Big Book of Reincarnation*, which documents his specific research into beliefs about reincarnation amongst the Druze of Beirut.

The notions and beliefs about reincarnation may have spread as a result of cross-cultural contact or arisen independently in different regions in the distant past: we simply do not know. What we can be sure of is that for ancient peoples, just as for us,

the continuous cycle of birth, death and rebirth, spring time and harvest, permeates the natural world, so it should not be too surprising that thoughtful observers in past times may have philosophized that the human spirit or soul, like the natural world, may also work on a cyclical basis. Like wheat and corn it may live again. And like the butterfly emerging from the chrysalis, at death our souls too may be transformed into a new form of life, perhaps even another human life.

The oldest and most detailed beliefs about reincarnation are to be found within Hinduism. According to Hindu teaching every creature on this planet has a soul; every individual soul is part of the Supreme Soul known as "Parmatma". The individual soul journeys through 84 million other creatures before it is able to attain the human body. (I am not sure how they can be so precise about the numbers here.) But according to Hindu beliefs, the ultimate aim of human life is meant to be one with the Supreme Soul. After death, each individual human death, our soul enters a new body; where and who it becomes depends on our Karma accumulated over past lives. This cycle of death and rebirth continues until we are pure enough to become one with the Supreme Soul.

But whatever version of reincarnation people believe in, there is always the question of when exactly the soul (whatever you conceive it to be) enters the human body. This debate is not restricted to believers in reincarnation: it applies to every religion that believes in the existence of a soul. This has been an issue of major debate in the Christian Church since its beginning. The early Church held various, and sometimes contradictory, views about the soul. St Augustine, for instance, adopted Aristotle's concept of the progressive development of the soul into the full human state during childhood. Following the Hebrew Talmud, St. Thomas Aquinas believed that the soul entered the fetus within the womb about 40 days after conception. Others believed that the soul entered the body as soon as the baby took its first

breath outside the womb. In the Vedas, the Hindu sacred scripts, it is written that the soul enters the body immediately at the time of conception. Even today, scientists still disagree as to when exactly Life begins; when does a fetus become a living conscious being? This of course opens up the hotly debated issue of abortion and fetal rights, and how we define the moment of individual consciousness.

Where does life come from? In Genesis 2:7, speaking of the creation of Man, it says that God *"...breathed into his nostrils the breath of life and man became a living soul."*

Here the Hebrew word *"Nephesh"* is used and contextually we are given to understand that Man (the entire being) *is* a soul, rather than his *having* a soul. The word breath, here is synonymous with the Spirit of life that is given by God. Ecclesiastes 12:7 speaking about death makes this clear: *"Then shall the dust return to the earth as it was: and the spirit shall return unto God who gave it."* In terms of One Self Existent Spirit of Life, this seems to make more sense than the idea of a separate nebulous soul. For myself I hold no dogmatic views on reincarnation or life after death, but the following series of photographs (immediately below) kindly sent to us by professional photographer, Laura Campion, certainly made us think much further about consciousness and the concept of the Spirit of Life.

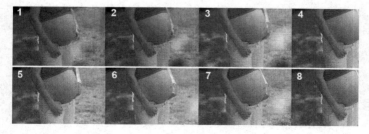

This series of photographs above of a pregnant woman, who was almost due to have her baby, were shot in rapid sequence without flash one sunny afternoon by photographer, Laura Campion.

I have simply numbered them in order from 1–8, and if we follow the sequence through you can see a cloud of hazy white light, on pretty much the same level as the baby's head would be; that progressively moves away from the pregnant woman and then returns to virtually the same position. Some have questioned if what Laura photographed here is some visual indication of an infant consciousness not yet permanently fixed in the unborn child. In certain esoteric teachings it is thought that before birth the baby's consciousness, as part of a wider consciousness, has the ability to move in and out of the body: a process akin perhaps to astral projection.

Obviously we cannot be certain that this is so but we can be certain that Laura photographed something very unusual here; something that suggests some kind of energetic activity centred on the unborn child. If you look closely at frame 2, what looks like a shadow cast by the white light – is nothing of the kind; when enlarged it looks definitely more like a vortex than a shadow.

Interestingly, the photographer, Laura Campion, made this

comment, *"I have to say I was a bit stunned when I saw the shadow too, as it is most definitely moving and with the speed in which my camera shoots it must have been moving at some speed to be showing movement."*

Here opposite is an enlargement of the "shadow" in frame 2, referred to by Laura; as you can clearly see this is something that is moving. Compare this in the enlargements of frames 2 and 3 below.

If we examine these two images, taken seconds apart, we can see that what at first glance appeared to be a shadow is in fact mirroring the white light and moving with it creating a kind of vortex effect in air that is fragmenting the background as it is captured by the camera. What we see here is definitely something unusual; something moving independently but which seems related to the condition of pregnancy. Could this be a visual manifestation of unborn consciousness affecting the mother's energy field? When we asked Laura if there was anything further she could tell us about the baby, she sent this reply:

One thing I would say about the little boy that was unusual was his strength. I photographed him at 6 days old and he was phenome-nally strong, able to hold his head up with the strength of a baby of

3 months old. He was actually really hard to photograph as he kept pushing off things and moving himself about. Which for 6 days old is unheard of. He was very alert too, with quite a few shots he was staring straight at the camera, again most unusual.

After this someone suggested to Laura that this effect may be "fluff" in the sensor, but if it was, why is the effect consistently on a specific part of the photograph; not on all the image, and whay is it not on other shots - before and after? As far as I can ascertain digital sensors are none discriminatory in terms of pixilation, anything that affected the sensor would have affected the whole image indiscriminately; not repeatedly affected one specific area across many images.

We later learned that the little boy was born on Laura's birthday.

Is this just random coincidence? In the context of these unusual photographs it seems more probable that we have, yet again, another instance of synchronicity, and the reciprocal visual effects of the wider nature of consciousness.

However, the astounding photographs Laura Campion sent us, as mentioned at the start are not the only ones we were sent relating to pregnancy. The following photograph of light before birth was sent to us by Julie and taken by her partner.

In this image you can clearly see a small bright arrow-like light

that has appeared over Julie's left index finger. She was wearing no rings; this is not a reflection, and no flash was used anyway. In the context of the lighting conditions at the time the photograph was taken there is no normal explanation for the presence of this arrow-like light over the index finger. It simply should not be there. Could this be yet another visual manifestation of some kind of interaction of infant consciousness displayed within the energy field of the mother to be?

At the moment there is no way of knowing this for definite but it seems unlikely that the photographs from either Laura or Julie can be explained in normal terms; the probability is that they show the presence of something extraordinary. In the context of our own research and experience in photographing paranormal visual phenomena, we believe both these photographs show the reciprocal affect of interactive consciousness manifesting in the visual spectrum; possibly even evidence for the interaction of the unborn infant spirit with a Wider Consciousness.

Here below is a little anecdote that I recently saw in our Unitarian Fellowship magazine; it has been retold in various forms, but where it originally came from no one knows. Because it links so well with both the theme of this chapter and the concept of a wider Reality beyond, we felt that we just had to include it here; slightly rewritten; it is called:

LIFE AFTER DELIVERY

A mother was having twins. Deep in mother's womb, one twin asked the other, "Do you believe in life after delivery?"

The other replied, "Yes, of course! After all there just has to be something after delivery, we are only here to prepare ourselves for the next life."

"Nonsense!" exclaimed the first twin. "I think there is no life at all after delivery. I mean, how could there be

when this is the whole universe, how could there be any life beyond that?"

"I don't know," said the second twin. "But it's very dim here, so maybe it will be lighter there; maybe we will be able to use our legs to walk, do things with our hands, and even eat with our mouths?"

The other laughed. "That is totally absurd! Walking is impossible; anyway we don't need to walk, we float – we are surrounded by water! And eating with our mouth: why – that is completely ridiculous. The umbilical cord has always supplied all the nutrition we need. Anyway life after delivery has to be excluded on scientific grounds; it is patently obvious that the umbilical cord is far too short to stretch beyond delivery!"

"Well," said the second twin. "I still think there is something beyond delivery; perhaps it is just different to what it is here."

The first twin was incredulous!

"What! You can't be serious...no one has ever come back from beyond delivery. Delivery is the end of life. After delivery there is nothing; we simply cease to exist!"

"I can't believe that," said the other, there has to be something! Maybe we will see Mother there and she will take care of us?"

"Mother!" exclaimed the first twin in shocked tones. "Don't tell me you actually believe in Mother? You are simply living in denial of reality...Mother isn't real! If she was, where is she now?"

The other thought for a moment then said, "I think Mother is all around us; it is because She *is* real that we are here. Without Her our world wouldn't exist."

"Rubbish!" exclaimed the first twin. "I don't see her so it is only logical that she doesn't exist!"

"Shush!" said the other. "Be quiet, just listen a moment.

Hear that distant soft rhythmic beating? It has been with us all our lives. Don't you find that sound really comforting?"

"Why yes," said the first twin. "Well, yes, I do...it's like, like the rhythm of life!

You know, I'm just so used to it I never hear it anymore."

"You can only hear it when you are really quiet, when you are only really listening," said the second twin.

"What is it?" asked the first twin.

"That is Mother!" said his sister.

Sometimes regardless of whatever we may surmise we can never really know what lies beyond until we get there; in that sense we always have to expect the unexpected.

FROM ORBS TO BEYOND

Our journey beyond photography began with the mystery of orbs; the appearance of interactive luminosities, and the questions that this raised. It has been a journey of discovery during which we have questioned many things, and seen and experienced many events and phenomena that have led us to a wider spiritual perspective. Looking further back, the tiny twinkling circles of light, (Small Transient Lights) which Katie first saw many years ago before we even met, led her towards the spiritual path we are now both on. Those same tiny lights gave us a vital connection to orbs and luminosities, which in turn led us to photograph all the amazing transformations of this incredible unfolding phenomenon. However, our individual spiritual journey is not dependent on either orbs or paranormal phenomena, no more than it would be on being an artist or studying for a degree; all of which may offer us knowledge or insights but none of which are in themselves spiritual. Being psychic or experiencing paranormal phenomena do not make you any more spiritual than anyone else. As far as we understand it, spirituality is not in some metaphysical state or paranormal experience; it is rather in the quality of our compassion, empathy, and understanding as human beings. In that sense spirituality is as much available to an atheist as it is to a theist. It is our attitudes to experience, whether normal or paranormal, that makes us more or less spiritual as people. What has happened with us, as with everyone, is simply part and parcel of our individual experience; but throughout all the unexpected transitions, synchronicities and mysterious occurrences, orbs and luminosities have been a constant and consistent factor.

Why such a whole range of phenomena has happened here right on our own doorstep, we have no idea. That it happened is all that matters. It is a bit like asking why this has happened at

this time to me, when the fact is that it has happened; all we have to do is to choose how we will respond; how we will use the time that is given us. As individual spiritual beings every choice that we each make will make us more, or less. As we said at the beginning of this book, when a piece of the universal puzzle falls in our path, we can choose to ignore it, to walk around it, or we can choose to try and figure out where it fits. That is simply what we, like many others, have tried to do. In this specific instance our quest began with orbs – your quest may have started elsewhere, everyone is different; each life reflects Reality in its own unique way. Where our journey takes us depends largely on the decisions we make; in our case our research into orbs and the entire related phenomena led us to become members of the Unitarian Movement. As with our exploration into orbs this was a matter of choice. As beings with individuated consciousness and comparative free will we are all in the happy position of being partners with destiny rather than merely puppets of fate. But as well as our choices, history shows us that coincidence and synchronicity also play a vital part in determining our future. This can be seen in some family histories, where "chance" coincidence has not only affected the lives of our ancestors but in turn our own lives.

For instance, Katie's, Grandmother, who was called Elsie, as a young unmarried woman, worked at a firework factory in West Yorkshire. She never missed a day's work but one day she was ill and so didn't go in to work that particular day. This was a day that very definitely determined her future, because that day the gunpowder stored in the factory exploded, killing almost everyone inside! If Elsie hadn't been ill that day, neither Katie nor her own mother, nor most of her family would have probably ever existed! Neither my own life nor the lives of all Katie's friends and relations would be the same as it is now. Perhaps if you look back at your own family history you too may find some synchronistic or coincidental event, which if it hadn't happened

exactly when and how it did, meant you probably wouldn't be here now!

Deciding to investigate the orbs phenomenon led to us viewing orbs as visual symbols of Oneness, which in turn led us to join the Unitarian Movement, a decision that has only added to our own spiritual journey. How can I best briefly sum up what being Unitarian is all about. Look for a moment at the photograph below, it is of pebbles on the beach on the Isle of Iona taken by our friend, John Hetherington, for whom Iona has a special significance.

From a distance all the pebbles look pretty much the same – but when we begin to look at them closely we see that every one is uniquely different! And so we end up going home with pockets full of pebbles: gifts from the sea. Like both snowflakes and pebbles, each human being is also different; we have each been shaped by the ocean of Life. Each of our stories is ours alone; no one else anywhere in this world can be the person that you are today – or bring to this life all that you as an individual can contribute – you are unique! Your own spiritual journey and insights are a special unrepeatable one-off offer that will never be

seen again! Individuation is the gift of Creation! Unitarians recognize this and value it; this is why within the Unitarian Movement you don't find a package of doctrines, but instead a whole spectrum of positive complimentary beliefs and philosophies that include, Theists, Atheists, Christians, Humanists, Pagans, and many others; all united by the shared values of Truth, Compassion, Freedom, Tolerance and Understanding, which gives it the spiritual dynamic to be an evolving rational Movement with a social conscience. Essentially being Unitarian is about building bridges between people, not walls. To us this seemed to be something worth being part of, especially as it complimented our own belief in the underlying Oneness of Existence. Indeed Unitarians in general view all life on Earth as part of the diverse but interconnected Cosmic Web of Life. We shall look at our own specific Unitarian connection with orbs in the next chapter. But for now we shall return to the subject of Orbs and Beyond. Some may fail to see why synchronicity or paranormal phenomena is relevant to ordinary life. First, I would say there is no ordinary life – just Life! Secondly, as those who study such subjects know, the paranormal, just like quantum physics, definitely affects everyday events in what we like to think of as the *normal* world. However, I must point out here that the study of paranormal phenomena does not imply a belief in the *supernatural* anymore than the study of theology implies a belief in a fundamentalist view of God!

As previously mentioned, in our talks and presentations, we have always been concerned to point out that all experience is subjective; the terms we use are descriptive rather than definitive. In any field of study there are always more opinions than there are facts. In many areas of life, as with conceptual and philosophical perspectives, especially with regard to both quantum physics and metaphysics, we are simply all on a learning curve. The main difference is some of us realise this and others do not!

When we first began to photograph orbs we asked all the obvious questions: were they lens flare, dust, moisture in the air, digital artefacts etc. Of course some photo anomalies may be explicable in those terms; but the fact is, after much investigation, no such prosaic explanations adequately accounted for the photographs we have included in this book of orbs and especially all the other related visual phenomena; added to which we had to account for repeating synchronicities and other experiences connected to the visual phenomena. In that context we have categorised all this as "paranormal" in the sense of being visual and experiential indications of a Wider Reality underpinning or interfacing with our own.

However, as we have pointed out previously, whenever we photograph or record anything by any means, at the very moment we do so, it is part of our physical universe, part of our natural reality. Therefore logically it cannot then be supernatural because we are able to record it by natural conventional means. For instance, whatever paranormal phenomena we and others may have photographed, we have only done so because at the moment of capture it becomes part of the visible light spectrum detectable to our eyes on the wave length of 4000 to 7000 angstroms – between ultra violet and infrared within the infinitely larger electromagnetic spectrum. All that is visible to us is but a tiny fraction of the immensity of the electromagnetic spectrum. Therefore it is reasonable to assume that the paranormal phenomena we and others have photographed also represents a tiny fraction of a much wider spectrum of Reality. All metaphysical and paranormal phenomena only make sense in the context of a Wider Reality beyond our physical universe. Some would argue that by definition the Universe is everything; there is nothing beyond it. But what if that which we define as the Universe is merely all that is conceivable and detectable to us, as beings locked into the material universe? Is it possible that our situation is comparable to intelligent goldfish swimming around

in a huge goldfish bowl? They may make intelligent and correct deductions about their environment but they are always limited by that same environment and have neither the reference points nor the capacity to understand what lies beyond the goldfish bowl. They may see distorted shapes or colours passing beyond the bowl; they may feel the water disturbed for no apparent reason, and they may wonder how food regularly appears on the surface of the water. Intelligent goldfish could devise all kinds of rational and metaphysical concepts to account for such strange phenomena and how it may relate to what they know of their own environment. Is this not exactly what we as human being do? Locked into what we discern to be the universe we are as limited in our understanding of what may lie beyond it as the fish in the bowl. Whether or not something does lie beyond it is, of course, a matter of speculation. In the past it was metaphysics that suggested the presence of something beyond the material universe, but now the most recent research and experiments in quantum physics also strongly suggests that the universe is not entirely as 19th-century rationalism perceived it to be. That there is a Wider Reality beyond, is no longer just a possibility, it is now more than ever before, a probability.

When an anomalous, mysterious or paranormal phenomenon occurs that we cannot instantly slot into the currently acceptable view of reality it may cause us to question – what is it that we are and what is it that we are part of. The very existence of any phenomena, normal or paranormal, can always lead the inquiring mind back to the fundamental question of origins: where did it all start and was there a beginning? To try to understand what is involved here we sometimes have to take a step beyond what may be the acceptable view.

One thing we do know for sure, it is not possible to scientifically prove the Origin of Life; we cannot observe it, and we certainly cannot replicate it. All scientists and philosophers can do is to make rational assumptions based on observations of

what is. In science these assumptions are known as theories. The currently acceptable theory about the beginning of the universe is what is now popularly known as *Big Bang Theory*, the cosmological model of the hot and dense primordial condition that initiated the explosive creation and expansion of the Universe. Big Bang theory was developed from both astronomical observations and theoretical concepts. Originally this was known as the *"hypothesis of the primeval atom"*. Proposed by Georges Lemaître, a Belgian physicist and Roman Catholic priest, but it was astronomer Fred Hoyle who was credited with first using the term *"Big Bang"* during a BBC radio broadcast in 1949. Big Bang theory relies on two major assumptions: 1. the universality of physical laws as we know them, and 2. the Cosmological Principle, which presupposes that at the largest scales the Universe is homogeneous (uniform in structure and composition) and isotropic (identical in all directions).

The fundamentals of Big Bang Theory – the early hot state, the explosive expansion, the formation of helium and the forming of galaxies – are largely, but not entirely, derived from astronomical observations, including the pervasive cosmic microwave background, the profusion of visible light elements and the immensity of cosmic structure.

Like most previous theories of Origins, Big Bang presupposes a beginning. All that now is had to come from something, because logically Something could never come from Nothing. As Big Bang theory has developed, this initial Something has become much vaguer and slightly lost in the complexities of the theory itself. However, the best guess would be that whatever initiated the Big Bang, flinging energy and matter out in all directions with the explosive force of a billion, trillion thousand megaton atom bombs all going off at the same time, was infinitely smaller than the universe we see around us. In simple physical terms, this minuscule initial dense condition has been likened to a primordial atom about the size of a grapefruit that

for some unknown reason exploded in the Big Bang. This immense release of energy resulted in the electromagnetic spectrum; the creation of helium and the formation of stars and galaxies. So even if we take a purely materialistic view, at some distant point in the past, all diversity that exists now was once One! Everything that was there in the primordial state before the Big Bang is still there now; nothing has been added or taken away. All that has happened, according to Big Bang, is simply that energetically and materially at one explosive point in time, the One became the Many.

Many scientists, for no other reason than for them Divine Creation is not an option, see Big Bang in purely materialistic terms of a random chance event. In those terms Big Bang theory leaves several major questions unanswered, the fundamental one being what caused the Big Bang itself?

However, today the indications from quantum physics are that we do not live in a completely material universe; that synchronicity happens at both the quantum and the material level strongly indicates that what appears to be random chance is nothing of the kind and that all phenomena is underpinned by a connective process pervasive throughout the whole of Existence.

The latest research from practically every discipline, when viewed holistically suggests that this universal connective process is driven by a ubiquitous Consciousness that is extent throughout the whole of Existence, even down to the quantum level. Through many experiments over many years quantum physicists now know that quantum phenomena are affected, not only by the act of observation, but by the conscious intent of observation. If human intent affects phenomena at the quantum level that strongly suggests that consciousness is both interactive and pervasive outside of the human mind. If that is so then our individuated consciousness may only exist in the context of a

wider consciousness woven into the whole fabric of Existence.

If that is so, then the beginning of the universe may be something more than simply a Big Bang that occurred for no apparent reason. The very fact that creation exists universally may indicate that there may be a Creator: a Self Existent Reality beyond the created. The notion of a Big Bang happening by random chance, resulting in the coherent complexity of Life as we know it, in terms of probability, is akin to an explosion in a printing factory resulting in the spontaneous creation of the Oxford English Dictionary! Highly unlikely!

Thinking back to the metaphor of the mirror that we used earlier in this book, we could liken primordial potential (the potential which was there before there was anything) to a mirror that only reflected One Reality. In another sense we could liken it to thought; as individuals we all have the potential for creative thought; when creative thought happens it fills the void where before there was only potential. Before our universe existed, let us assume that there was One Self Existent Creative Reality in which creative thought initiated the act of creation; the dynamic vibration of creation then initiated Motion, energy and matter. The primordial potential that before was only a void was then transformed into a billion trillion fragments of diversity; each piece of which, like pieces of a mirror still reflecting that original One Self Existent Reality. If we view the universe with all its systems, processes and levels of life as a created image of, and by, something else, then we see the possibility that everything may be a reflection of One Creative Reality that is always beyond us, just as we are always beyond the fish in their goldfish bowl universe we mentioned previously in this chapter. It is from this viewpoint that we are looking from orbs to beyond.

So, is there a rational theory which unites both the physical and metaphysical within the essential Oneness of Existence that is derived from One Self Existent Creative Reality? I think there is.

Reciprocal Realities

In my estimation, there is a theory which provides grounds for the possibility that One Self Existent Reality initiated our universe of movement and form; it also has a bearing on the interconnection of consciousness and occurrences of paranormal phenomena. Although I am sure none of this was the intent of the originator of the theory, which is essentially a scientific theory of physical and energetic phenomena pervading the universe. The theory I will refer to is the *Reciprocal System of Physical Theory* originated by Dewey B. Larson.

This theory essentially describes the closest thing we have for the basis of a unified theory for all phenomena in the Universe. It was Larson's theory that opened the door on the present day quantum view of the configuration of space inside the atom. In fact the Reciprocal Theory gave scientists a rational and understandable view of the reality underlying quantum phenomena, which Quantum Theory itself failed to provide.

In the Reciprocal System, the cosmos is not a universe of matter, but a universe of Motion, in which the base reality *is* Motion! All elements – particles, atoms, fields, forces, in fact all forms of energy – are merely manifestations of Motion. What caused Motion is another matter.

In terms of the physical universe the notion of a Reciprocal System is a conceptual innovation of unprecedented proportions which works better at every level than the old scientific paradigm of viewing phenomena as existing *in space* or *in time*. This naturally affects how we view the electromagnetic spectrum, which in classic terms was seen as being *within* space and time. But if both Space and Time are reciprocal aspects of Motion, they do not exist independently and so there is no intrinsic significance to either, except as a common reference to describe phenomena.

If then the only Reality is Motion we have to assume that either Motion is eternal or that it had a beginning. Whichever

way we look at this idea it brings us back to the ancient esoteric view that all Existence is Vibration, with both space and time being resonances of this Vibration.

We now know from research and experiments done over many years by quantum physicists, neuroscientists, parapsychologists and cutting edge researchers in many related areas that mind can affect matter; that consciousness is not a closed phenomenon inside the human cranium; that consciousness is interactive and pervasive, even at the quantum level.

This idea of a pervasive interconnected consciousness when put alongside the Reciprocal System theory of Motion being the only base reality, leads, I believe, to the possibility that a creative consciousness initiated the Primal Act of Creation that we now look back to as The Big Bang.

In the Genesis story, verse 1:3, God (The One Eternal Conscious Reality) speaks (vibration) and light (energy) becomes manifest. It seems beyond mere coincidence that the two basic cosmic forces, Light and Vibration, integral to the Hebrew story of Creation are also fundamental to both quantum theory and the Reciprocal System Theory. Certainly if the act of creation was initiated by vibration, then from that point onwards, Motion would be the fundamental universal driving force of all phenomena. Because Frequency is also an aspect of vibration we have the electromagnetic spectrum: Light, in all its wavelengths. We could say that everything that exists is the reciprocal effect of a continual dynamic interchange between One Creative Consciousness and the continual Process of Transformation of Energy that was set in motion by the initial Act of Creation, which itself was manifested through Vibration (Motion).

Taking for granted that all our descriptions of the Totality of Existence are inaccurate and incomplete, the concept of a single Creative Consciousness initiating a universe, in which Consciousness/Thought and Vibration/Motion are pervasive and where all phenomena are reciprocal reflections of that One Act of

Creation, parallels the ancient views of mystics throughout history in which the universe is seen as full of movement, flow and change at every level. It is this concept of the harmony and balance of Universal Motion and Diversity that is enshrined in the familiar symbol of Tai Chi – the Yin Yang of Taoist philosophy. In this view of the universe there is no division between natural or supernatural, mind or matter, it is all One – and yet Many.

My own slant on Larson's Reciprocal Theory comes not from quantum physics or from ancient teachings, but from my own experience; so this view of going from orbs to beyond is very much a personal perspective, the roots of which we will look at in the next chapter.

IMAGES OF ONENESS

Sometimes on a good clear night we carry my Newtonian Reflector telescope out into the garden to look at the Moon or one of the planets. It is pitch black at night where we are, so it is ideal for stargazing. Looking up at the night sky often reminds me of how ancient people must have looked up to trace patterns in the stars, wondering what all those tiny glittering lights really were – signs from the gods or holes in the sky? One thing is for sure there is much more to what we see in the heavens than meets the human eye. The same could be said for the phenomena we have photographed: it is the light in the distance; the tip of the iceberg. The same is true for all paranormal phenomena. We never see the complete picture. Just as with the stars above us, there is always more beyond. In looking at the stars ancient peoples made coherent images out of the patterns in the sky; so we now have all the pictograms of star groups and constellations that reflect various mythologies and legends. This all makes for interesting cosmological maps and helps us to find our way around but it really has no other relevance to what is out there. Historically we have done the same thing with paranormal phenomena; it has been labelled and catalogued over the years as this or that. Sometimes it has even been fashionable in esoteric circles to define it as whatever is the most popular view at the time. In my view labelling orbs as angels or spirits or whatever, like naming planets or stars, though it may be a fascinating exercise and useful up to a point, it does not help us to understand the phenomenon. The danger is, just like in the old Zen anecdote about the finger pointing at the moon, we get hooked up on the label, on our own idea (our pointing finger) of what is happening, rather than looking at the reality itself. As mentioned before, we cannot with any intellectual honesty tell people that orbs are angels, or faeries, or whatever may be popular at the

time. What has been important to us is the reality of the phenomenon and how engaging with that reality at various levels, rationally, psychologically, imaginatively and spiritually, has affected our lives and the lives of others. In our experience the most important aspect of orbs was their circular shape. Since ancient times the circle has been an important symbol for humanity, from rock carved ring marks on standing stones to the ubiquitous Tai Chi or Yin Yang – all the images of Oneness.

The circle, the orb, the sphere: all these forms have a deep resonance in the human psyche. Throughout history and all across the world they are universal symbols for God, Oneness and Unity. From the beginning it seemed very relevant that the circular symbolism of orbs was appearing all over the world, photographed by all kinds of people, with all kinds of cameras, particularly at a time when oneness and unity are critically meaningful for us as a species; simply because it is one thing that we currently lack, but desperately need. So in orbs we see, not angels or spirits, but Images of Oneness; something that crosses all faith and cultural boundaries; the archetypical symbol that lies at the heart of all religion and metaphysics. Across the

centuries it is this image of Oneness that has been fundamental to the spiritual quest of the vast inquiring soul of humanity. For us, seeing this was fundamentally important in relation to that Wider Reality.

Photo by NASA Hubble Space Telescope

Orbs are everywhere; even in outer space! The photograph above is of the biggest "orb" so far known to astronomers: this is the Bubble Nebulae in the constellation of Cassiopeia, which is just over 7,000 light years from Earth. The incredibly huge Bubble Nebula surrounds a star that is forty times more massive than our Sun – a cosmically massive reminder that images of Oneness are a universal phenomenon. Everywhere you look in the Universe you see circles and spheres.

Our solar planets, the stars in their courses and vast galaxies turning in the immensity of space, all follow circular or elliptical orbits. In fact the word orbit comes from the Latin *orbitus*, meaning circular which comes from *orbis* meaning orb; so the universe is literally full of orbs; full of cosmic wheels, orbital paths to Oneness!

It was this universal ubiquity of the sphere, the circle as symbols of Oneness that drew us to view orbs as images of

Oneness. As far as our own experience went, we could not with any intellectual honesty define orbs as spirits, angels or any of the other currently fashionable New Age icons. What was, and is, important for us are orbs as symbols of Oneness, visual indicators of a Wider Reality. This was something that was already part of our own spiritual journey; orbs were an added dimension affirming the essential importance of Oneness. It was this idea of Oneness that drew us towards the Unitarian Movement, but as we later discovered orbs had a part in that too, though we did not realise it at the time we first began to learn about the Unitarian perspective. Unitarians are in no way evangelical; in fact you seriously have to want to find them, and often it is more by so called luck, that you do. As mentioned previously Unitarians are a Movement, not a religion, although they initially rose from dissenting Christians and had their roots in the Reformation of 16th-century Europe. The name Unitarian comes from the historic affirmation that God is One, the belief that God is a unity rather than a trinity. Today Unitarians have a spectrum of beliefs that includes both theists and atheists; pagans and humanists; essentially Unitarians view all life as part of the vast interconnected universal web of life in which Oneness underpins all Diversity! I would out myself on the God end of the Unitarian spectrum, which means that I meet the atheists coming the other way, which lends an interesting perspective to spiritual life, which of course merely stagnates if we only converse with those who agree with us. This is why fundamentalists of any persuasion mostly find it difficult to think outside of the doctrinal box.

At this point, in order to explain how the essential Oneness of existence connected us with both orbs and Unitarians we must step back in time for a moment to the time before we knew anything about Unitarians. Back then, when we first began to photograph orbs, for months we could only get them in one

room in our home: our sitting room! We just couldn't photograph them anywhere else – no matter how we tried. But it was there, as we have previously related earlier in this book, that an important turning point occurred that gave us a different view of orbs, as an interactive and possibly conscious phenomenon. After that, as you now know, the whole phenomena evolved.

As strange as it may seem the important factor here in relation to Unitarians was that very same sitting room where we had photographed orbs! But we did not discover this until well after we had become members of the Unitarian Movement. After that, our sitting room, being of a reasonable size, became a regular venue for our local Unitarian discussion group. It was not until about four years later that the treasurer, of our Unitarian Chapel, referred us to a book about local history in which he had discovered the amazing fact that the very first *"Quaker-Unitarians"* in our area had actually met regularly in our sitting room in the 1840s!

This was the very same room where we had photographed our first "orbs", which as symbols of Oneness had indirectly led us to the Unitarians and where we now held our own Unitarian meetings!

The synchronicity here was astounding!

Orbs as symbols of Oneness, pointed to the interconnected Circle of Life; for us this also now related to the Unitarian concept of *"Oneness in Diversity"*. Quite pointedly the connectivity here was not merely symbolic but literal, forming a Unitarian circle of connection through time!

Such synchronistic events often go beyond whatever rational views we may place upon them. First and foremost such personal experiences touch us at an emotional and spiritual level. It is through such meaningful personal experiences that each of us as individuals may engage with the spiritual dynamic for change! Sometimes such changes in our individual lives lead to larger changes in our spiritual perspective that may also affect others. If

we look back at history, most key changes in both religion and society have been made because of the personal vision of certain individuals. None of us live unto ourselves alone, everything we do touches others; everything is connected: this is the outworking of Oneness in the world of diversity.

From the ancient stone circles to the Tai Chi symbol, and mystic Mandalas, the circle has been an important symbol in the human psyche. Today we see it repeated in crop circles, in UFO spheres in the sky and in the ubiquitous orb phenomenon being photographed by people all over the world. Is Someone trying to tell us something? Is Something drawing our attention to the most important orb of all – the orb of Earth on which we all live?

The orb of our Earth is beautiful and unique but it is only one small globe of life in a cosmos so vast, it is almost beyond imagining. For instance, the volume of our Sun is so great that you could pour a million Earths into it and still have room to spare! Yet our familiar Sun is just an ordinary star on the periphery of the Milky Way galaxy. It is but one of over 100,000

million stars in our galaxy. In galactic terms Earth is "out in the sticks" at the edge of this vast rotating city of stars, which is but one of billions of other galaxies in the Universe. It takes our solar system over 200 million years to do a complete rotation of our Galaxy. This is called a Cosmic Year. In that context all of human history has been but a flicker of a second!

From all we can see around us the universe is not a finished product – it is a work still in progress. But it seems that this vast and mysterious universe is only part of a much wider reality. In that context we are surrounded by cosmic immensities of which, even with all our knowledge, we still know next to nothing!

In *Orbs and Beyond* we have travelled full circle, from our first encounters with orbs and luminosities, to a whole range of incredible transitions, visual manifestations and images, which have brought us back again to orbs – but now as symbols of Oneness that reflects both the primal reality of Existence and the fundamental dynamic underlying human spirituality.

In our travels, people have asked us questions about the paranormal to which we honestly do not know the answers, in this realm there are always more questions than answers. Of course as some have done it is all too easy to speak with authority on the vaguest esoteric matters; after all who is going to challenge you if you claim convincingly enough to be guided by some higher being or have access to some supernatural repository of truth. People will either believe you or not. But the proof of the pudding is always in the eating; as with our pseudo-orb expert we mentioned at the very beginning of this book, who could not back up his claims with action, by their fruits you will know them. This has been unequivocally demonstrated recently when whole galaxies full of channelled masters and higher dimensional entities who for years of churning out prophetic claims about 2012 and the end of the Mayan calendar all turned out to be completely wrong.

We have to be aware that supernatural deceptions may also be driven by super egos. Yes, we may each have our own individual beliefs and experiences about the paranormal, but we have to first concern ourselves with what we know to be true. In most cases the truth is that such experiences are largely subjective; unverifiable and unquantifiable in strictly scientific terms.

Although this does not mean that not being able to quantify or replicate something makes it untrue. It patently does not; we can show good convincing evidence for many things but we cannot prove them scientifically. Indeed most of our views of present reality as it is taught in schools and universities are based on things we cannot prove. For example, Macroevolution by random chance is taught as a fact, yet scientifically it is not a proven fact; nor can we either observe or replicate the origin of Life; all we have are theories or beliefs. In school, for instance, we all learned about Julius Caesar as a historical person. There are writings about him and even statues of him, but all this is only evidence – not absolute proof; it is impossible to scientifically verify that Julius Caesar ever existed. We cannot prove he existed by direct observation or replication; we cannot absolutely verify his existence as an incontrovertible fact. We simply accept that he existed because the evidence seems to point that way. The same is true in the case of some paranormal phenomena; when all things are considered, although we may not be able to prove it absolutely, the evidence seems to point to it being paranormal rather than a normal occurrence. We have to use labels and categories to separate one thing from another, but in the area of the paranormal to absolutely define such phenomena as say, angels or faeries or whatever, is simply less than intellectually honest, especially when we realise the limitations of labels that we all apply to familiar everyday phenomena. A well-known Zen anecdote makes this clear. One day the Zen master asked his student, "What is that?" Instantly the student confidently

replied, "It is a tree, master."

"No," said the master, "that is only the name we give it – what is it?"

Time after time the student came back to the master with all kinds of rational explanations for what it may be, none of them were correct. In the end he gave up and humbly asked, "What is it, master?"

The Zen master relied, "It is a tree!"

The point of this story is, we have no idea what it is! The word "tree" is simply a label, not the reality – if this is true for all natural phenomena, then how can we possibly define paranormal phenomena in any kind of absolute terms. Transparently we cannot.

All any of us, who have encountered such paranormal phenomena can do is to share our individual experiences and thoughts with the hope that this may resonate with the experiences of others, adding to our infinitesimally small store of human knowledge about that Wider Reality. With the paranormal, as with many other areas of inquiry, we must all hold our beliefs and theories on an open hand for, regardless of what anyone else may tell you, the indications are that we are all only seeing the tip of the leaf on a branch on the tree when it comes to that vast unknown Wider Reality beyond our own.

For us, orbs and the other phenomena we have shared with you in this book, have given us an intriguing and inspiring glimpse into new possibilities and mysteries beyond the commonly accepted views of reality. This has opened up new questions about life and the cosmos. It has taken us from those first orbs we photographed in our sitting room to the wider concept of Oneness. It is not easy for individuated beings to intellectually comprehend Oneness, other than as an abstract concept, unless they have caught a glimpse of the reality of Oneness through personal metaphysical experience. Such encounters with the Wider Reality often bring with them a profound sense of

connectedness, which often brings about a spiritual awakening for the individual. Such awakening often results in transformed lives, which is perhaps also a reflection of the vast transformational processes at work in every aspect of Existence.

Oneness can be said to be a bit like an orchestra: made up of many individuals all playing their distinctive parts yet together they form a symphonic wholeness of musical diversity transcending all of them as individuals. For me not only did the phenomenon of orbs, as symbols of Oneness, form a connective circle including Unitarians of the past and present, it also formed a circle that like a planet orbiting the sun, brought me back again to the starting point.

For me this began one summer long ago, when as a boy of fourteen. I was at my Grandmother's house which lay at the edge of a small rural market town. It was the last house in the row right next to open fields. There were comparatively few cars back then so the roads were usually quiet: the summers long and hot. I remember the tarmac on the road in front of the house melting in the afternoon heat and the paths across the fields dry and cracking in the glare of the sun. Haymaking had just finished; the fields were spiky with stubble and the tall square stacks of piled hay bales stood like huge golden monuments in the sunshine.

In those days travellers – gypsies and other itinerant wanderers – were not uncommon in summer, passing as they did along the country roads to who knows where. On this particular afternoon I was messing about in the front garden when along the road came a travelling man. I did not see him until he stopped by our garden gate and asked for a drink of water. So I went inside to get him a drink. My Grandmother had just made a big apple pie, so I got him a slice of that as well. It seemed a good thing to do as he'd most likely walked a long way and would probably be quite hungry as well as thirsty. This obviously pleased him immensely for he smiled and said, "Thank you, son, that's very kind of you." Putting his pack

down, he sat by the gate on the corner of the stone wall next to the privet hedge and looked out across the fields as he ate. He didn't speak, so I leaned on the old green gate and looked out in the same direction. I pointed towards a wooded slope in the distance. "That's Blue Bell Wood over there."

He nodded. "So it is!" But he didn't say anything else.

Looking back now, I find it difficult to say what age the wanderer was – anywhere between twenty-five to forty maybe. Of average height with a short beard he wore his long dark hair tied back and had very bright blue eyes. Possibly an Irish gypsy, though I don't remember any gold earrings but do I remember his voice had a definite lilt to it, different to the way folks normally talked. I don't remember seeing a coat, though I think he carried something rolled up in the top of his pack. I recall he wore drab brownish trousers tucked into big old army-type boots, a collarless grey shirt with a belt over it, with some kind of pouch hanging from it. That's about everything descriptive I can recall with any certainty. After he'd eaten he asked for a piece of paper, so I went back inside and got a tatty old school exercise book I didn't need. He took a black pencil out of his pack, then wrote on the first page and handed the book back to me. He shouldered his pack and smiled.

"It's a gift," he said. "Read it and remember, I pass it to you as it was passed on to me."

This is what he'd written all those years ago:

There is only One.
And the One is the Many.
Formless and Formed,
Spirit and Matter; Light and Dark,
You and Me;
In each is the All
And All are the One.

Back then even though it was sufficiently interesting enough for me to keep, and remember, it wasn't until many years later that I realised the value of what he'd written. Who he was and why he wrote that I do not know, but the fact that this unknown wanderer gave me something simple but profound that was to be so incredibly relevant in spiritual terms for my future life and individual spiritual quest is so incredibly synchronistic that I do not believe this happened by chance. Just like the orbs this is not just for us alone, but for everyone, to make of it what they will in their own terms. But we must not forget that all paranormal phenomena, all religious or psychic experience means nothing – unless through it we become spiritually transformed individuals. Only changed individuals can change human thinking and action. Humanity will only survive on this world if we are at one with the Earth and with each other: united by values, not divided by religion or politics!

Whatever we each think orbs may be – the circular symbolism of the phenomenon gives us a profound basis from which to focus on the concept of Oneness. Once we realize the relevance of Oneness in our individual lives we will become more connected to each other, to the Earth on which we live, to the diversity of life forms we share this world with, and to a Wider Consciousness and Greater Reality beyond our own. Individuation is connected to diversity and it is only when we see the two in balance that we begin to understand how the reciprocal nature of this Wider Reality may affect and connect us all as temporal beings within space and time.

So it is here that we conclude this part of our journey from Orbs to Beyond. We hope, dear reader, whoever you are, that you have found it an interesting and inspiring glimpse into that sense of Oneness which unites us all in the unfolding mystery and wonder of Life.

More About Orbs and How to Photograph Them

The purpose of these appendices is to both provide a summary of some of the material covered in this book and to expand on some themes touched on in the previous pages; of necessity this requires repeating some of what has already been written. It should be noted that our views and speculations are, as with all perceptions of all paranormal phenomena by anyone, largely subjective to our own individual personal experience and understanding.

Summary of the Orb Phenomenon

In our experience there seems to be three key aspects to the orb phenomenon:

1. The ubiquity of orbs: Thousands of individuals all over the world are photographing the same phenomenon with different cameras in widely different conditions.
2. The majority of orbs cannot be adequately explained in prosaic terms: i.e. they are not dust, moisture, digital errors or the planet Venus etc.
3. People all across the world consistently report that orbs respond to individual human thoughts and actions and appear to exhibit purposeful behaviour.

In our own experience, orbs are part of a whole spectrum of paranormal phenomena, which seems to be interconnected and interactive.

Over the past seven years we have photographed an unfolding phenomenon which has included luminosities,

columns of light, dynamic light-forms and light beings, but throughout it all, orbs have been the one consistent factor. In one sense perhaps orbs are an invitation to connect the dots because it is, I believe, no mere coincidence that orbs are connecting people all over the world, crossing religious and cultural boundaries with images of Oneness that all can recognise at a time when our human world desperately needs a sense unity between all peoples and with the ecosphere of Earth in order to survive. Whether we are Christian, Atheist, Buddhist, Jew or Muslim we are all united by the *fact* of our existence on this one blue sphere. Perhaps Something is drawing our attention to the idea of Oneness and in that context, for us to the most important orb of all – the orb of Earth on which we all live. We need to think seriously about this, because if we cannot learn to live as one people sharing this one world with compassion and empathy for all its diversity of life-forms, our future as a cosmic species will end in the graveyard of a once blue planet that has become a dead world like the Moon.

Misconceptions About Orbs

There have been many popular misconceptions about orbs and luminosities: foremost is the silly notion that orbs are only photographed by digital cameras. This is a complete fallacy. Orbs have been photographed by all kinds of cameras: film, digital, analogue video, even by mobile phones and CCTV – as anyone who has seen one of our presentations will know!

The second glaring misconception trotted out by sceptics is that orbs are merely the result of CMOS errors in digital cameras; this in totally incorrect. The fanciful notion that the same digital error affects every make of camera in the entire world causing them all to photograph orbs is as unlikely as every Crop Formation in the world being made by two old men with a length of rope and wooden planks!

We had a digital camera for two years; we took hundreds of

shots during that time and never photographed even a single orb with that camera.

The fact that the majority of people photograph orbs with digital cameras today is due solely to the proliferation of digital technology. Having failed to convince us of the digital explanation for orbs, sceptics, who lack any empirical knowledge of the subject, will then usually resort to proclaiming that orbs are dust or moisture, or lens flare – or anything other than paranormal.

Earlier in this book you can see an example of an orb behind a person's head taken by an ordinary film camera and you can also see this on the negative. Our photographs, both film and digital, of orbs behind things or people, revealed that such orbs were not digital errors or dust as sceptics claimed. Anything behind an element in a photograph is almost certainly part of the world outside of the camera. Also, dust, pollen or moisture effects always appear in the foreground, they do not appear *behind* three dimensional objects in a photograph. Some circular anomalies on photographs may be due to ordinary effects such as sunlight striking the lens, rain drops or flash feed-back. But it does not take more than simple observation and common sense to realise which photo-anomalies can be explained as normal events. What we are concerned with are those anomalies that cannot be adequately explained in such terms.

DETECTING PARANORMAL ACTIVITY

Electromagnetic Gadgets

The electromagnetic theory is the best approximation we have to describe frequency events in the phenomenal world. So, does the electromagnetic spectrum influence or affect the detection of paranormal phenomena? This is debatable.

Today's TV Ghost hunters have used various electromagnetic gadgets to great effect: a prime example of which is the *Gauss*

meter, as was used in the popular TV series, Most Haunted.

The beeping of the Gauss meter certainly elicited lots of unwarranted excitement: all good for entertainment but as a scientific tool it is useless for detecting paranormal phenomena. That is not the function for which it was designed. Specifically a Gauss meter is extremely useful for detecting microwaves, mobile phones, wireless broadband and other sources of electro-magnetic radiation, *which it is designed to detect,* and eliminating them as a possible cause of any paranormal incursion. Strangely, for some reason, on TV it mostly seemed to work the other way round. A Gauss meter is great for discovering leaks in your microwave but not in the astral plane!

Psychic phenomena usually only registers (if at all) very subtle changes in the background radiation level of the normal electromagnetic environment; a much better gadget to monitor this is a Natural Electromagnetic Field Meter (NEF). This less beepy but much more effective meter has the capacity to blank out our human generated electromagnetic fields and read only the natural magnetic field. If you set up the NEF meter in a room it will calibrate itself to the natural electromagnetic level there and register any small changes in that environment, such as when another person or animal – or anything with an electro-static field comes within range.

Cross Referencing

When attempting to photograph paranormal events, especially for research purposes, it is useful to cross-reference your still shots or video. You could try using a combination of the following:

NEF meter readings,
Audio recording: Mini-disc recorder with stereo microphone and headphones.
Infrared digital video recording.

It also helps to have someone who is empathic or psychic working with you; someone who is well balanced and preferably not committed to any particular belief about the meaning of the phenomenon. It is also necessary to be duly sceptical, to first look for all possible natural explanations before jumping to conclusions or instantly labelling whatever it is as paranormal.

You need to be quietly focused: the screaming and shrieking you may have seen on some TV programs, supposedly investigating the paranormal, is all to do with entertainment and nothing to do with any serious investigation. Photographing or recording paranormal phenomena is more like being a wildlife photographer; you have to be patient, careful, methodical and dedicated.

How to Photograph Orbs

The great thing about orbs is that they are there for everyone, whoever you are, wherever you are. You don't need to be in a sacred place to photograph orbs – in fact they are more likely to appear in your home or garden than in a church or temple. Orbs seem to respond to individual emotions and positive frequencies – but they are not a predictable phenomenon. They may appear when you least expect them, but equally, they may also appear if you ask them to.

Seven Guidelines for Photographing Orbs

1. It doesn't matter what kind of camera you use – you can photograph orbs equally well with an SLR film camera or an analogue video camera as you can with a digital camera. It is not the means which is important, but the interaction between you as an individual and the Wider Reality which generates the orbs phenomenon.
2. Use your common sense: avoid taking photographs in dubious conditions, such as shooting directly into strong sunlight or on wet or misty nights or in places where there

may be any kind of light contamination from other sources. Dusk is an ideal time but you can also get orbs in daylight. Don't shoot into the sun. You want to be as sure as you can be that your photographic results are the genuine article. Anything less is as pointless as a person trying to have a relationship with a window dummy.

3. Treat the phenomenon with respect. Don't try to take photographs in a hurry.

Take time. Make your intentions known, in whatever way seems best to you. But you could try asking at the beginning of your session and saying thank you at the end.

4. Remember, the photographs are only the visual aspect of the phenomena – as you become more in tune with the phenomena you will begin to notice that it is relating to you as an individual. You may notice increased instances of synchronicity in your life.

5. Be aware that orbs come in all sizes from the very tiny to huge orbs over twenty feet in diameter. An apparently tiny orb may be large but far away – and vice versa.

6. Some orbs may have bits missing this may be because they have not completely manifested – or because the camera shutter has cropped them.

7. Some believe the various colours of orbs relate to electro-magnetic frequencies beyond the visual spectrum. Others believe them to represent the colours of the chakras. All this is open to question and to your own insights and investigations.

Photographing orbs is an opportunity for people everywhere to become connected with images of Oneness and to be part of a new spiritual perspective.

Further into the Light and Questions About Dark Entities

Concerning Light

When we first began to question what was appearing on our photographs we had to look at what made it possible for us to photograph orbs, or anything else for that matter – and that meant we had to look at Light!

Everything we normally see or photograph falls within the visible light wavelength of 4000 to 7000 angstroms between ultra violet and infrared in the electromagnetic spectrum. Wavelengths too short for us to see are bluer than blue, this is ultraviolet light and wavelengths too long for us to see are redder than red, this is infrared light.

The electromagnetic spectrum ranges from the shortest wavelengths – gamma rays, to the longest – radio waves. Light waves are measured in Angstroms, micrometers, centimetres and metres. If we were to reduce the electromagnetic spectrum to say, a schematic diagram 157 mm long, and mark off sections to represent gamma rays, X-rays, ultraviolet, infrared and radio waves, the visual spectrum (all that is visible to our naked eyes) would represent only a mere 5mm on that scale!

This gives a small indication of the comparatively narrow band of what we actually see; yet, even that is a bit like putting your thumb over a pocket Atlas map of Australia. The reality is vastly different to the representation. In terms of frequencies the extent of the visual spectrum is immense.

For example, red light emits at 428,570 billion cycles per second and every time you look at red light, your eye receives over four hundred trillion waves every second!

Some researchers claim that orbs are manifesting in, or from,

the infrared, which is the closest frequency to our visible light spectrum.

This may be one reason why digital cameras in particular pick up lots of orbs, because they see further into the infrared than film cameras. Even so, digital cameras merely translate infrared colours into visual spectrum wavelengths.

For anything to be seen or photographed, if only for a fraction of a second, it has to be part of our visual spectrum and therefore part of normal reality. This raises the question as to whether any photographs of ghosts, UFOs, orbs, or whatever, can truly be said to be "paranormal" because at the very moment we photograph them, they are already part of our normal physical reality. This calls into question the whole idea of the so-called "supernatural" as opposed to the "natural" world. Today, in the Universe currently being revealed to us through quantum mechanics and theoretical physics – String Theory and the Reciprocal System Theory – such dualistic distinctions are becoming as irrelevant as Ptolemy's view of an Earth-centred Universe.

According to Genesis 1:3, "And God said, 'Let there be light,' and there was light."

Light is the means by which we are able to see and record phenomena both normal and paranormal. Humanity's earliest experiences with light were of the natural world: sunlight, fire, and the reflective and refractive (light bending) nature of water or crystals.

The refracted light of the Rainbow has inspired spiritual insights and beliefs for many thousands of years: the colours of the seven Chakras, for instance, are derived from the seven colours of the Rainbow.

In 1704, Isaac Newton published *Opticks*, his great work on light, but long before that, in 300 BC, Euclid of Alexandria had made the first recorded observations about visual phenomena in an in-depth study of visible light, called Optica. Here Euclid

defined the laws of reflection of light from smooth surfaces. Both Aristotle and the great Sicilian mathematician Archimedes also studied the nature of light. But it wasn't until the 1800s when Michael Faraday first proposed the idea of electromagnetism, that we saw the beginning of the electromagnetic spectrum as we know it today. Even so, Faraday didn't have the mathematical skills to prove his theory and it wasn't until it near the end of Faraday's life, that James Clark Maxwell formulated the electromagnetic theory, which united all previously unrelated observations and experiments of optics, electricity and magnetism into a consistent theory. Maxwell's equations elegantly demonstrated that electricity, magnetism and visible light are all manifestations of the electromagnetic field.

Normally we are incapable of perceiving the vastness of the electromagnetic spectrum and therefore entities or phenomena that may exist in other frequencies are invisible to us – but photographs of paranormal phenomena show that there are exceptions.

Because of the known limitations of the frequencies in the visual spectrum anything we can see or photograph should not, in terms of the old physics, be paranormal – and yet the images many of us have taken patently *are* paranormal, at least in terms of transcending the accepted materialist view of reality. Most of the images we ourselves have taken should not be there – and yet they are! Even more astounding is that using standard equipment we were able to photograph them!

Maybe we should not be too surprised, because even today the nature of light and the electromagnetic spectrum in general is far from being understood in totality. Newton for instance, believed light to be particles and was completely mystified as to why certain objects reflected certain colours, which in turn affected the eye's ability to perceive those colours. Later, Thomas Young came along to prove that light was waves not particles,

and his simple demonstration of this theory changed the way scientists viewed light. Much later still, Albert Einstein put forward the view that light contained photons, which made sense in terms of Einstein's own physical theories but conflicted with Young's wave theory of light. Even to this day there is some dispute as to whether light is made up of photonic particles or waves. The best scientific compromise so far is that light can be viewed as either, depending on the prevailing conditions.

It seems unlikely that science will have a complete answer to the paradox of light until scientists themselves completely understand the total nature of gravity, electricity and magnetism. Are these primary forces in themselves or by-products of fundamental forces yet to be discovered? So far no one really knows the answer to this.

Werner Heisenberg, the 20th-century German physicist, recognised the immense conceptual problems faced by physicists delving into the subatomic world in which classical materialist concepts of physics no longer worked. Heisenberg's work led to the formulation of the "Heisenberg Uncertainty Principle", which is basically a set of mathematical relations that determine the limits by which classical physics may be applied to subatomic phenomena.

In the realm of quantum physics both the observer and the observed are part of the same event. In this subatomic quantum universe scientists influence the properties of observed objects, simply by observing them. At this level of reality, space, time, light, dark, cause and effect, all lose their meaning. The base reality of Existence at the quantum level seems to be metaphysical rather than material. In that context, as we cannot separate either visible light, or indeed the whole of the electro-magnetic spectrum, from quantum realities underpinning material existence, the occurrence of paranormal visual anomalies may be natural indicators of the existence of a Wider Reality implied by the work of many present day cosmologists

and quantum theorists. In short – there is ample room for both normal and paranormal events in the Universe being revealed to us by today's cutting-edge science.

When God said, "Let there be Light", he called into being a fundamental principle both cosmic and spiritual that affects all life everywhere. In terms of material reality, it is within the One Light of that first burst of creative energy that we live and move through space and time! In metaphysical terms, we understand that from the light of a billion stars to the flicker of single candle flame – all Light is One! Within this Light are all phenomena, normal and paranormal, and it is by this Light that we humans are able, at times, to glimpse a Wider Reality. Whenever we do that, and try to figure out where it all fits, however puzzling it may be, we are no longer mere bystanders but participants in the mystery and wonder of Existence!

Light-Forms and Other Apparitions

In this section we shall comment on some of the apparitions we have taken and look in brief at some of the implications and meanings. Our photographic voyage into paranormal photography started with orbs and luminosities but that was only just the beginning. Although orbs have been a constant factor, the phenomena soon began to change into other more exotic visual forms.

We labelled these mysterious transitions variously as *Light Rods, Winged-things, Faerie-like, Sprites, Light-Forms and Light Beings.*

But do remember, as mentioned previously, all these terms are descriptive – but not definitive.

What they really are is still open to question and further research. Labels certainly helped us to categorize the various visual manifestations which had common features. Simply calling them all "apparitions" didn't seem any more helpful than calling all non-human creatures "animals"! There is a world of

difference between a horse and a bumblebee – and so it seemed with the various transitions the phenomena was manifesting. Visually there were clearly different groupings or types. The appearance of the first "Winged Thing" made us aware that we *may* be dealing with some kind of evolving phenomena. At first the odd bright little bundles of energy, which we also thought of as "Faerie-like", seemed to be a more complex form of the luminosity end of the orbs spectrum. This seemed a reasonable assumption, as after we'd got that first image of a "Winged Thing", we were soon regularly getting images of other faerie-like forms along with our usual photographs of orbs. The more shots we took, the more we became convinced that the faerie-like forms were essentially the same phenomena as orbs and luminosities, just configured differently.

This was the beginning of a consistent and repeating aspect of the whole phenomena. Once we got one unusual image that we'd never photographed before, it repeated and recurred over and over again – until a different transition manifested. What we called "Light Rods" were another such case, except this time the phenomenon was, at least on occasions, also visible to the eye, and moving, just as with the Luminosities.

The same sporadic visibility later happened with Light-Forms and Light Beings.

In the beginning, although we took hundreds of shots we only got orbs; after that we only got a specific transition appearing until a different transition occurred. However, over the past few years we have had instances of all the transitory forms occurring randomly, almost as though all the stages of the phenomena are now complete.

We have been privileged to have photographed most of these amazing transitions.

Light-Forms

After the Light Rods the next major transition was the

appearance of what we termed "Light-Forms" which were also accompanied, in their close proximity, by some kind of electrostatic effect in the air, such as may be felt during a thunderstorm.

The distinctive visual impression of these Light-Forms was of a swirling dynamic vapour that seemed to have structure to it – which ordinary mist does not. Nor did we ever get any vaporous forms before taking that shot of the first Light-Form in which Katie is literally enveloped in a thick curling vapour. Typically, as with the start of every transition, orbs and luminosities were present at the first appearances.

Light-Forms may be seen by some as having a ghostly aspect, but we never thought of them as any kind of spooky entities at all; these mysterious ethereal forms seemed to us as things of beauty, more like works of transient art.

Light-Forms *may* be "spirit phenomenon", but all we can say is that we certainly never felt in any sense at all that we were in the presence of ghosts or spirits of the departed. There is little doubt that spirit phenomena exists – phantom forms and haunted houses – all of which are well recorded by other authors. Many tales of ghosts and spirits include strange light phenomena, such as floating lights, columns of light, luminous mists and flickering flame-like effects. In some places the regular appearance of misty forms may have given rise to ghostly tales with which to frighten listeners on dark nights. But for us there was never anything remotely frightening about the Light-Forms: rather there was a joy about them, an excitement, such as you may feel in the long grass of a windblown meadow or stepping out of your door on the first sunny day of spring.

If this phenomenon was supernatural then it was so naturally a part of our reality that the distinctions between normal and paranormal no longer seemed to have meaning.

Dark Entities?

Where there is Light there is also Dark – one cannot be known

without the other.

In our dualistic world, we usually see Light as Good and Dark as Evil, but intrinsically both Light and Dark are essential for the Whole: as symbolised in the Tai Chi, they are neither good nor evil, just aspects of the ebb and flow of Existence.

We shoot into the dark, and orbs, luminosities, light-forms and light beings appear!

All we ourselves have photographed or experienced of these phenomena has been spiritually inspiring rather than the reverse. But as some may see all contact with paranormal phenomena as an invitation for dark or evil entities we shall now endeavour to address this conceptual error.

In our experience what may be commonly described as dark entities do not pose for photographs for they inhabit a much different sphere of activity. Nor do they leap out of graveyards at night to scare us, because they simply do not need to! These kinds of spooks are the inhabitants of fantasy films and books about vampires, werewolves and other such fictional fright-fests. The reality of dark entities and negative forces is quite different and much more insidious.

To get a spiritual perspective on this let us turn to St Paul who said, *"We wrestle not against flesh and blood, but against the rulers of the darkness of this world."*

The darkness Paul speaks of here is a spiritual darkness; this is the sphere where dark entities are active. Like Dark Matter they exist invisible in the gaps between selflessness and selfishness; between goodness and cruelty; between truth and a lie! Dark entities are the invisible deceivers but their effects in our world can be seen and felt nevertheless.

We only have to look back at history, or read today's news to see the terrible effects of dark entities on their human hosts and their prey: diabolical dictators, genocidal mass-murderers, terrorists and child molesters, the callous exploiters of the weak

and vulnerable everywhere.

It seems likely that dark entities and the *"rulers of the darkness of this world"* which Paul spoke of, are one and the same: and their remit seems simply to destroy the human spirit and to stunt and retard human spiritual development.

Dark entities are the psychic vampires of the Soul. Even within our own "civilised society", we can see dark forces at work attempting to degrade or destroy human souls. For wherever there is addiction, whether to drugs or alcohol, where there are psychopaths, drug pushers, and abusers or corrupters of innocence, dark entities are there like vampires, feeding on human hopelessness. Wherever there is cruelty, indifference or lack of love and compassion, dark entities are there too!

Some psychics have reported dark entities around those addicted to alcohol or drugs. But aside from addictions, these psychic predators can affect ordinary lives in other ways: a common parallel to dark entities can be seen in the Clinical definition of a Controlling Personality. As many innocent ordinary people fall prey to this it is worth mentioning here. Controlling Personalities are so cunning and conniving we do not usually see them coming! In cults or religious communities Controlling Personalities will often claim to speak for God. In the New Age they may try to establish control by claiming to know you in a past life. But whatever ruse they employ it will always be under the guise of offering help or protection that *only they* can give, but ultimately you are a victim to feed *their* needs. You may not even realize you *are* a victim once they have a foothold in your psyche! Once established as your "friend and protector" they will try to erode past relationships with all those who love you, such as your family and friends, simply because anyone who really loves you is always a threat to their control.

Dark entities operate on the same divisive basis: addiction, religion, politics, and anything that can be used to divide humanity and degrade or stunt its spiritual growth is the

province of dark entities! But in reality dark entities have no power – except that which we give them! As with the individual who has defeated alcoholism, humanity needs to take back the power to say No to negative forces and Yes, to positive living!

Only Love can empower us to do this. If anyone you know seems to be the prey of dark entities, you *can* help them by sending them love and compassion whenever you pray or meditate; by living compassionately but rooted in reality. You cannot condone either by your words or actions anything that is destructive for the individual. A consistent, compassionate example by the way you live, really could help to free them. In that sense you have to be a Spiritual Warrior.

The Spiritual Warrior

There are many agencies set to damage this world and its people, many battles to fight, many causes for truth, freedom and humanity. Take Jesus for example: when we examine the gospel accounts the Love that Jesus spoke of was anything but meek and mild, it was radical and revolutionary! His followers endured years of persecution and thousands gave up their lives because of it. Jesus' views on love and freedom went against everything the might of Rome stood for and yet Rome fell, and Jesus' teaching about Love and Freedom spread across the world. Once our consciousness is orientated towards that Love which Jesus and other spiritual teachers have spoken about, once we have taken that on aboard as a spiritual reality in our lives, we are well on the way to becoming Spiritual Warriors. In that context compassion is not something passive at all; just like truth it is a primary weapon of the Spiritual Warrior!

Like the Jedi's light saber, once unleashed it can cut through the darkness. As with truth, compassion is both the challenge and the means by which we can effect positive change in this world!

Two statements which may help to give us a solid objective

reference point for compassionate living and help make us more effective Spiritual Warriors are these:

The first is from Jesus, who said,

"...in as much as you have done it unto the least of these my brethren, you have done it unto me."

The second statement is this:

"If we are not part of the solution, we are part of the problem."

Implicit in both these statements is personal responsibility for our own actions and the way we live in relation to the world in general, and to others, especially to the weak and vulnerable.

In practical terms this simply means that we have to be part of the answer, rather than part of the problem! Living compassionately then, means that we do not condone by our lives or example anything which exploits, degrades or damages this world or its people.

Once we understand what compassionate living really means, we can better identify the main causes of human suffering, exploitation and world problems.

We can then more clearly act in such a way as to minimize or counteract those things in our own lives. In that sense, compassion is not a fuzzy feeling, but often a deliberate, positive act of the will in relation to others and to the world we all share.

When we externalise the spiritual reality of love in our lives we become effective Spiritual Warriors in the battle against dark entities everywhere for no spiritual darkness can exist when confronted by the Light of Love given unselfishly, consistently and compassionately for the sake of others.

Through the Looking Glass and Thinking Out of the Box

THROUGH THE LOOKING GLASS

When Alice stepped through the looking glass she found herself in a world far different to that of 19th-century England. The world revealed to us now by quantum physics and Chaos Theory is as far removed from the world of 19th-century rationalism as a butterfly is from a steam engine: for a butterfly is far more complex, sophisticated and infinitely superior! A butterfly is part of the matrix of Existence in a way that manmade cogs and wheels will never be.

In stark contrast to old 19th- and 20th-century conventional science, where space and time were seen as the framework *within* which the drama of Existence is played out, today's quantum mechanics reveal an entirely different view of the cosmos. This is graphically expressed in Dewey B. Larson's Reciprocal System of Physical Theory, which is accepted by many quantum physicists, as being a better explanation of quantum realities than quantum theory alone can produce. In the Reciprocal Theory Time and Space are not absolute or self-existent; they are both reciprocal effects of One Primary Reality: Motion!

Science recognises two types of motion: Linear or Vector Motion, which has two characteristics, a magnitude and a direction – and Scalar Motion which has only a magnitude. It is this *"scalar motion"* or speed that is the *content* of the physical universe, moreover, it is *the only sole content*. Through quantum physics we now glimpse the inexplicable processes underlying all existence: here we see not a universe of matter, but a universe of motion, in which the only base reality *is* Motion! All primary

elements: particles, atoms, fields, forces, in fact all forms of energy – are merely manifestations of Motion!

In this new paradigm Space and Time are both reciprocal aspects of Motion, and do not exist independently. There is no intrinsic significance to either time or space, except as a common reference to describe phenomena. This very pertinently reinforces ancient metaphysical views in which all Existence is seen as Vibration: matter, space and time being resonances of this Vibration. At the quantum level everything is continually moving; that which has no motion, cannot not exist!

Taking for granted that all our descriptions of the Totality of Existence are inaccurate and incomplete, the concept of a Reciprocal Reality Universe in which Motion is the primary basis of everything, parallels the visionary views of mystics throughout history in which the Universe is seen as a dynamic holistic whole, full of movement, flow and change at every level. It is this concept of the harmony and balance of Universal Motion and Diversity that is enshrined in the familiar symbol of Tai Chi – the Yin Yang of Taoist philosophy, which is also the symbol of Primordial Unity: of Oneness! Yet at our level, this Oneness seems fragmented into a myriad of diverse forms!

In Lewis Carroll's *Through the Looking Glass"* there is an interesting conversation between Alice and the White Queen, who said that in her realm *"memory works both ways."* Just like Alice, the Queen remembers things from the past, but she also remembers *"things that happened the week after next."*

Alice just can't believe this, and says, *"I'm sure mine only works one way...I can't remember things before they happen."*

The White Queen isn't impressed and replies, *"It's a poor sort of memory that only works backwards."*

In terms of what we are now learning from quantum physics this may not be as incredible as it sounds: if Oneness exists, both past

and future will co-exist at the same time. We now know that the same photon can be in two places at once, and that the very intention of observing quantum phenomena affects the way that such phenomenon behaves!

From this and in many other experiments that have been repeated and replicated over the last decades we now know that *intent* affects quantum phenomena: this strongly suggests that consciousness is not merely some electro-chemical process locked inside your head, but a dynamic and interactive force that is pervasive through time and space. Essentially in terms of the concept of Oneness, consciousness is ubiquitous: connecting everything everywhere, all the time. There is more to the phrase, *"Through the Looking Glass"*, in quantum terms than meets the eye.

For instance, a mirror is a reflection of reality. As a single complete mirror it reflects that reality, but if you shatter it into a thousand pieces, all those tiny pieces of the mirror still reflect reality! Metaphorically this is a reflection of what happened in the Big Bang, or at the moment of Creation. The One became the many which in all its billions of parts and levels still reflects the One Single Original Reality!

In the first chapter of Genesis, the Act of Creation begins with the spoken words, *"Let there be light!"* Here vibration, motion, initiates creation. This is qualified in the New Testament, in John 1:1 where we read, *"In the beginning was the Word and the Word was with God, and the Word was God."* Here again we are confronted with the idea that the Word (vibration) is the One Primary Reality! Just as with the Big Bang in terms of the physical Universe, in which energetically and materially all was once One Primordial Singularity, so in metaphysical terms the Base Reality of the Word or Vibration is the Oneness that underlies all Existence!

Without movement of thought or action there is no creativity and

without the One Single Act of Creation there would be no Universal Diversity! For me Reciprocal Theory, ties together quantum physics and metaphysics in a workable concept of a universe of diversity reflecting the underlying Oneness of both Consciousness and Existence. If we accept the idea of Universal Oneness, in which all the myriad parts, like the shattered mirror, are reflections of that same One Reality that existed in the beginning, then individual consciousness is also a fractal reflection of the universal Oneness of Consciousness! Put in that context, Jung's idea of a Collective Unconscious, unbounded by time or space would make sense of synchronicity, clairvoyance and the spiritual insights of mystics. If Oneness exists, then as with God, it is present everywhere all the time!

The concept of Oneness is expressed through positive values and principles: *Truth, Compassion, Understanding, Justice and Liberty.* All these form a Circle of spiritual inclusiveness and freedom, rather than the walls of division and separation erected by fundamentalist religion or politics.

For instance, Quakers and Unitarians are founded on these positive values, on the idea of inclusiveness, of building bridges between people rather than walls. Certainly Unitarians have the capacity to accept new possibilities: unbounded by static dogma they are free to reflect the fundamental cosmic dynamic of Creative Thought!

In the concept of Oneness we have an indivisible quantum basis for a living spirituality that connects us with the very fabric of the Universe! In the concept of Oneness we engage with the dynamic principle underlying Existence. Whichever way we look at it, only a spirituality that reflects this is of any real value for the future of humanity.

One Light: Many Colours

When Newton split white light through a prism and revealed all

the colours of the rainbow – it was a radical step forward that led to the understanding of the Electromagnetic Spectrum. Not long after joining our local Unitarians this is what inspired me to create the postcard below depicting a prism and a rainbow, for it seemed to me that the Unitarian ethos is like that prism – One light – but many colours!

This idea is reflected in the lighting of a chalice candle at the start of every Unitarian service or meeting. Lighting the chalice is not only a symbol of the light of compassion, truth and freedom but is also a tangible reminder that though the flames are many, the Light is One! Here we have a meaningful embodiment of the dynamic cosmic principle of Oneness reflected in Diversity.

The One *is* The Many! This is the same concept which is beautifully depicted by the ancient Tai Chi symbol and today eloquently expressed scientifically through the Reciprocal Theory of Physical Systems. For Unitarians it is also enshrined within Unitarian principles and values! Being Unitarian equals Spiritual Freedom, Community and Shared Values! The Capacity

to evolve and change, without fearing new possibilities! Such a dynamic spiritual perspective reflects cosmic fundamental principles and realities!

Being Unitarian offers a progressive practical spirituality, which is, I believe, is the most realistic spiritual perspective for humanity in the 21st-century and beyond. For me the concept of many flames but One Light echoed the words I was given as a child, which are worth repeating here:

THERE IS ONLY ONE.
AND THE ONE IS THE MANY:
FORMLESS AND FORMED,
SPIRIT AND MATTER; LIGHT AND DARK,
YOU AND ME.
IN EACH IS THE ALL
AND ALL ARE THE ONE.

This concept of Oneness runs parallel to the new physics and is evidenced in the work of cutting-edge researchers such as Cleve Backster who has highlighted what he termed, "Primary Perception" (consciousness) in plants. Backster's later research also convincingly demonstrated that human tissue responded to the emotions of the donors, even though separated by distance, which strongly suggests that consciousness is not localised within the body. The work of Dr Masaru Emoto has graphically documented the fact that concentrated positive intention can affect the structure of water crystals, making that which was impure, whole again. The work of both Backster and Emotto show that consciousness is not limited spatially – and indeed may be everywhere.

If focussed thought can affect the physical structure of water crystals, it can surely affect us and the world around us. For if we factor consciousness into the context of the vibrational universe

of Reciprocal Reality we begin to see the that perhaps Time and Space are not only manifestations of Motion but that Motion itself may be an effect of Consciousness: an omnipresent dynamic Consciousness connecting everything.

Today in the Universe revealed by modern advances in Neurosciences and Quantum Physics we see the probability of a metaphysical basis for Existence where we are part of a Wider Reality; in that context the reciprocal effects of a Greater Consciousness may well generate paranormal phenomena in our own physical reality.

Quantum Theory, String Theory, Reciprocal Reality, the Taoist Yin Yang, the Universal Mind, The Creator Spirit: all these concepts give us a small glimpse into the possibility of a multi-dimensional intelligent universe in which at every level, paranormal events may be symptomatic of a connective Consciousness pervading the whole of Existence, which is itself the reflection of a much Wider Reality beyond. In this new paradigm the material Universe is not the whole – it is merely part of a larger picture we have only just begun to notice. The more we learn about the quantum universe the more we are faced with intangibles and paradoxes that do not fit with natural physics at the everyday level, and which increasingly endorse a metaphysical basis for Existence. That we live in a material universe based purely on random chance seems less and less likely at the quantum level, which reflects a single metaphysical dynamic as the Source of all phenomena at every level of Existence. The inherent interconnectedness and design of the whole thereby implies a Designer: a Creator or Creative Process that is separate to and beyond creation.

This metaphysical basis for Existence is something that has been advocated or implied by mystics, spiritual teachers and philosophers since ancient times.

One of the fathers of modern rational philosophy, Immanuel Kant, his Preamble put it this way:

The very concept of metaphysics ensures that the sources of metaphysics can't be empirical. If something could be known through the senses that would automatically show that it doesn't belong to metaphysics; that's an upshot of the meaning of the word 'metaphysics.' Its basic principles can never be taken from experience, nor can its basic concepts; for it is not to be physical but metaphysical knowledge, so it must be beyond experience.

It is to this *"beyond experience"* that I believe all paranormal phenomena points; we can only see it as a reflection because we have neither the reference points nor the capacity to see or understand the whole. We can see the indications that it is there, just like we can tell when the wind blows, but we cannot see it directly; it is always beyond us. When we go to the seaside and look at the waves, we are not actually seeing waves at all – what we are seeing is the water that is the medium through which waves flow. The energy of the wave is translated through water just as the ripples from that Wider Reality are translated through paranormal phenomena. As with a painting we have to be careful not to mistake the medium for the art that is expressed through it: for great art is always more than the material sum of its parts. All art reflects its creator but it is not the creator: for the creator is always separate from the work, always more than the two- or three-dimensional image. Reflections of the Creator are always within us and around us, but the Reality of the Creator is always more: always beyond us.

At one time religion was the final arbiter of all truth – then it was science. We cannot look with hope to any system whether religious or scientific that has become moribund by dogmatism. But in the Universe as we see it today there is plenty of room for both science and belief: for both physics and metaphysics. Only

truly unbiased scientific inquiry and compassionate spirituality will help us to see the indications of that Wider Reality.

The fundamental reflection of that Reality is Movement, both physical and spiritual. We live in a dynamic Universe and it is, I think, most probable that in our world, only those individuals, systems and beliefs which reflect that dynamic process will persist to survive into the future. In our Universe there is no future without change. In the familiar Yin Yang symbol we see the One that is the Many: a constant flow of movement, Light and Dark, Time and Space, in the Cosmic Singularity of Diversity.

It was this awareness of Oneness which led us to support the Unitarian Movement. For it is an open-minded Movement without dogma, in which both theists and atheists are equally at home: united by values, not divided by doctrines. The Unitarian view is that it is better to build bridges, than walls – which have sadly become the hallmark of so many religions.

The Unitarian practice of lighting the chalice flame – the One Light that is also many – is a tangible reminder that Oneness and Unity are not merely abstract concepts but spiritual imperatives for living that can transform our individual lives and change our world for the better.

For both Katie and I, our journey through orbs and beyond has not only been an exploration of paranormal phenomena it has been a personal spiritual journey.

Our own experiences have led us to question many things and to learn many things. The more we have learned the more we realize how little we all know, and how much more we all have yet to learn, especially about spiritual values: love, compassion and truth. We have been privileged to photograph some amazing images, which we believe are visual indications of the reciprocal nature of an all pervading Consciousness connecting our Reality, at many subtle levels with a Wider

Reality beyond our normal range of perception. Although this Consciousness may be beyond scientific detection by methods now available to us, it is very probable that all documented authentic paranormal phenomena may well be evidence for its existence.

If that is so, then IT is part of us and we are part of IT.

THINKING OUT OF THE BOX

One positive thing about encountering anomalous or paranormal phenomena is that it often provides a kick start to get us thinking out of the box; to look beyond what is commonly acceptable to see new possibilities and new horizons. One such thought provoking incident, although in no way did it involve the paranormal, it is an extraordinary story that caused many to rethink their views of consciousness.

In 1965, a baby female chimpanzee was captured to be used by the US Air Force for research in the space program. This chimpanzee was named Washoe, after Washoe County, Nevada, where she was raised.

In 1967, Doctors, Allen and Beatrix Gardner initiated a project to teach Washoe ASL – American Sign Language, at the University of Nevada. Previous attempts to teach chimpanzees to imitate vocal languages had all failed. But the Gardner's believed these projects were flawed because chimps are physically incapable of producing the sounds required for spoken language. Their solution was to utilize the chimpanzee's natural ability for making diverse body gestures, which is how they communicate in the wild. It was from implementing this concept that Washoe became the first non-human to learn to communicate using sign language; this was so successful that other chimps were soon brought into the project.

But the point of this story is an incident that happened with Washoe herself.

As part of the project Washoe had her own accommodation at the University: with a couch, a refrigerator, and a bed with sheets and blankets. She had access to clothing, toys and books. Much like a human child Washoe also had a regular routine with chores to do, outdoor walks and play times, all of which were used as learning opportunities by the project team.

As part of the learning process Washoe was taken for regular walks in the park where there just happened to be a lake where swans lived. On her first encounter with the swans, the behavioural psychologists on the project, as was their plan, tried to teach Washoe the ASL sign for swan – but for some reason, in spite of repeated attempts by the team, Washoe never caught onto this sign; so after a while they simply gave up trying to teach her that particular sign. This was no problem as she was so good at learning other signs.

This was all forgotten about until one day when out walking with Washoe they again encountered a swan, but this time one of the team noticed that Washoe was now making a new sign they'd never seen before. Naturally they were fascinated and made a careful note of the new sign. Then it suddenly hit them – Washoe's new sign was a combination of two other signs! Washoe was now signing "WATER-BIRD"!

Harvard psychologist Roger Brown said this was *"like getting an S.O.S. from outer space"*. It was a turning point in the whole project, but more it was a pivotal point in advancing our understanding of non-human consciousness.

Washoe's two word sign – "Water-Bird" is both inspiring and incredibly important because it clearly demonstrates that chimpanzees are capable of constructive thinking, deductive thought and imaginative thought processes: qualities which were once thought to be the unique and sole consequence of human evolution!

To qualify this, it was later discovered that Washoe and the other chimps on the project were all now able to combine the

hundreds of signs that they'd learned into new combinations they had never been taught, but which they'd created by themselves, for themselves. For instance, Washoe's mate Moja had rejected the ASL sign for "thermos" but replaced it with his own original combination sign of "METAL CUP DRINK". In creating their own signs the chimps showed they could be both imaginative and consistently logical. But that was not the end of the learning curve.

Being Human: Non-Human Empathy

Washoe became much attached to the humans regularly working with her on the project and was upset when any one of them was not there as usual. She became quite distressed when Kat, the caretaker, was absent for a few weeks. When Kat finally returned to work with the chimps, Washoe was deliberately ignoring her as a way of registering her disappointment over Kat's absence. Kat felt that she should explain the truth about her absence to Washoe, and persisted to try to get her attention. When she finally got it, Kat signed to Washoe:

"MY BABY DIED."

What happened next took Kat completely by surprise. Washoe stared at her; then looked down, and then she looked into Kat's eyes again and carefully signed, "CRY" and touching her cheek, traced her finger down the path a tear would make on a human.

This incident is incredibly thought provoking for two reasons: firstly Chimpanzees cannot shed tears – and secondly, Washoe herself had lost two children; one died shortly after birth of a heart defect and the other died of an infection at two months of age! Kat later remarked that this one sign – "CRY" – told her more about Washoe and her mental capabilities than all of the project data they'd collected. In a simple but profound way Washoe had demonstrated both understanding and empathy for a member of another species.

It now seems somewhat ironic that Biblical fundamentalist

critics of Charles Darwin often used to try to scorn him in their publications by joking that he thought his uncle was a chimpanzee, but in the light of what Washoe communicated to Kat, this was really a compliment, because in that one incident Washoe evidenced far more intelligence than Darwin's fundamentalist 19th-century critics!

Washoe's "Water-bird" was the first intelligently constructed communicative sign originated by what some would have once seen as a "lesser species" but I believe Washoe gave us all an inspiring incentive for us to re-evaluate our definitions of intelligence and our own place in the scheme of things. For if a chimpanzee, with its necessarily limited view of the human world can evidence such empathy for human grief, how much more should we as members of the human species show empathy, understanding and compassion both for each other and for all those other species we share this world with? This of course brings us back to the concept of Oneness and the connectedness of all life within a more holistic view of a cosmos spiritually connected through a ubiquitous consciousness that flows through all phenomena whether normal or paranormal.

In terms of our own spiritual evolution as a species, I believe, studying and documenting paranormal phenomena, is certainly important – but it is not all important; if our encounters with such phenomenon do not help to transform us spiritually, as human beings, it is all useless.

If we hope to ever move beyond greed and materialism as a species, our next major step must be a spiritual one. This is the essential message that has consistently unfolded through all our experiences from Orbs to Beyond!

RECOMMENDED READING

The Authors wish to thank and acknowledge both the authors and publishers of the references and quotations used or referred to in this book and to recommend them, and the other books listed here below, for further reading.

A Field Guide to the Stars and Planets by Donald Menzel (Collins).

Anam Cara by John O'Donohue (Bantam Books).

Angels by Hope Price (Macmillan).

An Index of Possibilities by Clanose Publishers (Arrow Books).

Alien Investigator by Tony Dodd (Hodder Headline).

Alien Interface by Mike Oram & Fran Pickering (Star Hill Publishing).

Asimov's New Guide to Science by Isaac Asimov (Penguin).

Beyond Coincidence by Martin Plimmer & Brian King (Icon Books Ltd).

Beyond Photography by Katie Hall & John Pickering (O-Books).

Cosmos by Carl Sagan (Macdonald Futura).

Does it Rain in Other Dimensions? by Mike Oram (O-Books).

Encounters with the Numinous by E. Avariel (Farstar).

Gaia the Growth of an Idea by Lawrence E. Joseph *(Penguin).*

In These Sign Conquer by Ellis Taylor (TGS Publishers).

Ley Lines and Earth Energies by David Cowan & Chris Arnold (Adventures Unlimited Press).

Lost Eagle by Steven Ingman-Greer (O-Books).

Mystery Sky: Photography of the Unseen by Diana Lane Lambert (Balboa Press).

One in a Hundred by Aidan Shingler (Thorntree Press UK).

Orbs, Lightwaves, and Cosmic Consciousness by Sandra Underwood (Xlibris Corporation USA).

Orbs Around the World editor Sandra Underwood (Xlibris Corporation USA).

Passport to the Cosmos by Dr John E. Mack (Thorsons/Harper Collins). *Psychoenergetic Science: A Second Copernican-Scale Revolution* by Professor William A Tiller (Pavior Publishing USA).

Revelations of Things to Come by Earlyne Chaney (Astara Inc).

Saved by the Light by Dannion Brinkley (Piatkus Books Ltd).

Swirled Harvest by Andy Thomas (Vital Signs Publishing).

The Big Book of Reincarnation by Roy Stemman.

The Cult of the Virgin Mary: Psychological Origins by Michael P Carroll (Princeton University Press).

The Demon Haunted World by Carl Sagan (Hodder Headline).

The Heretics: Past and Present by Brian Allan (O-Books).

The Hidden Messages in Water by Dr. Masaru Emoto (Beyond Words Publishing).

The Language of Symbols by David Fontana (Duncan Baird Publishers).

The Middle Kingdom by Dermot Mac Manus (Colin Smythe).

The Orb Project by Miceál Ledwith and Klaus Heinemann *(Beyond Words Publishing)*.

The Quantum and the Lotus by Matthieu Ricard & Trinh Xuan Thuan (Three Rivers Press).

The Secret Life of Plants by Peter Tompkins & Christopher Bird (Penguin).

Synchronicity by Deike Begg (Thorsons).

The Tao of Physics by Fritjof Capra (Fontana).

The Zen of Ben by Mike Oram & John Pickering (Star Hill Publishing).

Uninvited Visitors by Ivan T. Sanderson (Neville Spearman).

Unitarians: The Spiritual Explorers by John Pickering.

WEBSITES WORTH A SECOND LOOK

www.lights2beyond.com
www.sandraunderwood.com
www.mysterysky.com
www.thank-water.net
www.bens-world.co.uk
www.inotherdimensions.com
www.thesanctuaryofhealing.co.uk
www.unitarians.org.uk
www.johnodonohue.com
www.lucypringle.co.uk
www.nasa.gov/
www.otherworld.ellisctaylor.com
www.dailymail.co.uk/news/.../Picture-The-ghostly-Angel-Vatican.html
www.reverbnation.com
www.cafepress.co.uk/bensfunworld
www.starhillpublishing.co.uk
www.paranormalmagazine.co.uk
www.nexusmagazine.com
www.o-books.net

PHOTO AND IMAGE CREDITS

All photographs and images in this book are copyright Katie Hall & John Pickering 2010, unless otherwise stated below.

Although every effort has been made to contact the owners of copyright material used in this book it has not always been possible to do so.

Woodcut: © *The Wickiana Collection Zurich Library*

Black & white photograph of sphere in Basle Zoological Gardens 1907: © *M.Bessy*

Photograph of Katie and Spirit of Life mural: © *Sally Jones 2010*

Photograph of "Valentino" apparition: © *Sara Saunders 2008*

Angel of The Vatican Photograph: © *MMP of Cambridge.*

Universal puzzle, Ben's World cartoon © *Mike Oram & John Pickering*

Circle of Spirit Healing photographs of spirit manifestations: © Isobelle Duchene and Jim Sherlock's Psychic Circle 2010

Photograph of large blue woodland luminosity: © *Ellis Taylor 2007*

Photograph taken during the reputed "Dance of the Sun" at Fatima on 13th October 1917,Copyright unknown

Eight photographs of light outside the womb © *Laura Campion*

Photograph of pregnant woman © *Julie Owens*

Photograph of Pebbles on Iona beach © *John Hetherington*

Photograph of the Bubble Nebula, taken by the NASA Hubble Wide Field Planetary Camera 2 © and *Courtesy of NASA*

We hope you enjoyed our book.
If so, please recommend it to all your friends.
Thank you.

May Love and Light be with you.

BOOK ONE IN THE BEYOND TRILOGY
BEYOND PHOTOGRAPHY by Katie Hall and John Pickering
The Original Classic Book on Orbs and Paranormal
Photography!

First published in 2006 by O-Books, BEYOND PHOTOGRAPHY
was the very first book to examine the orb phenomenon in
any detail, and was also the first book in the world to
photographically document one couple's encounters with a
whole range of paranormal phenomena. This amazing story of
first contact with orbs and related paranormal visual
phenomena is documented by incredible photographs and
opens up a whole Pandora's Box of questions about psychic
phenomena and the nature of Reality.
"Beyond Photography is a *must* for all those interested in the
paranormal and for everyone who have ever pondered the age
old question: 'Are we alone?'"
The late Tony Dodd, leading Ufologist and researcher.

BEYOND PHOTOGRAPHY by Katie Hall and John Pickering
Published by O-BOOKS
ISBN-13: 978 1 905047 90 1 ISBN-10 1 90504 790 8
Available from any good bookshop:
In the UK from: Orca Book Services:
orders@orcabookservices.co.uk
In the USA from: National Book Network:
custserv@nbnbooks.comIn
Australia & New Zealand from: Brumby
Books: sales@brumbybooks.com.au
Available online from:www.o-books.net and
www.amazon.co.uk

6th Books investigates the paranormal, supernatural, explainable or unexplainable. Titles cover everything included within parapsychology: how to, lifestyles, beliefs, myths, theories and memoir.

AN
UNDOCUMENTED
WONDER

AN
UNDOCUMENTED
WONDER

The Making of the Great Indian Election

S.Y. Quraishi

RAINLIGHT
RUPA

Published in Rainlight
by Rupa Publications India Pvt. Ltd 2014
7/16, Ansari Road, Daryaganj
New Delhi 110002

Sales centres:
Allahabad Bengaluru Chennai
Hyderabad Jaipur Kathmandu
Kolkata Mumbai

ISBN: 978-81-291-3106-5

Second impression 2014

10 9 8 7 6 5 4 3 2

The moral right of the author has been asserted.

Printed at Replika Press Pvt. Ltd, India

*Dedicated to
the memory of my father,
Maulana Zubair Quraishi, who instilled in
me the value of the pursuit of knowledge
and the desire to excel.*

CONTENTS

FOREWORD

I mean to diminish no individual, institution or phase in our history when I say that India is valued the world over for a great many things, but for three over all others:

- The Taj Mahal
- Mahatma Gandhi
- India's electoral democracy

The credit for the last of the three fames goes to the people of India who have embodied that achievement and given it utterance. It also goes to the political parties of India who have recognized the value of the electoral system though they have had to take the bitters of defeat no less than the sweets of victory. And it goes, very specially and tellingly, to that which has given India's electoral democracy shape and definition, namely, the Election Commission of India (ECI).

The people of India are the propulsive fuel, the driving energy, of the vehicle of India's electoral democracy. Our political parties are its complex and often convoluted innards. But the vehicle's engine, where ignition and combustion take place and where the fuel and engine combine to move the vehicle forward, is the ECI. And behind the vehicle's steering wheel is the Chief Election Commissioner of India, the CEC as he is called. (I do hope that seat which has until now been monopolized by gentlemen, will soon be 'manned' by one of the many outstanding women officers who serve our country.)

One of the most remarkable CECs that we have ever had or are likely to have is S.Y. Quraishi. He has given us in this volume a vivid portrayal of what makes India's elections work and prevail over the many obstacles that confront it. And by so doing he has not just given us information and knowledge but confidence and pride.

Elections *are* our pride. They have operationalized for us a fundamental goal of our freedom struggle, namely, popular representation in the country's legislative bodies. In other words, they have given us, the people of India, a voice in determining the way our lives are run. This has been no easy task. In a country as large as India with a bewildering diversity, strong sentiments, a predisposition to take offense and a tradition of feudal prescriptions being 'dictated' from the vantage of caste, class and doctrinaire hierarchies, the ECI has shown monumental forbearance. Not only has the ECI had to contend with undemocratic latencies in our society, it has also had to address attempts at counter-democratic subversions in the form of new and ingenious manipulations of the electoral procedures and processes. The manner in which the ECI, our CECs and Election Commissioners (ECs) have kept their faith and maintained composure has been nothing less than remarkable. It is because of this that our electoral democracy has stayed the course with our election laws, and after the catharsis of polling and counting, delivered, time and again, mandates while maintaining the assurance of voter confidentiality, fairness and freedom.

The biggest attempt at manipulation of the electoral system has come from money and the attempted use of what is best described in a straightforward manner—undisguised bullying.

The mass of India's people, our huge and growing electorate and the ECI have, in a remarkable partnership, defeated these attempts; though in several individual battles the manipulators have won.

The Commission knows, better than others, how money, authorized and unauthorized, and human biceps and triceps, authorized in the armed personnel billeted to election duty and unauthorized in others, can play a role in the proceedings.

Small arms like the pistol, the hand grenade, the rocket-propelled grenade, the landmine and the sub-machine gun, associated with the ubiquitous 'muscle-man', come into play.

Which political party has been able to keep the 'mustanda' out?

Giving the S. Ranganathan Memorial Lecture in New Delhi in 2007, I quoted C. Rajagopalachari from a diary he maintained while in Vellore Jail in 1921–22. A soldier fighting for Swaraj, he could yet have the uncanny foresight and inconvenient objectivity to say the following:

'We all ought to know that Swaraj will not at once or, I think, even for a long time to come, be better government or greater happiness for the people. Elections and their corruptions, injustice, and the power and tyranny of wealth, and inefficiency of administration, will make a hell of life as soon as freedom is given to us.' Believe it or not, this was written twenty-five years before independence. He continues, 'Men will look regretfully back to the old regime of comparative justice, and efficient, peaceful, more or less honest administration. The only thing gained will be that as a race we will be saved from dishonour and subordination. Hope lies only in universal education by which right conduct, fear of God, and love will be developed among the citizens from childhood. It is only if we succeed in this that Swaraj will mean happiness. Otherwise, it will mean the grinding injustices and tyranny of wealth.'

In the first few years since 1937, elections meant the chance to select, objectively, A over B. Today, it *can* still mean that. However, it *cannot but* mean the pitting of A's money resources against those of B. Elections have come, by definition, to mean the infusing of candidature with cash. The weaker the candidate, the stronger the cash. The glamour of money—white, black and grey—pervades the election air.

An incident from the 1937 elections has been recounted by Lal Bahadur Shastri in a 1959 tribute to Jawaharlal Nehru:

'The general elections under the new Government of India Act took place in 1937; they were of great significance. In these elections Nehru played a very important role. I remember his visit to the district of Allahabad. It was about 8.30 p.m. when he finished his speech. As soon as he had done so, he

enquired from the local Congressmen whether he could leave. Pat came the reply, "Yes, sir." After having driven about a furlong Jawaharlal said that the Congress workers of Mirzapur had no sense of hospitality. "I said I wanted to go and they agreed to it without even offering me a cup of tea." Nehru had taken no tea in the afternoon and [...] he was feeling very hungry. He asked me whether there was any restaurant in the city [...] I remembered the railway station where one could get some tea. He said, "Let us go there." We motored to the railway station and went to the railway restaurant. After having the tea we were asked to pay the bill. Every one of us searched his pockets and found that none of us carried sufficient money. Between us we could collect about two and a half rupees. Nehru had about a rupee and a quarter, Mrs Purnima Banerjee another rupee and I gave the few annas to complete the full amount required. How awkward would it have been if we had failed to make up the amount among ourselves!'

Today no such awkwardness is likely to assail any candidate or campaigner! Money flows into election sites.

Currency notes come into the election bazaar first in container and cargo quantities, then in truck-loads, going into wholesale, small retail and finally in attachés, thailas, jholas and jeb-sized portions, every five years at the least and often oftener than that. They originate either legally, through licit company donations or come from a myriad sources which, as Professor Amit Bhaduri explained to a Chennai audience in 2010, necessarily and unavoidably go back to our natural resources such as mines, forests and land. Illegal transactions in all these yield harvests of black cash.

The problem of money and elections is, of course, not peculiar to India. I came across a memorable quote by Mark Hanna in *The Hindu* of 20 October 2007:

'There are two things that are important in politics. The first is money, and I can't remember what the second one is.'

As our law stands at present, a political party may receive any amount by way of contributions under the Companies Act. By an independent encouragement for corporate funding, Section 77 of the Representation of the People Act excludes expenditure incurred by political parties from the computation of the ceiling on an Election Commission-prescribed candidate's election expenditure.

There are two consequences of all this: First, candidates backed by political parties and corporate donations enjoy a privileged position over independent candidates. Second and more important is the fact that before an election weighs votes on its balance, cash weighs itself on the same scale's trays. Examples can be cited of clear, bona fide and transparent donations by business houses to political parties. Rajaji himself approached industrial houses for open donations to the Swatantra Party. But a board of directors payment by means of a white cheque to a party is not the only source of funding. There is the Hindi saying: 'Haathi ke paaon mein sab ke paaon.'

Vast sums get flung into an election both from within and *outside* of the provisions of the Companies Act. This is where black money mingles with the white, making the whole thing as grey as smog. Beyond the action of grey money in elections lies the important question: Once elected with the help of another's money—be it an individual's or a company's—can the victorious candidate look the donor in the eye and say 'No' when that donor asks for an inappropriate concession? The 'power of wealth' then becomes, to use Rajaji's phrase, a 'tyranny', not only for the losing side but for the winning side as well.

Shortly after taking over as CEC, S.Y. Quraishi told the nation he would address the question of money's role in elections. He has not disappointed us. This tells us about the salutary steps taken by the EC to curb the brazenness of money's illicit role in our elections. Officers on election duty

have shown remarkable courage in intercepting vehicles carrying black money from point to point during campaigns. This is because the EC has by now acquired a mystique no less than our elections themselves, a credo and a credence, of which election personnel are proud. They function, barring exceptions which are quickly spotted and removed from duty, with rare dedication bordering on a faith and passion to render a clean result through clean procedures observed in the full light of day.

More, of course, remains to be done. I believe the time has come for the laws in respect of the funding of our elections to be brought bravely and transparently under the public scanner once again, focusing on the working of Section 293A of the Companies Act. But going beyond research, hard and exemplary action needs to be taken by those who are empowered to do so, whenever and wherever funds in excess of permissible quantities are patently employed.

Simultaneously, I believe government and political parties should hearken to the public mood and disengage senior politicians, and certainly those who are in public office, from responsibilities in cash-rich sports federations. Their dual charge can only be to the detriment of either the sport or of the public office concerned. The public is no fool; it knows who is where for what.

The Supreme Court of India, in a landmark judgement, recently described certain institutions of our Republic as 'integrity institutions'. The ECI and its head, the CEC, are among the most important of these, the others including the Indian judiciary itself: the Chief Vigilance Commissioner, the Comptroller and Accountant General and the Chief Information Commissioner. Of all these, the CEC is organically connected to our democratic being. And therein lies its exceptional importance.

We cannot afford to let our elections be suborned by corrupt practices to drive a wedge between the law and democracy, between legal and lawful activity on the one hand and election

practices on the other. The people have no role in choosing who the candidates are: that is the prerogative of political parties who choose to field them. But apart from the right to make their choice from among the candidates they have a right to free and fair elections; in other words, to a clean site for the contestation, unvitiated by blandishment, bullying or blackmail. That right the Election Commission of India protects with a devotion that amounts to passion.

I recommend this book to those interested in India's electoral democracy, but more than that, to those who are interested in seeing our democracy go well beyond its procedural successes to become not just the world's largest but its greatest democracy.

Gopalkrishna Gandhi

PREFACE

Indian democracy and competitive elections continue to generate global interest and wonder partly because of their uninterrupted success despite the obvious challenges of demography and geography, but also due to inadequate knowledge of the context. The book is my modest attempt to unravel the myth and mystery behind the great election machine, the men and women who run it for the world's largest democracy and the citizens who participate in it with great gusto.

It contains inside stories of the Indian elections illustrating how individuals made a difference to the entire electoral process, how money and muscle power were contained, how unruly politicians and apparently invincible satraps were reined in, how a proactive enforcement of the Model Code of Conduct put stalwarts on the back foot, how a level playing field was created for thousands of contestants, how voters were enabled and empowered, how millions of voters were studied and sensitized, how a participation revolution was unleashed through a massive voter education campaign, how training and capacity building were converted into a religion for ensuring a zero-error election, and how a protective judiciary, an ever alert media and a vigilant civil society have made deviant electoral behaviour so difficult.

All of these together ensure the Indian elections have come to be widely viewed as the 'gold standard', as Hillary Clinton once remarked.

The title of the book was inspired by an article written by a journalist whose harsh criticism of the ECI turned into admiration after just a couple of opportunities, during a pre-election run-up, when he had a sneak preview of the things

the Indian election machine does. 'How little do we know, or care?' he remarked. 'ECI is the most self-effacing organization, and the Indian election an undocumented wonder!' I thought this would be the most apt theme and title for this book.

The book is designed as an experiential knowledge product and presents precious lessons learned from a variety of electoral practices. It addresses the interest of a cross section of individuals and institutions around the world who have watched the peaceful transfer of power and stable governments in India ever since independence with admiration and fascination, and wondered how these happen with an assured regularity in a world where other emerging democracies have suffered coups, chaos and violence. It may also have insights and lessons for election managers worldwide.

While there was 'explosive' material aplenty, I have consciously avoided a sensationalist approach. Instead, my attempt has been to serve and satisfy readers' genuine curiosity largely through a first-person account of the electoral history and challenges encountered. The pages are replete with anecdotes, case studies and analyses which the readers and researchers may enjoy. I share with the readers how we stood up to a host of old and new challenges and pressures every day, and how certain core principles and beliefs guided our response and actions. The book would also answer why the body of Indian knowledge and practices in electoral democracy has been spotted as a golden resource that many democratic nations are lining up to share in recent years.

The book ends with a chapter, 'Reflections and Afterthoughts' that peeps through the window of time, and identifies a few unresolved issues that afflict the Indian polity and electoral scene, while analysing ways to ensure good governance through good elections.

The analysis also includes mention of the paradoxical issues like the great elections yet flawed democracy, election as mother of corruption, the rise of the rich in politics, participation

without representation, protest and participatory politics, the election as a festival and not a funeral, and various other controversies, bouquets and brickbats.

Democracy continues to be a work in progress towards the ultimate goal of freedom of choice and freedom from poverty. During my six years in the ECI, I saw every one putting in extra effort to add speed and creativity to the wheels of the electoral machine.

My effort was to innovate while consolidating the rich experience we had gained over six decades. The creation of Voters' Education Division, Election Expenditure Monitoring Division, India International Institute of Democracy and Election Management (IIIDEM), the introduction of the National Voters' Day to focus on youth and women and distribution of voter slips were some of the initiatives that paid instant dividends.

It is my firm belief that credible and participative elections along with legitimacy-building institutions are the best way for resolving social conflicts and promoting democratic governance. The real challenge ahead is how to build on this progress and transform the largest democracy into the greatest.

1

ODE TO INDIA AND HER DEMOCRACY

Polling officers check electronic voting machines at a distribution centre in Howrah, West Bengal in May 2009. 1.18 million EVMs were deployed for the 2009 general elections.
File photo: Arunangsu Roy Chowdhury, *The Hindu*.

'It is truly the greatest show on Earth, an ode to a diverse and democratic ethos, where 700 million+ of humanity vote, providing their small part in directing their ancient civilisation into the future. It is no less impressive when done in a neighbourhood which includes destabilising and violent Pakistan, China, and Burma,' reports V. Mitchell, in the *New York Times* on 2 June 2009, about the fifteenth general elections in India—the world's largest democracy and the most diverse nation on earth in terms of language, religions and cultures.

Explaining further, Mitchel says, India is the nation where

four great religions of the world, namely, Hinduism, Buddhism, Jainism and Sikhism were born. She is also the country with the second largest number of Muslims in the world. A country where Christianity has existed for 2000 years; and also a place 'where the oldest Jewish synagogues and Jewish communities have been living from the time when Romans burnt their 2nd temple; where the Dalai Lama and the Tibetan government in exile reside; where the Zoroastrians from Persia have thrived since being thrown out of their ancient homeland; where Armenians and Syrians and many others have come to live...' Another little known fact in the world outside, and yet very significant, as noticed by Mitchel is that Indian democracy has had three Muslim Presidents, and a Sikh representing a small minority is Prime Minister, and interestingly, the head of the ruling party a Catholic Italian woman. One of the three Presidents was a rocket scientist and a hero of the nation. It is also a country where 'a booming economy is lifting 40 million out of poverty each year and is expected to have the majority of its population in the middle class, already equal to the entire US population, by 2025; where its optimism and vibrancy is manifested in its movies, arts, economic growth, and voting, despite all the incredible challenges and hardships; where all the great powers are vying for influence, as it itself finds its place in the world.'

Concluding, Mitchel states, 'Where all of this happens, is India, and as greater than 1/10 of humanity gets ready to vote, it is an inspiration to all the world.' (V. Mitchell, *The New York Times*, 2 June 2009)

When 119 special trains with 3,060 coaches speedily roll out, transporting millions of paramilitary, police and security forces, and dozens of helicopters join the operation performing hundreds of sorties, and eleven million people criss-cross from border to border, anyone would assume that India is at war. Yes, from the outside it indeed looks like all-out war but the difference is that this war is waged in peace time by the people

themselves, not against an enemy but for the preservation of democracy in a country with 1,163 million citizens and 783 million voters above the age of eighteen years. This largest dance of democracy in the world has to be seen to be believed, for the voting public itself is larger than the population of three continents—Europe, South and Central America and Australia—combined.

Referring to this as a 'jumbo election' in 2009, *The Economist* reported: 'Like a lumbering elephant embarking on an epic trek, the operation spreads over four weeks in which 4,617 candidates representing 300 parties contest for 543 constituencies.'* It is 'hard not to be impressed by the process and its resilience', remarked the magazine.[1] It is not just the magnitude of Indian democracy in terms of the geographical area or size of the electorate, but the honest anxiety to reach every single citizen which makes it unique in the comity of nations. The efforts made to ensure that every eligible citizen has the opportunity to vote are praiseworthy. When 100 million voters were involved in a state election, the Election Commission of India (ECI) was focusing on twelve men trekking 45 km in knee-deep snow to reach two polling stations with thirty-seven voters in Ladakh. It may sound amusing at first but all modes of transportation from the primitive to ultra-modern—elephants, camels, boats, cycles, helicopters, trains and airplanes—are used to reach voters and to move men and material through deserts, mountains, plains, forests, islands and coastal areas. The shift from the 'Biggest Gamble in History', as Ramachandra Guha described the Indian democracy at inception, to such absolute faith in institutionalized electoral democracy represents a marked jump in public esteem. When faced with a comprehensive fact sheet of a general election where seven national and thirty-four state parties contest elections,

*The actual number was 8,070.
Source: http://eci.nic.in/eci_main/press/GE-HIGHLIGHTS.pdf

Table 1.1: General Elections to the Lok Sabha (House of the People) Fact Sheet

	1951-52	1957	1962	1967	1971	1977	1980	1984-85	1989	1991-92	1996	1998	1999	2004	2009
Electorate	173212343	193662179	216361569	250207401	274189132	321174327	356205329	400375333	498906129	511533598	592572288	605880192	619536847	6.71E+08	716985101
Votes Polled	106950083	120513915	119904284	152724611	151536802	194263915	202752893	256294963	309050495	285856465	343308090	375441739	371669104	3.9E+08	416672994
Turn Out	61.17	32.23	55.42	61.04	55.27	60.49	56.92	64.01	61.95	55.85	57.99	61.97	59.99	58.06	58.19
No. of Candidate	2833	2281	-----	3244	4440	4392	7281	9588	10355	-----	20583	6219	5771	6774	11252
Contested Candidate	1874	1519	1985	2369	2784	2439	4629	5493	6160	8749	13952	4750	4648	5435	8070
Total no of Seat	489	494	494	520	518	542	542	542	543	534	543	543	543	543	543
Contested Seat	479	482	491	515	517	540	529	541	528	537	543	543	543	543	543
Won Candidate	489	494	494	520	518	542	529	542	529	534	543	543	543	543	543
Women Candidate	0	22	31	29	0	19	28	43	29	39	40	43	49	45	58
Total no of Constituency	401	403	494	520	518	542	542	542	543	543	543	543	543	543	543
Seat Reserved for SC	0	0	79	77	76	78	79	79	78	79	79	79	79	79	84
Reserved for ST	8	16	30	37	36	38	41	41	39	41	41	41	41	41	41
No. of Recognised Parties Contested	53	15	17	21	25	20	25	26	28	36	38	37	47	42	41
National Parties	14	4	6	7	8	5	6	7	8	7	8	7	7	6	7
State Parties	39	11	11	14	17	15	19	19	20	27	30	30	40	36	34

Source: ECI

there is a sense of incompleteness if even one voter in a remote location is not covered.

Like the proverbial Siamese twins, democracy and elections have a congenital, inseparable relationship. In India they have been conjoined ever since the country became a republic, helping create a responsive social order and avoiding coercion in decision-making. ECI was created as an independent constitutional authority to safeguard this newborn democracy by facilitating free and fair elections that allowed people to choose their own leaders and determine their own destiny. The country went for its first general elections in 1952. The new Constitution of independent India which came into existence on 26 January 1950 has 395 articles in 18 parts, 12 schedules and 97 amendments to date and with a detailed list of fundamental rights and a fairly long series of directive principles of state policy that the state is obliged to promote. It also prescribes another shortlist of fundamental duties for citizens. The exercise took a very long time and the Constituent Assembly sat continuously for two years, eleven months and seventeen days to complete the draft, resolving many conflicting issues along the way. It created an elaborate constitutional architecture with a bicameral, federal legislative structure, state assemblies, an independent judiciary and, crucially, the Election Commission.

A subtle difference between Western and Indian democratic models is that the 'state policy' here aims at ending lingering inequities of traditional social relations through positive discrimination (affirmative action), social justice and welfare. Representative democracy in India ended this inequity first by conferring the right to vote on all its citizens, men and women, above twenty-one years of age in 1950. Enfranchisement was further enlarged in 1988 to cover all those above eight years of age. Both steps were hallmarks of great vision when they were taken, considering the fact that many older democracies had taken longer to confer these rights on their citizens. For

instance, it took the USA 144 years to confer equal voting rights on women (in 1920), while the UK, the mother of modern democracy, took 100 years to grant such equality in 1928. Switzerland only granted women the equal right to vote as recently as 1971.

However, India was not entirely new to the concept of democracy as there is credible evidence that it existed in the country in various forms as early as fifth century BC, almost at the same time when ancient Athens practised it.[2] In small communities, villages and tribal societies, participation in decision-making through discussions was the normal practice in India, which sociologists now call 'primitive democracy'. Ancient and medieval India had also witnessed other forms of rule like monarchy, autocracy, aristocracy and oligarchy. Almost two centuries after Alexander's invasion of India, Deodorus, a Greek historian, had written about the existence of independent and democratic states and principalities in India; these republics were known as 'samghas' and 'ganas'. Leaders of these systems were rajas assisted by deliberative assemblies with full financial, administrative and judicial authority. A raja was elected by ganas or the people and all free men were eligible to participate in this assembly. The rule book guiding the system was Kautilya's *Arthashastra*, that also describes the role of 'samghas' or local unions and how the state can rule more efficiently through these structures. Its only limitation is that it is silent on the need for an inclusive social body for the mass of citizens. It is interesting to note that property and education were considered essential qualifications for candidature. There was a maximum age limit of seventy years. Those deemed as corrupt, tainted or guilty of moral turpitude were disqualified as were their close relatives!

In another extensive study on democracy in ancient India, Steve Muhlberger, Professor of History in Nipissing University, Ontario, Canada, insists that democracy existed in India well before the Greeks, the Mauryas and Manu but became extinct

in 400 AD.[3] To substantiate his thesis, Muhlberger refers to Arrian's *Anabasis of Alexander*, which describes eyewitness accounts of 'free and independent Indian communities' existing with royal dynasties. He also quotes from a Buddhist text *(Mahaparinibbana-Suttanta)*—a conversation between Buddha and his most trusted disciple Ananda—where Buddha enquires: 'Have you heard, Ananda, that the Vaijjans hold full and frequent public assemblies?' When Ananda confirms this, Buddha says, 'So long as they hold full and frequent public assemblies, carry out their undertakings in concord, enact nothing not already established, abrogate nothing that has already been enacted, so long as they honour the elders and women and girls are not detained by force or abduction [...] so long as they honour and support and protect the shrines [...] They are not expected to decline...'

The tradition continued for a long time after the Buddhist period in different parts of the country, as is evident in the stone inscriptions in some ancient temples in Tamil Nadu in southern India. Historian and archaeologist Dr Nagaswamy, in his book *Uttaramerur: The Historic Village in Tamil Nadu* (Tamil Arts Academy, Chennai, 2003) refers to some historical documents inscribed in stone in the mandapa of the Vaikuntaperumal temple. This inscription, dated around 920 AD in the reign of Parantaka Chola, gives astonishing details about the constitution of wards, the qualification of candidates standing for elections, the disqualification norms, the mode of election, the constitution of committees with elected members, the functions of these committees, the power to remove the wrongdoer, etc...' The villagers even had the right to recall the elected representatives if they failed in their duty!

Election Rules and Processes in Early Medieval India

Before elections, the nominees' names written on a pre-designed palm leaf are dropped in the common pot (kodavolai in Tamil).

On the Election Day, amidst all seniors, officials and common public, the oldest priest of the temple randomly selects a few names from the pot and transfers the content into another pot. From this, one name is picked by a small boy amidst the crowd, who does not know what the contents of the pot are! This is read out by the chief election officer and thus agreed upon. So goes the full election for various heads, committees etc.

As per the agreed rules, the nominee should fulfil the following criteria:

- He must own more than a quarter of taxpaying land,
- He must live in a house built on his own site,
- His age must be below 70 and above 35,
- He must know the rules and intricacies of the law (*Mantra-prahmaana*) and be capable of explaining it to his people,
- If the nominee has just one-eighth of the stipulated land, even then he is eligible if he has learnt the Vedas, and one of the four bhashyas (commentaries) and is capable of explaining them to others.

Among those who possess the foregoing qualifications:

- Only those who are well conversant with business and running affairs will be considered and
- One who possesses honest earnings, whose mind is pure and who has not been on any of the committees for the last three years shall also be chosen.

Conditions for disqualifications are:

- One who has been in any of the committees but has not submitted the accounts, or,
- Those who have accepted bribe in any form. The relatives, as specified below, of such persons shall not have their names written on the pot-tickets (contestants):
 - The sons of the younger and elder sisters of his mother

- The sons of the paternal brother of his mother
- The uterine brother of his father
- His uterine brother
- His father-in-law
- The husband of his uterine sister
- The sons of his uterine sister
- The son-in-law who had married his daughter
- His father
- His son
- One against whom incest (*agamyagamana*) or the first four of the five great sins are recorded.

All the above specified relatives shall not contest after one stands for election in the same given year.

And further disqualifications are:
• One who is foolhardy
• One who has stolen the property of another
• One who has taken forbidden dishes of any kind and who has become pure by performing expiation
• One who has committed sins and has become pure by performing expiatory ceremonies
• One who is guilty of incest and has become pure by performing expiatory ceremonies

Source: J. Chandrasekaran, PRO, Reach Foundation (www.conserveheritage.org).

In view of the above mentioned evidences, many proponents of democracy believe that the ancient consultative and participatory traditions of decision-making, despite some aberrations, made acceptance of modern representative democracy easier in India. Today, in the post Second World War period, India's democracy, along with that of Japan, is considered the oldest and relatively most stable in Asia and has survived a number of challenges and setbacks. In 2011, the world witnessed mass awakening and popular protests in many countries for

democracy, dignity, freedom and participation in policymaking processes. And those living in stable democracies agitated for better and cleaner governance and access to equitable economic delivery. If autocrats of today are panicky and feel that they are standing on the sword's edge and apprehensions about political unrest is shaking the confidence of rulers in 'pressure cooker dictatorships', it is only because of the increasing popularity of democratic governance facilitated by free and fair elections.

In his thoughtful analysis in the book *Working a Democratic Constitution: The Indian Experience*,[4] Granville Austin identifies two basic elements in the core vision of the Indian Constitution: (i) preserving and defending national unity by establishing strong national institutions that work to promote the spirit of democracy, and (ii) providing space for a self-correcting social revolution to improve the living conditions of its citizens. The constitutional tradition of the country, despite occasional hiccups, has converted its Parliament into a place facilitating radical socioeconomic changes in areas of governance and human development. Through bills and enactments like the Right to Information, Right to Education, Right to Work, disability rights, rights of minorities and the socially disadvantaged, Right to Food and a plethora of national policies and welfare programmes, the country has responded to concerns of the larger society from time to time. A proactive judiciary and an ever vigilant Election Commission have been zealously guarding the constitutional morality of the country.

These factors have enabled Indian democracy to survive in an unstable neighbourhood with a history of autocracy, dictatorships and military intervention and takeovers. In 1950, Sukumar Sen was appointed the first CEC of India, a month before the Representation of the People Act was passed in the Indian Parliament. While Prime Minister Nehru was keen to see the first elections held in 1951, the machinery was made ready only in early 1952. Since the first general elections in

ODE TO INDIA AND HER DEMOCRACY • 11

1952, the country has moved a long way during the last six decades, successfully conducting fifteen general elections and three hundred and forty assembly elections that ensured the peaceful transfer of power between democratically elected governments. In the first general elections, about 84 per cent were unable to read and write, forcing the Election Commission to print pictorial party symbols on ballot papers to make voting easier for the unlettered mass of voters. By the fifteenth general elections in 2009, the electorate had already crossed 730 million while the literacy level had also crossed the 70 per cent mark.

The positive experience of Indian democracy has been impacting its neighbourhood where the seeds of democracy are germinating. For instance, **Bangladesh** experienced a long spell of military rule and is now attempting to recover its place as a relatively stable democracy in the region. In its short history of four decades, the country saw its first popular government overthrown, two of its presidents slain in military coups and as many as nineteen other failed coup attempts.

In **Pakistan**, a country familiar with frequent coups against democratically elected governments and usurpation of power by the military, democracy has made repeated comebacks. Yet, democracy continues to be troubled by a larger than life military continuously breathing down the neck of the civilian government. For instance, a report in *The Times of India* (5 February 2012) quoted Pakistan Prime Minister Yusuf Raza Gilani pointing out the difference in the continuity of democratic systems in India and Pakistan, saying: 'Pakistan and India were created on the same date,' but there was a 'stark difference in how they have continued' with their democratic systems. For a long time, not a single government in Pakistan had been allowed to complete its term, he remarked. The elections in 2013 were a milestone in the sense that a democratically elected government gave way to another elected government for the first time in its history.

In neighbouring **Maldives** democratic alternation took

place after thirty years of one party rule. However, the first democratically elected head of the government in 2008 had to resign in a coup-like political crisis created by the police, political opponents and paramilitary forces in February 2012. The chaos quickly deepened, leading to a prolonged electoral battle (a poll, a re-poll and a run-off) that seemed to depend as much on the Supreme Court as the ballot box.

Sri Lanka, another close neighbour of India, has managed to survive as a democracy under difficult situations and despite a long period of civil war which has now ended.

In **Nepal,** the ruling monarchy was forced out in favour of a constitutional democracy which has been punctuated by unrest and thorny conflicts not yet fully settled. The November 2013 elections to the constituent assembly, bitterly contested, are only a step towards restoring parliamentary rule.

In an interesting contrast, **Bhutan's** fourth king, Jigme Singye Wangchuck, recently took the initiative of holding elections and converting the country into a constitutional monarchy even against popular sentiment. It has been suggested that the king was immensely inspired by his large democratic neighbour to the south in thinking of imposing democracy on his people when they all loved and aspired for his enlightened rule.

Myanmar (Burma), ruled by the military for decades, does not seem to be returning to democracy by holding elections and releasing democratic leader Aung San Suu Kyi after many years of house arrest.

While **Afghanistan** is still labouring to survive as a unified state, much less a new democracy, winds of democratic change are blowing in Iran which conducts regular elections now.

In communist **China,** under one-party rule since 1950, talks of democratization at the grass-roots level have generated new hopes among advocates of democracy. Although citizens are allowed to vote for representatives in direct elections for local level administration, these are widely perceived as being controlled by local party branches. Recently, after revolts in some

rural areas, Premier Wen Jiabao asked for a strict legal system to regulate elections but he has not yet spelt out whether he is going to end party-backed, stage managed electoral contests.

Malaysia, where a majoritarian and ethnic United Malay National Organization has been ruling, the country has now entered into an alliance with other ethnic groups towards an aggregative democracy which is another indication of electoral politics levelling differences and divergence.

The 'Democracy Asia: State of Democracy in South Asia' study (2008), using a diversity of methods, captures the unique feature of the region and reveals how democracy itself has been democratized. 'The experience of South Asia,' the study says, 'demolishes any remaining excuse for not adopting democracy' when one finds it becoming a fact of life and taking roots in a region marked by complexities, a bewildering array of diversities, multiple and overlapping structures of social hierarchy, widespread poverty and inequality, and intolerably high level of illiteracy.[5] It is only through electoral democracy that life expectancy has jumped from 31.4 to 67 years and literacy from 16 to 75 per cent in this region. About 97 per cent of the children are now in schools and that includes 94 per cent of the girls. Millions have been lifted out of poverty and the country has been displaying a consistent economic growth even during the depression.

However, along with hopes, democracy also generates fears among many. In the Federalist Papers (1788), political theroist and former US President James Madison (1751–1836), has explained how democracies have always been spectacles of turbulence and contention and found to be incompatible with personal security or the rights of property.

Madison concludes by saying in the federalist paper no. 51 that it was of great importance in a republic not only to guard the society against the oppression of its rulers, but to guard one part of the society against the injustice of the other part since different interests necessarily exist in different

classes of citizens. Giving an example he has explained that if a majority be united by a common interest, the rights of the minority would be insecure. (*Source*: Independent Journal, Wednesday, 6 February 1788, James Madison.)

Experts have divided political systems and electoral behaviour, winning attitudes, expectations and ethos broadly into four categories: (i) no losers, (ii) winners-take-all, (iii) winners-took-all and (iv) single arbiter.[6] In the 'no losers' category, political conflict is channelled into open public debate and resolved through free and fair electoral processes. Roughly one-third of the countries around the world follow this process wherein every interested group joins the electoral process and brings some degree of influence to bear on the government of the day. No particular group seeks massive gains and none of them face massive losses either. There is wide respect for civil and human rights and the rule of law. This ethos is conditioned by a promise of economic prosperity and welfare for the voters. The second category of 'winners-take-all' ethos is more commonly found among less developed (economically) democracies. In this ethos, each contending political force perceives a loss in the elections as a threat to its continued existence and relevance. The winner, therefore, tends to use its gain to either limit or destroy the opponents.

In the third category, 'winners-took-all', which is prevalent in about 10 per cent of the countries in the world, there is no base for major civil conflict as all potential opposition has been totally eliminated in an earlier 'winners-take-all' conflict. Examples are post-revolutionary regimes like the former Soviet Union, Cuba and Vietnam. The fourth category is the 'single-arbiter' ethos in which a more or less benevolent traditional authority like a king or an emir becomes the final arbiter of any social conflict or unrest. One-party rulers of egalitarian states can also come under this category. In this ethos, elections are continuously postponed or considered irrelevant.

One of the problems that the first and second approaches

entail is a situation of heightened conflict which can degenerate into violence with dangerous consequences for democracy, development and national unity. There are many instances of this, including the recent assassination of Benazir Bhutto, a former prime minister of Pakistan in December 2007 while campaigning prior to general elections.

Electoral tension sometimes accelerates into civil war and violence, as was seen in Burundi in 1993, Liberia in 1997 and Kenya and Nigeria a few years ago.[7] Former Prime Minister and the then leader of the opposition, Rajiv Gandhi, was assassinated in 1991 in the midst of an election campaign by a terrorist linked to the Tamil Tigers of Sri Lanka. Violence during the 2007 Kenyan elections, that reportedly left more than a thousand people dead and hundreds of thousands of people displaced, underscores how electoral processes afflicted with fraud and mismanagement or excessive politicization stimulate deeper and serious social conflicts. Electoral malpractices, real or perceived, also open up other underlying conflicts and ethnic tensions. We have experienced such scenarios from Afghanistan to Zimbabwe in the recent past.

Elections present both new challenges and opportunities for resolving conflicts through debate and discussion. For instance, in 1986, when the assembly elections in Jammu and Kashmir were widely perceived to be rigged in favour of a particular political formation, a long spell of insurgency followed resulting in the loss of life of thousands of innocent citizens. Later, with extraordinary precaution taken by the ECI to ensure free and fair elections in 1996 and 2002, the situation changed for the better by the same process of electoral democracy itself. In 2008, when the Election Commission was expecting a dream election, a sudden incident involving the Amarnath pilgrimage returned the situation to that of extreme polarization. Amidst demands from all quarters including the main political parties for postponing the elections to avoid apprehended bloodshed, a daring initiative by the Election Commission to go ahead

with the elections again transformed the situation almost as dramatically.

In the state of Punjab, which borders Pakistan, militancy inspired by a call for separatism continued unabated for more than a decade. A bold decision by the then government and the ECI to conduct free and fair elections helped turn the situation around to the eventual return of normalcy. Between 1983 and 1991, the state lost eighteen thousand lives and had been under President's rule since 1987. In this scenario, the elections in 1992 proved to be a great opportunity to retract the intractable. People participated in large numbers in the subsequent elections putting the turbulent and tragic history behind.

If the elections are not near perfect, they carry with them the potential of heightened conflict; consequently, the Election Commission and its machinery has to be extra vigilant. Elections are fought with the aim of capturing political power and, thus, have a high-stakes context.

Despite its inbuilt flaws and on account of non-availability of a better alternative, more and more countries around the world are adopting democracy as a system of governance. Today, more than one hundred and forty of two hundred countries in the world are holding multi-party elections; although a few of them have returned to authoritarian rule, some to pseudo democracy and a few are shuttling to and fro. In fact, in as many as forty-six countries, elected governments were forcibly replaced by authoritarian regimes under the guise and plea of maintaining civil peace. In most of the cases, national armies were directly involved. About seventy-three countries with 42 per cent of the global population do not hold free and fair elections, and one hundred and six governments, many of them democracies, are restricting civil and political freedom to their citizens.[8] However, the good news is that the number of authoritarian countries has also fallen from seventy in 1980 to less than thirty in the initial years of the twenty-first century

or the third millennium. And during this period the number of democratic countries has also doubled including limited democracies indicating a historic shift. Reinforcing this trend, about eighty-one countries are reported to have taken initiatives towards democratization. Out of these twenty-nine are in sub-Saharan Africa, fourteen in Latin America, ten in Asia and five in the Arab world.[9] This number has gone up further after the democracy movement in 2011 in the Middle East and North Africa. 'Arab Spring' has now become an everyday expression.

Yet, although the euphoria in favour of electoral democracy after the end of the Cold War and the collapse of the Soviet Union persists in some measure, true democratic spirit is slowly declining at the level of implementation. This is partly because the dividend that democracy was supposed to produce in many developing countries has not materialized. Large sections of people are struggling to overcome both income and capability poverty. The political landscape is increasingly getting darker because of soft money and manipulation. It is estimated that 80 per cent of campaign finance in India is coming not from party members and followers but from corporates and big business houses with the aim of eventually influencing policy-making processes. A worried ECI has initiated a number of steps for reforming political financing, increasing transparency and disclosure of sources, setting clear limits on spending and decriminalizing the electoral process. The progress is slow and cooperation of political parties continues to be lukewarm.

The other area of concern is the performance of the Parliament and behaviour of the elected representatives in our country. About 30–35 per cent of the Parliament's time is lost due to unproductive debates and frequent disruptions. According to a PRS Legislative Research study,[10] in 2011, the Parliament sat for seventy-three days in three sessions and 258 of the 803 hours earmarked for business were lost. Out of fifty-four bills listed for consideration, only twenty-eight were passed and eighteen of them in less than five minutes.

The situation was worse in 2010. The Parliament in a democracy is not a place for display of table-thumping skills and microphone-breaking vigour but a platform for thought-provoking deliberations, creative debates and wise decisions. As this is not happening, people seem to have less confidence in political parties as compared to their belief in religious outfits and the media. Anti-politician rhetoric is becoming shriller! The 'sab neta chor hain' (all politicians are thieves) refrain has become alarmingly loud. This is a cause for concern. Hate campaigns against politicians are dangerous trends. However, can there be democracy without politicians? One cannot love democracy and hate politicians. Such public perceptions and pronouncements need to be addressed urgently.

In an electoral democracy, political parties are supposed to organize the views of their members and followers into a set of public policies and form their platforms based on these policies. They also have a key role in balancing local concerns with regional and national priorities. Within the legislature, the representatives' main focus is lawmaking and coordinating legislative behaviour. To restore public confidence and trust in representative structures, political parties need to re-examine their role and functioning in order to strengthen democratic values and practices.

In India, the profile of the party-based democracy passed through a crucial stage at the turn of the century. The three general elections held in close succession towards the end of the 1990s threw up four major trends: (i) the decline of a dominant pan-national party, (ii) the emergence of regional parties in a national role, (iii) multi-party coalition politics and (iv) the ethnicization of the political culture, with each party claiming and often surviving on sectarian support. Both small and large political parties compete in adopting emotive poll planks playing social and community groups against one another. This behaviour polarizes the electorate and burdens the election machinery. Identity politics being a double-edged

sword has led to a weakening of the political base of stronger parties.

Democracy and Civil Society

Thanks to long spells of political struggle, South Asia has witnessed the emergence of a vibrant civil society and experienced different stages of evolution. This operates in an arena of voluntary collective action around shared concerns and values outside the state, family and the market. Civil society in India has expanded the scope of democracy through policy advocacy and by working as pressure groups, often reminding the government about its own commitments. The most recent case in point is the 2011 countrywide anti-graft movement led by civil society groups that made the government dust off and revive the Lok Pal Bill pending in the Parliament for the last forty-two years, which was eventually passed in 2013. Similarly, there are a number of social audit and election watch-bodies functioning in different parts of the country closely monitoring violation and dilution of the electoral process and whistle-blowing to alert the ECI. It is quite possible that the government that finds civil society a noisy opposition in such situations can actually appreciate its push with respect to policy inertia.

While civil society groups and community based organizations enlarged the scope of democracy, India amended its Constitution for the seventy-third time in 1992 to decentralize and deepen the democratic decision-making process further down to the grass root level by reviving the traditional village level decision-making structures like panchayats and gram sabhas to encourage popular participation. These lowest ground-level democratic units are expected to plan, prepare and implement social welfare and development schemes to ensure social justice to the poor and needy, conduct a social audit of the development funds, etc. India has more than 2,65,000 gram panchayats spread over 630 districts in its twenty-eight

states and seven union territories. Significantly, in a number of states, 50 per cent of the seats in these village assemblies are now reserved for women. The other two tiers of this system are the panchayat samitis at the block level and the zila parishads at the district level. In each state there is a separate State Election Commission to superintend elections to these local self-government institutions.

Extending this logic further, the seventy-fourth amendment to the Constitution was made for deepening democracy through self-governance of towns and cities in urban India. This devolution of power through elections based on adult suffrage decidedly made democracy stronger and its roots deeper and widespread in the country. However, despite these positive developments, the voting power of women, barring at the panchayat level, is yet to be reflected in Parliament and state legislative structures through the Women's Reservation Bill which has been pending since 1996. Even when more women are coming forward to vote, and indeed outnumbering men in several states, this does not translate into seats in Parliament for the women. A glaring example is Kerala, a state well known for consistently high human development indicators. Here, in the elections to the 140 member state assembly in 2011, an astonishing 127 constituencies witnessed more women voting than men. Yet, the state assembly has only seven women members.

Democracy building is a difficult and time consuming process. It requires patience, practice and perseverance. Elections are only a facilitating instrument of democracy. The spirit of democracy is to be included and internalized through attitude and value change and it must evolve from within society to become a fixed part of its culture. Therefore, it can neither be compared nor prescribed to another country as each country is unique. Similarly, it can neither be imported, nor exported or transplanted. However, providing technical support to democratic and electoral processes is another matter which occurs regularly among nations depending on mutual

experience and expertise, with India fast emerging as a global guru in this regard.

Recent incidents in the Middle East, North Africa and some other parts of the world show how ordinary people dare the extraordinary, how they compel even running democracies to re-evaluate their roles and bring in democratic and electoral reforms. For instance, the young democracy in Mongolia recently added a ninth Millennium Development Goal to the existing eight, to uphold all human rights as spelt out in the Universal Declaration and promoting democratic principles and values, and to combat corruption. Similarly, the Indian Parliament responded to public opinion and passed the Lokpal Act 2013, which also carries the influence of the UN Convention against corruption. In fact, Article 6 of the UN Convention enjoins member states to constitute regulatory bodies to implement the Convention's recommendations for preventing corruption in their countries; this also includes corrupt electoral practices. These instances prove how laws, treaties and covenants at the international level also contribute to strengthening democracy at the national and local levels.

Democratic reforms by themselves generate new demands for more reforms thereby creating a cascading effect. This was evident during 1980 in the form of glasnost and perestroika in the then Soviet Union under the weight of which the authoritarian one-party rule collapsed. This is one reason why autocratic regimes steadfastly resist and prevent evolution of democratization processes and instead try to either suppress or lure and co-opt potential dissidents into their single party outfits. To achieve this, they convert the party into a patronage machine and a self-serving oligarchy overriding genuine problems of the larger civil society. Such approaches have a short life span, and eventually, it is constitutional and representative democracy which emerges as the only platform safeguarding political, civil and human rights including the right to participate in and change governments.

The essence of democracy lies in voting through free and fair elections on a level playing field, although it may not be the last word on political participation or self-rule, empowerment and good governance, because not all voters vote with the same intention and for the same purpose. Not many voters vote to comply with the social obligation and as a sacred expression of citizenship. That is why even when people all over the world have fought long and hard for electoral democracy, not all of them are happy with its outcome. Democracy evolves through a long process of experiments, observations, innovations and self-correction because even well-thought-out democratic structures created to promote accountability and participation are only blunt instruments and cannot ensure absolute safeguards for freedom of expression and choice. In fact, looking at the behaviour of political parties in India, some progressive political thinkers like Jayaprakash Narayan pleaded for a shift from a party-based democracy to a party-less democracy. 'Just because some people participate in elections once in five years to choose their representatives, it does not mean there is democracy,' he used to say. Clarifying further, he said: 'But I'm not asking to abolish the party system immediately. It would be foolish to do so because there is nothing to take its place.'

In *Everyman's,* a weekly paper that Narayan started to disseminate his views, he reminded readers about the limits of power politics: '...politics at least under a democracy must know the limits it may not cross. Otherwise, if there is dishonesty, corruption, manipulation of masses, naked struggle for personal power and personal gain, there can be no socialism, no welfare, no government, no public order, no justice, no freedom, no national unity—in short no nation.'[11] Gandhi had identified seven social sins* one of which was 'Politics without Principles'.

*The other six sins were: Wealth without Work, Pleasure without Conscience, Knowledge without Character, Commerce (Business) without Morality (Ethics), Science without Humanity, Religion without Sacrifice.

However, this does not build a case for undermining elections. Of course, elections are effective instruments which enable and empower voters to change as well as end the tenure of elected representatives, assemblies and parliaments. As democracy is considered the best among the available systems, elections could be the best among the available means to create and sustain democracy. But without eternal vigilance, they cannot always protect the rights of the disadvantaged, marginalized, vulnerable and the socially handicapped.

While decentralization and devolution of power often bring the government nearer to the people, this also has the potential to reinforce power and authority of traditional local elites in the absence of open democratic practices. Today, most of the governments around the world claim legitimacy through some form of electoral process. One of the dangers to guard against is the subtle desire of rulers to wear democracy as a garment and manipulate elections for their own legitimacy. That is the reason why even dictatorial regimes love to use terms like 'republic', 'democracy' and 'elections' to demonstrate and deceive the world into believing that supreme power in their regimes is held not by them individually but by the people or their elected representatives. There is an international recognition of this prospect of a sham democratic process flaunted through hypocritical elections and that is why a system of international observation has been recommended. The flip side is that the observation system is liable to be misused as an instrument of coercion and arm twisting against nation states and for thrusting external models of electoral democracy on them. But people always know the real meaning of freedom, as was proved in the 1980s, when thousands risked death scaling the Berlin Wall and more than that number crossed the shark-infested seas in China and Vietnam in the 1970s for a taste of freedom and democracy.

When elections meet international standards of fairness, they provide popular support and legitimacy to elected governments.

Yet, often good elections get a bad name on account of bad governance perpetrated by elected representatives. Even the most rigorous and well managed elections cannot guarantee honesty and efficiency in the practice of democracy. This is particularly so, when the priority of political parties is to devote their full energy and prime time to prove that the other parties or opponents are worthless and unfit to rule. The methods used in support of this argument are not always above board either. Indian election campaigns are invariably marked by rivalry and revelry, both serious and melodramatic, as well as adherence and violation of the code of conduct by criminals and crorepatis (billionaires) influencing the process and pushing legitimate governance issues to the background. According to the 2007 Democracy Index published by *The Economist*, India, despite its credible elections, stood seventh in the list of fifty-four 'flawed democracies' in the world.[12] In the six years thereafter, the country could have only slipped a few ranks with corruption and lack of governance being the dominant discourse. The Election Commission's role in the electoral agenda and campaign dialogue has been rather limited.

In this context, it is worthwhile to refer to a global opinion poll undertaken to see to what extent a 'global human conscience' exists. The Gallup International Millennium Survey, held on the eve of the second millennium, interviewed 57,000 adults in sixty countries between August and October 1999, providing a representative sample of 1.25 billion of the world's inhabitants.[13] The survey covered a wide variety of issues of ethical, political and religious nature, focusing specifically on subjects close to people's democracy, human rights, women's rights and the environment. One of the shocking findings of the survey was that an overwhelming proportion (two-thirds) of the respondents, including many from Western democracies, said that their country was not governed by the will of the people. There was additionally a general lack of faith in governments, and a view that the systems were corrupt and bureaucracies and

democracies were weak and frail. The survey results showed that when people in both developed and developing countries were asked if they have to choose between 'standard of living' and 'health, family, freedom and to live in peace', an overwhelming majority preferred the latter.

Voting is a key human behaviour that keeps democracy alive and enriches its quality and credibility. A mass of well-informed citizens, willing to exercise their right to vote wisely, can help create a conducive environment for free and fair elections. They can prevent money and muscle power from derailing elections and protect democracy from corrupting and degenerating influences while encouraging larger participation of marginalized groups such as the poor, women, minorities and special ethnic groups and communities. The journey is long and arduous and should begin with self-evaluation and introspection based on lessons learned from past experience. There are perceptible improvements in the electoral scenario if we look at about a dozen general elections that took place in India between 2010 and 2012 and this generates a lot of hope. Voters as well as vote seekers have become more aware, alert and wiser over the years. Let me conclude this chapter with a meaningful quotation from Plato's *Republic*: 'Mankind will never see an end of trouble until [...] lovers of wisdom come to hold political power or the holders of power [...] become lovers of wisdom.'[14] Counting of heads is definitely important in all electoral democracies but more important than that is what exactly there is in these heads.

Notes

1 'India's jumbo election'. *The Economist*. 16 April 2009.

2 Steven Muhlberger and Phil Paine. 'Democracy's Place in World History', *Journal of World History* 4, no. 1 (1993): pp. 23–45.

3 Steven Muhlberger. 'Democracy in Ancient India.' Published online at: http://www.hvk.org/specialreports/demo/index.html

4 Granville Austin. *Working a Democratic Constitution: The Indian Experience*. New Delhi: Oxford University Press, 1999.

5 Harsh Sethi (ed.). *State of Democracy in South Asia: A Report by the CDSA Team*. New Delhi: Oxford University Press, 2008.

6 George E. Delury, Deborah A. Kaple. *World Encyclopaedia of Political Systems and Parties*, Vol-1. USA: Schlager Group Inc., 1983.

7 Jack Snyder. *From Voting to Violence: Democratization and Nationalist Conflict*. New York: W.W. Norton & Company Incorporated, 2000.

8 UNDP. *Human Development Report 2002: Deepening Democracy in a Fragmented World*. New Delhi: Oxford University Press, 2002, pp. 1–17.

9 Ibid.

10 PRS Legislative Research. 'Vital Stats: Parliament in 2011.' Published online at: http://www.prsindia.org/parliamenttrack/vital-stats/parliament-in-2011-2161/

11 Ajit Bhatacharjea. *Transforming the Polity: Centenary Readings from Jayaprakash Narayan*. New Delhi: Rupa. & Co., 2002, pp. 65–67.

12 Laza Kekic. The Economist Intelligence Unit's Index of Democracy. 2007.

13 Rene Spoogard, Meril James. *Governance and Democracy–The People's View*. A Global Opinion Poll. , Secretary General, Gallup International, Denmark.

14 Plato. *The Republic*.

EMPOWERING THE ELECTION COMMISSION

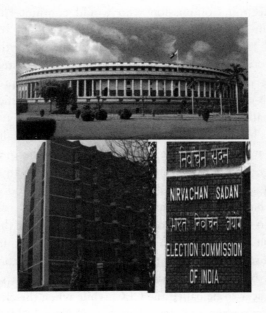

Rationale for an Independent Election Commission

So far as the fundamental question is concerned that the election machinery should be outside the control of the executive government, there has been no dispute. What Article 289 (later renumbered as Article 324) does is to carry out that part of the decision of the Constituent Assembly. It transfers the superintendence, direction and control of the preparation of the electoral rolls and of all elections to Parliament and Legislatures of the States

to a body outside the executive to be called the Election Commission. That is the provision contained in sub-clause (1). Sub-clause (2) says that there shall be a CEC and such other Election Commissioners as the President may from time to time appoint. There were two alternatives before the Drafting Committee, namely, either to have a permanent body consisting of four or five members of the Election Commission who would continue in office without any break, or to permit the President to have an ad hoc body appointed at the time when there is an election on the anvil. The Committee has steered a middle course. What the Drafting Committee proposes by sub-clause (2) is to have permanently in office one man called the CEC, so that skeleton machinery would always be available. Elections no doubt will generally take place at the end of five years, but there is the question, namely, that a bye-election may take place at any time. The Assembly may be dissolved before its period of five years has expired. Consequently, the electoral roll will have to be kept up-to-date all the time so that the new election may take place without any difficulty. It was, therefore, felt that having regard to these exigencies, it would be sufficient if there was permanently in session one officer to be called the CEC, while when the elections are coming up, the President may further add to the machinery by appointing other members to the Election Commission.

Now, Sir, the original proposal under Article 289 was that there should be one Commission to deal with the elections to the Central Legislature, both the Upper and Lower Houses, and that there should be a separate Election Commission for each Province and each State, to be appointed by the Governor or the Ruler of the State. Comparing that with the present Article 289, there is undoubtedly a radical change. This Article proposes to

centralise the election machinery in the hands of a single Commission to be assisted by Regional Commissioners, not working under the Provincial Government, but working under the superintendence and control of the Central Election Commission. As I said, this is undoubtedly a radical change. But this change has become necessary because today we find that in some of the provinces of India, the population is a mixture. There are what may be called original inhabitants, so to say the native people of a particular province. Along with them, there are other people residing there, who are racially, linguistically or culturally different from the dominant people who are the occupants of that particular province. It has been brought to the notice both of the Drafting Committee as well as of the Central Government that in these provinces the executive government is instructing or managing things in such a manner that those people who do not belong to them either racially, culturally or linguistically, are being excluded from being brought on the electoral rolls. The House will realise that franchise is a most fundamental thing in a democracy. No person who is entitled to be brought into the electoral rolls on the grounds which we have already mentioned in our Constitution, namely, an adult of 21 years of age, should be excluded merely as a result of the prejudice of local government, or the whim of an officer. That would cut at the very root of democratic government. In order, therefore, to prevent injustice being done by provincial governments to other than those who belong to the province racially, linguistically and culturally, it is felt desirable to depart from the original proposal of having a separate Election Commission for each province under the guidance of the Governor and the local Government. Therefore, this new change has been brought about, namely, that the whole of the election machinery should be in the hands of a Central Election

Commission, which alone would be entitled to issue directives to returning officers, polling officers and others engaged in the preparation and revision of electoral rolls so that no injustice may be done to any citizen in India, who under this Constitution is entitled to be brought on the electoral rolls. That alone is, if I may say so, a radical and fundamental departure from the existing provisions of the Draft Constitution.

—B.R. Ambedkar, Chairman of the Drafting Committee
of the Constituent Assembly, 15 June 1949

Introduction

Constitutional experts regard the Election Commission as the greatest gift of the Constitution of India to the nation. The remarkable wisdom and foresight of the founding fathers ensured the formation of an institution that has stood the test of time as a powerful watchdog of democracy.

Empowering the Election Commission in a federal state empowers citizens to participate actively in the democratic process, as well as promotes transparency and accountability in politics. Good public policy and public welfare ultimately originate from fair elections supervised by a credible and empowered constitutional authority. The Constitution of India proclaims the country as a Sovereign Socialist Secular Democratic Republic. Thus, democracy, a basic inalienable feature of our Constitution, is well understood to be a form of government 'of the people, by the people, for the people'. For the formation of such a government, the will of the people has to be ascertained through periodic elections, regularly held at prescribed intervals. And such elections have to be free and fair, if they are to be reflective of the true choice of electors. In other words, free and fair elections form the cornerstone of all democratic institutions. Thus, it needs no arguments to claim

that the ECI, which has been charged with the constitutional responsibility of conducting free and fair elections, is also a part of the same basic structure of the Constitution. This issue was settled by the Constitution Bench of the Supreme Court (AIR 2003 SC 87).

Free and fair elections postulate three basic requirements:

1. an independent electoral management body to conduct elections,
2. a set of rules governing the conduct of these elections, and
3. an effective mechanism for resolution of disputes arising out of, or in connection with, elections. The founding fathers of the Constitution took care to meet these three basic postulates. In Article 324 of the Constitution, they provide for the establishment of an independent Election Commission; by Article 327, they empowered Parliament to enact laws governing all aspects of conducting elections; and by Article 329, they provided a mechanism for resolving all electoral disputes by judicial fora through election petitions.

Historical Evolution of the Election Commission of India

The framers of the Constitution of India, after a careful study and analysis of various democratic forms of governments prevalent in different parts of the world, adopted, with modification to suit our own needs, the Westminster type of parliamentary form of government functioning in the United Kingdom. The Westminster model, however, has hereditary monarchy while in India the President is elected, as are members of the Upper House unlike nominated members of the House of Lords. Most importantly, the Election Commission was a total departure from the Westminster model. The only election body referred to in the Constituent Assembly in that model

was the one set up in Canada, under the Dominion Elections Act of 1920.*

The Constitution makers weighed several options to establish parliamentary institutions based on free and fair elections. They considered whether an electoral management body should be created at the centre for electing the President, Vice President and the Union Parliament, and separate electoral management bodies for elections to respective state legislatures; or whether a central electoral management body should be entrusted with the responsibility of conducting elections both for the Union and the states. Concerned about the political situation prevailing in various states which stood divided on many ethnic, religious and linguistic considerations, they chose a unified command in the hands of a single electoral management body for conducting all elections. While introducing draft Article 289 (which later became Article 324 in the final Constitution) on 15 June 1949, in the Constituent Assembly, B.R. Ambedkar, the Chairman of the Drafting Committee of the Constituent Assembly, explained the rationale for an independent central and federal Election Commission which has been quoted at length at the beginning of this chapter.

Thus, a central Election Commission was provided to be constituted under clause (1) of Article 324 in which was vested the superintendence, direction and control of preparing electoral rolls for, and the conduct of, elections to Parliament as well as state legislatures and to the offices of the President and Vice President of India.

Another notable fact was that the Election Commission came to be constituted even before India became a sovereign republic on 26 January 1950. Article 324 of the Constitution was brought into force on 26 November 1949, when the

*Alistair McMillan, 'The Election Commission of India and the Regulation and Adminstration of Electoral Politics', *Election Law Journal*, Vol. 11, Nov. 2012.

Constitution was formally adopted by the Constituent Assembly. This Article was one of the few articles which the Constituent Assembly in its wisdom thought fit to be brought into force urgently even before the date of commencement of the Constitution. This evidently shows the significance which the Constitution makers attached to conducting elections to Parliament and state legislatures. Pursuant to this constitutional provision, the Election Commission was established on 25 January 1950, that is, a day before the country became a sovereign republic on 26 January 1950. Notably, from 2011, on the request of the Election Commission, 25 January of each year has been declared by the Government of India as the National Voters' Day (see details in Chapter 9).

Sukumar Sen, ICS, was appointed the first Chief Election Commissioner on 21 March 1950. Sen's contribution in laying the foundation of a robust election management system is historic, though not adequately celebrated. This is largely because he left no memoirs. The nation owes him gratitude for laying the foundation of a great institution and for his superhuman effort in conducting the first general elections in 1951–52 in the most difficult circumstances with no infrastructure.

Composition of the ECI

Article 324 (2) of the Constitution provides that the Election Commission shall consist of the CEC and such number of other Election Commissioners, if any, as the President may, from time to time, fix. The Election Commission could, therefore, be either a single-member body or a multi-member body. To begin with, the Commission was established as a single-member body with only the CEC as its head. This continued till 16 October 1989 when, for the first time, two Election Commissioners, S.S. Dhanoa and V.S. Seigell, in addition to R.V.S. Peri Sastri, CEC, were appointed by the President. This arrangement proved to be short-lived, as on 1 January 1990 the two posts of Election

Commissioners were abolished by another presidential order and the Commission was again converted to a single-member body.

The story behind this is interesting and has been vividly told by J.M. Lyngdoh, former CEC, in his book, *The Chronicle of an Impossible Election,* published in 2004. When Janata Dal (JD) wanted the wheel with twenty-four spokes as its symbol, Dhanoa and Seigell gave it only three. Since it seemed to resemble the logo of the Youth Congress, Dhanoa agreed to increase the number of the spokes to six. Dissatisfied with the decision, the fiery Devi Lal, a member of the JD delegation, stomped out of the Commission's room thundering, 'We shall be back in a couple of months and you will be the first to be thrown out.' This was one poll 'promise' that was honoured. On 1 January 1990, the President issued a notification reverting to a single-member Commission.

Dhanoa challenged this presidential order before the Supreme Court mainly on the ground that he was appointed for a term of five years, as per the service rules framed by the President under Article 324 (5) then governing the office of the Election Commissioners, and that his term could not be curtailed by the presidential order (S.S. Dhanoa versus Union of India and others, 1991). The Supreme Court, however, did not agree with this contention and upheld the presidential order holding that the creation and abolition of posts was the prerogative of the executive, and Article 324 (2) left it to the President to fix and appoint such number of Election Commissioners as he may from time to time determine. The apex court further observed that the power of the President to create posts was unfettered, so was his power to reduce or abolish them, and with the abolition of posts the service rules pertaining to those posts also ceased to have effect and, therefore, the petitioner could not validly claim to continue for the full tenure. It also observed that the role of the two Commissioners was not defined. But while dismissing Dhanoa's

petition, the Supreme Court observed:

> There is no doubt that two heads are better than one, and particularly when an institution like the Election Commission is entrusted with vital functions, and is armed with exclusive uncontrolled powers to execute them, it is both necessary and desirable that the powers are not exercised by one individual, however all-wise he may be. It ill-conforms the tenets of democratic rule. It is true that the independence of an institution depends upon the persons who man it and not on their number. A single individual may sometimes prove capable of withstanding all the pulls and pressures, which many may not. However, when vast powers are exercised by an institution which is accountable to none, it is politic to entrust its affairs to more hands than one. It helps to assure judiciousness and want of arbitrariness. The fact, however, remains that where more individuals than one man an institution, their roles have to be clearly defined, if the functioning of the institution is not to come to a naught.

Taking a cue from these observations by the Supreme Court, the President again converted the Election Commission into a multi-member body with effect from 1991. This law created a distinction between the CEC and the Election Commissioners in terms of status, retirement and perquisites.

From 1 October 1993, the Commission became a three-member body with the addition of two Election Commissioners, M.S. Gill and G.V.G. Krishnamurty, besides T.N. Seshan, the then CEC. A three-member Commission has been a regular feature since then.

There is also a provision in Article 324 (4) for appointing Regional Commissioners to assist the Election Commission in the performance of its functions. It provides that before each general election to the House of the People and to the Legislative Assembly of each state and each biennial election

to the legislative council of a state, the President may appoint, after consultation with the Election Commission, such Regional Commissioners, as may be considered necessary. But such Regional Commissioners have never been appointed except at the time of the first general elections in 1951–52. Two Regional Commissioners were then posted—T.G.N. Iyer, an Indian Civil Service (ICS) officer in Patna from 31 October 1951 and M.R. Meher, a retired ICS officer in Bombay from 1 November 1951. They held their offices up to 1 April 1952.

A look at the Election Management Bodies (EMBs) functioning in some of the important democracies shows that their composition is vastly different. The Federal Election Commission (FEC) of the United States of America consists of six commissioners who are appointed by the President with the advice and consent of the Senate. They can be members of political parties, but not more than three commissioners can be members of the same political party. They serve for a term of six years but two of them retire every two years.

The Electoral Commission of South Africa consists of five members, one of whom is a judge, appointed by the President on the recommendation of the National Assembly. The National Assembly makes its recommendations on the basis of a list of at least eight candidates recommended by a selection committee consisting of: (1) the President of the constitutional court, (2) a representative of the Human Rights Commission, (3) a representative of the Commission on Gender Equality, and (4) the public protector. The term of a Commissioner is seven years, which may be extended by the President on the recommendation of the National Assembly for a specified period. He may be reappointed, but only for one further term. He can be removed from office on grounds of misconduct, incapacity or incompetence by the process of impeachment.

The Electoral Commission of Ghana consists of seven members—a chairman, two deputy chairmen and four other members. The chairman and members of the Commission are

appointed by the President on the advice of the Council of State. The chairman has the same terms and conditions of service as a Justice of the Court of Appeal, whereas the two deputy chairmen have the terms and conditions as applicable to a Justice of the High Court. The other four members are paid such allowances as Parliament may determine. The chairman and the two deputy chairmen have permanent tenure of office.

In Brazil, the Electoral Management Body at the centre known as the Superior Electoral Court (TSE) consists of seven judicial members (ministers)—three from the Federal Supreme Court (STF), two from the Superior Court of Justice (STJ) and two judges chosen from a list of six attorneys appointed by the Federal Supreme Court. They serve for a period of two years and cannot hold office for more than two consecutive terms. The President and Vice President of TSE are selected from among three members from STF, while there is one Electoral Inspector General who is one of the ministers of STJ.

In Canada, the electoral management body, 'Elections Canada', is an independent non-partisan agency of Parliament. It is headed by a Chief Electoral Officer, who is appointed by a resolution of the House of Commons, so that all parties represented in the House may contribute to the selection process. Once appointed, he reports directly to the Parliament and is thus completely independent of the government. He serves until the age of retirement, that is, sixty-five years. He can be removed from office by the Governor General after a joint request following a majority vote by the House of Commons and the Senate.

Closer home, in Southeast Asia, Election Commissions follow a model similar to India. For instance, the Election Commission of Bangladesh is an independent constitutional authority created under Article 118 of the Bangladesh Constitution. In this Commission also, there is one CEC and such number of other Election Commissioners as the President may from time to time direct. They are appointed by the

President, subject to the provisions of any law made on that behalf by Parliament. They serve for a term of five years and after retirement they are not eligible for further appointment under the government, except that an Election Commissioner may be appointed CEC. They can be removed by impeachment on the same grounds and in the same manner as a judge of the Supreme Court.

The Election Commission of Pakistan is also an independent autonomous constitutional body. It consists of the CEC and four other members. The CEC is appointed by the President who is, or has been, a judge of the Supreme Court or is, or has been, a judge of a High Court and is qualified to be appointed as a judge of the Supreme Court. The term of his office is three years, which may be extended by the National Assembly by a resolution for a period not exceeding one year. He enjoys the same privileges as those of the Chief Justice of Pakistan. The four Election Commissioners are drawn from judges of provincial high courts—one each from each of the four high courts. They are all sitting judges of the respective high courts and are appointed by the President in consultation with the Chief Justice of the High Court concerned and the CEC. In the matter of decision-making, they have equal say. Bhutan and Nepal also have EMBs similar to India.

It is clear that while each country has its own wisdom about the size, composition, tenure and process of appointment, the underlying concern is the same, namely, independence of the Commission. It is noteworthy that the Election Commission is a multi-member body in every country and it is remarkable that the largest democracy in the world conducted its elections till 1993 with a single member, the CEC, with complete credibility and trust. Canada is probably the only other exception where a single member, designated as the Chief Electoral Officer, with absolute powers conducts all elections with equal credibility. Many small countries have very large Election Commissions, going up to eleven, thirteen or fifteen members.

In my view, the enlargement of the Indian Election Commission to three members is one of the most significant developments. This is not to negate the absolutely neutral and fair conduct of the single-member Election Commission before 1993, but a three member composition is a near foolproof measure to ensure fairness, neutrality and independence and for protecting the Commission from any allegation or perception of bias. Even the quality of decisions improves with three heads. Many a time, what I thought was my 'bright' idea, was tempered with the wisdom of my two brother commissioners. In an earlier dispensation, even I had played the moderator when the situation so demanded (and that was many times!). That is the reason why many decisions that could have created unnecessary controversies and bitterness were checked in time. That was the phase in which there were too many 'leaks' vitiating the bonhomie among the commissioners. It was then that the three commissioners decided to meet often without aides, so that our differences of opinion were resolved within, unlike earlier where some officers, who were privy to the differences, either indiscreetly leaked them outside or exploited them by playing one against the other, leading to considerable acrimony occasionally.

My conclusion, thus, is that a multi-member Commission is essential, and the size of three is ideal; anything larger than that could be unwieldy.

Manner of Appointment of Election Commissioners in India

The manner of appointment of Election Commissioners is extremely critical for the neutrality and a perception of neutrality of the institution. Most countries, therefore, appoint their commissioners through a system of collegium or different elaborate processes. In India, Election Commissioners are appointed by the government of the day without any consultation mechanism. The Law Minister puts up the file to the Prime Minister who recommends a name to the President.

After his approval, the law ministry issues the notification. It is a miracle that the incumbents so appointed have commanded the trust of the nation.

Suggestions have often been voiced that in the appointment of the CEC and Election Commissioners, the opposition should also be taken into confidence so that their appointments receive wider acceptance. For that purpose, several collegiums are being suggested to include, among others, the leader of the opposition in Parliament, the Chief Justice of India and so on. The time has come for these suggestions to be taken up seriously. My advice would be to include the outgoing CEC too in this process, as he understands the job requirement the best.

Conditions of Service of Election Commissioners

Clause (5) of Article 324 provides that the conditions of service of the CECs and other Election Commissioners and their tenure of office be regulated by law and, until such law is made, the President shall determine by rule all such matters. However, to insulate the Election Commission from interference by the executive and to ensure its independent functioning, a safeguard has been provided that the conditions of service of the CEC once determined shall not be varied to his disadvantage after his appointment and that he shall not be removed from his office except in like manner and on the like grounds as a judge of the Supreme Court. Election Commissioners once appointed cannot be removed from office except on the recommendation of the CEC.

From 1950 till 25 January 1991 the conditions of service of the CEC were determined by the President under the rules framed by the government and he was given tenure for five years. The Parliament enacted the CEC and other Election Commissioners (Conditions of Service) Act, 1991 with effect from 25 January 1991. Under this Act, the CEC was given tenure of six years or upto the age of sixty-five years, whichever was earlier, and his salary and allowances and other perquisites

were to be the same as those for a judge of the Supreme Court; whereas the Election Commissioners were given tenure of six years but upto the age of sixty-two years and their salaries and allowances were equated with those of a judge of a High Court.

This act was, however, significantly amended in 1993 and even its nomenclature was changed as the CEC and other Election Commissioners (Conditions of Service) Amendment Act, 1993. Under the amended Act, the CEC and Election Commissioners were brought at par in all respects—they all now have terms of six years or upto the age of sixty-five years, whichever is earlier, and they are all given the same salaries and allowances and other perquisites as a judge of the Supreme Court. Further, they have equal powers in decision-making and wherever unanimity cannot be reached in deciding a particular matter, the opinion of the majority prevails. I have pleasure in recording that such occasions, where matters had to be decided by majority opinion, arose only on three occasions during my tenure of six years as Election Commissioner and CEC.

A narration of developments will not be complete without mentioning that the amendments to the conditions of service of the CEC and Election Commissioners brought about in 1993 were challenged before the Supreme Court by the then CEC, T.N. Seshan. This challenge was, however, rejected by the court on 14 July 1995 (T.N. Seshan versus Union of India and Others (1995 (4) SCC 611). The court held:

> The scheme of Article 324 is that there shall be a permanent body to be called the Election Commission with a permanent incumbent to be called the CEC. The Election Commission can therefore be a single-member body or a multi-member body if the President considers it necessary to appoint one or more ECs. The argument that a multi-member Election Commission would be unworkable and should not, therefore, be appointed must be stated to be rejected as acceptance of such argument

would tantamount to destroying or nullifying clauses (2) and (3) of Article 324.

By clause (1) of Article 324, the Constitution makers entrusted the task of conducting all elections in the country to a Commission referred to as the Election Commission and not to an individual. It may be that if it is a single-member body the decisions may have to be taken by the CEC but still they will be the decisions of the Election Commission. They will go down as precedents of the Election Commission and not the individual. It would be wrong to project the individual and eclipse the Election Commission. Nobody can be above the institution which he is supposed to serve. He is merely the creature of the institution, he can exist only if the institution exists. To project the individual as mightier than the institution would be a grave mistake. Therefore, even if the Election Commission is a single-member body, the CEC is merely a functionary of that body; to put it differently, the alter ego of the Commission and no more. And if it is a multi-member body the CEC is obliged to act as its Chairman. Having regard to the meaning of the word 'Chairman', it has been variously defined in dictionaries as a person chosen to preside over meetings or a presiding officer, etc. Therefore, the function of the Chairman would be to preside over meetings, preserve order, conduct the business of the day, ensure that precise decisions are taken and correctly recorded and do all that is necessary for smooth transaction of business. The nature and duties of this office may vary depending on the nature of business to be transacted but by and large these would be the functions of a Chairman. He must so conduct himself at the meetings chaired by him that he is able to win the confidence of his colleagues on the Commission and carry them with him. This a Chairman may find difficult to achieve if he thinks that others who are members of the Commission

are his subordinates. The functions of the Election Commission are essentially administrative but there are certain adjudicative and legislative* functions as well. The Election Commission has to lay down certain policies, decide on certain administrative matters of importance as distinguished from routine matters of administration and also adjudicate certain disputes,** e.g., disputes relating to allotment of symbols. Therefore, besides administrative functions it may be called upon to perform quasi-judicial duties and undertake subordinate legislation-making functions as well.

Removal of Election Commissioners from Office

As mentioned earlier, in order to ensure the independence of the Election Commission and to insulate it from Executive interference, the Constitution provides that the CEC can be removed from office only in like manner and on like grounds as a judge of the Supreme Court—in other words, by the process of impeachment laid down in the Constitution. It is, however, paradoxical that the same protection in the matter of their removal from office has not been provided to the Election Commissioners. Only limited protection is available to them in that they cannot be removed from office except on the recommendation of the CEC. The Commission has been

*The Election Symbols (Reservation and Allotment) Order, 1968 promulgated by the Election Commission on 31 October 1968 is one such piece of legislative activity of the Commission.
**The Constitution of India has also vested under Articles 103 and 192 the power of adjudicating disputes relating to disqualification of sitting members of Parliament and state legislatures and tender opinion in such cases to the President and Governors. The Commission also goes into the disputed question of disqualification of candidates filing their returns of election expenses under section 10A of the Representation of the People Act, 1951.

insisting with the government for several years that the Election Commissioners be placed at par with the CEC in the matter of their removal from office, as the underlying intention and object of creating an autonomous Election Commission is to ensure the independence of the Commission as an institution and not only of the CEC.

Functions of the Election Commission of India

The Constitution of India has vested in the Election Commission the superintendence, direction and control of preparing electoral rolls, and conducting elections to the offices of President and Vice President of India and to both the Houses of Parliament and state legislatures. Additionally, the Commission has also been conferred the responsibility of tendering its opinion to the President and Governors of states on questions of disqualification of sitting members of Parliament and state legislatures. The opinion of the Election Commission in such questions to the President under Article 103 (2) in relation to sitting members of Parliament and to the Governor of a state under Article 192 (2) relating to sitting members of the state legislature, is binding on them and they have to act according to such opinion, without reference to their council of ministers. The Commission has the powers of a civil court while making enquiry into such questions of alleged disqualifications for the purpose of formulating its opinion. Besides, the Commission has the exclusive jurisdiction to decide on disputes between rival groups or factions of a recognized national or state party under the provisions of the Election Symbols (Reservation and Allotment) Order, 1968.

It is pertinent to clarify here that elections to lower bodies like municipal corporations, municipalities, district councils (zila parishads) and village councils (panchayats) are conducted not by the ECI, but by the respective State Election Commissioners (SECs) who are also independent constitutional authorities.

These authorities were created by the Constitution (seventy-third and seventy-fourth) Amendment Acts, 1992, which came into effect on 1 June 1993. This distinction between ECI and SECs is not widely understood with media and political leaders regularly blurring the distinction, particularly referring to the Chief Electoral Officer (CEO) of a state (an officer of ECI) as the SEC.

The roles and responsibilities of Electoral Management Bodies (EMBs) across the globe vary significantly in different countries. For instance, the Federal Election Commission (FEC) of the United States of America is not directly concerned with conducting elections, either at the federal or state levels. These elections are conducted by EMBs of the respective states whose composition and functions vary from state to state and they conduct elections as per the laws made by those states. The FEC's role is confined to administering and enforcing the Federal Election Campaign Act which governs the financing of federal elections. It is an independent regulatory agency created in 1975 and its duties are watching over the disclosure of campaign finance information, enforcing limits and prohibitions on contributions and overseeing the public funding of presidential elections.

In the United Kingdom too, the responsibility of conducting national and local elections is not that of the Election Commission—these elections are managed by the Home Department. Here again, the role of the Election Commission set up in 2001 is just registering political parties and overseeing election expenditure and the public financing of elections.

The Electoral Commission of South Africa has been entrusted with the duty of conducting all national, provincial and local elections. In Canada, the Chief Electoral Officer is responsible for the administration of general elections and bye-elections and also of referenda and other important aspects of the democratic electoral system in the country.

In Bangladesh, the role and responsibilities of the Election

Commission are almost similar to those of the ECI. Its Constitution also vests the superintendence, direction and control of preparing electoral rolls and conducting elections to Parliament and to the office of the President in the Election Commission. This Commission, unlike India, is also responsible for delimitation of constituencies for the elections to Parliament. Election tribunals for disposal of election petitions are also constituted by the Election Commission. The Bangladesh Election Commission can also be entrusted with such other functions as may be prescribed by law. Under this prescription, conducting elections to local bodies is also the responsibility of the Election Commission.

The Election Commission of Pakistan is charged with the function of conducting elections to both national and provincial assemblies. However, conducting elections to the office of the President and the Senate is the responsibility of the CEC and not of the entire Commission. Likewise, conducting local government elections and referenda is also the responsibility of the CEC.

It is clear from this discussion that each country has its own variations. Some commissions conduct all the elections—national or local—some even have delimitation under their jurisdiction. However, in India, the ECI conducts all elections up to the state legislature with only elections to local bodies being the jurisdiction of state ECs. The delimitation of constituencies is also not the jurisdiction of the ECI.

It is interesting to see that two of the most respected democracies, the US and UK, set up Election Commissions very recently (1975 and 2001 respectively) and with very limited roles and powers.

Secretariat of the Election Commission of India

The Election Commission superintends, directs and controls the largest man-managed event in the world when it conducts countrywide general elections to the House of the People,

involving over seven hundred million electors and eleven million polling staff and security personnel. Almost an equal number are posted in all the states put together. The Secretariat of the Commission comprises, however, only about fifty officers and three hundred officials to assist it in the performance of its gigantic functions. At present, there are three Deputy Election Commissioners and three Directors Generals* at the senior level heading certain departments. They are assisted by some directors, principal secretaries, secretaries, undersecretaries and other officials at the lower levels. Some of them have been seconded to the Commission on deputation and they are members of various all-India services, whereas others are part of the permanent cadre of the Commission. Their conditions of service are mainly regulated by the rules framed by the President under Article 309 of the Constitution.

Administrative Expenditure of the Election Commission

Expenditure on salaries and allowances of Election Commissioners and other officers of the Commission and other administrative expenditure for the day-to-day functioning of the Secretariat of the Commission are voted by Parliament. The Commission is of the considered view that in order to ensure full independence of the Commission, its expenditure

*Two new divisions were created in 2010 to meet the changing needs of the Commission to undertake the task of voter awareness, which was hitherto left to political parties and civil society organizations, and monitoring of election expenses of political parties and candidates. To head these divisions, the posts of two Directors Generals were also created. In addition, the Commission also established the India International Institute of Democracy and Electoral Management to meet its needs of imparting training to millions of officers and staff engaged in various election duties in the country. The institute has also become a focal point for meeting the training needs of various EMBs across the world. This is also headed by a Director General.

should be a 'charge' on the Consolidated Fund of India like the expenditure of the Supreme Court, the Comptroller and Auditor General of India and the Union Public Service Commission. Such a measure of making the expenditure of the Commission a charge on the Consolidated Fund of India will further enhance its independence and insulate it from Executive interference making inroads in its financial autonomy, for any control on the Commission's budget might be misconstrued as a check on its activities by the political executive.

The First Indian Elections after Independence

Since the Constituent Assembly adopted the Constitution on 26 November 1949, it was provided in the Constitution (Article 379) that the Constituent Assembly shall itself be the provisional Parliament of India till the regular constitution of Parliament. The Constitution makers took another historical step by declaring that elections to the House of the People and State Legislative Assemblies shall be held on the basis of universal adult suffrage. In spite of the fact that the country was passing through great turmoil after its division into India and Pakistan and there was a large migration of population from one place to another, the Constituent Assembly started giving directions to state governments on how to proceed with the registration of electors in anticipation of the law yet to be enacted.

The situation was now ripe for conducting the first-ever general elections in independent India. For conducting these elections, it was now necessary for Parliament to enact a further law governing all aspects of the electoral process. Such a law came in the form of the Representation of the People Act, 1950 (on 12 May 1950) and the Representation of the People Act, 1951 (on 17 July 1951). The former dealt exclusively with the matters of the electoral rolls. The Act of 1951 governed the conduct of the electoral process and the qualifications and disqualifications for contesting elections (in addition

to those which were already prescribed in the Constitution itself), specified corrupt practices during elections and electoral offences and provided for a legal mechanism for resolution of all doubts and disputes in connection with elections.

This Act also provided for determining the territorial extent of parliamentary and assembly constituencies by the President on the recommendation of the Election Commission. The President passed necessary orders delimiting the parliamentary and assembly constituencies on 13 August 1951 which formed the basis for conducting the first general elections to the House of the People and Legislative Assemblies in 1951–52. Before these delimitation orders came into force, an enumeration of electors had already been done by electoral registration authorities district-wise and the enumerated electors were thereafter assigned to the constituencies concerned where they were ordinarily residents. Polling stations were set up at convenient places as close as possible to the places of residence of electors and the electoral rolls already prepared were subdivided into convenient parts for each polling station.

The formal process of elections commenced on 10 September 1951 with the issue of the notification by the President calling for general elections to the House of the People. Polls were held in various phases, starting with the first phase on 25 October 1951 in the high altitudes of Chini and Pangi assembly constituencies in Himachal Pradesh before the onset of winter and closure of the high passes in those regions. In all, polls were held throughout India on sixty-eight days, that is, in sixty-eight phases; ending with the last phase of elections on 21 February 1952 in Uttar Pradesh.

As many as 1,96,084 polling stations were set up throughout the length and breadth of the country, of which 27,527 were exclusively reserved for women. The total electorate of the country then stood at 17,32,12,343 of whom 10,59,50,083 voted. The world wondered how elections would be held in India where the literacy rate at that time was hardly about 16

per cent. To enable an overwhelming majority of the population who were illiterate to cast their votes, the Commission had to devise a system whereby such electors could exercise their franchise with due regard to secrecy. The Commission, after great deliberations, decided to adopt the balloting system of voting. Each contesting candidate was allotted a separate ballot box in the polling station on which his name and election symbol was labelled. A voter had to simply insert the ballot paper given to him in the ballot box of the candidate of his choice in the voting compartment. All these ballot papers were centrally printed by the Election Commission at the Government of India Security Press at Nasik where the Indian currency was printed. After the counting of votes and the declaration of results, the first House of the People was constituted by the Election Commission on 2 April 1952.

Elections were also held to the State Legislative Assemblies around the same time. Soon after the constitution of the State Legislative Assemblies, elections were also held to the Council of States for which the electorates consisted of elected members of State Legislative Assemblies. On the basis of these elections held in March 1952, the Council of States was first constituted on 3 April 1952. Now there was a regular Parliament to replace the interim Parliament which held its last sitting on 5 March 1952.

Empowerment of the Election Commission

There are seven pillars on which the strong edifice of the Election Commission is solidly built:

1. The Constitution of India
2. Parliament which formulates acts
3. Supreme Court of India and various High Courts
4. Political parties who formulated the Model Code of Conduct

5. The bureaucracy that conducts the mammoth exercise fearlessly
6. The media that acts as the eyes and ears of the Commission
7. The people of India, who repose full trust in the Commission

The Election Commission owes its empowerment to these seven sources.

Empowerment by the Constitution

Around the same time when the Constitution of India was under preparation, the United Nations had also embarked on an exercise of codifying basic human rights with a view to strengthening democracy in different parts of the world. The Universal Declaration of Human Rights, 1948, provided that:

- Everyone has the right to take part in the government of their country, directly or through freely chosen representatives (UDHR Article 21.1).
- The will of the people shall be the basis of the authority of government; this will shall be expressed in periodic and genuine elections which shall be by universal and equal suffrage and shall be held by secret vote or by equivalent free voting procedures (UDHR Article 21.3).

The prerequisite for realizing these basic democratic rights is the conduct of free and fair elections in which the people are in a position to express their will fearlessly and according to their own free choice, in a fully secure and secret manner. This was the mandate given to the Election Commission by the founding fathers of the Constitution of India. They took further care to ensure that the Commission was vested with all necessary powers to discharge its functions independently and that it was insulated from interference or pressures from the political executive of the day. The Constitution empowers the Commission with complete freedom in its allotted domain. Parliament is the authority that formulates laws under Article

327 of the Constitution 'with respect to all matters relating to, or in connection with, elections to either House of the Parliament or to the House or either House of a Legislature of a State including the preparation of electoral rolls, the delimitation of constituencies and all other matters necessary for securing the Due Constitution of such House or Houses'. However, this power of Parliament to make laws is 'subject to the provisions of this Constitution', which includes Article 324.

Thus, Parliament cannot make any law which may have the effect of diluting or whittling down the powers given to the Commission by the Constitution. In fact, any such law may amount to affecting the basic structure of the constitution, as the Commission was also formed as a part of the Constitution's basic structure. In this context, the Supreme Court observed in Special Reference No.1 of 2002 (AIR 2003 SC 87) that: 'The Parliament is empowered to frame laws as regards conduct of elections but conducting elections is the sole responsibility of the Election Commission. As a matter of Constitutional mandate, the plenary powers of the Election Commission cannot be taken away by law framed by Parliament. If Parliament makes any such law, it would be repugnant to Article 324.' What the Constitution has vested, by Article 324, in the Election Commission is the 'superintendence, direction and control' of elections to Parliament and state legislatures and to the offices of President and Vice President of India. The Supreme Court held in Mohinder Singh Gill and another versus Chief Election Commissioner and Others (AIR 1978 SC 851) that the words 'superintendence, direction and control' are the broadest terms and Article 324 is a plenary provision vesting the whole responsibility of national and state elections in the Election Commission. Further, the apex court held that where any law made by Parliament is silent, Article 324 gives power to the Commission to act in such a vacuous area. The apex court's landmark verdict (see box) sums up, most graphically, the sweeping powers of the Commission:

Not to fold hands and pray to God for divine inspiration

The framers of the Constitution took care to leaving scope for exercise of residuary power by the Election Commission in its own right, as a creature of the Constitution, in the infinite variety of situations that may emerge from time to time in such a large democracy as ours. Every contingency could not be foreseen or anticipated with precision. That is why there is no hedging in Art. 324. The Commission may be required to cope with some situation which may not be provided for in the enacted laws and the rules. That seems to be the raison d'être for the opening clause in Arts. 327 and 328 which leave the exercise of powers under Art. 324 operative and effective when it is reasonably called for in a vacuous area. Where the existing laws are absent and yet a situation has to be tackled, the CEC has not to fold his hands and pray to God for divine inspiration to enable him to exercise his functions and to perform his duties or to look to any external authority for the grant of powers to deal with the situation. He must lawfully exercise his power independently, in all matters relating to the conduct of elections, and see that the election process is completed properly in a free and fair manner.
—Hon'ble Supreme Court, 1978

It is in exercising such inherent powers under Article 324 that the Election Commission promulgated the Election Symbols (Reservation and Allotment) Order, 1968 governing, inter alia, the recognition of political parties as national and state parties.

Empowerment by Parliament

The Parliament, by exercising its law-making power, has made all necessary provisions in the laws governing the conduct of elections, mainly, the Representation of the People Act of 1950

and 1951* and the Presidential and Vice Presidential Act, 1952 and the rules made under these Acts, to strengthen the Election Commission and to effectuate its powers. Wherever these legal provisions were found wanting in any respect, amendments were made from time to time to overcome them. For instance, under Section 159 of the Representation of the People Act, 1951, as originally enacted, the Commission could requisition the services of employees of only local authorities, in addition to government servants, for deployment on election duties as they would be subject to the control and discipline of the government at all times. Employees from the private sector were deliberately kept out of election duties as no administrative control could be exercised over them once the elections were over. But the Commission found on experience that government servants and employees of local authorities were far less in number than the actual requirement. On the recommendation of the Commission, Section 159 was amended in 1997 to provide that the services of employees of universities established by the central, provincial or state acts or any other institution, concern or undertaking, including a government company, controlled or financed wholly or substantially by funds provided directly or indirectly by the central government or state government, could also be utilized for polling duties.

The Commission also felt handicapped in disciplining officers and other staff members deployed on election duties for any acts of omission or commission in performing their election related duties on account of lack of any express provision in the law as such officers and staff were governed by their own service rules.

Though the Constitution makers had intended that all election machinery shall work subject to the superintendence,

*It is intriguing how the same title was used for two different Acts. The former deals exclusively with electoral rolls issues, the latter with the conduct of elections.

direction and control of the Election Commission, some institutions pleaded that their officers were subject to their disciplinary control and the Commission could not directly seek explanations from them or subject them to any disciplinary proceedings for any lapse on their part in performing their election related duties. Here, too, the Parliament amended the law in 1988, inserting Section 13CC in the Representation of the People Act, 1950 and Section 28A in the Representation of the People Act, 1951, mandating that all officers deployed on election duties shall be deemed to be on deputation to the Election Commission during the period of such deployment and that they shall be subject to the control and discipline of the Commission during that period.

Likewise, when the Commission decided to use electronic voting machines for the recording and counting of votes during elections to the House of the People and State Legislative Assemblies, legislative sanction for the use of such machines was provided by Parliament in 1989 by making necessary provisions in Section 61A of the Representation of the People Act, 1951. Earlier, the Supreme Court had held in 1984 that such machines could not be used by the Commission in the absence of a law providing for their use, and Parliament removed that legal obstacle by amending the law. There are several other examples where Parliament came to the aid of the Commission to arm it with necessary powers to discharge its functions more effectively.

Empowerment by the Supreme Court

The authority that the Commission wields and the respect it enjoys today comes, to a very great extent, from the Supreme Court's benevolent interpretation of the various provisions in the Constitution and the laws relating to elections and the Election Commission. The Supreme Court interpreted the word 'election' in Clause (b) of Article 329 as the entire process starting with the issue of the notification calling the elections

and culminating in the declaration of result, in N.P. Ponnuswami versus Returning Officer, Namakkal (AIR 1952 SC 64) in 1952. It also placed a bar on the interference by courts in electoral matters, and these steps have gone a long way in helping the Election Commission conduct elections and bye-elections. In the very early stages of a nascent democracy, that is, at the time of the first general elections in the country, this interpretation was rendered by a Constitution bench of the Supreme Court and the conduct of elections has been left to the Election Commission according to the timetable set by it.

There were doubts in the minds of certain authorities whether the election schedule drawn by the Election Commission was binding on the President and Governors, who have to issue notifications setting the electoral process in motion, or if the Council of Ministers at the centre and in the states could make any alterations in such schedule, as under the Constitution, the President and Governors have otherwise to act on the aid and advice of their Council of Ministers. This doubt was set at rest by the Supreme Court in Special Reference No.1 of 2002 (AIR 2003 SC 87). The Supreme Court held that, 'So far as the framing of the schedule or calendar for election [...] is concerned, the same is in the exclusive domain of the Election Commission, which is not subject to any law framed by the Parliament.' This was done so that the ruling party or ruling alliance was not in a position to take undue advantage of its incumbency. In most countries the date of the elections is decided by the political executive, except where the date is permanently fixed (like in the USA). In UK, the decision on the date of elections had been the domain of the Prime Minister since 1715. In 2011, however, the Act was amended to create a fixed term Parliament. It has now been decided to hold the future general elections on 7 May every five years, starting from 7 May 2015.

Some other important examples of similar far-reaching interpretations by the Supreme Court need mention. The

direction given by the Supreme Court in 1993 to the government that the Commission's perceptions of the law and order situation be given due regard and the Commission be provided with the services of central police forces for ensuring the requisite precautionary and remedial measures during polls led to peaceful polls. Its seal of approval on the agreement between the Commission and the government that the Commission will have disciplinary control over all the government personnel seconded to it for deployment on election duties, including the power to suspend and transfer them has ensured that the officials deployed for elections remain non-partisan. Again, approving that the Model Code of Conduct will come into force from the date of announcement of the election schedule by the Commission has ensured clean and orderly campaigning. Upholding the constitutional validity of the Election Symbols (Reservation and Allotment) Order, 1968 which provides for, inter alia, the recognition of political parties as national and state parties confirmed the power of the Election Commission to make subordinate legislation.

Empowerment by Political Parties

Though in the Constitution, as originally enacted and in the laws framed thereunder, there was no mention of political parties, yet the Election Commission recognized their role in the functioning of a democracy as envisaged in the Constitution from the very beginning. From the very first general elections in 1951–52, it recognized a number of political formations functioning at the national, regional and state levels under its own powers of Article 324. Political parties are one of the main stakeholders in the electoral process and, but for their satisfaction, no electoral outcome can receive general acceptance essentially needed for smooth and orderly transfer of power. It is gratifying to note that political parties have all along accepted electoral verdicts gracefully and also appreciated the role which the Election Commission has played in ensuring free

and fair elections. This has been one of the greatest sources of the Commission's empowerment.

The faith reposed in the Election Commission by political parties is evident from the fact that enforcement of the Model Code of Conduct has been entrusted by them to the Election Commission. The Model Code of Conduct is a unique device evolved by political parties themselves which binds them to observe certain exemplary good practices in their election campaigns so as to maintain a healthy decorum for clean elections, to provide a level playing field among them and to place restrictions on the use of government power and machinery by the ruling parties for their partisan ends. Generally, the political parties have shown strict adherence to the Code and wherever the Commission has, on observing any infraction or breach of the Code, asked for any explanation from the person or authority concerned, the explanation has come forthwith irrespective of the post or position held by the said person, together with an assurance that such breach would not be repeated. It is worth noting that any decision rendered by the Commission in such cases has been promptly, and without demur, accepted and complied with.

Empowerment by Bureaucracy

The admirable manner in which the bureaucracy has responded to the call of duty and stood by the Commission to assist it in the discharge of its onerous duty undoubtedly deserves a special mention. The way it has looked to the Election Commission to observe and adhere to its directions and instructions, ignoring sometimes even the threats of political bosses, is noteworthy. Bimal Jalan, former Governor of the Reserve Bank of India once remarked that the same bureaucracy which is otherwise much maligned renders perfect elections when it comes under the command of the Election Commission. The large number of observers and micro-observers deployed by the Commission act as its eyes and ears in the field. In my capacity as a former

head of the Election Commission, I would be failing in my duty if I do not acknowledge the crucial role played by the Indian bureaucracy, including the IAS, IPS, IRS and other services, in conducting free, fair, peaceful and smooth elections, paving the way for smooth transfer of power after elections. The bureaucracy's brightness and constant innovations have made the ECI a powerful and effective body.

Empowerment by the Media

The Commission has always accepted the media as its ally. With its wide reach in every nook and corner of the country, the media is more vigilant and often quicker in noticing and highlighting malpractices resorted to by candidates and political parties in their political campaigns. Quite often, it is through the media that the Commission observes or becomes aware of violations of the Model Code of Conduct or other corrupt or illegal practices being indulged in by certain candidates and their supporters and workers. In all such cases the Commission promptly and without loss of time directs urgent remedial action; it does not wait for a formal complaint from any other source for launching any investigation or inquiry in such matters. That apart, the Commission heavily depends on the media's power to inform and educate all stakeholders about its directions and instructions as well as its programmes, election schedules and awareness campaigns. It is because of the media that the Commission effectively implements the Model Code of Conduct, as it is the fear of adverse publicity that makes political parties and candidates wary of violations of the Code. Public censure through the media is the sanction behind the Model Code of Conduct.

Unfortunately, a disturbing phenomenon has been noticed recently which has acquired the nickname of 'paid news'. This phenomenon has been discussed in detail in Chapter 11. Hopefully this is an aberration that will be tackled largely by the media itself through its vigilance and self-regulation.

Empowerment by the People

The foremost source of the Commission's empowerment is the faith reposed in it by the people of India. The way they have respected the electoral verdicts during the last fifteen general elections to the House of the People, 348 general elections to State Legislative Assemblies and thousands of bye-elections to Parliament and state legislatures bears ample testimony to the fact that the Commission has not failed the people of the country in performing the sacred duty imposed on it by the Constitution. It has been working consistently to safeguard and increase the political strength of ordinary voters and citizens.

THE NUTS AND BOLTS OF ELECTORAL OPERATIONS

Officials carrying EVMs to far-flung areas.

SCENE 1:
Date: 15 June 1949

Situation: Discussion in the Constituent Assembly on draft Article 289 of the Constitution of India, regarding how powerful the Election Commission of India ought to be.

Speaker: Dr B.R. Ambedkar:

A Committee was appointed to deal with what are called Fundamental Rights. That Committee made a report that it should be recognized that the independence of the elections

and the avoidance of any interference by the executive in the elections to the Legislature should be regarded as a fundamental right and provided for in the chapter dealing with Fundamental Rights. When the matter came up before the House [...] the House affirmed without any kind of dissent that in the interests of purity and freedom of elections to the legislative bodies, it was of the utmost importance that they should be freed from any kind of interference from the executive of the day. In pursuance of the decision of the House, the Drafting Committee removed this question from the category of Fundamental Rights and put it in a separate part containing articles 289, 290 and so on. Therefore, so far as the fundamental question is concerned that the election machinery should be outside the control of the executive Government, there has been no dispute. What Article 289 does is to carry out that part of the decision of the Constituent Assembly. It transfers the superintendence, direction and control of the preparation of the electoral rolls and of all elections to Parliament and the Legislatures of States to a body outside the executive to be called the Election Commission.

This article proposes to centralize the election machinery in the hands of a single Commission to be assisted by Regional Commissioners, not working under the provincial Government, but working under the superintendence and control of the Central Election Commission. [...] The House will realize that franchise is a most fundamental thing in a democracy. No person who is entitled to be brought into the electoral rolls on the grounds which we have already mentioned in our Constitution, namely, an adult of 21 years of age, should be excluded merely as a result of the prejudice of a local Government, or the whim of an officer. That would cut at the very root of democratic Government. In order, therefore, to prevent injustice being done by provincial

Governments to people other than those who belong to the province racially, linguistically and culturally, it is felt desirable that the whole of the election machinery should be in the hands of a Central Election Commission which alone would be entitled to issue directives to returning officers, polling officers and others engaged in the preparation and revision of electoral rolls so that no injustice may be done to any citizen in India, who under this Constitution is entitled to be brought on the electoral rolls.

SCENE 2:
Date: 29 January 2012

Situation: Editorial entitled 'The Election Commission at 60' in *The Hindu*:

After overseeing 15 general elections to the Lok Sabha, the Election Commission of India, in its diamond jubilee year, can with justifiable pride claim to have nursed and strengthened the electoral processes of a nascent democracy. The successes have not been consistent or uniform, but over the last six decades the ECI managed to make the world's largest democratic process freer and fairer…

The journey from the ECI's embryonic days as a special child of the Indian Constitution to modern times, when it is recognized as a fiercely independent Election Management Body (EMB), has not been easy. The main reason for this has been the enormity of functioning of the Election Commission. Take the case of the numbers that the Commission has to deal with: it has the unenviable task of managing an electorate of 814 million* for 543 parliamentary constituencies in India. The utter magnitude

*Figures projected for the 2014 general elections.

of these numbers can be better appreciated when we look around the world a little bit. The number of registered voters in India is more than the electorate of the entire continents of Europe, Africa and the Americas, or all countries of the Commonwealth except India put together.

Table 3.1 brings home the reality of the sheer logistics that we are dealing with here!

Table 3.1: Electorates in Different Countries

Electorate of:	Population	Electorate
India	1,220 m	814 m
Europe (50 countries)	742 m	492 m
Africa (54 countries)	1,110 m	737 m
North, Central & South America and Caribbean put together (56 countries)	972 m	645 m
Commonwealth except India (52 countries)	900 m	597 m
Australia/Oceana (23 countries)	38 m	25.2 m

Source: The United Nations World Population Prospects, the 2012 revision.
Note: The size of the electorate is approximate, calculated by the author at 66 per cent of the total population, as in India.

The Scale of Operations

At the time of the last general elections in 2009, India had seven recognized national political parties, forty-four recognized state political parties and more than 1,300 registered political parties. ECI used almost 1.4 million electronic voting machines (EVMs) and more than eleven million polling staff were deployed in and outside 834,944 polling stations, including about 2.5 million security personnel. Over 2,000 observers,

all senior officers of the IAS and allied services, were also deputed, as were almost 1,40,000 micro-observers and about 75,000 videographers...and yet the picture is not complete. You have to add deployment of 40,599 digital cameras, 119 special trains comprising 3,060 coaches for transporting central police forces all over the country, 55 helicopters to do more than six hundred sorties and airlift security personnel; and innumerable election material and complement it with countless buses and jeeps, tractors, motorcycles, bullock carts, mules, camels, and elephants for transportation of men and material.

Pre-poll exercises are as enormous. After all, when you are trying to locate eligible or missing voters from within a population of over 1.2 billion spread over a geographical area of 3,287,240 sq km, distributed over 640 administrative districts, 5,924 sub-districts, 7,935 towns and 640,867 villages, it is no mean task, and all the efforts have to be infinitely colossal to match the requirements.

Reason would dictate that only a supercomputer can perform such tasks. But facts at hand clearly indicate that the ECI has proved to be more potent than any machine. The great Indian election machinery has the very complex goal of consistently delivering free and fair elections in a politically charged yet vibrant atmosphere, within the backdrop of a nation with logic-defying diversity and an incalculable magnitude. This machinery has to be kept well-oiled for it to function efficiently and effectively at all times.

District Election Officers (DEOs) are the kingpins in the electoral administration around the country. When not in their election officer avatar (which is more often than not), the DEOs look after a wide range of activities such as land administration, civil supplies, law and order, licensing and public service delivery, etc. Similarly, returning officers (ROs) or electoral registration officers (EROs) are of the rank of deputy collectors and when not doing election related work, they are either busy with developmental work, or approving arms or explosives licenses,

or raiding black marketers, or even taking dying declarations of persons who are about to suspiciously succumb to injuries or might have attempted suicide!

Figure 3.1

Source: ECI Presentation in IIIDEM

The great Indian election machinery revolves around three principles of operation for its basic functioning. These are ensuring that:

- All persons who are eligible voters are included in the electoral rolls.
- All persons whose names are in the rolls come to vote during elections.
- All those who come to vote are able to do so in a convenient, peaceful, free and fair manner, without being induced by illegal gratifications or forced by some threat.

In line with these principles, the broad set of functions performed by the ECI include: registering voters, locating polling stations,

assigning voters to polling stations, registering political parties and allotting symbols, training election personnel, procuring, storing and distributing election material, monitoring campaign expenditure, educating voters, conducting polls, enforcing the election law and the Model Code of Conduct, counting votes, using appropriate technology, partnering with the media and coordinating with other government departments/agencies.

For efficient resource utilization, the core concerns are: time management, integrity of the rolls, identifying risks at each step and their mitigation and management, inclusiveness in both voters' registration and participation, personnel management, material management, security management, increasing the use of technology, voter education, monitoring and evaluation of roll revision, voter registration, grievances and conducting polls. Minute detailing for performing all operations whether in the pre-poll phase, during the polls or in the post-poll phase is the heart of these operations.

Hallmarks of Credible Elections

Four hallmarks characterize the way in which the EC handles the mammoth task: independence, transparency, neutrality and professionalism.

Independence

The ECI is not only independent in its structure but it is unquestionably and fearlessly independent in its functioning. The manner in which it announces the elections to deny the ruling party the incumbency advantage of choosing the date to suit its political interests, and the way it takes disciplinary action if the personnel fail in delivering are cases in point.

Transparency

No effort is spared to ensure that the entire electoral process is transparent and there is a level playing field for all. Some

of these measures are listed here to show the extent to which the Commission goes for transparency:

- Electoral rolls are shared with all political parties/candidates and hosted on web portals for the voters to see.
- Any applications for additions, deletions and corrections in the rolls are published locally and read out in gram sabhas (in rural areas) and in ward sabhas (in urban areas).
- All candidates are made to declare their assets and details of criminal cases in an affidavit filed by them along with their nomination papers. These are then displayed on all notice boards and shared with civil society; any citizen is free to get a copy of these on a minor payment. These details are also put on the website.
- All EVMs are checked by engineers before deployment in the presence of agents of political parties.
- All candidates are entitled to have their agents present at the polling stations and in counting centres to see that polling and counting is done in a free and fair manner. Publication and announcement of results is done after every round of counting to ensure that no manipulation takes place.
- Video recording of all critical elements of the electoral process is done.
- The Commission's website is one of the multiple indicators of its devotion to transparency. Every decision of the Commission is uploaded on this website on a day-to-day basis.

Neutrality

Equal opportunity is made possible for political parties and contesting candidates as unquestionable neutrality is ensured

at all times. With the help of the Model Code of Conduct and its strict implementation, the stage is set for conducting democratic elections with no one, especially the ruling party, getting an unfair advantage. The polling staff is carefully selected and randomized for deployment and anyone suspected of partisanship is removed forthwith irrespective of the rank. Even Chief Secretaries, Home Secretaries and Directors General of Police (DGPs) have been removed on reasonable suspicion of political alignment.

Professionalism

One of the secrets of the ECI's success is the professionalism of the election machinery. Each and every person engaged in any manner in election management is properly trained for her/his job; be it the returning officer or the observer or videographer whose only role is to cover poll day activities outside a polling station. It is not just fear of the powers that the ECI derives from the Indian Constitution, but also the respect that it generates due to its commitment to exercising these powers without fear or favour. And that affords it the success rate with which elections have been held on time every time for six decades.

Complexities of Election Management

Given the magnitude of Indian elections, it takes enormous effort—from detailed planning to perfect execution—to deliver a perfect election every time. The following aspects need to be mentioned:

Timely delivery is the basic requirement and involves tremendous time management. Elections can neither happen too soon nor can they happen later than legally permissible. They have to happen at the time fixed by law. The Representation of the People Act, 1951, provides the Commission a window of six months before the term of the House expires or within six months of a vacancy arising, within which elections must

be held. If the House in not constituted before the date of due constitution, it results in a constitutional crisis as no government can survive a single day beyond its life of five years. In that event, President's rule has to be imposed. The Election Commission has faced this problem on more than one occasion. In 1982, the Commission had to conduct general elections to the Legislative Assembly of Assam at the height of the violent Assam agitation. Similarly, in Jammu and Kashmir, the Commission has conducted several elections in spite of the problems of militancy.

We faced a severe dilemma in 2008 when the elections to the Karnataka assembly were due. There was massive pressure from various stakeholders that, in view of the problems with the electoral rolls, the elections be postponed. This was one occasion when the Commission found itself divided. But by a majority decision, we went ahead with the polls within the mandatory timeframe.

A similar dilemma was waiting for us in 2009 when elections to the Jammu and Kashmir assembly were due. The volatile political environment combined with a fragile law and order situation in the wake of the Amarnath Yatra crisis created circumstances in which it was extremely difficult to conduct peaceful, free and fair elections. Here again, by a majority decision, we decided to go ahead to keep intact the unbroken tradition of holding elections in time. Our bold decision was rewarded with great success, but that is a story in itself.

While the Commission has a window of six months for conducting elections, the flexibility available to the Commission for making the schedule is limited by provisions of the law. The date of issue of notification, last date of filing nominations, date of scrutiny of nomination papers, the last date of withdrawal of candidature and the number of campaigning days put together add up to twenty-six days. In addition to this, the Supreme Court has ruled that the Commission cannot announce elections more than twenty-one days before the date on which the

notification is to be issued, so that the incumbent government does not get neutralized for inordinately long, which happens as soon as the election dates are announced and the Model Code of Conduct comes into operation. If several elections are due around the same time, the Commission holds them together to avoid the impact of the results of one election influencing voter behaviour in another election. Sometimes logistics and availability of security forces require that elections are held in several phases. Add to this the requirement of taking care that the polls do not take place during festivals of any community, or at the time of examinations, or during the agricultural season or extreme weather conditions. Therefore, managing time in scheduling and conducting elections is a very complex process.

Sanctity of the Electoral Rolls

The integrity of the rolls is a key area of focus during non-election periods. In 2006, we devised a statistical approach for comparing the integrity of the rolls with a benchmark that we set for it. In this system available figures of the Census are compared to calculate gender ratio, the elector–population ratio and the status of registration of voters in different age brackets. This has become a standard tool for checking the health of the electoral rolls. Similarly, door to door verification, linking with data from birth and death registers, appointing a Booth Level Officer (BLO) who is familiar with the local populace and situation are some of the interventions for maintaining the integrity of the rolls.

While election management now has standard protocols, certain distinctive ground realities have to be taken into account. Risk management is a very local exercise under the overall umbrella of the election plan. Because of the constant need to adapt to the culturally and socio-politically dynamic and diverse environment in the country, the ECI does not have a typical or rigid strategic plan for delivering its functions.

Rather, it has a continuous, rolling plan process, with each election providing inputs for improving the system. Different sets of challenges in each state have to be addressed individually without any preconceptions. In the 2010–12 elections for some state assemblies, the following issues were identified as crucial which required appropriate interventions:

In Bihar—History of security breaches and booth capturing, low voter turnouts particularly among females.

This was handled by holding elections in seven phases and the deployment of central armed police forces, leading to the most peaceful polls in the state ever. Voter education programmes were launched for the first time leading to the highest turnout in history.

In West Bengal—Maoist insurgency, political violence and politicization of the bureaucracy due to the continuous rule of a political formation for thirty-four years.

Our response was to hold the elections in seven phases with massive deployment of central armed police forces weeks before the polls and sending IPS observers to the state for the first time ever in the country.

In Tamil Nadu—The misuse of monetary power in elections.

This was tackled by strict enforcement of the new expenditure guidelines and a strong contingent of expenditure observers.

In Uttar Pradesh—History of poll violence and booth capturing, low voter turnout, low literacy, low female voter turnout and low registration of youth.

The measures taken were a seven-phase polls with deployment of central armed police and a massive voter education programme.

In Punjab—Besides money, alcohol, muscle and gun power, drugs was a serious issue, otherwise not found elsewhere in the country.

Special task forces to detect drugs led to the seizure of over 50 kg of heroin, among other hard drugs.

In Manipur—Insurgency related threats and poll violence, bogus voting and booth capturing.

Here we introduced face recognition software Picasa for the first time ever, with dramatic results, including the discovery of a female voter who came to vote over sixty times in different guises!

Separate strategies were laid out for each state by clearly identifying the risks involved. This was how the Commission conducted the most peaceful polls in Bihar in 2010, seized six hundred million in cash from Tamil Nadu alone in 2011 and held incident-free elections in Uttar Pradesh in 2012.

Inclusivity of Diversity

A very important concern for elections in this diverse country is inclusiveness. From the process of registration to polling, it is a very sensitive and often very challenging issue. The Commission has to deal with twenty-eight states and seven union territories; a great mountain zone in the north (Himalayas), vast plains in the north and central parts, a desert region in the west, forests all over, and a long coastline surrounding the peninsula in the south; four seasons (winter, hot summer, monsoon and post-monsoon); many religious groups (Hindus, Muslims, Sikhs, Christians, Jains, Buddhists, to name the major ones); about a 30 per cent urban and 70 per cent rural population and twenty-two official languages listed in the VIII Schedule of the Constitution and 1,652 dialects spoken across India. To add to this, the literacy rate in the country is an unhappy 74.04 per cent (82.14 per cent for men and 65.46 per cent for women as per Census 2011).

To deal with each of these concerns, the Commission has individual measures in place. There are specific directions for registration of nomads, homeless persons, youth, women, transsexuals, etc., as voters. The registration of about 800 million voters is done by about 4,000 electoral registration

An overview of the highest polling station, 59—Hikkam, (15,000 feet) in the cold desert of Lahaul & Spiti district

officers who are not on the permanent rolls of the Commission. The real challenge is the fact that we have a system of continuous revision of rolls interspersed with declared schedules of summary or intensive revision, implying that any eligible person can apply for voter registration at any point in time during the year and the non-permanent administration is obliged to take up the case. It is a rather difficult scenario on the face of it, but the Commission has made several systematic interventions to ensure streamlining of the process for both the voters and the election staff.

The creation of Booth Level Officers (BLOs), one at every polling station in the country, has been one of the best interventions for voter registration, particularly for the illiterate and for those who have no access to the internet. The BLO is like the friend and confidant of existing and potential voters. Besides online registration, they set up voter facilitation centres targeted at registration of women, youth, homeless persons, residents of old age homes and students enrolled in higher educational institutions.

Yet another example of the inclusive approach are the efforts towards making the system illiterate friendly. To deal with

this, each candidate is given a symbol by which he/she can be easily identified by the voters. The list of symbols is very interesting. A candidate can choose anything from a television to a broom as a symbol. (Which incidentally was the symbol of the Aam Aadmi Party which achieved a stunning win in Delhi Assembly elections 2013.)

For Easy-to-Recall Symbols, You Have Sethi's Pen to Thank

Records with the Election Commission of India (ECI) show that both political parties and voters have a single man to thank for the unique symbols which serve as the identity and a sort of a 'trademark' for the candidates. The Late M.S. Sethi, who retired from the ECI in September 1992,was the last draughtsman employed by the nodal body to sketch symbols. Back then, Sethi and a team of ECI officials would sit together and think of daily objects that the common man could identify with. Many established symbols of political parties—bicycle, elephant, broom—were born of these sessions. Some not so familiar objects too were suggested by this group—a pair of glasses, a nail cutter and even a neck-tie, which was popularly worn by the English-speaking crowd post-Independence.

As officials named objects in the meeting, Sethi would sketch them using his kit of HB pencils. In the late 1990s, almost a decade after Sethi's retirement, the ECI compiled a collection of a hundred of his sketches, known today as the list of 'free symbols'. This list is circulated during every election across the country. K.F. Wilfred, principal secretary, ECI, said, 'The post of a draughtsman was abolished after Sethi's retirement. The present list of free symbols is made entirely of his designs.'

In 1996, during the Tamil Nadu Assembly elections in which 1,033 candidates contested, the ECI allowed candidates to 'modify' objects on Sethi's list. After this,

in the late 1990s, the list of symbols was 'restricted' to hundred. Most of the symbols Sethi designed were of products of his era. ECI officials say people often mistake the TV set in the symbol list for a microwave! 'A mobile phone, or a SIM card is not likely to be included in the list any time soon, since of the 100 symbols, only six have been reserved by national parties so far,' Wilfred said. State parties can only reserve their symbols in their respective states. To reserve a symbol, a political party has to field its candidates in more than ten constituencies. Parties which do not fulfil this criteria have to choose from the list of free symbols. In subsequent elections, these symbols are declared free again. In the absence of any documented records, only scattered memories of the artist who continues to give identity to generations of politicians remain. A few senior citizens, who were his friends, remember him as a soft-spoken artist and a painter.

Source: Ananya Bhardwaj, Pritha Chatterjee, *The Indian Express*, 4 December 2013.

The symbol fan
as seen by an enthusiastic observer

The Commission is very strict about removing all symbols, pictures and photographs, which in some way are likely to influence voters in favour of a particular party or candidate from polling venues on polling day. Sometimes, this can be interpreted in a very convoluted manner. In a bye-election in Gujarat in 2010, held in the middle of the hot, desert-induced summers in the state, a particular independent candidate chose a 'fan' as his election symbol. Gujarat is a state where temperatures below 42 degrees Celsius are considered pleasant but this was a period of unpleasant heat. The observer appointed by the Commission went hammer and tongs after the district election administration to remove all fans from all the polling stations, as he was convinced that one look at those fans by

the unsuspecting voters was enough to persuade them to vote in favour of the said candidate! It took a great deal of patient cajoling to convince the observer that this was too far-fetched an interpretation of the Commission's directives!

Personnel Management

Scalability is the key. Given that elections usually take place at intervals of five years, having a large full-time team of dedicated staff available for looking after aspects other than conducting elections is not feasible, as they would remain idle during the non-election period. The ECI at the state level has only a small core staff for conducting elections. Elections at the field level are conducted only by civil servants whose services are temporarily requisitioned by the ECI.

Elections being highly human-resource intensive, personnel management obviously has to be rather comprehensive and sophisticated. But the numbers in India are dizzying. For example, each of the approximately 930,000 polling stations in India requires a polling team of five persons inside the polling station. Outside the polling station there are sector officers to monitor the elections process (one sector officer per ten–fifteen polling stations). Besides these, there is also elaborate machinery for monitoring the Model Code of Conduct, for monitoring election expenditure and for maintaining law and order. For each constituency there is one returning officer and at least two assistant returning officers. Each district has a District Election Officer (DEO) who is in the overall charge of elections in the district. At the state level, there is a Chief Electoral Officer who is assisted by a staff of fifteen–twenty people.

The specifics of this management are so huge and sometimes so complex that any normal administration—public or private— will use the words 'humanly impossible' if presented with the prospect of taking over. The management of personnel involves,

among others, selecting personnel through a random selection process, issuing appointment orders and allocating work areas.

To complicate matters further, personnel are allotted polling stations on a random basis to avoid bias, and they are not told till the very last moment the name of the polling station where they have to serve so that they cannot be approached and compromised. These persons have to be properly trained. Arrangements have to be made for their transport and stay, food and drinking water. In order to facilitate the election staff to exercise their franchise, postal ballots have to be issued to them. They have to be paid remuneration on time. It would suffice to say here that the fact of delivery of near perfect elections reaffirms each time that there is a unique management style that has been adopted by the Commission, which leaves nothing to chance.

Material Management

Material management for conducting elections in India is a stupendous task. An interested reader can see the ECI's website for details (www.eci.nic.in) and go through the checklists for CEOs, DEOs and ROs. These checklists are based on all the laws, rules, directives and day-to-day instructions of the Commission for conducting elections and each of them runs into eighty-five pages each or more! This is certainly a monumental management exercise that is not even taught at some of the best business schools in the world!*

Polling Officers' Kit

In the pre-poll phase several activities are taken up such as preparing a comprehensive and standardized list of election materials and making them ready for actual use. This includes

*Late in 2012, Harvard did start discussing with the EC about developing some case studies.

preparing the electoral rolls (electoral register), polling stations, ballot papers to be pasted on EVMs, Braille ballot papers and postal ballots; procuring important items such as indelible ink, paper seals, brass seals, other items like twine, paper clips, pins, rubber stamps and ink pads; printing all the forms to be filled on the day of elections and preparing the EVMS. It may surprise many that in all there are 122 items in each polling station's kit! This, of course, does not include several other items like video and still cameras, vehicles, wireless radio communications sets, computers and printers that are used outside the polling station. Each of these items has to be procured in time, their quality and dependability needs to be tested and then they have to be distributed to all concerned after giving requisite training regarding their proper use. There has to be adequate reserve kept in such a manner that replacements, if necessary, can be done in the shortest possible time on polling day.

Security Management

Unique security plans are made for each election based on the local conditions. Vulnerable booths and communities are identified for providing additional security, which may include both static security at the polling stations and also mobile security teams. While the primary security duty is assigned to the state government police and state government armed reserve, the ECI also provides for central armed police forces to ensure neutrality in the elections. An innovative measure is the use of non-police personnel also during elections for peripheral security duties by declaring them special police officers under law.

Extensive use of appropriate technology is considered necessary by the Commission to facilitate free and fair elections. Though this is discussed in detail in Chapter 7, a peep into the multifarious world of technology and its innovative use by the Commission is given here:

- The Commission has been using EVMs for conducting elections for over fifteen years. Aside from being voter-friendly and an excellent time saver during the counting process, EVMs are also very environment-friendly. By using EVMs in all the polling stations in the country in the 2009 general elections, 11,000 metric tonnes worth of paper was saved!

- A new text or SMS based monitoring system was used. Through this system pre-coded messages are sent at predetermined times by polling officials from polling stations which enables senior officials to know the exact status of polling on poll day.

- Use of webcasting from sensitive booths was first experimented with to overcome the challenge of monitoring remote and inaccessible areas. The entire proceedings in the polling stations are telecast over the web for control rooms at the district, state and ECI levels and even for the general public to monitor.

- Use of information technology for managing electoral rolls had its beginnings in the 1990s, but it was only in 2010 that the full infrastructure was set up for the entire rolls to be hosted on servers. Additions, deletions and corrections are done in the database by subordinate offices over the web.

- A single toll free 24X7 complaint number, 1950, for election related complaints, is a unique addition.

- The Commission uses a multi-modal approach for information management. All important information is posted on the website of the Commission so that it can be accessed by everyone easily. Facility for searching names in electoral rolls in provided on the website of CEOs.

Education for Voter Participation

Democracy is meaningless without people's participation. Therefore, a systematic effort towards voter education is now

made through the strategy for Systematic Voter Education and Electoral Participation (SVEEP) (see details in Chapter 8). Under this programme, a detailed strategy has been planned to ensure that all registered voters enrol themselves in electoral rolls, come to vote in elections and follow ethical practices like voting without fear or inducement. There is a cafeteria approach, where all mediums of information dissemination are made available to subordinate authorities for local use, obviously catering to local requirements. These are not only limited to traditional methods like posters, banners, TV and radio, but also utilize voluntary bodies, field formations of government departments, women self-help groups, schools and colleges.

The voter education programme has now become almost omnipresent and follows the life cycles of voters. When an urban voter picks up the milk packets lying in a basket outside his door early in the morning, he may read voter education slogans on the milk packets. His electricity, telephone and domestic gas connection bills may all contain a line or two about his democratic rights and duties towards elections. He may encounter similar messages on the ATM screen just before he hits the button for 'cash withdrawal'. His children are likely to come back all charged up from school, exhorting him to register as a voter if he has not done so already. His boss in the office might just circulate an appeal from the election machinery of the state. It is as if the election machinery is following Newton's first law of motion, that is, it will continue to be in motion for voters' education and not rest unless acted upon by the force of a voter getting registered and then also turning up to vote!

Election Monitoring

Monitoring the massive polling operation is itself a giant exercise which is done through several means. An example

of monitoring is cited here that involves the use of observers for conducting polls. Observers are directly appointed by ECI and are senior officers from outside the 'poll-going' state. A roll observer is appointed for looking into the integrity and accuracy of the rolls under preparation for an imminent election; a general observer is appointed for monitoring the conducting of elections; an expenditure observer monitors campaign financing; police observers monitor the security set-up during elections and awareness observers oversee the efforts put in for voter education. In addition, micro-observers are appointed in polling stations on the day of polls and also on counting tables. Observers have been known to recommend changing of polling stations to make them more accessible, or changing officials who are perceived as partisan and even recommending re-polls on the basis of a sound assessment of the local situation and on the basis of evidence. They assist in augmenting the credibility of the Commission.

Preparing a Polling Station

Preparing polling stations is a mammoth task. For preparing one polling station (out of the more than 930,000 in the country) during a parliamentary election, the groundwork includes:

- Identifying the polling station within a 2 km diameter of the residences of a given set of voters;
- Ensuring it is a government owned building and not a private one, and never in a religious centre or a hospital;
- It must be located on the ground floor of the building to take care of the differently-abled, the old and the infirm;
- It has to have good ventilation, electricity connection and neat surroundings so that the polling personnel who stay there overnight and also the voters are not inconvenienced;
- It must have clean drinking water and washroom facilities;
- It must not be located in an area where the vulnerable

population has no access;

- It must have a ramp for differently-abled voters;
- Shade has to be provided for voters queuing up in adverse weather;
- It must not have pictures/photos/symbols of political leaders that are likely to influence the voters to vote for a particular party/candidate. The only pictures that are allowed are those of the President of India and Mahatma Gandhi, the Father of the Nation;
- No one can carry cell phones, weapons (even licensed), etc., within 100m of the polling station. Thus, a clear marking has to be done;
- Within 200 metres no campaigning is permitted and no vehicles are allowed; that, too, is to be clearly marked;
- No media person who is not accredited can come anywhere near the polling station. Thus, accreditation is to be done beforehand. Even if accredited, media persons can only stand at the entry point of the polling station and view the activities.

Measures for Poll Safety

Creating a suitable environment for free and fair elections is key. Vulnerability mapping of all the villages and hamlets in all constituencies is done to identify potential trouble-makers and their personal details and whereabouts are recorded. The vulnerable population and their contact details are also collated. Based on such specific information, appropriate confidence-building measures are initiated by the RO, DEO and police officials to eliminate and mitigate such potential threats to law and order on polling day.

Preventive action is taken against people who are likely to disrupt the elections by executing non-bailable warrants and by taking a legal bond under law promising good conduct. Checking on the use of licensed arms is done through scrutiny of licensees and temporary surrender of licensed arms as well

as seizure of illicit arms and ammunition. Prohibitory orders regarding carrying and displaying licensed arms are also promulgated. Strict vigil is kept over the law and order situation in the run-up to the elections. Every law and order problem is reported to the ECI headquarters. Checking the sale of liquor and preventing production and consumption of illicit liquor is also undertaken. Prohibitory orders regarding sale of liquor near polling and counting days are also issued well in advance. Police officers at the state, district and sub-district levels are brought under the control and superintendence of the ECI. Area domination activities and neighbourhood familiarization patrols are started a few weeks before polling day to instil confidence among the voters about peaceful conditions.

Communication Plan

A very meticulous communication plan is implemented. it includes response to complaints, controlling vehicular in the poll phase movement, tight security management and synchronized monitoring at all management levels for quick detection and prompt and effective resolution of any electoral poll day issue. To ensure that everything goes like clockwork, the polling party reaches the booth a day in advance with all the election materials and stays inside the booth building the night before the elections. This ensures that the mock poll (a trial to test the working of the EVMs) can be held early in the morning before the actual polling begins.

There are some interesting implications of conducting polls in such an organized manner. In the new SMS monitoring system of polling-day activities, hitherto untapped IT abilities of the polling personnel are coming to the fore.

Saving a New Idea

From the day I joined the Election Commission, there was a palpable feeling of inadequacy in its training and capacity

building systems and infrastructure. There was a clear need for a more structured and standardized training programme at all levels if eleven million poll staff members had to deliver a zero error election. Besides our domestic needs, requests had started pouring in from other countries to share our best practices and train their election managers. During one of my visits to Lucknow, Uttar Pradesh CEO Umesh Sinha raised the need for good training. 'Why not establish a national and international training facility?' we thought. While I was keen to name the institute the Indian Institute of Democracy and Election Management, like our well-recognized IITs and IIMs; Senior EC Advisor Bhagbanprakash insisted that we must include the word 'International' in the name as we proposed to have programmes for other countries too. Deputy Election Commissioner Balakrishnan contributed many bright ideas. My intention was to make him the first Director General of the institute but his sudden illness came as a dampener. Fortunately, a brilliant officer, Akshay Rout, had meanwhile joined the new Voter Education Division. He volunteered to take the additional responsibility and brought great energy into the effort.

Voter education, civic participation, research and international cooperation are areas that need continuous knowledge support in the information society of today. Efficient election management in a country of continental dimensions naturally requires high quality human resources. I shared my concerns with colleagues and we set up a national working group led by a reputed human resource development expert who worked hard and submitted an elaborate concept framework and project document.

The idea found instant international support and was even included in the Indo–US strategic dialogue before the visit of President Barack Obama in 2010. The Commonwealth Secretariat and its EMB forum also showed great enthusiasm along with many others including UNDP, IFES, BRIDGE and universities abroad. The then Law Minister, Veerappa Moily, found the idea exciting and promised full support. The Prime

Minister also showed keen interest, matched by cooperation from the Department of Expenditure, the Ministry of External Affairs and the Attorney General. However, without wasting any time, we created an improvised facility in the ECI premises and started offering domestic and international training courses on election management. The makeshift institute was inaugurated on 16 June 2011 jointly by the Election Commissioner of Kenya, Ken Nyaundi, and me. For its permanent and more befitting location, two acres of land was allotted by the government of Haryana. But our Delhi CEO, Rina Ray, insisted that we house this prestigious institution in Delhi and promised to locate suitable land for it. Due to her efforts, prime land was identified and acquired in the upcoming institutional area of the Dwarka sub-city, near the international airport at a nominal cost, thanks to Delhi's Lieutenant Governor, Tejinder Khanna. The foundation stone was laid on 30 April 2012 in the presence of the heads of the election management bodies of SAARC countries, all of whom planted a sapling each. We decided to inscribe their names on the foundation plaque giving them a feeling of partnership and participation. Mahindra Deshapriya, the Commissioner of Elections of Sri Lanka, made an interesting remark that in his forty years of public life, he did not yet have his name inscribed on any stone in his own country!

Good ideas are known to have a history of hurdles and IIIDEM was no exception. Presently, it gives us immense satisfaction that we saved the idea and converted it into a reality. In just two years, over forty countries across continents have sent their officials, including Commissioners, to learn the art and craft of India's election management. Some Commissioners labelled India as a global guru. Prime Minister Manmohan Singh, in one of my meetings with him, described it as a great initiative of soft diplomacy.

Duty with Pride

The professionalism that ECI brings to the exercise of conducting polls has even inspired some BLOs to request returning their remuneration due to the sense of pride that they develop in performing this national duty. So moved was an assistant teacher of a government school in Gujarat's Jamnagar district by his experience of participating in election work that he wrote to the EC urging that he should be remunerated. To have gained the chance to serve with sincerity in such a cause was his reward, he said. When ordinary folk think that way, we know the EC has performed well and democracy has takers*.

In the post-polls phase, safe transportation of sealed EVMs and of the staff and their records along predetermined routes to strongrooms for storage and to receipt centres for analyzing the records, is of utmost priority. Candidates are allowed to move along with EVM-carrying vehicles and to put their seals also on the strongrooms. Meticulous arrangements are made through a large number of dedicated counters for receiving different categories of election materials. This work invariably goes on all night and there have been almost zero cases of dereliction of duty despite hardships.

At the end of the day, the Commission's credibility depends on its adherence to its values and to the democratic process. This is the real cornerstone of a successful election. It is of paramount importance that people must have faith in the impartiality and capability of the Election Commission. Even the slightest perception of wrongdoing will lead to loss of credibility and effectiveness of the Commission. The Commission enjoys the full trust of all stakeholders not only because it is completely non-partisan, but also because, by its actions, it projects a completely neutral image. Every person who is deputed to

*'EC did a great job: can it do better', *The Asian Age* editorial (14 May 2009)

the Commission right from the poll staff to officers of the Commission must, in speech and deeds, make his or her neutrality clear to everyone. The Commission puts a lot of emphasis on this during the training of its staff members. And they have almost never failed the Commission. Those irrespective of rank who dared faced serious consequences, including immediate suspension and departmental inquiries that followed them for years, jeopardizing their career prospects.

ECI in Action—A Journalist's Peek

The EC could be my candidate for the most self-effacing organization in India. How little do we know about it or care! A week before the last phase of polling in UP, to research this column, I was a fly on the wall for the EC's drills. I wish they could be televised. They would do more for our confidence in our steel frame, the derisively typecast babu, than the people they help us elect. In scope and stakes, a management exercise of India's scale could feature in a Harvard case. Put in more homely idiom, the 'babu's bandobast' could well be a template for a daughter's wedding, with the entire country invited! This essay could well be dedicated to that unknown civil servant, teacher, bank manager and policeman, who we derisively call babu. To write this, I had to understand how the EC discharges its dharma with a staff of 300, the rest drafted on loan. To align them, train them, and motivate them around a mission to deliver a zero-error poll is as easy as nudging the Aussies into letting Sachin get his 100th ton*. But unlike the attention we give to the great player, we seldom bother about the men and women who give us the power of booting out our rulers. Team Anna's latest hobby horse, the right to reject, a process

*This was a reference to the Australian cricket team, repeatedly thwarting the legendary Indian cricketer, Sachin Tendulkar, from scoring his 100th cricket test century.

which would essentially mean another election if 'Mr None of the Above' is polled the maximum number of votes on the electronic voting machine, needs to factor these babus too. I wonder if Team Anna has met these babus, many of them women who leave their children and families to give us a political leadership.

Before this sweeping argument, I watched with closer interest the processes placed by the election babus to anticipate what could vitiate the D-Day. Matching a challenge of this kind is often about finding the right metric. The one here was simple enough: 'Turnout of every single voter.' I overheard deceptively simple questions: Are ramps in place for the handicapped? What is the status of voter slips to women? Has there been 100 per cent postal voting among poll officials? What may discourage the last 'purdanasheen' (photographs of all women candidates are erased out of the soft copy EC shares with political parties)?

I can't help but repeat an instruction that charmed me: For every man allowed to go inside the voting booth, two women must be allowed.

Over a NIC video link, I heard the bright IAS district magistrates of 10 districts in western UP offering specific and credible assurances on what the Chief Election Commissioner, S.Y. Quraishi and his colleagues V.S. Sampath and H.S. Brahma demanded. Incidentally, all three are former IAS babus. Not a single answer seemed to slip into no man's land, no 'fact' passed off without counter check. Sampath often remained quiet poring into the crisp two-pager, in a preordained format that had been supplied in advance. Brahma supplemented Quraishi's polite inquisition. The two-pager ended with three factors which the administration apprehended could torpedo the level playing field. Coming clean was a finer option. Reason? In the long run, the EC has the neck of these permanent civil servants for as long as they would superannuate. (A large southern state has questioned this sort of control by the EC, but the courts

have refused to buy the government's argument.)

The result is candour and a culture of professional pride. As a student of communication, I was struck how Quraishi's very first instruction in a multiple video link was to ask all NIC cameramen to give him tight shots of each babu while he was speaking. In close-up, question marks on India's much derided 'bamboo frame' appeared largely misplaced. Each district magistrate, who until a few weeks back must have been battling a survival war with the BSP satrap of Chief Minister Mayawati, seemed to morph into a professional to boot. His superintendent of police sat next brimming with details from the law and order angle. The revenue observer (an IRS import from another state) would assuage EC Director-General P.K. Dash's concerns on searches and seizures. The general observer (an IAS officer from another state) would give an 'outsider's peer review' as the eyes and ears of the common man. The rewards and punishment system seemed to ensure that no one had much interest in batting for the other man. Everyone's career was at stake. Yet, they were better off as one team, batting for Team India.

In one video link, the general observer hinted that he may be falling short of a company of paramilitary force. When pushed back, he tried to change his mind. But by then deputy EC Vinod Zutshi had ensured that the force had been sanctioned. Ten years ago, Zutshi would have had to beg the Union Home Secretary.

We have a stake in knowing how democracy is brought to our doorstep. But we don't. Who can we blame? It's never nice to blame the mainstream media.

Well, thanks to the babus, the flags have gone. The jeeps in the convoy can be counted on one hand. EC's digital cameras have trailed even the 'honourable' Raja Bhaiya, IPS babus from other states make checklists of men rounded up under preventive detention, each firearm seized and the last cartridge

deposited, the last gram of heroine seized. IRS folks turn the screws on electoral funding. The rule book doesn't help them control expenses of parties, but individual candidates were curbed through a byzantine net of affidavits amounting to perjury, registers, complaint helplines, name-and-shame, model code notices, and raids. Hopefully, the EC will now focus on more proactive policing like raiding dens of black money.

My tuppence to EC in 140 characters: 'You are our hope. Sure, You "babus" threw "fun" out of the window. Thank God, You did!'

(*Source: Governance Now* and www.governancenow.com March 2012 by Rohit Bansal).

This report by Rohit Bansal, a senior journalist, is a case study in itself. Although an old personal friend, he was bitterly critical of many things that the EC does or does not do. Like many of his tribe, he thought he knew it all and we were all nincompoops. Fortunately, he readily responded to my invitation to have a peek at some of our activities. What he saw was enough to change his opinion about us, 'the babus', particularly those working under the command of the Election Commission.

The reality is that what he was exposed to was only the tip of the iceberg. Even that limited exposure convinced him that Indian people in general, and the media in particular, know very little about the great Indian election machine. The fault is probably ours as we do not expose the management of what is perhaps the biggest human event in the world. Even with the little exposure of our election management exercise, Rohit remarked that the Indian elections are perhaps the biggest undocumented wonder. I thought that would be a good title for this book!

4

INCLUSIVE ELECTIONS:
REACHING THE LAST VOTER

A ninety-two-year-old voter being carried to the polling booth

Death of a Polling Booth

What does the ECI do when three hundred and fifty people registered in a particular polling station decide to migrate to another area leaving only one voter behind? It simply continues to maintain the polling station for the lone voter! Four decades ago, Charangattu estate, situated in a dense forest near the hilly Kakkayam dam site was operational and several voters were employed there. This is a part of the Vadakara Lok Sabha and Perambra assembly constituency in Kozhikode district in Kerala.

Over the years, the estate became defunct and all its inhabitants except Charangattu Dasan, left to settle elsewhere. Dasan had joined the estate as an employee in 1968, and continued to live there until his last breath, doubling up as a watchman for whatever was left of the estate. An unsuccessful attempt was made to convince him to vote at a nearby booth with more voters. In the face of his refusal, the Election Commission chose to respect his right and, during the 2004 Lok Sabha elections, it decided to set up a polling station for him alone, even if it meant transporting a polling party of six officials—three polling officers, two policemen and a driver—an EVM and other election material to the site. A polling station was set up for him as per ECI norms, near his place of stay, in the office of the assistant engineer of the Kerala State Electricity Board. Polling officers had to wait till noon for the first—and the last—voter in the booth.

Charangattu Dasan died in 2007 and a newspaper reported his death with the headline 'Death of a Polling Booth'.

Single voter booth at the Kakkayam dam site in
21 Perambra LAC in Kozhikode district.

Indian elections are not just about big numbers, they are also about concern for every single voter. That is why the ECI has deployed several mechanisms to ensure that not a single eligible person is left out. Appointing Booth Level Officers to reach every house, vulnerability mapping for identifying those who are suppressed and prevented from voting and celebrating National Voters' Day to focus on the youth, especially those who become eligible to vote on turning eighteen are some of the interventions to penetrate the layers in order to reach the last voter.

Voters are not a homogenous group anywhere in the world. The Election Commission has to go through several layers of systems, manpower and other logistics to reach them. It also has to deal with the fact that though there will be voters who are active participants in the election process, there will also be those who are indifferent to the whole process. In a country like India where geography, history, culture, language, religion, ethnicity, customs, socio-economic realities and power relations are so diverse, there cannot be a simple solution.

Since democracy implies participatory governance, an election, in order to be inclusive, must cover all categories and strata of the population and ensure all measures to facilitate and enable every eligible voter to vote, irrespective of all differences, whether it be geography, demography, ability, language, gender or age. Such inclusivity has to relate to various stages of the electoral process including enrolment and registration of voters, representation of social and ethnic groups such as women, backward and schedule castes and tribes and, of course, the nomination process of the candidates.

Over the years the ECI has carefully identified categories of voters with special needs or those voter groups who are unable to actively participate in the democratic process of elections. It is commonly understood worldwide that the differently-abled, illiterate, ethnic and other minorities and those living in far-flung areas constitute voters with special needs. However, the

Commission broadened the special focus categories to include youth, women, NRIs (Non Resident Indians), migrants, the homeless, voters who are vulnerable from the point of view of security, nomads, transgenders and sex workers.

Lastly, but most importantly, the ECI is alive to the fact that without full participation of every section, elections can never be considered absolutely 'representative' even if they may be 'peaceful'. The ECI endeavours to ensure an enabling environment for each voter to vote without pressure or undue influence. While doing so it focuses on putting in place user-friendly, honest and transparent processes while instilling a sense of confidence, justice and belief that every single vote counts.

Deep in the forests of Una block in Junagadh district in Gujarat, there is a century-old temple of Lord Shankar, popularly known as the Banej Temple. It is looked after by fifty-nine-year-old Guru Bharat Das, a disciple of Guru Darshan Das, a priest who has dedicated his life to the service of the Lord for about thirty-five years now. This temple is situated about 20 km from the nearest habitation, village Sapnesh Biliyat. Aside from this priest, the only other inhabitants in the forest are lions, leopards, nilgais and deer. There is no bus, train or any other form of public transport connectivity to this area. The priest survives on the food and other subsistence items brought to the temple by the devotees. The devotees only visit between sunrise and sunset. None of them ever dares to brave a night in this forest with the priest.

Close to the kacha (unpaved) road leading to Banej Temple there exists the only other construction in this wild forest in the form of a small room made by the Forest Department. For the last thirty years, this room has served as the polling station for the lone voter in the area. In every parliamentary or state legislative assembly elections, a polling booth is set up in this room with all the necessary paraphernalia including an EVM. Elections are the only time when the priest has overnight human company in the wild forest. Members of the polling party camp

in the forest building about twenty-four hours prior to the date and time of actual polling as per the guidelines of the ECI. Of course, the priest shows his democratic inclination by never missing to cast his vote! However, even if he casts his vote in the forenoon, the polling party stays back till the end of polling hours just in case someone might like to challenge his vote! After all, the law has laid a procedure for a 'disputed vote'.

A.R. Krishnamurthy, son of B. Rachiah, a former Governor of Kerala, was widely reported to be the first contestant in India to lose by one vote. He lost to R. Dhruvanarayana in the Santhemarahalli constituency in Karnataka during the 2004 state assembly elections. Through the counting process, there were moments of anxiety and ecstasy, hopes and fear as the lead position between the two candidates kept changing. When Dhruvanarayana was declared winner, his opponents asked the returning officer for a recounting of the tabulated figures. The process was repeated and finally the result was declared at 8.00 p.m., after a delay of eight hours. In the photo finish, Krishnamurthy, the incumbent, secured 40,751 votes; but Dhruvnarayana, with 40,752 votes, won by a margin of one vote.

That may have been the first one vote result for Karnataka, and may be in the whole country since the introduction of EVMs in 1998, but factually, he was not the first to lose by one vote. There have been such cases prior to this incident. Close margins always lead to a recounting of votes amidst grave tension. In the pre-EVM days, the manual count process was a lot more complex because of the possibility of human error. Sometimes, there was recounting of the recount too, when the latter showed a discrepancy.

Interestingly, not only a one vote margin, even a 'tie' has occured at least twice. On 2 February 1988, in the assembly constituency of Kherapara in the West Garo Hills district, Meghalaya, a tie occurred between Chemberlin Marak (Independent) and Roster M. Sangma (INC), both polling 2,591

votes. The returning officer declared Marak the winner by a draw of lots.

In an earlier case in 1974, in the Benolim assembly constituency in Goa, something like a toss-up situation arose out of an election petition. When the Bombay High Court found that the rival contestants had actually polled the same number of votes, the fate was also decided by the draw of lots.

A newspaper report suggests that a study by some American psephologists found that in the history of the American democracy, in 16,577 national elections since 1898, only one electoral result was decided by a single vote.[1]

Power of One: The C.P. Joshi Story

The story of C.P. Joshi has a lesson for all those who fail to understand the power of one vote in an election. C.P. Joshi (born 29 July 1950) is an experienced politician from Rajasthan who was a Member of Parliament from Bhilwara in the fifteenth Lok Sabha and was sworn in as Union Minister for Road Transport and Highways on 22 May 2009.

In 2003, as an opposition MLA, he was appointed President of the Rajasthan State Congress Committee. In a few months, he brought the state unit together to win the 2008 assembly elections. But he lost his own seat by one vote! Surprised and shocked, he appealed for a recount of the postal ballots. The total number of postal ballots was 501, out of which 158 were rejected. There were five candidates in the fray—Kalyan Singh, Ramesh Chand, Lalit Tiwari, Ramchandra and C.P. Joshi. Out of the 343 valid votes, Kalyan Singh got 217 and C.P. Joshi 122, Ramesh Chand 1, Lalit Tiwari 2 and Ramchandra 1. Joshi wanted a recount hoping for a possible mistake in the counting since there is no scope—or need—for recounting in the EVMs and thus, his last hope was the postal ballots, the only paper ballots. The result was the same even after a recount. Joshi's final tally was 62,215 votes against Chauhan's

62,216. He then requested a re-tabulation of the totals of each EVM as totalling is done manually. The result was the same. As a mature and sagacious politician, he lost no time in congratulating the Election Commission for a fair election. Yet, the irony is, as reported, that two members of his family did not turn up to vote on the polling day! Since he was the party president in the state, had he won, he would probably have become the Chief Minister.

Similarly, during elections to Madhya Pradesh Legislative Assembly in 2008, Neena Vikram Verma was elected with a margin of only one vote over her rival candidate Balmukundsingh Gautam in Dhar constituency. While Balmukundsingh polled 50,509, Neena Vikram Verma polled 50,510 votes. The returning officer declared her the winner.

The power of one vote played out in another interesting case, this time in Parliament, that was closely watched at the national level as well. Those were the days that saw the beginnings of various coalitions as the only way of obtaining majority in Parliament to form a government at the centre. In 1998, the national government was formed under the prime ministership of A.B. Vajpayee of the Bharatiya Janata Party (BJP). Thirteen months after this government took over, one of the allies of the ruling party, the All India Anna Dravida Munnetra Kazhagam (AIADMK) withdrew its support from the government. A vote of confidence had to be resorted to. The ruling coalition lost the vote of confidence held on 19 April 1999 by one vote. The opposition, however, was not able to garner the required numbers to take over the reins of the national government. So the ECI had to conduct parliamentary elections again within six months.

ECI Partnering with Corporate India—India Voting

Just as each vote counts, it is necessary for each segment of the population to be accounted for in the elections. Be it urban

youth, women in the workforce or the modern day corporate worker moving to a different city every two years, these citizens need to be registered as voters for there to be true representative democracy.

A good cause can come to life by the sheer force of persuasion and persistent advocacy. In September 2013, Som Mittal, then president of NASSCOM, referred my way a charismatic lawyer and MNC executive, Hitesh S. Barot, who had proposed an innovative partnership. Troubled that many young people were not voting because they did not have voter cards, he wondered whether members of the corporate and industrial sectors could partner with the Election Commission of India for voter registration and awareness. This was, in fact, one of the ECI goals, and I encouraged him to speak with other industry leaders. FICCI Secretary General, Didar Singh, was immediately sold on the compelling idea by the double Berkeley graduate. As the Honorary Chairman of the not for profit organization, Centre for Ethical Life & Leadership (CELL), I suggested that Hitesh should utilize the CELL platform to propel the initiative. Soon thereafter, Subodh Bhargav, Chairman of CII's Public Policy Council and D.S. Rawat, Secretary General of ASSOCHAM were also approached and recognizing the importance of the cause, both agreed to lend their support.

The ECI was approached, and naturally it showed great interest, sought a written submission from the partners and promised to study the matter. The approaching National Voters' Day celebration of 25 January acted as a catalyst to accelerate this partnership. On National Voters' Day, Pranab Mukherjee, Hon'ble President of India, made a speech exhorting corporates to get involved in voter registration and that provided the final burst of energy to the enterprise. The initiative was quickly launched on the website www.indiavoting.org and gained immediate acceptance with the likes of Shekhar Kapur and Sam Pitroda tweeting about it. The Chief Electoral Officers of the states welcomed and supported the initiative with all gusto. On-

the-ground partners like Nasscom Foundation's MyKartavya, Volunteer for a Better India and Bangalore Political Action Committee swung into action. In all, given the cumulative size of the membership, employee-base and affiliated organizations of the industry bodies, the call to action reached approximately 1.5 crore inboxes. CNBC covered the campaign with a thirty-minute feature on how corporate India was coming together to fight voter apathy. India Voting gave the urban employee of corporate India an opportunity to register without leaving their campus or office cubicle. Capgemini, Wipro, TCS, Reliance and ICICI Bank were amongst the hundreds of companies that took part in promoting voter registration of their employees. A historical precedent had been set with a readymade template for getting Corporate India involved in registration and awareness opportunities going forward. In future elections, with additional time for meticulous planning, the same coalition of partners can build on this framework and even extend it from corporate campuses to college campuses.

Women as Equal Partners

The foremost demand of inclusivity in our democracy certainly is to include women.

The Indian National Congress and several other leaders of the freedom movement never really saw any dichotomy between the need for universal suffrage and the goal of representative democracy. Therefore, every effort that was made towards women's suffrage before 1947 was fully supported by most Indian opinion makers to the chagrin of the British Raj.

In 1917, Sarojini Naidu and Margaret Cousins, along with a few others, formed a delegation of women and went to England to meet the Viceroy to demand suffrage for women. Sarojini Naidu was a respected Indian freedom fighter and a poet of national fame, well known for becoming the first Indian woman president of the Indian National Congress in 1925. Margaret

Source: The Pioneer, 8 February 2012.

Cousins was an activist known for her pioneering role in the Irish movement for women's suffrage in the first half of the twentieth century. The British did not agree to bring in this reform in India at that time. However, they conceded that the provincial legislatures would be free to take a call on this. In 1919, when a few constitutional reforms took place and provincial legislatures came into being, this demand was placed for discussion before them. Madras became the first province to take the revolutionary step to allow women's franchise, which was followed by women also participating in elections. Britain, of course, was utterly shocked particularly because the only progress it had made on home turf in this regard was very recent and hard fought. In 1917 Britain had decided to extend suffrage to British women aged over thirty years but with some conditions attached, such as holding a college degree or being a householder or being married to a householder. It was only in 1928 that Britain extended universal adult suffrage with no

conditions. India, meanwhile, had progressed further by that time. A forty-one-year-old medical doctor, Muthulaxmi Reddy had become the first Indian woman to become a member of the Legislative Council in Madras in 1927. In contrast, Britain, in its three hundred years of democratic history, had the first, and the only woman leader of a major party in 1977, when Margaret Thatcher became the head of the Conservative Party and subsequently the only woman Prime Minister in 1979. Indira Gandhi had already been the Prime Minister of India for a decade-and-a-half by then!

Women waiting patiently for their turn to exercise their franchise in Ahmedabad—State Assembly election, 2012

Source: IANS. 'Gujarat set for final round of polling'. 16 December 2012.

Today, the Speaker of the Lower House of Parliament and the chief ministers of two states in India are women. Just a couple of years ago, we had a female President and three women chief ministers. But the empowerment at the top has not trickled down. Despite the glorious past and bright present, there are obstacles to the complete and unhindered engagement of women in the election process. The hindrances include traditional

and cultural barriers and social norms that are compounded by gender stereotypes, illiteracy, lack of awareness, lack of motivation, safety and security issues including intimidation from males and inability to step out of their roles as mothers, wives and homemakers.

Registration of Women Voters

India suffers from one of the lowest sex ratios among the South Asian countries. Provisional figures in the 2011 Census of India put the sex ratio of the country at 940, the highest since 1971. But among the ten most populous countries of the world, only China is behind us with a sex ratio of 926. Similarly, the female literacy rate was 65.14 per cent in 2011 as compared to a male literacy rate of 82.14 per cent. With this background and awareness about the socio-economic-political milieu, several steps were taken by the Commission to ensure that eligible women are not left out from attaining their right to register and exercising their right to vote.

There is a very comprehensive system of statistical analysis in place in the Commission to ensure that no citizen of eighteen years age is left out of the electoral rolls. It calculates the gender ratio, the elector–population ratio and the age cohort of voters as against the population figures given by Census, which are projected on an yearly basis with the help of the decadal growth rate. This kind of broad strategy then forms the basis for developing a polling station-wise strategy for positive intervention by the electoral registration officer of each assembly constituency to ensure that not one eligible voter is left out. An analysis of the gender ratio is one of the main focus areas in this strategy, which has been scrupulously followed since 2006.

It was felt in the middle of the last decade that due to the social structure of Indian society, which is still somewhat restrictive for women, some radical efforts needed to be made. Consequently, the system of appointing Booth Level Officers (BLOs) was devised and recently, the Commission has initiated

the system of annual house to house verification of voters with the help of the BLOs. A BLO is a government or semi-government functionary (like a school teacher or patwari (revenue official)) who is designated to work within the geographical limits of a single polling station area for the purpose of voter registration, roll verification and awareness building about electoral processes. This is an additional responsibility and in lieu of these functions, they receive a small honorarium. Out of the 824,000 BLOs in the country, a substantial number are women and that has been a major contributory factor in an enhanced registration of women voters. For instance, in West Bengal, most of the districts took an initiative to reach out to the women through anganwadi workers (village level child welfare workers); some also roped in women's self-help groups. Partner agencies like Nehru Yuva Kendra Sangathan (NYKS) and the Song and Drama Division of Government of India were also involved. Prior to the assembly Elections in 2011, senior officers of the office of the CEO, West Bengal, emphasized on issues pertaining to women's participation in television programmes. The shows on All India Radio and other FM channels too dwelt on the issue.

A concern that is taken into account while publishing photographs on the electoral rolls is the socio-cultural gender related sensitivities in the country. It is mandatory to give hard copies of these rolls to recognized political parties during every revision at the draft level, as well as of the final publication. These rolls are also shared with various government departments, academics and researchers and civil society groups, if they so require. However, it is the policy of the Commission to share the soft copy of the rolls without photographs of the voters keeping in view cultural sensitivity about women. It was felt that a soft copy of women's photos could be subjected to abuse like morphing. The printed copy with a small postage stamp size photo was considered good enough for identification. With regard to non-inclusion of women in electoral rolls on

account of shifting of residence due to marriage, a number of FAQs were designed to address the issue of electoral rolls of newly married women in their spousal families.

Female Participation in the Voting Process

Several steps have been taken to encourage and facilitate women's participation on polling day. For one, there are separate queues for men and women. To make it faster for women, in the Uttar Pradesh elections in 2012, it was decided to allow two women in the queue to proceed for every one man. This worked wonders as their queues moved very fast and the women were able to return quickly, which motivated others to go and vote. This has been made a nationwide practice. There is invariably one female polling staff member to take care of the sensibilities of female voters who, for example, may not like to have a male polling staff member applying indelible ink on their fingers or they may prefer to be identified by a female staff member. All-women polling stations are set up with only women staff members in areas with purdahnasheen (veiled) voters. Women police forces are also deployed with a view to encouraging female voter turnouts.

Pre-election Survey

Since 2010, when a voter education division was set up, a system of a Knowledge, Attitude, Behaviour and Practices (KABP) survey has been taken up as a mandatory pre-election activity that has revealed several reasons why female turnout is lower than that of males. In fact, KABP has emerged as an important election management tool to assess voter perceptions about physical and psychological barriers amongst various voter segments. The surveys have empowered election managers in addressing various issues that the voters face. The knowledge and insights gained from these surveys have also led to the fulfilment of service gaps hitherto unknown.

An analysis of gender-disaggregated data in the electoral

rolls indicated a considerable gender gap, much below the national population ratio. The survey highlighted areas where interventions were required. Concern for personal security (as women feared that polling booths attract antisocial elements), dependence on the approval of family elders, especially men, and lack of adequate toilet facilities were some of the factors that kept many women away from voting. Consequently, a communication targeted at family elders to break their resistance to women of the family participating in polls and messages allaying fears on security were included in the overall communication campaign.

Women voters show their ink-marked fingers at a polling station after casting their votes

Source: IANS. 'Delhi Votes, India Watches.' 4 December 2013. Photo credit: PTI

The innovations continue, for example, in the Bihar state assembly elections in November 2010, the strategy included motivation through generating awareness by having a popular local female icon, Sharada Sinha, as the face and voice of the campaign. The focus of the strategy was twofold—provide a

safe and secure environment for voting to women and motivate women to come out and cast their votes as a sign of their empowerment. Areas with relatively greater gender gaps were identified for increased ECI intervention; this worked. As a result, female voters at 54.85 per cent outnumbered male voters at 50.77 per cent—a clear lead of eight per hundred.

Participation of Women as Candidates

Active political participation of women as candidates is an issue that is attracting the attention of legislatures, law making bodies, women activists and pressure groups universally. Let us look at some figures. The total percentage of women in parliaments in the world as per data on *www.ipu.org* updated on 5 February 2014 was only 21.4 per cent in both the houses combined.

Table 4.1 gives a comparative analysis of India and some of her neighbours. There appears to be no correlation between the size and population of a country and the number of women who are members in its legislature.

It is interesting to note that Muslim countries in South Asia like Afghanistan, Pakistan and Bangladesh have very high female representation despite an image of conservatism, not just when compared to the Arab world but when compared to India as well.

More or less the same story is reflected in female membership in state legislatures in most parts of the world. However, the real dent in this age-old issue was made in India with the enactment of the seventy-third and seventy-fourth amendments of its Constitution. On 27 August 2009, the Union Cabinet approved an increase in reservation for women from 33 to 50 per cent in Panchayati Raj Institutions (PRIs). A number of states have also introduced 50 per cent reservation for women in municipalities and corporations. Regarding state assemblies and the Parliament, a bill for women's reservation is pending with the Parliament, which has been debated ad nauseum for the past several years, but is yet to be passed.

No major studies have been conducted, but there is enough evidence to show the connection between the participation of Indian women as candidates in local body elections and their subsequent participation in all other democratic processes.

Table 4.1

S. No	India and some neighbouring countries	Sex ratio (male/female)	Percentage of women members in the Lower House of its Parliament	Percentage of women members in the Upper House of its Parliament (where it exists)
1	Afghanistan	1.03	27.7	27.5
2	Pakistan	1.06	20.7	16.3
3	China	1.06	23.4	-
4	Bangladesh	0.95	19.7	-
5	India	1.08	11.0	10.6
6	Bhutan	1.10	6.4	8.0
7	Sri Lanka	0.96	5.8	-
8	Myanmar	0.99	6.0	1.8

Source: IPU Women in National Parliaments World Classification. http://www.ipu.org/wmn-e/classif.htm; CIA World Factbook, https://www.cia.gov/library/publications/the-world-factbook/fields/2018.html

Nomads, Homeless Persons, Sex Workers, Transgenders and the Differently-abled Voters

India is a country where different and sometimes contrasting cultures and ethnicities exist side by side in a harmonious fashion.

So, on the one hand, while a majority of the communities are patriarchal and patrilineal, we also have traditional matriarchal and matrilineal communities in the Northeast (Khasi tribes of Mizoram) and the south (Nairs in Kerala). Similarly, while monogamy is the general rule, polygamy and polyandry also exist. Further, while settled habitation is the rule, the exception, that is, nomads, also exist. Nomads in India are persons who are identified as de-notified tribes. The Criminal Tribes Act, 1871 of the British era notified several tribes unjustly as habitual criminals giving sweeping powers to the police to arrest members of these tribes on grounds of suspicion at any point in time. This Act was repealed in 1952 and, therefore, these tribes are now known as De-notified Tribes (DNT).

It is not easy to locate DNTs and enrol them as voters. They are always on the move and do not stay at any one place beyond two to three months. Special efforts have been made by the Commission to mainstream them in the electoral process. Just as an example, before the Legislative Assembly elections in Gujarat in 2007, it was decided that the state election machinery will coordinate with the Department of Social Justice in the state government to actively enrol persons from various DNTs in the state as voters. District social welfare officers and District Election Officers (DEOs) from eleven districts got together and identified the areas where DNTs were temporarily found and devised a system under the directions of the Commission for fulfilling the legal requirement of being 'ordinarily resident' of a place to be enrolled as a voter of that polling station. Grass-roots level revenue officers (or the talatis) were empowered to do a panchnama* of such persons wherever they were located on the day when this exercise was done. Certain NGOs that had been actively working with these tribes also got involved in

*A panchnama is a local term used for a document, which is prepared in the presence of two or more independent witnesses to record any proceedings.

certifying the panchnamas. Just before the 2007 state elections, after due verification and with these efforts, 3,393 members of various DNTs were registered as voters and most of them exercised their franchise. Since then it has become an ongoing process in Gujarat. In 2011, when over 5,000 of them got together at one place for a 'Ram Katha' (a religious discourse), voter registration counters were immediately set up and almost 1,000 persons registered as voters.

The Commission has identified other such categories of voters whom it is not able to reach due to its stringent guidelines for giving proof of residence to apply for registration as a voter. So it relaxed the provisions for producing documents as proof of residence for some more categories of voters, that is, homeless persons and sex workers.

Transgenders

A few years ago it came to the notice of the Commission that some voters were not enrolling as they refused to be identified as either 'male' or 'female' in the voter registration forms, as they were transgenders. This has an important implication for contestants in local body constituencies reserved for women. Therefore, in November 2009, the ECI directed all the provinces to amend the format of the application form and the electoral rolls to include a column entitled 'others' to enable transsexuals to tick this column if they did not want to be described as males or females. This is in keeping with the Commission's sensitivity about the dignity of human beings and the right of every single individual as a voter.

The Differently-abled

A continuous effort for making the process of registering and voting trouble-free for the differently-abled has led the Commission to adopt a standard policy for these voters. This includes constructing ramps for entry to each and every polling

station in the country, whether a voter of this category is registered there or not; locating all polling stations on the ground floor of a building and only in the rarest of rare cases on a higher floor; permitting a companion in the secret ballot compartment to assist in voting and; having Braille facility on all EVMs across the board. Differently-abled voters and senior citizens are given priority on polling day for the voting process.

Inclusion is a matter of human rights of every individual and every section of society. Therefore, all citizens and voters are entitled to equity of access to electoral processes. The United Nations Millennium Declaration, 2000 focused on the value of inclusive political processes that facilitate genuine participation by all citizens including the marginalized and under represented. The role of the Election Commission is to work vigorously towards identifying these groups and individuals and creating an enabling environment for them to exercise their choice. The golden rule is, when confronted with a doubt or dilemma, a responsive electoral system should always err on the side of inclusion by revisiting electoral laws, reform proposals, institutions and processes.

Notes

1 MB Maramakal. 'First to lose elections in Karnataka by one vote.' *The Times of India*, 12 April 2013.

5

ENGAGING YOUTH: CONVERTING SUBJECTS INTO CITIZENS

Walking for a Cause: Abdul Mujeeb Khan (centre), Vivek Reddy (left) and Faiz Rai on their way to Srirangapatna on Monday Photo: M.A. Sriram (courtesy: The Hindu[1]*)*

Why is this young man walking so much?

You know how activist types are always talking about 'starting a conversation?' It is a concept that many find infectious—the idea that somebody good and honest will start talking, people will pick up on his message and, before you know it, a groundswell of popular opinion will force the 'corrupt' government to mend its ways.

Abdul Mujeeb Khan took the notion quite literally. On 18 December 2011, this young man from Hyderabad began walking northwards from Kanyakumari 'to talk to people'.

Zig-zagging through the bottom half of India, this afternoon he reached Jantar Mantar in Delhi after having covered a total distance of 5,550 km, 3,200 of which he did on foot. The rest was traversed by bus and by hitching rides in passing cars.

Mujeeb, who studied engineering at Osmania University in Hyderabad, did a Masters in Communication at MICA [Mudra Institute of Communications], Ahmedabad, and now runs an NGO that works with the underprivileged, says he talked to 'between 30,000 and 50,000 people' about corruption and how it makes our lives poorer. With one vital difference, though. Rather than simply point fingers at the government, Mujeeb would like us to look inwards.

His conversations with the individuals who make up the giant milieus of India, says Mujeeb, usually go something like this. First he asks them what things are like. They tell him life is difficult and that the government isn't doing enough for them. He then asks them how they usually choose who they are going to vote for. Most times, the answer is whichever candidate gives them the largest handout, money or liquor.

Which is when Mujeeb asks: 'If you vote for somebody because of the money he pays you, then do you really expect the politician to not make money in return? After all, he has to recoup his investment.'

Early on Thursday morning, he was at it again in Gurgaon. Talking to a bunch of twenty-somethings at a business school, he asked them how they voted. The answers were sufficiently city savvy. Caste, the usual decider in an Indian election, was not mentioned. But the incumbent not having done a good job or having a

great track record were discussed:

> Did you check how many candidates there were in total?' Mujeeb asked. The number of raised hands fell. 'Did anybody check every candidate's track record?' No raised hands left in the room. 'How then can we expect the country to get better, when we don't have the time to check up on who we're electing to govern us?

What Mujeeb is in effect telling people is that they're also to blame for the state of our society. And that simple things like jumping a red light, cheating in an examination, and demanding dowry are forms of corruption.

Sociologist Yogendra Singh, Professor Emeritus, Jawaharlal Nehru University, says Mujeeb's central idea is close enough to that of the great men who walked before him. That one cannot transform society without first transforming oneself.

How much people listen to him will depend on his personality. That Mujeeb will need to work on. But for now, people are listening to him. How can you not pay attention to somebody who's walked through half the country talking about change, hope and renewal?'

Source: Parakram Rautela. 'Why is this man walking so much?' The Times of India, 8 April 2012.

Come election time, parties big and small, with their netas, followers, supporters and hired crowds, start beating drums, shouting slogans, singing songs and dancing to their pulsating rhythms, organizing yatras and roadshows, defacing walls, berating opponents and bringing in popular actors now and then to attract the youth.

The irony, however, is that, often, all these inducements fail to bring the youth to the booths. The youngsters of today have other apolitical goals and priorities in life. In fact, they

are more than visible at protest marches, in cricket grounds, at music concerts, cultural events, and can be seen blocking roads, stopping trains, throwing stones, burning tyres, raving and ranting against corruption and bad governance. But when the real time and opportunity comes to participate in the decision-making process and change the system and its culture by electing the right leaders, many of them prefer to stay away. Obviously, they are not seen in the daily discourse on democracy.

When I began my tenure in the Election Commission, it was distressing to discover that the voter enrolment ratio among eighteen-twenty year olds was only around 12 per cent! India is blessed with a mega generation of hope, and it is my firm conviction that the youth of the country have real potential to be the political game changers of tomorrow.

If elections in India, both at national and state levels, continue to be the largest democratic exercise in the world, the country's young people must be its primary participants and target audience. The electoral exercise enables the youth of India, now exceeding 500 million, to exercise their choice and articulate their voice as soon as they cross the age of eighteen years*. The participation of the youth in elections will make universal adult franchise a complete reality and enhance the quality of democracy in the country.

Young people study and write examinations on democracy, but elections provide the first opportunity to practise it. Voting is translating a part of this learning into participation.

Moreover, elections in a democracy are also a reminder to the youth of their rights, responsibilities, representation, aspirations and transformation. Elections sustain and facilitate a just and equitable society. Therefore, it is vital that the most energetic and productive section of this society—the youth—take part in elections in large numbers as they are the most important constituency of the political democracy

*They have to be eighteen on 1 January of the year.

in any country. However, to promote this, it is necessary to understand their current thinking, preferences, priorities, attitudes, behaviour and beliefs.

It helped that before joining the Election Commission I was Secretary in the Ministry of Youth Affairs and Sports, where we had brought together seven national-level youth volunteer networks, representing 22 million students and other youth, to launch a national awareness campaign on HIV and AIDS with spectacular success. Of these, the National Service Scheme (NSS) had 3 million student volunteers spread over 400 universities and 10,000 schools. The Nehru Yuva Kendra Sangathan (NYKS) had 8 million rural youth volunteers spread over a quarter million youth clubs in 600 districts. The Bharat Scouts and Guides and the National Cadet Corps had 2.5 million youth volunteers each, while the Junior Red Cross and Youth Red Cross together had 8 million volunteers. If the galloping rate of HIV infection in the country has been halted and reduced substantially today, a major part of the credit goes to these youth volunteer networks. In fact, the NSS had launched a nationwide 'Universities Talk AIDS' programme even before the National AIDS Control Organization (NACO) was born.

Genesis of YUVA (Youth Unite for Voter Awareness)

The year 2011 was the golden jubilee year of the Election Commission. Coincidentally, it was also the twenty-fifth anniversary of the International Youth Year (IYY), which marked the occasion with the slogan 'Our Year, Our Voice'. So, we at the Election Commission also turned our focus on youth in a big way.

That year the Commission issued voter identity cards to 17 million new voters, out of which 5.2 million were young voters who had attained the age of eighteen years on 1 January. This was done on 25 January 2011, designated the First National

Voters' Day (NVD),* and could perhaps qualify as the biggest youth empowerment programme conducted on a single day anywhere in the world. The next year, on the second NVD, more than 10 million youth were handed their elector's photo identity cards (EPICs) as new voters; 28 million other voters too were handed these cards in that year.

This historic achievement has a simple side story. In 2010, I happened to be in Bhubaneswar to give a keynote address to youth and development professionals in a civil society meeting. There, a youth programme manager, Capt. Subhash, stood up and remarked that eighteen years is an age that deserves to be celebrated, and that one day of the year should be dedicated to these new voters. This sounded like a good idea and set us thinking. I requested Professor Bhagbanprakash, my erstwhile colleague in the Ministry of Youth Affairs and Sports, who was present at the meeting and by then was an internationally reputed youth development professional, to develop a plan of action in order to implement this idea. He came up with the blueprint of a scheme named New Voters' Day.

The issue was discussed in the Commission and subsequently with the government, which supported it wholeheartedly. The government wanted to know whether the New Voters' Day would need to be declared a national holiday and how much extra money we would need for it. We said we did not need a national holiday nor one extra rupee, since our existing funds for updating electoral rolls could be suitably adapted for the purpose. And we launched the programme with a zero budget. Initially we considered calling it 'New Voters' Day' as suggested by Bhagbanprakash, but we changed it to National Voters' Day (NVD) and decided to celebrate it on 25 January, since it was on 25 January 1950 that the Election Commission was born as an independent constitutional authority.

During the second visit of the Commission to Bhubaneswar,

*Described in detail in Chapter 8 of this book.

the Odisha Nagarik Samaj, a network of civil society organizations headed by Bhagbanprakash, expanded the idea further and made another elaborate presentation on how the youth in India could be motivated and mobilized to participate in the electoral process to strengthen India's democracy. The new approach was called Youth Unite for Voter Awareness, or YUVA (which means 'youth' in Hindi).

YUVA argued that the best way to convert a country's demographic dividend into democratic dividend is through mass participation of youth in elections. In order to substantiate this argument, YUVA quoted from three documents—the National Youth Policy (NYP) of 2003, the National Policy on Education (NPE) of 1992 and the United Nations Millennium Development Goals (MDG) of 2000.

The National Youth Policy 2003, in the formulation of which I was closely involved, recognizes the need for developing among youth 'qualities of citizenship' (4.2) and their 'effective participation' in 'decision-making processes' (5.1). And what can be a better indicator of this participation than exercising their newly acquired power of voting to articulate their voices and views? Similarly, the National Policy on Education also emphasizes the acculturating role of education in promoting independent minds and spirits towards furthering the goals of secularism and democracy as enshrined in the Constitution of India (Part 2: 2.2). It mentions how education in schools and colleges can improve political and social life. The sections dealing with the National Curricular Framework (NCF) divides the curriculum into core and flexible components and rightly recommends values of democracy to be part of the core curriculum.

Likewise, emphasizing that political participation through electoral democracy are fundamental requirements of human development, the UN's Millennium Declaration states: 'We will spare no efforts to promote democracy and strengthen the rule of law as well as respect for all internationally recognized

human rights and fundamental freedoms.'

Thus, the YUVA argument was based on solid national and international policy frameworks of political participation.

In the fifteen general elections conducted in India so far, the rate of voter turnout has hovered between 55 to 60 per cent. In 2004, the voter turnout was not more than 56 per cent. When the last general elections to the fifteenth Lok Sabha were held in 2009, the country had 714 million eligible voters and the average turnout in all 828,804 polling stations was 59.7 per cent. This means that 281 million eligible voters in the country, half of whom were under thirty-five years old, did not exercise their voting rights for some reason or another. For a country known to be the largest democracy in the world, this is definitely not a healthy trend.

Other democracies around the world are also worried about similar trends in their countries. Many of them have started reducing the voting age to encourage greater participation. Social scientists and youth experts have argued that at the age of eighteen, one is old enough to make such decisions as are required by an election. Consequently, in the aftermath of the first IYY (International Year of Youth, 1985) in India, the sixty-first Constitutional Amendment Act, 1988, was unanimously passed in Parliament, lowering the minimum age of voting from twenty-one to eighteen. The Act came into effect in March 1989 and was hailed as a great historic move which opened the doors of democracy and empowered millions of women and men to participate in decision-making processes and structures at various levels. If, in today's Lok Sabha, there are as many as seventy-one members below forty years of age, the credit for this goes to this important milestone in electoral legislation. Moreover, since that day in history, young people have emerged as a highly visible political category, the significance of which has not been researched properly.

In terms of demography India, today, is a country of the young. It has close to 500 million young people under thirty

years of age. Among these, close to 300 million are adolescents in the age group of ten–nineteen years. They will have their first experience of political empowerment, a benefit of the age-reduction legislation, and become eligible for voting at the threshold of their entry and transition to adulthood. Therefore, the strength of Indian democracy will greatly depend on the degree and extent of youth participation in the electoral process. YUVA pleads that in the fitness of things, a demographically younger country should be represented by a younger leadership. For that to happen, voter queues of younger people at polling booths must be longer than those for other age groups. The proactive participation of youth always contributes to the sustainability of democracy and confirms the legitimacy of elected representatives.

An advertisement encouraging youngsters to vote

Voting awareness and behaviour of this very important segment of the population will also determine the strength and resilience of our adult franchise. In fact, in some parts of the democratic world, a question is frequently raised whether the voting age be lowered even further to sixteen years, in view of the rapid mental growth and early maturing of young people due to

their extraordinary exposure through the burgeoning media. Countries like Iran, Brazil, Cuba, Bosnia, Nicaragua, East Timor, Serbia and North Korea have already gone ahead in this matter and pressure is building up in the US, Japan and Europe to follow suit. Since, internationally, youth is defined as someone in the age bracket of fifteen–twenty-four years, the argument in favour of further reducing the voting age down to sixteen years sounds logical and needs a revisit. Of course, reduction itself will not automatically lead to larger participation. For instance, it is estimated that in urban, educated India, the youth voter turnout varied between 10 to 15 per cent. By 2014, enrolment of the youth in the eighteen–nineteen years age has grown up to 73 percent. However, enrolment does not guarantee they will actually vote.

It is necessary to reach out to the remaining eligible, yet non-voting youth in the country, to know where they are, what they are doing, why they are not turning up at polling booths, why urban youth are participating in elections in smaller numbers than their rural counterparts? Why is the city voting lesser than the slum, why is the percentage of voter participation lower among the urban educated, and in the rich and middle class than among the poor and illiterate and many such related questions.

The feedback we received from the KABP studies highlighted several factors. Often, young voters are not inspired by the negative profiles and mediocre performances of candidates. Stress at work, lack of time, difficult rules, working outstation, ignorance of eligibility and the procedure for enrolment, lack of comprehensive civic education, general cynicism and pessimism about parties and politicians, distance of polling booths, homelessness, reluctance of female voters to venture outside without a male family member, inconvenient timings, aversion to standing and waiting for hours in serpentine queues are some other factors.

The obsession of candidates with identity and vote bank politics often puts off young voters. It is also true that younger

candidates usually motivate younger voters. Yet, there is reluctance among elderly politicians to step aside and allow younger candidates to contest and take up public office. Desire to avoid hassles, lack of a voter-friendly environment, lack of freedom for negative voting and the non-availability of the option to reject were other inhibiting factors, as identified by the YUVA strategy document. These factors need to be understood and analyzed before any new awareness campaign is undertaken.

Experience shows that young voters may not always be influenced by monetary benefits, material incentives and non-monetary cost factors. In fact, much of the motivation for voting for the youth comes from a combination of causes like joblessness, homelessness, education, income, etc. They will only engage when they are finally convinced of the utility of their votes, sense of civic duty and confidence in the credibility of the voting process.

There are also sociological and demographic factors which are influenced by a voter's socio-economic location in society. Older people are more inclined to vote than the youth in areas where average age and life expectancy are higher. Mobile and migrating population areas and regions with lower marriage rates also affect voter turnouts. Simpler electoral rules and laws motivate youth voters to come out and vote.

It has been observed that voter turnout is more in multi-party than bi-party democracies as more parties reach out to a larger number of voters in multi-party democracies. Similarly, more young voters turn up at polling booths when they discover a meeting ground between their expectations and the capacity of candidates to fulfil them. The modalities and procedures of how a voter is registered also influence voting behaviour, as the Election Commission has seen in recent elections when delivering voter slips by BLOs at the doorstep of voters substantially increased voter turnout.

An enabling environment free from pressure, fear and

intimidation and an improved law and order situation are other contributing factors, besides voter-friendly procedures and facilitation that encourage people to step out of their homes and vote. Similarly, when the youth do not have political choices, social coordinates like locality, caste and class do not operate. With regard to party affiliation, the youth do not behave as a single political community and tend to exercise their free choice, unlike the older voters.

A message for voters encouraging them to use their vote wisely

YUVA's strategy, based on different studies of voter behaviour, provides a brief analysis of voter types and pleads for an Enlightened Voters' Movement, which it calls the EVM-2.[2] An understanding of different types of voter behaviour is likely to help in preparing an Enlightened Voters' Movement. This alternative EVM will make the original EVM (electronic voting machine) more relevant and powerful. Who are these enlightened voters? Enlightened voters are the ones who find voting an opportunity for bringing in change, those who are aware of their role and are neutral in respect of caste, religion, community or other identity differences, those who have their

own views about a party and its performance and change their preference from election to election if needed. An enlightened voter compares words and deeds and wants to know from the candidates what are the causes that they are fighting for, what exactly is their vision, plan and roadmap for the constituency and the country. An enlightened voter is one who, during elections, refuses to be treated as a commodity for commerce, a client, customer or beneficiary and is not influenced by the freebies and largesse offered by parties and their candidates.

Passive and casual youth voters are those who either do not care to vote or vote without bothering to check the performance or integrity of the candidates. On the other hand, captive voters are those who are influenced by social, caste, ethnic and regional pride and cultural factors and are often beholden to a party or a candidate. Any youth awareness campaign must work out its strategy innovatively for increasing the number of the enlightened in order to improve the quality of participatory democracy.

What can students and teachers do?

Politics has become the greatest question mark of this decade. Some of the trends are obvious. Political disintegration is likely to spread; selfish splitting up of parties rather than their ideological polarization will continue; devaluation of ideologies may go on; frequent change of party loyalties for personal or parochial benefits, buying and selling of legislators, inner party indiscipline, opportunistic alliances among parties and instability of Governments—all these are expected to continue. This situation is a challenge as well as a possibility for all of us. If we sit idle hoping for a miracle to happen when some great leader may come to our rescue, or some dictator or political party will be born to cleanse all this filth, I may humbly tell you, we have kept our reason in abeyance and become oblivious of our duty as citizens.

The question then is: what shall we do? The answer is obvious. We should understand and do our duty as citizens of a democratic country. Political parties, legislators and ministers are becoming autocrats. They are not afraid of public opinion since there is no public opinion. They care less for their voters because voters are not enlightened or organised. Political parties do make their own propaganda, but that is not to create a healthy and impartial public opinion, which may rise above party politics, and effectively express itself in matters of right or wrong, moral or immoral, just or unjust. To build such a public opinion is the greatest national task and bounden duty for us.

Unfortunately, the community of scholars in the last few years has shirked its responsibility in this respect. Some teachers and students have participated in party politics and those having taste for it will continue to do so. But this process does not help in the formation of a non-partisan public opinion, which could make an impact on all political parties. We have to appreciate the difference between party view and general public opinion and explain this difference to others.

...now, when the general elections are held, every now and then, presiding officers and their agents of requisite mettle are not easily to be found, nor is it possible for the police to be so watchful as to ensure proper observance of procedures. During the elections, falsehood and mutual abuse become rampant. So, the voters need to be acquainted with election manifestos of political parties and also to be given authentic information about the life and work of candidates. If teachers and students of universities and colleges take this work in their hands honestly and are able to secure the co-operation of common citizens, it is possible to eliminate the prevailing weaknesses of our political life such as instability, opportunism, selfishness. Is it too much to expect this service from our educated community? It will be wrong to treat this work as equivalent to taking part

in party politics, for this will truly be a noble task of social education. Is it not surprising that when there is so much talk of political degeneration and corruption, in no constituency have the voters ever gathered together to condemn the corrupt practices of their representative. The ultimate control upon the legislators is the collective expression of their constituents. To realise this objective of national importance, voter's education societies should be established all over the country.'

Source: An extract from a convocation address by Jayaprakash Narayan at Banaras Hindu University, 1970.

Young people love to live in groups and are prone to peer pressure. They have great potential to influence their own group as well as others and can work as catalysts, for educating voters, and for advocacy on electoral reforms. Further, young people are also optimists and through imaginative voter education, can also be helped to realize that they can create positive social and political change during their time only through informed voting. As communicators they can also participate in media campaigns and street awareness activities to increase youth voter turnouts. They can coordinate or be part of voter registration drives, promote voter education efforts through interpersonal, inter-group and mass communication, assist the Election Commission's flying squads and surveillance teams and act as watchdogs of electoral malpractices to ensure that there is no electoral manipulation, corruption, violence, proxy-voting, vote-buying, booth-capturing, dummy candidates and other existing forms of political manipulation and patronage. Recently, the youth came out in large numbers to express their solidarity with anti-corruption meetings and movement.

Voting itself is a key human behaviour that influences the quality of an election. Therefore, it is important to recognize and sensitize voters at an early age. This requires a concerted effort to

convince and explain to them their role, responsibility and rights. In fact, it will be appropriate if young people are sensitized well before they become eligible for voting about the link between democracy, development, elections and human rights. This kind of sensitization may be organized at the community and campus levels. Here, they need to be properly briefed and educated about why, when and how they should vote, registration requirements and processes, importance of photo identity cards, types of elections, location of polling stations, the Model Code of Conduct, antecedents of candidates, withstanding pressure and allurements and use of electronic voting machines. Keeping this in view, the Booth Level Officers (BLOs) in local areas will reach youth in their houses for enrolment.

Getting the right to vote is the first official entry of youth into the maturity of adulthood, the first formal admission into the adult world. Therefore, by not voting and not participating in an electoral democracy, all eligible yet non-voting citizens including young people simply reduce their roles to mere critics of the government. By remaining indifferent, silent or abstaining from elections and then blaming the elected representatives afterwards for all the ills and evils, they only allow the decision-making process to be hijacked by others. Studying and playing well, paying tax and obeying laws are very good habits but they are not enough to be good citizens. Young people need to be told that it is also 'cool' to be smart citizens by voting. They need to invest a small part of their time in asserting their political identity and belief as voters. The YUVA strategy gives several reasons to eighteen-year-olds on why they must 'Stop Complaining and Start Voting'.[3]

The youth need to know:

• Why they should get united and take charge of their lives and their country.
• Why they should not take democracy lightly and neglect their rights to vote.

- How it was the youth who spearheaded the freedom struggle to win freedom and democracy for the country which they must defend now.
- What is the opportunity cost and social consequence of not participating in the electoral process.
- How right to vote is a judicially protected youth right, a civic duty and privilege of our democracy.
- Why they should exercise their choice in order to make people respect their voice.
- How it will facilitate access to power and decision-making structures at various levels and enable them to pursue their ideology, dreams and creativity in a free and open society.
- How optimum voting can prevent and control abuse of power, authority and electoral fraud.
- How large-scale youth participation will give representational legitimacy to representative democracy in the country.
- How a voter can periodically hold the rulers to account and demand answers to questions about their policies, plans, decisions and actions.
- How mass voter participation will add value to democracy and change the nature of 'conversation' between the voter and the voted.
- How non-participation weakens and puts a question mark on the representative democratic structure.
- How their ideas, opinions, views and voices can be best expressed through elections.
- Why choosing the right candidate is their right as well as duty and responsibility.
- How power of voting can make them more important, more relevant and more visible.
- How it can help in creating new opportunities for the youth to play leadership roles in public affairs.
- How voting in elections and a democratic form of government protects people from calamities like famine and hunger.

- How voting in elections strengthens effective civilian control over the military and the police and prevents authoritarian rule.
- How voting is a powerful tool to safeguard social justice, the rights of minorities, women, marginalized and weaker sections.
- Why they must 'cast' their votes and not vote the 'caste', vote for the common good and not the community, vote religiously and not for a religion to keep the country united.
- How voting allows a culture of debate, discussion and dissent, respects freedom of thought and enables peaceful change of government and orderly transfer of power at the central, state and panchayat levels.
- How voting is the first critical and concrete step towards youth empowerment, using which the youth influence decisions on who should run their country, their state, their municipality, their panchayats, their village and how they should do it.[2]

Earlier in this chapter a reference was made to the convocation address on Jayaprakash Narayan about 'What Students and Teachers Can do'. Here is just one example of what they actually did in Bulandshahr.

Do Minute Vote ke Liye

The biggest rangoli of the world...that too on elections... seemingly implausible? And yet a rangoli sprawling a mindboggling 1,90,296 sq feet in Bulandshahr did just the impossible in the D.A.V. grounds. The aim was to motivate voters to cast their votes.

The rangoli was conceptualized as a narrative on the history of India. Divided into approximately seventy blocks, each spoke for itself. It started with *Bharat—Sone ki Chiria* (India, the Land of Gold) followed by the arrival of the East India Company

and its eventual control over India to the revolt of 1857 and the journey towards independence and then democracy. This was followed by blocks on Election Commission, conduct of elections as also the imperative to vote.

The rangoli witnessed participation from seventeen colleges in the district with each block assigned to a team of ten students each. Arranging colours was an uphill task as no single vendor was able to provide them in such large quantities. After much effort and traversing various states, finally a vendor in Gujarat agreed to produce and supply the rangoli colours as required. Then sponsors were taken on board to fund the expenses, including transportation and distribution of the colours. The training of students was another endeavour. Finally, six hundred students worked for three complete days to give a final shape to this spectacular creation, which was open for public viewing from 16 January. Numerous flags fluttered along the pathways with the message *'Do minute vote ke liye'*.*

There was more to follow: Nikunj created the biggest pyramid in the world with thirty thousand thermocol cups. Each cup in the giant pyramid was inscribed with the slogan *'Do minute vote ke liye'*. NSS volunteers and students of many colleges created messages with candles to motivate the voters to spare two minutes for voting. This slogan, a take-off from *'do boond zindagi ke liye'* (two drops for life—the slogan for the pulse polio campaign), had indeed done wonders.

It seems that the district was out to make one record after the other. The stupendous success of creating a world record with the rangoli was the harbinger of another mindboggling record, 'Matdeep', the biggest lighting of lamps for the cause of elections in the world. A giant map of India was carved out with 2,40,000 candles and diyas in the Police Lines ground of

*'From cleaning the ground to marking and conceptualization of each block, then arranging for rangoli colours, training and motivating students and the final presentation of rangoli...our team thoroughly enjoyed it,' —Kamini Chauhan Singh, District Election Officer, Bulandshahr.

Bulandshahr. 'The response was overwhelming. We got calls from all over for voluntary donation of candles; the factories in Bulandshahr went into a tizzy making candles,' says A.K. Singh, a member of the team.

'Do minute vote ke liye' candles

Public enthusiasm was infectious. To capture and propagate this further, cartoonist Irfan created a series of cartoons on voting. The 'Azad Family' cartoon series with Mr Azad, Mrs Azad, Bunty and Babli was carried by all newspapers making elections the buzzword for the common man. 'We associated each aspect of everyday normal life with voting, stressing on the fact that it takes very little time and effort to vote,' said Irfan.

Nothing Succeeds like Success

The buzz that the movement created brought in more support. Even cricketers and cine-stars readily agreed to motivate voters. Cricketer Praveen Kumar and actors Sridevi, Jackie Shroff, Arbaz Khan and Mithun Chakraborty exhorted all to vote. 'In fact, the celebrities were delighted to be associated with this noble cause. It was the first time someone had approached them to

issue an appeal to vote,' says Saumya Srivastava, SDM, Khurja.

Khurja is synonymous with pottery. So, the district administration smartly released a series of vases, mugs, plates, clocks and dinner-sets carrying the symbol of the Election Commission, slogans, cartoons and appeals by celebrities for voting. This added colour and style to the election process!

But then, how can celebrations be complete without music? A song on voting sung by Nawed Khan was uploaded on YouTube with a link to 'Kolaveri-di'. Thousands downloaded it and it became quite popular, especially amongst the younger generation who hummed it through the day.

Rural areas too were covered with 'matdata jagrukta vaahans' (voter awareness vehicles) and 'krishi vaahans' (agri vehicles) which traversed across villages, projecting a movie on elections. The movie demonstrated the effort and money spent to make booths so that each citizen of India can exercise his right to vote, and how very few people actually cast their votes as the booths lie vacant. This elicited a positive response. Moreover, given the high mobile connectivity in rural areas, appeals were issued through SMSes to 1,80,000 voters, besides 75,000 sugarcane farmers.

The efforts have been enormous. From arranging slogan and poster competitions at each block, tehsil and district level to 'gubbara diwas' (balloon carnival), where thousands of balloons bearing election slogans were released in the sky, to 'patang pratiyogita' (kite flying competition) where similarly thousands of kites with election slogans adorned the skies, to the human chain with thousands of people gathered together to form the map of India—the fanfare accompanying the efforts was almost a reward in itself.

This is not all. A voter awareness marathon, signature campaign, cricket matches, ceremonies to pledge to vote in schools and offices, innumerable rallies by students and women, plays and shows of the documentary film *Hum Azad Hain* were organized with great fervour. Alongside, a district

election website was launched which provided comprehensive information on all queries related to elections.

Efforts that continued for months paid rich dividends on poll day. Bulandshahr fared with flying colours with a poll percentage of 61.33 per cent in the 2012 elections, up from 48.61 per cent in 2007, a marked increase of nearly 26 per cent.

Once we succeed in developing an active interest in political affairs of the country amongst the youth, the nature of electoral democracy will also undergo change. Because the youth in India are not a single unitary public and are segmented, representing several publics, like those below the poverty line and above the poverty line, educated and drop-outs, urban and rural, literate and illiterate, belonging to different caste, ethnic and minority groups, students and non-students, employed and unemployed, youth living in slums, migrant youth workers, youth in border areas, youth volunteers, youth artists, writers, sports persons and entrepreneurs—all these aspects have to be considered followed by proper target audience segmentation before developing a realistic operational strategy. The youth rainbow will make Indian elections more colourful, more meaningful and more vibrant.

Mapping out Youth in Politics in the 2009 Elections

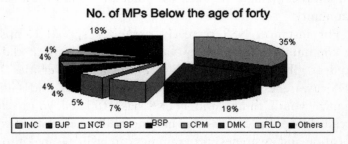

Figure 5.1: Political/Party affiliation of the seventy-one young MPs in 2009 Parliament

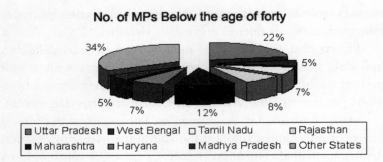

Figure 5.2: State-wise distribution of the seventy-one young MPs in the present Parliament

Source: http://www.lokniti.org/KAS-CSDS_study_on_youths_in_indian_ politics php, based on ECI data.

Voluntary, proactive and willing participation of the youth in the electoral process is considered a hallmark of a functioning democracy. Various researchers on voting behaviour say that persons who have voted once are likely to vote again. As already stated, India not only has a huge educational infrastructure and vast human resource but also has a large number of organizations for youth volunteers (OYVs). This is a powerful youth resource, which can be engaged in voter awareness campaigns for their own members and for the larger community.

For instance, NSS regularly organizes special camps in the community during every vacation. In the past it did an excellent job by involving folk media in its 'Universities Talk AIDS' awareness programme. NCC and Scouts and Guides organize youth camps and NYKS has affiliated youth clubs spread all over the country and in almost all panchayats. If voter education and awareness programmes can be integrated into the activity curriculum of these organizations, it has the potential to reach every nook and corner of the country. Consequently, the entire secondary and tertiary education system can be mobilized

and engaged. Increased youth participation in democracy will neutralize youth vulnerability towards crime, replace youth violence with a youth voice and provide a constructive and constitutional outlet to the young people.

Dancing the EC way to a voter's heart

One of the methods to reach young audiences, especially women, is the use of folk singers. At the top of the list was Malini Awasthi. Malini bestowed vibrancy to traditional folk music, giving it the respect it truly deserves. A post-graduate in Hindustani classical music from the famed Bhatkhande Music University, Malini, in her interactive shows, makes it a point to share the nuances of each folk composition, leaving her audiences mesmerized.

Without compromising her unique *gayaki* (singing style), she has adapted to the demands of the times. A disciple of Padma Vibhushan awardee Girija Devi, Malini has popularized various forms of music from the Banaras and Awadh region such as Dadra, Sohar, Banna, Jhoola, Kajri, Holi, Chaiti and Dhobiya, showcasing these on the national and international stage as well as well-received television reality shows. She was honoured by the Election Commission for her proactive role as its brand ambassador in Uttar Pradesh, where women's participation increased by a phenomenal 42.77 per cent and the total voters increased by a whopping 1.98 crore!

Malini spoke to *The Tribune* of her experience in motivating voters, especially youth and women:

How did you get involved in this exciting assignment with the Election Commission?

This was the idea of Uttar Pradesh Chief Electoral Officer Umesh Sinha. He came up with this proposal for me to be the brand ambassador of the state. I guess it was due to my non-political image. He thought being a woman I would be

able to connect better with women and the youth, who till then had a dismal record in exercising their franchise.

How did you go about this responsibility?

This was a collective effort with many people diligently working under the overall guidance of Umesh Sinha.

We first worked on a theme song, *Jago jago desh ke matdata* (Wake up voters of the country). The wordings were penned by Umesh, and I set it to tune. We then worked on a repertoire of songs keeping in mind the linguistic and folk diversity of the state. If it was in Brajbhasha for the western districts, it was Bundeli, Bhojpuri or Awadhi elsewhere. We incorporated various forms like qawwali, birha, or instruments like the nakkara, to widen the appeal.

Did you have special performances in the districts?

I travel a lot for my musical performances. Special programmes were arranged in colleges, universities, the city town hall or elsewhere.

What was the response?

It was tremendous. There was excellent contribution of the National Service Scheme (NSS), with university professors coordinating the show. Earlier the campaigns were restricted to tehsil offices. This time it was focused on university campuses, which motivated the youth—first time voters—to come out in large numbers to become voters.

Soon a momentum picked up. It really became a peoples' movement.

What were the challenges?

It was not easy. My job was to motivate people for political participation, without appearing to be partisan. I remember during one such interaction at Banaras Hindu University, a student complained that he would not vote as he had seen all political parties and did not want to vote for any. My

responsibility was to explain how he had to be the change he wanted to see in the system.

I also had many moving experiences. For instance, while interacting with students in Gorakhpur, a young girl told me she had observed during past elections that her mother was not allowed to vote by her father despite her wanting to. 'This time, I will ensure my mother votes,' the young woman assured me. It was truly a satisfying experience.

My biggest moment, however, came when during a felicitation programme CEC Quraishi asked me to give a special 25-minute lecture-demonstration showing how I did it!

Source: Shahira Naim, *The Tribune*, Delhi.

The other challenge is addressing the issue of low youth voter turnout in certain areas in the country where young people live at different socio-economic levels. Apart from urban youth, a large number of literate youth also live in rural areas in the country. Many of them are guided by what they see happening around them.

A survey by the Centre for Study of Developing Societies on 'Youth in Indian Politics' (CSDS-KAS) states that 48 per cent of the youth strongly believed in democracy while 27 per cent were indifferent.[4] About 66 per cent of the youth thought that their vote could make a difference. This probably needs further study. The challenge is how to convert the growing youth interest in political affairs into voting behaviour. Furthermore, the study also finds that youth *per se* do not display any preference for a particular political ideology which implies that they are mentally autonomous and are in a position to judge issues on merit. This is a positive trend which needs to be reinforced.

Thanks to the seventy-third and seventy-fourth amendments to the Constitution, in India, there are more than a million women representatives sitting in elected bodies of local self-governments in villages and towns. Yet, the extent of women's

participation in the electoral process is not very encouraging. YUVA raised several questions that needed answers in order to plan for increasing young women's participation in electoral democracy:

- Are young women less involved citizens or less interested than young men to participate in political activities?
- How often do they discuss public affairs among themselves?
- Are there participatory opportunities, both formal and informal, for young women in Indian society?
- Why are young women under-represented in public institutions? And wherever they are represented, do they have the freedom to think and act on their own?
- Are there inhibiting social norms disabling women from participating in the electoral process?
- Why is it that in slums, the community, religions, academic institutions and civic organizations young men have larger representation than young women?

The fact is, women are more likely to vote than non-participants where they participate in public affairs. In the recent Bihar elections, the voting percentage of women outstripped that of men by a whopping 10 per cent and many of them voted independently defying the diktats by their menfolk. Significantly, states like Odisha, Bihar and Uttar Pradesh became the first to reserve half of all panchayat and local self-government positions/seats for women. Other states reserved 33 per cent of the seats for women. Now the 110th Constitutional Amendment (2000) has further enhanced such reservation from 33 to 50 per cent.

Thus, the tasks and activities to address and involve young women may include educating them about their new roles and responsibilities, targeting and training their self-help groups in women empowerment programmes, sensitizing marginalized women groups about their civic responsibility for and from panchayats to Parliament and enhancing their social confidence,

assertiveness and political awareness. Women's entry into the voting age begins with the end of adolescence and legal entry into the age of marriage. Society can celebrate the 'golden five' rights associated with young women at eighteen—biological, legal, social, democratic and demographic (puberty, age of marriage, end of adolescence, entry into adulthood and voting rights).

Another youth category living mostly in urban and semi-urban areas are the netizens. It is estimated that in India, almost a third of the youth are on the web.

Today, many young people, particularly students, skip books to surf the net and watch TV. Virtual universities are becoming popular. Internet has emerged as a friend, philosopher and guide for urban youth, reaching them with endless friendship requests, offering emotional support and enlisting them for social causes and community concerns. By 2015, the optical network would have connected a quarter million panchayats in the country and by 2020 half the black boards in schools will have been replaced by computer screens and rural India will be connected to urban India through high speed broadband.

The I-Cube Report published by the Internet and Mobile Association of India and IMRB (2011) states that almost 10 per cent of India's population is covered by the Internet. They attribute this growth to increasing affordability of personal computers and rising interest among the country's young population. The study found that more than 75 per cent of Internet usage is still driven by the young population, including school and college students. Emails, education, social networking, music and text chatting have emerged as the most popular activities among urban Internet users although usage patterns differ among rural users.

An aggressive and imaginative use of the internet and the electronic media doubled youth voter participation in the 2008 US elections. During the fifteenth Lok Sabha elections

in 2009, a majority of eligible voters were in the age group of eighteen–thirty-five years and there were many who cast their votes for the first time. Moving away from traditional methods, and keeping in mind the media preferences of the youth, a number of contestants took online initiatives asking young voters to come out and vote. Google tied up with a national daily to facilitate this process. Increasing technology density is going to change the character of our elections in the years to come and this is going to be led by a huge population of aspirational youth. Therefore, another effective strategy will be to make use of SMSes, online blogs and social networking sites and applications like Facebook and Whatapp to reach out to young voters including first-timers. Similarly, using online ads and YouTube for disseminating election-based information can help in promoting voter awareness. Updating young voters about political parties, their manifestos, duties and obligations helps informed voting. However, any youth awareness strategy must be preceded by a communication need analysis to respond to quick changing tastes of youth voters. By 2015, as many as 600 million Indians are expected to have a Unique ID (Aadhar card), a mobile and a bank account, thus compelling election managers to redefine their approaches and strategies.

India has a rich folk cultural tradition the potential of which is underutilized. Nukkad-nataks (street plays), puppet shows, individual discussions and group meetings can be organized to make the youth aware of their rights and why they should exercise them with sincerity and without fear. I have seen from my own experience that a culture and idiom that directly connect and relate to the youth is always more effective as we saw in the case of the 'Pappu doesn't vote' campaign. During my days in NACO, I had seen how the 'Bula di' campaign worked wonders in promoting HIV awareness in West Bengal. Similarly, the 'Pappu' campaign was built around a Hindi film song, *'Pappu can't dance saala'* which was rephrased

as '*Pappu doesn't vote ahaa*'. It became a big success and was followed by another youth focused campaign, 'Wake up and vote' based on young film star Ranbir Kapoor's song 'Wake up Sid' calling on youth to register as voters. This led to a substantial rise in voters' enrolment on NVD-2012. Another song that instantly motivated and connected the youth to voting was '*Har vote zaroori hota hai*' based on Airtel's jingle, '*Har friend zaroori hota hai*'. When I met Rajan Mittal to talk about using the mobile service provider's jingle, he not only agreed but suggested that he too would join this campaign as Airtel's corporate social responsibility initiative. These campaigns tried to shame those for whom not voting was a fashion statement. After the campaign, many youth were seen displaying their ink marked fingers to prove that they had indeed voted and were, therefore, not Pappus. Not surprisingly, the voter turnout witnessed a jump.

A correspondent from *The Asian Age* (7 February 2012) reported another very interesting story from Lucknow about shoppers' and sellers' involvement and motivation in promoting democracy among young and new voters. Under the caption 'Shop Till You Drop', it said: 'This time you can really shop till you drop—only if you cast your vote.' In an interesting initiative—possibly the first in history—commercial establishments and business houses are offering discounts on consumer items for those who exercise their franchise. Schools and hospitals are also joining in the fray to promote voter awareness. A local amusement park on the outskirts of Lucknow has announced a 60 per cent discount for those who cast their votes all through February. All that one has to do is to show the ink mark on the finger to avail the discount on the entry fee and eatables sold inside the park.

Winning Entries—Poster Making Competition (State Level)

Vote Gains

10% AT BAKERY

Hot Breads, a bakery in Sarabha Nagar has announced that anyone who shows the indelible ink mark after casting his vote will be given a 10 per cent discount on all items. The bakery is in Ludhiana West, a constituency where the majority of voters are urban. Polling has traditionally been low, always less than 60 per cent.

10% AT RESTAURANT

Yellow Chillies, a restaurant in the same market, gave an identical discount on meals ordered after showing the ink mark.

100% AT DENTIST'S

Dr R.S. Thind, a dentist with a clinic each at Dugri and Jamalpur, has posted a message on Facebook saying, 'Get one week free consultation if you show the ink mark after casting your vote.' That's because the mark remains for a week, he tells *The Indian Express*.

Thind says it is not a gimmick, but an effort to encourage

voters to carry out their duty to vote: 'Perhaps with this allurement, they will turn out to vote bring a change now, rather than complain later.'

Ludhiana district did, indeed, break all records with 77.5% turnout! Muktasar crossed 85%

Source: Raakhi Jagga, 'Shops' novel offer: Show your ink mark and get a discount.' *The Indian Express*, 30 January 2012.;

Raakhi Jagga, '77% polling in district; large turnout of youth.' *The Indian Express*, 31 January 2012.

The two lessons learnt from what is discussed earlier were: (i) whenever there is a youth connect behind a song, they instantly identity with it, and (ii) the business world including small shopkeepers can also play a constructive role in promoting positive awareness in favour of participative democracy and elections. This way democracy can become everyone's business.

Young Voters Festival

a. Young Voters Festival or YVF consisting of state and district level competitions was declared by the office of the CEO, Gujarat in December 2012. It was celebrated in Higher Educational Institutions of the state (including at Higher Secondary Schools and above, such as in Degree colleges, industrial training institutes, professional institutions, etc.) by inviting them to participate in two competitions held uniformly throughout the State in a pre-planned manner. The two categories of competitions were based on the changing world-view of the youth these days and the fact of their fascination with IT and its applications. The traditional contests of elocution, essay writing, etc. were held only at a local level. The following two categories of competitions were held in the YVF at the District and State levels:
 • Poster making competition—that is of digitally made posters or handmade posters,
 • Jingles/raps/song writing competition, setting it to music

and submitting the song and recorded song on CD.

b. These competitions were conducted under the supervision of the principals of the educational institutions/organizations. No funding was done for any educational institution as it required only submission of entries of the school/college/institution to the District Election Officer. A choice of three topics was given for both categories: Why becoming a voter is cool? Why youth must participate in democracy? OR iVote (a youth-run movement towards voter registration).

c. The system adopted was that the school/college /institution selected the best entries at its own level and forwarded three of the best entries in each of the two categories to the DEO for scrutiny at the district level.

d. After the top three selected entries from each institution were sent to the District Collector, they were placed before a jury appointed by him/her for selecting the top three awards in the district in each category. At the district level the jury consisted of the DEO (Chairperson), principal of any one college from the district, the deputy DEO, one ERO, and two experts drawn from different fields such as music, arts, technology, theatre, photography, films, etc. One IT expert could also be co-opted on this jury.

e. More than 380 schools and 240 colleges across the state participated. Thousands of entries were received. Out of these, more than 1,400 poster entries and 225 jingle entries were selected at the district and eighty posters and jingles each at the state level. At the state level seven entries won prizes for the poster competition and nine entries for the jingles/rap competition. The state level winners were given awards by the Governor at the NVD celebration.

Source: CEO, Gujarat.

Co-opting young people early into public life makes them develop voting as a social habit. In order to reinforce this habit,

academic curriculum planners can introduce voting and elections as a part of citizenship education in schools and colleges. It will also be good to encourage habits of newspaper reading, watching debates on public affairs on television, knowledge of current events and promoting faith and belief in voting as a civic and moral duty. Promoting active citizenship among youth means more than voting and holding office. It reinforces the values of civic participation.

Conclusion

The Election Commission of India adopted YUVA as an innovative approach and integrated it fully with its voter education drive with encouraging results in state elections from 2010 onwards leading to unprecedented turnouts in the history of Indian democracy.

India continues to expand its youth bulge and, as estimated by demographers, by 2025 the average age of an Indian will be reduced to twenty-nine years. Their participation in elections will help a plural society and secular polity that we are proud of and which the world admires. In fact, youth and democracy could be the country's two bestselling propositions to project a young, bright brand India to the world.

During elections, I used to get hundreds of messages from different sections of the society, especially the youth, many of whom had lingering doubts about the electoral system and chose to be indifferent. However, our efforts to reach out to them with clarifications about their doubts and concerns were well rewarded. They responded in ample measure. I am just quoting here one sample relating to youth. On 31 January 2012 I saw a comment in tweets from Bobby Kewalramani:

> Hope snobs from South Mumbai/Delhi have learnt from Rural Punjab and U'khand on why it's crucial to vote. Getting youth to vote after 2011's crusade against

politicians is no mean feat...great job EC. Seems EC's campaign has finally managed to inspire voters...record turnout for polls keeps democracy alive. Congrats EC team for ensuring peaceful and successful polls in Punjab and U'khand...Hope the momentum remains for the UP polls. Very heartening to see long queues at polling booths...seems public trust in democracy is regaining ground. Politicians fail democracy...at least voters are keeping it relevant by voting in hordes to 'change' the system. Youth finally realizes the power of ballot...comes out in full strength to vote. Someone sitting somewhere in Nirvachan Bhavan has finally cracked the code...record voter turnout in Punjab and U'khand.

In retrospect, we realize that putting the youth on top of the election agenda has really been a productive and rewarding exercise. Given responsibility and recognition, young people never fail the country and its democracy.

Notes

1 http://www.thehindu.com/multimedia/dynamic/00882/02bgMYRKKHI-W020_GF_882227g.jpg
2 'Bhagbanprakash. YUVA- Youth Unite For Voter Awareness', a report submitted to the Election Commission of India, 2011, pp. 12–26
3 Ibid. pp. 35–72
4 http://www.lokniti.org/KAS-CSDS_study_on_youths_in_indian_politics.html.

SECURE ELECTIONS, SAFER DEMOCRACY

In Maoist populated areas, where security forces themselves are often targeted, providing security to a candidate, voters and polling parties is a real challenge. The Maoist armed cadres are well-versed with their terrain, and are trained in guerrilla warfare. On the other hand, the forces deployed by the Election Commission of India are new to the area and their movements have to be at fixed hours to fixed places making them all the more vulnerable. But even in this backdrop, the ECI tries to ensure foolproof security, by doing its homework well. We have to first foresee all possible threats and document them. The idea here is to leave nothing to chance to ensure that even the last link in the chain is properly tied. For achieving all this, we have to know our requirements of the resources, ensure that they are available and then ensure their optimum utilization to achieve the desired ends.

Golden rules we followed:

- We first assessed the threats properly to think of all possible eventualities.
- Formed strategies to minimize the risks, counter the threats, pre-empt possible eventualities and devise ways to handle them.
- Surveyed all the voting locations and developed them into a GIS.
- Developed a foolproof communication plan to connect control rooms.
- Ensured information about all mobile numbers of all parties.

- Deployed watchers to keep vigil over difficult booths and possible ambush points.
- Introduced the concept of Data Tracking Forces with flying squads.
- Deployed a 60 member security force to watch hilltops and dense forests.
- Ensured multi-layered briefing and introduced aerial domination over infested areas, kept choppers ready with wireless sets/mobiles.
- Anticipated as many things which could go wrong.
- Planned possible replacements of all links in the chain to meet emergencies.

Source: A DIG police officer in a Maoist affected district, reporting his security plan and strategy for the Bihar Assembly elections, 2010.

Secure Elections, Safer Democracy

The political nature of an election makes it prone to a plethora of security threats that include those to voters, contestants, infrastructure, material including EVMs and the people managing the electoral process. Further, each process consists of an intricate series of interconnected and interdependent subprocesses like voter registration, candidate nomination, campaign duration, voting operations, protection of voting machines, counting, re-counting, announcements of results, complaints and dispute resolution. Each one of these sub-processes has a security implication and hence requires thorough preparedness for both conventional and new security threats.

A secured election is one which is not only genuinely so but which is also perceived as fair, free and peaceful. Perception is important because when an electoral process is seemingly unfair, unresponsive or corrupt, the stakeholders are more likely to be motivated to go outside the established norms to achieve their objectives and resort to electoral violence. At times, electoral

violence is used as a tactic to intimidate the non-committed or hostile voters from coming to the polling stations to vote. It is, therefore, essential for election managers to protect the election process from conflict and violence through security planning and proper enforcement of the law. Election managers have to be alert to the possibilities of non-violent methods of intimidation in the form of silent booth capturing which at times may happen in some polling booths.

Violence in Indian elections is induced primarily due to various electoral and social anomalies in Indian society. In a pluralistic society like India, there are multifarious challenges including undercurrents of diversities, caste polarizations, communal divides, economic inequalities, varying regional and linguistic aspirations. All these factors get heightened and charged during election times. The increased role of money power, muscle power and criminalization in politics has become a major source of violence and insecure elections in the present context.

Ensuring Safe Elections

The Election Commission's primary concern is to conduct a peaceful poll where the voters, polling officials and security personnel are absolutely safe with zero risk to their lives. The list of measures taken is comprehensive and includes (but is not limited to) the following:

- Vulnerability mapping of potential trouble zones and identification of likely mischief-makers
- Classification of the polling stations according to their sensitivity to decide the level of security
- Maximum possible deployment of forces to keep miscreants away
- Transfer of election-related officials posted in home districts or posted for over three years in the current position to prevent their partisanship

- Deployment of Central Armed Police Forces (CAPF) like CRPF, BSF, since political parties often lack trust in local police and demand deployment of forces from outside the state
- Conducting election in several phases to efficiently utilize the CAPF by rotating them
- Video surveillance of all suspicious activities and persons,
- Seizing all illegal arms and ammunition and getting many arms license holders to deposit their arms in the police station in apprehension of breach of peace
- Relocation of sensitive polling booths and creation of auxiliary booths for pockets of voters under potential threat,
- Tracking of the movements of polling parties to and from the polling stations using GPS and keeping an eye on all election day activity by maintaining a foolproof communication network (ComET)

The Background

From the 1950s till the 1970s, violence was not a serious concern and state governments were able to manage elections without any extra support in the form of CAPFs. However, the mid-1970s onwards, violence became an integral part of the election process though in a limited manner. After the mid-1990s and early 2000 the issue of election violence became an inevitable factor in electoral management. The Election Commission, subsequently, had to issue new guidelines and specific instructions to take care of this menace.

The Commission's policy and strategy, therefore, now revolves around keeping a hawk-eye on law and order at all stages of election.

To ensure secured elections, it is necessary to study the tensions and conflicts that are confronted at different levels at various stages, that is, pre-election, in the campaign period, poll day and post-election stages.

Nature of Tensions at Different Stages

Pre-election conflicts are primarily concerned with fidelity issues and possible manipulations in electoral rolls, while those during the election campaigning period include disruption of opponents' campaigns, intimidation of candidates and voters and a general atmosphere of threat and violence. The poll day conflicts comprise preventing people from voting, violence at or around polling stations, booth capturing and rigging, damage to electoral voting machines and threat to election personnel. Post-election tensions include counting day conflicts, victimization of voters and clashes between the winners and losers.

Vulnerability Mapping

Pre-poll: The exercise for the safety and security of voters on poll day actually begins much earlier in the form of vulnerability mapping. 'Vulnerability'—in the context of elections—may be defined as the susceptibility of any voter or section of voters, whether or not living in a geographically identifiable area, to being wrongfully prevented from or influenced upon, in relation to the exercise of his or her right to vote in a free and fair manner.

Vulnerability mapping consists of three meticulous exercises done to identify critical polling stations and critical clusters at the micro level, based on the likelihood of intimidation, threat or other forms of pressurizing the voters either to vote or not to vote for a particular candidate. The three stages are:

 i. The first is the 'location specific' stage. Here vulnerable villages, hamlets and wards are identified. During this stage, the sector officer (an officer in-charge of eight–ten polling stations) must necessarily visit every locality/pocket in the area of every polling station in his sector, hold widespread discussions with people there, collect intelligence and list the vulnerable households and

 families, as well as the persons and factors causing such vulnerability there. He reports about each area in a standardized format. This stage is completed before the notification for the elections is issued for the concerned constituency.

ii. In the second stage, that is the 'person specific' stage, potential troublemakers who are likely to pose a threat to voters by intimidating them are identified. This exercise is completed within five days of the issue of the gazette notification that announces the dates of nomination, etc. After that the Superintendent of Police (SP) and the District Magistrate (DM) initiate all possible preventive measures in a focused manner.

iii. In the third stage, which is an 'action and responsibility specific' stage, a host of preventive measures are undertaken and reports are submitted. This is done at least five days before poll day. To ensure that troublemakers are kept under watch, police personnel by name are designated as responsible for each critical cluster. Contact persons from within the communities that are vulnerable are also identified and the law and order machinery keeps in touch with them to instil a sense of confidence.

The guiding factors in identifying sensitive and trouble-prone areas/polling booths are:

i. Past history of the constituency or the polling area

ii. Incidents of booth capturing, violence, riots, large-scale impersonations etc.

iii. Information regarding an abnormal law and order situation in a particular area

iv. Specific complaints made by political parties and candidates

v. Political profile of candidates

vi. Political rivalries

vii. Number of history sheeters and absconders
viii. Number of SC/ST* electors

Based on the detailed exercise of vulnerability mapping, every District Election Officer and returning officer ensures that a confidence building campaign is run under which every vulnerable hamlet and vulnerable person is visited and contacted and assured of his or her safety and security during the electoral process as well as on poll day. In the elections held in Uttar Pradesh in 2012, the instructions to the sector officers were that on poll day they must contact each and every such vulnerable person either by visiting their houses or contacting them through mobile phones and ensure that none of these refrained from voting due to any threat or intimidation.

Security in Maoist Areas

The biggest threat in elections comes from Maoist and extremist affected areas where insurgents are very likely to create havoc in the local area and spring surprises and attack the security personnel for a psychological impact. Extremist outfits use the visibility of electoral campaigns to conduct attacks against the government and its symbols in order to gain publicity. They consider elections as a big threat to their position and often call for mass boycotts of the entire election process by making threatening calls to voters.

Many incidents of Maoist and extremist violence in the country have occurred, mostly in states like Andhra Pradesh, Odisha, Chhattisgarh, Jharkhand, Bihar and parts of Maharashtra. Violence by separatists, extremists and insurgents has been observed in Jammu and Kashmir and in the Northeastern states. In the elections held in 1999 as many as thirty-three police personnel were killed in Maoist and extremist

*Scheduled Caste (SC) and Scheduled Tribe (ST)—Weaker sections identified in the Constitution of India in a specific schedule.

related incidents. However, in the last few elections held in the Maoist-affected states of Jharkhand, Bihar and West Bengal, the spate of violence by these elements has abated to a very large extent. The fact that there have not been any killings in the last assembly elections in Bihar (2010), West Bengal (2011) and Chhattisgarh (2013) is acknowledged to be mostly on account of efforts by the election machinery, especially the efficient measures taken by security forces.

The safety and security of polling parties, voters and the poll material requires very special measures like forming cluster points for polling personnel, movement of security personnel for anti-landmine vehicles, road opening measures, aerial surveillance, airlifting of poll personnel to and from the polling stations and emergency rescue measures.

In Maoist and other insurgency affected areas, CAPF are deployed in mobile patrols with magistrates, area pickets, check posts and quick reaction teams. Central forces are not kept as 'reserve' at any level. In rare cases when they are to be kept as reserve, prior ECI approval is obtained and they are made available with suitable communication and mobility facilities for contingent deployment and movement at short notice. (This came to the notice of the EC when, the CAPF sent to the state was kept in 'reserve' by a state police chief basically to keep it away from the election. The EC had reasons to suspects his intentions.)

For the poll day the CAPF is assigned duties of guarding the polling stations, poll material, poll personnel and the poll process. For this purpose the CAPF is deployed in any of the following manners:

a. Static guarding of chosen polling stations solely and exclusively by CAPF; or as part of a mixed (composite) team with local state forces.
b. Patrolling on assigned routes covering a fixed cluster of polling stations.

c. Patrolling as 'flying squads' in a defined area with a surprise element.

d. Escorting polled EVMs with polling personnel back to receiving centres/strongrooms after the polls are over.

CAPF takes positions in the assigned polling stations on a day prior to the polls. When CAPF personnel are assigned duties of mobile patrolling they are provided a list of critical polling stations falling on that route to maintain constant and close supervision of such polling stations.

No police force is allowed inside a polling station. However, one CAPF jawan is stationed at the entrance of the booth to keep a watch on the proceedings that are going on inside and to ensure that:

- No unauthorized person is present inside the polling station at any time during the poll.
- The polling party or polling agents do not attempt to cast any vote when no voter is present inside the polling booth.
- No polling officer accompanies any voter to the voting compartment.
- No polling agent or polling officer threatens any voter or makes any gesture to threaten a voter.
- No arms are carried inside the polling station.
- No rigging of any kind takes place.

The identification of the voters coming to the polling stations to cast their votes is not the jawan's duty but that of the polling personnel inside the polling station. However, if he discovers any violation or something unusual going on inside the polling station, he reports it to the officer-in-charge of the CAPF party at the polling station or to the election observer.

Wherever CAPF arrives in advance for area domination, it takes out flag marches, point patrolling and engages in other confidence building activities. The flag marches are focused. In order to make them effective the CAPF contingent is provided

with a list of area-wise anti-social elements for it to undertake a spot verification (of their whereabouts, presence and activities). Such flag marches by CAPF are usually on foot; they are directed to interact with the local population with a view to enhancing public confidence in the law and order arrangements.

In a 'flying squad' mode the CAPF is fully and constantly mobile and undertakes random surprise checks on polling stations falling within the area and reports to the district control room on its findings. These squads are accompanied by a 'zonal magistrate'.

The Election Commission's concern about conducting safe elections, of course, extends to the safe return of poll personnel after the poll process is over.

Communal and Caste Issues

Common incidents related to competitive politics include political murders and attacks, use of illegal arms and explosives, attacks on rival party offices, rallies and meetings and forceful entry into polling stations and intimidating the voters perceived as not belonging to their group. Communal elements exploit the high voltage atmosphere of elections to their advantage to disrupt the delicately balanced harmony. Similarly, caste conflicts contribute to tensions among various classes of society and result in clashes. The politics of caste and community for electoral gains has been fairly detrimental to the electoral process. Against the backdrop of political, communal and caste violence, the Election Commission has to be constantly alert and devise and innovate newer policies to ensure peaceful elections.

The objective of a good election is not merely to have peaceful polls but to also ensure that the polls are free and fair. Conducting peaceful polls with no untoward incident does not necessarily mean that the elections were fair and free. Silent rigging by way of covert intimidation could be a part of a peaceful election but such polls cannot be termed as fair and

free. The Commission's erstwhile strategy of macro planning was no longer sufficient to deal with the new situation and it was felt that macro and micro issues would have to be addressed together to get desired results. Therefore, various proactive initiatives were taken during the last decade, such as extensive use of central armed police forces, use of videography, photography, border sealing, identification of critical polling stations, vulnerability mapping, deployment of general and police observers and vigorous implementation of the Model Code of Conduct.

In view of the increasing penetration of criminality, muscle and money power in elections, a large number of measures over and above normal arrangements have also been taken up. These include regulating and banning the sale of liquor in close proximity with the dates of the poll and the dates of counting and seizure of illegal cash and illicit arms including review of licensed arms. These measures tend to inspire confidence in the impartiality of the election machinery among the electorate. Assurance of peace encourages many voters to come out to vote.

These extra measures taken by the Commission cannot absolve the normal law and order outfit of the state from taking such preparatory steps as are necessary for generating an atmosphere conducive to the conduct of peaceful, free and fair polls during the run-up to the elections. It is indispensable to tighten the local law and order machinery and enforce with adequate strictness the day-to-day criminal administration.

CAPF and its Role

The demand for CAPF has been increasing with every election with the result that in many elections, armed police from another state has to be deployed in the state going to the polls. All opposition parties demand deployment of central forces since they do not trust the local police. Ironically, even the ruling party makes the same demand. For instance, in the Bihar assembly

elections in 2010, Chief Minister Nitish Kumar insisted that central forces should be deployed at every polling booth, even if it required holding elections in ten phases! Obviously, even he did not trust his state police as many of them were loyalists of his rival.

Award for CAPF Management

Nishant Kumar Tiwary, SP, Bettiah, Bihar was given a national award in recognition of his work for CAPF. Poor arrangements for force mobility and logistics sometimes lead to disgruntlement among the forces. This upsets their coordination with local forces and affects their performance. Nishant Kumar Tiwary made the following innovations:

- Wrote welcome letters to company commanders and senior officials.
- Guides for each company were sent in advance to their locations at the donor district itself.
- Provided a police station-wise information booklet for each company.
- Organized an ice-breaking session with CAPF officials with a briefing by the SP and co-hosting of lunch by the DM and SP.
- Decentralization of resource allocation (PoL/recharge coupons, etc.) by tagging police stations with the nearest possible petrol pumps to obviate the need for them to come to district headquarters.
- Prepared a deployment plan well in advance and delivered it to the company location.
- Asked local officials to reach out to help the force, to create happy memories of a welcoming hospitable state.

The measures were greatly appreciated by CAPF and raised their morale and performance.

CAPF deployment plans: The process starts with a state deployment plan which takes into account available forces from all sources. It is prepared in consultation with the Chief Electoral Officer of the state. A state-level police force coordinator appointed by the Ministry of Home Affairs assists the CEO in this task.

As a rule, central forces are deployed in a minimum strength of one section* for reasons of their own safety. Smaller numbers may be targeted easily. However, based on its experience, the Commission persuaded the Ministry of Home Affairs to allow splitting the sections and deploying a half section of CAPF in areas which are not insurgency, militancy or Naxalite affected. This is based on a certificate by the district SP.

The state deployment plan is based on district deployment plans which are prepared by every district taking into account the forces being made available. The district plans are formulated under the chairmanship of the District Magistrate/District Election Officer. On his arrival in the district**, the EC observer is consulted by the District Magistrate and the Superintendent of Police and it is mandatory for the views of the observer to be incorporated before giving a final shape to the plan.

District deployment plans are further broken down to assembly constituency security deployment plans.

All these three-tier plans are ready at least one week before the day of the poll.

The extraordinary powers which the Election Commission gets during the election process enables it to ensure free, fair and peaceful elections. With the announcement of elections the entire police force of the state comes under the purview and radar of the Election Commission of India. Because of this

*Ten persons make one section; three sections make a platoon; three platoons make one company.
**The observer has to arrive in the district on the last date of filing of nominations by the candidates (seventeen days before the poll).

empowerment the Election Commission is able to direct the state and union territory administrations to undertake standard precautionary measures which include the following major ones:

- Preventive actions and special drives to update lists of history sheeters, declared absconders, criminals (where action is taken under the Indian law of the Criminal Procedure Code under Sections 107, 109 and 116).
- Expediting the investigation and prosecution of pending election-related cases.
- Prohibitory orders under Section 144 of the Indian Criminal Procedure Code.
- Unearthing illicit liquor.
- Seizure of illegal arms and ammunitions, etc.
- Checking and de-positioning of licensed arms with the police.
- Ban on issuing new arms.
- Check posts to check vehicles for movement of illegal arms and antisocial elements, carrying of unaccounted-for cash and liquor.
- Executing non-bailable warrants:

An important feature of election security is execution of pending non-bailable warrants. We often receive complaints that many criminals, against whom the court had issued non-bailable warrants of arrest, continued to roam free, hoodwinking the law. It is alleged that these criminals enjoy political patronage and their protectors ensure that the police does not arrest them. These elements are then used by politicians to help them during elections, and this was a tool of poll related intimidation. A few months before the due date of the polls, the Election Commission starts monitoring the execution of all non-bailable warrants and ensures that all the absconders are rounded up. This contributes to peaceful elections.

Recent years have seen a gradual increase in the use of CAPFs for conducting elections. Their use has even been

extended to bye-elections that may be taking place in otherwise peaceful states in the country. This is also based on the demand of political parties and candidates.

Confidence Building Measures

Violence-free elections are a prerequisite for the active participation of people. Measures taken include regular meetings with political parties and candidates by the Chief Electoral Officer, District Election Officers and police officers, regular press briefings to disseminate information to the electorate about the security measures taken by the election machinery, voter contact programme by sector officers in their allotted area of around ten polling stations from the day the election schedule is announced, regular patrolling by the district police and flying squads, area domination by the central police force and speedy redressal of complaints. The voter awareness campaign facilitates building confidence among the people. Recent elections in Bihar, West Bengal and Uttar Pradesh have proved that public faith in the safety and security of the election process resulted in record voter turnouts, especially among women.

Voter Slip—A Game Changer

Local administration often adopts interesting means to build the confidence of voters. In the 2012 legislative assembly elections in Uttar Pradesh the Commission's directions to distribute voter slips to each and every voter at his doorstep was done in a very innovative manner. A voter slip is a document that gives individual details of the voter including his/her photograph, EPIC details, number, name and location of the polling station where the voter will cast his or her vote. In Barabanki district in Uttar Pradesh, another slip along with the voter slip was distributed which was issued on behalf of the Superintendent of Police, giving telephone numbers of the local police station, district police control room and that of the election control

room, along with a tiny note informing the voters that the election administration will leave no stone unturned to ensure a safe and secure atmosphere. The district SP, R.K. Bharadwaj, also sent SMSes to voters assuring them a safe atmosphere for voting and giving his own cell phone number to them. In another innovative intervention, he directed the police control room to call up 1,000 voters every day to interact with them and assure them about safe and secure elections. This was probably one of the contributory factors for Barabanki registering its highest voter turnout in assembly elections. This model deserves to be emulated in all sensitive districts.

Polling personnel being airlifted for cluster point

In sensitive areas the Commission resorts to 'area domination' with the help of central police forces, which acts as a deterrent to criminal and antisocial elements while simultaneously restoring confidence among the people at large. One such successful example is of the West Bengal elections in 2011 where central police forces were deployed in a large number in Maoist affected areas in the state three months before the actual polls. This action had a salutary effect in

conducting free, fair and peaceful polls in the state. From then onwards, it has almost become a norm to begin the elections from the most difficult regions with force deployment several weeks in advance. Obviously, advance deployment is not a luxury in between phases where the gap is only about four–five days and the troops get just enough time to pack and unpack.

Poll Day Security

During the 2009 Lok Sabha elections an interesting surveillance system was devised for the remote and especially vulnerable polling stations in the tribal districts of Panchmahals, Dahod and Ahmedabad, among others. Cell phone cameras were linked to the central server of the CEO's and DEO's offices from forty-seven locations in over one hundred and fifty polling booths. These cameras were timed to take a picture, once every three minutes, with the help of a special software. Interestingly, while the CEO received telephonic complaints about minor violence in one of these polling stations, real-time photographs revealed that polling was going on peacefully there. This was confirmed by the security forces sent to cross-check.

Since the arrangement for installing hidden cameras was given wide prior publicity without disclosing the exact polling stations where such cameras would be used, there were newspaper reports that many women voters in some districts preferred to go for voting in full make-up as they did not want the camera to capture them otherwise! Personally, I think it is an unfair attribution. The real reason probably is that polling day has now become like a festival, as elaborated upon in the chapter on voter education.

Even after peaceful polls, the possibility of violence cannot be ruled out. The victory procession, if not regulated or banned, sometimes results in clashes between the winning party and the losing one. This is primarily the reason why various provisions under Section 144 of the Code for Criminal Procedure (Cr.

PC) remain in force for a few days after the poll day; which includes a ban on victory processions.

The continuance of CAPF's presence after the poll day relieves the people from the fear of their safety and security being compromised due to the charged atmosphere immediately after the polls and when the results are declared. At times, the prior knowledge of the continued presence of central forces induces confidence among them to vote freely, without any fear of victimization later.

At the time of the West Bengal assembly elections in 2011, we faced a real-life situation of this kind. The rivalry between the CPM and TMC runs deep leading to frequent violent clashes. We had taken unprecedented security measures including deploying a large contingent of CAPF and holding the poll in seven phases so that the available forces could be redeployed again and again in every phase. Normally, CAPF is released from election duty a couple of days after the results are declared but in this case we had made a special request to Madhukar Gupta, Union Home Secretary, to let us retain some contingents for two weeks after the polls as we feared major post-poll clashes. He agreed, accepting our apprehension. This may sound simple, but in practical terms, it was a major operational issue, as these forces were already mobilized for their next pressing assignment and all logistical arrangements including train reservations for them were in place.

Security of the Poll Machinery

The safety and security of polling personnel is of paramount importance to the Commission. This is ensured through:

- Training on safety/security to poll personnel and the security forces accompanying them.
- Overnight security for poll personnel in polling stations where they are located from about twenty hours before

the polls.
- Security deployment at polling stations and all other levels, (like sector, zone, police stations) and QRTs (Quick Reaction Teams).
- Sending road opening parties (RoPs) to remove all possible obstructions, including landmines.
- Setting up safe cluster points/shelter points for Naxal areas—airlifting/rescue operations.
- Strict security measures at critical polling stations.
- Anti-landmine vehicles.
- First aid.

Security of Political Functionaries and Candidates

It is also necessary to provide adequate protection to political functionaries and candidates during the electoral process. If a party candidate is killed or dies during the electoral process, the entire election process has to be aborted and fresh elections have to be held. This provision was introduced after some candidates were killed by those who were apprehending defeat and wanted to get the elections countermanded so that they get time to reorganize themselves. Various measures that are taken up include:

- Security measures at public rallies, processions, meetings of political parties and candidates.
- Personal security officers (PSOs) for candidates having security risks.
- Extra security measures for VVIPs.
- Avoiding clashes between supporters.
- Allowing different routes for processions by different candidates to prevent clashes.

As a matter of precaution, the Ministry of Home Affairs is directed by the Commission to ensure that all international

borders are sealed at least one week in advance of the polls to prevent any movement of anti-national elements from across the borders to disrupt the election process. Interstate borders/inter-district borders are also sealed well in advance to prevent infiltration of antisocial and disruptive elements from neighbouring states/districts where polls are being held.

In normal 'safe' areas, the security is minimal. It could be just a constable with a lathi (baton) or even a Home Guard (trained volunteer force). Lately, even the volunteers of National Cadet Corps (NCC) and Scouts and Guides have been deployed for jobs like managing the queues and guiding the voters. This has proved effective, saving the armed police for law and order duty.

ComET or Communication-plan for Election Tracking

Good and smooth communication between the players is an integral part of security planning. The Commission has devised a micro level communication plan for this purpose.

ComET was based on a communication plan developed and used in the assembly elections in November 2008 when contact details for nearly 47,000 polling were collected and pre-tested. The communication plan includes micro-detailing of the means of communication at the polling station level like mobile and landline phones, along with telephone details of the nearest police station/post and the sector/zonal officers/ magistrates. Besides this, names and telephone/mobile numbers of suitable, reliable volunteers in relation to every polling station are collected. As a contingency measure, if all other means of contact fail, the names of two 'runners' (youth with sprinting ability) between the polling station and the closest telephone/ wireless establishment and other details thereof are taken!

ComET has become a valuable tool in election management as it speeds up the process of redressal of election complaints by minimizing response time and easing the generation of reports.

It creates a feeling of the widespread and strong presence of the ECI on poll days at the grass roots, at all levels of the election machinery and among the voters.

Many observers reported the deterrence value of ComET by driving a fear in the minds of potential trouble-makers that they cannot escape the hawk-eye of ECI. In one case in the Maoist affected district of Gadchiroli, Maharashtra, when a polling party was nearly ambushed, the quick report on ComET network brought in paramilitary reinforcement in helicopters that scared away the attackers.

Dealing with the Threat Within

The threat to security of elections is not only from external elements but the conduct of election officials themselves can be a critical factor in it. Corrupt or politically aligned officials can play miscreants in the process. The Commission does not spare even the most senior police or civil officers if their neutrality is even slightly suspected. An informal dossier is always kept handy and updated a few weeks before the election. Complaints by political parties against officers are examined very seriously and when the Election Commission feels that continuance of an officer on his job is prejudicial to non-partisan elections, it transfers him/her immediately. Normally, those police officers who are not directly involved in election management (e.g., intelligence, security) are not touched; but there are occasions when it becomes imperative to deal with them. One most glaring case happened in Tamil Nadu in 2011.

Our officers visiting the state reported that a senior police officer holding the post of ADGP* (Intelligence) is frequently calling up SPs and DIGs in the field with political intent. He had excessive influence and control over the police personnel by virtue of his close political alignment. Complaints were

*Additional Director General of Police

received and there were apprehensions that he would use his position to help the ruling party.

Based on the assessment of the situation, ECI came to the conclusion that it would be in the interest of free and fair polls that he was kept away from the scene during elections. We were reluctant to deviate from our own policy of not transferring security or intelligence related officers. The officer was summoned to the ECI headquarters for a discussion with the Commission where he was informed that he was being sent as an observer to West Bengal. Stunned by the suggestion, he came out with a story that he thought would make us cower. He said that there were serious intelligence inputs about LTTE planning to disturb the elections in the state and attack some top national leaders (he named three). Our gut feeling was that this was a bluff to not remove him from his powerful position. To prove his 'information' correct we thought he may instigate some disturbances here and there. We chose to confront him with our apprehension and told him that if there was any disturbance anywhere in the state, he will be our first suspect! That clinched it. He volunteered to go on leave and stay away from Tamil Nadu during the leave period. He actually went on leave—to Malaysia—till the elections were over. This unusual step was considered important as public perception is extremely important for credibility of elections.

Although the matter was settled, but to be doubly sure, I spoke to the Home Secretary, Gopal Pillai, who said the 'threat' theory was absolute bunkum. He mentioned two reasons: one, the LTTE threat was by then non-existent, and, two, the officer in question, who was heading the concerned cell earlier had actually been transferred out on promotion several months ago!

The state government sent a fresh panel and a neutral person from the panel was given additional charge of the post of ADGP (Intelligence).

The high credibility that the Indian Election Commission enjoys is not only due to its fiercely independent structure, but

also due to the enormous detailing that goes into its operational and strategic planning for every aspect of conducting elections. Safe elections in India over the years have been responsible for one of the most stable democracies in the world. Gone are the days when booth capturing was widespread.

I recall the Bihar election in 1996 when I was posted as an observer by the EC in a politically volatile constituency. The legendary CEC, T.N. Seshan, concluded his briefing with these reassuring words: 'Don't worry, nothing will happen—except a bomb on your face and a bullet through your stomach!' And sure enough, I saw two crude bomb explosions about 20 yards away. Fortunately, I returned with my stomach un-punctured!

7

USE OF TECHNOLOGY IN
INDIAN ELECTIONS

EVM and Counting Blues: Lessons from 20–Suangpuilawn

The 2003 election to the Legislative Assembly of Mizoram
in the 20–Suangpuilawn (ST) assembly constituency carries a
lesson for all election managers, particularly those in charge of
electronic voting machines (EVMs) and counting. The counting
hall was situated in the District Collector's (DC) office complex.
A posse of Border Security Force (BSF) police was present at

the entrance, a short distance from the counting place. The DC was confident that everything was in order but was anticipating some problems in the city after the counting. Further, there was no intelligence input about any problem in the counting. But when the police were asked to come inside the counting hall, the Congress Party's candidate objected to it. The DC obliged and the police was instructed to stand at the door of the hall. Then it was noticed that there were about twenty counting agents present along with the Congress candidate. Strangely, however, there were no counting agents with the Hmar People's Convention. These were the circumstances in which the counting started at 4.45 p.m. (on 3 December 2003).

The postal ballot papers were counted first. Then something untoward and unexpected happened. All of a sudden all the counting agents got up, grabbed the control units and banged them on the floor, breaking them instantly. They also hit the counting tables with their chairs, creating panic among the counting staff. The police were called in and directed to arrest all the culprits, including twenty counting agents of the Congress and two other women. Form 17C (used for keeping accounts of votes recorded) was signed by the counting supervisors, mentioning damage to the control units by the counting agents. Thereafter, all the pieces of the control units and all the records were put in steel trunks, locked and kept in a strongroom. The Deputy Election Commissioner was informed of the incident immediately and as per his instructions all the broken control units were brought to the ECI office, Nirvachan Sadan, New Delhi, along with the Returning Officer (RO) on 4 December 2003.

On reaching the Commission's office, the RO handed over the keys of the trunks to the Commissioner. The counting began again, witnessed by then Chief Election Commissioner J.M. Lyngdoh and the two Election Commissioners. H. Lalsangzuala, Hmar's candidate, was declared the winner. The entire proceeding was recorded, and once the counting was

over, the EVMs were resealed and kept in the Commission's strongroom for safe custody.

Subsequently, the Commission discovered that there was bitter political rivalry, communal polarization and intimidation of voters by underground elements in 20-Suangpuilawn. It was clear that the culprits from the Congress Party broke the EVMs out of frustration and fear of losing the elections to their opponents. Criminal cases were registered against the culprits.

Managing elections in a country of subcontinental dimensions cannot be done easily without the application of user-friendly technology. Realizing this the Commission has been steadily moving away from manual processes to electronic technology, which has brought great efficiency in the electoral process. These technologies have been thoroughly and rigorously field tested before being used to ensure authenticity. Many of the innovations for the use of technology actually came from the field and were subsequently adopted at the national level.

For instance, Kerala was the first state to conduct elections using photo rolls. The two bye-elections of May 2005 in 9–Azhikode and 14–Kuthuparamba (prior to delimitation), both in Kannur district, and the November 2005 bye-election for the 20–Thiruvananthapuram parliamentary constituency in November 2005 were all conducted using photo electoral rolls. Subsequently, elections to the Kerala Legislative Assembly in 2006 were conducted entirely with photo electoral rolls. It is noteworthy that it was also in Kerala that EVMs were used for the first time during a 1982 bye-election in the 70–Paravur Legislative Assembly constituency in Ernakulam district. Today, technology touches almost every aspect of elections in the country.

All technology related applications have been developed in-house by the Commission. In many cases the ideas have come up during discussions with field staff members and, often, their initial development was also undertaken by young and energetic District Election Officers. Broadly, these applications

are intended to achieve the following objectives:

1. Better service to citizens
2. Better management of elections, thus making them more cost effective
3. Improving transparency
4. Awareness and information dissemination

One of the biggest technological innovations to be used in the election process in India came in the early 1980s in the form of EVMs. Since then, technology in many other forms has been introduced into the election process. Computerization of electoral rolls began in the early 1990s, Elector Photo Identity Cards (EPICs) were introduced soon thereafter, while Photo Electoral Rolls (PERs) were introduced at the beginning of the twenty-first century. Today, EPICs and PERs cover about 99 per cent of the country.

Mobile technology in all its forms including voice, data and SMS communication, as well as satellite imagery and Geographical Information Systems (GIS), have also been put to very good use by the Commission. It is also working on integrating with the biometric database being created by the Unique Identification Authority of India (UIDAI) and the Registrar General of Census for National Population Register (NPR). The Registrar General of India (RGI) is planning to issue smart cards containing biometric data to every resident in India, and has agreed to include the EPIC number in the smart card so that in future it can be used for verification of identity using biometrics, if required*.

Technology Applications for Services to Citizens

The ECI wanted to make the experience of enrolment in electoral rolls and casting votes a pleasant experience. To ensure

*Linking it with Aadhar cards will also be a possibility.

this it took pains to provide services to citizens at their doorstep. The Commission appointed Booth Level Officers (BLOs)* for each polling booth for easy interaction with voters.

Technology is an effective way of reaching and serving citizens, especially in urban areas with high Internet penetration. Moreover, Internet penetration is also increasing gradually in rural areas where mobile phone use is already very high. The Commission has, therefore, started using mobile technology in all its citizen service applications. In modern times people have neither the time nor the inclination to visit government offices or stand in long queues to access services. Information technology offers them an easy way of accessing such services in the privacy of their homes or offices.

Mobile and online applications that are being used by the Commission to provide better services to citizens include:

1. Facility for online enrolment in electoral rolls
2. Online complaint registration and public grievance management
3. Call centres for public grievances
4. Online information sharing
5. Electoral roll search

Let us examine these in greater detail.

Online enrolment

Recently, the Commission started providing the facility of filing applications online for inclusion, deletion, modification and transposition of names in electoral rolls. Overseas electors, too, can fill these online forms. Applicants can even upload scanned copies of their photographs and documents in support of their claims. These application forms are then examined by the concerned Electoral Registration Officer (ERO). Printouts

*There is a good op-ed on BLOs: http://www.thehindu.com/opinion/op-ed/the-importance-of-being-a-booth-level-officer/article4756994.ece

are given to BLOs for verification in the field and decisions are taken based on the field verification and documentary evidence. Thereafter, applicants are notified about the ERO's decision via the website and SMS. If the ERO wants to meet the applicant in person, he/she notifies the applicant about the hearing schedule via SMS.

Online Public Grievance Management System

The ECI has always stressed the need for developing an effective public grievance management system. Raj Shekhar, the bright young District Magistrate of Jhansi in Uttar Pradesh, had developed a small web-based application for timely redressal of complaints and was using it in his office. During a bye-election in 2010, he modified this slightly and adapted it for managing election related grievances. The system worked very well, much to the satisfaction of the citizens. He made a presentation of this system called 'Jhansi Jan Suvidha Kendra' (People Facilitation Centre of Jhansi) to the Commission on 31 January 2011. We immediately decided that this system be adapted, modified and scaled up to for use across the country. A team of ECI programmers comprising Manish Kumar, Bikash Kumar Behera and Nitesh Agrawal developed the Commission's Citizen Service Portal within six months. The portal is now fully operational. Citizens can register complaints online on the ECI website. These complaints can be related to the working of the election machinery and any malpractice by political parties and candidates. As soon as a complaint is registered, an SMS notification is sent both to the complainant and to the officer concerned who is required to conduct an inquiry into the complaint. Inquiries are completed within a pre-announced time frame and action is taken, the reports of which are uploaded on the website. Notification of action taken is sent to the complainant via SMS as well.

The Commission has also put in place a mechanism for randomly checking the satisfaction levels of applicants. The

system provides online reports to Commission members and senior officers for monitoring the working of the public grievances management system. These reports are also sent via SMS. A good grievance management system provides insights into the shortcomings of the system and presents an opportunity for improvement, and conducting free and fair elections depends greatly on prompt action on all complaints. Thus, the Commission receives a slew of complaints related to violations of the Model Code, misuse of money power, paid news, distribution of money, liquor and other things during an election. Immediate and strict action on all these is essential to maintain the credibility of the election process and to ensure a level playing field. These complaints are received at all levels including that of the returning officer, the District Election Officer, other field officers, observers and even the Commission. It is necessary that people are able to send their complaints easily and even anonymously, if they desire. It is also essential that a perfect record of all the complaints and action taken on them is kept and that complainants are informed about any action taken by the Commission. The online public grievance management system has made all of this possible. In the 2012 Uttar Pradesh assembly elections over 20,000 complaints were registered on this system and all were disposed of within the specified time limits.

Call Centres

The Commission aims to be accessible. During elections we make it a point to meet all political parties and stakeholders proactively, and are always willing to meet others, whenever a request is made. The Commission is also conscious of the fact that many people may not be able to spend the time and effort required to meet officers personally or may not be inclined to come personally to maintain their anonymity. For this purpose the Commission has set up a call centre with '1950' as a toll-free number in every state. This call centre

functions 24X7 during elections, and during scheduled office hours at other times. Trained call centre operators interact with callers in local languages. Call centres in the states are seamlessly integrated with the operators of the online public grievances management system, randomly checking satisfaction levels among complainants.

Transparency—Online Information Sharing

This is another useful initiative for ensuring greater transparency. All important information is put up on the ECI website in a user-friendly manner. Citizens can search names, telephones numbers and addresses of local election officers including CEOs, DEOs, EROs, returning officers and BLOs. All press releases issued by the Commission, important letters, instructions and laws and rules relating to elections are also available on the Commission's website. Two programmers work day and night to keep the website updated. Its layout was recently improved and made more user-friendly, and it also has special sections on current affairs and ECI news.

Awareness and Information Dissemination—Search Facility for Electors

While it is easy for electors in rural areas to find their polling stations (since a village normally has only one or two polling stations), it may be difficult to identify one's polling station in a densely populated urban area. Similarly, in villages people find it easy to get in touch with their BLOs and find out whether they are enrolled and what their serial number on the rolls is. On the other hand, in cities it may be difficult to find one's BLO. It is often noticed that a person who has an elector photo identity card (EPIC) takes it for granted that his name is on the electoral roll, though it might have been deleted from it because he has changed his residence and has not applied for transposition of the name to the new address. A BLO may have visited his old address and recommended

deletion of his name because he did not find him living there. In these cases the elector may be deprived of his franchise on the day of the polls. Therefore, the Commission always advises people to check that their name is in the electoral rolls before every election. To make this easy a search facility has been provided on the website of each CEO by which electors can search for their name in either English or the local language.

In the 2012 Uttar Pradesh elections, Umesh Sinha, the CEO of Uttar Pradesh, thought that a search facility for electors should also be available on mobile phones through SMS. He had observed that access to the Internet and personal computers was still limited in rural areas, but penetration of mobiles was extensive. An application for queries through SMS was developed by the in-house programmers Shabab Beg and Harpal Singh in just ten days and was immediately deployed. This application has now been extended to many other states and will soon be used all over the country. In this application electors can SMS their EPIC number to a predetermined telephone number. They get an SMS reply informing them of the polling station in which they are enrolled and their serial number in the polling station. In case a citizen is not enrolled he gets an SMS informing him of the procedure to be followed to have himself enrolled. The facility for obtaining printed voter slips online or on cellphones has also been created in some states.

Voter Slips—A Welcome Innovation

During the 2009 Lok Sabha general elections it was noticed by certain perceptive DEOs/ROs that many voters were facing difficulties because they did not know whether their names were included in the electoral rolls or not and, if included, they were not aware of details of the polling station where they were supposed to go and vote. They were sometimes also handicapped because they did not know their serial number in the electoral roll. These were critical gaps in voters' education and awareness. A few DEOs like B. Rajender (DEO, Saran) and

Bandana Preyashi (DEO, Siwan) found that the old system of voters' slips being provided to the voters by political parties/candidates was not working. There were complaints that either the voters' slips were not being distributed or these were being distributed selectively in areas/pockets that had what the parties considered 'committed' voters. Hence, Rajender and Bandana came up with the idea of *also* distributing voters' slips through BLOs. They developed a software for printing these slips. It worked well as an experiment and positive feedback was received from the voters, especially those from the weaker sections. Hence, it was taken up in the entire state during the 2010 elections to the Bihar Legislative Assembly.

When the Commission visited Patna on 20 September 2010 to review the preparations for the Bihar assembly elections, the enthusiastic CEO Sudhir Kumar Rakesh mentioned that he proposed to distribute voter slips through BLOs. Initially, we were taken aback with this suggestion, considering the enormity of the task and the responsibility involved. If even one voter was left out the EC could be accused of discrimination. Unlike political parties and candidates, the EC could not be selective in distributing voter slips. We grilled him on this but he persisted with supreme confidence. We agreed, though with trepidation, to go ahead with this idea on an

A touchscreen kiosk

'experimental basis'. What followed was a game changer.

Sudhir Rakesh and his team introduced ATM type kiosks for elector search facility for several districts including the state capital and created a telephonic helpline for name searches. Touchscreen kiosks were set up at several places in

Patna including the airport and the CEO's office. These kiosks displayed all the necessary information about an elector through a simple search by name. Thousands of electors availed of these kiosks, and this arrangement was repeated during the elections to the Bihar Legislative Assembly in 2010.

In all the subsequent elections in Assam, West Bengal, Tamil Nadu, Kerala, Puducherry, Uttarakhand, Punjab, Goa, Manipur and Uttar Pradesh, the issuing and delivering of voter identity slips to the voters at their residence was made mandatory. The ECI also decided to discard the existing fourteen alternative documents as proof of identity at the time of voting for those who have been issued EPICs. Instead, only the EPIC or voter slip (with photo) is allowed.

The small voter slip had a large impact resulting in the mobilization and motivation of voters and allowing them to exercise their franchise without hassles, thereby ensuring their larger participation.

Technology Applications for Better and Cost Effective Management of Elections

Beside providing citizen-friendly services, technology has also improved election management in many ways and made it more cost effective.

The Electoral Roll Management System (ERMS)

The fidelity of electoral rolls is paramount for free and fair elections. Elections cannot be called free and fair if names of eligible electors are left out from the rolls, or if rolls are stuffed with names of ineligible persons. The Commission lays great emphasis on maintaining pure rolls and spends a lot of time and effort on it. Rolls are revised regularly after the first of January which is the qualifying date for enrolment every year.

This enormous task has been simplified by technology. In India the electoral roll database is maintained state-wise on state

level central servers. This is the largest database of electors in the world and has 814 million records. The online electoral roll management system has been developed and is used by the ECI to keep the electoral roll database updated at all times. Work on the online ERMS began in Chhattisgarh in 2008 before the elections to the Legislative Assembly in the state. The CEO, Alok Shukla, demonstrated this to the Commission during its visit to the state to review poll preparedness in October 2008. We were so impressed with him that we brought him to Delhi and posted him as Deputy Election Commissioner in the ECI. He was asked to work on developing an online ERMS for the entire country. Simultaneously, Naresh Gupta, CEO, Tamil Nadu, and Manoj, Special Officer in Karnataka, were also working on an online ERMS. With encouragement from the Commission, several other states, notably Gujarat and Kerala, also started working independently on developing online ERMS. Today, all Indian states use online ERMS; sixteen of them use the ERMS developed by the ECI.

The Commission is now working on an integrated ERMS for the entire country so that services can be provided to all citizens from a common platform and all elector databases across states are fully compatible with each other. The important modules of ERMS include:

- Online filing of applications
- Digitization of forms received on paper
- ERO module for inquiry, verification, hearing and order on the application
- Shifting of ERO approved data from a non-secure to secure database using digital signature security
- Merging of electors' photographs in electoral rolls
- Making a new duplicate EPIC
- Printing of electoral rolls and working copies for BLOs, checklists, etc.
- Statistical analysis of the health of electoral rolls

- Printing of photo voter slips
- Finding possible duplicate electors in electoral rolls and their deletion after due verification

With the use of ERMS it is possible to keep an audit trail of every transaction and a statistical analysis of electoral rolls to check its fidelity. Thus, the Commission regularly analyses data like elector–population ratio, gender ratio and the age (cohort) ratio to check that the electoral rolls conform to expected demographic norms. Wherever there is an unexplained variation, special campaigns are launched to take corrective action, like adding missing names and deleting bogus or duplicate names. On the basis of this analysis the Commission found that women and youth were under-represented and launched a special campaign for their enrolment in the entire country.

Use of GIS in Election Planning

Another initiative was using satellite imagery and Geographical Information System (GIS) to great advantage for rationalizing polling stations, preparing route charts for transportation of polling parties, deployment of the police force, etc. GIS has also been used for planning, logistics and sensitivity mapping of polling stations. This has been very useful in areas affected by terrorism and insurgency for planning the movement of polling parties and security forces. For instance, in Gadhchiroli district in Maharashtra and in Kandhamal/Malkangiri districts in Odisha, DEOs prepared several alternate routes for polling parties and gave the route information to them at the last moment as a surprise element to avoid ambush by Maoists. Similarly, polling parties were instructed to follow different routes to and from polling stations. In many areas vehicles carrying polling parties were fitted with GPS devices to track their movements.

Personnel Management

The integrity and accountability of election staff is critically

important. To ensure this a database of all employees posted in a district is prepared. Their deployment at the polling stations is randomized using a customized software so that there is no possibility of employees on poll duty being approached or influenced. Earlier, the payment of honoraria to employees on poll duty was often delayed. Now it is done quickly using the online core banking facility.

Observer Management

The ECI uses senior officers of the Government of India and state governments as election observers. Under Indian law, observers have some statutory functions. They are the eyes and ears of the ECI and can take immediate and effective action whenever necessary. Observer management is done by the ECI through the observer portal. All communications to observers including the call letter for training, duty orders and deployment status are issued online and information is also sent to observers through SMSes. Observers then send their reports to the Commission through the observer portal where it is quickly assessed and analysed using a specialized software. Honoraria to the observers is also paid using the online core banking facility. The deployment history of every observer is maintained by the ECI through this portal.

Sensitivity Analysis of Polling Stations

Many states have areas vulnerable to various malpractices including booth capturing. The ECI does a sensitivity analysis of polling stations before every election so that additional care is taken for sensitive and hypersensitive polling stations. This includes additional deployment of forces, use of video cameras and micro observers. Detailed objective criteria for sensitivity analyses of polling stations have evolved over the years. These criteria include EPIC and PER coverage, percentage of absentee voters, previous history of violence and turnout in previous elections. A lower EPIC and PER implies higher possibility of

impersonation. A large number of absentee electors (who are on the electoral rolls, but do not live there for reasons like being employed elsewhere) carries the possibility of bogus voting in their place. An extraordinarily high turnout flags the possibility of booth capturing while an inordinately low turnout may be indicative of voter intimidation. In 2010 during the elections to the Legislative Assembly of Bihar, Palak Sahani, the DEO of Jehanabad, developed a simple Excel spreadsheet using all the data mentioned earlier for a sensitivity analysis of polling stations. Among other things, this Excel sheet is now used by many DEOs to ensure peaceful polls.

Video as a Weapon

The Commission uses video cameras as a very effective weapon for tracking antisocial elements including candidates with criminal backgrounds and those with the potential of creating mischief. Video tracking candidates with criminal backgrounds reduces their propensity to engage in illegal activities or in intimidating voters. Video surveillance was used to monitor the implementation of the Model Code of Conduct and tracking expenditure by candidates and political parties. Installation of video cameras in polling stations ensured that nothing went unnoticed. In the elections in Odisha the Commission saw a video clip of a polling officer going into the voting compartment with a voter. Since this constituted a poll infraction the EC immediately ordered a re-poll in this polling station.

Video Conferencing as a Review Tool

The Commission uses video conferencing as a tool for conducting regular meetings with field officers. It offers great advantages in the form of time and cost savings when it is difficult to call officers for meetings outside their districts. With this technology the Commission is able to discuss important issues with field officers quickly.

SMS Poll Monitoring System

Getting information from polling stations in real time is extremely critical and has always been a challenge. Timely information about important events at polling stations ensures prompt corrective action. In 2009 Anita Karwal, the brilliant CEO of Gujarat, hit upon the idea of using pre-formatted SMSes to collect information. During the subsequent Lok Sabha elections she trained her zonal officers to send SMSes to about six–eight polling stations in their area at regular intervals. The system worked so well that information regarding 80 per cent of polling stations was received in real time. The system was immediately adopted by the Commission for national use. A SMS based poll monitoring application has now been developed by Amit Gautam, a computer programmer in the Commission. In this application event-based pre-formatted SMSes are sent by polling staff on duty to a predetermined phone number for monitoring poll related events, like the safe arrival of polling parties, conducting of a mock poll, start of polls, two-hourly turnout figures, the close of polls, and information regarding violence or other incidents at polling stations. These SMSes are auto-compiled in a server which sends reports to officers for management. An SMS notification of any unexpected event is also sent immediately to the concerned officers for taking corrective action. For example, an SMS notification of a violent incident will be sent to the Thana in-charge and Superintendent of Police for immediate action. An SMS notification regarding replacing EVMs is sent to the sector officer. This system ensures prompt necessary action and is now widely used for efficient poll management.

Expenditure Monitoring

Money power has been playing havoc with fair elections. Recently, therefore, the ECI has laid increased emphasis on monitoring election expenditure by candidates and political

parties. A full-fledged Expenditure Monitoring Division was created in 2010. It coordinated with several enforcement departments including the Income Tax Department to control the misuse of money power in elections. A software was developed by Rohit Chhabra, an in-house computer programmer of the ECI, to compare information in the account registers maintained by the candidates and shadow account registers maintained by election officers to check whether the election expenditure had exceeded the ceiling prescribed by law. Notices can be issued to candidates and action can be taken against them using this software.

Communication System

A prompt and effective communication system is essential for managing elections. During the 2008 elections to the Legislative Assembly in Madhya Pradesh Deputy Election Commissioner Balakrishnan developed a web-based portal for creating a communication system with the help of NIC (National Information Centre). Later, he perfected this system for the entire country. On his daughter's suggestion he named it Communication for Election Tracking (CoMET). This is a multi-modal communication system which uses landline and mobile phones, SMSes, and wireless communication using radio frequency and satellite phones. In cases where no other technology works human runners never fail. The bottom line is that the Commission must continuously get information about all polling stations and all polling parties at all times.

There is an interesting anecdote about the use of satellite phones in the 2009 general elections. Polling parties had to walk in knee-deep snow for three days and cross Ralakung La in Ladakh at a height of 16,500 feet and then descend to reach the polling stations at Ralakung (13,500 feet) and Phema (13,800 feet). Their movement was monitored through satellite phones. This helped us to conduct the polls barely half a day before the counting. It was impossible to bring the EVMs

back to the counting centre before the day of the counting (the Commission, as a special case, appointed the presiding officer of the polling party as Assistant Returning Officer for these two polling stations). Therefore, the counting for these two polling stations was done at the stations. The results of the counting were then communicated on satellite phone to the returning officer who added them to the votes counted in the rest of the constituency and declared the result on time.

Web-based Monitoring Mechanism

The Commission uses a web-based monitoring system for reviewing and monitoring the progress of summary revision of electoral rolls, progress of the PER and EPIC campaigns and monitoring complaints. Web forms are created on which data is filled by the CEOs. Reports are then generated and are available to the Commission and all its officers for comparison, review and monitoring. This website has been developed in-house by Amit Gautam, a programmer with ECI.

Complaint Monitoring System and Control Room: the Bihar Experiment

The Complaint Monitoring System in Bihar was a novel feature used for tracking and verifying every complaint received during the 2009 Lok Sabha election. A well-equipped control room was set up at the office of the CEO, Bihar. Similar control rooms were set up in all DEO offices. In the CEO's control room in Patna, a telephone with fifteen hunting lines*, fax machines with five hunting lines, twelve computers with broadband connectivity and an ADF scanner were installed. A sufficient number of officers and employees were deployed for round the clock operation. Complaints were received through telephone calls, faxes, e-mails, mobiles of different officers, TV bulletins/

*The number of telephone lines available on the same number.

newspaper reports and even from the ECI headquarters. These were forwarded to control rooms in the district concerned and to the DEO, RO and observer for information and verification. Tracking/verification of complaints was done by contacting different persons in the communication plan (CoMET) and the findings were recorded in registers and on computers. On the day of the polls all complaints were verified immediately and the results were reported to the ECI by the same evening. This ensured greater voter confidence and a completely transparent and efficient system of handling complaints, and contributed to the highest ever voter turnout in the state.

Electronic Voting Machines

History and Background

No presentation on the use of technology in Indian elections can be complete without a reference to EVMs. The voting system in India has undergone several changes over the decades. During the first two general elections to the Lok Sabha in 1952 and 1957, each candidate was allotted a separate coloured ballot box. The candidate's name and symbol were not printed on ballot papers. Voters would drop an unmarked ballot paper in the ballot box of the candidate of their choice. The system, though very simple, evoked fears of tampering in the minds of stakeholders. Therefore, a marking system on the ballot paper was introduced during the mid-term elections to the Legislative Assemblies in Kerala and Odisha in 1960–61. That system remained in vogue until the 1999 Lok Sabha elections.

Meanwhile, in 1977 the Commission introduced some form of electronic machines for recording votes in an error-free manner and removing the possibilities of invalid votes. S.L. Shakdhar, the then Chief Election Commissioner, while on tour in Hyderabad in December1977 requested M/s Electronics

Corporation of India Limited (ECIL) to study the feasibility of using an electronic gadget for conducting elections. M/s Bharat Electronics Limited, Bengaluru (BEL) had already developed microcomputer based voting equipment, which they had used for the elections for the various unions of the company. They approached the Commission in January 1981 for manufacturing EVMs. On 29 July 1981 the Commission held a meeting with representatives from BEL, ECIL, the Ministry of Law and some CEOs regarding the use of EVMs in elections. It was decided to introduce EVMs in fifty polling stations in the 70-Parur assembly constituency in the assembly elections to the Legislative Assembly of Kerala held on 19 May 1982 as an experimental measure (the machines used had eight candidate buttons in the ballot unit (BU) instead of the sixteen candidate buttons as in existing EVMs. However, seven such BUs could be connected in series to provide for a maximum of fifty-six candidates).

Since the central government could not take steps to introduce legislation as proposed by the Commission for amendments to the Representation of the People Act, 1951, and to the Conduct of Elections Rules, 1961 to facilitate the use of EVMs, the Commission issued directives under Article 324 of the Constitution of India for the use of EVMs and conducted elections at fifty polling stations using the machines. The use of EVMs was challenged in court and the Supreme Court of India*held that EVMs cannot be used in an election unless a specific provision is made in law providing for their use. The law was amended by Parliament in December 1988 and a new Section 61A was added in the Representation of the People Act, 1951, empowering the Commission to use voting machines. The amended provision came into force on 15 March 1989.

In January 1990 the Government of India appointed the

*Dated 5 March 1984 in EP No. 01 of 1982 filed by A.C. Jose.

Electoral Reforms Committee (Dinesh Goswami Committee) consisting of representatives from several recognized national and state parties. The Electoral Reforms Committee felt that the machines should be examined by technical experts with a view to removing any doubts or misapprehensions in the minds of the public with regard to the credibility of the working of the machines. To do so it constituted an expert committee under the chairmanship of S. Sampath, Chairman, TAC, Defence Research & Development Organization, Ministry of Defence, and comprising reputed scientist P.V. Indiresan of the Indian Institute of Technology (IIT), Delhi, and Rao C. Kasarbada, Director, ER&DC, Trivandrum. The committee, after meeting with the manufacturers, election administrators and technical experts and conducting detailed laboratory tests, came to the conclusion that the EVM was a secure system. In April 1990, therefore, the expert committee unanimously recommended the use of EVMs without further loss of time.

On 24 March 1992 necessary amendments to the Conduct of Elections Rules 1961 were notified by the government with regard to the use of EVMs. EVMs have been used in all bye-elections to parliamentary constituencies and Legislative Assembly constituencies since November 1998. The general elections to the Lok Sabha in 2004 and 2009 were conducted exclusively on EVMs. Several technological changes were made in EVMs in 2001 and again in 2006 to upgrade them. To address the concern that the fast changing technology may have overtaken older members, the Technical Experts Committee was expanded and it now has P.V. Indiresan as its Chairman, and D.T. Shahaniand, A.K. Aggarwala of IIT, Delhi, D.K. Sharma of IIT, Mumbai and Rajat Moona from IIT, Kanpur (now DG, CDAC) as its members. The Commission does not take any technical decision without their recommendation or approval.

Types of Electronic Voting

Across the world, electronic voting is essentially of two types. First and most commonly used is polling place e-voting. The second is remote e-voting online which has been used only experimentally in some countries like Switzerland, Canada,

An EVM

Estonia and Spain. Moreover, EVMs used in polling place e-voting are of two types, Direct Recording Electronic Voting Machines (DR-EVM) and those using optical scanners. When a voter presses a button on the DR-EVM his vote is recorded electronically in the machine's memory. EVMs used in India, Venezuela and Brazil fall in this category. In the other type a voter marks his choice on a paper ballot which is then optically scanned and the counting is done electronically. Some states in the US use this type of machine. Direct recording voting machines can either have electro-mechanical buttons or a touch-screen to record votes. These can either be stand-alone or networked. Networked machines can transmit results to a central server to compile results quickly and display them at a central website. Indian EVMs are direct recording voting

machines with electro-mechanical buttons for voters and are non-networked. Counting is done separately by each machine and the result from all machines is compiled manually.

Security Features in Indian EVMs

Technical Security—ECI-EVMs are manufactured by the Electronics Corporation of India Limited (Department of Atomic Energy) and Bharat Electronics Limited (Ministry of Defence), both central public sector undertakings which are entrusted with developing high security defence equipment. The machines are both mechanically and electronically protected to prevent any tampering. The software used in these machines is burnt into a one-time programmable/masked chip so that it cannot be altered or tampered with. These machines are not networked either by wire or by wireless with any other machine or system. Therefore, there is no possibility of data corruption by hacking. The software for this chip is developed in-house by BEL and ECIL independently. The software development team is separate from the production team and reports directly to the CMD.

Operationally, the Indian EVM is a set of two units—the ballot unit and the control unit. A vote can be recorded only after the presiding officer enables the ballot unit through the control unit. However, even the presiding officer cannot enable the ballot for twelve seconds after every ballot is cast. Thus, a maximum of five votes can be cast in one minute. Samples of EVMs from production batches are regularly checked for functionality by the quality assurance group which is an independent group within BEL and ECIL. Certain additional security features were introduced in 2006. These include dynamic coding between the ballot unit and the control unit, installing a real-time clock, installing a full display system, and date and time stamping of every key press.

Officials transporting EVM machines securely

Administration Security Measures for EVMs

The Commission has put in place elaborate procedural checks and balances aimed at preventing any possible misuse or lapses.

1. EVMs are kept in a secure room with only one double-locked door. The room is guarded twenty-four hours by armed police. The lock on the EVM warehouse is opened only after giving notice to political parties to be present at the time of unlocking.

2. First level checking (FLC) of each EVM is done before elections by BEL and ECIL. FLC is done transparently in the presence of representatives of political parties. A mock poll by casting at least a thousand votes in at least 10 per cent (now reduced to 5 per cent after political parties found 10 per cent too cumbersome) of EVMs randomly selected by political parties is done at the time of FLC. After the mock poll, a sequential printout of the result is taken and shown to the political parties for comparing the record of

the mock poll kept by them. The entire FLC process is videographed. After the FLC every EVM is sealed using a pink paper seal manufactured by the Security Printing Press, Nasik, using security paper and security printing technology. Every pink paper seal has a unique number. Representatives of political parties put their signatures on the pink paper seal. After it has been sealed thus, the plastic cover of the machine cannot be opened during the election without breaking it. Any machine with a broken or damaged seal will not be used.

3. EVMs are randomized by the District Election Officer before being distributed in the assembly constituencies in the presence of representatives of recognized political parties, to guard against the possibility of anyone manipulating the software.

4. Preparing EVMs for candidates' setting is done in the presence of the candidates or their agents or authorized representatives, and in the presence of the Commission's observer. At this stage, once again, a mock poll is conducted.

5. Multi-level thread sealing of various compartments and sections is done at the time of candidates' setting as:
 i. Thread seal for the 'candidate set' and power pack (battery) section of the control unit after setting the number of contesting candidates and installing the battery respectively.
 ii. Thread seal for ballot paper screen of the ballot unit after fixing the ballot paper.
 iii. Two thread seals for ballot paper cover of the balloting unit.

6. After this, the returning officers do the second randomization of the Control Units (CUs) and Balloting Units (BUs) to allot a CU and BU to specific polling stations.

7. These CUs/BUs are then stored in a strongroom in the presence of the candidates/their agents and the Commission's

observer. The candidates/their agents are allowed to put their seals on the lock to the strongroom.

8. The strongroom is opened in the presence of candidates/their agents and the observer on the day when polling parties are dispatched to their respective polling stations.

9. Before the actual poll, a mock poll of at least 100 votes is done by the presiding officer in the presence of candidates or their authorized agents to demonstrate that the EVM is working properly.

10. Sealing of the result section/bottom compartment of the control units is done by the presiding officer after the mock poll in the presence of polling agents with the following seals:

 a. Green paper seal for result section

 b. Thread seal for inner door of result section

 c. Thread seal for the bottom compartment

 d. Thread seal for connector box for the cascading balloting unit, if any (when there are more than sixteen candidates)

11. After the poll, the EVMs are sealed with paper seals and packed in plastic boxes, which are also sealed. These EVMs are taken straight to the strongroom from the polling stations. The strongroom is closed and sealed in the presence of the candidates/their agents and the Commission's observer. They are permitted to affix their own seals on the locks of the strongroom and are allowed to guard it till the counting begins. They are provided facilities for this purpose. In addition, an armed police guard keeps round the clock vigil. Arrangements are also made for video coverage and CCTV coverage of the strongroom round the clock.

12. The storage hall so sealed is opened in the presence of the candidates/their agents and the Commission's observer on the day of counting.

Advantages of using EVMs in Elections

India has more than 900,000 polling stations with an electorate of more than 814 million. When ballot papers were used for elections, counting them took several days. With EVMs counting is completed quickly and results are declared within hours. Some other advantages of EVMs are:

1. They are easy to operate. EVMs save paper. According to one estimate, ballot paper elections require approximately 10,000 metric tonnes of paper.
2. There are no invalid votes in EVM elections. In the earlier days the number of invalid votes sometimes exceeded the winning margin.
3. There is a limited possibility of booth capturing and rigging because not more than five votes can be cast in one EVM in one minute. Stuffing an EVM with votes will, therefore, take a very long time and the possibility of getting caught increases exponentially.
4. Moreover, while booth capturers could stuff ballot boxes with hundreds of ballots in a few minutes swiftly and quietly, EVMs do not accept a single vote without a loud beep, audible even outside the polling booth.
5. EVMs are robust and results can be obtained from them even if they are physically damaged. An example is the election to the 20-Suangpuilawn assembly constituency discussed at the beginning of this chapter. The twenty damaged EVMs were brought to Delhi and counting was done in the office of the Election Commission of India.
6. EVMs even have the possibility of identifying the votes cast by individual voters, if necessary under court orders. In election petition 4/2001, T.A. Ahammed Kabeer versus A.A. Azeez, evidence was brought before the Kerala High Court that thirty-one votes had been cast by impersonation. On 9 January 2002, the court ordered that votes alleged

to have been cast by these voters be shown to the court so that they can be discounted. A sequential printout of the votes cast in the EVMs was taken out in the courtroom and the votes cast by these thirty-one persons were identified by comparing them with the register of voters in Form 17-A.

Scrutiny of ECI–EVMs by Courts

The functioning of the ECI–EVMs was questioned before the Bombay High Court (Nagpur Bench) and the Karnataka High Court in two separate election petitions. Both the high courts examined some of the technicians and computer experts who were either produced by the parties or summoned by the court at length. Both the courts were satisfied about the non-tamperability of the ECI–EVMs. The Karnataka High Court went to the extent of observing that 'this (ECI–EVM) invention is undoubtedly a great achievement in the electronic and computer technology and a national pride'. The Kerala High Court also recorded its appreciation of the efficiency of the mechanism of the ECI–EVMs.

Controversies about EVMs

Early Controversies

1. Before the elections in Tamil Nadu, Jayalalithaa Jayaram, General Secretary of the AIADMK, had written a letter to the Commission to discard EVMs and use paper ballots in the state assembly elections in 2001 on the grounds that electronic devices had failed miserably even in scientifically and technologically advanced countries like the US and Japan. She also filed a W.P. No. 3346 of 2001 in the High Court of Chennai. The case finally went to the Supreme Court where it was decided in favour of EVMs.

2. Captain Amrinder Singh, President, Punjab Pradesh Congress Committee, raised objections in a petition before

the Punjab High Court prior to assembly elections in 2002. He sent a team of experts to the Election Commission, as directed by the High Court, to examine the machines. The experts could not come up with any concrete objection even after detailed examination of the EVMs.

3. Satinath Choudhary, a computer scientist in the USA and the President of Better Democracy Forum, could not demonstrate any tamperability of EVMs in a demonstration session on alleged tamperability of ECI–EVMs on 8 August 2009 in the premises of the Election Commission of India.

4. A demonstration session on alleged tamperability of ECI–EVMs by one Haneefa (who, incidentally, wanted to promote his own machine) was held on 12 October 2007 in Bangalore. He could not demonstrate any malfunction or tamperability and was fined by the court.

Recent Controversies

1. The Commission also received petitions from individuals raising doubts about the non-tamperability of EVMs. These include Kirit Somaiya of the Bharatiya Janata Party, G.K. Mani, President, Pattali Makkal Katchi, Omesh Saigal, retired Chief Secretary of Delhi, Subramaniyam Swami, President Janata Party and Satinath Chowdhery.

2. Rashtriya Janata Dal, All Indian Anna Dravida Munnetra Kazhagam, Telugu Desam Party, All India Forward Bloc, Asom Gana Parishad, Communist Party of India, Communist Party of India (Marxist), Indian National Lok Dal, Janata Dal United, Janata Dal (Secular), Rashtriya Lok Dal, Revolutionary Socialist Party and Samajwadi Party wrote a letter to the Commission requesting an all-party meeting on EVMs. The BJP also made the same request in a separate letter. The Commission held an all-party meeting on 4 October 2010 in which EVMs were discussed along with three other issues—monitoring expenditure, paid news and criminalization of politics. Most of the political parties

expressed satisfaction with EVMs. Some political parties requested the Commission that the Expert Committee may be asked to examine the feasibility of introducing a Voter Verified Paper Audit Trail (VVPAT) with the EVMs.

3. A programme on a Telugu TV Channel TV-9 by V.V. Rao and Hariprasad made a demonstration of alleged tamperability of EVMs on an EVM allegedly stolen from the office of the DEO, Mumbai. An FIR for theft of public property was registered. The trial in the case is ongoing.

4. The main points raised by people alleging tamperability and the reasons why these are not acceptable include:

 a. It has been alleged that there is a possibility of the presence of a Trojan horse in an EVM. However, there is no such possibility because the software code is secret and not readable by anybody. The software programmers are of very high integrity. EVMs are manufactured by reputed public sector organizations and have proved very reliable. Every EVM is subjected to rigorous checks before deployment in the presence of political party representatives.

 b. It has been alleged that there is lack of voter verifiability in EVMs. The fact is that the voter verifies his or her ballot by a beep and by a LED getting lit next to the candidate's button on the BU once the button is pressed.

 c. Some people say that there is a lack of a possibility of recount. The fact is that a recount is possible any number of times. There will not be any variance in the result displayed as there are no human errors in machine counting.

 d. Possibility of change of components (hardware hacking) has been mentioned. The fact is that after FLC an EVM is sealed and its inside cannot be accessed, making hardware hacking impossible.

 e. It was shown on television that the display on an EVM can be controlled from another Bluetooth device by passing the data in the EVM. This is not possible in a real election because in a real election nobody has access to EVMs and it is not possible to introduce a Bluetooth device in an EVM because of administrative safeguards and security.

 f. It was shown in the same television programme that using a chip on the memory, he could access and change the data in the memory of the EVM. This cannot be done in a real election because nobody can access the memory in an EVM without breaking open all its seals. A broken seal can be easily identified. If a seal is found broken or damaged, the machine is not used.

Voter Verifiable Paper Audit Trail

The demand for a voter verifiable paper audit trail (VVPAT) in the EVMs has been around for some years. VVPAT allows voters to verify that their vote was cast correctly, and to provide a means to audit the stored electronic results. It includes a direct recording electronic voting machine (DRE) and a printer to print the ballot recorded in the electronic memory. It was first demonstrated in New York City in March 2001 and first used in Sacramento, California in 2002. In a VVPAT system the voter can review a physical ballot to confirm that the electronic voting system accurately recorded his or her vote. In addition, the election officials may manually recount ballots in the event of a dispute.

 The demand was referred to the Technical Experts Committee by the Commission, as suggested in the all-party meeting held by the Election Commission. The committee anticipated several technical problems in a VVPAT system, including:

1. Possibility of the printer getting jammed

2. Requirement of a large battery to operate the printer, which is difficult to maintain and charge
3. Requirement of special technical training for all polling personnel
4. Longer time required per voter
5. Higher costs
6. Illiteracy in large sections of the population making it difficult for them to read the printout
7. Possibility of fading of the printout in a thermal paper printer

The Technical Expert Committee held consultations with political parties, civil society organizations and manufacturers of EVMs, and also saw a demonstration of the prototype VVPAT system developed by EVM manufacturers. The Technical Expert Committee recommended that a field trial of the system should be held in extreme environmental conditions.

A field trial was accordingly conducted in Thiruvananthapuram (coastal area in Kerala), Delhi (capital of India), Jaisalmer (hot, desert region in Rajasthan), Cherapunji (in Meghalaya, receives highest rainfall in the world) and Leh (snowbound region in Jammu & Kashmir) in July 2011 in the presence of all stakeholders including political parties, civil society organizations and the media. The Commission issued a press note for wide participation of voters. It was found that certain improvements were required in the VVPAT system before it could be considered for use in an election. The Commission asked EVM manufacturers to carry out the design changes required.

Thereafter, the manufacturers made several important changes in the design and produced an improved prototype. The Technical Experts Committee recommended that it should be tested in the field once again at the same places where the first field trial was held. Accordingly, the second field trial was held in July–August 2012, again in the presence of all stakeholders.

The Technical Expert Committee approved the final design of the VVPAT units in a meeting held on 19 February 2013. The system was demonstrated in another all-party meeting held on 10 May 2013. All political parties recommended that VVPAT should be used in elections as soon as possible. The Commission decided to use the system initially in a bye-election. Accordingly, the Conduct of Elections Rules, 1961, was amended and notified on 14 August, 2013, allowing for the use of VVPAT along with EVMs in elections, and it was first used on 4 September 2013 in a bye-election for 51-Noksen (ST) assembly constituency in Nagaland.

Subsequently, it has been used successfully in ten assembly constituencies in Mizoram on 25 November 2013 and one constituency of Delhi on 4 December 2013 during general elections to Delhi assembly constituency. The Commission has now decided to gradually expand its use and has placed orders for procurement of 20,000 units of VVPAT.

Sharing Technology

Indian EVMs have attracted attention in many Afro-Asian countries. Samples have been shared with many of them and demonstrations were organized for visiting delegations at the India International Institute of Democracy and Election Management (IIIDEM).

Godsent Crash Course!

As an example of the influence that Indian EVMs have had in other countries, one may cite how the Chief Election Commissioner of Bhutan announced at a conference that the Indian experience and technology helped an easy transition to democracy in that country:

With no experience or professional background, the Election Commission of Bhutan in 2006 ventured fearlessly

on its mission. Since 2008 was not far and we had to learn about elections and put in place a working electoral system capable of successfully conducting parliamentary elections in a matter of 2 years. It seemed like asking for a miracle.

Bhutan and India, although with obvious contrasts in size and strength, continue to share one of the closest relationships among nations, setting an excellent example to the global community efficiently. If we had to learn anything about managing and conducting elections, we had to look no further beyond India which has successfully managed electoral activities over the span of over 60 years. India, being the world's largest democracy, has had unwavering success in conducting democratic elections. The task of deploying thousands of officers and millions of Electronic Voting Machines and other materials to 828,804 polling stations (as of the 2009 Lok Sabha elections) and conducting elections of unquestioned-integrity is a major accomplishment for any democratic nation.

The Election Commission of Bhutan was invited by the Election Commission of India to visit India and study its electoral system and conduct of elections immediately after its establishment. Having had time only for the cursory readings of the draft Constitution and the draft Elections Bill, all the members of the infant Election Commission visited India. The firsthand exposure to the Indian election machinery and system was a Godsent crash course!

The orientation to the Indian experience proved truly worthwhile and helped in making a good beginning for the Election Commission of Bhutan. One of the biggest impacts made was the decision to use the Election Voting Machine (EVM), a very practical and user-friendly voting device that revolutionized Indian elections, for use in the conduct of Bhutanese elections for the very first time.

Source: Extracts from presentation by Dasho Kunzang Wangdi, CEC, Bhutan.

Improved Transparency

Transparency is essential for credible elections. The ECI, therefore, uses its website to put important information in the public domain to improve transparency and the credibility of the election process. For example:

i. All electoral rolls are in the public domain. Any person can take a printout and check their fidelity.

ii. Under Indian law every candidate is required to file an affidavit about criminal cases pending against him and his assets and liabilities when he files his nomination. These affidavits are immediately uploaded on the website of CEOs. Civil society organizations access this information and, after making their own analysis, further disseminate it through the media.

iii. Under the law every candidate is required to submit an account of his expenditure in elections to the District Election Officers within thirty days of the results being declared. An abstract of the account statement of every candidate is uploaded on the CEO's website immediately after the statement is submitted by the candidate. This gives the public an opportunity to examine the expenditure statement and to file an election petition based on it, if they find it necessary. Account statements of political parties are also put on the ECI's website.

iv. All orders, judgements, instructions and letters of the ECI are available on its website.

v. During the Arunachal Pradesh elections in 2010 the Commission was concerned about monitoring the polls in remote polling stations. Some of these polling stations are situated on the Myanmar (Burma) border and it can take three days to reach them on foot. Ankur Garg, a bright District Election Officer who was posted in Tirap district, and his equally bright wife Swati Sharma, DEO in West Kameng district, suggested that direct webcasting of polls

could be done from these polling stations using a laptop, a webcam and a data card. Direct webcasting was done for the first time from thirteen polling stations in West Kameng district and from five polling stations in Tirap district. The experiment was a great success. Sitting in our office in Delhi we observed a uniformed constable enter a polling booth in violation of rules, and an immediate phone call was made to inquire into this violation. Webcasting from remote and sensitive polling stations has now become routine. Recently, in the 2012 Uttar Pradesh elections, the Commission was able to view some malpractices in remote polling stations through webcasting and ordered re-polls.

Information Dissemination

The Commission uses the Internet and other media for wide dissemination of information. All information about the Commission and its activities is on its website, as are all laws and rules relating to elections and all instructions of the Commission. Trends and results are uploaded on the ECI website in real time. Statistical reports of all previous elections are also available on the ECI website and are a big source of information for academicians and researchers. The Commission has also started using social media in keeping with the times. I too was (and still am) on Twitter (@DrSYQuraishi) and have found that interacting with people, particularly the youth, directly, every day, is an exhilarating experience.

If elections in a democracy are to be cost effective, green and sustainable, then technology is the silver bullet. India is already an ICT mega power and taking advantage of this the Election Commission has rapidly and dramatically changed the way elections are conducted in the country. Fortunately, the initial resistance to some technological innovations has been overcome and people in general have accepted these with trust and confidence in the Election Commission.

8

VOTER EDUCATION TOWARDS PEOPLE'S PARTICIPATION

Cycle rallies by the differently-abled were huge draws in some districts

*Rallies by Higher Secondary school students
were organized across districts*

One Vote for Parivartan

Kanke (District Ranchi), 25 November: Budhu Mahto has no 'expectations' from 'netas', but has been casting his vote since 1952. Reason: the 110-year-old strongly believes that the ritual of democracy will herald 'parivartan' one day.

A native of Hochar village, which falls under Kanke assembly segment, Mahto was among the 223 out of 914 voters who exercised their franchise today.

Riding a wicker basket to the polling booth at Hochar Panchayat Bhavan, the ailing elderly mused that the youth had lost interest in politics because leaders failed them. 'A bridge has been built over Potpota river and there is power connection in my village, but the condition of roads is poor. And we are left to fend for ourselves when it comes to irrigation despite tall promises by MLAs,' said Mahto, living in a constituency that can be well described as the 'vegetable basket' of Ranchi.

The devoted veteran takes part in the ritual of democracy every five years, but never cares to find out who the contenders are. 'I vote for a symbol and am not interested in any candidate.'

Mahto underscored that today's politicians lust for only power and pelf. '*Jo paisa kha rahein hain so kha rahein hain* (those who are making money through unfair means will continue doing so),' he said, emphasizing his indifference towards candidates.

Like most others in the village, Mahto's family, too, ekes out a living by cultivating land, which is at the mercy of a maverick monsoon. A well ensures water for irrigation during winter and early summer. Development is still a distant dream for Hochar and other villages in Kanke.

'The state is yet to compensate us for land acquired for a ring road project,' said Rajesh Sahu, a youth at the

booth. The elderly man smiled weakly. His experience had taught him stoic endurance above all things.

Source: *The Telegraph*, 26 November 2009

We have come a long way from the era of violence and booth capturing to an era of peaceful, free and fair elections. However, the issues of poor voter turnout, under-participation of women and urban apathy hovered in my mind, and I wondered what could be done about them. It remained a matter of debate whether or not voters' education should be a mandate of the Commission. The general perception in the Commission was that 'we are umpires and our job is to set the rules of elections and enforce them rather than be concerned about voters' turnout'. Some officials lamented over the laziness of citizens for not making efforts for registration and voting. 'Not our problem,' some said. Voter education as an integral part of the Election Commission of India's responsibilities was, in fact, mooted by me in my very first month of joining the Commission in June 2006. The Commission itself shot it down with a cryptic comment: 'Do it in your time.' So I waited patiently and did it in my time.

While some initiatives had been taken up in the past, I strongly felt that voters' education and their motivation must become an integral part of electoral management. With complete conviction that participation deficit was a glaring weakness in our elections and that a management response was long overdue, I announced on the day I took over as CEC (30 July 2010) that increasing participation of citizens in the democratic electoral process would be one of my two priorities, the other being the fight against money power in elections. Thankfully, I got full support from my fellow Election Commissioners and some officers in making voters' education an important mandate of the Commission. As a result, within the first two years of my tenure, the Commission had moved from the concept of

symbolic reference to voters' education to the era of serious engagement on the matter.

We set up a division for Voters' Education and Awareness in the Commission and created a post of Director General to head it. The next job was to get a capable officer to fill the position. Akshay Rout, a senior and proactive officer of the Indian Information Service (IIS), who knew exactly what I wanted, eminently fitted this requirement and was brought in. Then, we conceptualized guidelines and instructions to run a national voters' awareness and education programme in the country. The efforts made by this wing started bearing fruit very soon. A new wave was generated and many CEOs in various states and DEOs in several districts started activities and programmes on this front. All kinds of innovative and colourful activities were started to educate and motivate voters towards electoral registration. Introducing the National Voters' Day (NVD) acted as a further catalyst to this agenda. Partnerships with educational institutions, youth organizations, civil society and media proved very rewarding. As a result, there was a phenomenal rise in voters' turnout in all the twenty-one states where assembly elections were held since 2010. There was also an unprecedented participation of women and urban voters in these elections.

Voters' Awareness among Youth through Film and Discussion: An Innovative Method in Firozabad District

A youth plays a double role in society—one, as a carrier of social behaviour, and the other, as a change agent in reorienting the behaviour of his or her family and society. Keeping this fact in mind, DEO Firozabad, Surendra Singh thought of an innovative way of educating college-going youth who were either new voters or prospective voters. He planned to target the youth for voter awareness to motivate common voters through them. For this he created teams of four motivators each

and gave them thorough training to create awareness among the youth in colleges. These teams were assigned the duty of visiting four colleges every day showing two locally produced voter awareness movies and two ECI voter awareness movies at each location. More than fifty colleges were covered by these teams. The movies were followed by speeches and discussions involving the youth and their voting rights and role in forming the government and in the functioning of democracy. An appeal was also made to the youth not only to cast their own votes but also to bring family members to vote and educate other voters in their neighbourhoods. The role played by the youth made a significant contribution in the historical rise in voters' turn out in Firozabad.

Source: CEO, UP

Context and Purpose of Voters' Education

The Constitution of India grants citizens rights and freedoms that ensure one's ability to participate in the civil and political life of the state without discrimination or repression. They are also a necessary condition for achieving accountable, transparent and participatory governance. These rights empower people to hold the public authorities accountable for their actions on a regular basis. These rights help transform a representative democracy into a participatory one.

The political rights that every citizen enjoys take various forms, such as the right to vote for public offices, to join a political party, to contest in an election, to participate in a demonstration, freedom of association, and the right to criticize the government. But the most notable among these political rights is the right to vote, which entails that every adult citizen has the right to express her/his opinion by casting a vote to decide which persons she/he desires should undertake the task of governance.

A sound and professionally managed electoral process facilitates the full expression of the people's will which, in turn, forms the basis for state authority and power.

Participation by both men and women is a key element of good governance. This is possible only when they are aware of their rights and duties. However, people need to be informed of their rights and responsibilities within a democracy, which includes education on the technical aspects of casting one's vote. In every election, voter education is necessary to ensure that all constituents—men and women alike—understand their rights, their political system, the contests they are being asked to decide, who is eligible to vote, where and how to register, how electors can check the voter lists to ensure they have been duly included, what type of elections are being held, where, when and how to vote, who the candidates are and how to file complaints. For an election to be successful and democratic, voters must be sufficiently knowledgeable and well informed to cast ballots that are legally valid. Voter education is informing the public about their democratic rights, election procedures, political candidates and issues, and motivating them to participate fully in the process.

Educating a citizen about his or her right to good governance is a relatively new term often used to describe the desired objective of a nation-state's political development. Therefore, for good governance to exist in both theory and practice, citizens must be empowered to participate in meaningful ways in decision-making processes. Jayaprakash Narayan, a leading freedom fighter and Gandhian thinker, used to say that '*lokniti* (people's power) would soon purify *rajniti* (state power).' It is voters who represent people's power and, thus, it is voters who can purify politics as well as public service by participating in the electoral process in large numbers.

One of the functions of voters' education is addressing voters' motivation and preparedness to participate fully in elections. It pertains to relatively more complex types of

information about voting and the electoral process and is concerned with concepts such as the link between basic human rights and voting rights; the role, responsibilities and rights of voters; the relationship between elections and democracy and the conditions necessary for democratic elections; secrecy of the ballot; why each vote is important and its impact on public accountability; and how votes translate into seats. Once citizens are aware of their rights and entitlements, they will ultimately participate in the decision-making process and the process by which decisions are implemented or not implemented.

Looking at India's decision to be a democratic republic in 1950 and the year of its first general elections in 1952, American diplomat Bill Bullitt wrote in *Life* magazine: 'An immense country containing 357 million people, with enormous natural resources and superb fighting men, India can neither feed herself nor defend herself against serious attacks. An inhabitant of India lives, on average, twenty-seven years. His annual income is about $50. About ninety out of 100 Indians cannot read or write. They exist in squalor and fear of famine.' Six decades later, Amartya Sen, a Nobel Laureate in economics, observed that 'a country does not have to be deemed fit for democracy, rather it has to become fit through democracy'. This is exactly what has happened. Despite serious misgivings and reservations, India adopted universal adult franchise when literacy in the country was around 16 per cent and its standard of living and life expectancy were abysmally low. Interestingly, it is India's poor and illiterate who create and sustain its Parliament and even now come forward in large numbers to exercise their franchise, unlike the urban educated whose electoral apathy continues to be a serious concern.

In India, the voter turnout rates have hovered between 55 to 60 per cent. In the 2004 general elections the voter turnout was not more than 56 per cent. In 2009 59.7 per cent of the 714 million eligible voters cast their votes. This means that 281 million eligible voters in the country, many of whom were

below thirty-five years, did not exercise their voting rights, for whatever reasons.

It is not as if the people are not used to the idea of voting. In fact they vote every day for a range of things that have quick appeal to the senses: television serials, song and dance shows, film awards and beauty contests, not to speak of 'Kaun Banega Crorepati' and 'Big Boss'. But they need to be guided from serial to serious voting for their own country and to participate in the dance of democracy. But then, we have to understand and appreciate the fact that in the high consumer society of the twenty-first century electorate, the aspirations of the voters are also changing rapidly. Those born in the 1990s will be voting for the first time in 2014. They are impatient and want immediate results in the field of education, healthcare, employment and good governance. If they realize that participating in elections can bring them closer to these aspirations, they are more likely to vote.

No democracy can survive and grow without citizens' participation for which electoral literacy and civic engagement in public affairs is essential. It is now a universally accepted principle that any democratic election requires informed participation which, in turn, calls for a huge voter outreach program. When voters are poorly informed on various socio-economic issues that affect them, their representatives are under less pressure to perform and they get away with inflated claims and promises. But then, voters, like consumers, cannot be treated as a uniform entity. Within the overall category of voters there are several sub-categories such as first-time voters, women voters, senior citizens, urban voters, rural voters and voters in difficult conditions, each of which have differing needs, identities and access to information. One of the key principles of social marketing is the logical segmentation of the target audience and designing specific communication strategies for each segment. Therefore, when we talk of voters' education, one of the most difficult tasks at hand is understanding the

ground reality and then framing a strategy to achieve well laid down objectives for every segment of the target audience.

Capable leaders can only be elected by an informed electorate and education and awareness are the tools that can make this possible. A cultural and ethical habit of voting for the best candidate in a voter-friendly environment can be the game changer. As more and more voters turn up at polling booths, less and less will be available for street politics.

From Hesitant Steps to Systematic Efforts

Since late 2009, the Commission has been seriously engaged in devising strategies and policies for increasing voters' participation, especially of youth, women, urban voters and socio-economically deprived sections through education and civil society partnerships.

The Systematic Voter Education for Electoral Participation (SVEEP) division soon became the nerve centre of this initiative. The Commission adopted a multi-pronged approach for voters' education. The classic approach of studying the knowledge, attitude, behaviour and practices (KABP) of voters was combined with several mediums of education. Many of these approaches are designed with inherent measurable indicators while some do not have tangible assessment criteria. This system has already yielded results reflected in voter registration and voter turnout figures in the elections to the legislative assemblies of some states, conducted between 2010 and 2013.

It is not that the Commission did not engage with voter information activities before this initiative. For the elections conducted to the Lower House of Parliament or to state legislative assemblies, the Commission generally sought to keep the voters informed about the details of the voting place and timing, kind of identification (documents) required, the registration process and how to vote using EVMs through standard notifications. Some proactive officers tried to strengthen this communication

in their areas through individual efforts. Yet, giving voters' information was at best considered an add-on.

Early Initiatives

However, it was only during the Delhi assembly elections in 2008 and the Lok Sabha elections in 2009 that a few notable interventions were introduced in some states, which may be called precursors to the SVEEP programme.

Pappu campaign case study

The 'Pappu campaign' in the NCT of Delhi, based on a popular Hindi film song, mainly targeted the reluctant non-voting youth through jingles on radio, TV and the print media. The approach was to provoke voting action through chiding and shaming. Later, in 2011 in West Bengal, the 'Anand Babu' voter facilitation and awareness helpline was a hit with callers who were able to obtain important information about elections. In Mumbai 'Jaago Re' (Wake Up), a private initiative aimed at improving voter registration, in the form of an advertisement by Tata Tea corporation in collaboration with the NGO Janaagraha, became very popular. These advertisements were viewed by millions on YouTube, motivating many to enrol.

SVEEP Miracle: These were tiny steps that gently pushed the Election Commission of India's arrival on the scene of 'voters' education'. In a way, the Commission was trying to make up for six decades of dithering on this important democratic business. There was need to gallop forward.

For the Commission, voter education is a dynamic and continuous process integrally linked to the two processes of voter registration and turnout. The Commission first took up the process of identifying the key gap areas, especially shortfalls in enrolment in the age group of eighteen to nineteen years, gender gap in participation, low voter turnout and urban apathy

and youth indifference. Some of these were not too difficult to find out as the Commission was already taking up a periodic health analysis of electoral rolls. An in-depth analysis of the electoral rolls revealed the gender ratio, elector–population ratio and number of electors in a given age cohort for each assembly constituency. These findings served as a reasonable basis for taking up some planned voters' education.

In a systematic approach, a new division—Information, Education and Communication (IEC)—was set up in mid-2009. This division was renamed as the Voters' Education and Electoral Participation (VEEP) division before Legislative Assembly elections in Bihar in 2010. With the prefix 'Systematic' added to it the division settled down as the Systematic Voters' Education and Electoral Participation division, or SVEEP, with the charge of developing sustainable policy, supportive framework, adequate programmes, necessary partnerships and requisite activities. This change in nomenclature was done on the suggestion of eminent journalist Shekhar Gupta in the course of an interview with me in his programme, 'Walk the Talk', on 21 April 2011. 'Veep' evokes tears, he remarked and suggested that we call it SVEEP.

Scientifically formulated KABP (Knowledge, Attitude, Behaviour and Practice) surveys were conducted for understanding voter behaviour; these served as a starting point for specific interventions. KABP surveys are taken up in the election going states in two stages—a baseline survey is conducted before the election process starts, while the end-line survey is done after the elections are over. The baseline survey helps to analyze voting behaviour in the previous elections held in the state, and thus to design a proper IEC plan which is called the SVEEP plan, for ensuring a high voter turnout during the current elections. The endline survey is done to find out the reasons why people voted or did not vote in the elections that just went by, and its findings become the basis for taking appropriate action in future elections.

The objectives of the baseline survey are to identify reasons for apathy towards voter registration; to identify the underlying reasons for low voter turnout in the last elections in the state/union territory and the barriers to voting; to understand the demographics of elector segments with lower enrolment and lower participation during polls; and to suggest measurable interventions for ensuring higher enrolment and higher voter turnouts.

The survey uses the random sampling method with proper representation from both urban and rural areas; it is done with the help of a structured questionnaire. The sample size depends on the number of assembly constituencies in a state. The findings that emerge are used for formulating SVEEP interventions in the states/union territories.

Some of the interesting findings of the surveys conducted between 2010 and early 2012 include voters having the impression that if they did not possess an EPIC, they would not be allowed to exercise their franchise. A sustained campaign was launched to clear this misconception and they were informed that other alternative documents (identity cards) could be used if the EPIC had not been issued to them.

In some states voters did not feel secure to cast their votes due to a call given by Maoist militants that they would 'chop off' the fingers on which the indelible ink mark was seen. Accordingly, awareness campaigns were launched in the elections in Jharkhand in 2009 and Bihar in 2010 to disseminate information on security arrangements made to improve law and order conditions.

While studying gender behaviour in Bihar it was found that women felt the need for a more safe and secure environment for voting as violence at the polling booth was a common occurrence. Based on a targeted women-specific SVEEP campaign highlighting the security and facilitation measures taken, women voters' turnout exceeded all expectations. There was a record turnout of women and they even outnumbered male voters. This

was unprecedented in the history of Bihar since independence. In Tamil Nadu, money power emerged as one of the factors used to influence gullible electors. A sustained ethical voting campaign ensured that money power was curbed strictly, with many voters and civil society organizations reporting incidents of bribes and inducements (money power is explained in detail in Chapter 10).

The timings of the polls or the poll hours were not correctly understood by a significant number of respondents. They thought that if they were still in the queue at the stipulated time of closing of polls, they would be turned away and not allowed to vote. A campaign was launched across all the states to dispel this misgiving, and voters were assured that slips would be distributed from the last person backwards in the queue and all of them would be allowed to exercise their franchise. Interestingly, Umesh Sinha, CEO in Uttar Pradesh, appeared on many important electronic channels on the days of polling throughout the seven phases of elections in the state to explain this procedure to voters.

In this survey based intervention social marketing techniques were introduced by involving specialist advisors led by Kapil Kaul and Bhagbanprakash and by taking up a proper situation analysis and pre-testing measures and communication planning. Besides the findings of the survey, SVEEP programmes took into account the best practices and innovations adopted in various parts of the country and the world, which now get exchanged and documented through an initiative of the Commission. Regional and national workshops were held, including a national consultation on voters' participation, to pick up expert ideas on how to elicit the fullest participation of citizens in the electoral process. With every passing election SVEEP could also access a larger pool of innovations, experiences and material for the next election.

The SVEEP programme stands on the tripod of information, motivation and facilitation, as seen through twenty-two elections

during 2010–13. Participation in elections means, firstly, registering the voters. New social energy had to be pumped into this job for achieving fullest enrolment. Since the frontline worker of the EC is the Booth Level Officer (BLO) a 'know your BLO' campaign was launched to publicize the official's contact details. Colleges, universities, institutes of technical education, vocational studies and even schools have been made the new hubs of registration to ensure enrolment of students at the time of their admission (those who have attained the age of eighteen years and above). Corporate groups/houses are contacted to ensure registration of their employees. Draft electoral rolls were earlier provided only to political parties, but now the strategy includes handing them over to Civil Society Organizations (CSOs) as well. Forms related to voter registration are made available at all prominent places such as post offices, banks, fair price shops and educational institutions. Training camps are organized in schools/colleges to get the forms filled. Special attention and facilitation measures for youth and women are devised by each state/union territories. CSOs, NGOs and Resident Welfare Association (RWAs) are engaged in urban areas and NYKS/NSS/anganwadi/self-help groups are engaged in rural areas to improve registration and participation.

Partnerships for voters' education have been pursued with educational institutions, civil society, election watch-bodies, school, college and university students (who were involved in educating elders and neighbours), through the mass media, organizations like NYKS, NSS, National Cadet Corps (NCC) and Bharat Scouts and Guides, apart from government media organizations like AIR, Doordarshan, Directorate of Audio Visual Publicity (DAVP) and the Song & Drama Division, Directorate of Field Publicity (DFP). The Commission recognizes that the success of SVEEP depends on the passionate work of the agencies outside it. Hence, it remains in constant consultations with partner agencies through advocacy measures. Provisions have been introduced to recognize partnership

efforts through awards. Most of these partnerships are now based on coordinated work; at the same time, however, in Andhra Pradesh and Karnataka, the Commission has started having formal Memorandums of Understanding (MoUs) with CSOs for clearly demarcated functions. The most positive development was the private media's decision in 2012 to join the Commission's efforts for voters' participation, yielding a magical effect.

Special campaigns in the print and electronic media for voters' awareness is now a continuous process. Steve Jobs, whose marketing strategies have come to light and are much admired today after his sad and sudden departure from the world, said that 'people don't know what they want until you show it to them'. Today we are living deep inside an information and entertainment age. Even political campaigns to influence voters are now packed with entertainment icons, popular songs and dance, roadshows and videos. The Commission realized the role of icons in the country and persuaded former President A.P.J. Abdul Kalam and the Indian cricket captain M.S. Dhoni to promote election participation messages. From election to election, states are now involving regional and local icons both for registration and voter turnout. Their contribution has motivated millions of their admirers to join the electoral process. Contributions by female folk artistes like Malini Awasthi in Uttar Pradesh and Sharada Sinha in Bihar have been specially noted, as also by Remo Fernandes in Goa, for youth participation and voting without inducements. We had popular musician Zubeen Garg in Assam, Bickram Ghosh the percussionist in West Bengal, cine-stars like Suhasini in Tamil Nadu and Puducherry, humourist Jaspal Bhatti in Punjab, mountaineer Bachhendri Pal and environmentalist Sundarlal Bahuguna in Uttarakhand, and film stars Kaiku and Gokul in Manipur with a good overall effect.

For the implementation of the strategy a great deal of cooperation and coordination has been emphasized by the

Commission. Therefore, all campaign material developed is regularly checked for its relevance, it is updated if required or fresh material is produced based on social marketing research before it is extensively used. Sharing success stories from states where elections were last held is encouraged, and the best practices are adopted by field formations for their own campaigns. CEOs are expected to coordinate among themselves for this kind of mutual exchange. New material is also constantly developed and circulated. Chief Electoral Officers have been asked to come up with state level SVEEP plans and the districts are to prepare district plans keeping the local requirements, gap areas, culture, language and socio-economic realities in mind. For example, Gujarat conveyed messages through traditional theatre called 'Bhavais', Maharashtra through 'Laavnis', Uttar Pradesh through 'Avadhi, Bhojpuri and Bundeli songs' and Delhi through pop 'Wake Up' campaigns. We made extensive use of folk groups and street plays in the Jharkhand and Bihar assembly elections where these forms of entertainment are popular. Local festivals and cultural celebrations became the venues for electoral participation campaigns. The strategy also included time-lines for achieving each specified objective, and monitoring and review of all SVEEP activities. Be it youth or senior citizens, women or men, urban or rural voters, differently-abled or illiterate, transsexuals or homeless, minorities, nomads, service voters or newly enfranchised NRIs, the EC found a special means for reaching out to each one of them.

Once SVEEP activities were taken up in earnest across twenty-one state assembly elections starting from Bihar in 2010, they yielded unfailingly encouraging results, irrespective of the heterogeneous character of these states. Quantitative gains do not reveal the process nor do they project long term dividends, but they provide a pointer, particularly when the trend is so sustained. Earlier, Jharkhand, which had a rudimentary application of the SVEEP programme, registered a voter turnout of 57 per cent in contrast to the Lok Sabha

elections held in April-May 2009 when it was around 51 per cent, thus registering an increase of 11.76 per cent over the Parliamentary polls in a short time. Bihar showed an increase from 45 per cent in 2005 to 53 per cent in 2010—a jump of 16 per cent; and Kerala registered an increase of 4 per cent in 2011 over the previous elections conducted in 2006. Assam and Puducherry also showed modest increases. In 2012, Manipur had a turnout higher than that for the Lok Sabha elections in 2009 despite extraordinary regulation of voting in the wake of apprehensions of some bogus voting. Six states of West Bengal (84 per cent), Tamil Nadu (78 per cent), Uttar Pradesh (59.5 per cent), Uttarakhand (67 per cent), Goa (82 per cent) and Punjab (78 per cent) set records of voter turnouts in electoral history. The participation turnaround in Uttar Pradesh will remain a very special story for some time to come. A former professor of Jawaharlal Nehru University, Dipankar Gupta wrote in *Mail Today* (16 March 2012) about how women outnumbered men at polling stations:

Men Smart, Women Smarter

There has been a near 50 per cent rise of women voters in Uttar Pradesh, but this is often presented as yet another charming election statistic... Thank God, little girls grow up to be free voters one day! That this trend was present all over the country is good news, but that it should be so in India's undisputed basket case called UP makes it remarkable. This signals a gentle but determinate shift in the character of Indian politics.

The high turnout of women voters has so delighted some activists that they are posting 'Thank You' notes to themselves. Undoubtedly, years of democratic practice has encouraged women to break free on Election Day. No question either that Panchayati Raj and gender sensitive programmes have given women a better understanding of their rights...

Notice how big the numbers actually are. In UP alone there were as many as 15 million women who were freshly enrolled in the 2012 voters' list. There will be many more by the time the next elections are announced.

Politics in India is looking better for it is getting feminized, but not feminist. Women have put 'aspirations' on the front page for they are thinking of the future and the long term, as they are wont to. This might pressure the political class to think development and not just growth. If that happens, India will invest in infrastructure and human capital and not just in machines. Villages will have schools and hospitals and not just sweat shops. Men have needs that can easily be met; but because women have aspirations there is hope in this world.

National Voters' Day

The founding fathers of India had complete faith in the role of the youth in running the affairs of the state. From its inception the Constitution provided every twenty-one-year-old the right to vote in direct recognition of the role of the youth in the democratic process. The voting age was reduced to eighteen in 1989 through a constitutional amendment. In one stroke 30 million young persons were enfranchised, a revolution of sorts, the potential of which is, unfortunately, far from realized. This is reflected in the low registration and low turnout of young voters in successive elections. Among the missing voters in India's electoral rolls the largest proportion is from the age group of eighteen–twenty years. Even when about one-fourth of registered voters were in the age group of eighteen to thirty-five years, this did not reflect in the turnout.

The Commission observed sixty years of its formation on 25 January 2010; the year was celebrated as the Diamond Jubilee Year by the ECI and offices of the Chief Electoral

Officers across the country. The adopted theme of the year was 'Greater Participation for a Stronger Democracy'. A range of activities taken up during the year-long celebrations included zonal symposia on sharing the best electoral practices, commemorative photo exhibitions depicting highlights of Indian elections from across the country, civil society organizations and academic institutions to assist in raising awareness among voters about their rights and duties. As a result the participation of voters during the elections to the Legislative Assemblies of Jharkhand held in 2009 and of Bihar in 2010 witnessed significant increases.

It was found that a significant number of newly eligible voters (eighteen-plus) were not getting enrolled, in spite of the annual revision exercise undertaken at the grass-roots levels. To overcome this problem it was decided to take up a vigorous exercise to identify all eligible voters who had attained the age of eighteen years, as on 1 January every year, in each of the over 0.8 million polling station areas in the country. Such youth would be enrolled on time and handed over their EPICs on 25 January at a brief felicitation (including a pledge) to be organized in every polling station area as a part of the country wide National Voters' Day (NVD) celebrations. Though the main objective of the Commission for celebrating NVD was to increase enrolment of voters, this initiative was taken up to give the youth, in particular, a sense of citizenship, empowerment, pride and participation and also inspire them to exercise their franchise, when the time came.

Here, it is necessary to mention that it was Umesh Sinha, CEO of Uttar Pradesh, who gave the idea of the pledge. He also sent the draft of the pledge which was adopted after some modifications. The newly enrolled electors were also given a badge with the slogan 'Proud to be a voter—Ready to vote' along with their EPICs. The event is now being celebrated with both essential and added components at the national, state and district levels in association with all stakeholders

including political parties.

National Voters' Day has proved to be the world's largest empowerment of youth on a single day, as 5.2 million freshly eligible and registered youth in the age group of eighteen-nineteen years were given their voter card on the very first NVD. There were overall 17 million electors who were given their EPICs on this day, belonging to other age groups. Next year, on NVD 2012, the additional electors enrolled shot up to more than 38 million. Out of these, over 11 million were in the age group of eighteen–nineteen years. New voters on NVD 2013 were 28 million and on NVD 2014 they shot up again to 37 million. The addition of 100 million voters between the general elections of 2009 and 2014 is largely due to NVD.

NVD is the time when we planned to go on innovation overdrive to reach out to the community. There was large-scale mobilization of school children, college/university students, students from vocational institutes, youth volunteers like NSS, NYKS, NCC cadets, SHGs, NGOs and Bharat Scouts and Guides. All across the country we organized marathons, processions, motorcycle and cycle rallies, local theatre, human chains, quiz competitions, newspaper and TV advertisements, radio jingles, talk shows and signature campaigns, pledge taking, essay writing, drawing and debate competitions in schools and colleges, street plays and many others to reach out to everyone in the community both by creating the right environment and getting in touch.

A whole spectrum of innovative activities were organized during the second NVD in 2012, which included mock registration and polling; special training for filling up various forms; workshops on election processes and procedures for students; 'Know your BLO' campaigns, hoardings and advertisements on bus queue shelters and public utilities in metro trains; SMSes to mobile subscribers; folk songs to spread the NVD message; voters' fairs and NVD discussions in gram sabhas; telecast of short video films over cable TV/cinema

halls and local media; special outdoor campaigns involving magicians, folk artists; live webcasting of district and state level functions; theme songs composed on ethical voting; friendly cricket matches between young voters; kite flying with the Commission's slogan; video spots/audio jingles and ECI's illustrative messages displayed through local municipal corporation screens; older voters and female voters given special honours; a mass run titled 'Run For Democracy'; T-shirts with the NVD logo distributed; 'democratic friends' on the lines of 'friend of the police' at the grass roots to assist BLOs; special NVD lectures by eminent scholars; functions by mahila mandals to focus on women registration; videos and audios aired on TV channels and FM channels; special facilitation centres involving the community and civil society members; and developing and distributing NVD memorabilia. In fact, the diverse and innovative activities taken up by the ECI's state offices and the district collectors to reach out to the community were phenomenal. It looked as if they were waiting for the Commission's signal to connect to the people. A tableau of the Election Commission of India was presented in the Republic Day parade in New Delhi; this was on the theme of NVD. Similarly, in seventeen states/union territories, such tableaus were displayed during Republic Day parades/functions.

A tableau on the National Voters' Day during a Republic Day parade.

In a brief two-year period (2010–12) the coverage of eighteen–nineteen-year-olds in electoral rolls nearly quadrupled from 12 per cent to about 45 per cent. There is no doubt that the remaining will soon come into the fold of this great democratic exercise. NVD has emerged as a global model that seeks to fulfil a constitutional and democratic responsibility of providing franchise to all eligible citizens through the strategy of social mobilization, in an 'event' mode.

Connection with the Campus

An educated and aware citizenry is the best guarantee for both democracy and development. Hence, the Election Commission is adopting voters' education as a central part of election management operations.

But then education need not be voter-centric only and must cover political parties and their candidates, CSOs, the media and other advocacy and interest groups. When the edifice of a democratic polity is built on voters the process is influenced by arithmetic. What it needs is an organic relationship with the larger social and democratic value orientation for collective participation in public affairs and public service, the real sociology of democracy. Despite fifteen national elections democracy in India is still 'a work in progress' as each new election offers a few new lessons.

The Commission got into a dialogue with policymakers in the education and youth ministries to integrate citizenship and voter education as a part of the curriculum. The youth of India need to be educated about their roles and responsibilities as informed citizens. This will be a continuous process not tied exclusively to the electoral cycle. Such education may be carried out beyond the school and university systems covering CSOs and other social and volunteer networks of youth. Only asking people to participate in the elections and allowing political parties to contest once in five years does not make for democracy

if this opportunity is not used to build a liberal and humane society. EC has high hopes from this newly forged partnership with educational institutions and voluntary groups.

Kuch tum chalo, kuch hum chalein...

Saathi haath badhana... (friend, extend your hand...) was the call and thus was formed the longest human chain ever, 52.5 km long, reiterating our right to vote on 24 January 2012. The human chain traversed the entire district of Barabanki, from the Lucknow border on the west to the Faizabad border on the east; 250,000 people joined hands to pledge themselves to exercising their right to vote.

The preparations for the mega event started much earlier, with meticulous planning. The route for the human chain was charted out and villages and towns on the way were identified. Then started the work in the field—information regarding the human chain broadcast in schools, colleges, institutes, hospitals, mandis and even the weekly haat bazaars.

The entire length of 52.5 km was divided into sectors of a kilometre each. Each sector was supervised by a designated magistrate. In villages BLOs and village level functionaries were given the responsibility of ensuring that the people reached their respective sections of the chain on D-day. Fair price shop dealers and supply inspectors, too, pitched in by motivating everyone and arranging for light refreshments. In the urban areas institutes, government colleges and industries were given the responsibility to ensure maximum participation.

This long human chain had participants from eleven town areas and nearly 125 villages. 'The response was mind-boggling; so much so that we had two chains running simultaneously— the participants and the onlookers! One could hear dhols and nagadas being played and enthusiastic dancing troupes all along. Even eunuchs danced merrily. Moreover, it did not end at participation only; it was ensured that every participant and onlooker was included in the voter list,' says Kinjal Singh,

CDO, Barabanki.

The human chain saw the DM and the SSP move with a torch in an open jeep followed by twelve different jhankis (tableaux) on elections. At the end of the chain a cultural event had been organized where a CD on election songs by Malini Awasthi was released and twenty-one torches were lighted for the twenty-one identified vulnerable booths. Also 5.5 lakh 'vishwas parchis' (trust slips) conveying the commitment of the administration for free and fair elections were distributed. The slips also publicized the telephone numbers of the control room, SSP and the area's thana.

The action plan to galvanize voters had begun much earlier with rallies being organized at the district and block headquarters. The youth brigade not only pledged to vote but also played a significant role in spreading awareness across all ages. In each school, children were motivated to ensure that their parents had their EPIC cards; forms for these were made available in the schools. The BLOs had the onerous duty of conducting door-to-door surveys to record every member of each household. The BLOs were also provided with cameras to take photographs for EPICs, which they then distributed to each and every voter!

Election time saw festivities all around. Banners with catchy slogans on elections adorned the city of Barabanki while car stickers exhorted everyone to vote. Even DJs were requested to play the official election song at each function and they complied willingly.

Polling day on 8 February started with heavy rains. But the downpour was no dampener for the zeal of the voters! The effect of the serpentine human chain was evident in the long queues witnessed at the booths despite the rain. District Barabanki passed with flying colours with a voter turnout of 65.30 per cent in these elections as compared to only 52.15 per cent in 2007—a jump of 26 per cent. The media, which had been supporting the election campaign from the very beginning, gave a thumbs up with such reports as, '*Jhama-jham barsa*

paani...jhama-jham barse vote.'

The incredible increase in voter turnout was possible only due to the combined efforts of the Election Commission, the district administration and each and every individual in the district. Truly, the slogan for the entire campaign had borne fruit—*Kuch tum chalo...kuch hum chalein...loktantra ke naam.*

Electoral education aims at creating the broadest pool of enlightened and serious voters who do not take democracy for granted. Some people preferred to call it the second EVM, meaning Enlightened Voters Movement. In fact, in another strategic initiative YUVA (Youth Unite for Voter Awareness) contributed by Bhagabanprakash, a long time friend and one of the wisest persons one has come across, we plan to rope in more new and young voters into this process. The ultimate indicator of democracy is not the extent of freedom, equity, equality and security given as a gift or as charity, but when one gets it through informed participation in the electoral process.

Young students played a very supportive role in promoting informed participation. For instance, in Uttar Pradesh, a special partnership was built with the National Service Scheme (NSS) where all coordinators and programme officers and more than 2.5 lakh student volunteers participated proactively in an awareness programme run in colleges and in the neighbourhood and contributed significantly in voters' registration and motivating people to vote. The number of new voters in Uttar Pradesh increased from an average of one million to 1.5 million every year rising to 5.4 million in 2011; and the number of women voters reached about 7 million. Looking at this, many individuals were motivated and carried out awareness drives on their own. One of them was a social worker in Sultanpur, near Allahabad, who called himself P.A. Pappu Neta and went round the countryside with the slogan: *Desh Mahan, Pradesh Mahan, Voter Mahan—Apni Taakat Janein, Vote Zarur Dalein* (Your Vote is Your Strength). I could not help writing a letter of appreciation to him. There were numerous other inspiring

examples including a report about how a bridegroom reached a polling station to vote, leaving his own marriage party behind! Now, voter education is increasingly focusing on rights, duties, values and ethics in elections, besides keeping voters informed about legal provisions for campaigning.

Shehar, kasba aur basti, har taraf matdaan ki masti

When Arpita Tyagi and scores of her classmates set about to make hundreds of colourful cards exhorting people to come out and vote in the 2012 Uttar Pradesh assembly polls, little did they know that they were creating history. The slogans were catchy: *'Mazboot loktantra sab ki bhagidaari'* (participation makes democracy strong) and *'aapka mat desh ke future se bhi adhik mulyawan hai'* (your vote is precious)... how apt!

Situated on the confluence of the Ganga, Yamuna and the mythical Saraswati rivers, Allahabad went to the polls on 15 February 2012. Though the city boasts of the highest number of assembly constituencies in a single district (it has twelve), it was a challenge for the district administration to ensure a healthy turnout as the assembly constituency of Allahabad North had registered the lowest voter turnout of 24.01 per cent in the 2007 assembly polls.

In order to increase the turnout the office of the District Election Officer adopted a two-pronged strategy. In the first stage, villages with a low elector–population ratio were identified. Then numerous awareness campaigns such as *'Jago Matdata Jago'* (Wake up voters) were initiated. As a part of this campaign, a mobile van was engaged to disseminate information pertaining to voting. It traversed the length and breadth of the district and educated the common man regarding the importance of casting one's vote. The vehicle made special trips through the constituencies of Allahabad North, Allahabad South and Allahabad West. 'Alongside, a singer was hired to prepare parodies in the local dialect to mobilize rural residents.

We also organized rallies, public marches, skits and street plays in public squares,' says Chandrakala, CDO, Allahabad.

The lopsided male–female ratio in the electoral rolls was also addressed. For this, special lady officers were designated in each assembly constituency to visit those polling stations which had a deficient percentage of female voters. They encouraged the women to vote through motivational talks and self-explanatory leaflets. Short plays to mobilize women and youth were uploaded on YouTube along with latest updates on voter awareness programmes and theme songs.

Knowing that an increase in the EPIC percentage will have a direct impact on the increase in voting, the DEO ensured operationalization of the voter registration centres. Moreover, polling stations having maximum deletions of voters in 2010 were identified and door-to-door verifications done by BLOs to ensure that no voters had been deleted for ulterior political motives. Higher ranked revenue and other district-level officers toured polling stations on the days of the special campaign.

Aimed at maximizing youth participation a slogan writing competition and painting exhibition were also organized. On voters' day a pledge to vote was undertaken by all sections of society, be it college going youth, morning walkers or newspaper hawkers! This day also witnessed a human chain and candle march with everyone pledging to vote. Special advertisement vehicles were also pressed into service and hoardings in local dialects were put up in different assembly segments of the district. The Magh mela (a month long annual religious congregation of lakhs of people at Sangam) witnessed rallies and awareness campaigns.

Another uphill task for poll officials was ensuring a high voter presence in polling stations which had the minimum turnout during the last assembly elections and the 2009 Lok Sabha elections. A targeted approach was adopted for such booths. Senior nodal officers were made responsible for particular assembly constituencies. Students from colleges and

technical institutes were apprised by the DEO on the importance of voting to ensure maximum participation of all establishments in creating a positive atmosphere. This, in turn, would directly motivate the voters to come out of their houses on voting day. These painstaking efforts were acknowledged by the media too, which heaped accolades on the Election Commission with headlines such as 'From educational institutes to Magh Mela, EC burns midnight oil to raise voting percentage'.

As polling day approached sector magistrates were deployed to oversee the distribution of voter slips, a control room was set up and an SMS system was activated to help voters locate their booths. In addition the website of the DEO was revamped so that voters had access to all information just at the click of the mouse.

Social networking websites were also used to spread awareness about voting among youngsters, especially girls. Rajendra Singh, the Magsaysay award winning water crusader, urged people to cast their votes in the name of the holy Ganges. And on D-day the 55.12 per cent turnout (a jump of 135 percent from 24.01 in 2007) truly reflected Allahabad celebrating the festival of democracy. The clarion call *'Shehar, kasba aur basti, har taraf matdaan ki masti'* had certainly borne fruit.

From marriage mandap to polling mandap

A bridegroom in Poochhpura village in Narmada district reached the polling booth to vote, still smeared with turmeric paste (*pithi*), during the Lok Sabha elections in 2009.

Caution and Learning

The need for political neutrality in voters' education programmes and related communication was a priority that threw up its own challenges. Unlike communication in health, education, rural development and several other sectors, political participation campaigns can be strewn with mine fields. Though we knew this we learnt it more in the course of implementing these programmes. In the West Bengal state assembly elections a very enthusiastic campaign was planned involving Sourav Ganguly, former captain of the Indian cricket team and a true icon of Bengal and India, only after checking that he did not have any political affiliations, as the EC does in all cases of engaging icons for the SVEEP programme. But some political parties in West Bengal objected to this, raising instances of Ganguly's participation in certain events. Not to leave scope for even the slightest doubt, the Commission decided to drop the campaign. Similarly, a print media campaign with the famous quotation by Mahatma Gandhi 'Be the change you want to see' drew objections from the ruling party in Tamil Nadu, which alleged that it exhorted citizens to vote for a change in the government! The ECI ordered field staff to withdraw the message and even destroy the posters that had already been pasted.

In mid-2011, the District Collector (also the District Election Officer) in Madurai district in Tamil Nadu was dragged to court for appealing to college students to participate in maximum numbers in the forthcoming Legislative Assembly elections. The court exonerated the collector after an affidavit was filed by the ECI that it was under its instructions that the collector made his appeal. Significantly, the court upheld the role to be played by the Commission towards voters' education.

The principle of clarity in voters' education is given due importance. In fact, under the directive of the Commission, each state has to get all its voter education messages filtered and screened by an expert committee especially formed for this purpose.

The Take Away

Citizens' energy for political participation through the method of representative democracy has been ignited. SVEEP has gained the momentum of a national movement. A participation revolution is in sight, much different from the street agitations of Anna Hazare and his team but not quite unrelated to it. It is heartening to watch higher participation catching up even in campus elections, and to see that the State Election Commissions want to adopt the SVEEP mantra to make people wake up to their responsibility in local polls.

There is a much bigger picture that has already attracted the notice of psephologists, political analysts and politicians. Is it possible that SVEEP has started impacting political outcomes and the formation of legislatures and executives? Certainly, this will require a much more scientific analysis. But young voters, women voters and urban voters, who were clearly the missing link in elections earlier, are the most visible link today. Millions of these new voters are not yet entrenched in religion or caste or defined by any other label. Once they are connected to the electoral process, they constitute an informed and motivated part of the electorate. These SVEEP voters, not taken into calculation by political parties, could provide the winning edge to candidates in constituency after constituency. The sooner these new voters are recognized the better it will be for democracy.

An essential feature of SVEEP is that it works for, with and among the community. It means working with many other partner agencies and organizations. The ECI cannot enforce it

through cold instructions and rigid enforcement. The manner and format of execution has to be much more flexible and innovative as compared to what normally happens in other areas of election management. Leadership is important, whether at the level of the Commission, the Chief Electoral Officer in the state or the DEO in the district.

For all the EC's efforts the glorious history of participation in the twelve states could not have been written without the stellar role played by Sudhir Rakesh, Umesh Sinha, Sunil Gupta, Praveen Kumar and a few other Chief Electoral Officers and many hugely passionate district collectors like Kamini Ratan, Mayur Maheshwari, Surendra Singh, Vikas Gothlwal and Anil Kumar. It is also pertinent to mention here that cynicism in the minds of some of the officers that SVEEP is only extra-curricular work and not the mainstream activity of electoral management must be washed off after the fruitful results of these initiatives. The lesson is clear: those who started SVEEP activities much before elections, especially the periods of electoral registration and NVDs, reaped rich dividends from these initiatives at the time of polls. Indirectly, this also contributed in curbing other menaces like luring of or threatening voters.

With the Commission carrying forward these early achievements and nurturing the passion to create a well informed citizenry willing to act and ready to vote, Indian democracy is becoming truly participatory. 'The silence of the graveyard' has given way to a festival of democracy.

9

THE MODEL CODE OF CONDUCT: NEW CHALLENGES

Source: CEO, UP

Views of a Veteran: Tragedy Beyond Words

The matter is not as simple as the government and the ruling Congress make it to be. Law Minister Salman Khurshid breaks the poll model code during electioneering and sticks to the violation even after a warning by the Election Commission. In fact, he defiantly says that he would reiterate what he said even if 'they hang me'.

Both the government and the Congress party consider his apology adequate. The Election Commission too has not made it an issue. Yet it is too serious a matter to be dropped like this. While campaigning for his wife, Louise Salman, the Law Minister promises a 9 per cent sub-quota for backward Muslims out of the 27 per cent

quota for Other Backward Classes in jobs and education. His purpose was to placate the Muslim voters in UP. Whether he has succeeded or not is yet to be seen. But he has communalized the atmosphere and has helped the BJP which wanted to polarize the voters in the name of religion.

The Election Commission had to take the unprecedented step of writing to the President of India, Pratibha Patil, for 'immediate and decisive' intervention. Chief Election Commissioner S.Y. Quraishi says in his letter that the Commission has found Salman's tone and tenor 'dismissive and utterly contemptuous about the Commission's lawful direction to him, besides the fact that his action is damaging the level playing field in the election.'

I have known Salman Khurshid as a liberal person who articulates his secular point of view despite the barbs of criticism that the fundamentalist hurled at him. He reportedly left the charge of the Congress party in UP a few years ago because he found the state environs too communal. Therefore, I am surprised to find him joining issue with the Election Commission, and playing the Muslim card. He has defended that there was nothing wrong in owning the community. Wearing the hat of the 'Minorities' Minister, he is understandably worried about the plight of Muslims, whose condition is described as worse than that of the Dalits in the Sachar Committee report. But when he commends a quota for backward Muslims he entices a particular segment of society and arouses doubts about his secular credentials.

I hope I am wrong in my conclusion that Salman is trying to project himself as leader of Muslims when the community does not have an articulate and credible person to stand up for its cause. If my fears are justified India's pluralistic society has lost yet another leader to the

communalists. In any case he cannot remain as Minister for Minorities because he has enunciated a pernicious theory of a quota within a quota. The Election Commission has rightly rejected Salman's specious logic that the sub-quota isn't mentioned in the Congress manifesto and that it was the private secretary to the minister who sent an official note to the district administration asking for Salman's security.

Subsequently, Finance Minister Pranab Mukherjee said the Congress had made it clear that 'people occupying posts of responsibility should speak responsibly'. Party general secretary Janardan Dwivedi too reiterated that the Congress wanted all party men to speak 'as per norms of public behaviour and law of the land'.

The Election Commission is a constitutional body and lessening of its authority in any way would tell upon heavily on free and fair elections. So far, people have full faith in the commission, but examples like the defiance by Salman may give birth to doubts.

I can understand, if not appreciate, the compulsions of the Congress and these were evident when Veerappa Moily was shifted from the Law Ministry so as to give the portfolio to Salman. But the reticent Moily is far better than the articulate Salman, who has come to have the ambition of being a Muslim leader. That the grandson of Dr Zakir Husain, India's distinguished former President, should indulge in parochialism is a tragedy beyond words.

Source: 'Poll panel deserves respect' by Kuldip Nayar, *The Tribune*. 18 February 2012.

The Model Code of Conduct

During the 2011–12 state assembly elections, there was a good deal of debate in the country about the efficacy of the voluntary Model Code of Conduct (MCC) and whether it

should be made statutory. The ECI clarified that the MCC was working adequately without being a part of the statute and had repeatedly demonstrated its effectiveness by ensuring peaceful elections without hate speech, personal attacks or arousing caste and communal tensions. The MCC is a unique instrument evolved with the consensus of Indian political parties; indeed, it is a singular, significant contribution by them to the cause of democracy. With the Supreme Court's seal of approval on the MCC, the ECI enforces it from the day that it announces any election schedule, from a general election to a bye-election.[1]

The MCC, as the name indicates, is a set of norms for ideal conduct and behaviour during elections; a set of behavioural guidelines for political parties and candidates.

Evolution

The story of the model code dates back to 1960, when on the eve of the general elections to the Legislative Assembly, Kerala's state administration took the initiative of evolving a code of conduct for organized political parties within that state. A draft code was prepared, discussed and voluntarily approved by the leading political parties in the state. This code covered all important aspects of electioneering, such as public meetings and processions, speeches and slogans, posters and placards.

In 1962, before general elections to the third Lok Sabha, the Election Commission circulated the code adopted in Kerala to all state governments, with an advisory that they discuss it with the political parties in their states and urge them to give their consent to it. The political parties accepted and followed the provisions in the code in that election, leading to peaceful election campaigns in general.

In 1979, the Election Commission, in consultation with political parties, further amplified the code, adding a new section placing restrictions on the parties in power, so as to prevent them from getting undue advantage over other parties and candidates. The code was again consolidated and re-issued in 1991.

It was from the tenth general elections to the Lok Sabha in 1991 that the Election Commission started taking proactive measures to ensure strict compliance to the code by all concerned in both letter and spirit.[2] This is when the institution of election observers as an important aid for the Election Commission came into existence, as observers were essential to monitor how the code was being observed at the ground level.

Period of Enforcement

The MCC comes into effect the day the Election Commission announces or declares the schedule for any election and continues till the final announcement of results. A dispute regarding the period of applicability of the Code was raised before the Punjab and Haryana High Court,[3] after the Election Commission announced the election schedule for the state's assembly election on 30 December 1996. Naturally, the MCC would come into force from that date. However, the ruling party had announced certain welfare schemes just a week before the announcement of the election schedule. These new schemes were to be implemented from 1 January 1997, but the enforcement of the MCC meant that the new schemes could not take off. Thus, the petitioner approached the High Court with the contention that the Model Code could be implemented only from the date of notification of the elections and not from the date of announcement of the election schedule by the Commission. It was also the case of the petitioner that the Election Commission could not be permitted to control governmental activities before the notification by the Governor calling the elections.[4]

In a landmark decision the High Court held that the Election Commission was entitled to enforce the Model Code of Conduct from the date of announcement of the election schedule. The Union of India challenged the judgement in a Special Leave Petition (SLP) before the Supreme Court, contending that the MCC should be enforced only from the date of notification of

the elections.[5] While the SLP was pending before the Supreme Court, the Union of India and the Election Commission arrived at a mutual agreement that the MCC would be enforced from the time of announcement of elections, but with a rider that the gap between the date of announcement and the date of notification of an election should ordinarily not be more than three weeks. The Election Commission informed the Union Government that the MCC would be modified with this formulation.

Part VII of the MCC which relates to the ruling party has a provision that prohibits the laying of foundation stones, etc. of projects or announcing schemes of any kind after the announcement of elections.

Source: Ajit Ninan, *Mumbai Mirror,* 2 February 2012.

This provision was also reformulated to relax the ban and permit civil servants to lay foundation stones for projects that cannot be postponed. The Ministry of Law and Justice, taking note of the agreement reached by the Government and the ECI, placed the matter before the Supreme Court. The Supreme Court disposed of the SLP of the Union of India by its order dated 21 April 2001.

Having come into force after the announcement of elections, the Code remains so until the announcement of results. In countrywide general elections to the Lok Sabha the MCC applies throughout the country; in the case of elections to Legislative Assemblies the Code applies in the state concerned; and in bye-elections to fill casual vacancies it is in force in the district in which the bye-election constituency falls. The Code applies both to the state and central governments as well as their ministers. In short, it intends to ensure that the ruling and opposition parties contest the elections on a perfectly level playing turf. The ruling party obviously feels the heat of the Code the most as it is stripped of the advantage of being in power.

What does the Model Code regulate?

1. **Peaceful and orderly conduct**—For every meeting or procession, candidates and parties are required to obtain prior permission from the district administration. The Code stipulates observing traffic regulations, avoiding congestion on the roads and maintaining orderly behaviour.
2. **Equal opportunity**—Public places like government guesthouses are not allowed to be monopolized by any party or candidate, for meetings, helicopter landings, etc. Everyone must take prior permission for using such facilities. To prevent discrimination, applications are entered in a register (not on loose sheets) to ensure that the 'first come first served' principle is observed.
3. **Right of citizens to peace**—Parties and candidates cannot indulge in wall writing and pasting posters without the

prior permission of the owner or occupier of the property. These provisions are aimed at preventing public nuisance and defacement of property. They also protect the general public against harassment and intimidation. Parties' workers would forcibly indulge in wall writings and pasting posters on private property earlier, and the affected public was afraid of complaining for fear of reprisal from the parties' musclemen. Now, both this practice and fear have reduced considerably .

Prior permission of the returning officer is needed to deploy vehicles for electioneering. This prevents blatant and unrestricted use of vehicles and keeps expenditure in check. Prior permission is needed to use loudspeakers, also, to ensure that children in schools, patients in hospitals and people at worship are not disturbed. Use of loudspeakers is prohibited from 10.00 p.m. to 6.00 a.m.

The proactive implementation of these provisions by the Commission has come as a great relief to the harassed public and has been much appreciated across the country, notwithstanding criticism by some politicians and media persons that it has killed the festival of democracy.

4. **Decorum in a campaign**—Parties and candidates are to refrain from personal attacks and criticism of the private lives of individuals and from raising allegations based on unverified facts. The Code aims at promoting an issue based election campaign, not only to maintain the dignity of the elections but also to prevent violent clashes.

5. **Preventing corrupt practices and electoral offences**—Parties and candidates are to refrain from using religion and religious sentiments for obtaining votes, indulging in activities which may create mutual hatred between different castes and communities, and from bribing voters during the prohibited period of the last forty-eight hours before polling, etc.

6. **Preventing misuse of government machinery and position**

of power—The ban on using official vehicles or combining official visits with election work in any manner, and on launching new schemes and programs ensures that the ruling party is not able to get undue advantage over others.

7. **MCC and Governments**—Part VII of the Code places restrictions on ruling parties and the government of the day. It stipulates that ministers shall not use official machinery or personnel during electioneering work, sanction grants/payments out of discretionary funds, announce or promise financial grants in any form, lay foundation stones for projects of any kind, make promise of projects like roads, water facilities, etc., or make any adhoc appointments in government/public sector undertakings. This is necessary to neutralize the advantage of being in power.

The Authority of the MCC

The MCC, by its very nomenclature, is a self-regulatory code. It is not the creation of any statute, but the result of a consensus among political parties. Though the Commission cannot impose more than a reprimand, censure or condemnation in cases of MCC violation, political parties and candidates dread nothing more than a notice from the Election Commission under the provisions of the Code, as the action is not only widely reported in the media but also attracts condemnation from society in general. The experience of the last few decades shows that the lack of statutory status does not in any way diminish the Code's effectiveness.

This is not to say that the Code has no legal backing. Three important judgements have given the MCC judicial recognition.[6] The power vested in the Commission and the manner in which violations are handled, with the speed and urgency that an election situation demands, has become an established and accepted way of enforcing the Code.

Giving Teeth

Arguments in favour of giving the Code a statutory status hold that this will make it more effective and strengthen its binding nature. The Commission, however, felt that a statutory status was bound to dilute its efficacy and complicate the implementation of the Code in the middle of elections. Legal battles over Code violations are bound to linger for years rendering the exercise futile. The election period is short but charged and packed with incident. Because every activity is time bound, instant and effective action is essential. As a norm, cases of MCC violation are dealt with by the Election Commission in a matter of hours—even minutes. More often than not, the offender is forced to make amends in the quickest way possible. It is the speed and expedience with which decisions and justice are rendered that sustains the credibility of the Code. The Code is thus more about preventive than punitive action, and as a result, the Commission has hardly ever felt the need for statutory recognition for the MCC. Credit must also go to political parties in the country for recognizing the sanctity of the MCC, for their sincerity in observing it and their willingness to mend ways quickly in case of transgressions.

MCC and Article 324

Although the MCC is an agreement among political parties which is enforced by the Election Commission, the Commission is not helpless in case political parties do not follow its provisions. Article 324 of the Constitution has been interpreted by the apex court to be a fountainhead of authority for the Election Commission in all those cases where no specific provision of law exists.[7] The Commission has used the authority of Article 324 to take action in many cases where gross violation of the MCC took place. For example, in April 2012 in the Rajya Sabha elections in Jharkhand (referred to in Chapter 10), when a large

amount of cash was seized and the Commission had reason to believe that this cash was likely to be misused for buying votes while the MCC was in operation, the EC countermanded the election using the powers vested in it under Article 324. The Jharkhand High Court not only upheld the Commission's order but hailed it as 'the only step of great consequences taken by the Election Commission after independence of the country'.[8]

Model Code and Substantive Law

Many provisions of the MCC are also covered under substantive laws and their violation may be considered 'corrupt practices' under the Representation of the People Act, or punishable offences under other laws. Further, while appeals to caste and communal feelings are a violation of the MCC if such appeals incite violence, they are also an offence punishable under the Indian Penal Code. Defacement of public property is not allowed under the MCC, but most states also have substantive laws to prevent defacement of property. The Election Commission has always taken the view that action should be taken both under substantive law as well as the MCC. Thus in 2009, when BJP Member of Parliament Varun Gandhi gave a speech that could have incited communal violence, an FIR was registered against him alongside the action taken for violating the MCC.

The MCC came in handy in an interesting case during the 2009 Lok Sabha elections. In 16-Anand parliamentary constituency in Gujarat a tricky issue arose involving two candidates of seemingly similar names—Bharat Solanki (of the INC) and Solanki Bharat Babubhai (an independent candidate). Bharat Solanki's election agent represented before the District collector that Solanki Babubhai was preparing pamphlets designed to mislead electors; and, indeed, investigation found such an objectionable advertisement, the gist of which was: 'I do not need the votes of Muslim voters: Bharat Babubhai

Solanki, Anand.' The similarity in the names of the opponents had been manipulated to confuse voters. The publishers, printers and local dailies were warned that unauthorized printing of pamphlets or posters of this type was banned and it was an election offence to spread a feeling of enmity and hatred on the basis of religion, caste, etc. However, it was reported that the material had already reached many newspapers. Promptly, 35,000 copies of *Gujarat Samachar* were detained and 80,000 copies of *Sandesh* were intercepted and withdrawn, costing these publications lakhs of rupees. Though criminal cases were filed it was the prompt action under MCC that prevented a potential communal disturbance, besides damage to the reputation of the INC candidate.

Advice to Political Parties under Model Code

While action under the MCC is generally limited to censure or reprimanding an individual, the Commission may also write to political parties advising them to ensure that their members do not indulge in violations of the MCC.

Such advice has sometimes also been issued to state governments if the budget sessions of their legislatures fall during the election period, to consider bringing in a 'vote on account' instead of the regular budget so as not to infringe the MCC. The governments have always accepted this advice.

In May 2012 an unprecedented situation arose in Goa where a bye-election was to take place. The MCC had come into operation when the Election Commission received a representation alleging that the Chief Minister was planning to induct a probable candidate, Alina Saldanha, into the Council of Ministers prior to the bye-election to 27–Cortalim assembly constituency scheduled for 2 June 2012. The complaint was that this would disturb the level playing field as the voters would be swayed in favour of the new minister. The Election Commission issued an advisory to the government to defer the

inclusion. The Chief Minister was very agitated and argued that he had an unfettered constitutional right to constitute or expand his Council of Ministers any time he chose. The EC clarified that he indeed had the full constitutional right to do so, yet it reiterated that it was the 'advice' of the EC that he not do so. It is to the credit of Chief Minister Manohar Parrikar that not only did he accept the advice and defer the inclusion of the minister, but also remarked that he 'bows to the moral authority of the Model Code of Conduct, which should take precedence over his constitutional right'. This response was indeed statesmanlike. It is this spirit that strengthens the delicate constitutional arrangement between various authorities and parliamentary democracy, and which has put Indian elections on the world map.

Action Against Non-political Persons

Violations of the MCC are generally perpetrated by politicians. There may, however, be cases where politicians' actions may have been abetted by others. In such cases the Commission takes swift action against such persons as well. For example, in one case in which a helicopter carrying an important national leader landed on a highway, the Commission, besides taking action against the leader under the MCC, wrote to the Director General of Civil Aviation (DGCA) to suspend the pilot's licence. In another case when a headmaster postponed examinations in a school so that a public meeting by a leader could be organized on campus, the headmaster was suspended and disciplinary action initiated against him at the instance of the Commission.

What is Allowed under the Code

The MCC does not, however, bring administration to a standstill as is often alleged. All ongoing programmes, which started on the field before the announcement of elections are allowed

to continue. Relief and rehabilitation measures for people in areas affected by floods, droughts and other natural calamities can be undertaken. If any new development work or welfare measure needs to be taken up, the matter can be referred to the Commission which takes an objective view keeping public interest in mind. The litmus test is whether, in the opinion of the EC, a new announcement is meant to induce voters and if the work can wait till the elections are over. The EC uses its good judgement along with multi-stakeholder consultation to make its decision.

MCC and Development

In fact, of reasons why it is proposed that the MCC should have statutory backing is that the Code hampers development activities. However, no instances have been brought to the notice of the Commission whereby any development activity has been thwarted or abandoned because of the MCC. The MCC only comes into play for a very limited period of about two months, and even during that period, ongoing development activities are allowed to proceed unhindered and only new projects are deferred, though only for a short period till the elections are completed.

Moreover, all references under the MCC from different ministries are dealt with expeditiously, often within hours.

A telling example of how this is done comes from my tenure in the Commission. In 2011 the Finance Minister was permitted to announce an increase in grants to each Member of Parliament under the MPLAD (Member of Parliament Local Area Development) scheme with a huge financial implication. How this came about is related below.

I got a call from K.M. Chandrashekhar, the Cabinet Secretary, stating that Finance Minister Pranab Mukherjee was about to begin his reply to the debate on the Finance Bill and wanted to announce an increase in the grant of each MP under the MPLAD scheme from ₹2 crore to ₹5 crore. He

wanted the EC's approval in view of the fact that the MCC was in operation because of elections to five states (Tamil Nadu, Kerala, West Bengal, Assam and Puducherry).

In view of the urgency the EC's approval was given then and there with the proviso that the facility will not be implemented in the five poll-going states till the completion of the elections. This illustrates EC's responsiveness in urgent situations.

The EC is extremely reasonable in matters that affect public welfare. For instance, once the Ministry of Petroleum and Natural Gas wanted to announce a national reduction in petrol prices while the elections were going on in some states. The EC allowed this as being in the wider public interest, despite protests from a section of the opposition. When the Ministry of Food wants to announce an increase in the minimum support price of some foodgrains that will benefit farmers, the EC always allows it, if it is of the view that any delay will affect the cropping pattern. However, the EC will also check the dates on which such a decision was taken in the past. If the timing of any decision appears suspect, it will be scrutinized.

Several interventions by the Commission to defeat such designs have now reduced such misuse of office. Leaders and ministers are increasingly careful to not even attempt it.

Nature and Trends of Violations of MCC

One modus operandi used by ruling parties to misuse authority is appointing pliable officers in key positions. The Commission takes care to offset such underhand methods and ensures that officers appointed with ulterior motives are transferred at the earliest, before elections get underway. A transfer policy requires that all officers who have completed three years during the past four years at the place of posting (or are posted in their home district) must be transferred out.

Promises of welfare measures and launching new schemes is something that one witnesses in every election. It has also been

noticed that when governments lose the race against time or are stumped by the 'surprise' announcement of election dates, they try to antedate such decisions and present them as having been taken before the announcement of the election schedule.

There are examples of state governments making large-scale appointments, many of them antedated. One such case was in Haryana where, at the time of announcement of the assembly elections in 2005, the ruling party resorted to an appointment spree in various departments, many antedated to make them appear to have been made before the Code came into force, and mostly without following any proper procedures. The Commission directed the government to put the appointments on hold.

During elections to the Goa Legislative Assembly in March 2012 some political parties complained that the Government had issued antedated appointment letters after the MCC had come into effect on 24 December 2011, and also accepted the joining reports of the new appointees in an expedited manner. An inquiry revealed that 140 candidates had been issued appointment letters which were antedated 20 December and, of these, 136 joined their places of postings between 24 and 26 December. It was found that two officials had moved the files outside the file monitoring system without entering the details in the diary and despatch registers. The files had also bypassed the secretary of the departments. The Commission had to order the suspension of the director and head clerk.

Ruling parties across the spectrum resort to publicizing the achievements of the government with full page advertisements in newspapers, magazines and on TV channels at huge expenditure, all borne by various ministries and departments of the government. This usually happens a few months before the announcement of elections when the Election Commission cannot intervene. Once the schedule is announced, the Election Commission ensures that all such advertisements involving abuse of public money for political gains are stopped forthwith.

However, a new dimension has come to light recently after the phenomenon of 'paid news' raised its ugly head. Since the ECI has become vigilant in controlling election expenditure, candidates have started striking prior deals with media houses. The agreement works like this: I, the candidate or party, will give you, the media house, ads worth so many million rupees before the MCC comes into force; you will do stories in my favour without any charge as soon as the MCC becomes operational. This way nobody will catch you or me!

The Salman Khurshid Case

One aberration that hit the headlines recently was the case of Congress Minister Salman Khurshid, then Law Minister of India. When he announced some reservations in government jobs for minorities, the opposition party BJP complained that this was a serious violation of the MCC. The Commission, after giving both parties a hearing, came to the conclusion that Mr Khurshid had indeed violated the Code for which he was censured. However, the debate refused to die down even after several weeks. His violation of the Code invited a storm of condemnation from the media, civil society and common citizens. Even the EC was not spared by public disapproval. Many accused the EC of pussyfooting and letting him off too mildly. Some called it a fixed match! Many people refused to recognize the fact that the MCC is not a law but just a model code, and 'censure' or 'caution' is the maximum action that the ECI can take. Moreover, such action has serious repercussions for the reputation and image of a political leader.

MCC's Extreme Power

In the Election Symbols (Reservation & Allotment) Order 1968 there is a provision in paragraph 16A which empowers the Election Commission to suspend or withdraw the recognition of a political party for failure to observe the provisions of the

MCC. The Commission has not had to exercise this power ever since this provision was introduced in the Symbols Order in 1994, and the credit for this goes to the political parties as a class who have always respected the Code. There have been occasional cases, though, in which the Election Commission has issued notices to concerned political parties for violations of the Code by one of its leaders. This was in the wake of grave violations involving hate speeches and objectionable advertisements that had the potential of creating mutual hatred between religious communities. The impact of the Election Commission's action in those matters was evident in the way the concerned political parties decried and distanced themselves from the actions of the offending leader. For example, in the 2012 assembly elections when three ministers of a party were accused of violating the MCC in quick succession, there was a strong demand that action should be initiated against the concerned party if one more violation took place. Thankfully, the situation did not arise.

Attempts to Make the MCC Statutory

The Election Commission saw some press reports on 21 February 2012 that the government was considering converting the MCC into a statute. It was further observed from press reports that the Group of Ministers (GoM) constituted to go into the question of corruption proposed to discuss this issue at a very early date on the basis of a 'secret' note moved by the Union Law Ministry.

The ostensible reason in support of this move was that the MCC should be given sharper teeth. However, for many political analysts, it was a thinly disguised ploy to divest the Commission of its powers to enforce the Code because enforcement would move through executive and judicial channels outside the EC's control.

It may be a coincidence that the move came at a time when

the Union Law Minister was embroiled in a serious controversy over a violation of the MCC for which he was censured by the Election Commission. It was widely perceived that there was much more to this proposal move than met the eye.

A statutory Model Code, observed journalist Rohit Bansal, would have been like saying that hereon our courts and not (umpires like) Dickee Bird would decide if Tendulkar was out by lbw or not! And that too, after six or seven years!

The question, therefore, arises: What will serve the larger public good? A timely intervention by the EC followed quickly by a finding albeit without any penal consequences, or protracted legal proceedings that go on long after the elections when the complainants themselves would have lost interest?

The following illustration will demonstrate fully the futility of the MCC being given statutory backing. At the time of the elections to the Karnataka Legislative Assembly in 2008 a sitting minister was found bribing voters. This is both a specific violation of the MCC and an electoral offence, and a corrupt practice under the law. A notice was issued to the minister by the Election Commission for this violation of the MCC; alongside, a police complaint was lodged under Section 171B of the Indian Penal Code. The minister concerned submitted his reply to the Commission within a few hours and was reprimanded promptly, which stopped him from repeating any such misdemeanor. On the other hand, the investigation in the criminal case continued for months after the election.

When the Commission reminded it to expedite the investigation, the state government's cabinet decided in a meeting, at which the aforesaid minister himself was present, to withdraw the case before the trial court. When the Commission decided to intervene and oppose the withdrawal of the case, the state government took the matter to the district judge who held that the Commission had no *locus standi* to oppose the state government's decision. It took a lot of effort and expense by the Commission to get the district judge's order reversed by

the Karnataka High Court. And yet, the case is still pending before the trial court!

Judicial Recognition of the MCC

However, in the wake of the proposed move to give statutory backing to the MCC, it may be apt to point out that the MCC already has judicial recognition at the highest level. In the case of State of Andhra Pradesh versus the Election Commission of India, the state government contended before the Supreme Court that the MCC should be made applicable from the date of election notification and not from the date of announcement of the election schedule by the Commission.[9] In its judgement the Supreme Court observed on 25 April 1994 that 'The Writ Petition does not dispute either the desirability of the provision of the Model Code of Conduct or the requirement of following the same or its enforceability from the time of issue of the said notification'. Three years later, as discussed above, the Punjab and Haryana High Court agreed with the Election Commission that the MCC becomes operative from the time of announcement of elections by the Election Commission.[10] In a decision dated 27 May 1997 the High Court observed that:

> That code does not contain any provision contrary or derogatory to any enactment. Such a code of conduct when it is seen that it does not violate any of the statutory provisions, can certainly be adopted by the Election Commission for the conduct of free and fair election which should be pure as well.
>
> On the eve of election, political parties or candidates may come forward with tempting offers to the electorate to win their favour. If such a course is allowed to be resorted to by the parties or the candidates contesting the elections, it will certainly undermine the purity of elections. In such a situation, if Election Commission

took steps to implement the code of conduct which in no way infringes any of the laws, this Court, in exercise of the powers under Article 226 of the Constitution, is not to interfere... Model code of conduct adopted by the political parties does not go against any of the statutory provisions. It only ensures the conduct of a free and fair election which should be pure.

In a judgement dated 16 February 2012 the Allahabad High Court has gone to the extent of regarding poll eve announcements as a 'measure of allurement' and 'an instance of unfair practices'.[11]

It hardly needs to be stressed that free and fair elections form the bedrock of democracy, which is a basic structure of the Constitution of India. The MCC was evolved to ensure a level playing field and to see that the voters do not get swayed by sops and concessions. Nobody can deny that its strict observance by parties and candidates and its prompt enforcement by the Commission have brought about a sea change in elections and the electioneering process. The MCC is now regarded not just as a model code, but indeed as a *moral* code of conduct.

Notes

1 Decision rendered on 26 April 2001 regarding Special Leave Petition (C) No. 22724 of 1997 (Union of India Versus Harbans Singh Jalal and others).
2 David Gilmartin, 'One Day's Sultan: T.N. Seshan and Indian Democracy,' *Contributions to Indian Sociology.* 43.2 (2009): pp. 247–84.
3 Civil Writ Petition No. 270 of 1997—Harbans Singh Jalal versus Union of India and others.
4 The debate over when the Model Code should come into force is covered nicely by Ujjwal Kumar Singh, 'Between Moral Force

and Supplementary Legality: A Model Code of Conduct and the Election Commission of India,' *Election Law Journal* 11.2 (2002): 149–169.

5 SLP (c) No. 22724 of 1997.

6 The judgement of the Punjab and Haryana High Court in Harbans Singh Jalal's case (1997) and the Supreme Court's order in the SLP against the High Court's judgement (2001) and the earlier order of the Supreme Court in the petition filed by the State of Andhra Pradesh in 1994.

7 Department-Related Parliamentary Standing Committee on Personnel, Public Grievances, Law and Justice. 'Sixty First Report: Electoral Reforms—Code of Conduct for Political Parties & Anti Defection Law'. Presented to the Rajya Sabha on 26 August 2013.

8 On 5 April 2012 in WP (PL) No.1801 of 2012.

9 Writ Petition No.760 of 1994. The High Courts of Andhra Pradesh (1984) and Punjab and Haryana (1997) have upheld the MCC as has the Supreme Courts (1994).

10 In the case of Harbans Singh Jalal versus Union of India and Others (Civil Writ Petition No. 270 of 1997).

11 (Lucknow Bench) in Writ Petition No.1361 of 2012 (Dr Nutan Thakur versus the Election Commission of India).

10

MONEY POWER IN ELECTIONS

Courtesy: Rashtriya Sahara, 6 February 2012.

Corrupting the Election Process

It was 1.40 a.m. when the phone started ringing for Sangeetha M, Returning Officer of Tiruchirappalli West constituency. She had already fallen asleep after a long and busy day in office ahead of the Tamil Nadu assembly elections. The caller did not identify himself but what he said made Sangeetha sit up. He informed her that a bus was carrying about ₹20 crore in hard cash, obviously meant to buy votes. He said the bus would stop at a certain spot in Ponnagar area at 2.00 a.m., the cash would change hands and the bus would move on. She had exactly twenty minutes to intercept them. Obviously, she did not have time to take the flying squad along. Sangeetha got ready in ten minutes, called her driver and drove down to

Ponnagar, a seven-minute drive from her official residence. Of course, she was concerned about her safety but the information was too important to ignore. As soon as she reached the area she spotted the bus (registration number TN45-AP/2829) stationed there. She also noticed a Toyota Innova car moving towards the bus. Was it there to take delivery of the money? she wondered. Realizing there was very little time, Sangeetha hurried to a police check-post two minutes away and asked a special sub-inspector of the state police and a CRPF constable to accompany her. As they returned to the spot the men in the Innova drove off at high speed.

Sangeetha physically searched the bus, and—indeed the informant was right—she found five bags full of cash on its roof, packed with currency worth ₹5,01,27,000 (US$ 800,000). Later, anonymous tips also helped the young returning officer seize bundles of saris and dhotis as well as hundreds of gas stoves.

Like Sangeetha, Praveen Kumar, the Chief Electoral Officer of Tamil Nadu, recalls how he got a call at 1:30 a.m. one night (Monday, 11 April 2011) about money being distributed in the temple town of Madurai, a central minister's Lok Sabha constituency. He promptly passed the information on to police, leading to the seizure of ₹16 lakh (US$26,000) and a list of people who were to be given the money. Between 1 March, around the time the elections were announced, and 15 May, two days after the vote count, the Election Commission (EC) received a total of 3,159 such calls, with vigilant voters themselves reporting malpractices and demanding action.

Legal election expenditure covers posters, banners, rallies, meetings and advertisements in the media. For all these expenses combined, there is a ceiling of ₹16 lakh (US$32 000) for assembly elections and ₹40 lakh (US$80,000) for Lok Sabha elections.

Illegal election expenses cover a range of malpractices, from bribing voters with cash, gifts or tokens with promises to any expenditure that exceeds the legal limit.

If a candidate's expenses exceed the prescribed ceiling, this is treated as a corrupt practice under the Representation of the People Act, 1951, for which any candidate can file a case in the High Court within forty-five days of completion of elections. This practice is also punishable under the IPC. If convicted, the offending MP/MLA is unseated from his position and disqualified from contesting elections for a period of six years. However, as courts normally take a long time to decide such cases, this remedy is not adequate to curb the practice.

It should also be noted that the ceiling on election expenditure applies only to individual candidates and *not* to political parties. However, political parties are required to submit accounts to the EC. In the 2009 Lok Sabha elections three major parties reported the following expenditure:

BJP – ₹162.67 crore
BSP – ₹21.23 crore
INC – ₹380.04 crore

Money Power disturbs Free and Fair Elections

Of course, an electoral democracy cannot function without political finance. However, there is worldwide concern about money power in elections; and the consequent trend of treating voters as consumers whose votes can be 'bought' in exchange for cash, goods and services. This has marketized the political sphere in many democratic countries and exposed the glaring gap between the high ideals of democracy and the low levels of its abuse. It has also greatly increased the cost of contesting an election. As a result, political finance has emerged as an important electoral issue. Political finance usually refers to all funds collected and spent in order to promote candidates and political parties, and create access to power structures. In the democratic world, right thinking citizens are often concerned about the improper use of political finance and its consequences.

262 • AN UNDOCUMENTED WONDER

Common Understanding of Political Finance

Money is necessary for democratic politics and political parties must have access to funds to play their part in the political process.

Money is always a problematic part of the political system and regulation is desirable.

The context and political culture [of a society] must be taken into account when devising strategies for controlling money in politics.

Effective regulation and disclosure can help control adverse effects of the role of money in politics, but only if these are well conceived and implemented.

Effective oversight depends on activities through transparent interactions with several stakeholders (like regulators, civil society and the media).

Source: Political Finance Regulation: The Global Experience, Edited by Magnus Öhman and Hani Zainulbhai, IFES, Washington DC.

There are two basic aspects of money power in elections: 1. Collecting funds; and 2. Spending funds during an election campaign to benefit the party and its candidates. Obviously, these two aspects are interdependent. If you spend more, you need to collect more. Moreover, if the spending and collecting is uncontrolled, it can breed corruption, play hell with the system, and disturb the level playing field among parties and candidates.

Let's deal with the election expenditure first. The Representation of the People Act, 1951, says that election expenditure shall not exceed the amount prescribed. The Conduct of Election Rules, 1964, prescribes (and revises) this amount from time to time.

Now, as early as 1975, when expenditure violations were not as rampant as they have since become, the Supreme Court fully endorsed the principle behind expenditure control as follows:

...The object of the provision limiting the expenditure is twofold. In the first place, it should be open to any individual or any political party, howsoever small, to be able to contest an election on a footing of equality with any other individual or political party, howsoever rich and well financed it may be, and no individual or political party should be able to secure an advantage over others by virtue of its superior financial strength...

The other objective of limiting the expenditure is to eliminate, as far as possible, the influence of big money in the electoral process. If there was no limit on expenditure, political parties would go all out for collecting contributions... The pernicious influence of big money would then play a decisive role in controlling the democratic process in the country...

In such a situation, economically weaker candidates who do not have the resources to compete with affluent candidates get excluded from the contest. This leads to an unholy race among contestants, where not only cash but bribes of all sorts, from alcohol to narcotics, come to play a major role. Such unhealthy competition culminates in tainted governance. Recognizing this, the United Nations Convention against Corruption has encouraged its members to 'enhance transparency in the funding of candidatures for elected public office and, when applicable, the funding of political parties'. Besides, civil society groups have been raising this issue in various forums and have generated public awareness about how external funding corrupts political parties as well as the whole election process.

Meanwhile, over the years, candidates have devised novel methods to disguise illegitimate expenses. Community feasts and biryani parties are held frequently to win over voters. From birthday parties to marriages and mundans (hair cutting) ceremonies, there are parties for all occasions. A vigilant election observer once noted a huge feast going on in a constituency.

He became curious and decided to look in, and found that nearly four hundred persons were enjoying liquor and lavish food. He was informed that this was a marriage party. Being a courteous man, he decided to greet the newly-weds. To his horror, he found no sign of either bride or bridegroom; it was a false wedding party. From then on, the EC has been suspicious of all such feasts and discovered that the number of birthdays, mundans, engagement parties, and the like go up phenomenally during the elections!

Costly gifts, including motorbikes, are doled out during elections to influence the youth. Once, an observer's curiosity was aroused by a convoy of forty motorbikes on the highway, going from Assam to Arunachal Pradesh. As he got closer, he found that most of the motorbikes were brand new. He stopped the convoy and found that the bikes had been booked for distribution in a constituency on the eve of elections. All the bikes were seized immediately. Saris and dhotis are liberally offered on the eve of elections. Packets containing cash in thousand-rupee notes along with voter slips are slipped into the morning newspapers or distributed along with the morning's milk. Pawn brokers and aarthiyas (rural money lenders) in villages are engaged to distribute cash or asked to liquidate petty loans taken by the electors. Fake aartis (prayers for well-being with lighted lamps) are organized by women when a candidate visits his constituency so that packets of cash may be given as 'offerings'. Gunny-bags full of cash are ferried on top of buses and currency is hidden in the door panels of cars, to be smuggled into a constituency for distribution on the eve of elections. Cash is also carried in ambulances, milk vans and ATM vans! Indeed, the EC regularly received complaints from political parties that ministers and even senior police officers helped carry money in their cars to bribe voters.

Every year more ingenious methods of distributing cash come to light. For example, in some states, the micro-financing systems of self-help groups (SHGs) have been found to be

convenient routes for channelizing cash to voters. Sometimes, coupons are distributed to be encashed for attractive consumer goods. Mobile phones with free top-up facilities are booked in large numbers, again for distribution among electors. For a longer list of these ever-evolving methods, see the Box below!

Checklist of Modus Operandi

Types of illegal expenses during election

1. Envelopes of cash hidden in newspapers and slipped beneath the elector's door.
2. The morning's milk pouch distributed along with cash.
3. Through self-help groups for onward distribution among its women members.
4. Through pawnbrokers by reimbursing short term loans taken by electors.
5. Paying cash to *not* vote. This is offered to committed voters of the rival candidate. To claim his reward the voter must show that his finger is unmarked by the telltale indelible ink after an election.
6. Cash given *before* the notification of elections to local leaders, who can later distribute it among electors without drawing suspicion to the candidate.
7. Cash given through community feasts, hidden under the plate or banana leaf.
8. Cash given in the name of MGNREGA, DWCRA and other government projects.
9. Cash given to dummy candidates in exchange for the right to use the campaign vehicles or political agents allotted to them.
10. Cash given to non-serious candidates who contest only in order to divide votes.
11. Cash given to leaders of rival political parties or rival candidates to bribe them to not campaign seriously; that is, to 'throw' the election.

12. Black money raised by a party/candidate via coupon sales.
13. Cash given to polling agents of rivals candidates to ignore any malpractice during counting.
14. Cash given to a village headman who ensures a certain number of votes from the village.
15. Cash given to a village fund on the eve of elections for the construction of roads, temples, schools, etc.
16. Cash given to ladies who arrange an aarti for a candidate.
17. Cash given to those who attend public rallies arranged by a party or candidate.
18. Cash payment for vehicles or trucks hired to ferry voters to a rally or to the polling booth.
19. Cash given to journalists/media to report positively on a candidate or report negatively on rivals.
20. Cash given to journalists/media to black-out news about rivals.
21 Cash transferred through RTGS to electors' accounts.
22. Cash given to youth clubs on the eve of elections to organize cricket or football matches.
23. Cash given for charities like organizing medical camps, or for cultural events like melody parties, theatre productions, etc., on the eve of elections.
24. Distributing TVs, video recorders and projectors to village clubs.
25. Giving cash for constructing toilets or tubewells, or handing out mobile phones with top-up cards or laptops to voters or local leaders.
26. Organizing (and paying for) mass marriage functions during elections.
27. Distributing SUVs or other luxury vehicles to local party leaders.
28. Reimbursing fuel bills through negotiated deals with petrol pumps.
29. Promising jobs to unemployed youth in academic institutes

or companies in which the candidate has a stake.

30. Organizing religious functions like 'Prabachan', 'Ramayan', 'Hanuman Chalisha', etc. before elections.
31. Distributing free books to students just before elections.
32. Giving the children of influential voters free admission to engineering or medical colleges run by the candidate.
33. Distributing free cows or buffalos.
34. Distributing free seeds and manure.
35. Distributing free solar lamps.
36. Distributing diaries, calendars, purses, T-shirts, sarees and vanity bags.
37. Using aarthiyas (commission agents) to distribute cash among farmers, or getting them to waive their commissions.
38. Cash given to religious or caste leaders to ensure votes of their followers.
39. Distribution of liquor, drugs, poppy husks, etc.
40. Organizing rallies with film stars, musicians, orchestras, famous personalities, all of whom are brought to the constituency in aircrafts or helicopters, evidently at great expense, and then not showing correct expenditure.

Sadly, the ceiling of expenses is routinely violated with impunity. The Supreme Court observed as much in the case of Gadakh Yashwantrao (1994), when Justice J.S. Verma remarked:

> The spirit of the provision suffers violation through the escape route. The prescription of ceiling on expenditure by a candidate is a mere eye-wash, and no practical check on election expenses for which it was enacted to attain a meaningful democracy. The lacunae in the law are, however, for the Parliament to fill lest the impression is reinforced that its retention is deliberate for the convenience of everyone. If this be not feasible, it may be advisable to omit the provision to prevent the resort to indirect methods for its circumvention and subversion of

the law, accepting without any qualm the role of money power in the elections. This provision has ceased to be even a fig leaf to hide the reality.

Money Power and Paid News

Despite the solid support extended to the ECI by mainstream media, which ferrets out and highlights relevant information on electoral corruption to clean up electoral malpractices, there have also been several instances of some members of the media joining a racket called 'paid news' in exchange for a share of the pie. Certain unscrupulous media houses have started publishing motivated news during elections, especially on the eve of elections, to misinform and confuse electors. Of course, this is done in exchange for a consideration, in cash or in kind.

Various methods used by the media to lure voters towards a particular candidate have been noticed. One such case involved the identical news report being published in two or three rival newspapers. Election officials got suspicious about how different journalists could be using exactly the same language. Thereafter, it has been noticed that is the usual pattern when a news item has been provided by the candidate and is published across different newspapers.

Another modus operandi is that advertisement tariff is 'officially' slashed to suit a candidate's expenditure ceiling, but the actual rates are in fact *increased*, with the difference being paid in cash. Besides, last-minute poll surveys are sometimes organized predicting the victory of whichever candidate pays more than the others. Over and above this, expensive poll packages are offered by some media organizations to promote a particular candidate and black-out others.

Liquor in Elections

Besides money, liquor is freely distributed to woo voters. Section

123 of the Representation of the People Act, 1951, declares luring voters by liquor as a corrupt practice. Section 135C of the Act further provides that no spirituous, fermented or intoxicating liquor or other substances of like nature shall be sold, given or distributed at a hotel, eating house, tavern, shop or any other place, private or public, within a polling area during the period of forty-eight hours ending with the hour fixed for the conclusion of polls. Therefore, 'dry days' are declared and notified under relevant state laws for the stipulated period for poll areas. The intention of Section 135C is to ensure that people do not exercise their mandate under the influence of alcohol. Counting day is also declared a 'dry day' to prevent unruly behaviour.

From the Thirumangalam Formula to the Election Commission Formula

Tamil Nadu had earned notoriety for the practice of cash-for-votes by political parties. This was reported even in US diplomatic cables, as accessed by WikiLeaks. 'Bribes from political parties to voters, in the form of cash, goods or services, are a regular feature of elections in south India,' one cable noted. Another cable spoke about a particular Union minister's winning formula. It quoted a confidante of the leader as saying that the minister was paying up to ₹5,000 ($81) per voter in Thirumangalam, Madurai district of Tamil Nadu (January 2009 bye-elections). Over the years, the vicious practice has come to be referred to as the 'Thirumangalam formula'.

A front page exposé in *The Hindu*, 'Cash for votes, a way of political life in South India' (16 March 2011) described how workers of different parties resorted to ingenious ways of distributing money, hoodwinking security officials and workers of rival political parties. The seizure of cash to the tune of ₹62 crore ($10 million) and of other articles worth several millions only strengthened the case for stepped up vigilance

by the Commission to deal with corrupt political financing.

In response to a query by a citizens' group in Chennai, Forum for Electoral Integrity, on the eve of elections to the Tamil Nadu assembly in 2011, I promised that henceforth the Thirumangalam formula would be replaced by the 'Election Commission formula'. Thus, in 2011-12 the Election Commission decided to handle the issue head-on and asked officials to intensify search operations with a view to curbing 'money power'. I myself received scores of emails revealing illegitimate dealings every day, which I kept forwarding to the concerned officers. These were complaints against political parties as well as government officials. Whenever our officials found substance in a complaint, prompt and appropriate action was taken. It was encouraging to see many poor people informing authorities about the bundles of dhotis and saris deposited at their doorsteps instead of lapping them up. The election agents of several candidates made rounds with offers of gas stoves, television sets, laptops, bicycles and even gold and silver jewellery in lieu of votes, but many people turned them down. They could see through these games and demonstrated that their votes were not on sale.

Six ways of corrupt political financing

Experts have identified the following six aspects of corrupt political financing:

1. Political contributions and donations that contravene existing laws on political financing in the country.
2. The use of money, material and services for campaign or party objectives that a political office holder has received from a corrupt transaction.
3. Unauthorized use of state resources for partisan political purposes.
4. Acceptance of money in return for an unauthorized favour or the promise of a favour in the event of election to an office.
5. Contributions from disreputable, illegal and questionable sources.
6. Spending money for banned purposes such as vote buying and result influencing.

Source: Michael Pinto-Duschinsky, *Journal of Democracy*, Volume 13, Number 4, October 2002.

Source: The Times of India, 9 February 2012.

Illustration: C R SASIKUMAR

Source: The Indian Express, 13 February 2012.

Legislators Getting Richer

The increasing role of money in elections is disturbing the level playing field. In a developing country where about 30 per cent of voters are below the poverty line, can a poor elector ever dream of contesting an election, given the prevailing environment of excessive expenditure?

The increasing hold of money on elections is also leading to rich candidates winning elections. An analysis by ADR shows that among the affidavits declared by candidates in the 2011 assembly elections in Tamil Nadu, West Bengal, Kerala, Puducherry and Assam, 576 candidates (16 per cent of the 3,547 analyzed), were crorepatis (multi-millionaires) and yet 50 per cent of the candidates had never filed income tax returns. There was not a single candidate who came in the category of 'poor' as defined by the Planning Commission, or was subsisting below the international poverty line of two dollars a day.

Sahira Naim reported in *The Tribune* (2 March 2012) on how an MLA's assets nearly doubled, on average, in a five-year term: 'The 285 sitting MLAs re-contesting for the sixteenth Vidhan Sabha may find it difficult to explain how they positively contributed to progress of their respective constituencies. But how their five-year tenure benefited their assets is something that financial figures speak out aloud. It is also a miracle that legislators have added millions of rupees to their assets within five years by declaring professions like farming, social work, teaching and law.'

According to an analysis done by National Election Watch regarding assets of re-contesting MLAs in the 2012 Vidhan Sabha elections in Uttar Pradesh, Manipur, Uttarakhand, Manipur and Goa, the average assets of these MLAs, as declared in 2007, was ₹1.21 crore which increased to ₹3.56 crore—a growth of 194 per cent.

Thus, we have a sad scenario of poor voters and rich candidates, some of whom do not even find it necessary to submit income tax returns. A close look at the Punjab, Uttarakhand, Manipur, Uttar Pradesh and Goa elections of 2012 showed large-scale defaults. In Punjab ninety-two candidates had not filed their income tax returns, and three of these had assets of ₹128 crore ($22 million), ₹20 crore ($3.5 million) and ₹13 crore ($2.1 million). In Uttarakhand, ninety-nine candidates had not filed their returns and six crorepati candidates did not even have PAN cards. In Manipur. Thirty-three (13 per cent) candidates were multi-millionaires and 170 candidates had not filed income tax returns. The Commission decided to send these affidavits to the Income Tax Department and called for a report on the correctness of the facts declared in the affidavits.

With a proactive expenditure control division and a watchful media and civil society, manipulating expenditure to avoid the electoral code of conduct has become increasingly difficult. Candidates have been forced to reduce the fleets of cars used during campaigns and, in many cases, they have

switched from chartered planes to commercial flights.

There is a view that the old fashioned face-to-face politics based on door-to-door campaigns is more expensive than modern mass marketing and media-led methods of electioneering. Because of this, campaign expenditure and cost per elector is reported to be much lower in economically advanced countries than it is in other regions. However, there is little empirical data available on this issue. It needs further study by scholars, electoral reform lobbyists and organized political parties themselves. In fact, many Indian politicians argue that the ECI's stringent control has actually led to increasing expenditure on more expensive items, like mass media. The fact remains, however, that the most serious consequence of money power in elections is the spread of corruption. When crores are spent, crores have to be collected, usually from corporates, bureaucrats and contractors. This vicious cycle must be broken.

Modern political parties often depend on big political donations to run their offices, from national to local. An interesting anecdote illustrates this change: Baikunth Bhai Mehta, a close aide of Gandhiji, sought his permission to contest the 1935 elections to the Maharashtra assembly and Gandhiji agreed—but with the stipulation that Mehta must contest without spending any money on the campaign. Mehta followed the advice both in letter and spirit and sent postcards to his electors, making an appeal for their votes. Many thought this was not going to work. Yet, belying all apprehensions, Baikunth Bhai Mehta not only won the election with a clean majority but became the Finance Minister of the state, without himself having had a campaign financer!

New Strategy: Nine Point Programme

The Commission had been sending expenditure observers from the Indian Revenue Service to monitor irregularities but had not

achieved the desired results as the observers were not equipped with the manpower to collect information in real time. When the Commission analyzed the observers' reports, the complaints received and the cases registered, it realized that money power had gone unchecked in the marketization of elections.

As CEC the biggest challenge before me was addressing the use of money power. We decided to begin by opening a new division in the Commission for monitoring election expenditure and to bring in an officer on deputation from the Central Board of Direct Taxes. We asked P.K. Dash, a senior IRS officer of the rank of Commissioner, to work as Director General of this division. Since the Bihar elections had already been declared, we were keen to frame a new set of instructions on monitoring election expenditure and so we decided to take the bull by the horns. Dash and the expenditure monitoring division worked overtime to come up with its strategies, and as soon as these were finalized, we went full steam ahead to implement them.

Our nine point strategic intervention formula to make the abuse of money power more difficult, if not impossible, was as follows:

1. Search out the case laws
2. Change outdated procedures
3. Watch out for cash
4. Watch out for paid news
5. Ear to the ground
6. Manage susceptible areas
7. Educate the stakeholders
8. Discretion to the executives
9. Punish the guilty

1. Search out the case laws

The Commission decided to re-examine the steps being taken to control money power and then devise new measures. A Supreme Court judgement in L.R. Sivaramagowde versus P.M.

Chandrashekar (1999) gave us the necessary authority to look into the correctness of the accounts furnished by candidates. It stated that under Section 77 of the Representation of the People Act, 1951 every candidate is required to keep a separate and correct account of all expenditures in connection with the election, and to lodge a true copy of this account within thirty days from the date of declaration of the results with the District Election Officer (DEO).

Standard market rates of common heads of expenditure items such as wall paintings, hiring of vehicles, loudspeakers, procurement of POL, printing of handbills, etc., are made available to the expenditure observer and his staff to ensure that the candidates submitting their accounts did not under-invoice, as was the common practice. For failure to lodge the election expenses account properly and in time, a candidate can be disqualified for a period of three years under Section 10A of the Representation of the People Act, 1951.

In 2011 many defeated candidates and one winning candidate were disqualified for violating this rule.

However, it should be noted that there is a loophole in this system. The expenditure ceiling for a candidate is considered only from the date of his or her nomination as a contestant. Any expenditure incurred before that date is not taken into account. Consequently, potential candidates take advantage of this lacuna by spending large sums before the nomination date, which go unreported.

2. Change outdated procedures

The Commission studied the existing forms and statements of expenditure filed by candidates. Both the legal and illegal expenses incurred by candidates during elections were analyzed. This gave us an approximate idea of a candidate's illegitimate election expenses; on average, one-third of such expenses went to 'paid news' and two-thirds on bribing voters.

To ensure easy monitoring, all the candidates were asked to

open separate bank accounts exclusively for election expenditure. All political parties were asked to avoid large transactions in cash and to advise their functionaries and candidates not to carry cash to constituencies during the election process. The public was also advised not to carry large sums of cash during elections and, if it was unavoidable, to carry proper documents about its source and end use.

At least one expenditure observer from the Indian Revenue Service was appointed for each district, with ordinarily not more than five assembly constituencies under his/her observation. An expenditure monitoring cell was created in each district with a nodal officer. The cell also conducted two training sessions for candidates' agents: once, after the scrutiny of the nomination and once again, before the filing of expenditure statements. A separate expenditure agent was allowed for each candidate. By such means, we were able to ensure better compliances.

3. Watch out for cash

A flying squad was set up under each police station to track illegal cash transactions or any distribution of liquor or other items intended to bribe voters. These flying squads consisted of one senior executive magistrate, one police officer, one videographer and three to four armed police personnel. They were provided a dedicated vehicle, a mobile phone, a video camera and the necessary panchnama documents required for seizure of cash or goods. There were also one or two surveillance teams under the flying squads with three or four police personnel to man check-posts and keep a watch on the movement of large quantities of cash, illegal liquor or any suspicious items or arms. When complaints were received that local officers were following different rules, a standard operating procedure was prescribed to ensure uniform implementation and to check undue harassment of citizens.

To keep an eye on the money used in a campaign, video

surveillance teams were deployed to capture visuals of all big rallies, processions and public meetings. The expenses on all such meetings (*pandals* (tents), banners, posters, etc.) were calculated on the basis of such photographs and 'shadow accounts' as were maintained. This prevented the candidates from suppressing or under-reporting expenditure.

Investigation directorates of the Income Tax Department were deputed to maintain surveillance over movement of cash through airports, railway stations, hotels and farmhouses and to watch the activities of finance brokers, pawn brokers and hawala agents during the campaign period. The Financial Intelligence Unit of the Government of India was asked to pass on critical information about cash transactions in a constituency. Banks were asked to share information about large and suspicious cash withdrawals in concerned districts, which were analysed to find out whether such amounts were meant for the elections.

4. Watch out for paid news

The Commission decided that a Media Certification and Monitoring Committee (MCMC) in each district would keep an eye on all the advertisements and news published about candidates during the election process. They are supposed to report any suspected paid news published during this period to the returning officer and expenditure observer. Based on these reports, notices are given to candidates for not showing expenses on such advertisements or paid news.

5. Ear to the ground

A 24X7 call centre and a complaint monitoring cell in each district was set up. A toll free telephone number, 1950,* was widely publicized for the public to report corrupt practices. All

*This number was chosen to signify the year of founding of the ECI and the Republic.

such complaints were forwarded to the flying squad and records of each complaint were maintained. The telephone numbers of expenditure observers were also widely advertised, inviting the public to register complaints about electoral code violations. The complainants were informed of the action taken to boost their trust. Civil society organizations were encouraged to play watchdog.

6. Susceptible Area Management

There are areas where the voters are prone to inducements like cash, liquor and the like. Such areas were identified as susceptible using various parameters (for example, past incidents). Constituencies which have a large number of such areas are notified as Expenditure Sensitive Constituencies (ESCs). Extra infrastructure for susceptible areas' management was created with upgraded enforcement teams. The flying squads on continuous patrolling also used the public address system fitted on their vehicles to make announcements about the election codes and advised the public not to accept any bribes. The public was also informed about the legal consequences of accepting bribes during elections—one year rigorous imprisonment.

It it also regular practice for the DEO to convene a meeting with political parties and candidates and apprise them of the arrangements that have been put in place. Wide publicity about expenditure monitoring measures throughout the constituency is ensured to make the citizens alert.

7. Educate the stakeholders

We noticed that sometimes political parties and their candidates violated the law because of ignorance. Therefore, we decided to organize training for political parties about the new mechanism of election expenditure monitoring. A newly created training institute, IIIDEM, was asked to organize a training workshop for party leaders from all the poll-going states and to orient them about the new mechanism of expenditure monitoring. The

policy was to focus on prevention instead of resorting to punitive action. Initially, we were not sure how the political leaders would respond to this 'education'. Their overwhelming response and feedback came as a pleasant surprise. The attendance remained full throughout the day—4 October 2010 (10.00 a.m. to 6.00 p.m.)—and they demanded that in future this should be a two-day programme. Similar training programmes for candidates were organized by DEOs.

Private and state owned media were made partners in the campaign for ethical voting. School and college students were also involved to spread the message, as detailed in Chapter 5.

8. Discretion to the Executives

DEOs monitor largescale and 'fake' community feasts hosted by candidates on the eve of elections. Keeping a close watch on bookings for marriage halls in the districts helps in doing this. An eye is kept on self-help groups to see if they are engaged in distributing cash among voters. A discreet watch is also kept on large sums of cash withdrawals by NGOs during the election period so that freebies are not distributed among voters through NGOs.

9. Punish the Guilty

All the measures enumerated above are preventive measures and punishment is always the last resort. But it is drastic.

The Commission took an unprecedented decision to disqualify candidates who had not shown election expenditures correctly. In this regard three cases were taken up, including two erstwhile chief ministers, Ashok Chavan and Madhu Koda. The third was a sitting MLA, Ms Umlesh Yadav, who was unseated and disqualified from contesting for three years. Since Umlesh Yadav's case is the first ever case of disqualification of a sitting MLA for incorrect reporting of expenditure for election expenses and also for paid news, it is worthwhile going into its details.

The Umlesh Yadav case

Yogendra Kumar, a candidate in the 24–Bisauli assembly constituency in Uttar Pradesh, filed a petition in 2007 before the Press Council of India (PCI) against two major dailies, *Dainik Jagran* and *Amar Ujala,* for publishing paid news on 17 April 2007, that is, on the eve of elections, with a view to furthering the prospects of Umlesh Yadav, a rival candidate. The PCI, after conducting due enquiry, forwarded a copy of its adjudication order No.14/58-59/07-08-PCI, dated 31 March 2010, to the Election Commission with the following observation:

> The Council on perusal of record and the report of the Inquiry Committee held the respondent newspapers *Amar Ujala* and *Dainik Jagran* guilty of ethical violations and adopting the observations of the Inquiry Committee. It cautioned the media to refrain from publishing news masquerading as advertisements and vice versa. It also decided that adjudication along with all the case papers may be sent to the Election Commission of India for such action as deemed fit by them.

The Commission, on the basis of documents made available by the PCI, agreed that the publication in *Amar Ujala,* dated 17 April 2007, captioned, '*Charon oar Patang Hi Patang Hai*' (There is 'kite' all over the 'sky'—a kite being Umlesh Yadav's election symbol) and the publication in *Dainik Jagran,* dated 17 April 2007, captioned, '*Bisauli Ke Chunvavi Aasman Par Patang hi Patang*' were indeed cases of 'paid news'. The DEO, Badayun, reported that the expenditure for these advertisements was not shown in the account of election expenditure submitted by Umlesh Yadav, nor was any intimation under Section 127A of the Representation of the People Act, 1951 received from the publishers for the advertisements.

The Election Commission declared Ms Yadav disqualified for a period of three years for failure to submit correct

accounts in the manner prescribed, under Section 10A of The Representation of the People Act, 1951*. Her appeal in the High Court was dismissed. The case is now in the Supreme Court.

The Ashok Chavan Case

Some BJP leaders, namely, (i) Mukhtar Abbas Naqvi, Member of Parliament, Bharatiya Janata Party and five others, (ii) Madhavrao Kinhalkar, one of the rival contestants in the elections from the 85-Bhokar assembly constituency, and (iii) Kirit Somaiya, Vice President, Bharatiya Janata Party, Maharashtra, and four others, in their complaints submitted to the Election Commission towards the end of November 2009 alleged that Ashok Chavan got several advertisements published as news eulogizing him in various newspapers, in particular, in *Lokmat*, *Pudhari*, *Maharashtra Times* and *Deshonnati*, during the election campaign period and that the expenditure incurred or authorized on the publication of this paid news was not included by the respondent in his account of election expenses. The complainants alleged that the respondent showed only an expense of ₹5,379 as expenses on newspaper advertisements.

The Commission took the considered view that it had undoubted jurisdiction under Section 10A of the Representation of the People Act, 1951 to go into the question of alleged incorrectness or falsity of the return of election expenses maintained by the respondent under Sections 77-1 and 77-2 and lodged by him under Section 78 of the act.

Against the judgement of the Commission, a writ petition (Ashok Shankarrao Chavan versus Mahavrao Kinhalkar and others) was filed in the Delhi High Court questioning the power of the EC to hear this case. The petition was dismissed by the High Court which held that the Election Commission could enquire into the accounts filed by elected candidates.

*http://eci.nic.in/eci_main/recent/Disqualification_case_Umlesh_Yadav.pdf

Subsequently, a Special Leave Petition (SLP) was filed before the Supreme Court, which stayed the order passed by the High Court in writ petition (Civil) No.2511 of 2011). The Commission, therefore, had to postpone the hearing of the case. Since I was to demit office on 10 June 2012 the complainant moved a petition in the Supreme Court seeking direction to EC to complete the probe before 10 June, which was agreed to by the bench on 2 May 2012 with a rider that the Commission can complete the probe, but the findings should be kept in a sealed cover till the final pronouncement by the bench. The Commission, after hearing all concerned, decided to proceed with the case and hear arguments on merit and follow the procedure laid down in the Civil Procedure Code. In the meantime I demitted office. As of the publication of this book the case is pending in the Supreme Court.

The Madhu Koda Case

In September 2010 a petition was received from Saryu Rai that the winning candidate from the 10-Singhabhum parliamentary constituency, Madhu Koda, had spent over ₹10 crore ($ 20 million) for his election in 2009. A report published in *The Economic Times* on 27 September 2009 made the same allegation. The Commission called for an investigation report from the Income Tax Department. The DEO, Singhbhum, was also asked to offer his comments on the reports submitted by Madhu Koda.

The limited question before the Commission was on deciding whether Koda had lodged his accounts on time and in the manner prescribed by the Commission. After going through scanned copies of the evidence made available by the Income Tax Department, it was observed that Koda had actually spent more than the amount disclosed before the Commission and had not submitted a true and full account. Subsequently, a show cause notice was issued to him to explain why he should not be disqualified. Koda argued that the Commission had no

power to disqualify an elected candidate for not filing true accounts of his election expenditure. The Commission rejected this. Koda filed a writ petition in the Delhi High Court which was dismissed. Subsequently, the Supreme Court stayed further hearing of the case by ECI. That is where the case rests at the time of going to press.

The fate of the Commission's efforts against money power in elections rests substantially on these cases.

Implementing Expenditure Monitoring Strategies

The election expenditure monitoring strategies mentioned earlier were first used in Bihar, where it was found that the measures were not only effective in checking the use of money power but also in controlling violence. No criminal or goonda works without money and it is money that provides fuel to corruption, violence and terrorism.

Bihar Elections

During the 2010 Bihar elections it was noticed that cash was being transported through chartered helicopters and other aircraft. Therefore, orders were issued to check all aircraft at non-commercial airports and to frisk passengers. Simultaneously, air intelligence units of the Income Tax Department were activated at all airports to see that large sums of cash did not go by air to poll-going districts.

A senior party leader was found at Patna airport carrying ₹12.5 lakh ($200,000) in cash. He was detained by the air intelligence unit of the Income Tax Department deployed at the airport. He produced a handwritten voucher with the signature of his party's treasurer stating that the amount had been given to the leader for poll expenses in the state. We instantly issued a notice to the party to explain to whom the cash belonged and why the Commission's instructions on cash payment had been violated. The party confirmed that the said leader was

bringing back unspent funds in cash from Patna to Delhi. Following this, the EC issued an advisory to all parties to avoid cash transactions during elections.

Besides seizing cash, liquor and gift items in Bihar, notices were issued to the candidates in 121 suspected cases of paid news. Interestingly, most candidates owned up to the advertisements and included these expenses in their election accounts to save themselves from serious repercussions. Out of these, about fourteen cases of suspected paid news, which were obvious, were referred to the Press Council of India for necessary action.

Subsequently, the EC convened a meeting of all political parties on 4 October 2011 to get feedback on its measures and to orient their members to our new guidelines. It is noteworthy that all political parties, without exception, appreciated the Commission's efforts and urged that the measures should be strengthened further to curb the role of money power in elections.

Tamil Nadu Assembly elections in 2011

The Commission fine-tuned its strategies after the Bihar experience, and next implemented these in five election-going states: Tamil Nadu, West Bengal, Kerala, Assam and Puducherry. These elections set the benchmark for controlling money power and paid news.

A powerful chamber of commerce in Tamil Nadu threatened that it would boycott the polls if the 'coercive' measures of the Election Commission were not withdrawn. Next, a political party warned that the actions of the Election Commission would unleash large-scale law and order problems in the state; and this was followed by eight public interest litigations being filed in the Madras High Court by interested parties. The High Court passed an interim order directing the Election Commission to stop all intrusive measures. While the Election Commission complied with the order, a few counter petitions were also

filed by NGOs and the Citizens Forum for Electoral Integrity in favour of the EC's actions and opposing the interim order of the High Court. The Forum for Electoral Integrity, led by the indefatigable Ms Devasahayam, displayed tremendous courage, which deserves appreciation. Finally, the Division Bench headed by the Chief Justice, while deciding on the public interest litigations, clinched the issue with a clear verdict that: 'It is the duty on the part of the respondents (ECI) to see that the Elections Code of Conduct is scrupulously followed.' The litigation greatly taxed the EC's time and energy in the thick of election arrangements, not just in Tamil Nadu but in four other states as well, but ultimately, the Commission was able to stand its ground.

Punjab and Uttar Pradesh Elections in 2012

The EC's measures against money power were further fine-tuned and implemented in assembly elections in Punjab, Uttar Pradesh, Uttarakhand, Goa and Manipur in 2012. During the Punjab elections, surveillance by EC teams highlighted the use of drugs to influence voters. As much as 53.5 kg of heroin worth around ₹300 crore in the market, 3.6 lakh litres of

liquor and 1,500 kg of poppy husk and cash worth ₹120 million were seized.

In Uttar Pradesh, surveillance had to be continued for a longer period as the elections were held in seven phases. Cash worth ₹370 million was seized besides 3.7 lakh litres of liquor. This was another landmark election, free, fair and without any incident of violence.

It was after these successful polls that the *The Asian Age* (6 March 2012) brought out a cartoon showing the Election Commission and the common voter as the real winners of the election.

Corruption and Monetizating the Vote in Legislatures

Monetization of votes or 'cash for votes' in legislatures is another demon which raises its ugly head from time and again. Money is allegedly paid to elected representatives to either vote or abstain from voting on the floor of the House in favour or against someone, defying the party line.

In an infamous case in 2008 MPs were noticed waving currency notes in the Lok Sabha during a no-confidence motion against the then government. The incident was widely reported and drew the attention of the apex court, which ordered Delhi police to investigate the 'cash for vote' scandal. There have also been allegations in Odisha and Jharkhand that many MLAs abstained from voting during the Rajya Sabha elections because they received bribes.

The Jharkhand Rajya Sabha Elections

A glaring instance of 'horse trading' came to light during the 2012 Rajya Sabha elections in Jharkhand. On the eve of the elections three political leaders, Gurudas Dasgupta, Sharad Yadav and Babulal Marandi, met the Commission and informed us about a huge amount of cash being offered to MLAs to vote for a particular MP.

The EC was faced with a legal dilemma. Though the Election Commission is expected to conduct free and fair elections, the law does not provide any expenditure regulation during elections to the Rajya Sabha (Council of States). There is no provision for reporting expenses either by a party or by candidates. However, we could not have closed our eyes to this rampant play of money power. Therefore, we decided to refer the case to the Investigation Directorate of the Income Tax Department in Jharkhand and asked it to keep a close watch on the movement of cash on the eve of elections. The result was immediate. The next day (March 30, 2012), in the wee hours of the morning, I was woken by a phone call, telling me that cash worth ₹2 crore ($450,000) had been seized by the Income Tax Department from a vehicle belonging to the son-in-law of an independent candidate.

Unfortunately, by the time the investigation report arrived, most voters had already voted. The Commission, therefore, decided to let the poll be completed but stopped the counting of votes for the two seats, awaiting a further report from the field. On receiving the information we took the decision to countermand the election by rescinding the election notification. Our decision was challenged in the High Court but the court dismissed the petition.

After an emergency review, in a twelve-page order issued late at night, the EC pronounced that 'the current election process for Rajya Sabha election from Jharkhand had been seriously vitiated and could not be permitted to proceed'. It also recommended to the President of India to rescind the election notification dated 12 March 2012. On 31 March, on the ECI's recommendations, President Pratibha Patil rescinded the earlier notification for the poll in question. Subsequently, on 10 April 2012, following directions by the Jharkhand High Court to the ECI to conduct a thorough probe into the matter through an independent agency, the Commission wrote to the Secretary in the Department of Personnel and Training to

entrust the probe to the Central Bureau of Investigation. The EC announced fresh dates for biennial elections to the two Rajya Sabha seats from Jharkhand, which were completed without further problem.

It was heartening to see senior BJP leader Mr L.K. Advani hailing this as a landmark action, despite the fact that our decision also upset his own party's applecart. In his blog on 1 April 2012, he wrote 'Kudos for Dr S.Y. Quraishi, Chief Election Commissioner, for scrapping this year's Rajya Sabha elections in Jharkhand state. This is the first time in the history of Indian elections in any state that the polling to the Rajya Sabha in that state has been halted midway by the Election Commission itself, even before the votes have been full counted.' Advani concluded: 'I hold that today's decision of the Election Commissioner based on reasonable credible apprehensions is a landmark decision. Together with the NDA amendment of 2003, and today's precedent, moneybags with no political support would think thousand times before jumping into the fray.'

The Jharkhand High Court commended the historic decision and dismissed two petitions against the EC order, imposing a fine of ₹1 lakh on one petitioner.

Civic Vigilance

Of course, the Election Commission itself cannot prevent each and every violation of expenditure guidelines. During the state elections in 2011–12, close to a million complaints were lodged thanks to civic vigilance. To eliminate the problem at its roots, what we need is the eagle eye of a vigilant civil society and positive political education of candidates. The best antidote to bribing voters is an enlightened voter with a strong moral fibre. It is relevant in this context to refer to one of the inscriptions on the walls of North Block of the Central Secretariat, which says: 'Liberty will not descend to a people. A people must

raise themselves to liberty; it is a blessing that must be earned before it can be enjoyed.'

Expenditure Reporting by Candidates

There has long been persistent demand to 'rationalize' the ceiling on election expenditure to make it realistic. No consensus has emerged on what would constitute a rational ceiling.

The Election Commission does not fix the ceiling. It is fixed by the government. The ECI has suggested that this power should be delegated to it so that it can rationalize the ceiling, from time to time, in consultation with political parties. This is part of pending electoral reforms proposals.

Before the elections of April-May 2011, the ceiling was ₹10 lakh ($16,000) for State Legislative Assemblies and ₹25 lakh ($40,000) for the Lok Sabha. Some people suggested that the ceiling should be in crores, which some parties, especially the Left, felt that the ceiling was adequate. However, in view of the overwhelming opinion to 'rationalize' the limit, and taking into account inflation since 1996, when the ceiling was last revised, the EC decided to write to the Ministry of Law to raise the limit to ₹16 lakh ($25,800) for state assemblies and ₹40 lakh for the Lok Sabha.*

The expenditure reports we received after the polls, however, were surprising—not even 50 per cent of the ceiling was spent. If the actual expenditure as declared by an elected MLAs is not more than ₹8 lakh ($13,000), then what is the justification for demanding a manifold increase in this limit? How truthful were these reports when some candidates declared no expenses on public meetings, on the media, on vehicles and on campaign workers?

*While the ceiling for Lok Sabha is uniformly ₹40 lakh across the country, for Vidhan Sabhas, the smaller States have a lower ceiling: Delhi (₹14 lakh), HP and Uttarakhan (₹11 lakh), and Nagaland and Tripura (₹8 lakh)

How do Candidates Report Election Expenditure?

The Association for Democratic Reforms (ADR), an NGO working on voters rights, compiled some interesting information which is given in Table 10.1.

Sr. No.	Description	Tamil Nadu	West Bengal	Assam	Kerala	Puducherry
	**Table 10.1: Expenditure reported by winning candidates in assembly elections, 2011 (as percentage of ceiling)**					
1.	Average percentage of election expenses declared by MLAs compared to prescribed ceiling	45	54	56	59	39
2	Number of MLAs declaring no expenses on public meetings and processions	58	3	9	-	6
3.	Number of MLAs declaring no expenses on campaigns through the print and electronic media	58	162	93	54	7

4.	MLAs who declared no expenses on campaign workers	56	53	32	39	3
5.	MLAs who declared no expenses on the use of vehicles	5	3	-	-	-
6	MLAs who declared no expenses on the use of campaign material	7	3	-	-	-

Source: Compiled by ADR based on ECI data.

From this one may surmise that, prima facie, most declarations are suspect. Then the question arises: Why do MLAs begin their innings with falsehood? And that too, a falsehood that seems pointless. In informal conversations, several politicians admitted their lies in the declarations and explained that the reason behind this under-declaration was to leave a margin to 'cover up' any undeclared or suppressed items that might be discovered later! This is a wrong assumption as 'correct' reporting of all expenditure items is as important as keeping within the ceiling. The ECI can disqualify a candidate for any discrepancy even if his/her expenses are well within the ceiling.

Transparency of Funding of Political Parties

While election expenditure is one important issue, the collection of party funds cannot be ignored. Democracy cannot function

without political parties having access to adequate funds to run their organizations, publicity and electoral campaigns. Collection of funds is, therefore, a legitimate activity. However, such fundraising must be fully transparent.

Political parties cannot function independently if they are financed by business interests. Donors will naturally try to influence the political system and policies. If political parties become subordinate to campaign donations from wealthy industrialists and corporations, it weakens core democratic values and impacts the outcome of elections.

Funds are mainly collected through membership fees, sale of coupons and individual and corporate donations. Since 2003, donations to political parties are exempt from tax if the parties file a list of all donations exceeding ₹20,000 ($300) with the ECI. Donations by companies are limited to 7.5 per cent of their profits. Donations by cheque are not mandatory, since the possibility of black money and tainted money of criminals, smugglers and offenders finding its way to the party fund in cash or coupon sales cannot be ruled out. Similarly, foreign funds may also find their way through cash payments into parties' kitties. This is dangerous for the stability of the Indian polity.

It is not mandatory for political parties to submit these declarations to ECI. They need to do so only if they want to avail of Income Tax benefits, in which case they have to file a certificate from the ECI of having submitted their returns to it. On its part the ECI has no power (or machinery) to scrutinize these returns for correctness (see Table 10.2).

At present, the ECI receives only statements of donations exceeding ₹20,000. Should a person donate an amount below ₹20,000 but do so repeatedly, say in 100 instalments, the ECI will not get a report of these donations, though they may add up to much more than ₹20,000. Similarly, the ECI does not get reports of cash receipts through coupon sales.

The Commission has asked the Income Tax Department to verify the accounts of political parties that were not filing

Table 10.2: Voluntary Contributions Received by Political Parties For Financial year 2009–10

Party	Total Income (in ₹ crore) (A)	Total contributions/ donations (in ₹ crore) (B)	% of Total contributions over total income (B/A)	Amount received as contributions in sums greater than ₹20,000 (in ₹crore) (C)	% of contributions received in sums greater than ₹20,000 over total contributions (C/B)	Total number of contributors/donors who made contributions of more than ₹20,000
INC	525.98	95.91	18%	84.05	88%	226
BJP	258.01	222.62	86%	82.31	37%	269
CPM	73.28	40.42	55%	0.40	1%	23
BSP	56.98	28.25	50%	0	0%	0
NCP	44.85	4.04	9%	3.03	75%	12
CPI	1.29	0.47	36%	0.87	184%	32

(*Source:* ADR)

their returns in time. In this connection the Supreme Court, in a petition filed by Common Cause (1996), commented, 'A political party which is not maintaining audited and authenticated accounts and has not filed the return of income for the relevant period cannot, ordinarily, be permitted to say that it has incurred or authorised expenditure in connection with the election of its candidates in terms of Explanation 1 to Section 77 of the R.P. Act' (para No.24 Sub-para No. (5)).

The opaque fundraising system of political parties has raised concern from many quarters. The political scientist E. Sridharan, in his article *Reforming Political Finance*, comments that one of the most powerful motives behind political corruption is rising campaign costs. He further explains that the hawala scandal that broke in January 1996 (and featured pay-offs to politicians of most major parties via illegal foreign exchange transactions) focused public attention on both corruption and the underlying imperative for politicians to raise election funds for their parties and themselves. Rising campaign costs are causing unease even among political parties, but they have no option but to join the competitive phenomenon. The transparency of fundraising by the new entity, the Aam Aadmi Party, received a lot of acclaim for setting this trend in 2013.

The 1999 report of the Law Commission recommended a number of steps to be taken to amend the Representation of People Act, 1951, and advised insertion of a new section, Section 78A, requiring the maintenance, audit and publication of accounts by political parties. To enforce compliance, Section 78A would prescribe the following penalties:

(i) A political party which does not comply shall be liable to pay a penalty of ₹10,000 for each day of non-compliance for as long as the non-compliance continues.
(ii) If such default continues beyond a period of sixty days, the Election Commission may de-recognize the political party after affording a reasonable opportunity to show cause.

(iii) If the Election Commission finds that the statement of accounts filed is false in any manner, it shall levy such penalty on the political party as it may deem appropriate, besides initiating criminal prosecution as provided under the law.

In 2001, the National Commission to Review the Working of the Constitution recommended that 'audited political party accounts like the accounts of a public limited company should be published yearly with full disclosures under predetermined account heads.'

The EC had also recommended an electoral reform to the government, to the effect that political parties should get their accounts audited annually and publish them for the information of the general public. The auditing may be done only by a firm of auditors approved by the EC. For further transparency, the EC recommended the following measures:

• Any receipt by a political party either directly or through its executives or party functionaries should be deposited in the bank account of the party.
• All payments by a political party exceeding ₹20,000 to a person should be made by a crossed account payee cheque.
• All contributions or donations or gifts by any person to a party functionary shall be deemed as receipts of the political party and will be accounted for by the political party.

It was noticed that there are some fake political parties which exist only on paper and raise funds without any political activity. The Commission did a dipstick test check on some political parties and found that several of them had only name-plates! It found that two registered parties had spent funds for purchasing jewellery and shares! A TV channel (CNN-IBN) did a follow-up story exposing a number of such fake parties. Unfortunately, while the ECI registers political parties, it has no power to de-register them. And, since the government seems to be in no hurry to bridge this lacuna in the Act, the travesty continues.

Financial Discipline and Accountability

While the idea of an auditor from a panel proposed by the ECI is still to find acceptance, political parties continue to get their accounts audited by 'in-house' auditors. These auditors are naturally likely to do a perfunctory or whitewash job. To bring some semblance of quality and seriousness to the process, the Commission asked the Institute of Chartered Accountants of India (ICAI) to formulate accounting and audit standards for political parties and made these mandatory for auditors engaged by political parties. The salient features of the notified standards are:

- Accounting should be on accrual basis and not on the expenditure actually incurred, so that no outstanding payments can be suppressed.
- All political parties should follow a common format for presenting their general purpose financial statements. It is also recommended that the statutes having specific formats for financial reporting by political parties may also modify the same in line with the suggested formats.
- It should be made mandatory that parties have their accounts audited by a firm of chartered accountants chosen from a panel accredited by the Election Commission of India.
- The auditors should be appointed by rotation every three years.
- Auditors are required to follow the auditing and assurance standards issued by ICAI.
- Audit reports should be put up on the party's website.

While political parties are yet to fall in line, at least the auditors can be compelled by ICAI to follow these guidelines, since violators can lose their licences.

State Funding of Elections*

Over the last four decades, a suggestion to control corruption in election spending has come up repeatedly: that elections should be state funded. However, the Commission strongly feels that state funding of elections is no solution to control money power, especially black money power. Instead, the ECI has been asking for amendments to laws to bring in transparency and accountability in the functioning of political parties and candidates. The EC's attempts have been to control expenditure by candidates by strictly enforcing election laws and the Model Code of Conduct. The decision to reduce the campaign period from twenty-one to fourteen days was aimed at reducing overt and covert spending. Recent practices such as the EC itself distributing voter slips has saved parties and candidates a lot of expenditures on printing and staff, and on the facilitation counters (kiosks) they used and put up outside every polling booth.

Moreover, various committees appointed by the government or Parliament have recommended that state funding of elections should be considered only after some pre-requisites are ensured, that is, internal democracy in political parties and complete transparency in their financial affairs. The Indrajit Gupta Committee (1999) favoured state funding of elections on constitutional and legal grounds and in the public interest. But, significantly, its conclusion was that this would be a merely cosmetic change and would not be effective without electoral reforms. The National Law Commission in its 170th report (1991) says, 'It is absolutely essential that before the idea of state funding (whether partial or total) is resorted to, the provisions suggested in this report relating to political parties (including the provisions ensuring internal democracy, internal structures)

*Based on an article by the author in *The Times of India*, 30 November 2013

and maintenance of accounts, their auditing and submission to Election Commission are implemented.'

Corruption in governance has become a matter of grave national concern. Ironically, political parties themselves are increasingly making corruption a major election issue. Almost every party starts with a promise to cleanse polity of all corruption—but ends up doing more of the same. The public sentiment against corruption is very high, thanks to some high profile cases highlighted by CAG (Comptroller and Auditor General of India) recently. The fact that the Anna movement whipped up public anger so much that things almost went out of hand showed how widespread the anger against corruption is. It is a mystery how the movement fizzled out. It will, however, be a mistake to rule it out in the future. The dramatic success of the Aam Aadmi Party in the Delhi Assembly elections, 2013, has demonstrated this in unmistakable terms.

It is indeed an irony that the elections themselves have become the fountainhead of corruption. The way that money power is playing an increasingly decisive role in elections is creating a vicious cycle of corruption. A candidate who spends crores on his election is in a hurry to recover his investment by hook or by crook. The first thing a minister may do (or be 'compelled' to do) is to call his bureaucrats to start making money for him. This obviously creates an unholy nexus between politicians and bureaucrats. Once the two most powerful instruments of governance come to such an arrangement, it is impossible to stop it.

While all politicians are not corrupt, public perception does not spare any. Such an image of politicians is not good for democracy. We have had an impressive line-up of great politicians in the country. In fact, India has grown into a major power mainly due to the great political leaders we have had. A look at our neighbours, who became independent at the same time as India, will prove the point. The public perception that '*sab neta chor hain*' (all leaders are dishonest) is dangerous

300 · AN UNDOCUMENTED WONDER

and must end, if democracy has to be preserved.

What's the way out? Obviously, the money power has to be checked and political finance made transparent.

There are two aspects to the problem as we have seen above: raising of money by political parties, and expenditure by parties and candidates during elections.

The EC's efforts to control election expenditure have achieved considerable success. The creation of a new division for expenditure monitoring, new guidelines, flying squads, raids and seizures led to a haul of nearly ₹200 crores ($30 million approx.) between 2010 and 2013. Though it did put some fear in the minds of those used to violating the expenditure norms with impunity, it has surely not ended the problem. However, as I have explained above, state funding of elections will not help. How state funding will drive out black money from the elections has not been explained by anyone. In fact, the money saved by the contestants after state funding may, in fact, supplement the black money used for illegal activities like bribing voters, buying 'paid news', etc.

The second issue of concern, however, namely the financing of political parties, seems to have a potential solution. Political parties raise funds through donations by voluntary contributions besides income generated from their properties, investments, etc. Though fund raising is regulated (no foreign funding, no public sector donation, a cap on corporate donation) lack of transparency is a major concern. A large percentage (nearly 75 per cent) of funds are received from undisclosed sources. This raises doubts of whether these anonymous donations have hidden strings attached; is it tainted money from criminals, from contractors in quid pro quo of promises for return favour? In these circumstances people often suspect that big corporates are running the government by proxy—by influencing economic and political decisions, even getting ministers of their choice appointed. Crony capitalism is often mentioned as a consequence of this phenomenon. Thus,

along with the politician, the corporates also become suspect in people's perception.

Paradoxically, it's not the political parties alone who do not want to disclose the sources of their income. The corporate and business houses also seem to prefer secrecy. Their normal explanation is that if they give to one party, the others will be annoyed and become hostile. Therefore, they would not like the competing parties to know what they donated to their rivals. The real reason, however, may be that they would not want the quid pro quo or the return favour becoming public. This makes it impossible to bring about transparency.

A possible way out is state funding—certainly not of elections, but of political parties. This can be easily done by the state paying a fixed sum to a party for every vote secured. Thus, if a political party gets, say, one crore votes, it is entitled to state funding of ₹100 crore (@ ₹100 per vote).

In the year 2009–2010 the funds raised by major national parties from all sources (including donations and contributions) were as follows:

(figures in bracket indicate the percentage of funds received as donations and contributions):

INC 468 cr (21%), BJP 258 cr (86%), BSP 56 cr (50%), CPM 73 cr (40%), NCP 45 cr (40%) and CPI 1.3 cr (47%)

The figures for 2010-11 are:

INC 307 cr (5%), BJP 168 cr (74%), BSP 115 cr (62%), CPM 76 cr (32%), NCP 23 cr (0.62%) CPI 2 cr (54%).

(*Source*: ADR)

Restoring the Dignity of Political Parties

Let me explain how this could be implemented. In the General Elections 2009, the total number of votes cast was 42 crores ($6.7 million approx.). Even if we discount the independents and presume that all these votes went to candidates of political

parties, at the rate of ₹100 per vote, the total amount of state funding would come to ₹4,200 crores. Taking into account the state elections, bye-elections and mid term polls, the figure will double. With increasing voter strength and turnout the subsidy could go up to say ₹10,000 crores in five years. This roughly corresponds to the funds they (reportedly) collectively raise in five years through all kind of means, including dubious ones! The collection of money from corporates and anonymous donors will then be completely banned. The subsidy would be a small price to pay for bringing transparency to our political system, and free it from dependency on corporate and tainted funds and restore the dignity of our political parties and our democracy. The system may be freed from crony capitalism and backseat driving of government by big corporates and dubious financiers. Even the negative image of corporates will be salvaged.

How this money will be raised and the formula for its distribution is a matter of detail that can be worked out once the idea finds favour in principle. There could be a small corporate cess. What is clear is that the fund collection from all private sources will have to be banned. Will it stop the politicians taking bribes? Maybe not completely. But the fig leaf of 'election funds' or 'party funds' as a euphemism or pretence for bribes will go. The accounts will be subject to audit by an independent auditor from a panel prescribed by the Election Commission, if not by CAG itself.

A study of 'Political Finance Regulations Around the World' by International Institute of Democracy and Electoral Assistance (IDEA) (2012) in 180 countries showed that seventy-one countries have the facility of giving state funds based on votes obtained. Direct funding of political parties is practised in 86 per cent of countries in Europe, 71 per cent of Africa, 63 per cent of the Americas and 58 per cent of Asia. If it is working well in so many countries, there is no reason why it will not in India.

Early in 2013 the Indian National Congress had constituted a committee under Mrs Ambika Soni to examine the election reform proposals that have been pending with the government for years. She asked for my views. I made it clear that while state funding of *elections* is a definite no-no, an alternative proposal of state funding of *political parties* may be considered. That will rid the elections of the tainted money, restore the dignity of the political parties and the ignominy of the corporate world. I hope at least this reform will be considered.

11

MEDIA AND ELECTIONS

Election and the Mass Media

Lage Raho, EC-Bhai

They don't call it election fever for nothing. With five states headed for assembly polls, tempers rising like bile and pressure to perform fluctuating like the stock market, there's happily a doctor in the house. For, familiar electoral pains have begun. Take Punjab's first family of Badals: they're experiencing stormy clan fallouts over who gets more of the kaali dal, sorry, Akali Dal. Or consider the Congress. Flayed from Punjab to UP, the Grand Old Party's doubtless relieved that Team Anna called off its anti-Congress blitzkrieg. But, ironically, the shrillest campaign-style spleen to come its way has been

from Mamata-di, an ally who's not even a player in the poll-bound Famous Five!

It's good the Election Commission's begun administering sweet-sour medicine to politicos in poll delirium. The latter may be used to pumping placebos, from posters and banners to mixer-grinders and money, into voters and themselves. But elections 2012 feature a whole new prescription. Doc EC demands politicos cut out bad habits like bingeing on promises, throwing up surprises like sub-quotas and developing selective amnesia about the model code of conduct. It's determined to put netas on a fitness regime, whether or not they love it.

One prominent 'patient' administered a bitter pill is UP Chief Minister Mayawati. She's sprinkled India's most politically significant state with statues of herself, given company by full-size stone elephants, this noble animal oh-so-coincidentally being the BSP symbol. But the EC wasn't impressed by such poetry in concrete. Cover up, it ordered, until elections are through. Its aim was to give everyone a level playing field, shorn of giant stone replicas of Mayawati's signature handbags. No amount of cuss words—partisan, anti-elephant, plain party-pooper—could move the EC. So, local officials had to scramble to find enough fabric with which to drape UP's monumental art.

While—perhaps unwittingly—creating some amazing installations, the BSP should also take heart from the fact that the same treatment worked wonders on Tamil Nadu. Giant cut-outs of cheery politicos once punctured Chennai's skyline. But sensing electoral indigestion coming on, a stroke of the EC's pen prohibited such lavish cardboard fare. The new rule emphasised the point that elections are all about ground realities, dal-roti issues of naukri, kapda aur makaan, not whose body politicking stands taller in the sky.

With no amount of spongy idlis or Lucknowi biryani

changing the doctor's mind, we've been seeing a healthier poll culture emerge from earlier birthing pains. But for the election monitor's medicine to truly cure poll time ailments, politicos need to themselves shed some of that verbal fat and put away those showered promissory notes. They must instead develop the dietary fibre that real development needs. It'll help if, instead of focusing on caste, creed and quotas, netas pledge to deliver health, education and jobs. In short, not be driven by equality of opportunism but deliver equality of opportunity. Until that time—lage raho, EC-bhai.'

Source: 'What's up, poll doc', *The Times of India*, 14 January 2012.

This news feature was a significant endorsement of the tough measures taken by the ECI that many other media persons and some politicians described as the murder of the festival of democracy. It was particularly important in view of the fiercely independent Indian media, which has a high reputation for not sparing the highest in the land. The EC also had a taste of their brickbats, although, mercifully, the bouquets were more in number. Many media houses generously Reported expressions of support and trust by eminent citizens in conducting elections. The cartoonists, too, were very creative and imaginative in their art—replete with satire, caricatures and healthy humour about the electoral behaviour of politicians as well as voters. News publications and websites were replete with jokes about interesting aspects of elections and its humane and humorous sides. The print media also occasionally reported equally humorous aspects of the elections, not sparing the netas. One newspaper referred to them as 'graveyard campaigners' who had become 'overly gregarious, mingling and mixing with as many crowds of people as possible, attending wedding functions in their constituencies whether or not they are invited.' The paper continued in a satirical tone:

...Some smart candidates are in touch with owners or functionaries of banquet halls and venue owners to get advance information about bookings while others have even posted their men at cremation grounds and graveyards. This is the best PR exercise. If you attend a wedding uninvited, you get to meet the highly apologetic hosts and all the guests. Besides, you and your supporters get free lunch or dinner too. If you go to a funeral without being informed, you are bound to connect with the grieving family. Neither of these exercises entails any expenditure. On the contrary you can get more votes, confessed a candidate. Wonder what the Election Commission has to say on this graveyard shift?

Source: The Asian Age, 30 January 2012.

Elections—The Cartoon Festival

Election 'time' is a cartoonist's delight. Cartoons vary from serious to hilarious, with subtle messages for everyone. For example, a cartoon by Jug Suraiya and Ajit Ninan in *The Times of India* brought voters and the voted face to face and presented the reactions of candidates on high voter turnouts: 'I

hope Punjab's record voter turnout does not mean that voters want to turn *us* out.' In another cartoon by Surendra, a wife ridicules her poor husband about the freebies offered by a candidate: 'It was not your dream! He actually promised a free house, land, bank balance, son's education, job, daughter's marriage...' Yet another cartoon caption said: 'Parties can now hire a horse-trading firm to deliver cash at netas' gates.'

Referring to a violation of the Model Code of Conduct by Salman Khurshid, a cartoon made the then Law Minister defend himself in front of a shocked Sonia Gandhi and Manmohan Singh: 'When I did this to the EC I wasn't showing contempt—I was just showing the Congress hand in duplicate!' (*The Times of India* 14 February 2012). Cartoonist Surendra in his 'Tongue In Cheek' (*The Hindu*) captioned a drawing: 'Oops...I forgot our promises, find out from that fellow, he must have read our manifesto!'(16 February 2012). Sudhir Tailang, one of India's most creative cartoonists, gave a graphic picture about observing the Model Code (*The Asian Age*, 22 February 2012). Quite a few cartoons lent support to the EC's initiatives to ensure free, fair, clean and peaceful elections. Without such cartoons, elections would be very dull indeed.

'Let us be proud', wrote Gopalkrishna Gandhi in an editorial article in *The Hindustan Times* (9 March 2012), explaining: 'Five states went to the polls last month. The voter turnout was extraordinary. That of women voters, especially so. All these facts are not only well-known by now; they are axioms...The voters have won, voting has won. But the "man of the match" is the Election Commission (EC) of India.'

One felt truly humbled when this former administrator, diplomat and Governor of West Bengal in his last assignment, added: 'The EC represented principally by the Chief Election Commissioner, S.Y. Quraishi, and the team of officials working without fear or favour—and with fervour—under the EC's umbrella, delivered transparently clean elections in this theatre of violence and intrigue. They are not just winners, but heroes.'

Source: *The Asian Age*, 14 February 2012.

'When I did this to EC, I wasn't showing contempt, I was just showing the Congress hand in duplicate!

However, he tempered his generous praise with well-placed caution: 'But we cannot gloat. And there is a reason why we cannot. For there is a side player in our elections of whom we cannot be proud. Of whom we are to be ashamed. And "he" is that perfect scalawag called illegal money or black money… Elections now do not mean the spending of crores (of rupees), but of multiples of crores.' Giving credit to civil society groups and the team of electoral managers, he reiterated: 'But the constant fight of enlightened and concerned citizens and NGOs is doing its work. What is more, India's bureaucracy is receiving the message. Young administrators are as idealistic as those running India Against Corruption. Take our chief electoral officers. They have done us proud in election after election. They have intercepted vehicles carrying cash, stopped unlawful campaign practices indulged in by former and future bosses without fear or favour. These personnel are neither among the bullies nor among those that are bullied. They are counter-

bullying, counter-manipulating, counter-grabbing agents for good governance. I salute their courage. Our CAG, our CVC, our CEC and our Chief Information Commissioner are not the flamed tonsils of civil society. They are restrained members of the much-maligned bureaucracy.'

The grandson of Mohandas Karamchand Gandhi, the 'father' of the Indian nation, is not alone. More and more Indians from different socio-economic strata and walks of life are realizing that a right political choice can help us fashion our own destinies. And no small credit for this goes to the Election Commission of India.

India's Mediascape

India would not be able to describe herself as the world's largest democracy without the existence of an independent media. The mass media in India often reflects the diversity and plurality of the country, especially during general elections. At the same time, since much of the media is privately owned and driven by profit motives, commercial compulsions can and do sometimes distort the free and fair dissemination of information. This is especially true during periods of economic slowdown, when advertising revenues are low.

India's mediascape is unique in more ways than one. It is to be noted that ours is the only country in the world with over 72,000 publications of various kinds in different languages registered with the Registrar of Newspapers of India, which functions under the Indian government's Ministry of Information and Broadcasting. An estimated 1,900 'large' daily newspapers are published in the country—over 40 per cent of them in Hindi, less than 10 per cent in English and others in dozens of languages and dialects.

Till the early 1990s, television viewers in India could only watch programmes broadcast by the state-owned Doordarshan. Barely a decade later, they have access to hundreds of television

channels from all over the world, most of them privately owned. In 1995, barely 20 million households in the country had cable and satellite connections. This number has since gone up more than five-fold to over 100 million households. The Ministry of Information and Broadcasting has allowed more than 700 television channels to uplink and downlink from the country, and roughly half of these are categorized as 'news and current affairs' channels. The first India-based private television channel to enter the news space, Zee News, began operations somewhat tentatively in 1994. At present, India has the largest number of television channels that broadcast news and current affairs programmes in over a dozen languages.

We are aware that the Commission would not have been able to achieve what it did without the support of the mass media, which plays an important role in informing and educating voters, in particular women and young people. Voter demoralization was widespread in the past, with election processes marred by rampant rigging, brazen booth capturing and other malpractices. The cynicism and apathy of yesteryears is being gradually replaced by new-found optimism about the ability of ordinary voters, the proverbial aam aadmi, to participate freely and happily in the process of electing their representatives to legislatures. As voter turnout goes up, the mass media which was earlier content merely reporting events has now become an active participant and player in not just informing citizens about their rights and obligations as voters, but also empowering them to strengthen democratic processes and institutions. The world's most widely-circulated English daily, *The Times of India*, reported in an editorial titled 'Poll Doctor' (12 February 2012): 'By carrying out voter education and enrolment campaigns, checking and cleaning up electoral rolls, rapping model code violations and thwarting bids to disrupt or manipulate polls via intimidation or money power, the EC has enthused voters. Thanks also to well-deployed security personnel, elections have largely been violence-free,

be it in trouble-prone Bihar and Bengal in the past or Manipur and Uttar Pradesh in this round of state polls. All of this boosts people's faith in the electoral system—and, ultimately, in the power of their vote.'

While elections are integral to democracy, a free press is perhaps only second in importance. It is imperative that the news media disseminates accurate and fair reports on campaigns by contesting parties and candidates among the electorate. The freedom of the media in this context depends, to a large measure, on journalists conducting themselves with a sense of responsibility and impartiality. In an effort to help the media adhere to principles of fair and objective reporting of elections, the Press Council of India has formulated guidelines for the print media that are to be observed during elections. One of the guidelines reads: 'The press should observe all the directions/orders/instructions of the Election Commission, the chief electoral officer or returning officers that are issued from time to time.'

The implicit contract between the mass media and the functioning of democracy underpins journalists' claims for a substantial degree of autonomy. A healthy democracy requires, among other things, the participation of informed citizens. One of the roles of the media is to enhance the level of public participation by providing information and analyses on a range of political, economic, social and other issues. However, although mass media plays an essential role in the formation of public opinion and personal choices, most media organizations are commercial enterprises which not only seek readers, listeners or viewers, but also advertisements, a favourable regulatory environment and other advantages. This creates certain intrinsic conflicts between the media's social obligations and commercial considerations that can and often do result in compromising ethical standards.

Addressing an illustrious gathering that included Chief Election Commissioners from over thirty countries on the

occasion of the second National Voters' Day function on 25 January 2012 at Vigyan Bhawan, New Delhi, A.P.J. Abdul Kalam, former President of India, focused on the country's demographic profile: 'We have about 550 million youth in the nation and about 200 million are registered (as voters)...In the future, the number of youth voters and their relative share will only grow progressively. In this scenario, it is paramount for the efficiency of the democracy to ensure that these youth are an integral and vibrant part of the democratic participation. How do we motivate the youth to be partners in the democratic elections? How do we motivate others who don't vote normally due to various other reasons?'

An important way in which voters, especially women and young people, can be motivated to go out and vote in larger numbers is to get the media to side with the Election Commission. The media, which is otherwise extremely critical of the working of the bureaucracy, also acknowledges the fact that the same set of bureaucrats, when granted independence and autonomy to perform under this constitutional body, work wonders in strengthening democracy. The very same class of bureaucrats caricatured as babus, often derided as inefficient, lazy and corrupt, have, over the years, successfully conducted elections in a virtually error-free manner.

Media—A Great Ally

Moreover, in enabling the Commission to discharge its duties effectively, the media can be its most potent and formidable ally. The media not only acts like society's watchdog by spotting malpractices and violations of laws and the Model Code of Conduct, it also becomes a provider of vital evidence when the Commission has to initiate action against any person or party. Over the years, I have reiterated that the media has become our eyes and ears because they inform us about corruption, malpractices and violations of the Model Code of Conduct.

Although we deploy our men in large numbers, the media often gets the information first. Therefore, election officials have been asked to treat all media reports of malpractices as 'complaints' and initiate action without waiting for formal orders from the EC.

Clearly then, the collaborative relationship between the media and the Commission goes far beyond disseminating information relating to the announcement of elections, nomination of candidates, scrutiny of nominations, the campaign process, security arrangements, polling, counting and the declaration of results. Many ordinary voters become aware of facts on the what, when, where and how of elections through the media. Besides this, analysing the agenda of political parties, providing profiles of candidates, etc., is an extremely important task performed by the media. Of late, the media has paid particular attention to the criminal antecedents of candidates as well as their financial status, which have contributed towards imparting greater transparency to the election system.

The Commission, on its part, supports the media by not just providing information to journalists but also allowing them access to polling stations and counting centres. Special centres to serve media personnel are set up at state and district levels and these facilities are being strengthened. The experience of and research conducted by the Commission indicate that there are gaps between what voters should know and what they actually know—from facts regarding polling logistics to the unlawful use of liquor and other allurements and the use of money and muscle power. These gaps can be—and often are—filled up by the media.

The role played by government-owned media, including Doordarshan, All India Radio (AIR), the Song and Drama Division of the Ministry of Information and Broadcasting, the Directorate of Advertising and Visual Publicity (DAVP) and the Directorate of Field Publicity, in educating voters and spreading awareness is significant. But what is particularly encouraging

is that lately, privately-owned media organizations are also contributing towards these endeavours. The Commission decided to award media houses that carried the best voter awareness campaigns and the response was excellent. A campaign by Zee TV, *'Aapka Vote Aapki Taqat'* went on to enter the Limca Book of Records.

The fruits of this association between the media and the ECI were demonstrated quite dramatically during the February–March 2012 elections to the legislative assemblies in Punjab, Uttarakhand, Manipur, Goa and Uttar Pradesh, when all these states witnessed record turnouts of voters. Media support made an enormous contribution to this success.

Indeed, the role of the media is no longer a passive one, but proactive and participative, complementing the Systematic Voter Education and Electoral Participation (SVEEP) programme. However, while the media is a great pillar of our strength, it also creates problems, sometimes, by fanning, if not creating, controversies.

Some Overhyped Controversies

Every set of elections has its share of controversies and criticisms and the ones that took place in late-2011 and early-2012 were no exception. In some cases, I found myself being personally attacked in sections of the media. One such controversy related to the Commission's decision to cover the statues of Mayawati (then Chief Minister of Uttar Pradesh) and statues of elephants—the election symbol of the the Bahujan Samaj Party (BSP), which she heads—located in public parks that had been built using public funds.

The Commission's decision was attacked not so much by BSP functionaries and supporters but a section of the media. Even some senior journalists made flippant remarks like why did the Commission not ban the use of bicycles (the election symbol of the Samajwadi Party), or ban lotuses (the symbol

of the Bharatiya Janata Party), or cover everyone's hands with gloves (hands being the symbol of the Indian National Congress)? Some questioned the expenditure this exercise would involve. Eminent media leader and columnist Karan Thapar in his 'Sunday Sentiments' (*Hindustan Times*, 29 January 2012) wrote a critical analysis under the title 'So wrong, So long' in which he questioned the merit of the decision and wondered why we often make the wrong decisions?

All of them missed the larger perspective. The facts of the matter are that some people had petitioned the Supreme Court to ask the UP government to stop the construction of statues of the chief minister and the elephants in public parks, at public expense. It was also demanded that the elephant, as the party's symbol, should be frozen because these statues, in their hundreds, would be a permanent advertisement for the party at public expense, disturbing the level playing field among political parties. The Supreme Court referred the matter of the party symbol to the ECI.

The Commission heard the representation to freeze the elephant symbol in its quasi-judicial capacity assisted by a battery of lawyers from both sides. It decided that it would be an extreme step to freeze the symbol, though there was a lot of merit in the complaint that a huge amount of public money had been spent in building these statues, which were in fact logos of the ruling party. I consider it desirable to reproduce the operative parts of our order.

> It has to be borne in mind that the BSP is a National party and the symbol 'elephant' is reserved for it in the whole of the country, except Assam. Before taking any decision with regard to the withdrawal of the above symbol from the party, as prayed for by the petitioners, the Commission has to carefully weigh the implications which such withdrawal of symbol may have and cause confusion in the minds of millions of electors, apart from members, supporters

and workers of the party, across the country, who identify the party with its symbol 'elephant', on account of some action taken by one of the State Governments[...]

44. However, at the time of elections, the Commission would, no doubt, take appropriate steps and measures to see that the statutes of Ms. Mayawati and BSP's symbol 'elephant' do not disturb the level playing field and give undue advantage to BSP vis-á-vis other political parties.

Para 44, the penultimate paragraph, deliberately printed in bold in our quasi-judicial order of 11 October 2010 (as above), clearly shows that a forewarning for covering of statues was unambiguously made a full three months before the instruction to cover them was actually issued. The EC order was placed before the Supreme Court and the BSP did not question our order, neither before the EC nor the Supreme Court.

What the Commission did was to ensure a level playing field and neutralize the advantage that an incumbent party had. We followed the rules in letter and spirit. After all, why are even photographs of the ruling prime minister and chief ministers removed from walls of government offices before elections? Even a calendar with a picture of a serving political personality is removed! As N. Gopalaswamy and T.S. Krishnamurthy, former Chief Election Commissioners, pointed out in television debates, what would be the EC's response if other parties demanded that their symbols should also be erected at public expense in these public parks to ensure a level playing field?

Another criticism was regarding the cost of covering these statues, which was speculated to be crores of rupees. The Commission had indeed considered that issue as well. We had explored the option of closing the parks instead of covering the statues. That would have cost ₹500 for the padlocks on the two parks. But our legal sense dictated otherwise. What if a citizen went to the court complaining that his fundamental right to a walk in the park had been violated? That, perhaps,

would have been more difficult for us to argue against. Our legal advisor confirmed this. Then we did a quick check with the Food Corporation of India about the cost of covering their huge stocks of food-grain. The information was revealing. A plastic sheet to cover a stack of a size comparable to the tallest statue would be ₹7,150. Covers for the statues would need much less demanding specifications and would cost just half of this. If a huge cost ('crores'!) was actually incurred, it would be a matter for the CAG, in due course, and not the EC's concern.

The records of the CEO of Uttar Pradesh, however, show that the total expenditure on covering the statues was ₹2,23,191 in NOIDA and ₹66,900 in Lucknow (Total ₹2,90,091).

How costly is the cost of covering?

Amidst the heated debate about the cost of covering a statue during the Uttar Pradesh elections, we requested the Food Corporation of India (FCI) to inform the EC how much they spent in covering 150 metric tonnes (MT) of wheat/rice in their godowns. The following is the estimated expenditure as provided by FCI:

1. Standard size of a stack in CAP complexes/covered godowns 30ft x 20 ft x 15 ft? ft for storage of 150 MT of wheat in CAP and 162 MT rice in a covered godown.

2. Size of standard polythene covers as per BIS specification no. IS 2508-1984 = 9.8 x 6.4 x 5.2 mtr (32 x 21 x 17) of 1,000 gauge of low density black polyphone film.

3. The LDPE covers must have two funnels each length-wise and one funnel each width-wise. The funnels shall be in the form of cylindrical tubes which are approximately 30 cm long and 20 cm in diameter.

4. The polythene covers shall have uniform colours, texture and finish and shall be free from pin holes.

5. The polythene covers should be of average weight 55 kg

and in any case the weight shall not be less than 54 kg.
6. The prevailing rate of polythene covers is ₹7,150 per cover
 and cash discount @ ₹50 per cover is applicable if 100
 per cent payment is released by FCI within 15 days on
 submission of duly completed bills in all respects along with
 the certificates of receipt of material in good condition by
 the consignee.

Source: Food Corporation of India.

It is important to note that the EC's action also passed
judicial scrutiny with the Allahabad High Court's order in
the matter of covering statues dated 24 January 2012. It is
equally noteworthy that the media virtually blacked out this
information.

Relevant extract from the judgement:

... the direction in exercise of powers under Article 324 to
cover the statues of 'elephants' and of the incumbent Chief
Minister erected at government expense after the election
notification has been issued and the dates for the elections
announced has to be understood in the background that at
that stage there is a compelling obligation on the Election
Commission to ensure the conduct of free and fair elections
and the purity of the electoral process and that no party
gets any undue advantage over the contestants.

It was also argued in the media that the Election Commission's
order to cover up the statues of Mayawati and the elephants
would work in favour of the then incumbent government
in the state. The Commission is not concerned who benefits
and who does not; it only acts in good faith according to its
understanding of the concept of a level playing field and the
concerns of the Model Code of Conduct that must be enforced
in letter and spirit.

Hype of the Salman Khurshid case

Another action which was sought to be given a controversial colour by some sections of the media was the Commission's response to certain statements made by then Union Law Minister Salman Khurshid in the run-up to the Uttar Pradesh assembly elections. He was issued a notice by the Commission when he talked of a sub-quota for minorities within the quota of government jobs reserved for those belonging to the Other Backward Classes (OBCs). In a hearing before the EC, he contested it vehemently, through a battery of nine lawyers led by Abhishek Singhvi. The complainant, the BJP, was also represented by eight lawyers led by Ravi Shankar Prasad. The Commission found that the minister had violated the Model Code of Conduct for which he was appropriately censured (9 February 2011). The media repeatedly tried to project this as a personal rivalry between the minister and me. This also betrayed their ignorance or disregard about the EC's decision-making process where all the three members were unanimous in this decision—as indeed of all other decisions.

Following the EC's censure, Salman Khurshid issued statements that apparently challenged the authority of the EC, a constitutional body, and we were confronted with an unusual situation. Contrary to general perception, criticizing the EC is not a violation of the MCC; indeed, the Code does not bar anyone from criticizing the EC. This case, however, was that of a Law Minister challenging a constitutional authority instead of upholding it. This was something unprecedented in the history of India. It would have been unworthy of the positions the three of us were holding in the EC if we had been mute spectators. We decided to take what we thought was the most appropriate action, of writing to the President of India. The President immediately referred the letter to the Prime Minister. Before the PM could react, the minister tendered an unconditional apology which the EC accepted and dropped

the matter.

The minister, in cooler moments thereafter, rejected his utterances and stated that he meant no disrespect to the Election Commission. (Records of these proceedings are available on the Commission's website: www.eci.nic.in).

The entire episode was an aberration. Some sections of the media tried to trivialize the issue as a personal confrontation. The Commission was constrained to point out to journalists that it had issued thousands of notices for violations of the Model Code of Conduct and that we had not singled out any individual. Conversely, a large section of the people severely criticized the 'soft' action of the Commission, some of whom even called it a fixed match. Many, however, agreed that accepting the minister's apology was the most dignified response that the EC could have offered. (This episode is also referred to in Chapter 10).

On another occasion, the media reported that I came face-to-face with Salman Khurshid on 9 March 2012 at a public function organized by the Sir Syed Foundation, in honour of the founder of Aligarh Muslim University, that took place at New Delhi's Gymkhana Club. The event was marked by bonhomie and the Law Minister said it all when he spoke of 'the Election Commission, and the Supreme Court', as being among the 'institutions that protect democracy', and 'if we slip, *koi rokne wala zaroor hota hai*' (there is someone to check us).

Model Code of Conduct and the Media

A debate also arose around this time on whether the Model Code of Conduct should be made statutory. The position of the Commission has been clear on this issue (see chapter 9).

What started the debate was the following statement by Manish Tewari, Congress spokesperson (14 February, quoted in the *The Indian Express*):

Source: The Asian Age

> Without any disrespect for the Election Commission, which we hold in the highest esteem...time has come, in a wider sweep of electoral reforms, to think about giving Model Code of Conduct (MCC) a statutory backing. Perhaps it will be appropriate that the whole question should be looked at and the Election Commission should also revisit its own position on this issue.

The media response was instant and critical. A senior journalist wrote: 'It's a way of telling Chief Election Commissioner S.Y. Quraishi, "I respect you, so I'll make you toothless!"'

In an interview to Rakhi Chakravarty published in *The Times of India* (8 March 2012), I clarified the Commission's stand that the Model Code of Conduct should not be made statutory: 'That's totally uncalled for. We don't want any more power. The Model Code of Conduct is working fine. Haven't we demonstrated its efficacy by conducting peaceful elections? There were no hate speeches, no personal attacks mainly due to the Model Code of Conduct.'

Law and the Model Code

The [Congress] spokesperson [Manish Tewari], no doubt an expert on gauging how some in the media (and the social media)

can be herded, is banking on our laziness. How many of us would suspect that this is a Trojan Horse for extracting the EC's canines? What would the famed MCC be worth, if Mr Tewari had his way and all that Quraishi could do henceforth is to file an FIR and await the court's direction? It's like telling a fireman to be on hold and let the fire burn, while a court awaits expert input.

The genius of Mr Tewari's argument lies in the fact that if the courts were indeed smuggled in, the MCC [...] would take years (not hours, which is the present state of play!) for a matter to be resolved. Tewari, perhaps unwittingly, is junking what many democracies in the world want to emulate. Making the MCC, a voluntary compact agreed upon by political parties for three decades, might weaken most of the case law we have on hand. Importantly, EC will lose its sheen as well as the moral authority in instant situations. Of course, the courts will deliver reasoned orders, but those will come in the 'long term,' by which time we'll all be dead anyway!

In the quest for level-playing field, speed is the essence of equity. Even a cursory reading of the EC's powers to tame even the renegade Law Minister would bear me out regarding speed to market. Notice the time taken from complaint being made, to the Law Minister of the land going down on his knees. Would this have happened if the matter was burdened on the courts?

It isn't surprising therefore that a class of netas (many no doubt outside the Congress too) would like the MCC to be rolled back. It's amusing that the Congress spokesperson is leaning on a recommendation made in a report commissioned by the VP Singh government in 1990. A more detailed reform agenda, a set of 22 points, proposed by the EC way back in 2004, and its status (in varying degrees of pussy footing) shared by the law ministry in December 2010, is revisited (Rohit Bansal, CEO, India Strategy Group).

Source: Governance Now and www.governancenow.com, February 2012.

The Robert Vadra Incident

Another controversy that arose before the Uttar Pradesh assembly elections and was hyped by the media related to the transfer of Pawan Sen, an officer belonging to the Indian Administrative Service. As an election observer, he had reportedly ordered stopping a motorcycle rally led by Robert Vadra, husband of Priyanka Gandhi*, in Salon area of Amethi district. The EC was subjected to a bitter media attack for acting under political pressure. All protestations by the Commission that the transfer of this officer to Goa was not linked to this incident seemed to fall on deaf ears.

The Commission issued a clarification that the incident at Amethi was unrelated to the observer's transfer. During its meeting in Goa a week earlier, the Election Commission had reviewed complaints from various political parties about the conduct of the then DC in South Goa who was earlier the state Chief Minister's Principal Secretary. We had decided to post a new DC. For this purpose, we sought a panel from the state government of suitable direct-recruit IAS officers and among the panel was Sen's name, the other two being secretaries to the Chief Minister and Governor. In its meeting on the morning of 7 February 2012, the EC had selected Sen's name—for the obvious reason that the Secretary to the Chief Minister would not have been acceptable to the opposition and the Secretary to the Governor might not have been freed by the Governor. The incident in which Robert Vadra was involved happened later in the evening and the transfers therefore had absolutely nothing to do with the incident.

Clarifying that Sen was transferred as DC, South Goa, as he belongs to the Goa cadre, the Election Commission's statement added: 'To avoid misinterpretation by some mischievous people,

*Priyanka Gandhi is the daughter of Mrs Sonia Gandhi, President of INC and UPA (United Progressive Alliance), the ruling coalition.

we have since kept on hold his transfer. He will be relieved from his election observer duty only after the polls are over on February 19.' Incidentally, Sen was extremely unhappy that, because of the media furore, he almost lost the coveted post of Collector, which is every young IAS officer's dream.

Paid News—A Chink in the Armour

In recent years, corruption within the Indian media has gone far beyond the corruption of individual journalists and specific media organizations. From 'planting' information and views in lieu of favours received in cash or kind, to more institutionalized and organized forms of corruption, wherein newspapers and television channels receive funds for publishing or broadcasting information in favour of particular individuals, corporate entities, film producers and actors, you have it all. Although

the media was used in the past to manipulate stock and the real estate markets, the phenomenon of 'paid news' acquired a new and more pernicious dimension by entering the sphere of political 'news' or 'reporting' on candidates contesting elections over the last few years.

The malpractice of paid news has become widespread and now cuts across newspapers and television channels, small and large, in different languages and located in various parts of the country. Alarmingly, these illegal operations have become 'organized' and involve advertising agencies and public relations firms, besides journalists, managers and owners of media companies. So-called 'rate cards' or 'packages' that include 'rates' for publishing 'news' items in a predetermined manner, not merely praising particular candidates but also criticize their political opponents, are distributed. Candidates who do not go along with such 'extortionist' practices are blacked out, if not tarnished brutally.

Given the illegal and clandestine nature of such malpractice, it is not easy to find clinching evidence in the area of political 'paid news' that pins responsibility for such corrupt practices on particular persons and organizations. All we have is circumstantial evidence that points towards the growing use of the media for publishing 'paid news'. A sub-committee appointed by the Press Council of India, comprising K. Sreenivas Reddy and Paranjoy Guha Thakurta, documented instances of identical articles with photographs and headlines appearing in competing publications carrying bylines of different authors around the same time. You may even find articles praising competing candidates, claiming that both are likely to win the same elections, both on the same page of a newspaper, since both had bought the package! Nowhere is there any indication that the publication of such 'news' reports has been sponsored by certain individuals or political parties, or has entailed financial transactions.

Cost of Democracy

The EC strikes out at paid news, but what it has seen is just the tip of the iceberg. It's getting bigger by the day. If the sheer number of notices sent by the Election Commission to candidates and media houses is any indication, paid news is big news in the assembly elections in Punjab. By the time polling came to a close on January 30, the Commission's media certification and monitoring committees (MCMCs) in the districts had issued some 300 notices. More than 200 of those served notices have even admitted to paying or accepting payment, the candidates among them agreeing to show this spending in the Rs 16 lakh they are permitted to spend on canvassing.

It seems everyone does it, and most of them quite freely, admit it too. Notices were issued to candidates after MCMCs set up in each district tracked election-related coverage of candidates. The broad criteria adopted to identify paid news were: consistent coverage of a candidate in a particular newspaper; similar wording in the coverage of a candidate appearing in different newspapers; or the appearance of more than one news item about a candidate on a page. One committee at the state level scanned election coverage by TV news channels and clamped down on 'suspect' programmes.

Many a media house based in Punjab has been rattled by the Election Commission's first-time effort to curb paid news. Nevertheless, media watchers say what has been exposed is just the tip of the iceberg. 'The flip side of the EC's strictness in accounting for advertisements put out by candidates is that now there are very few candidates' ads in newspapers or on TV channels,' says Kanwar Sandhu, managing editor of Day & Night News, a TV channel. 'Instead, candidates either pay local correspondents or get paid news inserted.'

Source: Chander Suta Dogra, *The Outlook*, 20 February 2012

Table 11.1: Paid News Cases
Status of Paid News Cases during General Election in 2010

SI No.	Name of State/UT	No. of Paid News Cases
1.	Bihar	15

Status of Paid News Cases during General Election in 2011

SI No.	Name of State/ UT	No. of cases, in which notices to the candidate issued	No. of confirmed cases of Paid News
1.	Kerala	65	65
2.	Puducherry	3	3
3.	Assam	42	27
4.	West Bengal	15	8
5.	Tamil Nadu	11	22

Status of Paid News Cases during General Election in 2012

SI No.	Name of State/UT	No. of cases, in which notices to the candidate issued	No. of confirmed cases of Paid News
1.	Uttar Pradesh	97	97
2.	Uttarakhand	60	30
3.	Punjab	339	523
4.	Goa	63	9
5.	Manipur	Nil	Nil
6.	Gujarat	495	414
7.	Himachal Pradesh	190	104

Status of Paid News Cases during General Election in 2013*

SI No.	Name of State/UT	No. of cases, in which notices to the candidate issued	No. of confirmed cases of Paid News
1.	Tripura	Nil	Nil
2.	Meghalaya	Nil	Nil
3.	Nagaland	Nil	Nil
4.	Karnataka	93	93
5.	Mizoram	Nil	Nil
6.	Chhattisgarh	35	32
7.	Rajasthan	110	81
8.	Madhya Pradesh	279	165
9.	NCT of Delhi	80	25

*Some figures may change under future scrutiny
Source: Compendium of Instructions on Paid News and Related Matters (December 2013), Election Commission of India.

The small group of people, which secretly undermines from within the interests of the nation, is doing a great disservice. The widely read *Outlook* magazine in its February 2012 issue highlighted this problem in a cover story. What, if at all, can be done to check such corrupt practices in the media that compromise democratic processes? The answers are not easy. Despite its quasi-judicial status, the Press Council of India has limited powers. It has the power to admonish, reprimand and pass strictures but cannot penalize the errant or those found guilty of malpractices. Besides, the Council's mandate does not extend beyond the print medium. A proposal to amend Section 15-4 of the Press Council Act, 1978, to make the directions of the Council binding on government authorities, has been pending for a long time and, in my opinion, should be amended to provide the Council more teeth.

How to Detect Paid News

- Identical articles with photographs and headlines appearing in competing publications carrying bylines of different authors around the same time.
- Articles praising competing candidates claiming that both are likely to win the same elections that appear on the same page of a newspaper.
- News item stating that one candidate is getting the support of each and every section of society and that he would win elections from the constituency.
- News items favouring a candidate, but not carrying a byline.
- Newspaper publishing a banner headline stating that a party/candidate is ready to create history in the state/constituency but not carrying any news related to this headline.
- News item saying that the good work done by a party/candidate had marginalized the electoral prospects of the other party/candidate in the state with every sentence of the news item in favour of the party/candidate.
- There are instances of fixed size news items, each of a length of 125–150 words with a double-column photo. News items are seldom written in such a rigid format and size whereas advertisements most often are.
- In specific newspapers, multiple font types and multiple drop case styles were noticed within the same page of a single newspaper. This happened because just about everything—the layouts, fonts, printouts, photographs—was provided by candidates who had paid for slots in the pages of the newspaper.

Source: Compendium of Instructions on Paid News and Related Matters (December 2013), Election Commission of India.

Appointing ombudsmen in media organizations and better self-regulation are ways to check the 'paid news' phenomenon.

However, self-regulation though ideal, could just be wishful thinking and could at best offer partial solutions to the problem, since there will always be offenders who will refuse to abide by voluntary codes of conduct and ethical norms that are not legally mandated. The owners of media companies need to realize that in the long term such malpractices undermine not just the credibility of the media but imperil democracy itself.

That 'paid news' is a phenomenon that is deleterious to the credibility and independence of the media needs to be emphasized. Richard Edelman, an independent public relations firm, in its 2010 Trust Barometer Survey (conducted in twenty-two countries worldwide, including India and six other countries in the Asia–Pacific region) stated that the Indian media has been losing its credibility and trust among the people.

The study, which sampled 1,575 people in the 25–64 years age group and 200 opinion leaders in India, noticed a sharp drop in trust over the past two years in television news in India. However, newspapers are ranked a bit, just a bit, higher than other media in terms of credible news with people trusting newspapers more than any other medium: only 38 per cent of the Indians polled trusted radio and television, while 40 per cent trusted the news in newspapers. Over the past two years, trust in television news has dropped sharply from 61 per cent to 36 per cent, that of business magazines has gone down from 72 per cent to 47 per cent and that of newspapers has gone down from 61 per cent to 40 per cent. Trust in the media in India as a whole declined by 7 per cent (from 65 per cent in 2009 to 58 per cent in 2010).

On the other hand, the study states that China has seen the trust in media go up from 59 per cent in 2009 to 63 per cent in 2010. However, in terms of institutions in India that enjoy overall trust, the media performed better than the government. 67 per cent of Indians trusted business as an institution, followed by the Indian media in the second position, with 58 per cent Indians trusting it. Non-government organizations (NGOs)

and the government were placed in third and fourth positions respectively.

Certain publications have drawn up their own codes of ethics that are worthy of emulation as a measure of self-regulation. But self-regulation is not adequate for checking rampant malpractices and corruption that have assumed epidemic proportions in many sections of the print medium as well as the television medium. *Mint*, a daily business newspaper published by the *Hindustan Times* group in New Delhi (owned by HT Media), has devised a comprehensive code of journalistic conduct and provides all its employees with guidelines for appropriate professional conduct (the code is available on the newspaper's website).

The newspaper claims that the code is intended not as a statement of new beliefs or a codification of new rules of conduct, but as a reaffirmation of enduring values and practices. As per its code of conduct, the newspaper does not pay newsmakers for interviews, nor does it pay them for taking their photographs nor to film or record them. The code of conduct also enjoins upon its employees to prepare and place stories, graphics and interactive features based solely on their editorial merits with an intention to treat companies that advertise with the newspaper in exactly the same manner as those that do not advertise. It asks its employees not to favour any company, or the subject of a story, nor to discriminate against any, for whatever reasons.

Two of India's renowned journalists, the late Prabhash Joshi, and Kuldeep Nayar were the first crusaders against 'paid news'. They approached the Election Commission of India and the Press Council of India a number of times asking these two bodies to do their best to curb such malpractices. In one of his last public speeches before he passed away on 5 November 2009, at a seminar organized by the Foundation for Media Professionals in New Delhi on 28 October 2009, Joshi named some of the politicians who had either refused to pay money or those who

had complained to him about publications charging money for carrying news stories. Mrinal Pande, a senior journalist, former editor of *Hindustan* and the current chairperson of the Prasar Bharati Corporation of India*, in a two-part article written for *The Hindu* (18–19 March 2010), stated: 'Many recent steps redefining news and its dissemination in the newspapers were taken hastily after bypassing the editorial department. They may have introduced lethal and invisible viruses within the system that may corrode and finally kill the newspaper. The vernacular media may be feeling cocky, having pulled themselves out of physical poverty under their own steam, but they have yet to learn how to deal firmly and decisively with another kind of poverty—that of the professional, ethical kind.'

Media, Money and the Mafia

A leading crusader against the pernicious trend of paid news is P. Sainath, the Rural Affairs editor of *The Hindu*. In depositions before the Press Council of India on 13 December 2009, and again on 27 January 2010, Sainath observed that the general elections of 2009 witnessed a paradigm shift in the manner in which candidates and political parties worked hand in glove with the press and media houses in masquerading advertisements for candidates and parties as political 'news'. Speaking to the Press Council of India on 10 February 2010 in Hyderabad, the Director of the Centre for Media Law and Policy, Hyderabad, and member of the National Academy of Legal Studies and Research (NALSAR), Madabhushi Sridhar said that the paid news phenomenon represents a 'fatal combination' of three 'Ms', namely, the media, money and the mafia, that has subverted free and fair elections.

The Election Commission asked the Press Council of India 'to devote serious consideration to this growing menace

*Prasar Bharati is the public broadcasting corporation of India.

which, if not checked in time, may erode the credibility of the electoral system.' The Commission wrote: 'As any consideration of surrogate advertising will also involve issues like media regulation, media freedom, media ethics, etc., the Press Council of India may like to suitably address it. In particular, the Commission would like some guidelines to be laid down by the Press Council of India to determine what is "paid news", so that the expenditure incurred by political parties and candidates on such paid news may become accountable.'

The Press Council then defined 'paid news' as 'any news or analysis appearing in any media (print and electronic) for a price in cash or kind as consideration.' Paid news not only seeks to circumvent election laws relating to ceilings on expenditure that can be incurred by a candidate, but such advertising, masquerading as news, has the potential to exercise undue influence on voters and adversely affect their right to factually correct information. There has been widespread condemnation of this phenomenon within and outside Parliament.

Responding to demands for restricting this practice, the Commission issued instructions in June 2010 to state and district officers to scrutinize, identify and promptly report instances of paid news. It constituted Media Certification and Monitoring Committees at the district level to locate political advertisements and suspected paid news. During election campaigns, these committees submit daily reports to returning officers and expenditure observers on all expenditure on advertising, including any on paid news. The observers, in turn, send their reports on paid news to the Commission within twenty-four hours. District collectors and magistrates educate candidates and political parties about the consequences of paying for 'news' and owners of printing presses are informed about the rules relating to printing and publishing of pamphlets and posters.

These measures against paid news were initially enforced in 2010 during the assembly elections in Bihar. As many as 121

show cause notices were served on that occasion. Subsequently, during five state assembly elections in 2011, more than 250 notices were issued for suspected paid news. During the next set of five state assembly elections in 2012 the number of show cause notices issued went up to 581. The salutary effect of these measures is becoming increasingly evident.

While dealing with paid news, the Election Commission deemed it necessary to issue fresh guidelines to deal with politically-aligned media organizations before the five assembly elections that took place in 2011, in particular the election in Tamil Nadu where the media used to be traditionally polarized along political lines, and even owned by political parties. These fresh guidelines were issued in August 2011 to deal with advertisements on cable television channels that are owned by political parties and their office-bearers or functionaries, even if no consideration in cash or kind is involved. Broadly, the notional cost as per rate card of media time and space used was to be included as 'expenditure'. The approach of the Commission with regard to curtailing paid news has been to prevent rather than punish, as far as possible.

Is the 'Fourth Pillar' becoming the 'Fifth Column' of Democracy?

Some sections of the media in India have unfortunately begun to treat the political arena like any other market. If the politician pays, he will be covered in a complimentary and favourable manner. Or else, he will be blacked out, if not hounded with hostile reports. Publications that put out paid news items that are akin to pamphlets eventually end up damaging—if not destroying—their own credibility. Whereas such malpractices were confined to individual transgressions and to a few newspapers and television channels in the past, the sheer scale of what is taking place now is alarming and frightening. This phenomenon, according to Paranjoy Thakurta,

strikes at the very core of democracy, by turning the media, which is supposed to be the fourth estate and a watchdog of society, into a 'first estate' of sorts by adversely influencing democratic processes. My concern is that the 'fourth pillar' of democracy should not degenerate into a 'fifth column' of democracy.

What should be done? The evil practice should be debated and condemned in all possible fora like conferences, workshops, seminars, etc. Awareness-generating campaigns should be organized involving, among others, the Ministry of Information and Broadcasting, the Press Council of India, the Election Commission of India, representatives of editors' and journalists' associations and unions and political parties to deliberate upon the issue and arrive at workable solutions to curb corruption in the media in general and the paid news phenomenon in particular. Defaulters should be named and shamed. All these initiatives, if sincerely implemented, may reduce such malpractices in the Indian media though these may not stop altogether.

In this context, the case of Ms Umlesh Yadav* is significant as she was the first Indian politician to be unseated and disqualified by the Election Commission, in October 2011, for suppression of election expenses incurred by her when she was elected as a member of the Legislative Assembly of Uttar Pradesh in 2007 from Bisauli constituency. She was disqualified for failing to provide a 'true and correct account' of her election expenses by not including what had been spent on advertisements, dressed up as news, published in leading newspapers like the *Dainik Jagran* and *Amar Ujala*. After holding the newspapers 'guilty of ethical violations', the Council had asked the Election Commission to take 'such action as deemed fit'. The Commission found Ms. Yadav indulging in paid news and passed an order dated 20 October 2011

*Umlesh Yadav Case has also been referred to in Chapter 10.

finding her guilty of not showing a correct account of her election expenses, suppressing her expenditure on paid news. No sitting MP or MLA before Ms Yadav had ever before been disqualified by the Commission on grounds of incorrect reporting of expenditure—and certainly none on account of paid news. In its twenty-three-page order, the Commission made a wider observation that 'by suppressing expenditure on "paid news" and filing an incorrect or false account, the candidate involved is guilty of not merely circumventing the law relating to election expenses but also of resorting to false propaganda by projecting a wrong picture and defrauding the electorate' (order may be seen on www.eci.nic.in). *The Hindu* described the Commission's decision as a 'landmark order' and said it 'deserves the highest praise for functioning without fear or favour as the upstanding institution of Indian democracy that it is.'

EC versus Media on Opinion Polls

Ever since the advent of multiple news channels, opinion and exit polls at the time of elections have become a bone of contention between the EC and the media. While the media fully supports these polls, political parties and the Election Commission strongly oppose them.

Opinion polls by themselves, like all research, are useful to gain insight into what people think of policies, programmes and products. Research is an essential marketing tool to know about consumer needs, preferences, knowledge, attitudes and practices.

In fact, most democracies have opinion and exit polls during elections. However, the ECI opposes them because it strongly suspects the integrity of these polls having dealt first-hand with the ugly reality of 'paid news'. Also for this reason, a ban on opinion polls has been demanded by all political parties (some of whom were allegedly approached with the offers of

'favourable' polls!).

Restrictions on such polls are also imposed in democracies elsewhere, extending from two to twenty-one days prior to the poll, in countries such as Canada, France, Italy, Poland, Turkey, Argentina, Brazil and Colombia.

The media and some legal experts oppose this ban on the ground that freedom of speech and expression is granted by the Constitution of India (Article 19). They forget that this freedom is not absolute and allows for 'reasonable restrictions'.

Several restrictions have been imposed by the Indian Penal Code. Some have also been implemented by the Representation of the People Act, 1951. For instance, there can be no campaigning during the forty-eight hours preceding the end of the polls. Personal attacks and appeals in the name of caste and religion are disallowed. The use of loudspeakers from 10.00 p.m. to 6.00 a.m. is banned at all times by a Supreme Court order.

While freedom of expression can be restricted, the EC's mandate for free and fair elections is absolute. There can be no compromise or dilution of this mandate. The Supreme Court in a catena of judgements has emphasized this requirement: 'Democracy cannot survive without free and fair elections' (Union of India versus ADR 2003); 'Free and fair elections is the basic structure of the Constitution' (PUCL versus Union of India, 2003, NOTA judgement); and 'The heart of the parliamentary system is free and fair elections' (Mohinder Singh Gill versus CEC of India, 1977). No one can argue that free and fair elections must be subjected to restrictions. It is a non-negotiable requirement.

The fact is that the ECI feels that opinion and exit polls will interfere with free and fair elections. This is based on well-known perceptions that opinion polls in India are non-transparent, often sponsored, motivated and biased. With such infirmities, these may amount to disinformation designed to cause 'undue influence' which is an 'electoral offence' under

the IPC and a 'corrupt practice' under the Representation of the People Act.

The demand for a ban on opinion polls was not a whimsical *suo motu* act by the ECI. It was the result of unanimous demands at two all-party meetings in 1997 and 2004. The only difference of opinion among the political parties was whether the ban should apply from the announcement of the poll schedule or from the date of notification. In 1998, the ECI issued guidelines which were challenged in the Supreme Court. On the court's query about how the EC would enforce the ban in the absence of a law, the EC withdrew the guidelines till a law was made.

So, in 2008, the matter went to Parliament, which banned exit polls but not opinion polls (126A, Representation of the People Act). Soon thereafter, the parties came back to the EC complaining about opinion polls again! It is not understood why the parties, who were unanimous in demanding the ban, did not pass it in Parliament!

The issue got precipitated in 2013 when the EC, on the advice of the law ministry, sought the views of all political parties once more. This time, they demanded the ban, yet again, but with one exception.

It was interesting to watch the media debate on the subject. All the participants—media, pollsters and jurists—were heard supporting the polls, yet admitting serious flaws with them. Even those supportive of opinion polls admitted that there were rogue elements among the so-called professional psephologists. They described these as 'rotten eggs', 'unprofessional', 'not serious types', 'jokes', etc. Some even admitted that psephology was 'no exact science' and 'after all, the researchers are human'. One went on to say that the rogue polls were meant to influence the morale of party workers. Thus, no one gave an unqualified certificate to opinion polls. The bottom line of the pollsters was 'My poll was right', all others were dubious. Obviously, the EC was concerned about the dubious ones.

340 OF UNDOCUMENTED WONDER

Arguments by jurists in television debates were also noteworthy: 'By what law can EC take action? Defy the order,' one of them exhorted. The EC was certainly not ordering anything against the law. It had only asked the government to make a law. 'The citizens have freedom of expression,' reminded another eminent jurist. Yes, the Constitution does grant the freedom of expression, but is there a freedom for disinformation or to cheat? As the Supreme Court said in the M.S. Gill case, 'One-sided information, disinformation, misinformation and non-information all create an uninformed citizenry, which make democracy a farce.'

An interesting refrain that we heard was: 'Opinion polls don't make any *significant* difference to voters' choice'. Even a *single* voter, cheated into believing that 'X' is winning and thus falling in line (bandwagon effect) is bad enough. That can alter the result. I would like to remind readers about the case of Congress leader C.P. Joshi, who lost the Rajasthan assembly elections in 2008 by a single vote. It was widely believed that he would become the chief minister, if only he had not lost his own seat! There have been many victories and defeats by very narrow margins—including two tied verdicts, decided by a draw of lots!

The dim view of opinion polls is not just confined to the EC. Even the Press Council of India, a statutory media regulatory body, had this to say about them: 'This has become necessary to emphasize today, since the print media is sought to be exploited by the interested individuals or groups to misguide and mislead the unwary voters by subtle and not so subtle propaganda on casteist, religious and ethnic basis as well as by *the use of sophisticated means like the alleged poll surveys.'* (Italics added.)

It may seem paradoxical but the ECI is the biggest protagonist of the freedom of expression. The entire election exercise is about free expression of opinion by voters. Anything that interferes with this freedom of expression of voters is put down with a heavy hand.

The fact is that the EC conducts its own opinion polls. All twenty-one state assembly elections since 2010 were preceded by Knowledge, Attitude, Behaviour and Practices (KABP) surveys to know what voters think and want. The insights gained helped the EC develop communication strategies for voter education that have created a participation revolution with all states recording highest ever turnouts.

The difference between media opinion polls and the ones that the ECI commissions is that the ECI's surveys are not meant to mislead or fool anyone—including ourselves!—but only to give insights into how plans for voter education campaigns should be formulated.

It will be fair to conclude that opinion polls would be fine if their integrity were beyond doubt. Perhaps an independent regulator, as is the practice in the United Kingdom, would be a viable option.

Elections and Social Media

A recent development on the media scene has been the phenomenal rise of social media. The subject came up several times in the Commission's deliberations, both from the point of view of its unrestrained use by political parties, contestants and their supporters, as also the need for the Election Commission itself to use it in its voter education activities. With regard to the former, the EC noted the increasing use of social media by political parties and candidates and wondered about the cost of the media and the nature of its contents, which were both matters of concern for the EC.

However, the time was not considered ripe for any intervention, though without ruling out the possibility of such an intervention in the future.

The primary concern was the money spent by candidates on social media for their campaigns. The law requires that every rupee spent on a campaign must be accounted for. This

obviously includes expenditure on media, including print, electronic and outdoor. Among the new media, the EC noticed an extensive and increasing use of SMSes because of their instant reach. But no medium comes free. If a candidate spends money on it, she/he is by law duty-bound to show it in the mandatory expenditure statements. Many candidates have suffered consequences, including unseating and disqualification, for not submitting the returns correctly. Does this amount to interference with the freedom of expression? The Commission does not think so.

The other concern was about the nature and content of the campaign, which is certainly under the scanner of the EC under the Representation of People Act, the MCC and other laws. Social media such as Facebook, Twitter and YouTube are indeed powerful tools. While they represent free speech, a legitimate concern they arouse is that of the mischief that can be caused by the abuse of such media. Some social media content is often so explosive that it can set the country afire. Peace and harmony can be destroyed.

In October 2013, there were media reports that the EC may be attempting to control social media. This obviously became an instant matter of speculation and hostility. The opposition was based on the assumption that the media will be gagged and freedom of speech and expression will be threatened. I wrote an article in *The Indian Express* to dispel this fear as unfounded with full knowledge that 'the EC is a protagonist of the people's right to information and free expression. If it comes out with any order on social media, it can only be with reference to political parties and candidates, and that too in the context of expenditure and objectionable content that violates the MCC. The EC does not, and will not, ever interfere with citizens' right to free speech and expression'. A day later (25 October 2013) the ECI issued a clarification on exactly the same lines to dispel unnecessary fears and speculation of a gag on social media.

The opposition to the EC's anticipated action was based on the belief that the right to free speech and expression is absolute. This is not true. Article 19 of the Constitution, which grants the right to freedom of speech and expression, also makes it 'subject to reasonable restrictions' in the interest of the 'sovereignty and integrity of India, the security of the State, friendly relations with foreign States, public order, preserving decency, preserving morality, in relation to contempt of court, defamation, or incitement to an offence.' And these are some of the major concerns of the MCC. Many Supreme Court judgements have confirmed such restrictions.

Another question raised was that technically, it would be extremely difficult, if not impossible, to enforce any restrictions on social media. Anonymity, pseudonymity and fake accounts do indeed make violators particularly difficult to catch. However, difficulty in enforcement of a valid law or rule is no justification for closing one's eyes to it. There are innumerable 'difficult to catch' malpractices that some candidates indulge in, including distribution of liquor, cash and other goodies, and the EC constantly tries to stop them, albeit with varying degrees of success. When one fraud is discovered and checked, they come up with another modus operandi. Even if the EC cannot achieve total success, it at least tries to make it very difficult for political parties and candidates to indulge in these malpractices with impunity. This is vital for the conduct of free and fair elections.

It is necessary to consider a paradox in this case. If a candidate maliciously attacks his rival in print, on TV or in a public meeting, he is hauled up under various laws of the land, including IPC, the Representation of the People Act and the SC/ST Prevention of Atrocities Act, besides the MCC. But will it be all right if he commits the same offence on social media? That will be an anomalous situation difficult to justify as social media is also media. If the EC shuts its eyes to a blatant abuse of this media, it will be accused of dereliction

of duty. This will be worse than being accused of inability to *fully* control the potential pitfalls of social media.

Incidentally, the EC is not hostile to social media. At the time I was heading it, we toyed with the idea of using it for voter education. A massive campaign was planned and even the date was fixed for its launch (16 December 2011). However, a few days before the launch, the then telecommunication minister Kapil Sibal's statement about the need to control incendiary material on social media led to such a massive furore that we decided the time was not opportune to venture into this unknown territory. Encouraged by my friends and my children, I myself, however, decided to get on Facebook and Twitter in my personal capacity. It has been a mixed experience. While I gave up Facebook as I found it too time consuming and intrusive because I seemed to have no control on what my 'friends' and family were posting on it, Twitter has been a great instrument of communication. I have been able to remove umpteen doubts and clarify the ambiguities of thousands of young people about the election process. It has also been a great source of information for me.

I would like to record at least one instance when Twitter brought to my notice an ugly incident at a counting centre in Uttar Pradesh in March 2012. Late in the evening when the results had to be declared in just a couple of assembly constituencies, I left the office. As soon as I reached home, I saw a tweet on my phone, asking me, 'Dr Quraishi, what are you doing to rescue the journalists surrounded by a violent crowd outside the counting centre?' I had no clue about such an incident as none had been reported by our field officials. I called up Umesh Sinha, CEO, Uttar Pradesh, immediately. He, in turn, got in touch with Akhilesh Yadav, the leader of the party whose workers were involved. Yadav called up his local leaders to lift the gherao (siege) instantly, or he would expel them from the party. It had an instant impact and averted a potentially serious and destructive situation.

Media Regulation

Whereas much of the mass media in India covered the elections in a non-partisan manner, there were sections that compromised their independence for commercial interests. On the whole, a substantial section of the media in India was able to live up to the faith of ordinary people by disseminating information on a wide variety of issues and also views of interest and concern for the electorate. We in the Commission were clear that while there should be no move to curtail the freedom and independence of the media and that self-regulation is ideally the best form of regulation, effective steps to prevent the misuse of the media by vested interests are indeed required.

Self-regulation by the media and self-restraint by candidates and political parties is ideally the best solution to the malaise of paid news. The MCC is a shining example of restrictions voluntarily accepted by all political parties. However, after initially subscribing to the idea, I have come to believe that self-regulation is a delusion, though it may sound good in a seminar or in a conference. In view of the fact that the media has become too powerful, if it does not conduct itself responsibly it can cause havoc beyond imagination. This underscores the need for external regulation of some kind. Since government regulation is out of the question and self-regulation is a mirage, an independent regulator is the obvious answer. While it is true that the MCC in requires self regulation by political parties, it works only because of its independent regulator, the Election Commission.

In this context, the News Broadcasters Association's great initiative to set up the National Broadcasting Standards Authority is laudable. The fact that they chose Justice J.S. Verma, the legendary former Chief Justice of India (now deceased) to head it, and appointed eight other independent members (including four from the media) showed its honest intentions. I was also appointed as a member in 2012 and found

the authority working with fierce autonomy and independence and its member media organizations accepting all our verdicts (even when against them) very gracefully. That is a self-regulation model I definitely vote for.

Conclusion

People's participation is the key to democracy and elections. Passive and un-informed citizens cannot form a vibrant democracy nor elect a good government. This makes the media a central player. Notwithstanding the aberration of paid news, the Indian media has been discharging its responsibility with spectacular effect. No wonder, then, that when the world admires the world's largest democracy, it speaks of free, fair and transparent elections, a fiercely independent judiciary and a free and vibrant media in the same breath. We need to protect and nurture this partnership with all we have at our command.

It is heart-warming to see an honest introspection on the role and conduct of the media among media persons themselves. The movement against paid news was launched by members of the media itself, like Prabhash Joshi and Kuldeep Nayar. It was taken forward by the Editors Guild, led by Rajdeep Sardesai, along with other media associations like the Indian Women's Press Corp and the Press Association of India.

Sevanti Ninan, media critic, and editor of the media watch website, The Hoot, in a column titled 'Election Coverage for Whom?' (*Mint*, 15 March 2012) wrote:

> Elections are such a wonderful, airtime-filling carnival for the media that they are unwilling to let go. After the swearing in ceremonies this week they finally had to call it a day, though the 'fourth front' speculation has become a new bandwagon to hop onto for a while. But meanwhile a little audit is in order, to see who gains what from the process.

It is difficult to imagine elections in say, the US, without a pivotal role for the media, television online or print. They air issues and publicise candidates for the benefit of voters who have to make up their minds. But what makes the recent elections* in Uttar Pradesh noteworthy is that the tireless coverage was largely for the benefit of those who were not going to the polls.

Did voters in UP make up their minds on the basis of what they saw and read? Did the candidates benefit? Saturation coverage did nothing in electoral terms for the candidate favoured: the outcome suggested the media was more smitten by the Gandhi charisma than the voters. And if the vote share analysis indicates that Mayawati held on to the Dalit vote, and Akhilesh Yadav crafted his victory principally through a ground strategy which included cycles, and no less than 800 rallies, it suggests that media coverage of the candidates and what they stood for could not have counted for that much. Mayawati does not depend on the media to reach her constituency, and Yadav's good-natured cracks after the results were in, suggested that he did not think he owed his victory to media coverage either.

How much of a role district editions of the Hindi newspapers played might hold part of the answer. The state's leading newspaper *Dainik Jagran* adopts a consistently oppositional stance to the UPA at the centre, and to the Congress party in UP. And to the extent that local corruption and crime are a staple in the daily district editions of several big papers here they must have helped make governance an issue. Unless there is more research that can only be a surmise.

Whom is the media supposed to be relevant to in an election? To the would-be voter in the state where it is

*UP Assembly Elections 2012

348 OF AN UNDOCUMENTED WONDER

being held? Or to people across the country watching the elections unfold? Do elections do more for media to fill airtime and garner advertisements than the media does for candidates or would-be voters? I suspect they do. Times Now did its best to milk the exit poll phase with minimum outlay. It promised a 100 per cent focus for a 100 hours, waited for other channels to present their exit polls and proceeded to analyse them. Vinod Mehta cheerfully describes in his Delhi Diary what he calls a bums-on-seat marathon with very little to go on besides the exit polls. Elections also do something, presumably, for the TV analysts who find it worth their while to spend extended hours—day after day in this case—having a theory swapping session which is broadcast to the nation.

But our redoubtable chief election commissioner has a more charitable view of what the media contributed. If voter turnout was the big triumph of the 2012 polls he is happy to give credit to local television and newspapers in the states which went to the polls for strengthening his hand. The Commission reached out to newspapers and television asking it to be a force multiplier in the campaign to bring women and youth out to the polling booths and they obliged generously, he says. Whether it was ETV, Zee TV, Hindi *Hindustan* or *Amar Ujala* they were enthusiastic in their public service messaging response, and did it pro-bono. Partly as a result of this the female voter turnout was 80 per cent more than it was five years ago. There was also another kind of media at work: women brand ambassadors for each state to help get voters out. Bhojpuri singer Malini Awasthi was appointed brand ambassador of UP State Election Commission and recorded videos that were extensively used. If media helped the turnout, we have to grant that it played a yeoman public service role.

S. Y. Quraishi is also clear that the Election Commission

relied substantially on the media to be its eyes and ears on the ground and the EC's foot soldiers were asked to take all reports seriously and follow them up. At the same time this was an election where paid news was hunted down and its perpetrators nabbed.

EMERGING CONCERNS IN ELECTORAL REFORMS

My Vote is for EC, Real Custodian of the Idea of India

When did you last hear that quaint phrase booth-capturing? If you haven't come across it even as elections are on in places like Uttar Pradesh, have you wondered why? The answer is quite simple. It is because of the

Election Commission (EC). It is an oasis of excellence in an otherwise muddied atmosphere simply because it is executing its constitutional mandate without fear or favour.

In the past, especially in the northern belt, it was de rigueur during elections for the henchmen of one or other neta to pop around to the booth during polling and cast the votes themselves or intimidate people into voting for the candidate of their choice. No longer. Such people have made themselves scarce thanks to a vigilant EC which has refused to be cowed down by any politician.

No sooner had Union Law Minister Salman Khurshid come up with the self-serving promise of 9% quota for minorities within the sub-quota for jobs in the state government were the Congress to come to power in UP, the EC opened up the heavy artillery forcing Khurshid to beat a hasty retreat. Similarly, when Robert Vadra decided to take out a showy motorcycle rally, the EC stopped him in his tracks on the grounds that the 100-strong cavalcade of motorcycles he was leading violated the 10-vehicle norm laid down by the EC.

The heartwarming message is that *the system works, irrespective of who is the chief election commissioner.* To his credit, it was the rough and ready T.N. Seshan who put the EC on the map. Of course, he spoilt it by his megalomania and his over the top appearances in advertisements chomping carrots and gabbling on about how he eats politicians for breakfast. He also blotted his copybook image by trying to join the very political system he so disdained after he demitted office.

But, his successors proved no less effective in bringing an errant political class to heel. The soft-spoken JM Lyngdoh was such a stickler for rules that he moved Gujarat Chief Minister Narendra Modi to refer to him in public rallies as James Michael Lyngdoh in a sly reference

to the fact that he is a Christian. In the narrow focus world of Hindutva, that means foreigner of the same ilk as Congress president Sonia Gandhi.

From the days of EC activism by Seshan, today the EC has become a well-oiled machine with the CEC SY Quraishi preferring to stay out of the spotlight and get on with the job. And very well at that. Yes, covering stone elephants and statues may be a little too excessive but the EC'S strength lies in playing by the book. And clearly, the message has gone home to the political class. Mayawati may be the unchallenged leader of the Dalits and the only man in her Cabinet but her remark on the EC is telling: '*Khula haathi lakh ka, dhaka haathi sava lakh ka*' (If an uncovered elephant is worth one lakh rupees, a covered elephant is worth 1.25 lakh rupees).

The EC has chosen to ignore that one.
Of course, during the tenure of successive CECs, some have been accused of being anti-national, casteist, anti-dalit, pro-ruling party and so on. But, today, the EC has perfected the art of letting the caravan move on and managing elections with very few glitches. So much so that other countries, including developed countries, are trying to study the Indian model.

But the lesson for me lies in what miracles can be wrought when you empower a person and his office and leave well alone. The EC in the past was somewhat like the Central Bureau of Investigation, perceived as yet another arm of the government. Today, such a charge would be laughed out of court.

Incorruptibility combined with efficiency has streamlined one of the biggest and most complicated electoral systems in the world.

I am not suggesting that the EC is beyond reproach. But in many ways, it has come to enjoy the credibility that the army once had. Seshan made the EC all about

his own larger-than-life personality. Perhaps that was required at that time to get the creaky election machinery moving. But where the EC has bucked the trend in so many of our personality driven institutions is in that it has *superseded the persona of the person who heads it.* Its work is carried forward by the thousands of people who endure considerable hardship to go to all corners of the country lugging their electronic voting machines to ensure that everyone gets to cast their vote. For me, this is what sustains my faith in democracy. *My vote is for the EC, the real custodian of the idea of India.*

Source: 'Democracy seems EC', *Hindustan Times*, 12 February 2012

History of Electoral Reforms

Legislative Changes

Over the years, the Election Commission has gone from strength to strength. Through a series of electoral reforms it has evolved into an institution that the whole nation swears by. Yet, there are still some areas of concern that need to be addressed.

Electoral reforms, a subject deliberated upon by a number of committees and commissions, became a popular issue in early 2011. In fact, one of the issues that team Anna raised time and again during their fourteen-day fast at Delhi's Ramlila Maidan was the need for urgent electoral reforms. On 23 February 2012, a team led by Anna Hazare and accompanied by his close associates—Santosh Hegde, Prashant Bhushan, Arvind Kejriwal and Kiran Bedi—visited the Election Commission with the express purpose of demanding electoral reforms, with special focus on barring candidates against whom courts have framed charges. We explained to them that most of the demands that they had raised were already pending with the government.

Over the years, laws governing elections have undergone

numerous amendments to meet the requirements of new challenges and changing situations. A path-breaking change in these laws was the lowering of age for enrolment as elector from twenty-one to eighteen years by a constitutional amendment in 1989. Various amendments made to the Representation of the People Act, 1951, have effected many other changes. Open ballot voting for elections to the Rajya Sabha and voting through proxy for voters in the armed and paramilitary forces were introduced by amending the act in 2003. A provision for enrolling overseas Indian citizens in electoral rolls was made in the most recent amendment in 2011. Introducing a provision empowering the Commission to use electronic voting machines, conferring disciplinary jurisdiction over officers (including police officers appointed for conducting elections) to the Commission—these reforms have all strengthened the EC and streamlined its functioning. Printed electoral rolls have now been substituted by computerized photo electoral rolls. An elector's photo identity card (EPIC) is by now a cherished possession of all citizens.

Judicial Support

The courts have also strengthened the hands of the Commission through their positive interpretation of the law and by supporting the Commission's powers and efforts. The first such landmark judgements came in 1952 (N.P. Ponnuswamy versus Returning Officer, Nammakkal) in which the Supreme Court ruled that the bar in the Constitution (Article 329B) against questioning elections except through election petitions post the elections removed the jurisdiction of courts to entertain challenges against any action taken by the Commission or its officers in conducting elections before the elections were completed. The Supreme Court made it clear that all challenges had to be postponed till the election process was over. This position was elaborated upon by the apex court in 1978 (Mohinder Singh Gill versus

Chief Election Commissioner and others), when it held that the bar against limitative challenges to electoral steps taken by the Commission and its officers was a blanket ban. In that judgement, the Supreme Court also dwelt at length on the provisions of Article 324 of the Constitution. A detailed reference to this has been made in Chapter 2, regarding the plenary powers of the Commission under that Article. The Supreme Court ruled that Article 324 is a reservoir of power for the Commission to deal with dynamic, unforeseen situations in the midst of the electoral process for which the law does not contain enough provisions.

In 1986, the Supreme Court upheld the constitutional validity of the Symbols Order 1968, notified by the Commission to provide recognition of political parties and the allotment of symbols. This amounted to establishing the ECI's power to make subordinate legislation. This position was reaffirmed in April 2012.

The other major court intervention to reform the election system was the Supreme Court judgement of 1995 (Common Cause versus the Union of India and others) in which the court directed that political parties had to file income tax returns, and that the Election Commission, under Article 324, could ask parties to submit their election expense accounts to it for scrutiny. Since then, the Election Commission has been obtaining detailed election expenses of recognized political parties for all general elections to the Lok Sabha and elections to legislative assemblies. These details are put in the public domain through the Commission's website. In 2003, the Supreme Court passed another landmark judgement, ruling that electors have the right to know the backgrounds of candidates contesting elections to enable them to make an informed choice. In pursuance of this judgement, the Election Commission issued an order prescribing a format in which the candidates have to file affidavits about their criminal antecedents, assets, liabilities and educational qualifications. The information given in the affidavits is widely

356 of AN UNDOCUMENTED WONDER

disseminated at the constituency level and through the EC's website.

It was the Supreme Court again that, in 1993, directed the central government to have a consultative mechanism with the Commission for providing central police forces to the Commission for deployment during the election process. The central forces infuse more confidence among electors, candidates and political parties in the opposition.

Election Commission's Innovative Steps

The Election Commission has always been alive to the demands of changing times and the need to meet the requirements of free and fair elections. This began with the evolution of the MCC. The Commission has supplemented the MCC with instructions issued from time to time, all intended to facilitate and enforce compliance with the spirit of the Code.

Laws governing elections did not make any provisions for registration and recognition of political parties, nor for allotment of symbols to them. It was the Commission that took the initiative, before the first general elections in 1951–52, to recognize political parties and to allot symbols to them. Later, in 1968, the Commission issued the Election Symbols (Reservation and Allotment) Order 1968, as a consolidated set of instructions to govern recognition of political parties as national and state parties and for allotting reserved symbols to recognized parties and candidates.

In the late 1970s, the Election Commission started exploring the possibilities of polling through voting machines. In 1982, the Commission experimented with the voting machines in a part of a constituency in Kerala in the assembly elections there. Gradually, voting machines became the norm, and from 2000 onwards, all elections to the Lok Sabha and the legislative assemblies have been conducted using voting machines.

Towards the end of the 1990s, the Commission computerized

the electoral rolls for all constituencies. Later, to increase transparency in preparing electoral rolls and to allow for closer participation by political parties in this exercise, the Commission introduced the concept of Booth Level Agents (BLAs) for each polling station. Every recognized party can appoint a BLA for each polling station; the BLA not only interacts with the BLO regularly to improve the quality of the rolls, but can also be a great check on BLOs acting partisan.

In 1993, to prevent bogus voting by impersonation, the Commission passed an order to issue electoral photo identity cards to electors in all constituencies. Identification has been insisted upon at all elections from 2000 onwards.

From the 1990s onwards, the Commission has used central election observers to check electoral malpractices including booth capturing. This period also saw the deployment of central police forces to help conduct fair and peaceful elections. In recent years, the Commission has introduced other tools such as videography, CCTVs and posting of micro-observers at sensitive polling stations. More transparency measures in the handling of voting machines and counting of votes have also been introduced in recent times.

Emerging Concerns

Despite the improvements in electoral laws and procedures brought about by Parliamentary initiatives, judicial interventions and the EC's own proactive innovations, there are several areas regarding which the people, civil society organizations, NGOs, social activists and political parties are concerned and are demanding expeditious and urgent reforms.

Broadly, there are three sets of reforms proposed: (1) those that will reinforce the independence of the Election Commission; (2) those that will help cleanse politics; and (3) those that will make the working of political parties more transparent.

Reinforcing the Independence of the Election Commission of India

The quality of elections is largely dependent on the quality of incumbents of the Election Commission. The CEC and two ECs are appointed by the President, as per the advice of the Cabinet. There is no qualification prescribed under the Constitution or any law for any of these three posts. By convention, these offices have gone to senior civil servants largely because of their extensive experience of conducting elections at various levels. Once appointed, the CEC cannot be removed from office except (as in the case of a judge of the Supreme Court) through a process of impeachment by Parliament. This is a constitutional mechanism to insulate the CEC from intimidation and pressures from the Executive. The two ECs, however, do not enjoy the same protection as the CEC. The constitutional provision in their case is that 'they cannot be removed from office except on the recommendation of the Chief Election Commissioner'. This ensures that the executive alone cannot remove an Election Commissioner. The CEC has to agree to this removal.

Notwithstanding such constitutional protection against removal from office, the fact that the government appoints the CEC and the ECs could in itself be a reason to suspect the neutrality of the incumbents. There have been suggestions from various quarters including those from some former CECs that the appointment to this very important office should be based on wider consultations with an electoral college that includes the leader of the opposition.

In the Constituent Assembly, too, there was a suggestion that the appointment of the CEC and ECs should be subject to approval by Parliament. Much later, in 1990, the Dinesh Goswami Committee recommended in its report on electoral reforms that the appointment of the CEC should be made by the President in consultation with the Chief Justice of India and the leader of the opposition in the Lok Sabha. A bill was

also introduced in the Rajya Sabha that year, proposing the amendment that the CEC should be appointed by the President in consultation with the Chairman of the Rajya Sabha, Speaker of the Lok Sabha and the leader of the opposition in the Lok Sabha. This bill was, however, withdrawn in 1993, without assigning any reason.

The appointment of the CEC following a wider consultation process is bound to make the institution stronger, and also make incumbents to the offices of CEC and EC feel more confident about their acceptability. However, by no means is this intended to suggest any credibility crisis in the organization. Indeed, it goes to the credit of the persons who have occupied the post and the way they have conducted themselves, as well as to the stakeholders (primarily political leaders and the public at large), that the Election Commission has always been looked upon with great trust and respect, and the Commission has consistently proved itself worthy of this trust.

Process of Removal

Moreover, just changing the process of appointing the CEC and ECs is not sufficient, to ensure the independence of the Election Commission. For achieving its independence and complete insulation from Executive interference, it is equally necessary that their removal from office remains independent of the whims and fancies of the government of the day.

No doubt, the government has not committed such an indiscretion in the six decades of the Commission's existence. As discussed above, the CEC's post is protected by the makers of the Constitution, and he can only be removed from office by impeachment. But what remains is to provide similar protection to the other ECs. Although they cannot be removed except on the recommendation of the CEC, this limited protection is insufficient—they should also be given the same constitutional protection as the CEC. Unless the whole Commission is insulated from Executive pressures, it is always possible that

the Commissioners might feel as if they were on probation and, at least theoretically, might be tempted to tow the government line and outvote an inconvenient CEC by a 2:1 majority, thus rendering him ineffective. Equally, the Commissioners should not feel threatened by the CEC.

Since the inception of the multi-member Commission in 1993, the appointment of the CEC has always been by seniority. The sole instance of an effort by the government to break this convention occurred in 2003, when there was a hush-hush proposal to bring the then Cabinet Secretary as CEC. In protest, the two Election Commissioners, T.S. Krishna Murthy and B.B. Tandon, threatened to resign; and the effort to supplant the CEC was abandoned post-haste. However, in the absence of any law to elevate the seniormost EC as CEC, some uncertainty continues to exist. Recently, this issue has been revived in political circles, and now there is talk of a collegium to select the CEC. While a collegium is a good idea, it should apply only at the entry level, when a new EC is selected. The elevation to the position of CEC must remain strictly by seniority, as in the case of the Chief Justice of the Supreme Court. However, it would be useful to make the outgoing CEC one of the members of the collegium formed to appoint new commissioners, as no one knows the job requirements of an EC better than a former EC himself.

More Powers to the ECI

It is now well established that the Election Commission has plenary powers under the Constitution to take all necessary action to discharge its constitutional obligations of conducting free and fair elections. However, in areas 'occupied' by legislation (where a law has been framed), the Commission has to go by the provisions of the law. And at least a few provisions in the law need modification to further enhance the credibility of elections.

For example, let us examine the question of officials and police personnel deputed to the Commission. The law vests the Commission with total control over these men and women, who are indeed integral to conducting elections. However, there are cases where a political party is upset with the conduct of upright officials, especially when their unbiased approach and scrupulous implementation of the law hurts the interests of the party and its candidates. Now, while these officers enjoy the protection of the Commission during the elections, they are left to the mercy of the party afterwards. This problem becomes acute if the injured party or candidate comes to power and chooses to be vindictive towards officers who stopped their electoral malpractices. Lok Sabha elections and all bye-elections become especially tough for state officials on election duty as they are sandwiched between ECI on the one hand, which expects them to be tough, and the ruling dispensation of the state on the other, which expects them to be soft. Similarly, corrupt or pliable officers who are soft on the ruling party may be suitably dealt with by the Commission during the elections, but post elections, once the Commission's jurisdiction ends, the party rewards them.

To deal with this problem, the Commission has recommended that there should be legal provisions banning the transfer of election officials for six months before the date of elections without consulting the EC. Even after the elections, officers may need protection for some time, say a year. If any disciplinary action is contemplated against any officer by the government, consultations with the Election Commission should be made mandatory. This will provide a sense of security to upright officers.

Two more reforms that are needed to enhance the EC's independence are: (a) the Commission's budget should come directly from the Consolidated Fund of India, as in the case of the CAG and the Supreme Court; and (b) an independent secretariat on the model of the secretariats of the Rajya Sabha,

the Lok Sabha and Supreme Court Registry should be appointed for the Commission.

Even if some of these changes make little material difference immediately, as the Commission, in any case, does not succumb to influence from the Executive and no point of confrontation between the two has arisen so far, these changes will be of great symbolic value in public perception.

Cleansing Politics

Criminalization of Politics

For too long, contestants have resorted to muscle and money power to win elections. Every political party and most candidates are potentially involved in this evil practice, except that the extent of the damage is less in some parts of the country, where such tactics are known to be less effective. Candidates and parties would initially resort to using criminals to intimidate electors and even officials. There are pockets in the country where electors were subjected to intimidation and, for decades, could not dare venture anywhere near a polling booth. Then, over time, the criminal elements used for intimidation realized that they were contributing to the victory of others, and began entering the electoral fray themselves.

The law (Section 8 of the 1951 Act) disqualifies anyone who has been convicted of a crime and sentenced to imprisonment of two years or more from contesting elections. For certain specified offences, even conviction without sentence of imprisonment invites a ban on contesting election. This restriction would be acceptable our courts conducted trials and issued verdicts in reasonable periods of time. Unfortunately, our legal procedure being painfully slow, the completion of a trial in criminal cases takes long years, and persons facing trial for very serious offences often continue to contest elections and even win in many cases, even after the court has framed

charges. This has led to an embarrassing situation where we have several persons with serious criminal cases against them occupying membership of our legislative houses. Thus, law breakers become law makers.

Moreover, if a person already elected Member of Parliament or member of any state legislature is convicted during the period of his membership, the law (Section 8-4 of the 1951 Act) protects his membership. All he has to do is to file an appeal against the conviction order. His membership is then automatically protected for the duration of the House. During this period, the convicted member continues to be a law maker.

The Supreme Court Judgement: Lily Thomas

In a landmark judgement in 2013 (Lily Thomas vs Union of India and others), the Supreme Court declared Sec 8-4 of the Representation of the People Act, 1951, as ultra vires of the Constitution, as it violates the fundamental right of equality of all citizens. Consequently, the protection from disqualification from contesting that the legislators have been enjoying despite conviction withdrawn, stands.

Supreme Court ADR Judgement, May 2002

In response to such rampant criminalization of politics, the Judiciary came up with a milestone judgement. On 2 November 2000, regarding a writ petition (No. 7257 of 1994) filed by the Association for Democratic Reforms (ADR), the Delhi High Court ordered that the Election Commission must provide voters with information about the criminal antecedents of candidates, assets possessed by them and any other facts giving insight into their competence and suitability, so that electors could make an informed choice regarding their representatives. The Union of India took the matter to the Supreme Court in appeal.

The Supreme Court (Union of India vs ADR dated 2 May 2002) affirmed the High Court's order, directing the Election

Commission to issue orders requiring all candidates standing for elections to Parliament and state legislatures to furnish information about their involvement, if any, in criminal offences, their assets (including those of their spouses and dependents), their liabilities towards public financial institutions and government dues and their educational qualifications. Following this judgement, the Election Commission issued an order on 28 June 2002, prescribing a format in which candidates standing for all elections were to furnish this information. This prompted Parliament to amend the 1951 Act on 24 August 2002, inserting two new sections (33A and 33B) to stipulate that candidates shall give information only on cases in which charges have been framed for offences punishable with imprisonment of two years or more and cases of conviction with sentence of imprisonment of one year or more, and that candidates were not liable to disclose any other information notwithstanding any court order or directions of the Election Commission.

At this, the ADR and PUCL again moved the Supreme Court, contending that the amendments to the law were intended to defeat the disclosure requirements ordered by the Supreme Court and followed by the Election Commission. In its judgement of 13 March 2003, the Supreme Court struck down Section 33B, which said that candidates were not required to furnish any information other than what was required to be furnished under the amended law. The court reiterated that information on *all* pending cases, assets, liabilities and educational qualifications had to be furnished by the candidates, and directed the Commission to issue a fresh order in this regard. Accordingly, the Election Commission issued an order on 27 March 2003, prescribing a format in which candidates were to furnish the requisite information. As of now, candidates standing for all elections must disclose this information and the Commission ensures that it is disseminated as widely as possible so that people know who they are voting for.

Tainted MPs in Lok Sabha

An analysis by ADR of the information furnished by candidates in the 2009 elections to the Lok Sabha showed that 162 of the 8,070 candidates had at least one pending case, and 76 of these cases involved a serious offence. (These figures had risen from 128 and 58, respectively, in the 2004 general elections.) The total *number* of criminal cases against the 162 MPs elected in 2009 was 522, which shows that many of them were involved in multiple offences.

Concerned about the criminalization of politics, the Election Commission had sent a proposal to the government in 1998 to debar a person facing charges for serious offences from contesting elections. Many political parties opposed this proposal on the ground that false criminal cases might be filed by opponents, and that some criminal charges might stem from legitimate political opposition. Ruling parties could use this instrument to deny them electoral victory; that is, if you cannot defeat your opponent politically, get them disqualified by involving them in false cases. This concern is legitimate. However, the EC had offered three safeguards: (1) Not all criminal cases would lead to a bar on contesting, but only heinous offences like murder, dacoity, rape, kidnapping or moral turpitude; (2) To be considered, a case would have to have been registered at least six months before the elections; and (3) The court should have framed the charges.

The Commission's proposal was that if the court had framed charges against an accused person for an offence punishable with imprisonment for a term of five years or more, he should not be allowed to enter the election fray unless and until acquitted of the charges. The proposal was based on the proposition that framing charges would mean that the court, an independent authority, had arrived at the conclusion that there was a prima facie case against the accused person. In such circumstances, keeping the person away from contesting elections would be a

reasonable restriction in larger public interest. Those opposed to the proposal argued that the jurisprudence followed in India is that a person is deemed innocent until proved guilty.

I have a counter point to this argument. About two-thirds of the people lodged in jails are under-trials, unconvicted, and are therefore 'innocent'. Yet they are locked up in jails, denied their fundamental rights to liberty, freedom of movement, freedom of occupation and right to dignity. If the fundamental rights of an under-trial can be suspended, what is the fuss about temporarily suspending the right to contest elections, which, incidentally, is only a statutory right?

The EC is not alone in making these recommendations. In 1999, the Law Commission, in its 170th report[1] also recommended disqualification from contesting elections for a certain period upon framing of charges for serious offences. The National Commission for Review of the Working of the Constitution, too, in its report submitted in 2002, recommended disqualification on framing of charges with the rider that disqualification may commence after one year of framing charges. It went even further to recommend that conviction for heinous crimes like murder, rape, smuggling or dacoity should attract lifelong disqualification from contesting for political office.

It is really disappointing that the government and Parliament are dragging their feet on such an important measure to cleanse our electoral system and remove the blot on our august Houses of Parliament and state legislatures. Besides, such a reform will take the sting out of activists' attack on politicians, which tends to paint them all black.

Enhancing the Transparency of Political Parties

Transparency in the working of political parties is critical for the success of democracy. This issue is, therefore, high on the EC's electoral reform agenda.

Issue of Registration and De-registration of Political Parties

Political parties are registered with the Election Commission under statutory provisions in the Representation of the People Act, 1951. Section 29A, inserted in 1989, gives the broad framework for registration of an association or group of Indian citizens as a political party. An association seeking registration as a political party is required to move an application before the Election Commission within thirty days of its formation. It is interesting to note that before 1989 the term 'political parties' was not used in any law.

However, before this matter was brought into the statute books, the Election Commission had put in place a regime of formal guidelines for registration of political parties. This was in the Election Symbols (Reservation and Allotment) Order 1968, an order promulgated by the Election Commission in exercise of its plenary powers under Article 324 of the Constitution of India, to provide for registration and recognition of political parties, allotment of election symbols and resolution of disputes within recognized political parties. These were areas not covered by the statute at that point, and hence the need for an order by the Commission to fill the vacuum. The Supreme Court repeatedly upheld the constitutional validity of the EC's order in 1971, 1977, 1986 and again in a recent judgement in April 2012. Following the amendment of 1989, that is, inserting Section 29A in the 1951 Act, the Election Commission deleted the registration provisions from the symbols order.

One of the statutory requirements for a valid application for registration as a political party under Section 29A is that the constitution of the party should contain, among other details, an undertaking of allegiance to the Constitution of India and to the principles of socialism, secularism and democracy, and to uphold the unity, sovereignty and integrity of India.

Although political parties bind themselves to follow constitutional provisions and the principles of democracy,

etc., through an undertaking in their constitutions, at the time of registration, there are no legal provisions that enable the Commission to take punitive action against them or to withdraw their registrations in case of violation of such an understanding. In an appeal on the issue of cancellation of registration of political parties in cases of violation of constitutional provisions, the Supreme Court* held that the decision of registering a political party by the Election Commission is a quasi-judicial one, and in the absence of express provisions in law for de-registration, the Election Commission cannot de-register a party on complaints of its having violated its own undertaking. In a way, this is a rare case where the Supreme Court upheld a narrow interpretation of the EC's power to register a political party and thus actually restricted the EC's power to hold a political party accountable, thus making it toothless. Meanwhile, the Commission's recommendation to the government to amend the law, empowering the Commission to regulate registration as well as de-registration of political parties and their internal functioning as per their own constitutions, is languishing in government files.

Inner Party Democracy

Having undertaken to abide by the principles of democracy, secularism, etc., political parties are bound to observe democratic principles in their functioning. This implies a commitment to democratic processes in their decision-making, and more importantly, in intra-party elections to various offices and committees of the party at prescribed intervals. Though the period varies from party to party, most parties give three-year terms to their office bearers.

In 1996, the Election Commission conducted a review of intra-party elections among recognized parties and found many remiss on this score. The Commission sent notices to parties

*INC (I) vs Institute of Social Welfare (10/5/2002)

and directed them to complete their organizational elections within a timeline. From then on, the Commission has been monitoring the holding of internal elections in about fifty recognized national and state parties. In case a political party is not able to conduct its elections in time for any reasons, it approaches the Commission for an extension, explaining its reasons for the same. The Commission, while agreeing to extend the time, binds the party to abide by the extended limit.

However, the Election Commission does not oversee the internal electoral process in parties. It is expected that an institution as important as a political party in a democracy will have credible internal elections. Unfortunately, the general public perception is that elections in political parties are far from free and democratic. Although there are provisions in the parties' constitutions to deal with grievances, it is doubtful whether such complaints are adequately addressed in any meaningful manner.

The Commission's proposal of empowering it to regulate the internal functioning of political parties, if accepted, will go a long way in ensuring that parties faithfully abide by their own undertaking at the time of registration with the Election Commission. If not, they will risk losing their registrations.

Transparency in the Accounts of Political Parties

Existing laws fix a ceiling on election expenses for individual candidates, but political parties are free to spend as much as they like on their overall propaganda as well as on election campaigns for their candidates. How they raise funds and spend them is also unregulated, nor are their accounts in the public domain.

In order to bring transparency to political finances, the Commission has proposed that the accounts of political parties should be audited by chartered accountants from a list specified by the Election Commission (as detailed in Chapter 10). Further,

these audited accounts should be displayed on the EC's website and also on the party's own website, if any.

Problem of Dummy Candidates

An occasional phenomenon vitiating the electoral process is dummy candidates. A dummy candidate may be defined as a candidate who contests an election with no intention of winning. He is non-serious and stands for an election simply to influence the share of votes among genuine candidates or to take advantage of benefits given to candidates. Some dummy candidates are set up by 'rival' candidates so that they get more poll agents in polling stations and counting centres to influence the polling process, and often to circumvent the ceiling on expenditure. This is what happened in 2012 in the Kadappa constituency of Andhra Pradesh. The Election Commission declared eleven independent candidates in the Kadappa Lok Sabha constituency as 'dummy candidates' and withdrew all the privileges given to them. Of the eleven, the EC issued notices to seven. Three were found to be campaigning for Y.S. Jaganmohan Reddy of the YSR Congress party, while two others were supporting the Indian National Congress candidate D.L. Ravindra Reddy. The EC served show cause notices to both Jaganmohan and Ravindra Reddy, asking them why the expenditure incurred by these independent candidates should not be treated as their expenditure.

Dummy candidates can also be dormant candidates willing to withdraw from the electoral contest, often for a consideration, but remaining listed in the ballot. Yet another purpose of dummy candidates is to confuse voters by setting up candidates with similar names. In the elections to the Hisar parliamentary constituency in Haryana (2011), there were thirty-one independent candidates of which five, including the main candidate Kuldeep Bishnoi, had similar names. Fortunately, the other four 'Kuldeeps' could not confuse voters and had an average voting share of 801 only. All the twenty-seven

independent candidates polled 2,192 votes each on average, whereas the main winning candidate polled 3,55,955 votes. It is obvious that such candidates are mostly non-serious or motivated by other considerations. Once caught, dummy candidates are deprived of privileges like vehicles, nominating agents in polling booths and permission to be present at counting stations.

Right to Reject

Of late there have been proposals from social activists led by Anna Hazare seeking the right to reject all the candidates should an elector find none worthy of her or his vote. The activists did not spell out details of the exact proposal or procedure to be followed for this. The right to reject could either mean that the electors have the option of not voting for any candidates, or of nullifying the entire panel of candidates, if the reject vote exceeds the votes secured by any candidate.

The first option, of a neutral vote ('none of the above'), would mean that the candidate who gets the most votes is declared the winner, irrespective of the number of neutral votes. In such a case, the neutral vote will effectively amount to a 'no vote' (equivalent to a blank ballot) without any implication on the election of a candidate. The number of neutral votes will at best be an indicator of the extent of the elected candidate's unpopularity, which may be seen as a sort of stigma. This might put pressure on parties to nominate more acceptable candidates and force candidates to reach out to a larger section of electors.

The other interpretation of 'right to reject' would be that electors have the right to reject the whole panel of candidates. This would happen if the number of electors exercising the reject option exceeds the number of votes polled by any candidate in the panel. Such a provision would result in rejecting all the candidates on the panel and forcing a re-election with a fresh list of candidates. This is bound to raise several issues:

- If a panel of candidates is rejected by virtue of the rejection votes exceeding the votes secured by any one candidate, the question arises whether all candidates in the panel will be disqualified from contesting in the re-election.
- If they are not disqualified, the same set of candidates may contest again, which would defeat the purpose.
- If they are to be disqualified, then for how long? Would they be free to contest from other constituencies in the event of re-elections in other places? Or in a subsequent election? It would defy logic if they were prohibited from contesting in other constituencies since electors elsewhere might have a totally different view about the capabilities of those candidates.
- In a re-election, there could be cases where the electors find the new list of candidates worse than the original list. If the candidates in the re-election are also rejected, for how long can we go on conducting elections? Already, there are complaints of 'election fatigue' with frequent elections and bye-elections at the local, assembly and parliamentary levels.
- The Election Commission uses government officials, PSU staff, bank employees and school and college teachers for conducting elections. Re-elections will mean keeping these officials away from their normal duties for long periods, which will affect their regular work and adversely affect the interests of the public, particularly the student community, as school buildings used for polling stations will remain locked for long periods.
- Central police forces will remain occupied for longer periods in re-elections, jeopardizing security at critical places including international borders.
- Re-elections will burden the public exchequer and political parties.
- Conducting elections in difficult areas like those affected by Maoist extremism is already fraught with serious threats to the lives of voters and candidates besides polling staff and

security personnel. Repeated elections in these areas will compound the risks. And yet, we cannot have a different rule for such areas.

- The Model Code of Conduct remains in force till the completion of elections. Rejection of candidates and re-elections will result in the Model Code being in force for long periods. This will have an adverse effect on governance, especially with regard to the implementation of new schemes and development projects.

- Frequent elections at short intervals may lead to disinterest and apathy among electors. In a re-election, the turnout may be less than in the original election. There could well be cases where a candidate in a re-election gets less votes than some candidates from the rejected panel, and yet gets elected. Such anomalous situations can only be counter-productive.

- In worst-case situations, re-elections may also lead to political instability, if the number of such cases is large and particularly in the event of a hung House.

'None of the above' (NOTA) Option

One practicable way in which the right to reject could be operationalized is through a 'none of the above' (NOTA) option on EVM machines. A NOTA option is a facility that allows voters to express their rejection of all candidates in a constituency. Rule 49-O of the Conduct of Elections Rules 1961 (and not Article 49 of the Constitution of India, as the campaigners for the right to reject have been saying) provides that if an elector, after her/his identification and affixing of signature in the register of voters at a polling station, decides not to vote, the officer-in-charge of that register, on being informed by the elector of his decision not to vote, records a remark to that effect in the register of voters, and the signature or

thumb impression of the elector concerned is taken against that remark. The voter can then leave the polling station without voting for any candidate.

Although the intention of this rule is positive, the downside is that it violates the secrecy of the elector's ballot, since his decision not to vote must be declared before all those present in the polling station, which includes the candidates' agents. For this reason, many electors may not like to exercise the option under the existing rule.

Before the introduction of EVMs in 1998, voters wanting to exercise the option of non-voting in secrecy would simply put a blank ballot paper in the ballot box. Some deliberately spoiled the ballot by stamping it at more than one place to make it invalid. Interestingly, many just wrote *sab chor hain* (they are all thieves) on the ballot. All these amounted to invalid votes. They were counted but did not impact the result.

After the introduction of EVMs, 'non-voting' lost its secrecy since the press of a button is accompanied by a loud beep. No beep would mean that everyone would know the voter had not voted. This not only violated his secrecy but jeopardized his safety against reprisal.

The secrecy principle is integral to free and fair elections. Whether a voter decides to cast his vote or not his secrecy must be maintained.

The Election Commission, therefore, made a proposal to the government as far back as December 2001, that an appropriate provision should be made in the rules that EVMs should have a panel (or button) below the last contesting candidate marked 'none of the above', for electors to exercise the option of not voting for any candidate.

The NOTA Judgement

The 2013 Supreme Court judgement on the long pending question of the right to reject created great stir and excitement. Most people thought that the right to reject had been granted,

and were disappointed to find that their joy was unfounded. However, this was indeed a landmark judgement. The Supreme Court asserted that just as the people have the right to express their preference for a particular candidate, they also have a right to express their negative opinion. This can be exercised through an extra button on the EVM marked NOTA. The Supreme Court directed the Election Commission to introduce such a button on EVMs.

The court's order came in response to a writ petition filed by PUCL in 2004, under Article 32 of the Constitution of India, questioning the constitutional validity of the Conduct of Election Rules 41 (2 and 3) and 49-O as these violate the secrecy of a voter's ballot, as explained above. It also requested the court to direct the Election Commission to introduce the NOTA provision on EVMs (and ballot papers). Interestingly, the Election Commission itself had demanded such an option through an amendment of the act as early as 2001. Irked by the government's inaction, PUCL chose to go to the apex court.

What will be the effect of this innovation? Will it mean that all the candidates in a constituency stand rejected/ defeated if the NOTA votes exceed those polled for any of the candidates? The answer is a clear 'No'. To illustrate, even if 99 out of 100 votes go to NOTA, and candidate X gets just one vote, X is the winner, having obtained the only *valid* vote. All the other 99 will be treated as invalid or 'no votes'.

The question then arises, why did the Election Commission ask for this option? The Election Commission did not want to create the right to reject; it wanted merely to ensure secrecy to any voter wanting to do what amounts to abstention from voting, and also to ensure that nobody casts a bogus vote in such a voter's place by impersonation. Both these requirements have been met by the Supreme Court order.

So, what happened to the demand for the right to reject? The fact is that the demand did not exist in the PUCL writ petition! However, the Supreme Court's order did remark that

a high number of NOTA votes would put pressure on political parties to nominate only good candidates and not dubious or tainted ones.

Significantly, therefore, the apex court upheld the concept of 'negative voting':

> A voter may refrain from voting for several reasons including the reason that he does not consider any of the candidates worthy of his vote. One of the ways of such expression may be to abstain from voting by not turning up at all which is not an ideal option for a conscientious and responsible citizen. Thus, the only way by which it may be made effectual is by providing a button in the EVMs to express that right. This is the basic requirement if the lasting values in a healthy democracy have to be sustained, which the Election Commission has not only recognised but also asserted.

It is significant that the Supreme Court has gone to the extent of raising the right of negative voting to the status of a fundamental right! 'Not allowing a person to cast vote negatively,' it says, 'defeats the very freedom of expression and the right ensured in Article 21 i.e. the right to liberty.'

Elaborating on the need for this right, it says:

> For democracy to survive, it is essential that the best available men should be chosen as people's representatives for proper governance of the country. This can be best achieved through men of ethical and moral values, who win the election on a positive vote. Thus, in a vibrant democracy, the voter must be given an opportunity to choose none of the above (NOTA) button, which will indeed compel the political parties to nominate a sound candidate. This situation palpably tells us the dire need of negative voting.

The court also observed that the NOTA provision was being

used in several countries like France, Belgium, Brazil, Chile and Bangladesh.

My personal feeling, though, is that expecting moral pressure to work on political parties is being far too optimistic in view of their stubborn refusal to debar tainted candidates from contesting, despite public hue and cry on the matter for two decades.

Right to Recall

Right to recall is another electoral reform demanded by Anna Hazare. In essence, right to recall is a provision and mechanism for voters to un-elect and unseat an elected MP or MLA by following the recall process. As an electoral device, it allows voters to petition for the removal of a MLA or MP from office before the end of his term. It thus curtails the elected representative's fixed term of office. The compelling rationale for a recall mechanism is the voters' belief that errant, non-performing MPs or MLAs should be withdrawn from the House for having lost the confidence of their electorate.

Under the present Indian law, an MP (Lok Sabha) or an MLA (Vidhan Sabha) has a fixed tenure of office for five years (except in J&K where a MLA has a six-year term). Articles 102 and 191 of the Constitution of India specify situations and contingencies in which a person shall be disqualified for being a Member of Parliament or Legislative Assembly. For instance, he will lose membership if validly disqualified under the anti-defection law in the Tenth Schedule of the Constitution; or if he is declared of unsound mind by a competent court; or if he is found to be occupying an office of profit.

At present, however, there is no provision in the Indian Constitution or in the Representation of the People Act, 1951 for the recall of a duly elected member of an assembly or Parliament. Any proposal for a 'right to recall legislation will raise several important issues', according to Soli Sorabjee, former Attorney General of India. The questions raised by

Sorabjee and others are:

1. Who should be vested with the power of recall?
2. If the power of recall is to be vested in the voters of a member's constituency, what should be the number of registered voters who can sign the recall petition?
3. Can the voters who did not vote for the elected candidate, or those who did not participate in the elections at all, demand his/her recall?
4. If confined to the numbers that had voted, what should be the minimum number of signatures required?
5. Will there be a minimum period before which the option cannot be exercised? Otherwise, there is a very strong possibility that defeated candidates will resort to the tool immediately after they lose an election. In such a scenario, elected representative will not even get the time to settle down before they are removed from office!
6. Will the recall petition first be put to test by holding a referendum, and if the petitioners succeed in such referendum, will a a bye-election be held?
7. Can there be repeated petitions for recall, leading to election after election?
8. Will such repeated referenda and elections not affect normal development activities, because of repeated impositions of the Model Code of Conduct and the political executive getting busy with the elections? Also, will it not be a big financial burden on the public exchequer, candidates and political parties?
9. Can the elected representative who is recalled contest the bye-election from that constituency or any other constituency, and if not for what period will he be disqualified?
10. How will the losers be stopped from sponsoring a motivated recall campaign immediately following an election, simply to overturn or nullify the results of the election?
11. How will the money power of defeated candidates who

might instigate a recall be neutralized?

12. Should the recall petition specify the form of misconduct or non-performance or unsatisfactory performance as a ground for recall?

13. Can corruption and disproportionate asset accumulation be a factor for recall?

14. Can these include irregular attendance, lack of punctuality, sleeping during parliamentary proceedings, not having made a single intervention or asked a question during the entire session, disobeying parliamentary norms and procedures, not visiting the constituency once in six months after being elected, etc.?

15. Should a member be unseated merely on the basis of the number of signatories to the petition?

It is also noteworthy that the right to recall will involve not one but two elections: first, by way of a referendum on whether the existing representative should be recalled; and, second, the bye-election that will follow. Let it be clear that the logistics for the referendum will be the same as those for an election.

Recall provisions exist in a handful of countries, each with different procedures to effect a recall. Even where it exists, though, instances of its use are rare.

In Canada, under the Recall and Initiative Act, 1995, the minimum requirement for recall are signatures of 40 per cent of voters. Further, the BC (British Columbia) Act within the country stipulates that members cannot be subject to recall during the first eighteen months after election, in order to give the elected MPs reasonable time to demonstrate their performance. A voter can apply for a petition to recall an MP/MLA with a processing fee. The application also has to include a statement in two hundred words on why, in the opinion of the concerned voter, the member should be recalled.

The recall legislation in Canada has led to a series of

problems and also legal proceedings and problems. For instance, in March 1998, the BC Civil Liberties Association filed a constitutional challenge in the British Columbia Supreme Court on this issue. The group asserted that the recall legislation infringed a citizen's right to vote under Section 3 of the Charter of Rights and Freedoms because a recall petition is not a secret ballot and the votes of those not signing a petition are not counted. However, the challenge was withdrawn in June 1999. The association reconsidered a legal challenge in May 2003, but ruled it out because of limited resources

—Soli Sorabjee, *Hindustan Times*, 11 September 2011.

While some countries may have a full or partial right to recall, a little known fact is that even India has this right in some states at the panchayat level. The *Hindustan Times* surveyed the experience in some of these states (3 September 2011). The report is interesting because even at that small level, where there are only a few hundred voters, the experience is far from happy.

Some election experts say that the right to recall is fraught with serious consequences. A recall provision may add to the instability of governments by empowering not those who win elections, but those who lose. Losing candidates and parties are likely to adopt an opportunistic approach to unseat elected members on flimsy grounds and through dubious methods. Besides, a member elected to every House in the country already has a fixed term. Triggering a recall without waiting for the term to end may not be the best solution to the problem of non-performance. This may prove to be a case of the remedy being worse than the disease. Legislators will be wary of taking tough decisions on contentious issues for fear of reprisal and the threat of recall. They will be under constant pressure to take populist decisions. Good governance will be the ultimate casualty, which no well meaning citizen would desire.

A related issue, as Sorabjee points out, is whether the

concerned MP or MLA should not be given an opportunity in keeping with the principles of natural justice to deal with the specified grounds in the recall petition. The other question is, who will decide whether the alleged grounds in the recall petition are justified or not: civil courts or the Election Commission or some other authority? Similarly, if there are over a million voters in a constituency and 20 per cent have to sign the recall petition, who will verify these large numbers of signatures? We have often come across cases when the EC has been approached by two factions of a political party claiming to be the real party with the other just being a pretender. Both factions present signatures of their members, claiming that the signatures provided by the other faction are bogus. In all these cases, the number of signatures was never more than two or three hundred, but it was still a harrowing experience to examine the signatures for their genuineness. There could be demands for a forensic examination as well. In any case, it will be a time consuming and unrealistic exercise.

There is another dimension to be considered. If an MP wins by getting, say, half a million votes, these voters also have a right to their verdict allowing their elected representative staying in office for the stipulated term. How can their right be supplanted? How many detractors can supplant this? Five, ten or twenty thousand? How can twenty or even fifty thousand supplant the verdict of half a million?

Another objection to the recall provision is that it subjects an elected member to the supervision and control of his constituency, which would also include his opponents. That will impair the spirit of free and independent discharge of his functions in keeping with his conscience and common sense. There is also a danger of the electorate being emotionally carried away by the frenzy of a contemporary, inflammable popular issue. It will not be desirable to subject an elected member to the changing mood and temper of the electorate. Above all, it must be remembered that if a member is recalled, there has to be a bye-election in

his constituency. The country and its election machinery have to make anticipatory provisions for all constituencies to face the consequences of a recall. In such an eventuality, almost every week will be election week. The time and expense involved are vital factors to be kept in mind in a vast country like India. Another apprehension is that the process can have an intimidating effect during recall campaigns as signatories may fear reprisals, effectively discouraging some voters from participating in the process. Moreover, exposed voters might feel that it is their fundamental right to participate in an electoral process while having the secrecy of their vote protected. Signed petitions will negate that secrecy, the hallmark of any election.

Despite the arguments for and against the right to recall, says Sorabjee, the problem of delinquent MPs and MLAs is real. Therefore, it is essential to find an appropriate solution to this vexed issue. The best solution, of course, would be for the electorate to give up apathy or lethargy on the day of polling and to exercise their right to vote in a wise, sensible and ethically correct manner to elect the best candidate from amongst the contestants.

Compulsory Voting

Another electoral reform often mooted in response to chronic voter apathy, especially in urban areas, is compulsory voting. My consistent view has been that compulsion and democracy do not go together. The 'electoral right' of a voter is defined in Section 171A(b) of the Indian Penal Code and in Section 79D of the Representation of the People Act, 1951 to 'mean the right of a person to stand, or not to stand as, or to withdraw from being, a candidate or to vote or refrain from voting at election'. The decision to vote or not to vote is an individual's decision in exercise of his fundamental right of freedom of expression. Even in practical terms, it is very difficult to implement compulsory voting in view of the poverty and illiteracy prevalent in the country.

Compulsory voting is enacted by law in very few countries. The number of voters in these countries is much smaller than in to India. Moreover, some countries chose to withdraw the provisions of compulsory voting after experimenting with it for some time. Besides, the experience of compulsory voting in many practising countries is reported to be not encouraging.

Compulsory voting pre-supposes some punitive action against defaulters. In the last general elections to the Lok Sabha, about 300 million registered electors did not vote. If voting is made compulsory, non-voters will have to face legal proceedings for violation of the law. Even if a nominal punishment of, say, a fine of ₹1 is to be imposed, we have to follow the due process of law and natural justice. Issuing notices to such a large number of non-voters, giving them a hearing in a court in a quasi-judicial capacity, and giving adequate opportunities for defaulters to explain why they did not vote, and then, finally, write speaking orders, is not administratively feasible. If not voting is made an electoral offence, it will mean crores of new court cases after every election, adding to the already existing millions of pending cases. Only the lawyers will be happy!

I certainly do not favour compulsory voting. It is my considered view that the objective of enhanced voters' participation can be best achieved through systematic voter education, as has been amply demonstrated in the elections held in twenty-one states between 2010 and 2013, crossing even 80 per cent voter turnout in many cases, and 93 per cent in one (Tripura). Voter education activities led to the highest ever turnout in India's sixty-year electoral history. My consistent view, that motivation and facilitation rather than compulsion are the best ways to address the issue, has been clearly vindicated.

Relevance of the First-Past-The-Post (FPTP) System

Another emerging concern flowing from low turnouts is that

of candidates being elected with just 10 to 20 per cent of the total votes in their favour. This leads many to question the relevance of our first-past-the-post (FPTP) system.

Elections to the Lok Sabha and the legislative assemblies are held from single member territorial parliamentary and assembly constituencies, through direct elections. The FPTP system is followed in these elections. Elections to Rajya Sabha and legislative councils, on the other hand, are held under the system of proportional representation through single transferrable votes. In the FPTP system followed in India, electors vote for one candidate from among all those contesting elections in their constituency. The candidate polling the highest number of votes is declared elected. The percentage of votes of the winning candidate is irrelevant. The winner may or may not get an absolute majority of votes. If two or more candidates poll the same number of votes, the winner is decided by draw of lots among such candidates.

The advantages of FPTP system include:

- It is easy to understand for electors.
- Counting is simple.
- The winner is known immediately.
- Voters can elect a representative of their choice.
- There is an identified representative for each constituency, accountable to his electorate.
- All candidates get to know their relative support in the constituency.
- The system has given, by and large, stable governments at the centre and in the states.

The main demerit of the FPTP system, often mentioned by its critics, is that candidates are able to win even with a small number of votes. However, this deficiency pales in comparison to the advantages of the system in a country as vast as India, where electoral strength touches nearly 1.5 million in parliamentary constituencies.

Critis of the FPTP strongly advocate a run-off election between the top two contenders. Their logic is that, in the existing system, candidates with even as little as 10–12 per cent of the total votes are declared winners, which is anomalous. How can such a person represent a constituency where nearly 80–90 per cent of voters have not voted for him? Unless a person gets 50 per cent plus one vote, he cannot be considered to represent the constituency. So let there be a run-off election between the top two contenders. This proposition is deceptively simplistic.

While it is true that a majority of MPs and MLAs get elected with less than 50 per cent of the total votes in a constituency, the winner always has a clear lead over all others in the fray. A lead of even one vote is valid and justifies victory—just as in an athletic race, one who is ahead of others even by a fraction of a second is a winner. It is immaterial whether the winning sprinter has done it in ten seconds or twenty. It is enough that he has beaten all others. Now to come to the question of whether there should be a run-off election between the top two contenders. What difference will it make, one may ask. A person with, say, 12 per cent of the votes may end up with 52 per cent votes cast in the second round while the runner-up gets 48 per cent of the votes cast. The winner will still be the same person. Alternatively, the person with 8 per cent of the votes in the first round may get 52 per cent of the votes in the second round. In this scenario, a person who was even less fit than the highest-scorer becomes the winner. Does it really alter the 'people's verdict' significantly? A 'useless' person gets defeated by a 'more useless' person! And supposing the total turnout is less than 50 per cent, then the winner, even in the second round, would still not have '50 per cent plus one vote".

There is also the question of the feasibility of run-off elections. I have often heard people ask 'What is the difficulty in holding a run-off election the next day while the polling team is still there?' Well, the run-off the next day is impossible for the following reasons:

i. The result of the 'first round' is known only after four–five days because after the polls the EVMs are brought to the counting centre. Then the records are scrutinized to see if a re-poll is required. At least one day is given to let all voters know the date of the re-poll and for the polling parties to go back and set up booths. After the re-poll, the EVMs are brought back again and the counting begins.

ii. The run-off, for all practical purposes, will require the full polling drill. Ballot papers on the EVMs will have to be reprinted for the two candidates. EVMs will have to be reset. For this, the EVMs will have to be brought back to the RO's office. The same elaborate security drill to accompany the EVMs and the polling parties will be required. And not to forget, these elections could be in Maoist or militancy affected states! Neither the polling staff nor the voters will find this bright idea all that bright!

Proportional Representation System

Opponents of the FPTP system advocate introducing the proportional representation (PR) system, though they have not spelt out any details about it. The PR system has several variants. One such variant, the PR system by means of single transferable vote, is already followed in India in elections to the Upper Houses, Rajya Sabha and the state legislative councils. This system will obviously not work in elections to the Lower Houses, as it pre-supposes that every elector is literate and can read and write to mark properly his or her preference against the name of the candidate of his or her choice. Even in the elections to the Upper House, a large number of ballot papers are often found invalid as they are not marked properly, though the electorate is normally quite literate. Moreover, the counting of votes under this system is so complex that despite the electorate being very small (less than 5,000), the counting sometimes takes

days, especially if the number of candidates to be elected is large. In a country like India, with electorates running into hundreds of millions even at the state level, the system has to be simple, whereby even an illiterate voter is able to exercise his franchise according to his own choice easily and in secrecy.

Constrained by these limitations, the only variant of the proportional representation system which can be considered for elections to our Lower Houses is the simple system of each voter marking only one preference, as in the present FPTP system, on a ballot paper containing the names of all the political parties in the contest and the parties then being allocated seats on the basis of the total number of votes polled for each of them. This system, known as 'List System' envisages that:

- Elections will be contested by political parties alone and independents are kept out of the fray (which itself would be a major policy decision).
- Constituencies will be multi-member—maybe, the whole state will form one constituency with a number of seats being allocated to it as per its entitlement on the basis of its population and other relevant considerations like geographical and physical features, means of communication, and so on.
- Political parties will have to submit their lists of candidates in advance and the candidates will be declared elected in descending order in that list equal to the number of seats to which that party becomes entitled on the basis of its poll performance.

This system might give relief to some smaller parties as their total votes might entitle them to a few seats (as against the current 'winner takes it all'). But the disadvantages of this system outweigh these advantages:

- The winning party itself may not get more than 50 per cent of the total votes.

- A few leaders of the parties will sit perpetually and interminably in the legislatures, as they will always put their own names on top of their party lists.
- No winning candidate will represent any particular constituency and will thus not be accountable to the people of any given area, nor will those people be in a position to approach any particular candidate for redressal of their grievances.
- Prospective candidates, instead of campaigning in the field to woo the electorate, will choose to hover around their top party leaders to woo them instead, to ensure that their names figure higher up in the party's list of candidates.
- Society will get fragmented and further divided and sub-divided on grounds like caste, creed, language, ethnicity and religion, and each such group will make parochial appeals on narrow considerations to consolidate their votes so that each such group gets some representation in legislatures.
- The legislatures thus composed of small groups may lead to instability in the formation of viable and stable governments.

Misuse of Religion for Electoral Gains

A bill was introduced in the Lok Sabha in 1994 (Representation of the People (second amendment) Bill, 1994), proposing an amendment whereby acts of misuse of religion could be questioned before a High Court. The bill lapsed on the dissolution of the Lok Sabha in 1996. The Commission has proposed that the provisions in that bill should be considered again as religious fanaticism is a serious threat to fair elections and needs to be handled with tough hands.

Amending the Law to Make 'Paid News' an Electoral Offence

The scourge of paid news is a recent phenomenon as examined in detail in Chapter 11. The Commission has proposed

amendments to the Representation of the People Act, 1951, to provide therein that publishing and abetting 'paid news' for furthering the prospects of any candidate in an election, or for prejudicially affecting the prospect of election of any candidate, be made an electoral offence under Chapter-III of Part-VII of Representation of the People Act, 1951 attracting a minimum of two years' imprisonment.

Punishment for Electoral Offences to be Enhanced

Undue influence and bribery during elections are electoral offences under Sections 171B and 171C respectively of the IPC. These offences are, however, non-cognizable offences, rendering the provisions virtually ineffective.

Under Section 171G, publishing false statement in connection with elections with the intent to affect its results is punishable with only a fine.

Section 171H provides that incurring or authorizing expenditure for promoting the prospects of a candidate is an offence. However, punishment for an offence under this section is a meagre fine of ₹500. These punishments were provided as far back as 1920. This amount may have been a deterrent ninety years ago, but is laughable now.

Considering the gravity of the offences under these sections in the context of free and fair elections, punishments under all these four sections need to be enhanced and made cognizable, if they are to serve their intended objectives.

With regard to government sponsored advertisements, there are complaints galore. The EC has, therefore, been demanding that there should be a ban on advertisements about achievements of the government for six months prior to the date of expiry of the term of the House. Essential advertisements/ dissemination of information on useful announcements like health related schemes and drought and flood measures can be exempted from the ban.

Committees and Reports on Electoral Reforms

- Goswami Committee on Electoral Reforms (1990)
- Vohra Committee Report (1993)
- Indrajit Gupta Committee on State Funding of Elections (1998)
- Law Commission Report on Reform of the Electoral Laws (1999)
- National Commission to Review the Working of the Constitution (2001)
- The Second Administrative Reforms Commission (2008)
- Election Commission of India—Electoral Reforms proposed from time to time and compiled in 2004 and 2012.

Committees

During the last four decades, there have been seven national level committees and commissions that have given a number of suggestions on electoral reforms to cleanse the political system, not to speak of the Election Commission's own recommendations and repeated reminders. These reforms have been pending with the government for decades. Meanwhile, people's faith in the political system has been steadily decreasing. If the people's declining faith in democracy is to be addressed seriously, the government must act urgently before the situation gets out of control. The writing on the wall is clear. We only need to remove our blinkers.

13

REFLECTIONS AND AFTERTHOUGHTS

In a multi-party parliamentary democracy like India, with its unparalleled social and demographic diversity, its representative character and participatory nature can be mutually reinforced only through peaceful and credible elections. If only for the lack of a better alternative, democracy's passionate advocates will always outnumber its harshest critics. Some call it a tyranny of the majority, while for others voting along with ordinary people is embarrassing. There are instances of educated elites happily enjoying all the fruits of democratic freedom and yet proudly boasting that they have 'not voted even once in life' as if it was a fashion statement. But all that is changing.

India—a Land of Contrasts

Britain's wartime Prime Minister Winston Churchill famously said that 'democracy is the worst form of government, except all those other forms that have been tried' (and failed).[1] India has a federal structure and a representative democratic system, tried and tested time and again. It makes most Indians feel proud, and rightly so. We are respected as the world's largest and most vibrant democracy, and we regularly conduct free, fair and peaceful elections that are now internationally recognized as the gold standard. And still, it seems that our elected representatives are unable to ensure good governance to the people. Why is this so? Why is the per capita income of an Indian much less than that of a neighbouring Sri Lankan or Maldivian. After sixty-five years of independence we still have

close to 300 million people living below the poverty line. We are a food surplus country, an intellectual superpower of the world, an outsourcing destination for information technology and we have an excellent array of specialized health and medical services attracting patients from highly developed countries, making us a hub of 'medical tourism'. 'Made in India' goods are now competing in quality with global brands; and we produce graduates, post-graduates, doctors, engineers and managers in millions who are now serving the world. We are a nuclear power, we have sent a spacecraft to Mars and developed an inter-continental ballistic missile system. In terms of our thriving democracy and electoral system, Delhi recently inaugurated a Chief Minister whose party was hardly an year old. To go from political non-existence to the post of top executive in a state demonstrates the vibrancy of a democratic political system.

Why then is our service delivery so poor and corrupt? As long as ordinary citizens are routinely made to run from pillar to post whilst paying bribes to petty officials for routine services like obtaining a caste certificate, a driving license, a utility connection, a land deed or even a marriage or death certificate, our lofty discussions about development goals mean nothing to citizens at large. Still, when elections are announced, political aspirants dangle carrots promising voters almost everything except the moon—a temple for the devout, laptops for students and near-free foodgrains for the poor, gold for a bride and a mixer-grinder for the housewife.

Governance and Elections

The purpose of the entire electoral exercise is to ensure that the people get the best representatives to govern them most efficiently. Does this really happen? In 1999, the Gallup International Millennium Survey interviewed 57,000 adults in sixty different countries representing 1.25 billion of the planet's inhabitants. The survey covered a wide range of topics of an

ethical, political and religious nature, focusing specifically on issues linked to democracy and governance. Less than a third of the participants said that their country was governed by the will of the people. The question, therefore, arises why do more than two-thirds of these sixty countries feel that the government does not reflect the will of the people? Why did only one out of every ten citizens say that they were satisfied with their government? Why did most people consider their own government to be corrupt?

An analysis of the survey's findings showed that a major reason for this perception was a lack of *responsive* governance. That is, governance institutions in these countries failed to demonstrate that they cared for the needs and aspirations of the people. Responsiveness is generally defined as the receptivity of public service agencies to the suggestions of citizens, demonstrated by changes to existing culture, behaviour and service delivery patterns. The other indicator of responsiveness is giving equal access and control over resources and opportunities to traditionally disadvantaged groups like women, the physically challenged, ethnic minorities and indigenous people. Political parties, unfortunately, waste a lot of time on peripheral issues instead of policy-making for citizens welfare. Over the years, even voters had resigned themselves to accepting this hopeless reality.

Popular discontent with bad governance, however, is becoming more visible now than ever before. If this trend persists, people will gradually lose faith in electoral democracy. After all, when millions in the Middle East came out on the roads, the focus of their movement was bad governance, misrule and lack of democracy!

Joshua Kvalantzick, in a thought provoking study of democratization*, Points out a disturbing trend that democracy is in decline in a variety of countries worldwide. 'Today a

Democracy in Retreat: The Revolt of a Middle Class and the Worldwide Decline of Representative Government. Yale University Press, 2013.

constellation of factors, from the rise of China to the lack of economic growth in new democracies to the Wests Financial Crisis, has come together to hinder demoracy throughtout the developing world.' Among a variety of reasons he particularly highlights the revolt of the middle class, traditionally proponents of reforms who have turnd against democracy in countries such as Venezula, Argentina, Nigeria, Kenya, Hungary, Russia, Pakistan, Thailand and Taiwan.

An Enabling Environment

The United Nations has defined development as the process of enlarging people's choices, allowing them to live long and healthy lives, to have access to knowledge, income and assets and to have a decent standard of living.[2] Each one of these elements is related to good governance. In fact, governance is the vehicle for reaching the goals of development. 'Without good governance, without the rule of law, without a predictable administration, without legitimate power or responsive regulation, no amount of funding or charity will set us on path to prosperity,' remarked UN Secretary-General Kofi Annan.

Democracy and Aam Aadmi (Common Man)

There is a broad agreement about the three defining principles of democracy: i) participation; ii) accountability; and iii) rule of law. When every citizen is in a position to a) participate in the management of public affairs, b) when everyone has the right to access information on governance activities and c) when everyone has the capacity to petition and seek redressal through neutral administrative or judicial mechanisms, then the pace of development will increase. We need only to facilitate greater civic engagement. Initiating urgent administrative, political, police, judicial and electoral reforms is the way by which our governance structures will regain credibility. Our best hope is broadening and deepening democracy through enlightened citizens' movements. The December 2013 state elections in

Delhi, Rajasthan, Madhya Pradesh, Chhattisgarh and Mizoram demonstrated that the concerns of the voters are now focused on day-to-day governance rather than politically divisive propaganda. Perception of good governance was rewarded and poor performance punished. The stunning success of the Aam Aadmi Party in the Delhi assembly elections is the most eloquent proof of this. It reminds one of Churchill's famous remark that 'at the bottom of all the tributes paid to democracy is the little man walking into the booth with a little pencil, making a little cross on a little bit of paper.' Churchill's 'little man' is no other than India's 'aam aadmi'.

Trust in Public Institutions

Political parties, originally based on ideology and social movements, steadily started losing their moorings as their focus shifted to capturing the government at any cost without delivering governance. Consequently, public trust in them began to decline. In a survey by the Centre for Developing Societies (2004), respondents were asked to indicate their level of trust in public institutions, including political parties. Interestingly, out of the ten institutions covered, on a 100 point scale, the army scored the highest (85.5 per cent) and political parties the lowest (45.8 per cent). The scores in between were: national government (79.4 per cent), the Election Commission (79 per cent), state government (73.5 per cent), local government (72.5 per cent), courts (72.3 per cent), Parliament (67.1 per cent), civil service (57 per cent) and the police (48.8 per cent). These disturbing figures should provide a wake-up call to India's political parties to improve their performance. But the ground reality is disturbing.

Tally of the Tainted

30 per cent of MPs elected in 2009 face pending criminal cases. As of January 2014, 31 per cent of MLAs in India are similarly situated. In both cases, nearly half of those facing

criminal scrutiny face charges of a serious nature. Furthermore, in many states these worrisome numbers seem to be increasing.[3] According to an analysis by the ADR, 189 (47 per cent) of newly inducted MLAs in the Uttar Pradesh assembly in 2012 had criminal cases pending against them, compared with 140 (34 per cent) in the 2007 assembly. During the 2012 state elections, Goa, Punjab and Uttarakhand also increased their tally of the tainted. Only Manipur provides a refreshing contrast; here, going by the affidavits filed, not one candidate has a criminal past.

Enriching the Rich

In Chapter 10 we saw how politics is proving to be a lucrative business. For instance, 315 of the 543 members in the Lok Sabha and 100 of the 250 members in the Rajya Sabha are crorepatis (millionaires). This has led to progressive marginalization of candidates belonging to lower economic strata, making elections a playground of the ultra rich. An analysis by Milan Vaishnav shows, moreover, how candidates with serious criminal charges get richer faster, thus establishing how money and crime go hand in hand.[4]

Mother of All Corruption

Transparency International's Corruption Perceptions Index 2011 mentions widespread public frustration with governance systems. It says that no region or country in the world is immune to the damage of corruption; a vast majority of the 183 countries and territories assessed scored below five on a scale of zero (highly corrupt) to ten (very clean.) New Zealand, Denmark and Finland topped the list for honesty, while North Korea and Somalia were at the bottom. India ranked 95 with a score of 3.1. It is no consolation that Pakistan ranked 134 with a pitiful score of 2.5, Bangladesh 120 with a score of 2.7; or that Sri Lanka ranked 86, with a score of 3.3.

The Election Commission has consistently raised the issue

of how elections have become the mother of all corruption with money mafia and opaque political funding playing a key role. While waiting for electoral reforms proposals pending with the government to be cleared, the EC decided to proceed with providing norms for an audit of political parties. It consulted the Institute of Chartered Accountants of India (ICAI) and developed a framework for audits of political parties' funds. Now, all political parties registered with the Election Commission will be mandated to apply an accrual basis of accounting, reporting all financial transactions on a real time basis, including outstanding payments that would get suppressed earlier.

It will become obligatory for all parties to submit consolidated financial statements by the end of each financial year. This statement will be published in leading newspapers detailing revenue receipts for coupons, grants, donations and contributions. Simultaneously, the EC also recommended making amendments in the First Schedule to the Code of Criminal Procedure, 1973, to make bribing voters a cognizable offence. This may substantially reduce electoral malpractices. In Chapter 10, on the role of money power, I have proposed state funding of political parties based on their electoral performance but banning all private and corporate donations. This will end the dependence of the political class on money of the corporates.

One of the first things, however, that political parties can do to change the system is promote genuine inner-party democracy. Barring a few honourable exceptions, many of them bade farewell to this principle a long time ago. The second challenge is regulating the political behaviour of their elected candidates who, bargaining for spoils of office, cross over to rival parties as easily as they are readmitted into mother parties, thereby creating a culture of 'political nomadism' or defection. The selection of best-qualified candidates is another crucial test, particularly when the number of informed voters is on the rise. Candidates with questionable antecedents cannot deliver

good governance. When they win elections with the help of 'money bags', indebted candidates invariably give out-of-turn favours to those who funded the elections. Thus, instead of fighting corruption, they breed corruption, setting a vicious cycle in motion.

Out of the 8,070 candidates who contested the general elections in 2009, 15 per cent had criminal cases pending against them. If we narrow the scope to national parties, they fared worse, with a higher average of criminal cases at 25.46 per cent. Over 60 per cent of these candidates are accused of serious crimes like murder, kidnapping and robbery. The richer the candidate, the higher his chance of winning; and when they won, their riches increased faster than the others.

Good Elections, Flawed Democracy

It is no surprise, therefore, that despite the quality of our elections, India's democracy was classified as 'flawed' by the Democracy Index 2012 of the Economist Intelligence Unit. This index has been released annually since 2006, when India ranked 35; it has since slipped to 39 in 2011, recovering by one place in 2012.

The index evaluated 167 countries based on five parameters: electoral process and pluralism, functioning of government, political participation, political culture, and civil liberties. The survey classified twenty-five countries as 'full democracies', fifty-four as 'flawed democracies', thirty-seven as 'hybrid regimes' and fifty-one as 'authoritarian regimes'. This classification itself has been questioned by many scholars as flawed and they have suggested alternative descriptions like developing, transitioning or blossoming democracy.*

However, the fact remains that there are serious issues like criminalization of politics, the role of money power in

*Source: Samar Khurshid. *Hindustan Times,* New Delhi, 27 April 2013.

elections and the resultant vicious cycle of corruption that are troubling the nation. To get to specific evaluation parameters, India performed well in electoral process and pluralism with 9.58 (out of 10), and in civil liberties (9.41). What hurt its standing was political culture (criminalization, muscle and money power) (5.0); political participation (low turnout, urban apathy) (6.11); and functioning of government (which may be supposed to include corruption, slow decision-making) (7.50). Instead of quarrelling with the *Economist* survey, it will make better sense if we focus our energies on addressing these well-known weaknesses and on expediting electoral and governance reforms. As regards political participation, the ECI's voter education programme is already making great impact, both in terms of voter registration and turnout, and ethical voting.

Fifty Plus One

Poor voter turnout leads to a low percentage of votes secured by the winners. This is often raised as a question mark against India's democracy. This was the focus of debate at a national conference at the India International Centre on 20 August 2011, titled 'Urgency of Electoral and Political Party Reforms', a subject which was of importance to us in the Election Commission. Pre-eminent panelists included, among others, the former Chief Justice of India, the late Justice J.S. Verma, Dr Karan Singh, the former Speaker of the Lok Sabha P.A. Sangma, V.A. Pai Panandiker and Subhash Kashyap, former Rajya Sabha Secretary General. All the panellists expressed great concern about the lack of representativeness in view of the progressive fragmentation and reduction of the vote share of winning candidates. A unanimous suggestion was that the first-past-the-post (FPTP) system must be replaced by a two round election to ensure that the winner has at least 50 per cent plus one vote. With all humility I had to disagree with them, pointing out the difficulties. A second round, or run-off, is actually a full-fledged election, with all its attendant administrative, logistical

and security implications. It also involves suspended animation of governance, involving teachers, students, government officials and security forces besides the all too real phenomenon of election fatigue. To me, the answer lies in higher voter turnout through voter education, motivation and facilitation. The great participation revolution in the last three years that has foxed political parties and psephologists alike has established, beyond doubt, the efficacy of voter education and has set a trend that augurs well for our democracy.

Compulsory Voting: My Views

Such a dramatic voter upsurge provides a decisive answer to the frequent demand for compulsory voting. In a few countries like Singapore and Australia, when an eligible voter does not vote, he or she may be subject to punitive measures such as fines, community service, or even imprisonment. It has been argued that India must introduce compulsory voting to counter voter apathy. Although this may sound like a good idea, the very word 'compulsory' flies in the face of freedom of expression and choice. In any election, among the non-voting citizens there will always be some who do not vote out of conviction or ideological reasons. More importantly, there are millions of daily wage earners who cannot afford to forego their wages in exchange for the luxury of voting. They cannot be called anti-state or anti-democracy and punished. Some are forcibly driven out of their homes by riots or natural disasters. How can they vote in their forced homelessness? In the recent NOTA judgement, the Supreme Court has held that abstention from voting and negative voting are protected as freedom of expression—a fundamental right. (PUCL vs Union of India, 2013).

The logistics and practicality of implementing a compulsory voting system is the other issue in a large county like India. If voting is made compulsory then obviously there must be punishment for non-compliance. In the event of a law for compulsory voting and its violation, millions of cases would

have to be lodged, virtually choking the already over-burdened legal system besides causing harassment to millions of people. On the other hand, our recent experience in voter education in twenty-two assembly elections (2010–13) proved conclusively that it is possible to increase voter participation even up to 90 per cent and above with imaginative and creative information, motivation and facilitation interventions.

Funeral or Festival?

The overwhelming voter turnout has also dealt a decisive blow to the unkind comment that the Election Commission converted an election festival into a funeral when it tightened the Model Code of Conduct and expenditure control provisions. The criticism that the Election Commission had taken the colour out of elections was misplaced.

The real festival of democracy is when voters come out to vote in large numbers without fear, something that is now happening regularly. For instance, in the coastal state of Goa an estimated 81 per cent voters cast their votes in the last elections in 2012. The previous highest voting in the state was in 2007 when 70.51 per cent had voted. Election Commission officials were in for a surprise when a booth in Dovorlim locality near Margao in Goa reported 100 per cent voting by 3.30 p.m., a good ninety minutes before the close of polling. Two booths, one in Poriem and another in Sankhalim constituency, recorded 95 per cent voting by 4.00 p.m. In fact each polling station in India has this potential through successful voter education programmes.

All twenty-two states that went to the polls in 2010–13 after the creation of the Voter Education Division had historic turnouts with twelve of them registering the highest ever. Women outnumbered men in seventeen of these twenty-two states. Youth participation confounded all politicians, psephologists and poll pundits. Election Commission's flagship program Systematic Voters Education and Electoral Participation (SVEEP) created

402 · AN UNDOCUMENTED WONDER

an unquestionable participation revolution.

The unprecedented number of people who came out to vote in these elections showcased the real festival of democracy. There are no unnecessary rules binding candidates or their supporters. In fact, many added their own colours in innovative ways. Rich political candidates concealed their expensive designer watches and Louis Vuitton bags and started sporting coarse khadi instead; old leaders started learning to tweet and 'friend' the MTV generation on Facebook; the announcement of elections introduced lifestyle changes in the dull lives of our tiring, but not retiring* politicians.

We were told of a millionaire candidate who went around on a scooter cleaning the fans of his electorate to publicize his election symbol—the fan. We saw reports of a group of young musicians from Ludhiana who put aside their usual romantic lyrics and took up social issues neglected by the government, using their music to draw attention to civic and social problems in the district. Smart neckties gave way to open collars and well-pressed kurtas, as former top cops and civil servants left the comfort of their cozy offices and well paid jobs to enter the rough and tumble of politics in the electoral battleground. Less imaginative candidates started wearing turbans to impress Sikhs, a tilak for Hindus and skull caps for Muslims. Film actors turned politicians abandoned their expensive golds, diamonds and chiffons for crumpled, humble and coarse khadi. Public school educated English speaking candidates went aggressively vernacular, picking up the local lingo to please the 'aam aadmi'. What can be more colourful, more creative and more festive?

What the ECI did not allow was long motorcades, defacement of public property or blaring loudspeakers inconveniencing ordinary citizens. It is not the ECI that came up with these rules as they were already part of the local municipal and state

*Borrowed from a famous statement of former Prime Minister Atal Bihari Vajpayee.

laws. The ECI only enforced them. It is noteworthy that the same laws that are routinely flouted acquire sudden respect and compliance during the EC's 'rule'! The positive feedback that was received clearly shows the absolute faith that the people had in our peaceful democratic process.

Yes, We Can

Innovation and imagination are two raw materials of development that never get exhausted. We are now a technology superpower and in a position to adopt and afford more creative and innovative ways of communicating and interacting with citizens. We can introduce and extend the benefits of e-governance for public service delivery. Farmers can download land records and related information from nearby information kiosks with the same ease with which they are now downloading voter enrolment forms. A comprehensive online system can track and monitor court cases from first filing to the final decision. People can apply online for education and job vouchers as well as subsidies, avoiding time, cost and the proverbial red tape. Citizens can review policy and administrative proposals online and give their inputs before they are finalized. Periodically, a government–citizen consultation mechanism can be held to obtain precious feedback about implementing development programmes that affect the people.

By now, we have a plethora of laws and rights instruments, including the Right to Information (RTI), Right to Work, Right to Education and now the Right to Food, in addition to our fundamental rights. Besides, we have recommendations on administrative, police and judicial reforms by mighty committees. But then, how many of the recommendations have been implemented and put into practice? Can we think of a mechanism to fix responsibility for the delay in implementing them? Further, while we have many bills pending in Parliament for decades, the working days in Parliament have been steadily reduced. We need to realize that this has a direct link with

404 • AN UNDOCUMENTED WONDER

governance in the country and the people's faith in democracy.

I would like to assert my feeling that is best expressed in Urdu that: '*sarkar apne iqbal se chalti hai*' (a government can run only by its moral authority). With declining political standards, the 'iqbal' (moral authority), not just of the government but also of all its institutions, is fast eroding. There was a time when one constable with a simple 'lathi' (baton) was enough to control a crowd of a thousand people. Today, it seems we need a one-to-one ratio. And there, too, the stronger guy prevails! This spells danger, if not an impending disaster.

Now, why has the moral authority of the government as an institution reached its nadir? The main reason is the erosion of credibility of the politicians as a class. The way the persons charged with criminal cases are increasingly embellishing the benches of our Parliament and Vidhan Sabhas, and the money mafia is calling the shots, is fast eroding their image and institutional integrity.

The fact that Anna Hazare could galvanize millions of people not just at Jantar Mantar but across the country to rise in revolt against corruption is a phenomenon that can not be wished away or brushed under the carpet. Every one (like Arvind Kejriwal, Kiran Bedi, Baba Ramdev, to name a few) who questioned the government and the political leaders became an instant hero. Their agitation for a powerful corruption watchdog, the Lok Pal, did not go waste. The Lok Pal Bill gathering dust for over forty years was debated in a hurriedly-called *special* session of parliament. It was eventually passed in a subsequent session. The public had tasted blood. They could now use this tactic for future causes.

But it is my strong conviction that Jantar Mantar will not, and cannot, be a substitute for Parliament. The way out of street democracy is to strengthen the institutions of democracy by restoring the credibility of the political class and weeding out the corrupt among them. And the only way to do so is through electoral reforms.

Electoral Reforms Essential for Survival of Democracy

Electoral reforms can no more be treated as one of those 'nice' things that concerned citizens keep asking for as a favour from the government. They are central to the restoration of the credibility of the politicians, the legislature and the government. The dignity of the politicians and the authority of Parliament must be restored at all costs. It is for the honest politicians, of whom they are plenty, to weed out the black sheep, not only for the national good, but in their own self interest. If they don't, the public resentment may turn into anarchy which would spell doom for our democracy. History is witness to street protests turning into revolutions. Cairo's Tehrir Square is just one recent example.

Is AAP Movement Democracy or Anarchy?

The spectacular success of the Aam Aadmi Party within a year of its birth by coming to power in Delhi, with remarkable ripple effect in many parts of the country, is but a manifestation of the people's desperation for clean and healthy democracy. Most of their leaders are young and inexperienced. Condemning them for some immature acts, born out of exuberance, and calling them anarchist is inaccurate. The frustration of a vast majority of Indians with corruption and mis-governance is a hard fact. The choice of the electoral route to channelize this anger has actually saved the country from the path of anarchy and reinforced democracy. Contesting elections is democracy, not anarchy. Besides, they have done a lot for what the electoral reforms were seeking to achieve: no criminal candidates, no play of money power, total transparency of political fund collection and no caste or communal appeal to voters.

Their concept of 'direct democracy', however, as opposed to the representative, parliamentary democracy, has the potential of anarchy. Was the assault on one of their leaders by a lynch

mob earlier a sample of direct democracy?

President's Rule During Elections

There was a time when opposition parties clamoured for the imposition of a caretaker government or the President's rule when elections were announced, to prevent parties in power from unduly influencing the electoral process. In neighbouring Bangladesh, demand for an interim, non-political government to conduct the general elections on 5 January 2104, and a boycott of the elections by the main opposition party when the demand was not met, almost brought the country to the brink of disaster. Scores of polling booths were torched and many people were killed. Such lack of trust in the election machinery spells danger for democracy. However, in India, the Election Commission has been vested with adequate constitutional authority and administrative powers to prevent the ruling parties from unsettling the level playing field in any manner during elections. Here, once the elections are announced, the police, paramilitary forces and the bureaucracy come under the jurisdiction of the Election Commission while implementation of the Model Code of Conduct neutralizes the incumbency advantage of the ruling party. Indeed the system has virtually all the trappings of President's rule! In fact, it is even better, as President's rule still means the rule of a political party at the centre, while the Election Commission is totally non-political and neutral.

There are, however, some lurking concerns.

Level Playing Field

While the entire electoral arena is based on the principle of a level playing field, some intrinsic inconsistencies in this regard are apparent. For one, independent candidates have a clear disadvantage in terms of the ceiling on election expenditure. The absence of a cap on expenditure by a political party gives

a definite and unfair advantage to party-sponsored candidates. Even among political parties, 'recognized'* parties have an advantage over non-recognized parties, in terms of free air time on All India Radio and Doordarshan (state-owned media houses), free copies of electoral rolls and a permitted number of 'star campaigners'.

The biggest setback to level play is the incumbency advantage that sitting MPs and MLAs have, thanks to the legislators' local area development funds to the tune of ₹25 crore for an MP and ₹10–15 crore for an MLA during their five-year term. With this kind of funds for investment in the constituency, often accumulated and used in the last year to make a visible impact, the challenger has a serious disadvantage.

Freebies

Desperate attempts to woo voters have led to an unhealthy war of manifestoes and a vulgar competition for freebies. While the Election Commission does everything possible to intercept bribing of voters in cash and kind, there is nothing to stop the rain of freebies through manifestoes. Even the Supreme Court found it difficult to control this, as election manifestos are a legitimate, democratic activity. It, however, made the following significant observations:

'Although, the law is obvious that the promises in the elections manifesto cannot be construed as "corrupt practice" U/S 123 of the Representation of the People Act, the reality cannot be ruled out that distribution of freebies of any kind, undoubtedly, influences all people. It shakes the root of free and fair elections to a large degree.'

Therefore, the apex court directed the Election Commission to consult all political parties and formulate some guidelines.

*The parties are 'recognized' as national or state parties, on the basis of specified vote share and the winning of seats in the Lok Sabha and Vidhan Sabha.

Most political parties, as expected, opposed the suggestion. Election Commission, however, finalized the guidelines in the light of Supreme Court* observations and the consultation with political parties and added them to the Model Code of Conduct as a separate chapter (Part VIII). These will be applicable for all future elections.

Invoking its plenary power under Article 324 ('the fountainhead of the powers') of the Constitution of India, the EC prescribed three guidelines**:

- Election manifesto shall not be inconsistent with the ideals and principles of the Constitution and the letter and spirit of the Model Code of Conduct.
- That, in the interest of free and fair elections, the political parties *should*** avoid making those promises which are *likely* to vitiate the purity of the election process or exert undue influence on the voters in the exercise of their franchise.
- In the interest of transparecny, level playing field and credibility of promises, it is expected that manifestoes also reflect the rationale for the promises and broadly indicate the ways and means to meet the financial requirements for it. Trust of voters should be sought only on those promises which are possible to the fulfiled.

It is clear that the guidelines are advisory in nature and not regulatory yet, the whimpers of some political parites were instantly audible. We will have to wait and see how it plays out in the coming general election in 2014.

*Subramaniam Balaji vs. Govt. of Tamil Nadu and others, Supreme Court, 5 July, 2013.

**www.eci.nic.in, 19 Feb 2014, Judgment dated 05.7.2013 of Hon'ble Supreme Court in SLP(C) No. 21455 of 2008 and TC No. 112 of 2011- S. Subramaniam Balaji vs. Govt. of TN & Others framing of guidelines for election manifestoes- Final Guidelines- reg.

***Emphasis added

The situation may perhaps improve when competitive populism is left with no further innovative promises once televisions, laptops, bicycles, motor cycles and mixers and grinders have saturated every home of the voters. The signs are already visible as all parties offer more or less the same stuff leaving the voter ample choice to vote for any one. Whosoever may win, the voter will get all this!

Lack of Trust in State Police

A serious concern is the decline of the faith of the people and political parties in the fairness of the local administration, especially the state police. The fact that every opposition party wants the Election Commission to bring in central paramilitary forces instead of deploying the local police speaks poorly of the state police. It was surprising that before the 2010 elections in Bihar, even the incumbent Chief Minister, Nitish Kumar, demanded the deployment of central paramilitary police, even if it would need holding elections in ten phases. Did he also mistrust his own police? The fact is that many policemen have political loyalties. I personally tried my best to motivate state police officers to use elections as an opportunity to re-establish people's faith and trust in their neutrality and fairness.

It is highly creditable that in states like Uttar Pradesh (2012), Bihar (2010) and West Bengal (2011), the state police force did a commendable job in delivering the most peaceful and fair elections ever.

Another implication of the negative image of the state police, is the resulting over-dependence on central armed police forces like CRPF and BSF, that puts an extra burden on these forces which are already deployed in harsh conditions of extremism and militancy. They are hastily drawn from their postings and sent from one phase of elections to the next, and so on, without any break or rest. This takes a heavy toll on them as seen from the high rate of attrition through premature resignations and voluntary retirements. Besides, their removal from sensitive

areas like the Maoist hinterland and militancy prone sectors and the international borders makes the security of those areas more vulnerable.

Bureaucracy and Politics

One disturbing phenomenon is the increasing politicization of a section of the bureaucracy, the police and the armed forces, as evident from the fact that many of them are jumping into the election fray, with some even resigning prematurely to contest elections. We have come across several cases of senior IAS and IPS officers hobnobbing with politicians to obtain party tickets. With political ambition burning in their hearts, they start playing havoc with the system while still in office, in favour of the party of their choice. In every state that the Commission visited before or during the elections, the opposition parties complained against such officers and we were compelled to transfer many of them. In Punjab, for instance, the DGP was accused of misusing his office to nurse his future constituency. Almost all his field visits were to his chosen district. He even promoted and strategically posted 250 policemen to build a strong support base. Of course, as suspected, he contested the elections. EC took great pains to neutralize his self-created advantage by transferring all the police personnel who had benefited from his bounty. Former government officers joining politics well after retirement is understandable and even desirable as they will bring in a high level of education and experience, but there should be a cooling off period of one or two years, as exists for civil servants joining the private sector. I had sent a proposal outlining these ideas to the Ministry of Personnel in 2012. Unfortunately and surprisingly, it was shot down. One can only hope that some day better sense will prevail.

The politicization of the armed forces is even more dangerous. Political parties should desist from hobnobbing with service officers to woo them in order to benefit from

their clean image. I hope that this evil does not spread to judicial officers too. Their entry into politics has mercifully been limited so far.

Judiciary

One of the great blessings of our electoral system has been the supportive and protective role of the higher Judiciary. Many reforms in the electoral system have come from them. The order that candidates must declare their criminal and financial antecedents at the time of filing their nomination papers has been the biggest single contribution of the Supreme Court in making elections more transparent. Now at least the voters have an informed choice. Politicians should realize that when they fail in their duty to enact electoral reforms, the Judiciary has been stepping into their political space. They cannot blame judicial activism when they have themselves become so passive and unresponsive to the signs of the time.

While the Judiciary has been a great protector of democracy, it has been disappointing in at least one area, namely, the disposal of election petitions. The Representation of the People Act, 1951, requires the High Court to decide on election petitions within six months, but all high courts, except Kerala, have been taking four to five years or more to dispose of such petitions, making the exercise worthless, since by then the impugned MP or MLA has finished his full term. And when these election petitions are dismissed as infructuous after the term of the House, such MPs and MLAs, accused of corrupt practices also escape punishment of disqualification from contesting for six years. As the upholder of all the laws of the land, this is one law that the Judiciary itself has failed to uphold. I wonder if there has been any introspection about this failure to discharge its legal obligation, which does cast a shadow on the Judiciary's own moral authority. The government and Judiciary together must address this issue either by setting up fast track election tribunals or ensuring time bound disposal.

If Kerala High Court can do it, so can the others, if they choose to.

Three Cheers for Indian Bureaucracy

Though its core structure is not large, the ECI is an expandable organization that scales up according to the need of the hour. The law empowers it to draw staff from local authorities both for revising the rolls and for conducting elections. The ECI's permanent staff numbers less than 400 including the three Election Commissioners, three Deputy Election Commissioners, three Directors General, other staff at the Commission's headquarters and thirty-five Chief Electoral Officers heading operations at the state level. More than 8,00,000 Booth Level Officers (BLOs), are designated year round for electoral roll related work, but are in fact government staff members whose real or substantive postings are in various government departments; election work is an addition to their 'day jobs'.

Now, take the case of parliamentary elections in 2009, for which a huge contingent of over 11 million government employees was taken by the ECI as polling staff, supervisors, micro-observers, security personnel, etc. The law provides that this entire staff shall be deemed to be 'on deputation' during elections. In effect, this means that the ECI becomes their disciplinary authority during this period. The ECI takes this mantle very seriously. There are several cases of disciplinary action being taken against officers irrespective of seniority. The prime criterion is neutrality and non-partisanship that is ensured with a policy of 'zero tolerance'.

Year after year and election after election, the same bureaucracy that is often criticized for its non-performance in the delivery of public services gives near perfect elections to the country.

Three cheers for Indian Bureaucracy!

While this book was in the press, a bitter debate about fudged

opinion polls that affect free and fair polls hit the headlines.

A sting operation by a TV Channel, News Express, exposed fraudulent manipulation of the opinion polls by as many as eleven research agencies.

Salient Points of Operation Prime Minister

- Agencies were ready to manipulate the margin of error in return for money. They were ready to increase or decrease the margin to favour particular parties. The standard margin of error is 3 per cent but they were ready for 5 per cent.
- Opinion poll agencies were ready to increase the number of seats to favour a particular party and decrease the seats of their opponents. They were ready to project the upper limit too.
- They were ready to manipulate the sample size in favour of a particular party or individual.
- Agencies also agreed to delete the negative samples in return for money.
- Some agencies agreed to facilitate publishing or airing of opinion polls in print or news television channels.
- Few agencies even offered to field dummy candidates to make the chances appear bright for the paying candidate.
- They were even ready to provide the same data to different political parties by creating a new entity overnight.
- They demanded money to be paid in cash.
- They were ready to provide two reports: one which is actual and other which is fudged to favour a particular party.
- They agreed to favour particular individual leaders.

This revived a demand from all (but one) political parties to ban opinion polls before the elections. Most media—TV and print—immediately jumped into the act, calling the idea of a ban all kinds of names. They called it illegal, 'dictatorial', attack on freedom of expression, authoritarian and a regulatory mindset. Some went to the extent of calling it stupid, irrational

and immoral. Interestingly, these worthies forgot all about the sting operation itself. Not a word was uttered about the fraud that was going on in the name of opinion polls. No comment on the modus operandi that the fraud perpetrators revealed with gay abandon to convince the decoy customer not wanting to lose him. No discussion on its magnitude, its consequences, strategies to prevent it in the future.

Guess who was found standing in the dock, or witness box? Not the fraudsters but the EC!

Five Essential Electoral Reforms

The ECI has been suggesting the following reforms that have the potential to be game changers in establishing a healthy democratic culture in the country:

- Barring candidates facing serious criminal charges from contesting elections by amending the Representation of the People Act, 1951.
- Bringing transparency to political funding by auditing the accounts of all registered political parties through CAG (Comptroller and Auditor General of India) and putting the audit reports in public domain.
- Ensuring transparent inner-party democracy by making annual elections mandatory for office-bearers at all levels and considering tenure limits for political party executives.
- Checking the role of unaccounted and tainted money in the elections by replacing corporate and political donations by a transparent state funding based on electoral performance.
- Making the Election Commission of India stronger with a budget charged to the Consolidated Fund of India, ensuring full financial autonomy and making the selection process to the Election Commission more participatory involving a collegium. This will lend it greater public trust and insulate it from unwarranted finger pointing.

While independence and neutrality constitute the soul of

any election management body, public faith and trust are paramount. Of course, a certain amount of hue and cry is expected when strong action is taken against the errant, as is experienced from election to election. It would be suicidal for the ECI to dither or be diffident while carrying out its sacred duty assigned by the Constitution. Because of its time-tested authority, sanctity and authenticity, the Election Commission of India has already emerged as a global brand of hope for fledgling democracies. As such, our process needs continuous reappraisal and reinforcement if the largest democracy on the planet also aspires to be its greatest democracy.

The general elections to the Lok Sabha in 2009 were the biggest elections in world history. But that record will soon be eclipsed by the forthcoming general elections in 2014. In five years, we have added nearly 100 million voters, one lakh polling booths, 1.2 lakh EVMs, a voter verifiable paper audit trail* and one million officials to the system. As portended by the creation of the National Voters' Day, the youth are now enrolling in droves. Programmes like India Voting exemplify urban and corporate India joining the efforts. This is a great sign of a vibrant democracy. Judging from the overwhelming public response to the ECI's SWEEP programme, we can expect all previous records of voter turnouts to be broken. I congratulate the Election Commission for the great work they have done till date and the fabulous work I know they will do in the coming months.

Long live the festival of democracy!

Notes

1 Winston S. Churchill: *His Complete Speeches, 1897–1963*, ed. Robert Rhodes James, vol. 7, p. 7566 (1974).

*Voter verifiable paper audit trail (VVPAT) will be implemented in a few select constituencies.

2 Sabina Alkire. 'Human Development: Definitions, Critiques, and Related Concepts.' United Nations Development Programme, Human Development Reports Research Paper 2010/01, June 2010.

3 Trilochan Sastry. 'Towards Decriminalisation of Elections and Politics,' *Economic and Political Weekly* 49.1 (2013): pp. 34–41.

4 Milan Vaishnav. 'Crime but No Punishment in Indian Elections,' Carnegie Endowment for International Peace (2013). Available at: http://carnegieendowment.org/2014/01/24/crime-but-no-punishment-in-indian-elections/gz9k.

ACKNOWLEDGEMENTS

This book is a labour of love not just for me but for a number of my friends and well wishers who made it happen.

Material for the content was made available by my colleagues in the Election Commission, particularly (in alphabetical order) Akshay Rout, Alok Shukla, Anita Karwal, A.W. Wilfred, P.K. Dash, S.K. Mendiratta, Umesh Sinha, Vinod Zutshi, and many others. My friend Pranjoy Guha Thakurta helped me with the chapter on the media.

Dr Bhagbanprakash was the key figure in the entire effort, starting with motivation, and almost forcing me to undertake the project.

My gratitude to Mr N. Ram and *The Hindu*, Mr Shekhar Gupta and *The Indian Express*, Mr Chandan Mitra and *The Pioneer*, Mr Raj Chengappa and *The Tribune* for allowing me the use of pictures, text and images. I thank Mr Sudhir Tailang for his cartoons.

My daughter and resident critic, Sarah, helped with the editing, and son Mustafa sourced a number of photographs from his friends and colleagues. Renuka Puri and Neeraj Priyadarshi were particularly generous.

Dr Milan Vaishnav, Associate, South Asia Program, Carnegie Endowment for International Peace, and Yusuf Neggers, PhD. Candidate in Public Policy, Harvard University, did a last minute check and offered valuable inputs including citations.

Ahmad, Amit, Manoj and Vinod Thanakchan helped in typing and re-typing the various drafts. Jeevan Kanakkaserry was a great help in carrying out the corrections. Padma Angmo provided timely assistance to update media related information from time to time.

Thanks to Mr Vinod Mehta for suggesting the publisher, Rupa Publications India and Mr R.K. Mehra and Kapish Mehra for agreeing to accept it despite an extremely tight schedule. Their professional team took up the challenge without flinching.

Parvati Sharma worked extremely hard to edit the manuscript and helped with the style and consistency, constantly fighting against the clock. Hitesh Barot chipped in with valuable suggestions.

I am most grateful to Mr Gopal Gandhi for writing the Foreword and his appreciation of the efforts of the Election Commission for keeping the world's largest democracy on the rails.

My blanket apologies to those others whose help I am unable to acknowledge individually for lack of time and space.

REFERENCES

Landman, Todd (Ed.). David Beetham et al. *Assessing the Quality of Democracy: An Overview of the international IDEA Framework*, Stockholm: IDEA, 2008.

Mill, John Stuart. *Considerations on Representative Government*, London: 1861.

Muhlberger, Steven and Phil Paine. 'Democracy's Place in World History', *Journal of World History*, Hawaii: University of Hawaii Press, 2006.

Popper, Karl R. *The Open Society and its Enemies*, New Jersey: Princeton University Press, 1966.

'The Party System and Collective Action for State Funding of Elections: A Comparative Perspective'. *The Journal of Policy Reform*, Vol–3, Issue 3, 1990.

Governance Now, July 16–31, 2011, Vol–2, Issue 12.

//www.questia.com/library/book/principles-of-social-and-political-theory-by-ernest-barker.jsp

INDEX

in rural areas, 132
signature campaign, 132
SMSes, use of, 140, 162
social media, use of, 139–140
voter awareness marathon,
132
voter awareness vehicles, 132
Young Voters Festival,
143–144
Muhlberger, Steve, 6
Mukherjee, Pranab, 99
Murthy, T.S. Krishna, 360
Myanmar (Burma) democracy, 12
MyKartavya, 100

Nagaswamy, Dr, 7
Naidu, Sarojini, 100
Narayan, Jayaprakash, 22, 129,
211
National AIDS Control
Organization (NACO), 116
National Curricular Framework
(NCF), 118
National Policy on Education
(NPE) of 1992, 118
National Service Scheme (NSS),
116, 134, 219, 230
National Voters' Day (NVD), 33,
99, 116–117, 209, 223–227,
313
National Youth Policy (NYP) of
2003, 118
Nayar, Kuldeep, 332
Nehru, Prime Minister, 10
Nehru Yuva Kendra Sangathan
(NYKS), 104, 116, 134, 219,
225

Nepal democracy, 12
New Voters' Day, 117
'no losers' ethos, 14
nomads in India, 109
*N.P. Ponnuswami vs Returning
Officer, Namakkal*, 56

Obama, President Barack, 85
Odisha Nagarik Samaj, 118
one-party rulers, 14
Operation Prime Minister, 413
opinion polls, 337–341

paid news and elections, 268,
278, 325–333, 389
detecting, 326
mafia, role of, 333–335
'rates' for publishing 'news'
items, 326
and self-regulation, 332
Pakistan democracy, 11
Parantaka, Chola King, 7
party-based democracy, 18, 22
party-less democracy, 22
Patil, President Pratibha, 238,
288
personnel management, 77–78
Photo Electoral Rolls (PERs),
172–173, 183
Pillai, Gopal, 168
Plato, 25
political financing, 261–262, 271
political systems and electoral
behaviour, 14
poll day security, 163–164
polling officers' kit, 78–79
polling personnel, safety and